A HISTORY OF WRITING

Editorial coordination: Sophie Chambonnière
Editorial assistant: Marc Feustel
Translated from the French by Josephine Bacon (pp. 17–65, 168–284),
Deke Dusinbere (pp. 8–14, 287–303, 308–309, 312–394), and Ian McMorran (pp. 66–167),
and from the Italian by David Stanton (pp. 310–311)
Copy-editing: Special Edition Pre-press Services, London
Proofreading: Kate Lancaster
Design and typesetting: Yves Renaud, Paris
Color separation: Colorway, Arras, France

Originally published as *Histoire de l'écriture: De l'idéogramme au multimedia*
© 2001 Flammarion
English-language edition
© 2002 Flammarion

ISBN 2-0801-0887-5
FA0887-02-X
Dépôt légal: 10/2002

Printed in Spain

A HISTORY OF WRITING

from hieroglyph to multimedia

Edited by Anne-Marie Christin

Flammarion

CONTENTS

INTRODUCTION : FROM IMAGE TO WRITING. *Anne-Marie Christin*8

I. ORIGINS AND REINVENTIONS

THE PRECURSORS OF THE WRITTEN WORD IN THE DANUBE RIVER BASIN. *Michaël Guichard*17

CUNEIFORM SCRIPT. *Jean-Marie Durand*20

HOW CUNEIFORM SCRIPT WAS DECIPHERED. *Michaël Guichard*33

THE MESOPOTAMIAN SCRIBES. *Dominique Charpin*36

THE SCRIPTS OF ANCIENT EGYPT. *Pascal Vernus*44

ADAPTATION OF SCRIPT TO MONUMENTS. *Pascal Vernus*64

WRITING IN CHINA. *Léon Vandermeersch*66

THE PRACTICE OF CHINESE CALLIGRAPHY. *Léon Vandermeersch*86

FROM PYROSCAPULIMANCY TO WRITING. *Léon Vandermeersch*90

THE SCRIPTS OF CONTINENTAL INDIA. *Georges-Jean Pinault*92

WRITING IN JAPAN. *Pascal Griolet*122

THE WRITING IN THE PICTURE. *Jacqueline Pigeot*142

PICTURES IN WRITING. *Marianne Simon-Oikawa*145

BUDDHIST WRITINGS IN SOUTHEAST ASIA. *Catherine and François Bizot*148

THE KOREAN ALPHABET. *Daniel Bouchez*154

VIETNAMESE SCRIPT AND SOCIETY. *Nguyên Phu Phong*156

PRINTING AND THE REPRODUCTION OF THE WRITTEN WORD IN THE FAR EAST. *Jean-Pierre Drège*158

THE JAPANESE PRESS. *Cécile Sakai*166

MAYAN SCRIPT AND SOCIETY FROM THE SECOND THROUGH THE TENTH CENTURIES. *Michel Davoust*168

NAHUATL SCRIPT. *Marc Thouvenot*179

A MIXTEC MANUSCRIPT. *Martine Simonin*188

THE PERUVIAN QUIPUS. *Danièle Lavallée*190

RONGO-RONGO: THE EASTER ISLAND SCRIPT. *Michaël Guichard*192

II. ALPHABETS AND DERIVED SCRIPTS

AEGEAN SCRIPTS OF THE SECOND MILLENNIUM BCE. *Jean-Pierre Olivier*197

THE ORIGIN OF THE WESTERN SEMITIC ALPHABET AND SCRIPTS. *André Lemaire*203

THE *ALEPH* OF THE KABALISTS. *Charles Mopsik*216

ARABIC SCRIPT. *François Déroche*218

WRITINGS IN THE MARGINS OF ARABIC MANUSCRIPTS. *Jacqueline Sublet*228

THE GREEK ALPHABETS. *Catherine Dobias-Lalou*232

INSCRIPTIONS ON GREEK VASES. *François Lissarrague*241

THE SCRIPT OF ANCIENT ITALY. *Dominique Briquel*244

INSCRIPTIONS ON COINAGE. *Michel Amandry*254

CHRISTIAN ALPHABETS OF THE CAUCASUS. *Jean-Pierre Mahé*256

CYRILLIC SCRIPT. *Vladimir Vodoff*264

RUNIC SCRIPT. *François-Xavier Dillmann*271

OGAMIC SCRIPT. *Pierre-Yves Lambert*276

THE SCRIPTS OF SUB-SAHARAN AFRICA. *Jean Boulègue and Bertrand Hirsch*278

III. THE IMAGE IN WESTERN WRITING

WRITING IN THE MIDDLE AGES. *Michel Parisse*287

THE BOOK OF KELLS. *Jennifer O'Reilly*304

A MEDIEVAL STAGE MANAGING BOOK. *Darwin Smith*308

FORMS AND HISTORY OF WRITING IN ITALY. *Armando Petrucci*310

SPELLING IN FRANCE: TEXTS AND STYLE. *Nina Catach*312

SIGNATURES. *Béatrice Fraenkel*315

URBAN FORMS OF WRITING IN THE EIGHTEENTH CENTURY. *Daniel Roche*318

LETTER WRITING IN FRANCE IN THE SIXTEENTH TO EIGHTEENTH CENTURIES. *Roger Chartier*320

LETTER WRITING IN FRANCE IN THE NINETEENTH CENTURY. *Cécile Dauphin*322

FRENCH AND ENGLISH PRIMERS IN THE EIGHTEENTH AND NINETEENTH CENTURIES. *Ségolène Le Men*326

LITERACY IN WESTERN SOCIETIES. *Béatrice Fraenkel*329

THE MATERIAL SURFACE OF MODERN LITERARY MANUSCRIPTS. *Claire Bustarret*332

FLAUBERT: THE LABOR OF WRITING. *Pierre-Marc de Biasi*340

RAYMOND QUENEAU: THE FORM AND MEANING OF A MANUSCRIPT. *Emmanuel Souchier*342

THE RISE OF PRINTING IN THE WEST. *Henri-Jean Martin*344

THE HISTORY OF TYPOGRAPHIC FORMS IN EUROPE. *René Ponot*362

TYPOGRAPHIES FOR CHILDREN. *Annie Renonciat*366

LETTERING ON POSTERS. *Anne-Marie Christin*372

VISUAL POETRY, PAINTERS' BOOKS. *Anne-Marie Christin*376

DIGITAL FORMS OF TYPOGRAPHY. *Jacques André*384

WRITING AND MULTIMEDIA. *Yves Jeanneret*386

General Bibliography395

Index397

Photographic Credits403

Acknowledgments405

AUTHORS

Michel Amandry is chief librarian and director of the Cabinet des Médailles at the Bibliothèque Nationale de France.

Jacques André is a senior researcher with the Institut National de Recherche en Informatique et en Automatique, France.

Pierre-Marc de Biasi is a senior researcher with the Centre National de la Recherche Scientifique, Paris.

Catherine Bizot is an inspector general at the French Éducation Nationale.

François Bizot is director of studies at the École Pratique des Hautes Études (Section V), France.

Daniel Bouchez is senior researcher emeritus with the Centre National de la Recherche Scientifique, Paris.

Jean Boulègue is a professor at the Université de Paris I.

Dominique Briquel is a professor at the Université de Paris IV and director of studies at the École Pratique des Hautes Études (Section IV), Paris.

Claire Bustarret is a researcher with the Centre National de la Recherche Scientifique, Paris.

Nina Catach (†) was a senior researcher with the Centre National de la Recherche Scientifique, Paris.

Dominique Charpin is a professor at the Université de Paris I and director of studies at the École Pratique des Hautes Études (Section IV), Paris.

Roger Chartier is director of studies at the École des Hautes Études en Sciences Sociales, Paris.

Anne-Marie Christin is a professor at the Université de Paris VII.

Cécile Dauphin is a researcher with the Centre National de la Recherche Scientifique, Paris.

Michel Davoust is a researcher with the Centre National de la Recherche Scientifique, Paris.

François Déroche is director of studies at the École Pratique des Hautes Études (Section IV), Paris.

François-Xavier Dillmann is director of studies at the École Pratique des Hautes Études (Section IV), Paris.

Catherine Dobias-Lalou is a professor at the Université de Bourgogne, France.

Jean-Pierre Drège is director of studies at the École Pratique des Hautes Études (Section IV) and director of the École française d'Extrême-Orient, Paris.

Jean-Marie Durand is a professor at the Collège de France and director of studies at the École Pratique des Hautes Études (Section IV), Paris.

Béatrice Fraenkel is director of studies at the École des Hautes Études en Sciences Sociales, Paris.

Pascal Griolet is an associate professor at the Institut National des Langues et Civilisations Orientales, Paris.

Michaël Guichard is an associate professor at the Université de Paris I.

Bertrand Hirsch is director of the Centre de Recherches Africaines and associate professor at the Université de Paris I.

Yves Jeanneret is a professor at the Université de Paris IV.

Pierre-Yves Lambert is director of studies at the École Pratique des Hautes Études (Section IV), Paris.

Danièle Lavallée is a senior researcher with the Centre National de la Recherche Scientifique, Paris.

André Lemaire is director of studies at the École Pratique des Hautes Études (Section IV), Paris.

Ségolène Le Men is director of literary studies at the École Nationale Supérieure-Ulm and a professor at the Université de Paris X.

François Lissarrague is director of studies at the École des Hautes Études en Sciences Sociales, Paris.

Jean-Pierre Mahé is a member of the Institut de France and director of studies at the École Pratique des Hautes Études (Section IV), Paris.

Henri-Jean Martin is director of studies at the École Pratique des Hautes Études (Section IV), Paris.

Charles Mopsik is a researcher with the Centre National de la Recherche Scientifique, Paris.

Nguyên Phu Phong is director of studies at the École Pratique des Hautes Études (Section V), Paris.

Jean-Pierre Olivier is a senior researcher with the Fonds National de la Recherche Scientifique, Université Libre de Bruxelles, Belgium.

Jennifer O'Reilly is a professor at the National University of Ireland, Cork.

Michel Parisse is a professor at the Université de Paris I.

Armando Petrucci is a professor at Scuola Normale Superiore di Pisa, Italy

Jacqueline Pigeot is professor emeritus at the Université de Paris VII.

Georges-Jean Pinault is director of studies at the École Pratique des Hautes Études (Section IV), Paris.

René Ponot is a researcher with a doctorate in the semiology of typography.

Annie Renonciat is an associate professor at the Université de Paris VII.

Daniel Roche is a professor at the Collège de France.

Cécile Sakai is a professor at the Université de Paris VII.

Marianne Simon-Oikawa is a guest professor at Keio University, Tokyo.

Martine Simonin is a researcher.

Darwin Smith is a researcher with the Centre National de la Recherche Scientifique.

Emmanuel Souchier is an associate professor at the École Nationale Supérieure des Télécommunications, Paris.

Jacqueline Sublet is senior researcher emeritus with the Centre National de la Recherche Scientifique, Paris.

Marc Thouvenot is a researcher with the Centre National de la Recherche Scientifique, Paris.

Léon Vandermeersch is director of studies at the École Pratique des Hautes Études (Section V) and the former director of the École Française d'Extrême-Orient, Paris.

Pascal Vernus is director of studies at the École Pratique des Hautes Études (Section IV), Paris.

Vladimir Vodoff is director of studies at the École Pratique des Hautes Études (Section IV), Paris.

INTRODUCTION

FROM IMAGE TO WRITING

Anne-Marie Christin

In the 1820s Jean-François Champollion discovered that Egyptian hieroglyphics employed a phonetic system in addition to being composed of "figures," thus offering the West access to texts that had remained impenetrable for nearly two thousand years (Fig. 1). But he thereby provided a brutal, unanticipated refutation of one of the West's most tenacious beliefs: that only an alphabetic system was able to transcribe the sounds of a given language. This belief had resulted in the flattering if hasty conclusion that the alphabet, having emerged last, must be best.

Yet neither Champollion nor his contemporaries seem to have been troubled by this revelation. Opening the door to a civilization that had played such an important role in history as that of pharaonic Egypt probably made any preliminary stages in its development appear secondary or unworthy of great attention. Another explanation, however, can be offered for this oversight. Seeking the causes of the existence of purely phonetic values within a system of writing clearly dominated by analogical transpositions would have swiftly led to the recognition that this apparent incoherence was not due to the *verbal* functions of the system but related, instead, to the *images* and notably to the overall visual surface. But given the mentality of the era, such a supposition was literally inconceivable. Indeed, not only did Western culture, shaped by centuries of absolute confidence in the unique virtues of an alphabetic system, deal with writing solely from the standpoint of phoneticism—as though that were its exclusive criterion—but the West adopted a systematic breaking down into letters—or "elements"—as the universal basis of every composition, whatever it may be. Imagery had been the first victim of this tendency, as witnessed by the advice given by Leon Battista Alberti in his treatise of 1435, *On Painting:*

I should like youths who first come to painting to do as those who are taught to write. We teach the latter by first separating all the forms of the letters which the ancients called elements. Then we teach the syllables, next we teach how to put together all the words. Our pupils ought to follow this rule in painting. First of all they should learn how to draw the outlines of the planes well. Here they would be exercised in the elements of painting. They should learn how to join the planes together. Then they should learn each distinct form of each member and commit to memory whatever differences there may be in each member.[1]

Such faith in the exemplary value of the alphabet was inevitably paradoxical: while it imposed a definition on images that was never intended for them (nor, a priori, guaranteed to suit them), it seemed to want the alphabet to benefit from the authority of that very imagery, thus implicitly admitting the existence between them of a hierarchy directly opposite to the one it was trying to promote. True enough, Alberti's advice was not a mandatory injunction—for that matter, we know that few painters followed it, except perhaps Mantegna. It was, above all, revealing of Western society's fundamental difficulty in theorizing images, due to our own system of writing.

The alphabet we inherited from the Greeks owes its originality to the fact that, for the first time, syllabic notation found itself broken down into phonemes, consonants and vowels—it was also the first system (and would remain the only one) to have broken the links that until then had tied all writing systems to the surface on which they appear, and, inevitably, to the objects to which they refer. Obviously, it is hardly surprising that the alphabet convinced its users (and,

Fig. 1. Jean-François Champollion's chart of "phonetic hieroglyphs," from *Grammaire égyptienne, ou principes généraux de l'écriture sacrée égyptienne ...* (Paris: Firmin-Didot, 1836–1841), Chapter II, p. 35.

even more so, its theorists) that this break constituted a gain rather than a loss. The gain was partly real, in fact, although for reasons unrelated to writing's initial vocation: by freeing itself from the visible and manipulable space that had always governed it, writing became an almost abstract tool of classification and, consequently, all the more trustworthy. We should not be misled by the Romans' definition of an alphabet as "a representation of speech," which in no way conveys the inventors' concern to clarify the role of images in the alphabetic system. The definition stemmed from the arbitrary application of a concept of verbal origins on those images, inappropriately applied to writing as though it had been derived from it. In fact, this definition betrays the visible

even as it pretends to pay tribute to it. Paul Valéry sarcastically denounced this approach in his *Introduction à la méthode de Léonard de Vinci*:

> Most people see far more often with their intellect than with their eyes. Instead of colored spaces, they become aware of concepts. A whitish, cubic shape—tall and dotted with glassy reflections—immediately becomes for them a house: the House! ... They generally perceive according to their vocabulary rather than according to their retina ... They delight in a concept that teems with words.[2]

To speak of "representation" when referring to writing therefore misses the point of both images and writing. What was truly novel and groundbreaking in the development of the alphabet was not that it *represented* speech, but rather that it made speech *visible* (to echo Paul Klee's words, "art does not reproduce the visible but makes visible"). This approach was, in itself, profoundly revolutionary and, consequently, required all the more motivation on the part of its promoters, which is why it surfaced only sporadically and did not spread to every civilization, at least not in a spontaneous fashion. The problem, in fact, was how to combine two methods of communication that were indispensable to every society but whose operating principles were mutually incompatible: speech and imagery. Speech enabled a group to maintain its internal structures and myths, and to hand them down from one generation to the next. Imagery—whether as images per se or as oneiric hallucinations that provided access to the invisible, that is to say to the hereafter—was the only way humans could access a world where their language was not spoken. It nevertheless transpired that in different parts of the world, at various periods—3000 BCE in Mesopotamia and Egypt, 1,500 years later in China, and, for the most recent known example, 300 CE in the Mayan culture—certain civilizations felt the need (or found the opportunity) to employ the imagistic means of conducting *transgressive communication* between humans and gods for the sole benefit of human society. They attempted to adapt these means to the verbal nature of human communication, either because members of the society found themselves temporarily separated from one another, or because of the diversity of dialects being used used at the time, or, finally, because it was felt that archives could mitigate the vagaries of everyday memory.

Writing was born of a hybrid process, and it is this hybrid aspect that *The History of Writing* aims to emphasize. The main center of interest is nevertheless the role played by images in the birth and development of this

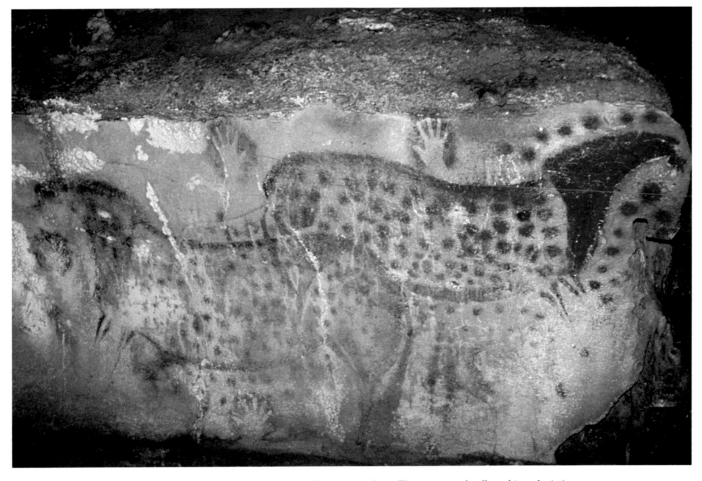

Fig. 2. Cave painting in Pech-Merle, France. Gravettian culture. This segment of wall combines depictions of horses, hands in negative, and black spots arrayed not only within the bodies of the horses but also across the whole surface.

crossbred system, a role that the West's alphabetic culture has so stubbornly helped to mask (the definition of images on which writing is based is foreign not only to the alphabet-based hybrid categories devised by Alberti but also to the conceptual representation stigmatized by Valéry). If Egyptian hieroglyphs had a phonetic value, it was not because certain specially designated figures in Egyptian iconography were employed to that effect. Instead it was because the space in which the iconography was inscribed had itself been conceived—for reasons that escape us—no longer as a medium for anecdotes but as a surface that could potentially host future, written, forms of language in such a way that it naturally became the site of syntactic transformations of these figures once they themselves had mutated—in a manner also all their own—into verbal signs.

The conditions behind such a mutation can only be made clearer or understood from the information that prehistoric frescoes provide about their own genesis. I would like to review here briefly a few hypotheses on this question that I have developed elsewhere.[3] The first puts forward the argument that humans initially had the simultaneously abstract and bold idea—it had no other model than the vault of the starry sky linking them to the afterlife—of conceiving certain surfaces as continuous and taking into consideration only their appearance. They would further delimit these surfaces by coating them in white or by sanding them (as at Lascaux and Pech-Merle, respectively, in the southwest of France). This idea of the screen as a surface for image-making is as typical of *Homo sapiens* as the mastery of language; from it would follow (several millennia later) two other major developments, agriculture and geometry. These human screens offered to the gaze of gods were not only spaces of induced communication with the invisible but also sites of creativity. The hand-prints found there illustrate in a disconcerting and moving fashion the basic conversion undergone by human gestures, henceforth

affirmed not only through the making of objects and tools but also in the elaboration of spectacles linking humans to the hereafter.

Specialists in prehistory such as Denis Vialou have noted that most of the figures etched or painted on cave walls are heterogeneous in nature—figurative representations are found side by side with symbolic forms and marks of purely ritual or rhythmic value (Fig. 2). This forces us to recognize that an apparently "realistic" parietal representation is meaningful not simply on the basis of the reality that it depicts but also through its association with the figures found nearby, all of which are part of a signifying ensemble. It is hardly surprising that the meaning escapes us: its thematic heterogeneity—which is usually accompanied by graphic heterogeneity—is part of a thought process specific to imagery, one more related to enigmas than to explicit messages and one that rests on strict conventions established by the society that produces them. It should be possible, on the other hand, to define the syntactic principles on which such compositions are based. If prehistoric fresco figures "hold together" despite multifarious references, it is in fact because their cohesion is assured by elements that themselves possess an autonomous status, namely the *intervals*—emanations of the surface of the wall—that separate them from one another yet also serve to orchestrate them. The intervals of an image are also those of the figures themselves, which are implicated in an appreciation of the space to be contemplated or scanned—a spatial appreciation that is not concerned with the narrative code or any language-based fiction. In looking from one figure to another the viewer questions their relationships and, by striving to intuit the scope of their association, ultimately masters it.

Such painters as Jean Dubuffet and André Masson have provided useful insight into the crucial role played by intervals in imagery. And no one has been more enlightening than Henri Matisse on the nature of ideograms as graphological signs produced by images that place themselves at the service of speech. "I cannot play with signs that never change," he said in explanation of his aversion to the game of chess.[4] Matisse thus unwittingly opposed Ferdinand de Saussure who, on the contrary, based his system of semiology on the fixed values of that game. But Saussure was speaking as a linguist—that is to say, as a man for whom the specific medium and graphism of words had no value, a man who used the alphabet to justify his disdain: "Whether I write letters in white or black," he stated, "in intaglio or relief, with a pen or chisel, it is all insignificant to their meaning."[5] For Matisse, the ability of signs to drift was not just an obvious fact, it was a prerequisite, because it reflected the necessity for a space where creativity could thrive.

In truth, an ideogram is not strictly speaking "a sign that changes." Rather, it is *a sign to be questioned*. Instead of being defined primarily in juxtaposition with its neighbors (like a letter of the alphabet) or remaining exclusively attached to a specific figure (like a pictogram), an ideogram offers readers three different verbal values (at least in theory—the reality varies as a function of the cultural choices specific to a given society): as logogram, for example when the word "pear" corresponds to the sign depicting it; as phonogram, for example when the same drawing refers to a homophone (pair, pare); or as key (or determinative), for example when it is linked to another ideogram in order to indicate the lexical category of the latter, in this instance the category of "fruit." It is only by examining both the semantic and the spatial context of the message—which may entail, as it did in Mesopotamia, the very shape of the tablet on which the message was written—that the reader will discover the complementary information required to make a decision.

Divination played a determining role in the mutation of images into writing, as demonstrated by Jean-Marie Durand (for the Mesopotamian region) and Léon Vandermeersch (for China). Indeed, divination introduced two new concepts to iconic communication. The first was the idea that, via certain highly symbolic media—a lamb's liver in Mesopotamia or a tortoise shell in China (both of which were viewed, in fact, as mirrors of the heavens)—the gods had invented a system of signs enabling them to send true visual messages to humans. The second was the appearance of soothsayers or diviners, those "super-readers" of divine writing; their job was no longer the same as the manipulative, material one of the miracle-producing magus, nor were they quite the same as prophets (who were expected to advocate their own reading, doomed to remain silent, to society). The sacred enigma of images had become *legible text*. So it was henceforth possible to use this system for the language of humans—especially since its origin was, in fact, entirely human—and thereby appropriate the writing of the gods.

What role did images play in the development of writing systems that succeeded ideograms? The question is less straightforward than it appears given that, first of all, none of the newer systems—including the Greek alphabet—imposed themselves as rivals to the one that preceded them; they appeared rather as variations, in which the image-language hybrid had adopted a different form in order to be more efficient. Moreover, the adaptation of an existing writing system to a language with different structures has always triggered unpredictable visual inventions alongside the inevitable linguistic readjustments, often in support of the latter, the case of Japan probably being one of the most spectacular and most complex. So in trying to

answer this question, *The History of Writing* approaches the issue as a function of the viewpoint that each specialist wished to adopt, either because that viewpoint seemed most relevant to the specific field or because the analysis behind it seemed more innovative. Depending on the case, then, special emphasis may be placed on the material forms of writing (from manuscript to printed books, from standard usage to individual practices, notably calligraphic); or on the distinction established between "scribe" and "literate reader" and the authority invested in each by the societies that invented their roles; or, finally, on methods of dissemination and preservation of writing as related to institutions and power—whether political or religious—plus the problems of decipherment raised by a given writing system. There is no question of being exhaustive here; such a claim would be absurd given that each writing system obviously calls for more than a single chapter, however soundly it may be argued. Each specialist was nevertheless asked to respect the main orientation of stressing the visual aspect, in whatever form it manifested itself, of the system under discussion.

The final section of this volume is devoted to the presence of images in modern and contemporary Western writing. I felt it was essential to show how we, as users of the alphabet, have began to reclaim the legibility lost through the graphic abstraction of the voice over the past twenty centuries, during which we trusted it as the sole conceptual guide to the realm of writing. The scope and diversity of research on this issue in the past twenty years, for that matter, has enriched the field with entirely new and valuable information. The section follows two main lines, one devoted to manuscripts, the other to printed works. The former extends from medieval lettering and page layout to the manuscripts of contemporary writers via various urban uses of writing. It underscores certain visual developments within the alphabet that appear strangely similar to other forms of "reinvented writing" such as the Japanese system. The emergence of printing, meanwhile, introduced a factor—within the overall history of writing—much more specific to Western culture. Unlike Asian countries (where printing was first invented), which found that woodcuts were more suited to the visual complexity of ideograms than typography, the West in fact discovered that movable type brought to the fore two properties of writing that manuscript techniques had made it overlook. Typography revealed firstly that a letter of the alphabet was above all a "sign," not only because it graphically represented a sound of the language but also because it constituted an autonomous formal unit that, once cut as a punch, permanently defined both a shape and a style, themselves determined according to laws different from those inspired by the practice of *ductus*

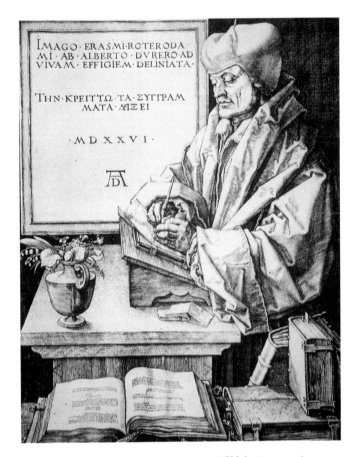

Fig. 3. Albrecht Dürer, *Erasmus of Rotterdam*, 1526, burin engraving.

litterarum, the tracing and forming of letters by hand. Secondly, manipulating typographic fonts made readers and writers realize that "spaces"—the intervals in the text—require as much attention as letters themselves. This discovery, as profoundly surprising as the one made much later in relation to the phonetic value of hieroglyphs, concerned the somewhat hidden part of writing (since it related to margins and blanks—to silences) and triggered an equally unexpected correspondence between the succinct rusticity of the alphabet and the infinitely subtle universe of calligraphy, a correspondence that would only dawn on the West at a very late date, thanks to Stéphane Mallarmé's poem *Un coup de dés.* The discovery also allowed painters and engravers to establish other correspondences, this time specific to Western culture, to which they were themselves immediately alert. This can be seen in a portrait of Erasmus engraved in 1526 by Albrecht Dürer (Fig. 3), a tribute simultaneously to stone-carved texts—in which the new, humanist world sought its ancient roots—and to the early sixteenth century's most advanced pictorial creativity, which linked portrait to landscape by placing a sitter next

to a window. Here, in provocative fashion, Dürer has replaced the illusion of depth recently mastered by painters—including himself, as seen in a self-portrait of 1498—with the staging of a text, or rather its *screening*. For Dürer, it was above all a question of stressing that a single medium—whether page, stone tablet, or painting, whether evoking the space of literary fiction or the phantom surface of trompe-l'oeil—had made it possible to create one and the other. Dürer's engraving celebrated, thanks to an inventive device as splendid as it is artfully demonstrative—namely, the double page of a printed book open in the foreground, seen as a reflection of the marble tablet above it—the spatial origins of our iconic imaginative faculty, which we now know to have been displayed for the first time on the walls of prehistoric caves and which most significantly led to the invention of writing.

By "focusing on the image," we decided to give this *History of Writing* a special structure, combining two different types of texts: illustrated articles with a primarily descriptive,

historical purpose, and discussions of "key images" that suffice to demonstrate the strength of the *visual* proposition inherent in writing. These are images to be read as well as to be seen, and the commentaries provided are there to help us in our explorations, no more. Writing has never really been about any other issue.

Notes

1. Leon Battista Alberti, *On Painting*, translated by John R. Spencer (New Haven: Yale University Press, 1970), Book III.
2. Paul Valéry, *Introduction à la méthode de Léonard de Vinci*, reprinted in *Oeuvres*, vol. I (Paris: Gallimard La Pléiade, 1957), p. 1165.
3. See, in particular, Anne-Marie Christin, *L'Image écrite ou la déraison graphique* (Paris: Flammarion, 2001) and *Poétique du blanc: Vide et intervalle dans la civilisation de l'alphabet* (Peeters/Vrin, 2000).
4. Henri Matisse, *Écrits et propos sur l'art* (Paris: Hermann, 1972), p. 248.
5. Ferdinand de Saussure, *Cours de linguistique générale* (Paris: Payot, 1969), p. 166.

I. ORIGINS AND REINVENTIONS

THE PRECURSORS OF THE WRITTEN WORD IN THE DANUBE RIVER BASIN

Michaël Guichard

Between the early sixth millennium and the fourth millennium BCE, a sophisticated culture flourished in the Danube basin. It spread throughout central Europe, and numerous vestiges of it have been found in Germany and even in France, from Alsace to the Paris region in the west.

The original civilization owed its development mainly to its skill at pottery-making, which became a major industry. Clay was the favorite medium for creating three-dimensional objects, including statues and graphic representations. Danubian art is also characterized by its range of geometric patterns incised into "decorative" vases. The patterns were not traced but incised individually, though they clearly had to conform to some strict, traditional format that has been lost. These graphs evolved into a set of signs and symbols that made good use of blank spaces such as the sides of earthenware pots. This is how the eye was first trained to read symbols, a trained eye being just as important for using script as the writing itself.

The Assyriologist Jean-Marie Durand claims that people learned how to read before they learned how to write. Early evidence of the precedence of reading can be found in the Neolithic calendar discovered in Bulgaria, near the village of Slatino. It takes the form of a graph or chart containing rows of numbers, represented by plain vertical lines indicating the phases of the moon. This document is not a text in the true sense of the word, because no words are present, but it needs to be "read," and it records an actual situation that existed elsewhere. The calendar clearly had a sacred, or even a mystical purpose. This astronomical table was found inside a clay dome resembling a kiln, and was evidently of a secret nature. The entrance to the "kiln" was defended by a serpent that also served as a handle; the actual inscription could only be seen clearly by elevating the object using this zoomorphic handle, and tilting it in a certain way (Fig. 1).

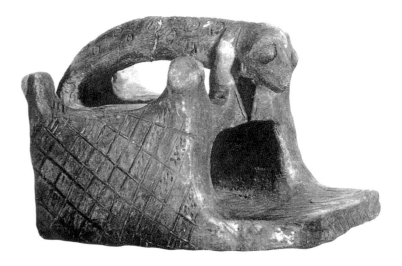

Fig. 1. Neolithic calendar discovered in Bulgaria.

Clearly, if the human race had reached the stage of being capable of schematizing the universe in this way, it was also capable of moving on to the stage of true writing. The question might well be asked as to whether the Danubian civilization had already crossed this threshold.

One of the main centers of worship for this civilization was Vinca, a city located not far from modern Belgrade. Vinca has given its name to the late Neolithic period of Danubian culture (5000–3800 BCE). Numerous clay figurines have been discovered in the various archaeological strata that accumulated over the course of time, evidence of the longevity of the shrine. The figures are mostly female, so this was probably a fertility cult, a form of worship that was quite common in agrarian societies (Fig. 2).

Six of the statues have been found to be engraved with abstract signs that, although clumsily executed, were certainly placed there intentionally. Similar idols have been discovered in Serbia and north of Sofia, Bulgaria. This type

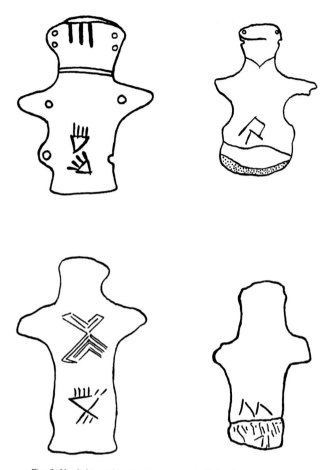

Fig. 2. Neolithic calendar discovered in Bulgaria.

of graffiti is found on vases and votive plaques. The marks are generally only made on the back of the figurines, usually on the hips. According to Emilia Masson, there is a "system" behind these marks, because she has found the same or equivalent marks inscribed on various media. She has therefore concluded that these were messages or at least "symbolism relating to fertility." Nor are such figures limited to central Europe, because the Danubian culture spread far from its birthplace. In 1970, French archaeologists working at Rosheim, Alsace, found a fragment of a seated statue, from the so-called Rubané culture, an offshoot of the Danubian civilization. Although only the pelvis remains, the statue is reminiscent of representations of seated oriental divinities as well as those of the Vinca culture of which some handsome examples exist. The fragment is covered in signs that are seemingly not intended to represent the folds of a garment and that are not unlike the marks on the Vinca statues.

Although the "system" used in this case is probably not the same as that of Vinca, because the signs covered the whole of the pelvic fragment, there would appear to be a relationship between the two practices. The content of

these "messages" remains a mystery, and the paucity of material found prevents any confirmation of Emilia Masson's theory that there is a "system" behind the graffiti.

The seals of Kotacpart are covered in glyphs and seem to convey a message that is currently indecipherable. A clay tablet found at Gradešnica (Fig. 3) provides an even more striking example, since here the marks are clearly incised in the clay and arranged in four rows. Since all of them look like letters, could their resemblance to a script be merely coincidental?

It must be stressed that the corpus of knowledge is still fragmentary, especially as regards the chronology. Obviously, there is too little evidence to risk drawing a conclusion as to whether the Danubian culture had its own system of writing. Furthermore, this "early draft of a graphic," to use Emilia Masson's neutral expression, did not survive the demise of the Danubian civilization. The present

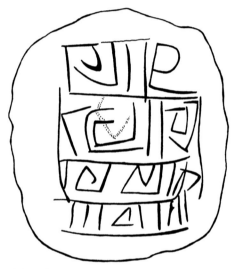

Fig. 3. Incised clay plaque found at Gradešnica.

author is of the opinion that, had this civilization evolved into one that built cities, as was the case for the village societies of southern Mesopotamia, these "marks" would no doubt have developed into an actual script.

All the documents discovered appear to be linked to religious practices. The break with traditional forms of worship that occurred upon the arrival of the Indo-Europeans *ca* 3800 BCE, condemned such records to disappear.

Further archaeological finds will no doubt bring more revelations to an area of history that is often content with simplistic definitions. There is the recent discovery (1996) in Syria of stone plaques, covered in crude engravings, dating from the tenth millennium BCE. Could these be a precursor of the written word? Both the choice of medium

and the engraved representation would tend to show a desire to permanently record a "discourse." This type of discovery would tend to transform the rather out-of-date notions of the origins of cuneiform writing, whereby certain authorities claim that it occurred solely as the result of a need to record transactions and keep accounts.

THE SPECIAL CASE OF THE WRITING OF TARTARIA

The three tablets found at Tartaria in Roumania occupy a special place in the story of the Danubian engravings. In the 1960s, a Roumanian archaeologist named Nicolae Vlassa unearthed the contents of a ditch. He described the finds, that included clay and alabaster idols, a bone bracelet, and inscribed tablets, as being of a "magical-religious" nature (Fig. 4).

The tablets were of unbaked clay but, as soon as they were discovered, they were baked in a kiln. Unfortunately, this precluded the use of carbon 14 dating to ascertain their age. They were inscribed on only one side. One tablet shows a schematic representation of two animals, one of them a goat, and an ear of wheat. The other two tablets are pierced, suggesting that they served as amulets. The surface is divided by lines into a quadrant whose sections contain engraved signs, some of which are easy to identify (an animal, a vase, plants) while others remain obscure.

These tablets are immediately reminiscent of early Sumerian texts from Uruk and Djemdet-Nasr. The Sumerologist Adam Falkenstein of Tübingen University made a famous study of them.[1] Could this be a local imitation of Mesopotamian objects?

In his report of the excavation Vlassa was more pre-occupied with studying the Mesopotamian influences than in describing the exact context of the find—so much so that today the authenticity of this sensational discovery has been very much called into question. However, the current tendency is to believe that if the material were faked this would have been done by the local inhabitants.

Note

1. Adam Falkenstein, *Die neusumerischen Gerichtsurkundenm* (Tübingen, 1956).

Bibliography

DENSUSIANU, Nicolae. *Dacia preistorica* (Bucharest, 1986).
DUMITRESCU, Hortensia. "Un modèle de sanctuaire découvert dans la station énéolithique de Cascioarele." *Dacia* XII (1968): 381–394.
DUMITRESCU, Vladimir. "Edifice destiné au culte découvert dans la couche Boian-Spanţov de la station-téll de Cascioarele." *Dacia* XIV (1970): 5–24.

Fig. 4. Tablets discovered in Tartaria, Romania. Inscriptions reproduced as drawings from an article by Emilia Masson.

GEORGIEV, Vladimir I., and Bogdan Nikolov. "Pismenosta varbu glineneta plocika ot s. Gradesnica." *Archeologija*, Sofia, 3 (1970): 1–9.
GIMBUTAS, Marija. *Civilization and Culture. Prehistoric vestiges in South-Eastern Europe* (Bucharest, 1989), pp. 51–123.
GORDON-CHILDE, V. *The Creation of the Civilization* (Bucharest, 1966), pp. 82–115.
——. *From Prehistory to History* (Bucharest, 1967), pp. 60–76.
KRAMER, Samuel Noah. *Sumerian Psychology* (Philadelphia, Penn.: University of Philadelphia, 1972).
MANSUELLI, C. A. *Civilizations of the Old Europe* (Bucharest, 1978), vol. I, pp. 64–109.
MARINESCU-BÎLCU, S. "Some aspects of the links between Roumanian Neo-Aeneolithic Aegean and micro-Asian cultures." *Pontica* XIII
MASSON, Emilia. "'L'écriture' dans les civilisations danubiennes néolithiques." *Kadmos* XXIII/2 (1984).
MELLAART, J. "Prehistory of Anatolia and its relations with the Balkans." *Studia Balcanica*, art. 5 (1971): 119–137.
MONGAIT, A. L. *Arkheologia Zapadnoi Evropi. Kamenii vek* (Moscow, 1973), pp. 195–247, 272–292.
NIŢU, A. "The plastic zoomorphic representations on Carpathian–Danubian Neo-Aeneolithic ceramics." *Archaeology of Moldavia* VII (1972): 9–96.

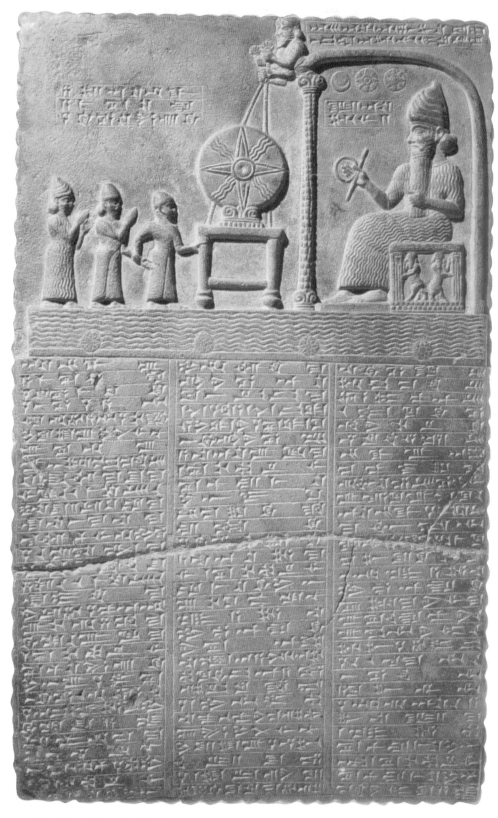

Fig. 1. Detail of a stele of the Babylonian king Nabu-Aplaiddina, representing the sun-god Shamash
in the form of a disk or a wheel with wide spokes between which emanate the undulating rays that are the typical
depiction of the solar divinity. Sippar, Iraq, *ca* 870 BCE. British Museum, London.

CUNEIFORM SCRIPT

Jean-Marie Durand

Writing is one of the basic characteristics of the culture of the ancient Near East. It first emerged in southern Meso-potamia at the end of the fourth millennium BCE in the form of the so-called "pictographic" tablets of Uruk.

The discoverers of the script gave it the name "cuneiform," from the Latin *cuneus* (wedge), on account of its wedge-shaped marks. This effect was created by using a calamus or reed pen to make three-dimensional marks, mostly on wet clay although other surfaces were used.

Cuneiform writing spread throughout the Near East, reaching its apogee in the thirteenth century BCE when it was even adopted in Egypt. The types of document written in cuneiform range from the most sophisticated literature (myths, religious texts, and scholarly writings), to a range of practical records (contracts, wills, law reports, invoices, receipts, and lists of expenses produced by palace or temple officials), with every other type of written material in between—magical spells, scientific writings, private correspondence, official diplomatic letters, and historiography.

Even though the script was in widespread use for private needs at certain times, it eventually ended up in the hands of a small group of experts, who developed a cumbersome system that took a long time to learn.

As for its diffusion, this falls into three easily distin-guished periods. Firstly, Ur, the capital of Sumeria, fell in the year 2004, marking the definitive end of the Sumerian period in which the system was "invented." The second millennium BCE was a period of relative political stability under Akkadian rule. This was the heyday of the phonetic system and its expansion that lasted until about 1200 BCE, when the Peoples of the Sea invaded the coastal plain of the Levant. Finally, after two poorly documented centuries in which local divergences grew more marked, the first

millennium saw a decline in the use of the script. A succession of universalist empires emerged that continued to use cuneiform for their writings, but these became less and less official and more and more scholarly. Then a new race, that of the Arameans, took over and settled in almost every part of the Near East. They brought with them a new language, a new script, and new media on which to record it.

THE ORIGINS OF THE SYSTEM

The development of the written word in the Near East is based on a single system that evolved from primitive Sumerian ideograms and culminated in the strictly phonetic Greek system. Even if passage from one form to another was achieved by grasping the tail-end of the previous one, it remained faithful to the spirit of its predecessor by offering a "choice of readings" in one or more competing semantic fields. Each time, the underlying motivation for that change was a desire to produce a more faithful phonetic rendering of the language, and it was determined by a different linguistic group.

The move toward a generalized syllabism was initiated by the inhabitants of the eastern end of the region, who spoke a Semitic language. The proto-alphabet was developed by the inhabitants of the western coastal plain and the Greek alphabet was promoted by the Indo-Europeans. Of course, the exact moment of passage from one to the other will never be known, and can we but guess at the crucial decisions that lay behind it.

The earliest origins of writing are shrouded in obscurity. Hitherto, attention has focused on two parameters: a long period (lasting three millennia) of figurative reproduction (sometimes representing numbers), independent of the

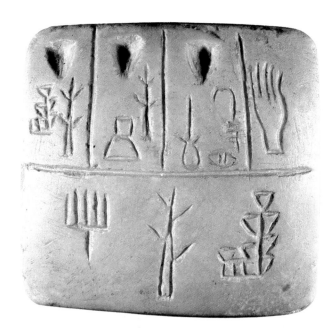

Fig. 2. Tablet dating from the late fourth millennium. Musée du Louvre, Paris.

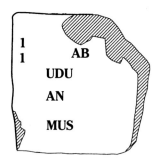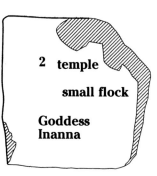

1	
1	AB
UDU	
AN	
MUS	

2	temple
	small flock
Goddess	
Inanna	

Fig. 3. Copy of a fragment of a tablet from Uruk, together with its transliteration and translation. At this stage in writing, syntactical elements were not considered necessary, the subject of the text being obvious to the reader, so the information was reduced to a minimum. For this reason, the contents of the message can be interpreted in various ways, such as "two sheep [destined for] the shrine of Inanna," but the opposite might be the case because this may represent an expenditure: "two sheep [from] the shrine of Inanna." Other combinations are possible.

existence of ideograms; and a hypothetical link between the drawing of ideograms and artistic representations.

These two hypotheses may well be of interest but they do little to explain how the phenomenon of the written word first emerged. Writing shares the fate of all those inventions that were discovered accidentally but for which uses were later found that went far beyond their original purpose. With the development of a new kind of annotation—computerization—we are currently witnessing one of the applications of which the development of writing has supplied so many examples. Computer processing was originally invented in order to speed up calculation, but it has transformed writing into "word processing."

The annotations from unspecified calculations that were made using a primitive abacus are partial acts, the purpose of which is unknown. Nothing in such a closed system can explain how it evolved into a notional code, although this code developed naturally through homonymics into phonetic encoding.

The same situation is found to exist when we investigate the similarities between "art" and "writing." The latter, unlike Egyptian notation, very soon evolved into a totally desubjectivized form of representation ("cuneiformization"). In the course of time, this form of writing underwent intensive analysis, which broke it down into its basic constituents, and produced a reinterpretation of complex primitive signs based on a minimum number of elements. The conditions in which writing emerged had to

have been created when notional fields were created that were sufficiently imprinted on the psyche of their users that they could be noted down, without having to produce a phonetic analysis of the language. This was the situation in which the proto-alphabet first appeared. The conceptual (annotation) came first in writing, not the phonetics (the spoken word).

This conceptual, rather than phonetic, approach to the basics of Sumerian writing can be clearly seen in the way it represents place names or the names of divinities. A Sumerian was capable of writing pure phonetics, for instance when indicating grammatical signs (such as the possessive ZU = "yours," or A = "sign of the dative or the genitive"). This was not done for place names, however, since they were more conceptual in nature. For example, the holy city of Nippur is denoted by its principal divinity ENLIL to whom the concept of PLACE is linked. The city is thus known as ENLIL-PLACE. This conceptualization predates the period at which the linear Sumerian code was fixed.

Similarly, the sacred names of the principal divinities of the pantheon such as EN.LIL himself, or EN.KI—understood in the early period as "Lord (en) wind (líl)" or "Lord (en) land (ki)"—appear, for grammatical reasons, to have had

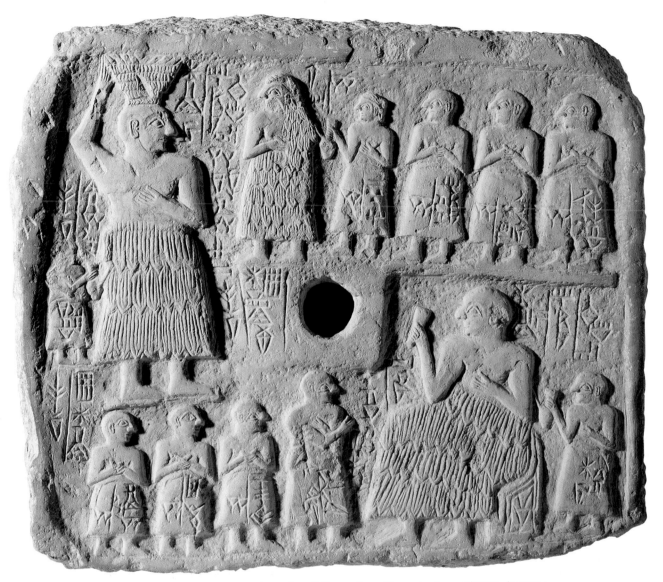

Fig. 4. Small limestone votive plaque from Tello, southern Mesopotamia, *ca* 2500 BCE, depicting
Ur-Nanshe, king of Lagash, accompanied by his cup-bearer and his children. Official inscriptions
started to develop in his reign. Musée du Louvre, Paris.

very different meanings at one time, but their coding has been lost.

The emergence of writing depended upon the creation of fundamental concepts that made it possible to analyze the world and permitted self-expression. This explains why phonetics were of no importance in early scripts. Annotation itself was also universal; it is only recently that an analysis has been performed to determine the minimum number of constituents required to convey meaning.

Annotation was originally used to commemorate complex situations for which a record needed to be kept, as seen in tablets found in northwestern Syria, which date from the tenth millennium BCE; but the process of commenting on the world began with the first manifestations of

human art, even if the meaning behind such commentary has been lost, and may always remain so.

Apart from the complex "tableaux" or artistic representations reproduced on votive tablets, the same signs were used over a huge area from a very early period. So-called pictograms not only had pictorial significance, at least in part, but were an ancient form of "text message." The more complex pictograms certainly fit this description. Modern pictograms, such as the circle containing a lit cigarette with a diagonal line through it, are not the equivalent of one these ancient ideograms, as is frequently maintained, but are a *combination* of several ideograms with lexical elements (CIGARETTE, SMOKE) and the FORBIDDEN bar across them that gives them their syntactical link. In this respect,

Fig. 5. Diorite foundation tablet of King Shulgi, Tello, Mesopotamia, 2100 BCE. Musée du Louvre, Paris.

The ancient pictograms found on megaliths have to be interpreted in this way, and that is why the very earliest texts are still incomprehensible, to such an extent that some experts even doubt that they are written in Sumerian. They are unable to parse them adequately because the encoding used is as complex as that of a whole sentence.

This is probably an opportune moment at which to introduce the concepts of "text" and "reading." If an ancient text is highly complex and calls for a wider, more "comprehensive" reading, that is because those who originally compiled it wanted to make it commemorative, rather than communicative. This basic difference has never been taken sufficiently into account. In the Near Eastern religious context, commemoration can take the form of a monument (a heap of stones) which would be referred to in writings at a later date. Without such writings (which may take a variety of forms and contain a range of subject matter) the cairn would be impossible to interpret.

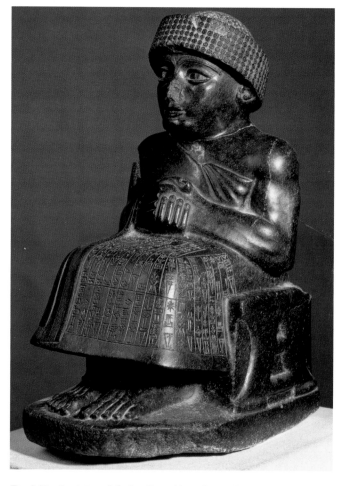

the NO SMOKING symbol is the perfect equivalent of a whole ancient Sumerian sentence since it contains the two key elements, namely:

(a) a display of the symbols as graphics, not in their phonetic order—the CIGARETTE does not precede the concept of SMOKE but is linked to it (CIGARETTE x SMOKE), and the meaning of (CIGARETTE + SMOKE), all of it crossed out, is clear; and

(b) a minimal lexical indication: the diagonal bar through the sign clearly indicates that it represents something that is forbidden.

Yet this coding is insufficient to represent all of the possibilities offered by English phonetics:

"Smoking is forbidden"

"Do not smoke"

"We'd rather you didn't smoke," etc.

Fig. 6. Diorite statue of Gudea, king of Lagash, southern Mesopotamia, *ca* 2100 BCE. The great achievement of this Sumerian prince, whose main preoccupation was the welfare of the gods of his kingdom, was the reconstruction of the temple of the god Ningirsu at Tello (formerly Girsu). The plan of the temple was revealed to him in a dream. Musée du Louvre, Paris.

Such a monument is thus a commemorative text with a universal message; when it is referred to in another text, however, the subject may be analytical and discursive.

The concept of a complex text is inevitable because, at least in the case of Mesopotamia, the activity of reading should be considered as having been practiced prior to writing. From the moment human beings found meaning in the world and presupposed the existence of a supreme being, they found themselves compelled to create texts that were designed to be read by other people. Two types of such arbitrarily created texts must have originally have had considerable importance, although they are only known in their more recent forms. They are those that consist of interpreting the desires of the gods by "reading" the stars and those that interpret such desires by examining the internal organs of sacrificial animals. Each of these religious practices involves: (a) isolation of the medium; (b) identification of symbols; (c) a specific order in which the symbols should be read; and (d) the consequent creation of a syntactical link between those symbols.

Even if activities of this type date from a much later period than that of the emergence of writing, and even if we do not know what they were since we no longer have the records, it is known that astronomy/astrology and divination date back to at least to *ca* 2400 BCE, much earlier than had been thought possible until recently. In view of the way in which these activities developed, they must certainly have been begun well before that time.

Writing presumably emerged in Mesopotamia, not through the utilitarian need to keep accounts—something that would have been necessary for the creation of a state—though this theory has been propagated *ad nauseam*, but as the consequence of religious observance, either in the service of the developing state or to predict the most propitious times for the Sumerian merchants of Uruk to embark upon long journeys.

DESCRIPTION OF THE SYSTEMS

Two main systems of cuneiform were used to represent Sumerian and other languages. Akkadian, the first of the other languages, was used as a reference point for the rest.

Sumerian script was originally based on ideograms. An ideogram can be defined as a sign (at first an actual drawing, but evolving over time into a mere convention) that conveyed both meaning and sound. Thus, the Sumerian sign for GARDEN conveyed the idea and the pronunciation [*kiri*]. This system is very cumbersome in theory since it presupposes that there are as many signs in the language as there are words that can be written.

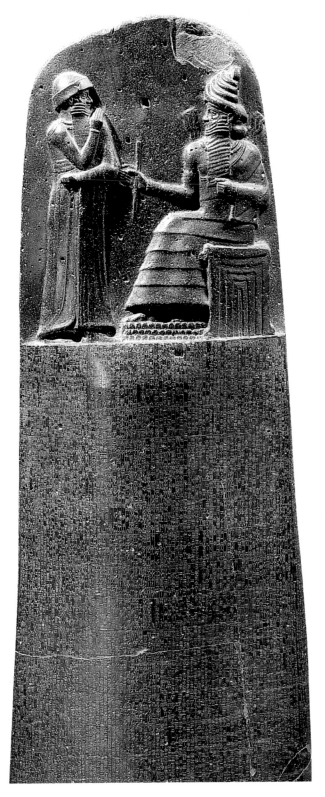

Fig. 7. The Code of Hammurabi (eighteenth century BCE), a legal codex carved on diorite stele. One version was deposited in the temple of Shamash, the sun-god of Sippar, other copies were found in various cities of Babylonia. This example was carried off to Susa as part of the spoils of war and was unearthed by French archaeologists. Musée du Louvre, Paris.

The first pictograms used graphics to provide a key to their meaning. Examples are GARDEN [*kiri*] = 𒃷 , BIRD [*mušen*] = ∼ , PALM TREE [*gišimmar*] = 𒄑 .

Important developments occurred subsequently. First, the signs were rotated 90 degrees and reinterpreted by being written in cuneiform, so that they were no longer line drawings but were impressed on the medium in a segmented fashion: 𒄷 [*mušen*]. Rotation and transmutation were inevitable as soon as stone, almost certainly the original medium, was replaced by clay. This is how the sign for a garden 𒃷𒃷𒃷𒃷𒃷 and the sign for a mouth 𒅗𒅗𒅗𒅗𒅗 evolved.

Then, the signs gradually became simplified and systematized after analysis had established the minimum number of segments that were required to represent them.

Greater sophistication was required for such abstract concepts as "friend," "enemy," etc. This is where the social conventions came in. "Friend" (𒅗) was indicated by two parallel lines, "enemy" by two intersecting lines (𒆪).

The Sumerians began to juxtapose two or more signs to produce a meaningful whole. Thus MOUTH + HAND indicates PRAYER (𒅗𒋗 𒅗) in accordance with Sumerian ritual. In the same way, MOUTH + BREAD or MOUTH + WATER means EATING or DRINKING (𒅗𒀀 𒅗 𒅗).

To keep to a minimum the number of signs that were needed, the Sumerians created composite signs. For example, 𒅗 denotes the lower part of the face. This same ideogram could be used with different pronunciations to convey different meanings: [*ka*] = mouth, [*kir*] = nose, [*zu*] = tooth, as well as [*inim*] = speech, [*gu*] = shout, [*du*] = to speak or to say. This is referred to as the "polyphony" of Sumerian signs.

The Akkadian cuneiform system and derivatives thereof used both ideograms and syllabic characters. They can thus be read in two ways: as concepts or as sounds. In Sumerian texts, the ideograms coincide with syllabograms—they represent the sounds to which a particular meaning is attached. In Akkadian script, however, most of the text consists of syllabograms, though parts of it may be written in Sumerian ideograms.

From its very origins, the system clearly used certain ideograms as pure syllabograms because they do not represent anything but sounds and are devoid of meaning. Sumerian contains more true ideograms and the syllabic signs exist only as pronunciation markers or as grammatical tools. The grammatical signs are easy to identify. They are usually placed after ideograms that denote nouns (to indicate the case) or verbs (to indicate the person or tense).

The pronunciation markers are more diverse and are represented by ancient ideograms that have no meaning in themselves but indicate phonetic values. Thus the sign for

Fig. 8. A bilingual petitionary letter: by his literary prowess, a scribe from Mari hopes to win the favor of the king. On the left, the Sumerian version, and on the right, its Akkadian translation. Mari, eighteenth century BCE.

GA (meaning "milk"), when it follows the sign for KA (and therefore also DU), has the effect of marking this sign with one of the values that ends in /g/ and of showing that it should be pronounced /*dug*/ ("to speak"); additionally, it shows that the verb ends in "a", an indication of its grammatical status; depending on the case, *duga* is either a past participle ("said") or a relative form of the verb ("who said"). Use of the sound GE would indicate not only the /*dug*/ pronunciation but also an "e" ending, giving it a different linguistic status.

Chosen from among the large number of ideograms that had no intrinsic meaning was a set of signs that indicated a "light" pronunciation; they are mainly "consonant + vowel" (CV) groups, more rarely "vowel + consonant" (VC) groups.

In this system, the "phonetic indicator" ligature plus "the grammatical indicator" were useful adjuncts, but they did not go beyond the syllabism so as to systematize a phonetic system that, given the morphological structure of Sumerian, would have been less economical.

The grammatical signs were necessary because the Sumerian ideogrammatical sign was polyphonic. With the exception of the realia, which are generally univocal, they do not denote an individual concept but rather a conceptual

Fig. 9. Dedication to the goddess Inanna. Writings on votive or official inscriptions (on steles)
were deliberately archaic. Mari, eighteenth century BCE.

field in which the reader must identify the units. As noted above, the sign that denotes the LOWER PART OF THE FACE could mean /dug/ "to say," /ka/ "mouth," /kir/ "nose," /inim/ "speech," /zu/ "tooth," etc. When one begins to learn Sumerian, the language appears at first to be totally monosyllabic, an indication that it was used over a long period of time. The sound representing the word /dug/ is thus used to convey the concepts of VASE, GOOD, TO SPEAK; the sound /lu/ those of PROSPEROUS, MAN, DISTURBANCE, etc. Each of these values is individualized by means of its own graphic sign. Modern scholars find their way through this maze by allocating a quotient of diacritical signs or figures to the transliteration of each cuneiform sign so as to individualize them. The /dug/ series is thus individualized as *dug* = VASE, *dùg* = GOOD, *dug*₄ = TO SPEAK, etc.

No one knows how it was possible in practice to distinguish orally between the various Sumerian homophones. The Akkadians who adopted these signs for their own semitic language, while observing that there were gaps that did not cover their linguistic requirements, also found many categories that were of no use to them.

The phonetic annotation of archaic Sumerian frequently resorts to "minimal practice." A person annotating a text prioritizes the annotation of concepts and attributes lesser importance to the morphological signs, to the detriment of the syntactical links. On the other hand, it is up to the reader to choose the verbal aspect and grammatical indicators. A modern parallel can be found in the wording of telegrams.

Let us suppose that a telegram contains the words: PETER TOMORROW MORNING LONDON. This is a minimal notation for "Peter will be coming to London tomorrow morning," in which LONDON is recognized as being the complement of the place merely by its semantics; the link between PETER, whom we know to be absent, and LONDON where we happen to be at the moment, indicates his imminent arrival in that city.

It is not known, especially in the case of the most ancient tablets, how closely the pronunciation of the text matched its annotation or whether it was amplified by the reader, in the same way as ancient melodic annotations to which the performer adds his own embellishments. A distinction should be made between administrative texts, in which concepts are merely juxtaposed, and literary texts that resort to articulated phrases.

The encoding system is so defective that in the case of literature, it can only be assumed that the work was already

known orally, which made it easier to decipher. As for the administrative texts, they reflect simple procedures, offering a limited range of possibilities, including such key words as "expenditure," "income," etc., to guide the interpretation. Many instances which today present some difficulty would have been easily understood by those living at the time.

No great advantage was gained by generalizing the phonetic annotation in a system such as Sumerian. Seen from the outside, the system is very complicated because a single graphic is used to convey a number of phonemes. A totally phonetic script would be even more obscure since it would deprive the reader of the means of identifying monosyllabic ideograms. A script used mainly for syllabic representations in the early second millennium BCE would be very hard to understand in today's world, unless it consisted of monosyllabic ideograms. Furthermore, an oral transcript would result in a number of phonetic confusions (haplology, syncope, and homonyms) that would be very unlike what has come to be expected in a standard text. Anyone attempting the experiment using languages in which the written word differs substantially from the pronunciation, such as English or French, would soon realize the difficulty. English "spelling" that distinguishes between WRITE, WRIGHT, RIGHT, and RITE is one example but not a very good one because the system recognizes that several words are pronounced in the same way and is careful to avoid confusion. This was also the case in semitic languages in which the pronunciation of ideograms was annotated by using a syllabary. When reading some of the translations supplied with these texts, it can be seen that what was lost in comprehension was gained in phonetic accuracy. Sumerian script was thus a hostage to annotation through ideograms.

The absence of "missives" in the early texts puts the researcher at a serious disadvantage because, by its very nature, this type of material would give broad hints as to its content. The "neo-Sumerian letters" are nothing more than routine administrative texts transmitting orders rather than conveying information about momentous events. In those distant times, anecdotes would have been conveyed through word of mouth by a third party. Correspondence was not recorded because it was too complex to be decoded using the ideogrammatical script.

In a text of Akkadian origin, the written content is presented quite differently. Akkadian had always been able to resort to Sumerian annotation. The ideogram is an economical way of reproducing a phonetic sound, as it uses one sign to replace a series of syllables. Akkadian, written in Sumerian script when in its prime, can be identified through the choice of certain ideograms, such as BA

(actually meaning "to share") instead of SUM, "to give." The shift in symbolism indicates the change of language. After the classical period, only a limited range of Sumerian ideograms were used in Akkadian text, to speed up the annotation. The principle of a script was used to a greater extent during the decline of Akkadian, when only a few symbols were used to record a long text. One of the perverse effects of this was to make the text so cryptic that it could only be deciphered by an educated elite.

Thus the Akkadian for "If a bird flies leftward, the enemy will attack the city" would be: "*summa iṣṣurum ana šumēlim illak nakrum âlam ikaššad.*" In syllabic Akkadian, the sentence would be notated as: *šum-ma iṣ-ṣu-rum a-na šu-me-lim il-la-ak na-ak-rum a-lam i-ka-aš-ša-ad*, which would be represented by twenty-three signs in paleo-Babylonian, using "light" signs annotations.

In a more recent system, the ideograms used would give: *be mušen éš gùb du kúr uru kur*, using only eight signs.

Akkadian has always reserved certain semantic categories for the use of ideograms. The names of materials (GOLD, SILVER, LEATHER), titles (KING, SON), and of the principal deities were usually recorded in this way. Otherwise, writers resorted to a minimalist system of annotation for practical reasons (correspondence between merchants, for instance).

A text that relies too heavily on ideograms risks becoming ambiguous. Thus, the statement: "*lugal kúr kur*" could be understood either as: "The king (*lugal*) will capture (*kur*) the enemy (*kúr*)" or as "The enemy will capture the king," since word order in Akkadian, a flexional language, is not of any significance.

Akkadian distinguishes between *nakrum* (subject) and *nakram* (object). It thus resorts to "phonetic additions," writing "*kúr-rum*" or "*kúr-ra-am*" to indicate whether the "enemy" was active (*nakrum*) or passive (*nakram*). Other systems derived from Akkadian, such as Hittite, abused this practice, thereby creating over-complicated systems.

Another option was to use an entirely phonetic annotation by increasing and systematizing the use of those signs that no longer had a specific meaning. The morphology of Akkadian, a semitic language, is quite different from that of Sumerian, and consists of triliteral roots in which a set of vowels (a, ā, i, ī, u, ū) or a "zero vowel" denote the basic meaning.

The syllabic system was gradually improved over time but never achieved adequate annotation. Each period used a different set of phonetic values chosen from the stock of Sumerian characters, mainly using "light" signs (VC, CV) during the periods when the culture flourished or "heavy" signs (CVC_2) when it was in decline.

The order of the final consonant in a syllable (C in VC or C_2 in CVC_2) was not specified, and this was a serious

disadvantage. The initial consonant (C, in CV or CVC$_2$), on the other hand, was indicated, since Akkadian marked it with a silent or voiced character or an emphatic for the dental and guttural sounds. These were annotated in various, temporary ways at various periods.

Furthermore, in the "heavy" signs, the vowel signs tended to become undifferentiated (especially on the periphery). The sign for KAR could be resolved as /kar/, /kir/ or /kur/, and these have now been annotated as $k°r$. This was the beginning of a consonantal system of characters that eventually gave rise to the proto-alphabetic systems of the western Near East where the alphabet first emerged. The Sumerian system used "sign-concepts" that could be pronounced in a number of ways. The "Akkadian revolution" indicated the order in which consonants should be pronounced and noted the vowel sounds fairly accurately. Even taking into account those VC signs in which C was completely undifferentiated, there was less ambiguity than in the original system, although it was awkward not to be able to determine clearly the unvoiced, voiced, and/or emphatic sounds that predominate in a semitic language.

The Akkadian system, in fact, did things the wrong way around. On account of its morphology, a semitic language does not need to annotate the vowels, because their use is not determined by the order in which the consonants are to be articulated. The "alphabetic revolution" consisted purely and simply of inverting the cuneiform system, fixing the vowel sound to the consonant, and thus economizing on vowels.

There were several precursory signs on the periphery, especially involving the lack of differentiation of the vowel in "heavy" sounds. This was first step toward the annotation of a zero (unvoiced) vowel.

THE THINKING BEHIND THE SYSTEM

Sumerian mainly expressed concepts. It is thus important, once the field has been identified, to choose the right contextual pronunciation.

Akkadian used phonetic annotation, but the principle of indetermination applies here. Take the case of two signs, that we shall call IZ and KU, to give each its most frequent phonetic value. A reader will first need to know whether the annotation is Sumerian (A) or Akkadian (B). Then, within each system, he will have to make further choices.

If the sign is in category (A), the choice, depending on the context, will be between GIŠ-TUKUL = "weapon" (A$_1$) and GIŠ-TAŠKARIN = "thicket" (A$_2$), with the pronunciation kakkum or taskarinnum, as required by the syntax.

In a (B) category, the writing expresses a phonetic sequence which might be using symbols, depending on how it is read, as in: I(E)Z/Ṣ/A-K/QU. The latter are based upon synchronous systems and the correct choice varies according to the period. The signs that represent the sequence I(E)Z/Ṣ/A-K/QU are typical of the early part of the second millennium BCE. Relying on the dictionary, the meaning can be narrowed down to the following possibilities:

– es-ku "they decided" /eskū/ ;
– es-qú "they were engraved" /esqū/ ;
– iz-ku "he was purified" (/izku/) ;
– "they were purified" (/izkū/).
The choice depends on the context.

The Akkadian system is not one of *conceptual determination* or *phonetic indetermination* as Sumerian is, but it has *conceptual indetermination* within the given *phonetic limitations*. The two systems are thus exact opposites of each other. They are not disconnected, but there is a switching effect. In Sumerian, the conceptual will work when applied to the symbols to be identified, but Akkadian dissociates the concept from the word and has a relationship with it that is first and foremost phonetic. One must therefore start by making a simple annotation of sounds. It is hardly surprising that such a system gave priority to speaking the words, despite a rather nebulous approach when viewed as a nascent alphabetic system, resolutely discarding the figurative ideogram and using only formally stylized signs to be increasingly analyzed as basic elements and reinterpreted on the basis of supposed combinations.

The disadvantage of system (A) is that in many cases there is no way of knowing how to choose the phonetic value, especially in derived expressions (the choices between KA = "mouth" and INIM = "speech," for example, are not always obvious). In system (B), on the other hand, the context ought to enable anyone with an adequate knowledge of the language or daily life to choose between the four potential meanings. These meanings tend to vie with each other, however (eskū, esqū), even in an administrative text.

The zero syllabic system that could almost be considered a proto-alphabet (the Phoenician system) avoids the phonetic indeterminacy of (A) but still remains largely indeterminate, due to the morphological vagueness resulting from the lack of vowels. This keeps the reader in a serious state of uncertainty, if he or she is not perfectly familiar with the language.

The invention of separate signs to represent vowels— apparently by the Greeks—was the culmination of the alphabetic system. The systematic use of vowels to

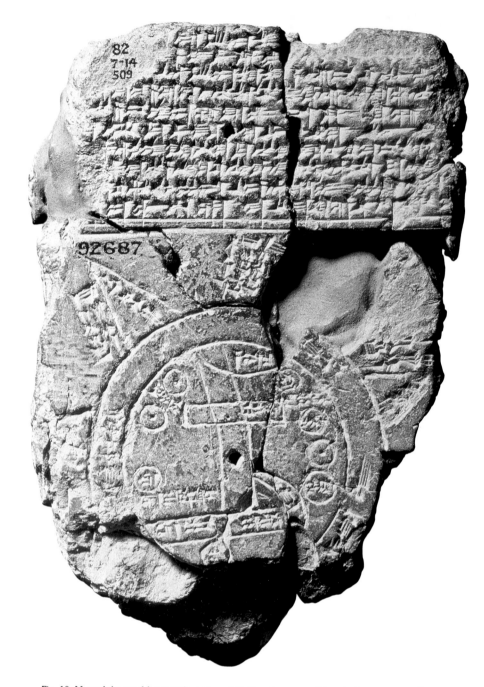

Fig. 10. Map of the world, seventh century BCE. The ring around the circle represents the ocean that surrounded the known world, namely, Mesopotamia. The Euphrates runs through the disk vertically and flows into the Persian Gulf (the horizontal rectangle). Babylon is in the center and on its left there are its two great cities, Assur and Nippur. Beyond the ocean, there are unknown lands to which Sargon traveled. The map illustrates the story of his semi-legendary expedition, a fragment of which is visible above. British Museum, London.

represent pronunciation accurately had the effect of creating the consonant sign, which does not exist in pure form in articulated phonetics. It is the product of complete abstraction which assumes a transition from detailed analysis of the phonetics of a language to the phonological algebraicization and conceptualization thereof. The Greek system, however, was only perfect at a particular moment in time. It can only be borrowed if the borrowers possess a phonetic system that is identical to it in all respects, but it becomes unbalanced as soon as there is any change in the

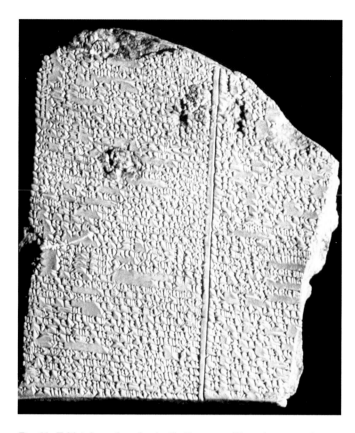

Fig. 11. Tablet from Assurbanipal's library at Nineveh, recounting an episode from the Epic of Gilgamesh. Uta-Napishtim (the Babylonian equivalent of Noah) tells the hero the story of the Flood. The discovery in 1878 of a version of the story of the Flood that predated the biblical account in Genesis caused a furor.

Fig. 12. This reconstruction shows how the scribes of Antiquity held the calamus. The point of the pen was beveled. Various types of nail-shaped impressions, horizontal, vertical, or oblique, could be made on the wet surface of the clay tablet, depending on the angle at which the calamus was held and the pressure of the hand. The hand holding the tablet had to be prevented from erasing the signs already written, especially as every available surface was written upon, not only the front and back. Great dexterity was therefore required for writing in cuneiform.

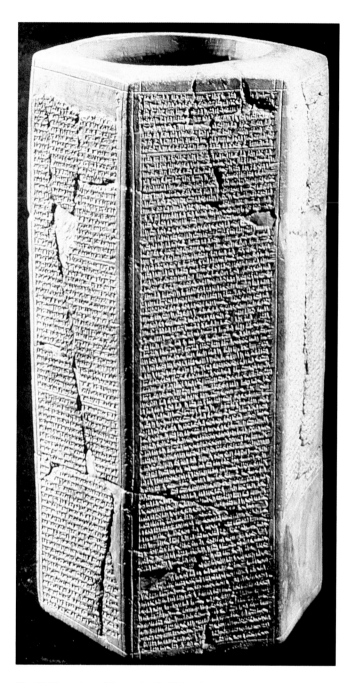

Fig. 13. The prism of Sennacherib (689 BCE), an annual report of the military campaigns of the Assyrian king. This type of medium (a prism or a cylinder) had been in use since the third millennium. The prism, which was not designed to be read by Sennacherib's contemporaries, was buried in the rubble of the foundations of a building so that it should be available to the gods and any later king who undertook restoration work. This is how the Mesopotamians believed they could keep the memory of their brave deeds alive forever.

phonetics of the language. At that point, the concept of spelling arises—that is to say when there is a tradition of writing and an evolved pronunciation and when there is the possibility of multiple annotations to represent the same sound. Under such conditions, the system creates different signs for the same sound and writers are tempted to use one instead of the other. The ultimate step, the establishment of a strict system of annotation that is applicable to any language and presupposes a rigorous analysis of articulatory phenomena, is represented by the creation of the international phonetic alphabet and is a very recent development in the annotation of articulated sounds.

The development of the analytical mind is mirrored through the development of writing in Mesopotamia. It was the people of the Middle East who first analyzed the grammar of the Sumerian language and who determined the minimum number of elements of articulation that, when combined, were needed to reproduce the phrases of the language. The analysis of the basic sounds of the language was the major contribution of the civilization of the western Near East. This where the first studies were made—not in phonetics as is so often claimed—but in phonology. The science of phonetics developed gradually with the refinement of syllabic annotation in southern Mesopotamia, but the major discovery by the West was the concept of "oppositional pairs," which did away with the need to use multiple systems to annotate a sound, something that cuneiform writing never mastered.

Bibliography

DE MEIROOP, Marc van der. *Cuneiform Texts and the Writing of History* (Routledge, 1999).

NEUGEBAUER, O. *Astronomical Cuneiform Texts* (New York: Springer-Verlag, 1997).

SAYCE, Archibald H. *Archeology of the Cuneiform Inscriptions* (Ares, 1976).

——. *The Astrology and Astronomy of Babylonia* (Wizards Bookshelf, 1981).

STROMMENGER, Eva. *5000 Years of the Art of Mesopotamia* (Harry Abrams, n.d.).

WALKER, C. "Cuneiform." *Reading the Past Series*, vol. 3 (University of California Press / British Museum, 1987).

HOW CUNEIFORM SCRIPT
WAS DECIPHERED

Michaël Guichard

The first examples of cuneiform writing encountered by Europeans were brought to western Europe from Mesopotamia and Persia in the seventeenth century. The shape of the signs, which at the time were understood only by their inventors, was compared to that of a wedge (*cuneus*) and this is the origin of the name "cuneiform." The study of cuneiform was only seriously pursued in the eighteenth century, when travelers brought back large quantities of inscribed objects. The heroic age of archaeology that began in the nineteenth and early twentieth centuries, yielded a considerable amount of epigraphic material, to such an extent that many such documents were dispersed in private collections or museums throughout the world and remain unread to this day. The huge amount of cuneiform material in the shape of tablets and inscriptions was very useful to the early decipherers and soon gave birth to a new science, that of Assyriology.

Since these earliest Assyriologists were starting from scratch, deciphering remained a rather hit-and-miss affair for more than fifty years. Although historiography has dubbed Henry Rawlinson, an English army officer, the founding father of the discipline, deciphering the script was more of a collective effort. Unlike Jean-François Champollion in his bid to decipher Egyptian hieroglyphs, Rawlinson did not have at his disposal an equivalent of the Rosetta Stone, on which text was written in three scripts and three different languages, one of which, the Greek script, was universally known.

So although cuneiform continued to be used until the dawn of the common era, once abandoned it soon fell into complete oblivion, despite the interest shown in it by certain Greek scholars such as Democrites of Abdera (*ca* 460–*ca* 370 BCE), who is credited with writing a treatise on Babylonian script that has now been lost.

In fact, cuneiform ought to be referred to in the plural since this form of writing was adapted for various languages that borrowed it during the three millennia of its existence. By the time cuneiform was last used, in ancient Persia, it had undergone such a major transformation that it no longer had anything in common with the Mesopotamian cuneiform other than the angularity of the wedge shapes.

The first attempt to decipher the script was made on this late version of it. The earliest texts to be studied originated from Persepolis and Naqdh-i-Rustam in Persia. The attempt made by Rawlinson (from 1836 through 1847) to decipher the inscription of Darius I engraved on a rock in Behistan, Iran, was ground-breaking on account of the length of the text (Fig. 1). The same official text describing the conquests of the great was carved into the rock in Persian, Elamite, and Akkadian.

In the late eighteenth century, the Danish explorer Carsten Niebuhr was the first to realize that the text consisted of three distinct scripts. He saw that they each contained a different number of signs. One of them had far fewer signs and could therefore only be an alphabet. As for the other two, it was soon worked out that they were syllabic and ideogrammatical.

Thanks to the work done in the mid-eighteenth century by the French archaeologist Anquetil-Duperron to decipher the Zoroastrian *Zend-avesta*, the German archaeologist Georg Friedrich Grotefend (1775–1853) was able to read the names in alphabetic cuneiform of Xerxes, Hystape, and Darius. The work was made easier by the fact that each word was separated by a punctuation mark in the form of an oblique wedge. Subscribing to the hypothesis, which had already been formulated, that the text could only have been written in ancient Persian (Farsi or Parsi), he began working on the basis, later shown to be correct,

Fig. 1. This inscription found at Behistan (near Bakhtaran in western Iran) made it possible to decipher cuneiform. It is a description by Darius the Great
(522–486 BCE) of his exploits during the first year of his reign and it is written in three languages, Persian, Elamite, and Akkadian.
Lieutenant (later Sir Henry) Rawlinson performed an incredible feat of agility by making a complete copy of the wording, which covers
a huge cliff rising to a vertiginous height. He published the Babylonian version (a copy of the inscription and its translation) in 1851.

that the text began with the titles of the Achaemenid kings, just like the Pahlavi titles deciphered by Sylvestre de Sacy, namely: "NP$_1$, great king, king of kings, king of Iran and elsewhere, son of NP$_2$, great king, etc." He was thus able to correctly read ten signs, but the gaps in his linguistic knowledge prevented him from making further progress. Eminent orientalists later completed the alphabet that contained a total of thirty-six signs.

The second inscription posed more serious problems because it contained more than a hundred different signs (and was thus a syllabic script) used to record a language that was unknown hitherto. There was even much uncertainty as to what name to give it. Jules Oppert demonstrated that this was the same language that had been found on tablets from the city of Susa. This was Elamite (or rather neo-Elamite); the name of the language is taken from the civilization that preceded that of the Persians. Elam flourished in the second millennium BCE Susa was its great capital city.

Although Rawlinson participated actively in the deciphering of ancient Persian and neo-Elamite, his greatest contribution was the deciphering of the third cuneiform script, which he achieved even though he was unaware of the work of Grotefend. This last script contained far more signs even than the Elamite script. Rawlinson concluded that it was a mixed syllabic and ideogrammatical system, but he uncovered a further, greater complication—polyphony. He suggested that the signs represented more than one sound and should be interpreted differently according to context. Only if the reader knew the correct context would he be able to interpret the meaning adequately. Hincks, who confirmed Rawlinson's intuition, had previously demonstrated that the cuneiform signs could represent open syllables (VC) or closed syllables (CV), as well as "heavy" signs (CVC).

The system appeared to be so complicated that at first Rawlinson's discovery was rejected and disputed. His opponents included the famous French philosopher and orientalist, Ernest Renan. At the same time that the Persian

inscriptions were being deciphered, however, Akkadian and Assyrian inscriptions were being excavated in Mesopotamia, including those at Khorsabad, thanks to the work of the French archaeologist Paul-Émile Botta. It soon became possible to link these texts with the Akkadian version of the inscription at Behistan.

The first orientalist to propose that Akkadian might be a semitic language was the Swede Isidore Lowenstern. As words were gradually deciphered and it became apparent that they had a semitic root, his theory was confirmed. Akkadian is an eastern semitic dialect that later spread to a remarkable degree throughout the region. It was known to exist in the third millennium BCE, and by the second millennium it had become the universal language of diplomacy. Eventually it was replaced in the first millennium by Aramaic, another semitic language, but it survived in parallel as the language of literature and royal inscriptions.

In order to be convinced that cuneiform had really been deciphered, in 1857, the British Royal Asiatic Society held a symposium whose participants included Rawlinson, Hincks, and the Frenchman Jules Oppert. Each of the orientalists who attended was given the task of translating a recently discovered cylinder from the reign of the Median–Assyrian emperor Tiglath-Pileser I. The various translations proved to be fairly similar. This experiment showed that the enigma of cuneiform had been solved.

Yet the story of the deciphering of cuneiform was by no means over. The archaeological excavations conducted by the French archaeologist Ernest de Sarzec at Tello exposed the remains of Sumer, an earlier civilization that was probably the inventor of this script. The language of the Sumerians belonged to no known group and even today its grammar is not completely understood. The discovery of Sumerian caused a major controversy because it called into question the primacy of the Semites in the Near East. At this time, scholars still relied heavily on the Bible as documentary evidence and it now had to be admitted that an "obscure" race, unrelated to the sons of Noah, had founded the Sumerian civilization. This shows how the deciphering of an ancient language can call a set of beliefs into question and thus contribute to a major change in the view of history.

This mindset did not die with the end of the nineteenth century, as is shown by the discovery, in 1975, of the archives of Ebla in present-day Syria. Italian archaeologists unearthed the cuneiform archives of a great palace built in the third millennium BCE. This discovery showed that a scribal tradition had existed in Syria at this period. Although Ebla had adopted its script from the Sumerian world, the writing had been adapted for writing Eblaite, a semitic language. Eblaite was recognized as a separate script and language in Assyriological studies. The first scholars to decipher the writing, however, were so carried away by the extraordinary enthusiasm aroused by this important discovery that they believed that the first tablets contained a mention of the Hebrews and of Abraham. In the context of the political situation in the Near East, this episode caused quite a stir and showed what passions the discovery of new documents can arouse.

The discovery of Eblaite suggests that more cuneiform discoveries may lie ahead. The principles of cuneiform, which were deciphered by men who were erudite explorers, provided the key to unlock several other cuneiform systems. This is how, outside Mesopotamia, Anatolian texts written in Capadocian style (an ancient Assyrian script of the nineteenth century BCE) were read, as well as Hittite (an Indo-European language, spoken from the seventeenth to the twelfth centuries BCE) and Hurrite (an agglutinative language that originated in the mountain chain that stretches from the Taurus in Turkey to the Zagros in western Iran).

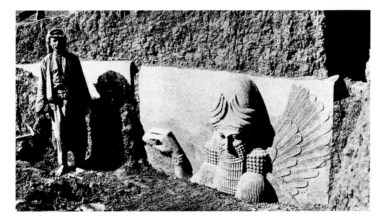

Fig. 2. Monumental orthostate with a winged genie relief carving, shown here at the time of its unearthing by American archaeologists in the 1930s at Khorsabad (G. Loud and C.B. Altman, *Khorsabad*, Oriental Institute Publications, 1938).

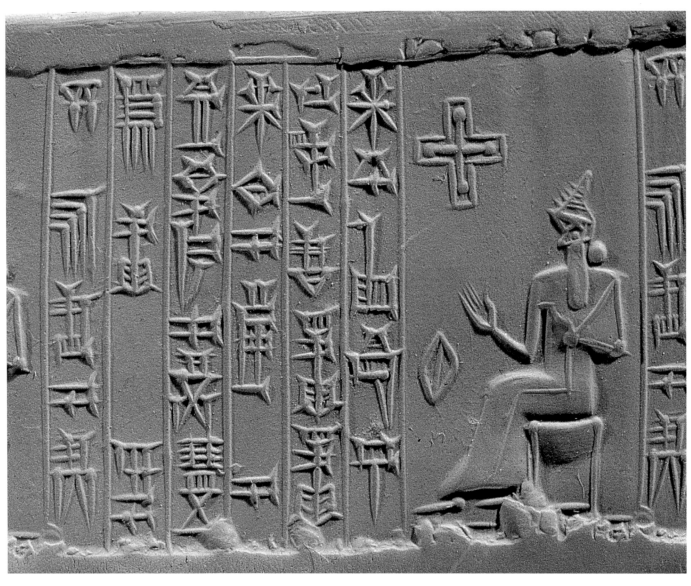

Fig. 1. Cylinder-seal (detail) of jasper, Babylonian era. The whole object is shown on page 43. Musée du Louvre, Paris.

THE MESOPOTAMIAN SCRIBES

Dominique Charpin

Clay and reeds are materials to be found all over the alluvial plain of the Tigris and the Euphrates. They were used to make the tablets that were the writing medium (Fig. 2) and the stylus with which signs were engraved on clay surfaces (Fig. 3). The clay tablets needed long purification and the addition of a degreasing agent to prevent them splitting as they dried, or the signs would have been difficult if not impossible to read. The scribe would cut out a strip of clay the right size for the tablet required and he would fold it back on itself several times (Fig. 4). The edges were then smoothed and the corners pinched. Tablets were sometimes mass-produced. A few such blank tablets, dating from the eighteenth century BCE, were found in the palace at Mari (Fig. 5). Once the scribe had written the text, he would leave the tablet out to dry. Contrary to popular belief, very few tablets were baked in a kiln; this was only done for library copies. On the other hand, it is not uncommon for tablets to have been baked by accident, when the archaeological stratum in which they lay was destroyed by fire. The shape and dimensions of the writing medium depended on the length and the nature of the text for which it was being used, though they also varied by region and period. 'n addition to the "traditional" tablet, tetrahedral labels have also been found that were used as seals for containers (bales of merchandise, coffers, etc.). In the first millennium BCE, commemorative royal inscriptions were often written on prims or cylinders. Bricks were often inscribed by hand but they could also be "printed" by being impressed with a stamp engraved in reverse. Clay was not the only medium used. Royal inscriptions could be

Fig. 2. A silted canal in the Mari region; clay is found everywhere in the Mesopotamian plain.

Fig. 3. Clumps of reeds on the edge of a canal in the Mari region. Reeds were essential raw materials in Mesopotamia and were used by the scribes to make their styli.

engraved on stone or metal. The inscriptions on the cylindrical seals were engraved in reverse by lapidaries. During the first millennium, scholars often wrote on wax-coated wood panels; an idea of what they looked like is provided by an example in ivory discovered accidentally at Nimrud.

The complexity of cuneiform script restricted its use in society: only the small caste of scribes was able to write. It is hard to calculate the number of scribes who were working at a particular era, but such a task has recently been undertaken for the third millennium. It is estimated that at Girsu, ca 2350 BCE, about thirty scribes were active simultaneously. A few decades later, there would have been about a hundred scribes in the whole of the Akkadian empire. Following the administrative reforms introduced by Shulgi, king of Ur, the number of scribes increased. There were 1,600 over four generations in the empire of Ur between 2100 and 2000 BCE. At the same time, writing came to be used in more and more situations. Contracts for the sale of land, which were very rare in the third millennium, became much more common at the beginning of the second millennium. This does not necessarily indicate that there were economic or social changes—for the transactions may not have been more numerous—but simply that contracts were now regularly produced in writing when previously they had been verbal. The second millennium thus appears to be a period when writing was used fairly extensively throughout society. It seems that at the beginning of the second millennium even members of the elite were able to read and write, perhaps because at this period cuneiform attained its greatest degree of simplicity. After the middle of the second millennium the scribes tended to move in the opposite direction, making the script more complex at the very time when the alphabet was emerging along the shores of the Mediterranean. It is as if, having understood that it would be impossible for them to compete, they deliberately chose to emphasize the esoteric nature of their erudition. Consequently, during the first millennium, the uses for cuneiform script were considerably reduced, since people resorted to other forms of writing, mainly Aramaic script. The new scripts were written on surfaces that were much less durable than clay—mainly parchment, which could not be preserved in the hot and humid Mesopotamian climate.

The work of the scribes varied greatly depending upon their employer. Some worked for individuals who needed to have the contracts into which they entered recorded in writing. Such contracts might cover a limited period, such as loans of grain or money. In other cases, such as adoption, marriage or the sale of land, the contracts were permanent. In general, the name of the scribe was recorded after the list of witnesses; it is not known how the scribes were remunerated for their services.

Most of the scribes depended on the large institutions, such as palaces or temples, that dominated economic life in Mesopotamia. Some were responsible for the accounts of a storehouse; they had to note on a little tablet each time merchandise went out or came in. At the end of the month, they would prepare an account. The individual clay tablets recording the stock movements were then no longer needed and could be recycled. They would either be dampened and the surface smoothed so that they could be re-used (Fig. 6) or simply discarded.

Higher up the social scale, some scribes became administrators, in which case they might then be given a more prestigious title. Newly-promoted scribes were particularly proud of their status. For instance, no sooner was Yasîm-Sumu promoted by the king of Mari than he erased the cylinder-seal that bore his former title of "scribe" and replaced it with that of "accountant-archivist." Many others continued to call themselves "scribe" even if they had attained a higher rank, so their true title remains unknown.

One of the essential tasks of the scribe was to compose correspondence. The Mari archives that date from the paleo-Babylonian period have provided valuable evidence in this respect. In certain cases, the scribe appears to have had the text dictated to him as he wrote. Several letters from King Samsî-Addu, in which the king fulminates against his son, were clearly dictated by a very angry man; certain sentences are incomplete, others rambling, and so on. However, more often than not, the monarch merely dictated the main points of the message. A few tablets contain notes that were taken during such sessions. They served as the basis for the final text. The scribe then composed the document and re-read it to his master before placing it in a clay envelope and rolling the cylinder-seal of the sender over it (Fig. 1). This sort of work could not be performed by just any scribe; it was highly confidential, and only a person in whom the king had complete trust would be considered worthy. There is proof of this because a king of Ekallâtum, who had not sent news of himself to his brother for a long time, uses the excuse of the absence of his secretary, yet it is highly unlikely that he would have had no other scribes in his entourage. The king's secretary would also receive the correspondence sent to the monarch by his civil servants, governors of provinces, diplomats on foreign missions, and so on. He was required to break open the envelope in the presence of the king and read the text of the tablet. In certain cases, correspondents wrote another letter, addressed personally to the royal secretary, giving the secretary advance knowledge of

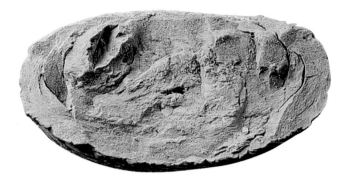

Fig. 5. Section of a cuneiform tablet that has been broken in half, showing how it consists of a strip of clay that is folded upon itself several times. Eighteenth century BCE, palace at Mari.

Fig. 4. Two examples of blank re-usable tablets. Eighteenth century BCE, palace at Mari.

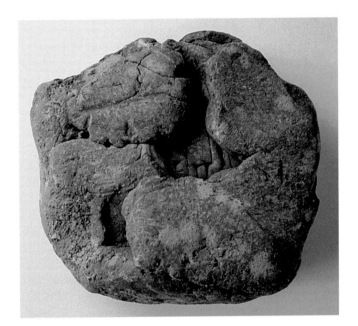

Fig. 6. Tablet in the course of being reshaped. Eighteenth century BCE, palace at Mari.

the content of the message he would be reading and asking him to draw the king's attention to a particular point; this type of missive generally advised the addressee that a gift was on its way!

The most learned scribes were true specialists. The best known are those who were in the service of the kings of Assyria during the first millennium BCE. They were diviners, exorcists, or astrologers who were responsible for the health of the sovereign and needed to use all their erudition to protect him.

Despite their specialization, all the scribes considered themselves to be repositories of the same fund of

"wisdom." They believed that their task was to identify signs in the universe that had been sent by the gods and to ward off any evil that was liable to befall the king.

Traditional texts from previous periods were copied in the neo-Babylonian, Achaemenid and Seleucid periods and even as late as the Parthians. The latest cuneiform text found thus far dates from as recently as 74 CE. No Mesopotamian text has been found that eulogizes the occupation of the scribe, as has been found in Egypt, but there is no doubt that scribes enjoyed a privileged status. Some kings even boasted of having mastered cuneiform and considered themselves to be "scholar kings." One such is Shulgi, king

of Ur, who reigned at the end of the third millennium, and later there was Ashurbanipal, king of Assyria. There was also a certain tendency for the post of scribe to become hereditary, but this is a common phenomenon in traditional societies and is not restricted to scholars. In any case, it became customary in the first millennium to identify a person by the occupation of an ancestor. Many of the scribes of Uruk shared a common ancestor, a certain Sin-leqe-unnenî, who was famous for having "edited" the *Epic of Gilgamesh* during the second half of the second millennium.

The Mesopotamian scribe has become a valuable link between antiquity and the historian. Most of the written evidence available to modern researchers was originally produced by scribes. Their way of life and the customs and conventions that governed the art of writing are thus known, though there may have been omissions, conceal-ment, or distortion of the truth, whether by accident or by design. The scribe therefore serves as a screen that both reveals and filters. For this reason, it is important to be aware of the training given to a scribe.

SCHOOLS IN MESOPOTAMIA

For many years, all that was known of the Sumerian schools (*eduba*) was based on anecdotes such as that of a student who wanted to get into the good books of his teacher and asked his father to invite him home. The teacher was well-treated and showered with gifts so that he then praised his pupil. Another revealing text reproduces a quarrel between two students who accused each other of being ignorant of all the subjects taught at school, thus providing a very enlightening list of them. Other documents of this nature have been found.

Some scholars have considered that these texts prove the existence of schools as independent institutions in premises that were set aside for the purpose of teaching, but they seem to have disappeared around the middle of the second millennium to be replaced by the transmission of knowledge within the family. This would be quite a surprising development, since it is the opposite of what might have been expected.

Data produced by teams working on archaeological excavations are also significant, but here too, caution is required. The discovery of a school building is often reported as "sensational," but some archaeologists, acting in good faith, believed they had discovered school buildings when in fact they had not. The most spectacular example is that of Room 64 in the palace at Mari. André Parrot claimed that this was a schoolroom, mainly because it was filled with parallel rows of benches. He deduced that these benches were occupied by school students, yet the tablets found in the room had nothing to do with school exercises since they turned out to be administrative records. In fact, the room was used for storing jars of wine whose pointed ends were lodged between two "benches."

Nevertheless, excavations have revealed sites at which apprentice scribes were taught, such as the house of Ur-Utu at Tell ed-Dêr. Of the two thousand or so tablets discovered in the home of the chief mourner (*gala-mah*) of the goddess Annunîtuym, dating from the seventeenth century BCE, a group of seventy-one were found in and around a stone trough in the center of the courtyard. They contained basic exercises for learning cuneiform. Another confirmed instance is that of the house at no. 7 Quiet Street, Ur. A family of purification priests lived there from the late nineteenth through the mid-eighteenth century BCE. Their archives have been found, as well as texts indicating that the house was used for training scribes.

The name "school" thus appears to be misleading. It confers an institutional nature upon the place that was used for training scribes and it also assumes a certain continuity of the occupation at a particular place. The archaeological evidence offers a different picture—that of scholars who taught young scribes in their own homes, beginning with their own children. In a traditionalist society such as that of Mesopotamia, most of the occupations were handed down from father to son and training was through apprenticeship. The education of scribes falls very much into this category, but by its very nature it has one significant difference from other occupations in that it has left written evidence. The exercises written by the apprentice scribes have provided us with most of the important texts of the ancient Near East.

The first thing a would-be scribe was taught was how to hold the calamus correctly. The exercises that are proof of this are sometimes referred to by the medieval term *probatio calami*. The students then had to copy syllabaries, beginning with lists of signs—the ABC of cuneiform is the series called "a-a me-me." First came the simplest of the signs to master, A, KU, ME, which were repeated in various combinations. After this, new signs were introduced. This continued with the "tu-ta-ti" series, which in this case were based on phonetic rather than visual principles. Each consonant was associated with one of the three basic vowels. The first lines of the exercise were thus *tu/ta/ti, nu/na/ni, bu/ba/bi,* etc.

Once the student had learned the signs, he progressed to the various possible "pronunciations" that were associated with them. This was the aim of the so-called "proto-Ea"

Fig. 7. Example of a school exercise: a long list of names of the gods being recorded in the home of the diviner Asqudum. Eighteenth century BCE, Mari.

series, consisting of a table in which the signs were grouped together on the basis of their configuration and repeated as many times as there were different ways of reading them. Thus, the sign KA could be read with the pronunciations *ka, inim, zu,* etc.

When the syllabaries had been mastered, there came the lists of vocabulary. The study of proper names was one of the first tasks that faced the young scribes. This list was called "Inanna-tésh," from the name that began "List A" of proper names. This had the advantage of being based on the student's prior knowledge. It was also based on the fact that in Sumerian (as well as in Akkadian), people's names always had a meaning. The next vocabulary was called "lú = *sha*" which contained titles and names of occupations. This is a list dating to the very beginnings of cuneiform writing, and for this reason, it was slightly out-of-date in relation to the actual situation in paleo-Babylonian times because some of the titles it contains were no longer in use. There were also lists of place names and something that is sometimes considered as a sort of encyclopedia, the "HAR-ra = *hubullu*" series, a list of all the types of animals, plants, objects, etc. These noun lists are evidence of the "knowledge of concrete objects" that has been interpreted as being typical of traditional societies (Fig. 7). Other lists such as "diri= *atru*," "izi = *ishatu*" and "ka-gal = *abullu*" were also copied by students.

The apprentice scribe was now considered skilled enough to begin copying actual texts. These were primarily texts written in Sumerian. At the time, Sumerian played a role comparable to that of Latin in medieval or modern Europe. The existence of a corpus of Sumerian literature during the paleo-Babylonian era was the result not of a noble desire to rescue it from oblivion but, more prosaically, of the fact that school teachers needed suitable anthologies of great works at their disposal. The first exercises consisted of copying proverbs, texts that had the virtue of being easy to remember and short in length. Most of the teaching exercises were written on lenticular tablets between two and five inches in diameter. First, the master would write down two or three lines of a proverb which the student would copy underneath. Then the exercise became more complicated. Once the proverb had been written down by the master on the obverse of the tablet, the student had to rewrite it from memory on the reverse. Hundreds of these circular tablets have been found, on which it is not hard to distinguish the practiced hand of the teacher from the hesitant and sometimes error-ridden writing of his student.

After this stage came the copying of short extracts, then whole compositions. Sometimes the master dictated text that the student would first have to repeat orally then write down. In other cases, a manuscript was supplied to the student who had to copy it, carefully transferring it to his own tablet. The sorts of texts copied in this way were very varied in nature. First, there are those that could be described as "literature"—myths and epics, hymns, lamentations, disputations, and so on. The curriculum also included the copying of letters written in Sumerian, especially "historical letters." That is how the correspondence of certain kings has come down to us, especially that of the kings of the third dynasty of Ur, as well as that of the kings of Larsa.

Future scribes also needed to learn the legal phraseology required for the drawing up of contracts. This was the purpose of the series called "Ana ittishu" which was probably compiled in Nippur in the paleo-Babylonian era, although no manuscript as old as this has yet been found. Some copies of the *Code of Lipit-Ishtar* seem to have been the work of a schoolboy copyist. There are also many model contracts. A young student boasted to a friend that he was capable of writing, "marriage contracts, partnership contracts [...], deeds for the sale of houses, fields, slaves, monetary guarantees, leases for fields, palm plantation cultivation contracts, and even tablets for contracts of adoption." The training of the apprentices also involved copying commemorative royal inscriptions. This fact is particularly well documented in Nippur where many copies

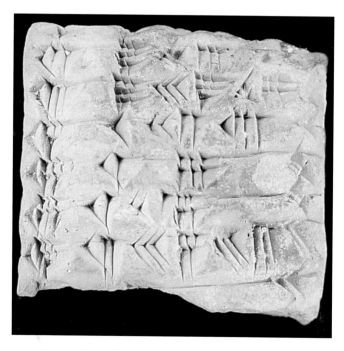

Fig. 8. Mathematical table: multiplication table. Eighteenth century BCE., palace at Mari.

of much older inscriptions from the paleo-Babylonian era (dating back to the era of Agade or Ur III) were found that had originally been inscribed on statues or steles displayed in the courtyard of the great sanctuary of the city, the Ekur. This was a sort of paleographical exercise since the students usually respected the exact form of the original. The exercise might, on the other hand, consist in modernizing the writing. Sometimes there is an indication of the original medium on which the inscription had been written—the originals frequently being lost—that may even specify the precise location of the inscription (on the shoulder, for instance).

A certain number of "catalogs" of literary works have also been found. Some are inventories of collections of manuscripts preserved in the house of a particular scholar. They are thus a valuable adjunct to the archaeological discoveries since they reconstitute the body of Sumerian literature. But many of these catalogs are repetitious so it is quite likely that they are a sort of syllabus of courses.

Teaching was not restricted to the reproduction of works of literature and similar material. The would-be scribes were also given the sort of practical training that would equip them for their other future tasks. It was not enough to have learned by rote the correct formula for writing a deed of bequest. It was necessary to know how to divide up plots of land so that they could be shared among the heirs.

Arithmetic (Fig. 8), weights and measures, and land-surveying were thus part of the curriculum. Other subjects, that at first might not appear to be relevant, such as music and singing, were also taught. The pupils needed to know the various musical genres (*shir*) and be capable of singing the compositions called *tigi* or *adab*.

THE LIBRARIES OF MESOPOTAMIA

A library can be defined as a classified collection of works. Even before the famous Greek libraries of Pergamon and Alexandria, the ancient Near East possessed such collections. Sometimes, the word "library" has been misused in this context, however. The tablets found in the palaces at Ebla and Mari were not libraries but archives.

On the other hand "Ashurbanipal's library" at Nineveh seems to meet the criteria. The Assyrian king, who reigned in the mid-seventh century BCE, assembled a collection in his palace consisting of more than a thousand cuneiform tablets. He is spoken of as an "enlightened monarch," but this is something of a misnomer. Ashurbanipal's intentions were not those of a learned collector. The king merely wanted to supply the scholars who were responsible for protecting him (physicians, astrologers, magicians, etc.) with plenty of resources to carry out their trade. Rather than a library as we would understand the term today, this collection was a veritable arsenal of magical and religious formulae to be used as weapons for protecting the king. This explains why the library contains so little "literature" (myths, epics, etc.). Only forty tablets of that type have been found, in comparison with the huge number of tablets dealing with divination, exorcism, etc. There are about three hundred divinatory tablets (astrology, teratology, the interpretation of dreams, divination through examining entrails, and so forth). A hundred or so others consisted of curses and spells, such as the great liturgy of purification by "Burning" that covers ten tablets and contains a large number of incantations.

There were two hundred lexicographical tablets; this large number is explained by the fact that Mesopotamian culture was bilingual and the Akkadian-speaking scribes had to learn Sumerian. The catalog of Ashurbanipal's library has been partially found and this shows that some of the tablets came from the homes of Babylonian scholars from whom they were confiscated after a rebellion had been quashed in 648 BCE. Another part came from private Assyrian libraries, such as that of the royal scribe Nabū-zuqup-kēna. Other tablets were copied especially for the needs of the sovereign and his entourage. These end in a "colophon," a few lines indicating the nature of the work, the number of

the tablet if it is part of a series, and a statement to the effect that the document belongs to the palace library. Other colophons show that certain tablets had been deposited in the Ezida, the temple of Nabū, the god of writing. These can be considered as votive offerings; just as large quantities of weapons were offered to Nergal, the god of war and of hell, so tablets could be offered to Nabū when soliciting his favors.

This was not an isolated case of votive offerings in the form of tablets. When tablets containing literary works were found in temples, they often proved to have been produced by apprentice scribes, and consisted of a dedication to the gods of writing. Such tablets, dedicated to the Sumerian gods of writing, Nisaba and Haya, have been discovered in the main temple of Shaduppum (Tell Harmal), dating from the eighteenth century BCE, and in the temple of Nabū in Babylon, dating from the sixth century BCE. Whether temples can be said to contain libraries is a matter of controversy. Some people consider them to be a sort of repository of Sumerian culture, but this is perhaps an exaggeration.

The German born professor of Assyriology at the University of Pennsylvania, Hermann V. Hilprecht (1859–1925), who excavated Nippur in the late nineteenth century, perpetrated a true mystification. He claimed that the numerous literary tablets written in Sumerian found in his excavations belonged to the library in the Temple of Ninurta. In fact, this was a collection of manuscripts found in the houses of the clergy who lived near the sanctuary that they served. The same is true of discoveries made at some other sites, such as Ur. In such cases, one cannot really describe the finds as a library, they are simply collections of manuscripts. The tablets were usually stored in reed baskets. Sometimes inventories of these baskets were made and these constitute rudimentary catalogs. The concept of a title did not exist at the time, so the works were indexed by their first lines, a practice also used in the Hebrew Bible and which continues today, in documents such as papal encyclicals.

A recent discovery reveals, however, that "temple libraries" did indeed exist. In 1985, the Iraqi archaeologist, W. al-Jidr, working on the Temple of the Ebabbar at Sippar, discovered a rather small room that contained a genuine library. Three sides of the room were occupied by shelving made of raw clay and consisting of four superimposed rows of fourteen pigeonholes in which the tablets were stored. This library appears to have been created in the neo-Babylonian era and was still in use in the early Persian period (*ca* 529 BCE). It contained copies of historic inscriptions, lists of vocabulary, hymns, prayers, spells, treaties on divination, and so on. The priests who created and used this library were not only fine scholars: they also appreciated the classics. Their taste is revealed particularly in the text of the myth of Atra-hasis, one of the Babylonian versions of the story of the Flood.

Bibliography

OPPENHEIM, Adolf Leo. *Ancient Mesopotamia: Portrait of a Dead Civilization* (Chicago, 1977).
PEDERSÉN, Olof. *Archives and Libraries in the Ancient Near East 1500-300 B.C.* (Bethesda, 1998).
SASSON Jack M. et al. (eds.). *Civilizations of the Ancient Near East* (New York, 1995).
VAN DE MIEROOP, Marc. *Cuneiform Texts and the Writing of History* (London, 1999).
VEENHOF, Klaas R. (ed.). *Cuneiform Archives and Libraries* (Leiden, 1986).
WALKER, Christopher B. F. *Cuneiform, Reading the Past* (London, 1987).

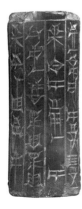

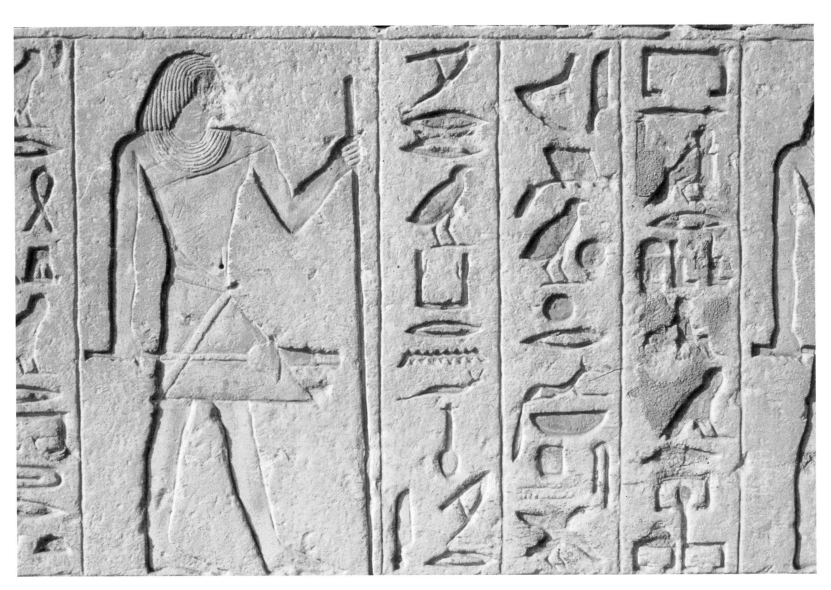

Fig. 1. Mererouka, known as Meri. Mastaba from the sixth dynasty at Saqqara.

THE SCRIPTS OF ANCIENT EGYPT

Pascal Vernus

THE BIRTH OF HIEROGLYPHICS

It is now accepted that writing emerged in the Nile Valley shortly before the birth of the pharaonic state. The emergence of this new state, in around 3000 BCE, was marked by the union into a single state of Upper and Lower Egypt under the rod of the first pharaoh Menes, founder of the First Dynasty, to whom later historiography has attributed the name of the pharaoh Nârmer and/or that of the pharaoh Âha. In fact, for less than two centuries previously, during the so-called "protodynastic" era, hieroglyphics were already being used in the kingdom of Upper Egypt (Fig. 2), including on valuable objects discovered at the site of Abydos, in the royal necropolis of kings who constituted what has been dubbed "Dynasty 0." It would appear that what produced, or at least stimulated, the creation of writing in the true meaning of a visual system for encoding the spoken word was the desire to perpetuate the king's person by mentioning his name in connection with the symbols of power and especially the *serekh*—that is to say, the facade of the palace surmounted by a representation of Horus 🦅, the falcon. By studying the marks on protodynastic objects, a development can be observed whereby the names of the monarchs of Dynasty 0 are gradually inserted inside this previously empty symbol.

HIEROGLYPHICS IN THE PHARAONIC CIVILIZATION

Once introduced, writing did not become widespread, nor was it used in all types of record. In fact, until the end of the Second Dynasty, known inscriptions were limited to short annotations, proper names, the names of ingredients, indications of quantity, origin, etc., constituting what has

Fig. 2. Fragment of a vase bearing the name of King Sekhen (Qaa or Ka) of the protodynastic era. Inv. E 29885, Musée du Louvre, Paris.

Fig. 3. Lintel from the reign of Sesostris III. The pharaoh is making an offering to the god Montu, master of the Theban name. Inv. E 13983, Musée du Louvre, Paris.

been called "statement-titles." It was not until the reign of the pharaoh Djoser (*ca* 2700 BCE), who built the famous stepped pyramid, that coherent texts consisting of complex sentences first appeared. From then on, writing spread throughout the various sectors of pharaonic civilization and was used in everyday life (correspondence, administration, legal documents) and in ideological and religious writings on temples, royal monuments, and funerary monuments, as well as in autobiographical documents, religious rites, and for magical spells (Fig. 3). Copies of literary and

"scientific" texts (treatises on medicine, mathematics, etc.) are unknown before the Middle Empire (early second millennium BCE). Some scholars claim that in the case of literary texts this was to be expected, since they continued to be transmitted orally as before. In the case of scientific works, it is possible that there was a transition from the old practice, whereby scientific knowledge was presented in the form of a table or chart in which several formulae were bracketed together, to the more advanced stage of a discourse or debate.

Fig. 4. Ostracon inscribed with text explaining how to open and close a window. Inv. AE/E 23554, Musée du Louvre, Paris.

Hieroglyphics proved to be very inconvenient for everyday use, so cursive forms or "tachygraphs" (speed writing) were created based on the simplified outlines of hieroglyphs. These were sometimes joined together by ligatures, combining several signs in a single outline. This made it possible to write long texts more speedily. The tachygraphs fall into two categories:

– **hieratic**: this type of tachygraph emerged under the Old Empire and continued in use until the Roman era. It was used for secular writings (Fig. 4), for literary and scientific works, for archiving religious texts and sometimes even for sacred writings as a substitute for hieroglyphics (Fig. 5). The name is misleading because "hieratic" means "sacred," but it was what the Greeks called this script at a time when it had been replaced for everyday use by demotic (Fig. 6).

– **demotic**: this is the name which is used for a form of the Egyptian language as well as for the tachygraphs that were used to write it. It emerged in the late seventh century BCE and survived until the start of the fifth century of the

common era. Its use was purely secular at first but it gradually came to be used for archiving religious texts and even for creating religious inscriptions, because a few formulae or signs would be sufficient to record the religious precept (Fig. 7).

Both of these types of tachygraph were written from right to left. The images which the signs originally represented ceased to be figurative, but this was the price to be paid for greater convenience of use.

SURVIVAL AND DISAPPEARANCE OF HIEROGLYPHICS IN GREEK AND ROMAN TIMES

The introduction of cursive script did not result in the abandonment of hieroglyphics. They survived the demise of the pharaonic state and the conquest of Egypt by Alexander the Great (330 BCE). From then on, Egypt was governed by foreign rulers—Greek at first under the Ptolemies, later Roman. The ancient religion survived, nevertheless, and with it the hieroglyphics which were its means of expression. The temples continued to be decorated with scenes from the Egyptian canon in which divinities were worshiped by a pharaoh, whose name in the cartouches might be that of a Ptolemy or the reigning Roman emperor, or even just the word "pharaoh." Hieroglyphic representations and inscriptions continued to be based on the principles that had been laid down three thousand years previously. Even the annotation in Greek letters of the contemporary Egyptian language that developed vigorously, after a few false starts, from the third and fourth centuries BCE did not cause hieroglyphics to fall into disuse. They did not disappear altogether until Christianity became the official religion of the Roman Empire and pagan cults were officially banned. The Edict of the Emperor Theodosius, promulgated in 392 CE, forbade this form of worship, and this proved to be its death knell, since the last places to perpetuate the knowledge of hieroglyphics,[1] the temples dedicated to the gods of the ancient pharaonic religion, were shut.

Hieroglyphics inspired two forms of script. The first is "proto-sinaitic," a writing system based on the attribution of a phonetic value to certain hieroglyphics that was taken from the first consonant of the name for the particular object the sign was supposed to represent in the semitic language. Recent discoveries of graffiti in the Egyptian desert suggest that this type of writing was fairly widespread and is probably the origin of all the ancient semitic alphabets and hence, via Greek, of European script.

The second script is Meroitic, the written form used exclusively for the language spoken in the kingdom of

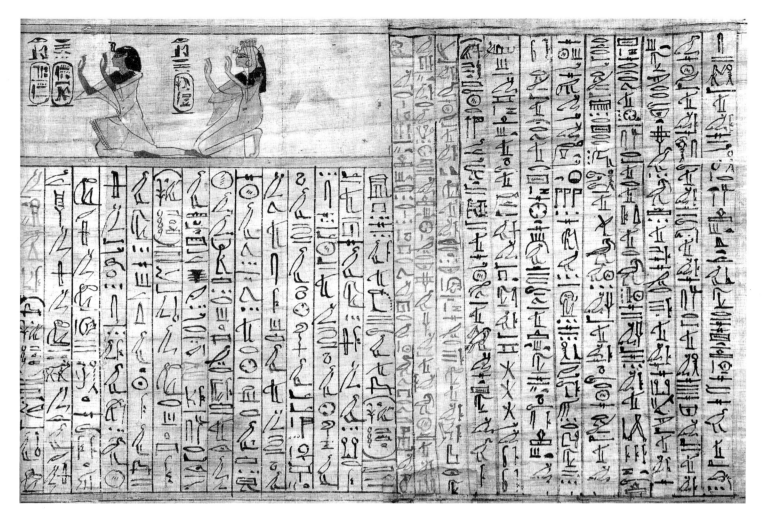

Fig. 5. Book of the Dead of Queen Mut-Nejemet, in which the name of the pharaoh Herihor appears. Inv. E 6258, Musée du Louvre, Paris.

Meroe, in what is now Sudan, using either hieroglyphics or demotics (the third century BCE to the fourth century CE).

THE REDISCOVERY OF HIEROGLYPHICS

After the closure of the temples, for more than a thousand years hieroglyphics lay buried under the dust of ages and oblivion. Paradoxically, it was Rome that brought them back to life. During the Renaissance, the cardinals who had undertaken the task of cleaning up and restoring the Eternal City discovered several Egyptian obelisks that had been brought to Rome during antiquity and long forgotten. They restored them, but the hieroglyphic inscriptions with which they were covered defied the wisdom of the greatest of scholars. A debate thus began that would last more than two centuries in which intellectuals fought over three conflicting theories.

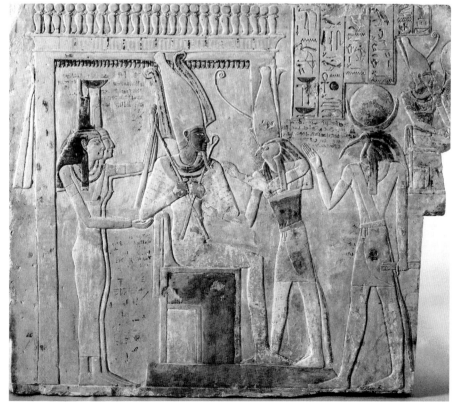

Fig. 6. Shrine of Amenhotep. There is a hieratic inscription on the left above the figure of Isis, beside the hieroglyphic inscription above Thoth (on the right). Inv. 31010–3, Staatliche Museum, Berlin.

Fig. 7. Torso of statue of Amasis, with a demotic inscription. Inv. n° 14460, Staatliche Museum, Berlin.

The first theory, the so-called "mystical" theory, considered hieroglyphics to be symbols through which revelations could be made to initiates. This belief was founded on such essays from antiquity as *Hieroglyphica* by Horapollon, of which the manuscript had been rediscovered in the fifteenth century CE. Horapollon had learned from his informants the exact meanings of certain hieroglyphs or groups of hieroglyphs, but he interpreted them through elaborate ventures into mystical and allegorical speculation. They inspired a particular tradition of Renaissance learning, represented among others by the German cleric Athanasius Kircher.

The second theory, the so-called "philosophical" theory, since it was supported by philosophers such as Karl Leibniz, believed Egyptian hieroglyphics to be a system of

Fig. 8. Papyrus in Greek (left and center colums) and in demotic (right column). Inv. N 2328, Musée du Louvre, Paris.

annotation of ideas, embracing the dream of a universal form of writing through which thought could be transmitted without having to pass through language.

The third, "historical," theory, predicted that hieroglyphics was simply a system of writing like any other and that it recorded in visual terms the language of the pharaohs. This theory, obviously the correct one, progressively gained ground in the eighteenth century and was triumphally vindicated in the following century when Jean-François Champollion announced in his *Letter to Monsieur Dacier* in 1822 that he had managed to discover the principles of this writing and revealed the first deciphered words. This had only been made possible thanks to the Rosetta Stone, inscribed in two languages, as well as the work of several other researchers, one of whom, Thomas Young, was familiar with Coptic, the most recent form of the Egyptian language that had survived as

the liturgical language of the Egyptian Christians. Nevertheless, this feat would never have been achieved without Champollion's hard work and strokes of genius.

The reason why the deciphering of hieroglyphics took so long and why it was so difficult to find the keys to the code is that it is quite a complicated system, and it is easy to make mistakes and become confused. It is important when trying to read hieroglyphics to study the external appearance of the sign and consider where it fits into the system of encoding ancient Egyptian pronouncements.

THE FUNDAMENTAL PRINCIPLES OF HIEROGLYPHICS

APPEARANCE AND FORM OF HIEROGLYPHIC SCRIPT

What has always made hieroglyphs a subject of such great interest and has contributed part of their mystery is that they are *figurative*. The signs are instantly recognizable images that can be identified even by non-experts (Fig. 9). In our own system of writing, a sign represents nothing but itself. For instance, the letter M only represents the sound M and its name has no intrinsic meaning. On the other hand, the hieroglyph 𓅓, which can be used to represent the sound *m*, is also an image that anyone can identify as a bird of some kind, specifically an owl. Generally speaking, hieroglyphs represented everyday things in the world of the pharaohs. These included people in various poses, parts of the human body, and animals large and small. The animals were the African fauna typical of the ancient Egyptian environment—crocodiles, hippopotamuses, lions, and leopards, as well as those that had already disappeared from that part of Africa before the coming of the pharaohs, such as the giraffe, the elephant, the baboon, etc. Parts of animals were also used, as well as plants, the sky and elements of the landscape, constructions and architectural elements, a wide range of religious artifacts and secular objects. There are very few abstract signs, but the imagination also contributed to the repertoire of signs, in the depiction of gods and goddesses.

The passage from reality to the hieroglyph that it represents was governed by the conventions of Egyptian art. Apart from the process of stylization, an object was not drawn as it would be seen by an observer located in a particular position—as it would be drawn in the Western tradition (that is to say, in perspective)—but in a way that would best emphasize its characteristics, even if seen from apparently contradictory angles. For instance, the faces of

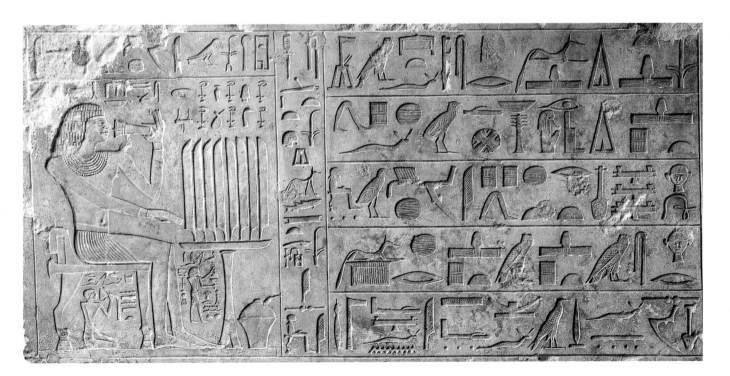

Fig. 9. Lintel of Isis. Inv. E 14329, Musée du Louvre, Paris.

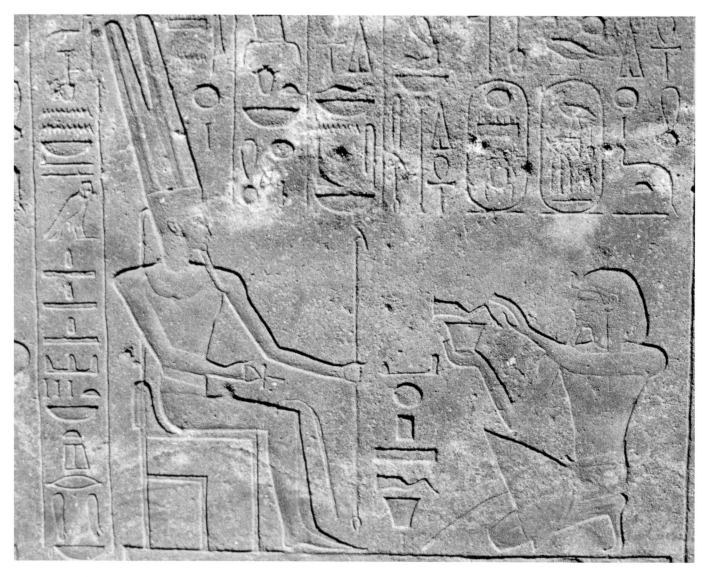

Fig. 10. The pharaoh Thutmosis III seen on the right kneeling and offering a haunch of beef on an earthenware bowl to the god Amon, seated on the left. Temple at Karnak.

human beings are seen in profile (with a few exceptions), but their torso is shown as front-facing, the pelvis in profile again, and so on. The fact that hieroglyphics are basically pictures is particularly clear in scenes in which the same element is used both in the depiction and in the writing of the inscription. For example, in the scene shown above (Fig. 10), the same object—a haunch of beef resting on an earthenware dish—is used both in the main image, in which the kneeling pharaoh (Thutmosis III) is holding it out as an offering to the god Amon, and as a hieroglyphic sign (written as ⛉) in the inscription column between the pharaoh and the god.

So, if hieroglyphs are images, what makes it possible to distinguish between text and representations? The answer

is that in order to be used as written signs, the images are turned into hieroglyphs by imposing three restrictions upon them.

First, there is the restriction of size. The proportions of the signs bear no relation to their proportions in real life. For instance, the sign for the cricket 🦗 when used in writing takes up the same amount of space as the sign for the hippopotamus 🦛 ! The size constraint is easily understood. In view of the wide variety of elements used as signs and their great disparities of size in real life, to reproduce them in proportion would require vast areas within the text to be reserved for their representation, unless some of the signs were reduced to such a small size that they became illegible.

The second constraint is to ensure that the space devoted to the inscription is filled densely but evenly. Hieroglyphs are never lined up in rows like garden plants, they are grouped and arranged on the basis of their shape inside "quadrants," virtual squares into which the available surface is divided (Fig. 11). For example the succession of signs:

representing the phrase "the lands that he owns" would be arranged in three quadrants as follows:

The value of this space-saving device can easily be appreciated. It was a general rule to leave as little white space as possible, in theory only the amount needed to separate the signs from each other. Furthermore, a hieroglyphic inscription is continuous, without separations between words and sentences.[2]

The third constraint is the orientation. Many hieroglyphs have an asymmetrical structure and those representing people and animals always face in the same direction. In an inscription, all the signs must face the same way as the sign at the start of the text, from which reading must begin. This constraint gives the text a uniform "color" in the typographical sense, especially as inscriptions can be arranged in the four directions of reading:

1) in a horizontal line from right to left;

2) in a horizontal line from left to right;

3) from top to bottom in a vertical column, columns and signs inside a quadrant being read from right to left;

4) from top to bottom in a vertical column, columns and signs inside a quadrant being read from left to right.

Here is an example of how hieroglyphs are arranged and used, facing in a single direction in a single phrase meaning "I was the leader of senior administrators":

1) in a horizontal line from right to left:

2) in a horizontal line from left to right:

3) from top to bottom in a vertical column, from right to left:

Fig. 11. Examples of quadrants: the first quadrant on the right consists of five superimposed signs, the second of a single but composite sign, a hieroglyph (a falcon) being enclosed within another (a building). From the temple of Hathor at Dendara.

4) from top to bottom in a vertical column, from left to right:

There is also a special way of orienting the signs that is known as "retrograde orientation." This means that asymmetrical signs face backward in relation to the starting point of the inscription and face the opposite way to the direction of reading from column to column. Inside a quadrant, however, the text is read from the direction in which the signs face. For example, in the following inscription:

the left-hand column should be read first, then the right-hand column. In the quadrant consisting of the signs , however, the sign should be read on its own, followed by the group consisting of .

The word is therefore written backward where there is a conflict between the reference point and the usual direction of the signs.

MECHANICS OF THE HIEROGLYPHIC SYSTEM

To the extent that hieroglyphs are images, one is instinctively led to conclude that the images record the very things that they represent. This natural but naive belief held up the deciphering of the script for a long time, and even Champollion found it difficult to abandon it. In fact, the true situation is far more complex, since hieroglyphs can assume three different functions in their encoding of verbal statements:

1. the function of an ideogram;
2. the function of a phonogram;
3. the function of a determinative.

Some hieroglyphs are used in all three ways, depending on the context, others serve in only two ways, and still others can only be used in one way.

The ideograms

An ideogram (a "word-sign" or "logogram") is a sign that includes all the lexicographical elements of the language—that is to say, a sign that can be used to represent a whole word or a concept representing several words with the same root, or even with different roots but with a similar meaning.

Since hieroglyphs are figurative, an ideogram could be expected to mean what it represents and this is true in several instances. The hieroglyph that represents a bull, 𓃒, is an ideogram meaning BULL ($k\!\!\!\!/$ in Egyptian).[3] The hieroglyph for an obelisk, 𓉶, is an ideogram meaning OBELISK ($t\d{h}n$ in Egyptian). However, the relationship between what the ideogram represents and its meaning is sometimes less apparent. Many signs do not mean the person or object represented but the action performed. Thus, a dancing man, 𓀁, means TO DANCE ($\d{h}bj$ in Egyptian); a cow licking her suckling calf, 𓃝, means TO TAKE CARE OF ($\!\!\!/ms$ in Egyptian). The meaning of the ideogram often results in metonymy. Examples are a ballooning sail, 𓏲, for WIND ($\bar{t}\!\!\!/w$); a jug of beer, 𓏊, for BEER ($\d{h}nq.t$); the scribe's equipment (a pen-case for holding quills with crushed tips, connected to a purse for holding pigment and a board containing two inkwells), 𓏞, for SCRIBE ($s\check{s}$). A few ideograms are formed from combinations of signs; thus a crouching man above whom is a vase from which water is pouring, 𓃀, means TO BE PURE ($w\!\!\!/b$). There is a commoner variation that is even more artificial since it represents the foot, a phonogram for the last consonant, b, topped by the vase 𓏴.

The phonograms

Many hieroglyphs have a phonogrammatic function—that is to say, they indicate *a sound* (or series of sounds) rather than a meaning since hieroglyphics are largely phonetic, contrary to what their figurative aspect might lead one to assume. The phonetic value of phonograms is based on the principle of the *transfer rebus*. A hieroglyph used in this way serves as a vehicle not for the meaning of what it is depicting but for its *phonetic value*. For example, the phonogram for the female hare, 𓃹, does not represent a female hare but represents instead the sequence of consonants $w+n$ used in the Egyptian name for a female hare. The rebus puzzles with which children amuse themselves have come back into fashion in the titles of certain movies, in which the Roman numeral II is used not in its meaning of *two* but to write the preposition *to*. French movie-makers have begun to copy the trend. One example is to write "cité" (city) *6T* (a homonym) as in the title of the movie "*Ma 6T va cracker.*"

In hieroglyphics, phonograms are only used to represent consonants or semi-consonants such as y and w,[4] just as they do in Hebrew and Arabic newspapers. That is because although Egyptian is not a true semitic language, its lexical arrangement is fairly similar to one since the semantic concepts are mainly based on roots consisting purely of consonants, the vowels being used to voice those concepts. A person who could read Egyptian fluently had no trouble voicing a written text that consisted purely of written consonants, in the same way as a reader of Arabic or Hebrew does today.

Phonograms can be written as one or more consonants. A very few of the phonograms consist of four consonants, and these are called "quadriliterals." Those containing three consonants are known as "triliterals"—for example, 𓋴, is the phonogram for the series of consonants $\!\!\!/+n+\d{h}$, and 𓐍 is a phonogram for the series of consonants $\bar{h}+n+m$. The "biliteral" phonograms, consisting of two consonants, are the most frequent; for instance, there is 𓂋 for $w+r$; 𓐝 for $m+j$; 𓈖 for $m+n$; 𓇯 for $\d{h}+\!\!\!/$; and 𓄿 for $m+\!\!\!/$.

Finally, there are "uniliteral" phonograms, also called "letters of the alphabet," that represent the 23 (or 25)[5] consonants in the Egyptian language, with the exception of l, which had no specific sign, at least not in the classical period. The following is the table:

𓅐 ꜣ This letter is called *aleph* in egyptological tradition. It originally denoted a liquid sound (r or l), but gradually evolved into the glottal stop of the semitic *aleph*. It is represented as a or ' in transcriptions made for the general public, although it does not represent a vowel sound at all.

〻 *j* Denotes the semi-consonant called *yod* (pronounced like the *y* in *yard*) and, in certain positions, the same glottal stop as 〻.

〻〻 *y* This is the semi-consonant *yod*, inside or at the end of words, often indicating the voiced version of this semi-consonant.

〻 ' This represents the consonant called *ayin* in semitic languages. It is often represented as *â* or ' in transcriptions for the general public, although it is not a vowel in itself but imparts a guttural sound to another vowel.

〻 *w* This semi-consonant is pronounced like *w* in the name "Walter," or as the long "oo" vowel sound in "cool."

〻 *b*

〻 *f*

〻 *p*

〻 *m*

〻 *n*

〻 *r*

〻 *h* Pronounced *h* as in the English "have."

〻 *ḥ* Pharyngeal fricative *h*, as in the Arabic "Hamed."

〻 *ḫ* Velar fricative similar to the *ch* in the Scottish "loch."

〻 ≈ *ẖ* Palatal fricative similar to the German *ch* in "ich."

〻 *s* These two signs once denoted, respectively, an unvoiced soft sibilant (*s* in the English "sound"), and a voiced sibilant (*s* as in the English "rose"). In classical Egyptian, the distinction between these sounds had disappeared.

〻 *š* Like the *sh* in the English "shack."

〻 *q* The uvular occlusive similar to the Arabic *q* in "qadi."

〻 *k*

〻 *g*

〻 *t*

〻 *ṯ* Affricative unvoiced dental similar to the "*ch*" in the English "channel." [6]

〻 *d* Probably an emphatic unvoiced similar to the Arabic *ṭ*.

〻 *ḏ* Affricative voiced dental, similar to the English *j* in "Johnny".[7]

The determinatives

In addition to their uses as ideograms and phonograms, hieroglyphs could also be used as determinatives. In hieroglyphics, a determinative is a sign that has no phonetic value or meaning in itself but is placed at the end of a word written using phonograms and/or an ideogram, to indicate its semantic category. For example, a word that means a building or group of buildings could have as its determinative the sign 〻, representing the plan of a house; a word that indicates a plant could use the sign 〻 (grass); a word indicating an activity involving the mouth, by the sign 〻 (person putting his hand to his mouth); a word indicating an activity involving physical strength by the signs 〻 (man wielding a stick) or 〻 (mailed fist); a word representing an abstract idea by the sign 〻 (a rolled and sealed papyrus), etc.

Determinatives are thus categorizing signs, and a word may include none or several of them. They are used as markers, indicating the end of a word, and this helps to separate the signs into words in texts in which neither the words nor the sentences are separated from one another. They make it possible to distinguish between two written words with the same sequence of consonants, the vowels not being indicated in any way. For example, the sequence *m+n* can represent either the verb *mn*, TO BE BAD, or the verb *mn*, TO BE STABLE. In the first case, the phonetic group 〻 (*mn*) would be followed by the determinative of the concept of evil, 〻 (a sparrow[8]), to produce 〻. In the second case, the same phonetic group 〻 (*mn*) would be followed by the determinative for an abstract concept 〻, namely the sealed papyrus scroll, producing 〻.

Determinatives often add semantic precision that is otherwise lacking in the written language. For instance,

the addition of the determinative for wood ⌣ after the name of an object indicates what the object is made of, without such indication being contained in the name or sound of the word. The determinative can thus be used on occasion to add meaning.

HOW THE SYSTEM WORKS

Hieroglyphics are used in different ways to perform the three functions described. The question arises of whether they can be combined to provide graphic encoding of the spoken word. There are certain guiding principles that also vary, depending on the period, the place, the medium on which they are written, the finality of the text, the traditions in which the scribe or engraver were taught, and other considerations. In short, hieroglyphics are not very systematic if the term is taken to mean organization on a purely logical basis.

Phonetic graphics

Most of the words are written using phonograms that are usually followed by one or more determinatives. Two examples of this are:

� (rk) ERA: The alphabetic phonogram ⌣ (r), plus the alphabetic phonogram ⌣ (k), followed by ⊙, the determinative of the concept of time.

‖⊜⌣ (sḫr) PLAN: The alphabetic phonograms ‖ (s), ⊜ (ḫ), and ⌣ (r), followed by ⌣, the determinative of an abstract concept.

These examples illustrate the simplest case, in which each consonant in a word is written using an alphabetic sign (one phonogram is used to represent a single consonant). There are also biliteral, triliteral, and even quadriliteral phonograms, and this opens up a much wider range of possibilities:

⌣ (ꜥwꜣ) TO REMOVE BY FORCE: The alphabetic phonogram ⌣, plus biliteral phonogram (wꜣ), both followed by , the determinative of the concept of physical force.

(ḥꜣqw) TO PILLAGE: The biliteral phonogram (ḥꜣ), plus the alphabetic phonogram with phonetic sign (ꜣ), plus alphabetic phonogram (q) plus alphabetic phonogram (w), followed by , determinative of the concept of physical force, and , determinative of a human being.

(mꜣt.t) MANDRAX: The biliteral phonogram (mꜣ) sits above two alphabetic signs ⌣ (t). The first is written as the t of consonantic root and the second is a suffix t, indicating the female gender; these three signs are followed by , determinative of the concept of a plant.

(tꜣšps) SPECIES OF TREE: The biliteral phonogram (tꜣ) plus the triliteral phonogram (šps) are followed by ⌣, determinative of the concept of tree and wood.

Two factors tended to influence the choice of phonograms, at least during the dynastic period. The first one was the relative paucity of biliteral and triliteral phonograms that were available to represent the many possible sequences of consonants. Thus, the word ⌣⊙ (rk) ERA, could only be written with alphabetic signs because there was no biliteral phonogram to represent the sound rk. Second, the number of possible combinations was also restricted by custom. Thus, the consonants forming the root of the verb nḥm, TO REMOVE, were always represented by combining the alphabetic sign ⌣ (n) with the biliteral phonogram ⌣ (ḥm)—without affecting the determinatives and the additional phonetics—but were never written by combining the biliteral phonogram (nḥ) with the alphabetic sign (m).

Additional phonetics

Furthermore, phonograms were not used solely for their primary function of representing the consonants that formed part of the root of a word. They had a secondary function as additional phonetics, whereby they clarified the phonetics represented by another phonogram (or ideogram) previously written.

For instance, the biliteral phonogram (tꜣ) often has its phonetic sound clarified by means of the alphabetic signs ⌣ (t) and (ꜣ) in the group , which should simply be read as tꜣ, and not as t+tꜣ+ꜣ; ⌣ (t) and (ꜣ) are thus redundant, because they duplicate the consonants—t on the one hand and ꜣ on the other—that have already been expressed as the single phonogram .

Thus, the triliteral phonogram ⌣ (mꜣꜥ) often has its phonetic value explained by the addition of the biliteral phonogram (mꜣ) and the alphabetic sign ⌣ (ꜥ) in the group , which ought simply to be read as mꜣꜥ and not as mꜣ+mꜣꜥ+ꜥ; and ⌣ are thus both redundant, since they merely double the mꜣ sequence of consonants (in the first case) and the consonant ꜥ (in the second case) that are already represented by the single phonogram ⌣.

These additional phonetics can only be used to explain part of the phonetic value of the phonogram (or ideogram).

For instance, the triliteral phonogram ⌇ (*nfr*) has its last two consonants explained by the alphabetic signs ⌇ (*f*) and ⌇ (*r*) in the group ⌇. The previously mentioned biliteral phonogram ⌇ (*tȝ*) can only have its first consonant explained by the alphabetic sign ⌇ (*t*) in the group ⌇.

A phonogram used as a phonetic addition to partially or totally interpret another phonogram (or ideogram), may itself be partially or totally interpreted by other phonograms, producing a case of additional redundancy, as, for instance, in the word ⌇ (*mȝt*), TO PROCLAIM. Preceding the sign ⌇ (determinative of activity of the mouth), there is a triliteral phonogram ⌇ (*mȝt*), the last consonant of which is represented by the alphabetic sign ⌇ (*t*). The first two consonants are represented by the biliteral phonogram ⌇ (*mȝ*), but the last consonant of this phonogram is itself represented by the alphabetic sign ⌇ (*ȝ*), which is another representation of the same sound, this time a phonetic one!

This is not the place to explain in detail the usages governing the use of additional phonetics. The point must simply be made that sometimes "calligraphic" imperatives were the reason. For example, if such biliteral phonograms as ⌇ (*wn*), ⌇ (*wr*), ⌇ (*mn*), etc., were usually used with an additional phonetic sign to reinforce their second consonant, that is because they groups they thus constitute, ⌇ ⌇ and ⌇ respectively, create a quadrant that is useful for filling the space reserved for the inscription.

Clearly, the use of these redundant phonetics is misleading for the decipherer. When Jean-François Champollion deciphered hieroglyphics, he had to deal with the group ⌇ inside the cartouche of Ramses II. This was a difficult task when the script was still a mystery, especially since, as we now know, the first of the two ⌇ (*s*) signs in this group is an alphabetic sign that acts as a phonetic back-up to the second consonant of the biliteral phonogram ⌇ (*ms*), which precedes it, while the second ⌇ is a true alphabetic sign, indicating the third person possessive pronoun, *s(w)* (his).

Ideographic graphics

The ideogram is used less frequently than one might be led to believe. In general, words written ideographically belong to such basic terms in the vocabulary as the names of the gods, parts of the body, animals, plants, architectural features, and everyday objects. A hieroglyph used as an ideogram may be used alone, as in ⌇ (*ḥr*), HORUS; ⌇ (*ḥr*), FACE; ⌇ (*db*), HORN; ⌇ (*ʿḥ*), PALACE.

But it would usually be accompanied by a short vertical line to explain this use: ⌇ (*ḥr*), HORUS; ⌇ (*ḥr*), ARM; ⌇ (*db*), HORN; ⌇ (*ʿḥ*), PALACE.

When an ideogram is used to represent a feminine word, the vertical line indicating the ideographic function is combined with the phonogram ⌇ (*t*), the suffix for the feminine gender, as in ⌇ (*jr.t*), EYE; ⌇ (*bj.t*), BEE; ⌇ (*pḏ.t*), ARCH; ⌇ (*ḫȝs.t*), FOREIGN LAND.

The ideogram on its own, or combined with the vertical line to indicate its ideographic function, and possibly with the phonogram of the feminine suffix, can also be supplemented by a determinative, as in ⌇ or ⌇ (*ḥr*), HORUS (⌇ = determinative of divinity), and in ⌇ (*jr.t*), EYE (⌇ = determinative of parts of the body).

This having been said, an ideogram, like a phonogram, may be accompanied by the addition of phonetics that completely or partially represents its sound. Thus, in the graphic ⌇ (*nḏm*), meaning SWEET, PLEASANT, the alphabetic sign ⌇ (*m*) repeats the last consonant of the ideogram ⌇ (*nḏm*). In the graphic ⌇ (*wbȝ*), PENETRATING THE FOREST, the bilateral phonogram ⌇ (*bȝ*) explains the last two consonants of the ideogram ⌇ (*wbȝ*). In the graphic ⌇ (*sr*), HIGH OFFICIAL, the alphabetic signs ⌇ (*s*) and ⌇ (*r*) explain how to read the entire ideogram ⌇, which could, of course, have been used on its own (possibly followed by a determinative).

Furthermore, the additional phonetics that clarify the meaning of the ideogram may themselves be partially or totally explained by additional phonetics to the second degree, as has already been shown. For example, in the graphic ⌇ (*msḏr*), EAR, the ideogram ⌇, which could be used on its own to represent the word, is totally clarified by the phonograms ⌇ (*ms*) and ⌇ (*ḏr*). Yet the last consonant of each of these two phonograms is itself explained by an alphabetic sign, namely ⌇ (*s*) and ⌇ (*r*), respectively.

In other words, in this system of writing, the consonants (*s*) and (*r*) are actually represented three times: in the reading of the ideogram ⌇, in the phonograms ⌇ (*ms*) and ⌇ (*ḏr*), and finally in the alphabetic signs ⌇ (*s*) and ⌇ (*r*).

The use of additional phonetics with the ideograms can be partially explained by the need to differentiate between words with different roots that were written using the same sign—for example, the ideogram ⌇, which can not only mean *msḏr*, EAR, as has been shown, but also *sḏm*, TO HEAR. Hence the preference for explanatory graphic images such as ⌇ (*msḏr*) and ⌇ (*sḏm*), respectively. But there are yet more reasons for this duplication, including the mere desire to facilitate the interpretation of an ideogram by showing partially or completely how it should be read.

Syllabic script, a phonetic sub-system

In order to reproduce words that lacked a "background"— that is to say, foreign words as well as Egyptian words in

the everyday, spoken language that were considered foreign to the written language—the scribes invented a writing system that was basically phonetic. It is known to many Egyptologists as the "syllabic" system, though Egyptologists from the English-speaking world tend to refer to it as group writing. In this system, which emerged under the Old Empire but is particularly well-documented under the New Empire, the ideogram is no longer used. The determinatives were retained, but words were broken down into written syllables, by means either of a sign or of groups of signs that, when read together, would be read entirely differently from how they would have been read under the classic system. For instance, the name of the city of Ugarit, a very important place, now occupied by Ras Shamra in Syria, is rendered by signs or groups of signs that correspond to syllables, completed by a determinative: 𓄿𓏤𓎡𓏤𓂋𓏤𓏏𓏤𓈉 (𓄿 = glottal stop + vowel; 𓎡 = k + vowel u; 𓂋 = r + vowel; 𓏏 = t with no vowel at the end of a word; 𓈉 = determinative of a foreign country).

The structure of these syllables is generally CONSONANT + VOWEL, though sometimes CONSONANT + VOWEL + CONSONANT. The details are quite complex, but it need merely be remembered that in certain groups, the vowel sound is fixed, though in others, the larger group, it is indeterminate, and it is up to the reader to supply it. Thus ‿ represents ʾ PLUS THE INDETERMINATE VOWEL. If one wants to specify the vowel sound, however, one can add a vowel sound sign. For instance, if one wants to specify that the syllable written as ‿ consists of ʾ AND THE VOWEL u (OR oo), the sign ℮ is added since in this sub-system it represents the vowel sound, u, creating the group ‿℮. Naturally, this sub-system varied in its applications throughout the days of the pharaohs, but the principles remained the same.

THE EXPRESSIVENESS OF HIEROGLYPHICS

Wordplay in hieroglyphics

The very existence of hieroglyphics shows that the Egyptians had managed to invent a writing system that did not rely exclusively on ideograms, by dividing up a word into syllables. Furthermore, the so-called "alphabetic" phonograms (see above) also indicate that they knew how to break down the sounds of their language into its basic elements, the phonemes. Furthermore, in hieratic and demotic they also possessed a writing style that used simplified outlines. Yet for three and a half thousand years, they continued to use hieroglyphics, a system whose signs are lengthy and difficult to reproduce, and which uses a

complex combination of ideograms, phonograms, and determinatives based on complicated and irrational usage. Proof of the difficulty of using hieroglyphics can be found in the numerous errors that litter the texts. How can such obstinate persistence be explained? Why bend over backwards to continue using this inconvenient style when it was so costly to reproduce and when they had the means to change it? This is a question that often disconcerts Egyptologists. When asked, they merely invoke the "conservatism" of the ancient Egyptians. This is a short answer but a feeble argument. In order to fully understand why hieroglyphics persisted, one has to take into account the fact that all of its disadvantages are outweighed by the advantages that it did have. In other words, what it lost in convenience of use, it gained in certain specific capacities. That is because hieroglyphic writing, far from being an entirely algebraic and linear annotation, draws upon its figurative and ideographic nature to produce a range of opportunities for expression that present themselves during the very act writing—that is to say, during the graphic encoding of verbal statements. It thus plays a dual role: while annotating statements visually, it also implies others.

The media of written wordplay

These possibilities were particularly well developed when it came to the tailoring of inscriptions to the surface on which they were written, whether this was an object or a building. Since hieroglyphics can be read in several directions, they can enhance the architectural features of a structure or monument by emphasizing its architectonic rhythms. A typical example is the decor of a lintel over a door. Its display of economy is achieved by organizing the inscription in two halves that match each other symmetrically on either side of a vertical axis passing through the middle of them. Western scripts would be incapable of achieving such economy harmoniously and would inevitably introduce a degree of asymmetry due to the limitations of their directionality. Hieroglyphics, on the other hand, can be produced in such as way as to comply with the symmetrical economy of a door lintel. A specific example of this is analyzed on pages 64–65.

Moreover, hieroglyphics are able to harmonize in a delicate symbiosis with the images with which objects and monuments are decorated. They do so on the basis of this directional plasticity that makes it possible to adapt the signs to the way in which the representations are organized, just as they can be adapted to the architectural features of the structure on which they written. One basic

principle applies in this context: the signs on an inscription always face in the same direction as the image. Text relating to a person facing right should be read from right to left, and vice versa.[9] Here is an example taken from a typical scene of which thousands grace the walls of Egyptian temples (Diagram A). The inscriptions in the columns numbered A_1 and A_2 refer to the king whose "first name" and "surname" are written inside ovals of knotted rope that are known as "cartouches." Here is the translation:

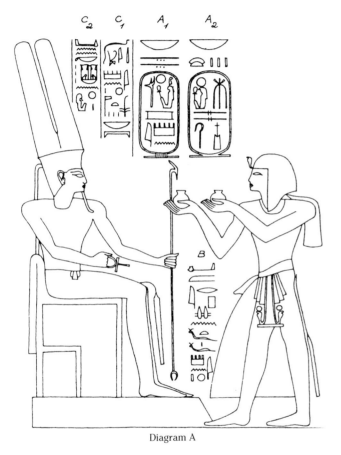

Diagram A

"The master of the two lands Ouser-maât-ra beloved of Amon [the "first name" of Ramses III], master of the coronations Ramses-regent of Heliopolis."

Each sign that has an asymmetrical shape, and particularly those representing a human figure (such as the goddess Maât whose name is written as $\frac{\wedge}{\S}$) face left, that is to say in the same direction as the king who stands on the right. On the other hand, in the inscription labeled C_1-C_2, the asymmetrical signs, and especially those representing human beings, such as the determinative 𝕘, are facing right, like the god Amon, who is seated on his throne, because this text refers to him:

"Pronouncing the words of Amon-Ra, king of the gods, master of heaven; I give you the festivities of Ra."

The inscription in column B refers to the king whose ritual act it describes:

"Making an offering of wine to his father Amon-Ra."

As a result, the asymmetrical signs, especially those representing a human being, face left like the king (such as the viper ⌣). Yet the terminal group of five signs faces in the opposite direction (the first sign to be read is ∫, which represents the first letter of the name of Amon). These five signs are those of the name of the god Amon-Ra, who, as stated, is facing right. Out of respect for the god, the order that governed the column of the inscription has been disregarded so as not to write his name in a direction opposite to the one in which he is looking. In fact, as can be seen, the group is written in exactly the same way as the same group of signs in column C_1, which again represent the name of the god.

The subtlety used in the arrangements of the inscriptions is due to the fact that their role is not limited to one of mere commentary (added to a scene but not really part of it). Not only are they captions but they constitute an integral part of the whole in which they feature because there is no discontinuity between representation and hieroglyphics. They are very much part of the image, even in the encoding of the spoken words. For example, in the previous scene, the name of the god Amon-Ra is written without recourse to the determinative representing divinity (𝓴 or 𝕘), which might have been expected. It is, in fact, present at the foot of column C_2 as the last sign in the name of the god Ra, 𝕘, who is not actually depicted in this scene.

There are so many iconic possibilities in hieroglyphics that they can even detract from the object or monument on which they are inscribed. For example, in the funerary chambers in which the deceased's body rests, in this crucial state in which death may be either a transitory stage of survival or complete annihilation, multiple precautions are taken to repel the threats of the incessant commotion make by evil spirits. The chambers thus contain hieroglyphs representing potentially dangerous creatures, human or animal, that must be neutralized by various processes. They are deleted, they are substituted by a harmless sign, they are mutilated, or they are pierced with arrows and knives.

This shows clearly how hieroglyphics are a monumental script that was an integral part of the economics and logic of the surface on which they were written.

Yet their specific capacities do not end there. They can also be used to produce their own effects, independently of the architectural or decorative context in which they are inscribed.

As an elementary, but frequently encountered example, there is the "honorific anteposition," through which writing

breaks the rules of linearity of the verbal pronouncements it is designed to encode. For example, the epithet "beloved of Amon" (*mry jmn* in Egyptian), where the word meaning "beloved" (*mry*) precedes the name "Amon" (*jmn*), is written ⌐⌐, with the group of letters that spells out the name of Amon, ⌐⌐, at the head, and the phonogram ⌐⌐ (*mry*) at the end.

There is an even more sophisticated use of this device. The name of Ramses II, read as *r'-ms-sw-mry-jmn*, meaning "It is Ra who has brought him into the world, beloved of Amon," is often written: ⌐⌐, where ⊙ is an ideogram for *r'* (RA); ⌐⌐ is the phonogram *ms* plus a redundant phonetic *s* (WHO BROUGHT INTO THE WORLD); ⌐⌐ is the phonogram for *sw* (THE); and ⌐⌐ represents *mry jmn* (BELOVED OF AMON—see above).

In addition to these graphic representations, in which the signs follow each other consecutively in the order of the sounds and meaning that they represent, with the sole exception of the name of Amon that is placed in front, some sets of hieroglyphics rearrange the inscription according to iconic logic. In such cases, the name of Amon is not written phonetically (⌐⌐) but as the ideogram ⌐, and this ideogram—as well as *mry* (BELOVED OF)—is then moved to the front so that it faces the name of the god Ra, itself also represented by an ideogram (⌐) written to face in the opposite direction so as to constitute a confrontation with Amon. This results in the graphic ⌐⌐.

A play on writing

There is an ancient tradition in Egypt that "plays on writing," making use of a resource that is specific to the written word. It sometimes manifests itself in very elaborate graphic representations that are sometimes referred to, incorrectly, as "cryptograms." If the writer sometimes chose to write a text by selecting unusual values for the signs he used, it was to disconcert and even baffle the reader, and thus display his superior knowledge, rather than to "conceal" (crypto-) the meaning. In some religious compositions a text is written in "cryptography" with its deciphered equivalent (the same text written in the standard way) alongside it. For example, in a scene that is a guide to the Next World, entitled *Book of the Caves*, the name of the god Anubis is written both in the standard form of ⌐⌐ (*j+n+p+w*), each consonant being represented by the usual sign, and in the cryptographic form of ⌐⌐, in which the same consonants are reproduced using signs that depart from their usual functions and whose meaning in the passage rests on rather far-fetched speculation.

The term used in the English-speaking world for these cryptograms is "fun graphs" or "puzzle writing."

The various types of plays on words include those which the author would call "iconic condensation." Take, for example, the name of the funerary temple of Ramses III, that is still marveled at by tourists at its site at Medinet Habu. The inscription is formed with the epithet *ḫnm.t (n)ḥḥ*, "who unites to eternity," that is normally written ⌐⌐. Sometimes, all these signs are contained in a single picture, using the representation of a woman—the personification of the temple—holding in her hands two examples of the alphabetic sign ⌐ (*ḥ*) with the determinative ⊙ placed between them. She wears the triliteral phonogram ⌐ (*ḫnm*) on her head (Fig. 12). These written plays on words use various devices, but all are based, in the last analysis, on the relationship between the substance of the hieroglyph and the image. Anything capable of being depicted can become a written sign, on the basis of need. Each sign in the traditional repertoire can

Fig. 12. Composite sign indicating the name of the funerary temple of Ramses III.

assume an ideographic or phonetic value in addition to its standard one, referring to the creatures or objects which are in some way related to it. Here is a sophisticated example of a play on words. "Chemmis," written in consonantic Egyptian *ḥm*, can mean either a deeply marshy area or the infant Horus hiding to escape from Seth, the murderer of his father Osiris, who is pursuing him. The name can be written "as a puzzle" using the sign for a child, 𓀔, which in this case is used as the biliteral phonogram for *ḥm*, with a complex determinative consisting of the combination of a clump of papyrus 𓇋, and the place-name symbol ⊚, hence 𓊖. This composite sign 𓀔𓇋 would give the written consonantic structure of the place name, would indicate the semantic category to which it belongs and, at the same time, would form an image representing a child sheltering in a papyrus reed bed, thereby developing pictorially the theological harmonics associated with the name of "Chemmis." The semiotic possibilities of writing are here deployed in two registers: that of the conventional sign used to represent a phoneme or group of phonemes and determinatives, and that of the image.

These cryptic signs are occasionally encountered in the dynastic period but are more often found in the religious or dynastic period, generally in religious or strongly ideological contexts. From the Ptolemaic era, however, in other words, as soon as political power fell into the hands of foreign rulers, pharaonic civilization withdrew into the closed space of its most irreducible identity. Hieroglyphics, the most elaborate means through which the Egyptian religion could express its vision of the world, became the subject of frantic speculation that systematically exploited the resources at its disposal. From a total of between 700 and 800 signs used during the dynastic period, the repertoire increased to several thousand. In fact, the exact number is not, and never will be, known because the specialists in ritual wisdom had the ability to create as many signs as they needed for their own particular purpose. Furthermore, each sign tended to find its values multiplied through the endless use of analogy and homology. The puzzle became the very purpose of theological theses and attained its ultimate refinement. For example, the great Egyptologist Serge Sauneron discovered a use of hieroglyphics that could be described as "dynamic" in systems used in Ptolemaic and Roman times. A name could be spelled using hieroglyphs that not only worked as signs that were phonetic or ideographic encodings of the name— or were even used as images—but furthermore represented simultaneously the attributes of the divinity that the subsequent text would develop one by one. This writing imbued a name with potential that the bearer could then deploy on a universal scale—the microcosm and the macrocosm. Conversely, since the power of a divinity is universal, the ideogram used to represent it was also used to write each of its attributes, and thus, ultimately, everything. Two hymns carved on a wall in the Roman temple at Esna, which face each other symmetrically in relation to the orientation of the monument, illustrate how this logic was pushed almost to the ultimate. One is invoking the rising sun in the form a crocodile god; the other, the setting sun in the form of a ram god. The first is written almost entirely with signs representing crocodiles, and the second with signs for rams (Diagram B). The differences between all these rams and all these crocodiles, and the few hieroglyphs that do not use these animals as referents—especially the first word of each hymn, 𓂝𓎡𓏏 (PRAISES)—were supposed to enable the happy few who were familiar with the religious traditions of the place to be able to read the inscriptions!

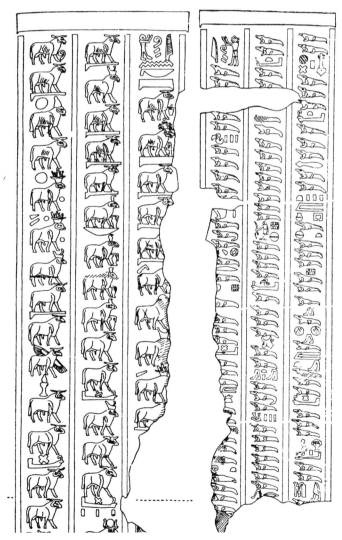

Diagram B

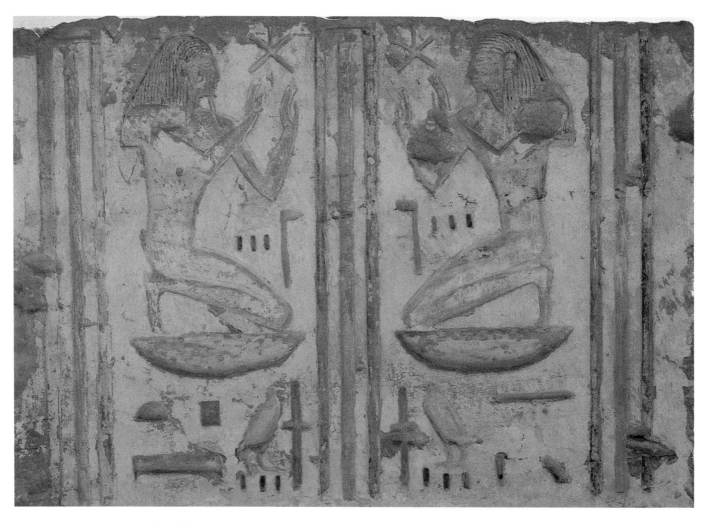

Fig. 13. Two signs in this inscription, the kneeling man and the basket on which he kneels,
have been drawn as very large. Consequently, although they are used as written signs, they are also used as images.
From the funerary temple of Ramses III at Medinet Habu.

The reason for using puzzle and cryptic writing

To realize its purpose this type of writing must have been the subject of much speculation and employed many artifices (Fig. 13). However, there should be no mistake, these representational conundrums were not mere acrobatics or decadent virtuosity. Like many other peoples, the ancient Egyptians considered the image to be not only the representation of reality but also as one of the means by which it manifested itself, a hypostatis, as it were. Consequently, the exploitation of the potential of writing was aimed at nothing less than to write down the world wherever its substance revealed itself, to uncover affinities and similarities, analogies and homologies behind the outward appearances of creatures and things. The term "sacred philology" has been used justifiably; it could be said that research into writing was a philosophy in itself. Whatever the case, this hermeneutic dimension is the reason for so many misapprehensions and serious misinterpretations. It why the vast majority of classical writers did not realize that hieroglyphics were a form of writing that conventionally annotated sounds and meaning. They believed that the body of esoteric symbols contained a "revelation" accessible only to initiates; after all, the very word "hieroglyph" means "sacred writing" in Greek. This is largely responsible for the aura of mystery that surrounded the Egyptian civilization in Greek and Roman times. This lasted through the Renaissance and even until the early nineteenth century. Only until the nineteenth century? One might be tempted to say that it has lasted until now, since hieroglyphics play such as large part in the fascination that pharaonic Egypt has for what the world knows as kabalists, occultists and theosophists.

Notes

1. Traditional worship, including the use of pharaonic writings, continued in the temple of Philae until the middle of the fifth century CE.

2. This characteristic explains that, even when in possession of the Greek translation of the hieroglyphic text on the Rosetta Stone, not all the problems were solved, for how could the sequence of hieroglyphics be determined that corresponded with each Greek work? The situation would have been inextricable if the cartouches, the ovals in which the names of kings and queens were written, had not by chance isolated discrete sections in the continuity of the hieroglyphic text. It was by using the cartouches that it became possible to decipher the hieroglyphics.

3. For an explanation of the characters used in the transcription, see the table of alphabetic signs in the section on phonograms.

4. The details are more complex. In certain uses, semi-consonants such as *w* and *y* can be used to indicate vowels, but this is not common.

5. The number varies according to the era. Twenty-five and twenty-three correspond respectively to Ancient Egyptian and Middle Egyptian. The details are rather complicated because some of the alphabetic signs can be used to denote different phonemes depending on their position, as is the case with certain letters in the English alphabet.

6. This traditional egyptological transcription is contrary to linguistic use in which *t* represents an interdental.

7. See previous note.

8. This sign should not be confused with the sign 𓅨 , which represents a swallow and is very often used as a phonogram in a word meaning "big" !

9. Except in the case of reverse orientation mentioned above.

Bibliography

BETRO, Maria Carmelo. *Hieroglyphics: The Writing of Ancient Egypt* (New York/London/Paris, 1991).

BUDGE, E.A. Wallis. *A Hieroglyphic Vocabulary of the Book of the Dead* (New York, 1991).

DERCHAIN, P. "Les hiéroglyphes de l'époque ptolémaïque." In C. Baudrain, C. Bonnet, and V. Krings (eds.), *Phoinikeia Grammata. Lire et écrire en Méditerranée*. Actes du colloque de Liège, Nov. 15–18, 1989, Collection d'études classiques 6 (Liège, 1991), pp. 243–256.

DERCHAIN-URTEL, M.T. *Epigraphische Untersuchungen zur griechisch-römischen Zeit in Ägyten* (ÄAT 43) (Wiesbaden, Germany, 1999).

DREYER, G. *Umm el-Qaab I das prädynastische Königsgrab U-j und seine frühen Schriftzeugnisse (Archäologische Veröffentlichungen 86)* (Mainz, 1998).

FISCHER, H.G. "Archaeological Aspects of Epigraphy and Palaeography." *Ancient Egyptian Epigraphy and Palaeography* (New York: The Metropolitan Museum of Art, 1976).

——. "More emblematic use from ancient Egypt." *Metropolitan Museum Journal* 11 (1976): 125–128.

——. "Redundant determinatives in the Old Kingdom." *Metropolitan Museum Journal* 8 (1973): 7–25.

——. "Some emblematic use of hieroglyphs with particular reference to an archaic ritual vessel." *Metropolitan Museum Journal* 5 (1972): 31–49.

——. "The evolution of composite hieroglyphs in ancient Egypt." *Metropolitan Museum Journal* 12 (1977): 5–19.

——. *L'Écriture et l'art de l'Égypte ancienne. Quatre leçons sur la paléographie et l'épigraphie pharaohiques* (Paris, 1986).

——. *The Orientation of Hieroglyphs. Part I. Reversals* (New York: Metropolitan Museum of Art, 1977).

GALGANO, B. "The multidirectionality of writing and its implications: some parallels outside Egypt." *Göttinger Miszellen* 179 (2000): 35–38.

GARDINER, A.H. *Egyptian Grammar Being, an Introduction to the Study of Hieroglyphs*, 3rd edn (Oxford, 1957).

GOLWASSER, O. *From Icon to Metaphor. Studies in the Semiotic of the Hieroglyphs* (OBO 142) (Fribourg/Göttingen, 1995).

GRAPOW, H. *Sprachliche une schriftliche Formung ägyptischer Texte* (Glückstadt/Hamburg/New York, 1936).

GUTBUB, A. "Jeux de signes dans quelques inscriptions des grands temples de Denderah et d'Edfou." *Bulletin de l'Institut français d'archéologie orientale* 52 (1953): 57–101.

HOCH, J. *Semitic Words in the Egyptian Texts of the New Kingdom and Third Intermediate Period* (Princeton, 1994).

KATAN, J., and B. Mintz. *Eyewitness: Ancient Hieroglyphs* (Ontario, Canada, 1981).

KURTH, D. "Die Lautwert der Hieroglyphen in den Tempelinschriften der griechisch-römischen Zeit – Zur Systematik ihrer Herleitungs-prinzipien." *Annales du Service des antiquités de l'Égypte*, 69 (1983): 287–309.

LACAU, P. *Sur le système hiéroglyphique* (IFAO, BdE XXV) (Cairo, 1954).

NIEBURH, R. and C. Walters. *Ancient Egyptian Hieroglyphs* (Bromell, Pa., 1994).

OUAKNIN, Marc-Alain. *Mysteries of the Alphabet*. Trans. J. Bacon. (New York/London/Paris, 1999).

SAUNERON, S. *L'Écriture figurative dans les textes d'Esna (Esna VIII)* (Cairo, 1982).

SPIESER, C. *Les Noms du pharaoh comme êtres autonomes au Nouvel Empire* (OBO 174) (Friburg/Göttingen, 2000).

VAN ESSCHE, E. "Dieux et rois face à face dans les inscriptions monumentales ramessides." *BSEG* 21 (1997): 63–79.

——. "La valeur ajoutée du signe déterminatif dans l'écriture figurative ramesside." *RdE* 48 (1997): 201–217.

VERNUS, P. "Des relations entre textes et représentations dans l'Égypte pharaohique." In A.-M. Christin (ed.), *Écritures II* (Paris, 1985), pp. 45–66.

——. "Espace et idéologie dans l'écriture égyptienne." *Écritures. Systèmes idéographiques et pratiques expressives*, Actes du colloque international de l'Université de Paris 7, April 22–24, 1980 (Paris, 1982), pp. 101–116.

——. "L'ambivalence du signe graphique dans l'écriture hiéroglyphique." A.-M. Christin (ed.), *L'Espace et la lettre. Écritures III* (Paris, 1987), pp. 60–65.

——. "La naissance de l'écriture dans l'Égypte ancienne." *Archéo-Nil* 3 (May 1993): 75–108.

——. "Les espaces de l'écrit dans l'Égypte pharaohique." *Bulletin de la Société française d'égyptologie* 119 (1990): 35–56.

——. "Supports d'écriture et fonction sacralisante dans l'Égypte pharaohique." R. Laufer (ed.), *Le Texte et son inscription* (Paris, 1989), pp. 23–24.

ZEIDLER, J. "A new approach to the late Egyptian syllabic orthography." *Sesto Congresso internazionale di egittologia. Atti* II (1993): 579–596.

ADAPTATION OF SCRIPT TO MONUMENTS

Pascal Vernus

The following two examples illustrate the various ways in which hieroglyphics could be adapted to the particular monument on which they were inscribed.

The first is a lintel (Fig. 1). From an architectural point of view, it is characterized by the symmetry of the two parts that lie on either side of a vertical central axis—an axis that was moreover extended by the vertical line formed by the passageway beneath the lintel. The decoration, representation, and inscriptions are arranged so as to emphasize this bipartite structure. The representation consists firstly of the winged disk of the sun in the upper register. This symbolizes the fact that the object that it dominates is an image of the universe in miniature, according to the well-known principle of macrocosm and microcosm. It is perfectly symmetrical, as if the two wings could be joined exactly in the center along a central vertical axis that cuts the solar disk into two halves. This same axis is extended below by the sign ♀, which appears in both the middle and the lower registers. The shape of this sign is also symmetrical, further reinforcing the line of the axis. It should be noted in passing that ♀ is the word for

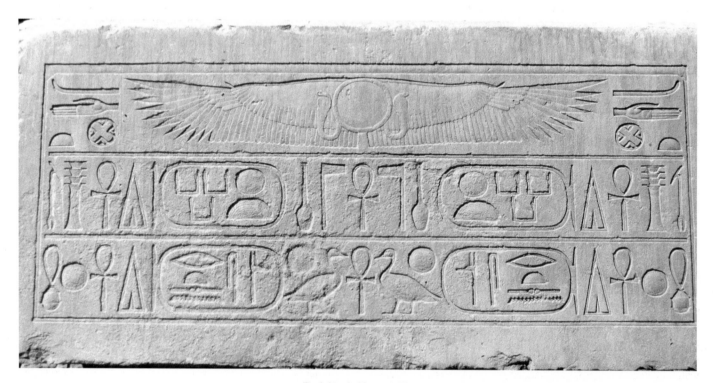

Fig. 1. Lintel of Sesostris III.

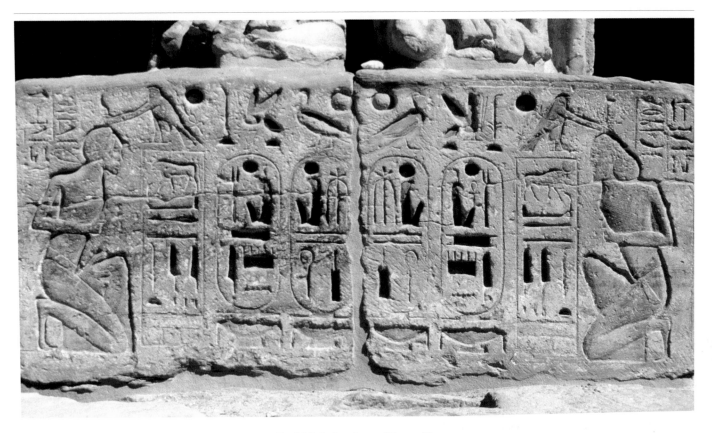

Fig. 2. Plinth of a colossus of Ramses III.

"life," and that it is no accident that the main axis should be represented by this sign. Furthermore, the sign reappears in both halves of the facing inscriptions that occupy the lower and middle registers. The fact that the inscriptions face each other—and are to be read in opposite directions, starting from the central axis—becomes clear when one studies the signs that are not symmetrical. In the middle register, in the inscription on the left side, the signs ⌐ and ⌠ face right, and thus towards the sign ♀, indicating that reading should begin from this sign. In the inscription in the right half, the signs ⌐ and ⌠ face left, thus towards the sign ♀, again indicating that reading should begin from here. The inscriptions in the lower register are organized similarly. In the inscription in the left half, the signs ⬿ and ⌐ are right-facing, and thus face the sign ♀. In the inscription on the right-hand side, the signs ⬿ and ⌐ are left-facing and thus face the sign ♀.

Consequently, each of the two halves of the lintel is to some extent a mirror image of the other.

The second example (Fig. 2) is a more complex design. It consists of the front of the plinth of a colossus of Ramses III (whose two feet can be seen at the top of the picture). As before, the surface is divided into two symmetrical halves by a central vertical axis, but one that extends upward between the feet of the statue. As in the previous case, the representations and the inscriptions emphasize this symmetry, but they do so in a different way.

The first thing to note is that although the words in the three columns to the left of the central axis are a mirror image of those in the three columns to the right of it, they should be read inward, *toward* the central axis, and not *outward* from it. This is immediately clear from studying the hieroglyphs. In the left half, the hieroglyphs ⬿, ⬿, and ⬿, are left-facing, indicating that the inscription should be read from left to right. In the right half, the hieroglyphs ⬿, ⬿, and ⬿ are right-facing, indicating that they should be read from right to left.

The second thing to note is that asymmetry is incorporated into the overall symmetry. At the extremity of each of the two halves is a representation of a conquered enemy, into whose head the falcon in the third column has planted a weapon, but the enemies are different. On the left it is a Nubian, on the right an Asiatic. Of course, this difference is reflected in the inscriptions which are otherwise very similar. On the left, the inscription reads THE VILE RULER OF KUSH [= Nubia and Sudan] WHO MASSACRED HIS MAJESTY; the right-hand inscription reads THE VILE RULER OF KHOR [= Syria-Palestine] WHO MASSACRED HIS MAJESTY.

Thus, beneath the feet of the colossus, there is a representation of the torture that the pharaoh inflicted upon those who shared the honour of being Egypt's greatest enemies at the time and who are distinguished by the region from which they hail, the south and north respectively. Thus there is symmetry in the asymmetry.

Fig. 1. Fuxi, the Great Heavenly One, as he is depicted in the *Collected Illustrations of the Three Cosmic Levels* (*Sancai tuhui*) of 1709. Fuxi, the first of the five legendary emperors of mythical times, is reputed to have invented divination as well as writing, which derived from it. Here, he is portrayed as having used only a brush to draw the eight basic trigrams of divination. The two lumps on his skull are a reminder that he is a dragon-man and consequently possesses the horns of that fabulous creature, the rest of its serpent-like body lying hidden beneath the human form shown here.

WRITING IN CHINA

Léon Vandermeersch

GENESIS AND CHARACTERISTICS
OF CHINESE IDEOGRAPHY

Chinese writing is ideographic, which means that it is a script in which the characters do not represent purely phonetic units that, in sequence, express words at the level of the physical production of the voice. Instead, the characters constitute semantic units that, in combination, express, at the level of meaning, the significant message conveyed by the spoken word. It was the summary assimilation of these semantic units to ideas that formerly led to the creation of the term *ideography* to describe this form of writing, and although it is not really adequate, it has now become sanctioned by usage. To gain a better understanding of the nature of an ideographic script—a phenomenon that Chinese culture shares with the even more ancient written cultures of Sumer and the Egypt of the Pharaohs—let us examine the general characteristics of the two major forms of writing.

A script is a system of graphic signs that refer to acoustic signs uttered in speech. Between the graphic and the sound a bi-univocal correspondence prevails in the system, which makes possible on the one hand the written representation—through the act of writing, or, what one might term more precisely, "graphing"—of any spoken discourse, and on the other hand the exact reconstitution of the spoken discourse by decoding its graphic representation through the act of reading, or "de-graphing." Inventing a script is equivalent to establishing such a correspondence by codifying the vocal signs pertaining to the spoken language in order to link them bi-univocally to a system of characters that have been specifically conceived as suitable for this correspondence. This shows that the invention of a script depended on solving an extremely complex problem consisting of two parts: an analysis of the organization of the linguistic signs used in the language under consideration (the way in which its sounds are articulated), and the creation of a system of graphic elements—a form of script—that would allow a reader to undertake the "graphing" and "de-graphing" processes with relative ease. No culture, however advanced, has really succeeded in finding a perfect solution to this double problem, but various writing systems have evolved in different ways in their respective cultures. The first obstacle to overcome was the difficulty of analyzing the way in which linguistic signs were organized, as demonstrated by the use, in cultures that failed to develop a true script, of various systems of signs to convey messages—signs that were coded, but not on the basis of linguistic units. A script could only appear when such units in sequences of connected speech had been identified more or less correctly—an identification that arose initially from a superficial analysis of the primary organization, with its sequence of immediately obvious meanings. This very obviousness facilitated their profiling as a sequence of elementary semantic units.

The first writing systems emerged as a result of more or less clear agreement (through distinguishing such sequences) on the linguistic units that constituted the primary organization. In theory, these were the *morphemes*, but in practice—and more approximately—they were words, and distinct graphic symbols were created to represent each one of these units by means of a written sign. This is the principle of the ideographic script. Later, however, the need to invent new symbols to represent more and more words led to the progressive discovery, everywhere except in China, of the second stage of linguistic organization, that of acoustic signs uttered in speech to distinguish between words. Such signs are formed by distinct phonetic units, or

phonemes, that are limited in number but are sufficient to express an unlimited number of words through an equally unlimited number of possible combinations. The idea of writing words indirectly, by means of the coded units generated in this second stage of organization (rather than directly, by means of ideograms), led to the second generation of scripts—phonetic scripts—in which the graphic elements represent the approximately identified phonemes of a language at the level of the syllable (in syllabic scripts), or even at the level of the syllable's constituent parts (in alphabetic scripts).

Why did the Chinese culture, alone among all the great cultures that have continued to develop up to the present day, not proceed beyond a first-generation script? Are Chinese ideograms no more than cultural dinosaurs from a bygone age, preserved by virtue of the well-known Chinese resistance to all forms of progress? The ideographic Chinese script, which, even in China, has been denounced as the principal obstacle in the way of the assimilation of Western scientific thought, has nevertheless proved to be open and amenable to whatever imported concepts have been necessary for the representation of the particular language that it is required to script. Moreover, it can be readily adapted to deal with the most sophisticated forms of information technology. The fact is that in China (and only in China) the ideographic system itself was rationalized to a remarkable extent at the level of primary organization. It was perfected to such a degree that any economy that phoneticization might have brought (in passing through second-stage organization) would not have been important enough to make it worthwhile; consequently, it never occurred.

How then did Chinese ideography become rationalized? It was through a process of methodical construction that continued throughout the thousand years during which the script came to maturity (from its first appearance in the Yin dynasty, around the end of the fourteenth century before the common era, until the full flowering of the first Chinese literature at the end of the Zhou dynasty, in the third century BCE). The script was predominantly influenced by the logical mindedness of the scribes, who were masters of both the writing and the science of divination. The methods used for this construction process were clearly set out in Han times by the author of the first dictionary of Chinese characters, the great lexicographer Xu Shen (*ca* 57–*ca* 147 CE). In brief, the rationalization of Chinese ideography conformed essentially to three major principles: first, the creation of new characters through systematic graphic derivation; second, the borrowing of homophones as substitutes for new characters when creating the latter would have been too complicated; and third, the double affiliation

of all characters in terms of the sub-graphic elements of which they are composed.

The principle of systematic graphic derivation made it possible to avoid the anarchy of a proliferation of distinct characters (independent of one another, and simply corresponding to words, as in ancient Sumerian ideography), by constructing new characters only on the basis of existing ones. Thus Xu Shen distinguishes between primitive characters, which he calls *wen* and derived characters, which he calls *zi*, the primitives being systematically re-used as elements, or sub-characters, in the formation of new characters, which are thus derived from them. Examples of derived characters will be given later. First, here are some primitives, in which the pictographic nature of the ancient form is evident (the modern forms—which have lost much of their pictographic quality—are given within square brackets):

SUN: 日 [日], MOON: 月 [月], RIGHT-HAND: 又 [又], DEER: 鹿 [鹿].

The principle of borrowing (Xu Shen called it *jiajie*) made it possible to compensate for the shortcomings of ideography when it came to words in the language for which it was difficult to conceive ideograms that would represent the meaning directly. The scribes re-used (or borrowed) characters that already existed in the script and that, in the spoken language, were homophones of the words for which it was too difficult to create specific new characters. For example, the four directions—north, south, east, and west—were obviously transcribed in this way, as the original meanings indicated by these characters have no semantic connection with the words they now represent; it must therefore be a case of the characters being used as homophones:

The word east was written with the ideogram: 東 [東], originally meaning TO TIE IN A BUNDLE;

the word south was written with the ideogram: 南 [南], originally the name of a musical instrument;

the word west was written with the ideogram: 西 [西], originally meaning a NEST;

the word north was written with the ideogram 北 [北], originally meaning TO TURN ONE'S BACK.

The principle of the double affiliation of characters in terms of their sub-characters made possible the complete restructuring of the whole ideographic lexicon through a double classification system that can be said to resemble a tree-like structure with a linear descent and lateral branches. It operated as follows. To create new (derived) characters, the scribes aimed to choose, as sub-characters in their combinations, primitive characters whose meanings were sufficiently coherent for the meaning of the new composite derivative to be immediately apparent. For example, to create a character for the word DESCEND,

they combined primitive (pictographic) characters of two feet, one under the other, and a ladder: 𠂆 + ㅄ + ㇌ = ⿰㇌ㅄ [降]. To create a character for the verb TO LISTEN, they combined the primitive characters for the EAR and the MOUTH: 𦔮 + ㅂ = 𦔮ㅂ [耵, a character that was subsequently transformed into the more complicated character 聽]. Xu Shen called this type of ideogram *huiyi* (combined meanings), which—to maintain a coherent nomenclature for the various sorts of ideograms—might be translated by the term "syllogigram," but it very soon proved too difficult to produce these in sufficiently large numbers. Consequently, the scribes widened their choice of sub-characters in the composition of derivatives by admitting borrowed homophones into the repertory. While observing the principle of retaining at least one sub-character on account of its semantic connection between its primitive meaning and that of the derivative (for example, the pictogram GRASS as a sub-character in derivatives signifying the names of plants, or the pictogram HAND as a sub-character in derivatives representing manual actions), they systematically chose, as a complementary sub-character, the sign for another word that was an approximate homophone of the word that the derivative was to represent. Xu Shen called this type of ideogram *xingsheng*: "form–sound" (a sub-character in which the form is the semantic element, along with a sub-character that is an approximate homophone), which, again to maintain a coherent nomenclature, might be translated by the term "morphophonogram." In such ideograms, lexicographers call Xu Shen's "form" the key (or radical) and his "sound" the phonetic. Below are a few examples in today's script:

1. The TREE radical (木) + the phonetic *mei* (每) = PLUM TREE, *mei*. The TREE radical (梅) + the phonetic *gui* (桂) = 桂 LAUREL, *gui*.

2. The SUN radical (日) + the phonetic *wang* (王) = 旺 TO SHINE, *wang*. The SUN radical (爰) + the phonetic *yuan* (暖) = WARM, *nuan*.

The process of fabricating morphophonograms, as it spread to the entire lexicon of characters—including a reinterpretation of syllogigrams that treated one of their component sub-characters as the radical and another as the phonetic—brought with it a complete restructuring of the characters through the interplay of double affiliation into graphic families linked either vertically by linear descent (derived characters having the same radical) or horizontally by virtue of having the same phonetic element (see the table on page 85). These families are not etymological ones—families of words in the natural language, formed in a process of spontaneous proliferation before being written down—but graphological ones, formed as a result of the scribes' controlled production of characters from an ideography that they had invented. It goes without saying that the etymological families became completely submerged beneath these graphological families and are no longer recognizable. The seminal prolificacy of the structure of the graphic lexicon, which in this way developed into a veritably organic network of semantic connections, proved extremely important. Here lies the reason for the strong inhibition that completely blocked any tendency toward a phonemic transformation of Chinese ideography. For, contrary to a widely held belief, the addition of a "phonetic" sub-character to the radicals of morphophonograms by no means constitutes a first step toward a phonemic script. It is no more than a process devised for getting around the impossibility of fabricating syllogigrams to represent all the words of the language. Moreover, one often finds a considerable variety—often a score—of phonetically different sub-characters in characters that are pronounced in exactly the same way, and, conversely, the same phonetic sub-character in characters that are pronounced quite differently. The fact is that the scribes paid less attention to the accuracy of the phonemic dimension of phonetic sub-characters than to ways of ensuring that they retained at least a minimal ideographic dimension. A certain more or less vague semantic value was attached to many phonetic sub-characters, taking precedence over the phonemic dimension and preventing the latter from being sufficiently taken into account to lead to any notion of a phonemic script. On the other hand, in the eyes of the scribes and lexicographers, the families of characters affiliated in horizontal branches were, like those of vertical descent, truly semantic families, even if less proliferous.

As is apparent from the above, the system of Chinese characters was so profoundly restructured by comparison with the words of the natural language it was used to transcribe that it became largely independent from it. This is why what the Chinese call the (classical) written language is sufficiently different from the spoken language for the term *graphic language* to be applied to it. This is, moreover, the exact meaning of *wenyan*, a term that the Chinese use for this language to distinguish it from the natural language (although it was obviously derived from it) rather than simply referring to its "written" form. Consequently, a veritable process of translation is involved in Chinese when passing from the spoken language to the graphic language, and vice versa. If, instead of formulating a simple script, the Chinese scribes put considerable effort into this graphic language, which is peculiar to Chinese culture, it was because, besides being the inventors of this ideography, they were above all specialists in divination, and they invented it as an auxiliary instrument in the service of their science.

In fact, Chinese ideography first appeared in texts recording the procedures of divination ceremonies involving pyroscapulimancy—a process in which the diviner applied a hot brand to the shoulder-blades of cattle or to tortoise shells, creating cracks that were interpreted as signs revealing the answers to questions asked. Engraved directly onto the shoulder-blades or tortoise shells, next to the magic cracks, these texts record the date and the purpose of the operation. They acquired by association something of the transcendental nature of the oracular response. Since their discovery in 1899, tens of thousands of these primitive texts (known as oracle bone inscriptions) have been collected, mostly on fragmentary pieces of bone, though occasionally some whole pieces have been found intact. They can be dated to the Yin period (the name given retrospectively by historians to the era dating from the final transfer by the Shang dynasty sovereigns of their capital to Yin, in the fourteenth century BCE, down to the end of the dynasty, *ca* 1050 BCE, when it was overthrown by the Zhou). The lexicon of the graphic language used in these inscriptions consists of about 3,700 ideograms, of which two thousand have today been both deciphered and thoroughly defined as regards their various usages. About three hundred pictograms have been identified, and these form the primitive nucleus of the Chinese ideographic lexicon, constituting between ten and fifteen per cent of the characters used in oracle inscriptions. Borrowings—or, more precisely, true borrowings, according to Xu Shen's definition—amount to about ten per cent of this lexicon. Indeed, true borrowings must not be confused with what could be termed false borrowings, which are defined as substitutes for the characters of homophones to which the scribes had recourse not by necessity but simply for the sake of convenience. For example, instead of the proper character for the word DEER, 鹿 [鹿], the character for the word FORTUNE 祿 [祿], a homophone, was often substituted because it was clearly easier to engrave (both words are still pronounced *lu* today). Whereas true borrowings are rare, false borrowings appear throughout archaic inscriptions. With this evidence, it could be assumed that if a tendency towards a phonemic script had prevailed in Chinese ideography it would certainly have been based on this practice of false borrowings. Yet although this practice was widespread in pre-Han times, it was subsequently to become the exception in the classical language, which thus reaffirmed its purely ideographic nature.

Once pictograms and true borrowings are set aside, all the rest—that is to say, three-quarters of the lexicon of characters figuring in the oracle inscriptions—consists of syllogigrams and morphophonograms, in a ratio of two-thirds to one-third, respectively. Gradually, however, the number of morphophonograms increased throughout the whole lexicon, not only through the creation of new graphic words but also through their use as substitutes for previous syllogigrams and even previous morphophonograms. For example, the primitive character for the expression TO SHOOT AN ARROW, 矢, which is purely pictographic, was transformed through a process of double corruption into the morphophonogram 射 (pronounced *she*, nowadays), composed of the THUMB radical, 寸 (a corruption of the radical ARROW, 矢), and the phonetic 身 (now pronounced *shen*), within the character of which the picture of a bow in the primitive pictogram has also (by corruption) undergone a metamorphosis. In Xu Shen's dictionary—posthumously presented to the emperor by the author's son, Xu Chong—which contains 9,475 graphic signs, more than eighty per cent are morphophonograms, twelve per cent are syllogigrams, and fewer than six per cent are pictograms.

Throughout its formative period, the use of the graphic language beyond the confines of the realm of divination increased, extending at first to the whole ritual and administrative domain, and subsequently, from the time of Confucius (551–479 BCE) onward, to that of literature. However, the Chinese graphic language retained some of the very special features of its divinatory origins. It has always been considered less as an instrument for anyone to express themselves by than as a sort of algorithm, analogous to that represented by the sixty-four hexagrams of the *Classic of Divination*, conveying an overall vision of things far more profound than that which the spoken language in its triviality can grasp only superficially. As a result, classical Chinese literature lacks those genres which, in other cultures, are the pillars of literary tradition: the epic, the play, and the novel. It is principally based on its own foundations in the collections of the classics and their exegetical commentaries.

Eventually, the epic, the play, and the novel also appeared in China, but as non-classical genres, and their appearance was linked to a new form of literature that was the product of adapting the old ideography to the direct transcription of the spoken language.

Although the divinatory affiliations of Chinese ideography had led to the construction of a specific graphic language, nothing prevented the use of its ideograms to transcribe spoken discourse directly. It was in this way that the ritual chants collected in the ancient *Classic of Odes* were compiled at an early date. It was in this way too that it proved possible, when searching for more lively quotations, to insert fragments of the spoken language into the most classic of texts in the graphic language, as, for example, in the text of the *Analects* of Confucius, compiled by his disciples.

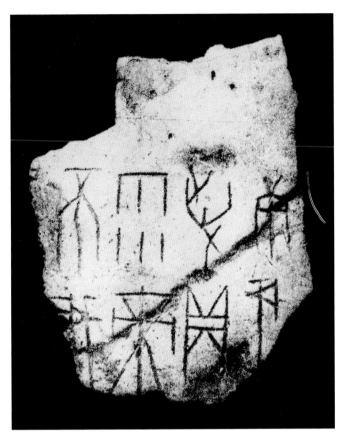

Fig. 2. Fragment of tortoise shell engraved with part of an oracular inscription (eight characters) concerning rainfall and sacrifice to the lord on high. Twelfth century BCE.

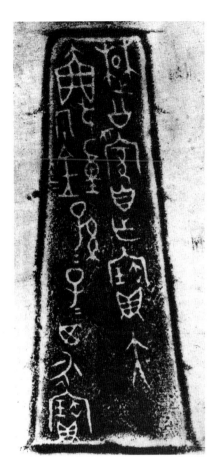

Fig. 3. Inscription on a bronze bell presented to Duke Meng of Chu during the reign of King You, the penultimate ruler of the Western Zhou (781–771 BCE). The characters are in *great seal script.*

Fig. 4. (right) Inscription dating a bronze standard measure of weight, cast in the same year as the founding of the empire in 221 BCE. The characters are in *small seal script.*

But for a long time this remained no more than a stylistic device. The systematic use of ideograms to record the discourse of the spoken language directly, which led to the emergence of what is known as the "literature of the spoken language," only began in ninth century, and at first only in very special writings designed to spread the Buddhist faith. This period—the Tang dynasty (618–907)—was the apogee of Chinese Buddhism. At this time, monks, when addressing a popular congregation, would customarily preach sermons featuring hagiographic narratives, recomposed as sequences of lively little scenes within the text proper, illustrated like comic strips and annotated in pure vernacular Chinese. Yet the resulting development of literature in the vernacular affected neither the graphic language in the form that it had long since assumed nor the classical literature written in that language, which had continued to flourish in the traditional genres. There was thus no simple transformation of the

graphic language into a full and faithful transcription of the spoken language. It was rather a case of drawing on the graphic language as a source for a script with which to write down a new form of literature. This innovation, which went against the entire evolution of the script up to that point, could only have occurred on the fringes of traditional Chinese culture. It was instigated in Buddist circles under the influence of a foreign culture characterized by a script that recorded the spoken language directly—Indian culture with its alphabetic script. Familiar with Sanskrit and Pali texts, Chinese monks had the idea of using ideograms rather like the letters of an alphabet. Hence the following curious anomaly in the history of writing in China: instead of the change from an ideographic to an alphabetic script that took place elsewhere, one observes the development of a kind of scriptural cross-breeding in the ideography through contamination by the foreign body of an external alphabetization.

Fig. 5. Fragment of a document on bamboo strips. This dates from the Han period, after the invention of paper, but the use of paper for writing only spread very gradually. The characters are in *clerical script*.

Fig. 6. (left) The three last lines of an inscription on a stele engraved under the Han dynasty in honor of the head of the district of Heyang (in what is now Shaanxi province) named Cao. The characters are in *clerical script*.

Nowhere, however, is the profound originality of Chinese ideography more apparent than in the art of calligraphy and its derivative, the art of ink painting.

THE CHINESE ART OF CALLIGRAPHY

In many cultures calligraphy is hardly an art or at best it is only a minor one, linked to the copyist's very ordinary trade. It only becomes a major art form when the script is itself a highly significant form. This is certainly the case with the Arabic script, which is in itself far more than just

Fig. 7. Calligraphy of Wang Xizhi (303–361) in *standard script*.

Fig. 8. Calligraphy of Wang Xizhi (303–361) in *running script*.

a succession of graphic signs: it is a veritable incarnation of the Qur'an. But in this script the interplay of readable forms is only that of the letters of an alphabet, a fact which limits the dimensions of Arabic calligraphy to those of a purely ornamental art, however beautiful it may be. Chinese calligraphy, for its part, has at its disposal an inexhaustible supply of ideograms that afford the calligrapher immediate access to the entire universe of the senses. This is why, in classical Chinese esthetics, calligraphy is considered not a just major art but the most sublime of the plastic arts.

Nevertheless, the art of calligraphy, in the true sense of the word, only began in China at the end of the Han period, fifteen centuries after the invention of ideography. Thus, in the inscriptions on bones and tortoise shells (Fig. 2) as well those as on bronze (Fig. 3), the graphic style of the ancient scribes, though often elegant, lacked what is peculiar to calligraphy: an esthetic quest related to the physical shape of the graphic strokes themselves. This proto-calligraphic style, which is by no means lacking in character, was later termed *zhuan* by Chinese calligraphers, a synonym for *yuan*, which, in Han times, referred to the scribes in the administration. This style is still used today, but only in engraving seals, and this has led Western sinologists to use the term "seal script" to refer to the *zhuan* style. During the reign of the last king of Qin (246–210 BCE), who became emperor of China, the seal script was adopted as the standard style and imposed in a somewhat simplified form, fixed by Qin scribes, on all the states that had been absorbed by the Qin kingdom and empire. Subsequently this form was given the name "small seal script" (Fig. 4) to distinguish it from that of the more archaic characters henceforth known as the "great seal script" (Fig. 3). This simplification facilitated the secretarial work in the various departments of the administration, which was already substantial, but it still fell far short of what prompted the

Fig. 9. Calligraphy of Xiao Sihua (406–458) in *cursive script.*

calligraphy—a practice that has been spoken of as a revolution in writing, that of *lishu* (clerical script) (Fig. 6). The creation of the clerical, or chancery, style is traditionally ascribed Cheng Miao, a scribe who is supposed to have perfected it during a period of ten years spent in prison, to which he had been sentenced during the reign of Qin Shi huangdi. In fact, this style is at least a century older and was already used in documents on wooden tablets discovered at Qingchuan in 1980 in a tomb that dates back to 309 BCE. Its appearance is linked to the development of written administrative procedures, which, during the Warring States period (476–221 BCE), gave rise to an increased use of the writing brush. The brush had already existed in China for a long time—the remains of brush strokes have been found on divinatory objects from the Yin period—but its use for routine inscriptions on wooden tablets or bamboo strips (Fig. 5) is relatively late. In 1954, at Zuojiagongshan (near Changsha), a brush was discovered in a tomb of the Warring States period. It differs from those in use today only in its method of adjusting the tuft of hair (rabbit hair): it is held in the split end of its bamboo handle instead of being inserted in the cylindrical aperture of the bamboo. But even in that form, the brush must have functioned very well as a writing instrument. Its use at the time revolutionized writing practice, primarily in two respects: first, it replaced all the rounded strokes of the seal style by orthogonal strokes (as it was unable to execute the rounded strokes elegantly); and second, it required the scribe to modulate the strokes by varying the pressure that he exerted on the brush, particularly in marking the commencement of a stroke (heavier and thicker) and its completion (lighter and finer). At the same time, in terms of the ideography itself, the ways of composing morphophonograms were defined more strictly: the sub-characters selected as radicals were systematically simplified (氵 for WATER 水, 阝 for TOWN 邑, etc.) and placed either on the left (the dominant side at the time) or on top, while the sub-characters chosen as phonetics were always placed on the right or underneath, but never simplified. In addition, the equilibrium of the characters was restored, through simplification, where necessary, the number of strokes.

This restructuring and standardization, which related directly to the actual brush strokes, along with the different ways of writing the characters and achieving a balanced effect, served as a prelude to the birth of calligraphy. However, two conditions remained to be met before it saw the light of day. First came a final technical condition: the ultimate perfecting of the writing brush by inserting the tuft of hair into the suitably prepared cylindrical aperture of the bamboo handle. The credit for this improvement, which

beginnings of calligraphy. As an indication of the volume of bureaucratic writing that was already being produced, Sima Qian (second half of the second century BCE) relates that every day the founder of the empire, Qin Shi huangdi, had to go through a mass of documents weighing about sixty pounds. These were, however, documents on the wooden tablets or bamboo strips that scribes used before the invention of paper (Fig. 5). It was another practice of the scribes of the times that really paved the way for

Fig. 10. Calligraphy of Zhang Xu (655–*ca* 747) in *wild cursive*.

Fig. 11. Detail of a piece of calligraphy by Emperor Huizong (1082–1135; reigned 1100–1125) reproducing the *Thousand-character Classic*. This little manual teaches the elementary vocabulary of ideograms and was composed during the Liang dynasties by the excellent scholar and calligrapher Zhou Xingsi (?–521). It takes the form of a didactic poem in two hundred and fifty rhymed lines of four syllables referring to heaven, earth, the stars, man, etc. To provide a list of one thousand basic characters, each word in the text occurs only once.

Fig. 12. (left) The beginning of a six-fold calligraphic version by Zhao Mengfu (dated 1320) of the *Thousand-character Classic*. The text is repeated across six parallel columns, in a different style of calligraphy each time. From right to left: great seal, little seal, clerical, running, standard, and cursive. Zhao Mengfu was the greatest calligrapher of the Yuan period (Mongol dynasty).

ensured the even distribution of the hairs of the brush in whatever direction a stroke was made, is traditionally given to one of Qin Shi huangdi's generals Meng Tian. The second condition was not technical but socio-cultural: that the literati should decide to employ copyists' materials for the purposes of artistic pleasure. It was under the Eastern Han (25–220 CE) that the fashion spread for scholars to use the brush and ink in this way: the first two Chinese treatises on

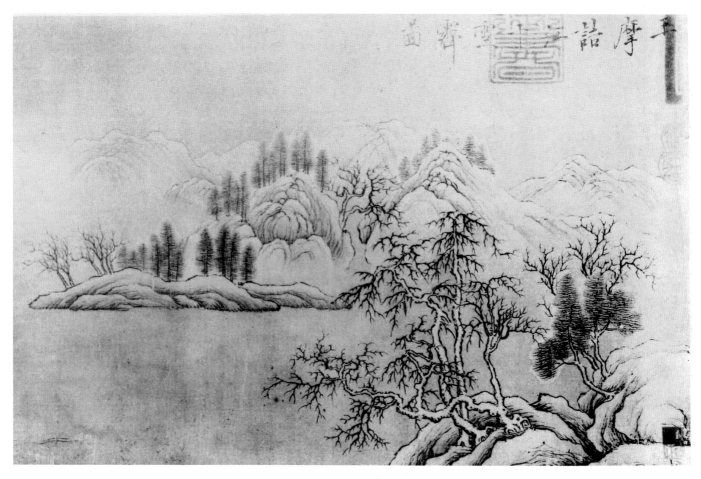

Fig. 13. Wang Wei (699?–759). *Winter Landscape.* Probably a copy of a copy.

calligraphy are those by Cui Yuan (78–143) and Cai Rong (133–192).

The whole of Chinese calligraphic esthetics comes down to the art of exalting the extraordinary plastic beauty of the brush stroke when it participates in that spirit of the transfiguration of the vision of things, which is the very spirit of ideography. To master this art requires a very strict discipline on three levels, proceeding from the most physical to the most spiritual:

The first level is called *bifa* (the rules of the brush) and concerns the manual techniques for using the instrument. There are rules for the different ways of holding it, of rubbing the paper with it, and of moving it, including the ascetic denial of one's whole body, which must be totally directed towards achieving a complete mastery of the movements of the hand and wrist.

The second level is called *bishi* (the dynamics of the brush) and concerns the execution of the brush stroke itself. The bone is produced by a perfectly controlled force in the stroke; the muscle by the vein adumbrated in the

stroke by the movement of the tip of the brush; the blood by the aqueous nature of the ink; and the breath by the rhythm of the variations in the pressure exerted on the tip of the brush as it executes the stroke.

The third level is called *biyi* (the idea of the brush) and concerns the creative idea directing the whole work of art.

Calligraphy is at the same time both the most sublime and the most popular of the arts in China. In the course of the centuries during which it has been extensively practiced, all of its aspects have been enumerated, analyzed, and codified in minute detail, including its rules, principles, variations in technique, and esthetics. For example, in one of the theories fashionable since Ming times (but whose author has long been forgotten), seventy-two varieties of the eight fundamental brush strokes are identified. This codification resembles the system of notating the fingerings designed to show an instrumentalist how to execute scores in the performance of Western music. "The brush," writes J.F. Billeter, "is not a tool, but a veritable instrument . . . the calligrapher plays on it like a musician, and he draws

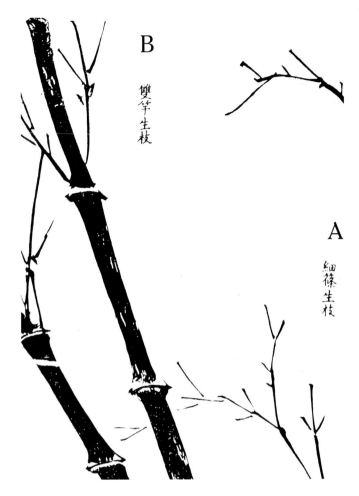

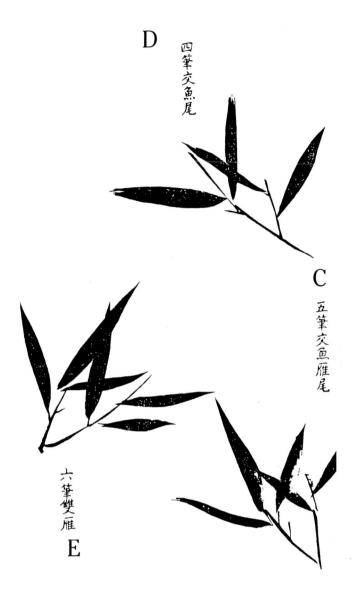

Fig. 14. Extracts from the *Mustard Seed Garden Manual of Painting*. This shows classified models of brush strokes representing *fine young live stalks of bamboo* and a *pair of bamboo trunks* (A and B), then bamboo leaves *crisscrossed in the form of wild goose tails, fish tails, and pairs of wild geese* (C, D, E) (the literal translations of the names in the Chinese classification of brush strokes are given in italics).

shapes from it as a violinist draws sounds from his violin" (*L'Art chinois de l'écriture*, Geneva: Skira, 1989, pp. 56–57). The playing varies according to the five major genres, all of which have existed since the beginnings of calligraphy and are characterized by different styles: in addition to the archaic style of the *seal* script and the post-archaic *clerical* script are three others: the *standard* script (Fig. 7), derived from the clerical by accentuating the rectangular nature of its characters; the *running* script (Fig. 8), a more rapid version of the standard, in which the brush strokes are no longer separate but joined up; and the *cursive* script (Fig. 9), an even more rapid version of the running style, in which the characters assume more condensed forms, reduced to their strong lines alone, and are written in a calligraphy consisting of a single stroke that continues unbroken from one character to another.

From Eastern Han times until the present, according to a calculation made by the author of a recent Chinese history of calligraphy (Zhu Jia, *Shuxueshi*, Chengdu, 1984), the names of more than two thousand great calligraphers have been recorded in the history of the arts in China. Each era has had its own dominant tendency, illustrated by its glorious exponents. Calligraphy reached its golden age very early: the period of the Six Dynasties (222–581) (Figs. 7, 8, and 9), when classic perfection in this art was attained by Wang Xizhi (303–361) (Figs. 7 and 8), who has always been considered the greatest calligrapher of all time. Under the Tang rulers (618–907), a need for freedom from the somewhat overpowering authority of earlier tradition led to a stylistic originality that an eccentric like the monk Zhang Xu (655?–747) developed into an absolute rejection of conformity in his "wild cursive" style (Fig. 10). Under the Song

Fig. 15. *Monk Riding a Mule*. Master Wuzhun of Jingshan monastery (1178–1249). This painting, impregnated with the spirit of *chan* (*zen* in Japanese), is a perfect example of the way in which images of the real world can be represented, in ink, by brush strokes that are codified like those of ideograms. The epigraph reads: "The rain comes, the mountain becomes misty, the mule takes on the appearance of a horse" and "Drawn by the Master."

dynasty (960–1279) it was an extremely refined literati elegance that triumphed in the persons of Su Shi (alias Su Dongpo, 1036–1101) and Mi Fu (1052–1107), and even Emperor Huizong, who is ranked among the greatest calligraphers of his time (Fig. 11). The Mongol Yuan dynasty (1206–1368) saw a return to the strictest traditional forms, and even to the archaic style of a Zhao Mengfu (1254–1322) (Fig. 12). The long period of Ming rule (1368–1644) came under the influence of Wang Shouren (alias Wang Yangming, 1472–1529) and his philosophy of the heart, which led to a style marked by subjectivity and spontaneity in the work of such calligraphers as Zhang Ruifu (1570–1641) and Ni Yuanlu (1593–1644). Under the Manchu Qing dynasty (1644–1911), the wary refusal of any compromise with the reigning power contributed to such robust, zen-influenced work as that of Zhu Da (alias Badashanren, 1626–1705) and Shi Tao (*ca* 1642–1718).

To the Chinese mind, the fantastic profusion of calligraphic creation over the course of the centuries reveals the entire universe. As Kang Youwei (1858–1927) wrote:

> When one has explored, through writing, all the metamorphoses of creation and all periods of history; when one has, through it, expressed all the emotions from despair to elation; when one has reproduced, in it, the movements and positions of the whole of Nature, flying, swimming, running, growing, slipping away, appearing; when one has mastered all the swift and slow gestures made with the writing brush and realized all the combinations of energy that the *yin* and the *yang* create in the course of the seasons— then, one fine day, quite naturally, a new physiognomy emerges (quoted by J.F. Billeter, *op. cit.*, p. 126).

It is thus that the Chinese calligrapher discovers, manifesting itself at the very heart of ideography, a new layer of meaning at the most profound level of existence.

THE ART OF INK PAINTING
IN THE CULTURE OF THE CHINESE LITERATI

It was in searching to express this new layer of meaning that the Chinese calligrapher transformed himself into a painter, thereby giving birth to an art form that exists only in China and countries influenced by its culture: the art of ink painting. In Chinese this is called *shuimohua* (water and ink painting) and in Japanese it becomes *sumie*. The father of ink painting—principally landscape painting known as *shanshui* (mountains and water)—was the great Tang poet and painter, Wang Wei (699?–759?) (Fig. 13). Of course, the history of

Fig. 16. *Winter Landscape*. Anonymous painting from the Southern Song period (1127–1279).

Fig. 18. (below) *In the Mountains and the Clouds*. Fang Congyi (active *ca* 1343). Fang Congyi, after initiation into the Taoist sect of the Heavenly Masters in the famous monastery on the Mountain of the Dragon and Tiger (Longhu shan, in central north-east Jiangsu), became a wandering Taoist monk and visited the most famous mountains in the country, giving mystical expression in his paintings to their cosmic sublimity.

Fig. 17. Painting by Zhao Kui (1186–1266), inspired by a poem of Du Fu (712–770): "Making a stop deep in a bamboo grove, enjoying the cool air by the lake of water-lilies." Not only a gifted painter, Zhao Kui was a courageous military leader who, under the Song, fought against the Mongol armies, and as a result of his meritorious services reached the rank of senior vice-president in the Department of State Affairs and military commissioner.

Fig. 19. *Banana Leaves*. Xu Wei (1521–1593). Poet, essayist, dramatist and an extremely prolific painter, Xu Wei led such a tempestuous life that he was said to be "perhaps a sage, or a saint, or a demon, or a devil." Among other eccentricities, he painted with his fingers as brushes. These banana leaves are an example of such painting. The inscription (a piece of calligraphy written with a brush) runs: "Having chopped down and brought home some wild jujube trees and some prickly yellow bushes, I am learning to draw the banana tree with fingers [as heavy as] hammers. Among these leaves is one that I know in particular: the one that in a former life covered the deer." (Xu Wei had previously addressed a report to Emperor Shizong, which he presented as having been drawn up by the white deer, and the emperor had particularly appreciated its style.) Musée Guimet, Paris.

painting in China goes back much further, but previously it had been the profession of artisans who specialized in interior decoration and embellished palace interiors or tombs with their wall paintings of sages, great men of antiquity, dragons, spirits, immortals, and fairies. It was during the Six Dynasties period, which was precisely the period during which calligraphy reached full development and the use of paper simultaneously became widespread, that brush and ink began to be used, on paper or on silk, in a new artistic genre of mountain and water painting. Song Bing (375–443), the first theorist of *shanshui*, declared that it aimed at "delighting virtue through the physical expression of the rapture of the Dao." A great landscape painter himself, he

was thoroughly imbued with the philosophy of the School of the Mystery of Being (*Xuanxue*), which was dominant at the time. Unfortunately, all his paintings have disappeared.

The technique for ink painting is basically the same as that for calligraphy in its various ways of manipulating the brush and of inking it up (particularly with more or less watery ink), which make it possible to achieve all the formal effects possible with the strokes of the brush. In ink painting, as in calligraphy, the whole art comes down to "the one sole movement of the brush which creates the stroke" (*yibihua*), and all the different strokes of the brush are codified. However, they are not codified according to the strokes of ideograms but according to the strokes needed to model whatever, in reality, can form part of a landscape. For example, just as the calligrapher practices drawing the brush stroke coded as a horizontal stroke in some character (or the stroke coded as an oblique stroke falling from the middle down to the bottom left or bottom right in some other character), so the painter practices drawing brush strokes codified as the representation of a bamboo leaf, a bamboo stem, the branch of a plum tree, a bunch of pine needles, the outline of a mountain, the planking of a little boat on the river, or the outline of a fisherman, and so on. All these types of brush stroke, as applied to *shanshui*, have been indexed in dictionaries of ink pictures to include everything that could feature in the composition of a landscape, in perfect correspondence with the dictionaries of ideograms used by calligraphers. The most popular one is the famous *Mustard Seed Garden Manual of Painting*, so-called after the name of the residence of Li Yu (1611–1662?), who wrote the preface to the book. This manual's first edition contained lists of 149 different forms of trees and foliage (Fig. 14); 91 forms of mountains, rocks, rivers, streams, and various clouds; 124 forms of human figures in different settings; 34 forms of animals; 37 forms of houses, walls, and pathways; and 30 forms of towns and villages. Naturally, certain brush movements that do not exist in calligraphy are found in ink painting—for example, strokes known as broken ink (or chopped ink) or splashed ink—but they are nonetheless direct extrapolations from calligraphic techniques. Moreover, *shanshui* painting is itself no more than an extrapolation from calligraphy. The scholarpainter composes his landscape on the paper as he would compose a piece of calligraphy (Fig. 15). Instead of the ideogram for a mountain, he pens, in calligraphic fashion, the form of a mountain; instead of the ideogram for water, the form of a river or a waterfall; instead of the ideogram for spring, the form of a flowering peach-tree. And he balances the whole like the words of a text in the graphic language, not to create a picture but to impart a meaning (Fig. 24). As the great Tang theorist of painting, Zhang

Fig. 21. *Early Autumn Landscape.* Dong Qichang (1555–1635). Dong Qichang was a great painter and an authority on painting at the end of the Ming dynasty. He initiated the transposition of the distinction between the Northern and Southern Schools of *chan* (zen) Buddhist doctrines into the realm of Chinese landscape painting. The calligraphy which figures as an epigraph to the painting reads as follows: "The earth is revealed as the mist clears/Clouds withdraw to the sky's end/Waves begin to rise on Lake Dongting/The leaves [begin] imperceptibly to fall away from the trees. Xuanzai [one of Dong's names]."

Fig. 20. *Landscape after the Style of Wang Meng.* Wang Hui (1632–1717). Wang Hui came from a family renowned for its painters over several generations and was himself a very great painter. He directed a team of court painters commissioned with the task of illustrating Emperor Shengzu's imperial journeys in the Yangzi region through a series of landscape paintings of South China. This painting is an imitation of the landscapes painted by Wang Meng (1301–1385), one of the "four great masters of the end of the Yuan dynasty," as the inscription at the top of the scroll states. Musée Guimet, Paris.

Yanyuan (815–880?) wrote: "The art of painting should aim further than the imitation of external forms. But it is difficult to make people understand this. Nowadays, paintings succeed perhaps in copying things, but they are lifeless and lacking in any spiritual resonance. Let spiritual resonance be the aim, then verisimilitude will be achieved at the same time!"

To the eye of someone unfamiliar with Chinese culture, an exhibition of the works of the greatest masters of ink painting would, once the initial wonder at the exotic technique and subject-matter had subsided, doubtless only offer a hodgepodge of clichés repeated *ad nauseam.* The problem is that they would have looked no further than the external form of the compositions. The gaze of the Chinese esthete penetrates that form and perceives the spirit of the painting, incarnated above all in the strokes of the brush. Each type of codified stroke was in the first place the creation of a master, and everyone tries to become imbued with some of that mastery through the act of copying and recopying his works again and again. The great works have been copied in this way any number of times throughout the ages, and today many are only known through copies of copies. This does not prevent the Chinese amateur from appreciating their quality any more than he would be prevented from appreciating the beauty of a poem because it figured in a text other than the original manuscript. None of

洪厓老夫煨榾柮

盡寒灰千加額是誰

敲破雪中門徇犖

蹲鴟以奉客

Fig. 22. *Sweet Potato*. Badashanren (alias Zhu Da, *ca* 1625–1705). The epigraph reads: "The old fellow from Hongya [not far from Shijiazhuang, in Hubei province] has burned twigs to warm himself, but they are just cold cinders. Who comes visiting and knocking on the door in the snow? Let's offer him a [nice warm] sweet potato!" Badashanren, a Buddhist who subsequently converted to Taoism, was one of the great eccentrics of Chinese painting. As a member of the Ming imperial family, he was even more hostile to the new Manchu regime than he had been nonconformist under the previous Ming dynasty, and he pretended to be mad in order to protect his freedom. Palace Museum, Taipei.

Wang Wei's paintings has come down to us except in the form of a copy (Fig. 13). And it was surely only in this second-hand form that Su Dongpo could have had access to the work of this great Tang poet and painter, of whom he wrote admiringly that "his paintings are poems … and his poems are paintings."

This aphorism is not a metaphor. It should be taken at face value for every Chinese painter of mountains and water. Wang Wei was simply the one who, thanks to his genius, illustrated it better than most. Poem and painting are the two perfectly interchangeable faces of the same vision of the world. Moreover, no ink painting is without its own inscription of a few characters of calligraphy. They form such an integral part of the work that, if they are

lacking—as happens, for example, when an author intends to have them written by a friend who subsequently fails to do so—the work seems lame. Conversely, painters, instead of choosing scenes from Nature as their subjects, have often selected poems describing them. Thus, when Chinese painters seek their themes directly in Nature—many of them having lived as hermits in magnificent wild places—it is not so that they may reproduce on their scrolls the landscapes that they have discovered, but so that they may become more imbued with the cosmic meaning of things, a meaning that finds mystical expression in their works. "The painter's master," said Wang Wei, "is creative Nature."

One of the great art historians of the first half of the twentieth century, Zheng Zhang (1894–1952), compiled statistics

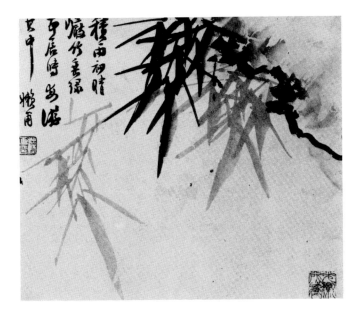

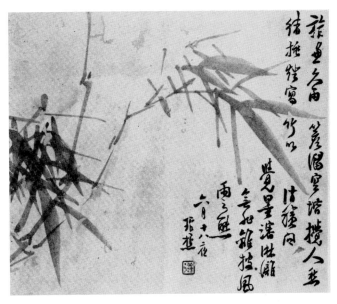

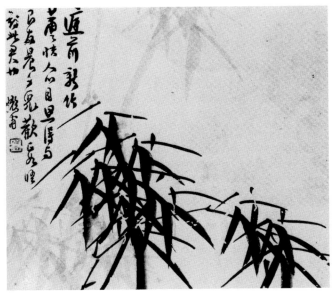

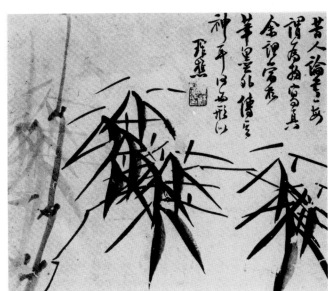

Fig. 23. Four bamboo paintings. Xie Yingsou (1811–1864?).

for famous Chinese painters under each dynasty. According to his calculations they numbered a score under the Sui, 385 under the Tang, 150 during the Five Dynasties, more than a thousand under the Song (Figs. 16 and 17), 420 under the Yuan (Fig. 18), 1,300 under the Ming (Fig. 21), and more than 4,300 under the Qing (Figs. 22 and 23). These large numbers demonstrate that painting in China was not a vocation that affected only a small number of exceptional artists but an activity in which the majority of cultured intellectuals were involved. Nevertheless, from Song times onward, a type of painting specifically an activity of the literati can be differentiated from academic painting as a result of the somewhat disdainful distance that the intellectuals, proud of their independence, maintained between

themselves and those who, by reason of their talent with the brush, were chosen to become members of the Imperial Academy. The distinction disappeared under the Qing with the abolition of the Academy. In the meantime, the literati painters (*wenhua*, also called *shifuhua*, "aristocratic painters"), who were far more numerous, made it a point of honor to despise technique and to abandon themselves to an inspiration free of all restraint, drifting willingly into eccentricity. The archetypal figure among these has remained the famous Song poet Su Dongpo, who has already been mentioned above as a calligrapher. According to an anecdote, one of his specialties was painting bamboos in red ink, and when someone pointed out that no one had ever seen a red bamboo, he replied that no one had

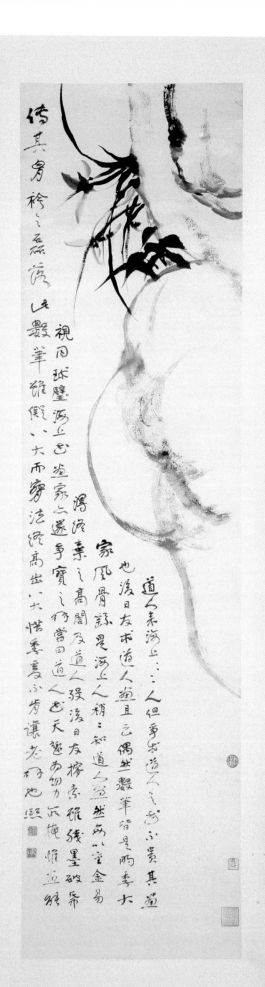

ever seen a black one either. But the "gay genius" of Su Dongpo's style, as Lin Yutang describes it, was far from being shared among all those literati painters who prided themselves on following in his footsteps. The aspiration to become carried away by pure inspiration alone led in the end to an affectation that took pleasure in feeble imitations of the great works of the past. Under the Qing, the official academic style disappeared, only to be replaced by one of facile brush strokes, bereft of any of the vigor displayed by the great masters of the past. This sealed the fate of traditional Chinese ink painting.

Bibliography

BOTTERO, Françoise. *Sémantisme et classification dans l'écriture chinoise.* Mémoires de l'Institut des Hautes études chinoises du Collège de France, vol. XXXVII (Paris: De Boccard, 1996).
HARBSMEIER, Christoph. "Language and Logic." Joseph Needham. *Science and Civilisation in China*, vol. 7 (Cambridge: Cambridge University Press, 1998).

Fig. 25. *Composition no. 8-83.* Chan Chin-chung. Oil on canvas. In the terminology of contemporary Western painting, the rigor of the production of meaning in the language of traditional ink painting has been converted into hyper-realism. The painter, born in 1939 in Longchuan, Canton province, studied art in Wuhan and Canton, and after a brief stay in Hong Kong, emigrated to Paris in 1969, where he now has his studio.

Fig. 24. (left) *Rock and Orchid,* a painting by Li Ruqing (1876–1920), with calligraphy by Zeng Xi (1861–1930). It was to study painting and calligraphy with these two artists that the famous Zhang Daqian (1899–1930) went to Shanghai in 1919 and 1930. Musée Guimet, Paris.

TABLE OF THE AFFILIATIONS OF *GRAPHOLOGICAL* CHINESE IDEOGRAMS

(with present-day characters and pronunciations)

	man 人,亻 *ren*	strength 力 *li*	heart 心,忄 *xin*	tree 木 *mu*	water 水,氵 *shui*	silk 糸 *si*	grass 艹 *cao*	wor 言 *yan*
half 半 *ban*	companion 伴 *ban*		disobedient 悖 *pan*	bowl 柈 *fen*	melt 泮 *pan*	hinder 絆 *ban*		
direction 方 *fang*	imitate 仿 *fang*			kind of tree 枋 *fang*	sail together 汸 *fanf*	spin 紡 *fang*	perfume 芳 *fang*	inquire 訪 *fang*
divide 分 *fen*	share 份 *fen*		anger 忿 *fen*	white elm 枌 *fen*	name of river 汾 *fen*	confused 紛 *fen*	fragrant 芬 *fen*	mumble 訜 *fen*
work 工 *gong*	big 仜 *hong*	achievement 功 *gong*	anxious 忙 *gong*	pole 杠 *gang*	Yangzi 江 *jiang*	red 紅 *hong*		discord 訌 *hong*
ancient 古 *gu*	price 估 *gu*		trust 怙 *hu*	dead wood 枯 *ku*	buy/sell 沽 *gu*	kind of tree 絝 *gu*	bitter 苦 *ku*	to gloss 詁 *gu*
trifles 戔 *jian*	pale 俴 *jian*		harm 悭 *can*	shop 棧 *zhan*	shallow 淺 *qian*	thread 綫 *xian*	kind of grass 葰 *shen*	praise 諓 *jian*
cross 交 *jiao*	elegant 佼 *jiao*	imitate 効 *xiao*	attentive 恔 *xiao*	check 校 *jiao*	name of river 洨 *xiao*	twist 絞 *jiao*	kind of grass 茭 *jiao*	call 詨 *xiao*
stream 巠 *jing*	skill 俓 *jing*	robust 勁 *jing*	rancor 悭 *xing*	beam 桱 *jing*	cesspit 涇 *jing*	warp 經 *jing*	stem 莖 *jing*	contradict 誙 *xing*
phrase 句 *ju*	obtuse 佝 *gou*	labor 劬 *qu*	ignorant 怐 *kou*	medlar 枸 *gou*	name of river 泃 *ju*	shoelace 絇 *qu*	careless 苟 *gou*	abuse 詢 *gou*
be able to 可 *ke*	which 何 *he*			branch 柯 *ke*	Yellow River 河 *he*	fine silk 絅 *e*	strict 苛 *ke*	reprimand 訶 *he*
each 每 *mei*	to shame 侮 *wu*	nimble 勄 *min*	regret 悔 *hui*	plum tree 梅 *mei*	sea 海 *hai*	numerous 繁 *fan*	strawberry 莓 *mei*	teach 誨 *hui*
in flower 甬 *yong*	figurine 俑 *yong*	brave 勇 *yong*	incite 恿 *yong*	bucket 桶 *tong*	gush forth 湧 *yong*			recite 誦 *song*

The meanings are given in roman letters, the pronunciations in italics. The columns contain the lines of vertical descent of characters that are affiliated through the same radical (placed at the top of each column), and the rows contain the lateral branches of characters affiliated through the same phonetic (placed at the start of the row, on the left). Only a small part of the lexical field is shown here; for a complete representation it would be necessary to add over two hundred columns at the right and more than fifty rows at the bottom of the chart. At the intersection of the columns and the rows, the empty slots indicate places where a theoretically possible combination of radical and phonetic did not take place (either because it was not needed or because it would have lacked semantic coherence). In other areas of the lexical field, where different radicals and phonetics from those in the table are less readily combined, there would be many more blank spaces. It is noticeable that the same phonetic may, in the various characters in which it occurs across the same row, represent pronunciations that are sometimes quite different—something one also observes in the archaic pronunciation. On the other hand, it is by no means rare for one and the same phonetic to convey, in ideograms that vary considerably in meaning (with different radicals), a certain shared nuance of connotation.

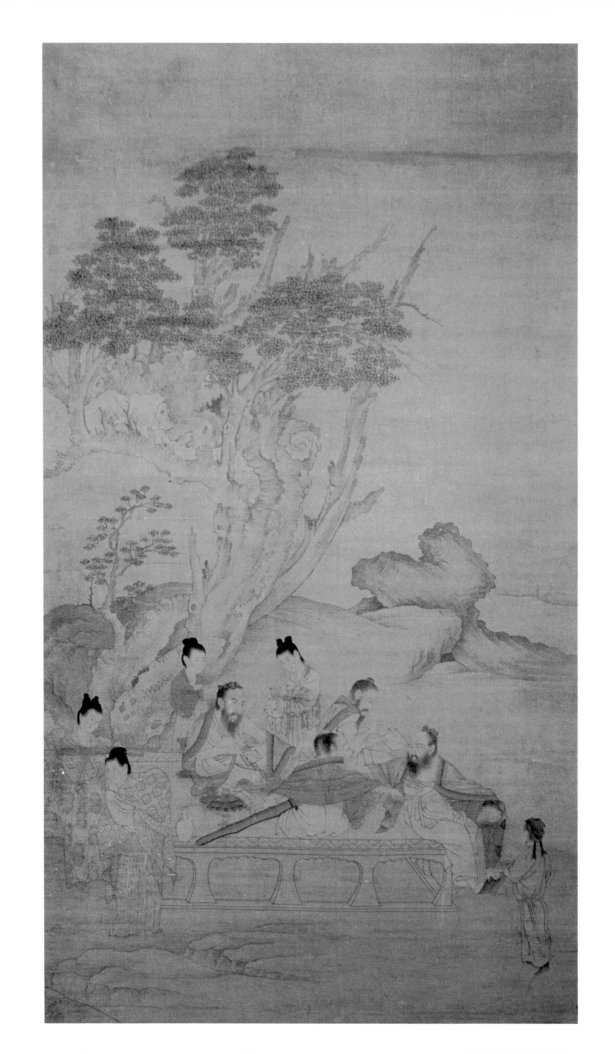

THE PRACTICE OF CHINESE CALLIGRAPHY

Léon Vandermeersch

The equipment necessary for Chinese calligraphy consists essentially of the *four treasures of the scholar's study*—paper, brushes, ink, and ink-stone—to which, in the case of the amateur, one should add various other accessories: metal or stone paperweights to fix the sheet on which one is working to the table, a porcelain cruet to pour water, drop by drop, onto the ink-stone, a hard-wood brush rack, a brush-rest made of wood or jade, bamboo or porcelain pots, and so on. As they are often precious, all these objects, including the blank paper, which is sometimes of a very expensive quality, may be much sought after by collectors as rare pieces.

What in the West is known as *rice paper* is in fact a Chinese paper fabricated from a pulp made of different plants according to local conditions: young bamboo in Fujian, hemp in Sichuan, rice straw in central China. The best paper is that fabricated from the pulp of the mulberry. Korean paper is also highly regarded. The finest paper that was formerly sought by calligraphers came from the *Pavilion of Spiritual Serenity* during the Southern Tang period (953–975) and was made from bamboo pulp. In later centuries, papers of the Xuande period (1426–1435) of the Ming dynasty and of the Qianlong period (1736–1795) of the Qing dynasty were prized.

The calligrapher's brush is shaped like the core of a jujube: the tuft of hair is drawn tightly together near the handle, bulges out in the middle, and tapers to a fine point at the end. It must be capable of holding and releasing the necessary amount of ink, and possess sufficient elasticity to resume its shape as soon as the calligrapher relaxes the pressure with which he applies it to the paper. To achieve this elasticity three-tenths of the tuft of hair must be inside the handle. The hair of all kinds of animals has been used: mainly rabbits and goats, but also wolves, foxes, sheep, deer, and pigs. The hair may be more or less hard or soft, depending on whether the artist seeks brush strokes that are strong and vigorous or fine and delicate. The handle is generally only some five inches long, even for the big brushes that are used for the calligraphy of inscriptions; these have a tuft shaped like a large pear and are used to paint on large horizontal wooden panels, such as those bearing the names of pavilions, temples, or palaces.

The ink is a liquid composed of water mixed with fine carbon particles that the calligrapher prepares each time he sets to work. First, he moistens the ink-stone with a little water, and then he rubs the end of a stick of solid ink on the stone's slightly concave surface. The ink sticks are made by mixing glue with lamp black obtained, ideally, from burnt pine wood. The mixture, consisting of two-thirds soot and one-third glue, is cooked for two or three hours and carefully ground; camphor and musk are added to neutralize the smell of the glue. The whole is then molded into little sticks, which may be parallelepipeds or any other shape (for instance, in the form of a pear, a gourd, or a disk). Famous brands of ink sticks are often decorated with delicately painted designs in gold powder, which accentuate the deep black color of the ink.

Ink-stones are made from carefully polished disks of very hard black clay, that from Duanxi in Guangdong, or from the Dragon-tail Mountain in Anhui, being especially prized.

Fig. 1. *Scholars in a Writing Group at the beginning of the Tang Dynasty.* A painting by Qiu Wenbo (*ca* 950). Portrayed here are some of the eighteen scholars who belonged to the Imperial College, founded in 621 by Li Shimin, the future Emperor Taizong (reigned 626–649), while he was still an imperial prince with the title King of Qin. At the time, the painter Yan Liben, who occupied a post attached to the College, was ordered to paint portraits of its scholars. The originals have been lost, but the painting reproduced here is a copy (possibly imagined) by Qiu Wenbo of one of the portraits painted on that occasion. It is preserved in the Palace Museum, Taipei.

Fig. 2. A set of brushes. Each calligrapher uses a very wide range of brushes of different sizes and varying degrees of hardness (e.g. wolf hair) or softness (e.g. sheep's hair). The big pear-shaped brush is used for the calligraphy of large inscriptions engraved on wooden panels in residences to indicate the names of ceremonial halls, and for the notices that feature on the walls within.

Fig. 3. Objects from a scholar's study. In addition to two pear-shaped brushes are a large water pot for washing the brushes, a little water dispenser for mixing with the ink, a handleless cup, a porcelain container of sealing ink paste, and a cubic porcelain paperweight. Musée Guimet, Paris.

Positioned on the periphery of the working area, these stones, which have been slightly hollowed out into a concave semi-lens shape, are often decorated with various carved patterns.

Usually, calligraphers hold the brush vertically. When using the big pear-shaped brush, they may hold it in their fist, but normally they grasp the handle between the first joint of the thumb and the last joints of the index and middle fingers. The grip is balanced by pressure from the back of the last joint of the ring finger and little finger applied to the brush from behind. This position ensures the best control when manipulating the brush. It is common practice to rest the middle of the fore-arm on the edge of the table, or on a wrist-rest, often made of bamboo, placed on top of the paper. The experienced calligrapher, however, operates without any support, with his fore-arm held aloft. This requires a long apprenticeship, but permits a much greater mastery of the brush-strokes. Such mastery may be observed in the way that the artist attacks, develops, and completes each stroke in one harmonious movement. The strokes are always drawn from top to bottom or from right to left, skillfully modulated according to the infinitesimal variations in the pressure brought to bear by the artist on the paper, and on his brush as he manipulates it in different directions.

Fig. 4. The correct posture of the calligrapher in action. The position of his body and the manner in which he holds the brush provide a perfect example of the Chinese calligrapher's technique.

Fig. 5. Schoolchildren learning calligraphy in Taipei.

Each character, however complex it may be in terms of the number and variety of its component strokes, is, in theory, a perfectly balanced construction, composed in an ideal square, and occupying the same amount of space as all the other characters throughout a given text. It corresponds, in fact, to what is practiced in printing. But in hand-written calligraphy the artist plays in a subtle way with the distinctive strokes of the characters to produce particular effects, through varying the bolder and the finer forms.

The equilibrium of the composition is to be found in the harmony of the proportions between, on the one hand, the characters themselves and the size of the columns of characters, and, on the other hand, between the written elements and the blank spaces left in between them. Huang Tingjian (1050–1110), the great esthete, who was a friend of Su Dongpo and Mi Fu, observed that the trouble with large-scale calligraphy was that the characters were too close together and did not have enough blank space surrounding them, whereas calligraphy in small characters was too spaced out, leaving too much blank space. Well-proportioned blank

spaces produce what is called "breathing space, during the run of characters." In *cursive*, and sometimes in *running script*, the characters are joined together. The links are made by allowing the ink-line from the last stroke of one character to flow into the first stroke of the next. This line is called "drawing the silk thread." The *silk thread* is not a brush-stroke as such, so it does not affect the calligraphic breathing space, which depends on the spirit expressed by the whole piece in its overall proportions. This includes various elements, such as the date, the signature—generally written in smaller characters and sometimes in a different style, away from the main text—and one of a whole range of seals, frequently cut by the artist himself, and chosen as being in harmony with his composition.

Bibliography

BILLETER, Jean-François. *L'Art chinois de l'écriture* (Geneva: Skira, 1989).

FROM PYROSCAPULIMANCY TO WRITING

Léon Vandermeersch

Pyroscapulimancy is a form of divination that was much practiced by the cattle-breeding populations of northern Asia from neolithic times. It consists of treating as divinatory signs the cracks that are produced when fire is applied to flat bones—most often the shoulder-blades of sacrificial animals (Fig. 1). In ancient China, this form of divination, which had been widespread since prehistoric times, benefitted from a number of technical refinements and enhancements over time, culminating in a high degree of sophistication toward the middle of the second millennium BCE. The shoulder bones of cattle were largely replaced by tortoise shells, as the tortoise was regarded as a small-scale model of cosmic space-time, its dorsal shell being dome-shaped like the heavens, its under-shell flat like the earth, and its lifespan measured in terms of the century.

It was on the internal surface of the shoulder-blade or tortoise shell, once it had been carefully cleaned and polished and any bony protuberances removed, that specialist craftsmen created a series of double cavities in neat rows. Each set comprised two hollows: a deep, elongated one in the shape of a date-stone, and, running tangentially from its center, a shallower one in the shape of a lozenge (Fig. 2). These systematic hollows were clearly designed to ensure a satisfactory standardization of the cracks. Indeed, when the hot brand was applied to the lozenge-shaped hollow, it created a compound split at the bottom of the double cavity in the bone or shell, which appeared on the other side—its reverse side—in the form of a regular sign composed of two lines, one running lengthwise (corresponding to the date-stone hollow) and the other running crosswise (corresponding to the lozenge-shaped hollow).

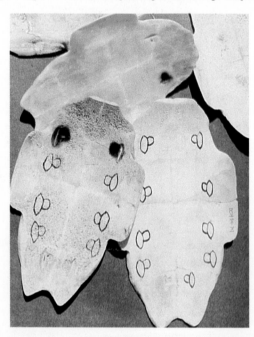

Fig. 1. Shoulder bones of cattle of the type used for divination in Yin times.

Fig. 2. Tortoise shells prepared for divination, showing special shapes that have been hollowed out to make the application of heat conform entirely to the norms of the divinatory process.

The crosswise line, which ran from the center of the vertical line, was more or less perpendicular to it and was sometimes forked (Fig. 3). It was this sign that was analyzed as an oracular diagram and read by the diviners as a representation, inscribed on the bone or shell, of the cosmic forces that were believed to intervene in the contingency that had to be forecast: whether the next ten days would be auspicious or not, whether a particular sacrifice was opportune or not, whether it would rain or not, the success or failure of a hunting expedition or a military campaign, whether a boy or girl would emerge from a forthcoming birth.

On divinatory pieces from the fourteenth century BCE onward, inscriptions appear in which notes are appended to the diagram, recording the date, the name of the diviner who interpreted it, the purpose of the divination, its result, and sometimes even the mention of some subsequent fact confirming the result. These are what are known as oracle-bone inscriptions, which may be traced back to the Yin period (from the fourteenth century to the eleventh century BCE, the last three centuries of the prehistoric Shang dynasty) and constitute the very first form of Chinese writing. This writing is ideographic, each character, or ideogram, representing a distinct unit in the discursive flow and being discrete in terms of primary organization (see page 67)—in fact a word, which in Chinese is all the more easily isolated insofar as the language is monosyllabic.

Comparisons have been made between the characters in oracle-bone inscriptions and the graffiti found on neolothic Chinese pottery, which are similar in style but are a thousand or two thousand years older. But although the inventors of the Chinese script—the diviners—may have been inspired by such graffiti in conceiving the first ideograms, the latter are nevertheless radically different because they represent the words of an organized discourse. In contrast, the neolothic graffiti are clearly not organized. The invention of writing is one in which signs are linked together in an appropriately organized fashion. How did the idea for such an organization occur to the diviners? Undoubtedly from their extraordinarily refined method of constructing divinatory diagrams, which were highly standardized and systematically organized in relation to one another. Indeed, the diviners operated in such a way that for each divination they obtained not one single diagram but a whole series of composite diagrams: as many as ten diagrams on the same tortoise shell, and up to five when each one was produced on a different shell. We know this from the detailed numbering of the series of diagrams referring to a particular divination that was recorded on the divinatory

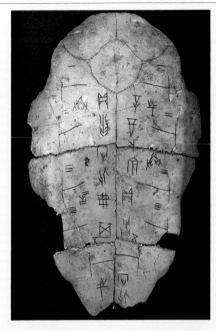

Fig. 4. A tortoise shell that has been used for divination and engraved with inscriptions. The inscription records an enquiry as to whether a certain action (probably military) performed by A (the illegible name of a Yin leader) would be disastrous or not for B (the illegible name of another member of the Yin ethnic group). The result of the divination (recorded on the left, between cracks 3 and 4) was "very favorable."

objects: each diagram has its own number. Clearly, the diviners arranged each series relating to a single divination along the lines of a divinatory polynomial. This would later give rise to the principle underlying the organization of the hexagrams of the *Book of Changes* into six single lines numbered from 1 to 6, line 1 being called the initial line and line 6 the top line (Fig. 4). Furthermore, the diviners preserved used divinatory pieces in archives, doubtless with a view to furthering the study of the configurations and meanings of the divinatory diagrams. From this emerged the classic texts of divination. The relationship between the divinatory diagrams and the meaning of things thus unveiled is the same as that between the characters of the script and the discourse read through them. It was thus by no means surprising that the diviners should have proceeded from one to the other, rationalizing the characters just as they had standardized the divinatory diagrams, and discovering an organization of the script reflecting that of the language, just as they had conceived an organization in the configurations of their diagrams reflecting that of the meaning of things.

The Chinese script is born of divination. And the classical literature written in the graphic language has remained so profoundly affected by this connection that, in Chinese eyes, each great literary text seems almost magically hermeneutic and the least bit of paper, from the moment characters are written on it, becomes so sacred that it cannot possibly be thrown away.

Bibliography

KEIGTHLEY, David N. *Sources of Shang History. The Oracle-bone Inscriptions of Bronze Age China* (Berkeley/Los Angeles/London, University of California Press, 1978).

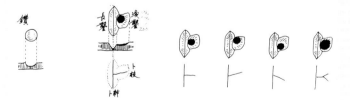

Fig. 3. Dr. Kang-yuan Chang's diagram shows the various ways in which the hot brand could be applied to different points on the shell, with diverse effects on the shapes of the ensuing cracks. Dr. Kuang-yuan Chang considers that it was thus possible for diviners to influence the results of divination.

THE SCRIPTS OF CONTINENTAL INDIA

Georges-Jean Pinault

Throughout its history and up to the present day, the Indian world has been characterized by the heterogeneous nature and the diversity of its formal scripts. To speak of a single "Indian script" it would be inappropriate, and we should even be wary of using the expression in the plural, as the use of these scripts has not been confined to the Indian sub-continent. Indeed, none of them can be described as being exclusively and originally Indian. This vast cultural zone seems rather to have been an area for experimenting with writing systems and adapting them. Moreover, writing, despite having existed for thousands of years as the "secondary" form of recording messages, has never eliminated the recourse to listening and memorizing. The two forms of transmission—written and oral—were used in parallel for long periods. India can demonstrate that there is no such thing as an irreversible passage from the oral to the written.

I. THE PRESENCE OF WRITTEN TEXTS AND THE REJECTION OF WRITING

The Indian world abounds in written documents, in the form of inscriptions and manuscripts, printed editions of which fill today's libraries. The media on which they are written vary greatly: whereas inscriptions are engraved on stone (either rough or polished) and metal (chiefly on copper and bronze), the basic material for manuscripts was mainly palm leaves, as well as the bark of the birch and the sap wood of the aloe. Books made from other materials (poplar wood panels, or paper leaves) have imitated the layout of

Fig. 1. A book composed on palm leaves: *Sundarakāṇḍam* in *Tamil* script, 1830. Ms. Indien 283, Bibliothèque Nationale de France, Paris.

books made up of palm leaves. These consisted of a pile of oblong leaves, shaped like slats, with holes pierced through them (one, two, or three, depending on the length of the leaves), which were joined together by means of a thread drawn through the holes (Fig. 1). The lines of writing run parallel lengthwise and are sometimes divided into columns. The leaves are flipped over once they have been read, revealing text on the reverse side. The materials of these manuscripts are obviously fragile in the monsoon climate of the Indian subcontinent, and the most ancient specimens owe their preservation to the dryness of the northwestern regions and of central Asia. Epigraphic texts are numerous, well preserved, and an essential source of knowledge of Indian history, geography, and society—more so than literary texts. Inscriptions record all kinds of texts, but principally those composed on a particular occasion: a panegyric accompanying a royal endowment or construction; a deed of ownership of a village, monastery, lake, or other property (Fig. 2); a votive inscription consecrating a devout offering or reliquary; a commentary or caption engraved on a new sculpture; a reference to the passage of pilgrims. If one adds to this mass all the books in manuscript, often illustrated with paintings (Fig. 21), it becomes apparent that the richness of Indian civilization is also due to its written heritage, which includes the various forms of writing that one finds in the rest of the world.

The extent of the written documentation possesses certain characteristics that are peculiar to the Indian peoples and distinguish it from other great oriental civilizations endowed with a rich literature (China, Japan, and the Muslim world). The limitations of writing are as much a matter of the times as the contents of the different texts. The first known written texts in Indian languages appear fairly late in the history of India (*ca* 273–232 BCE) and are

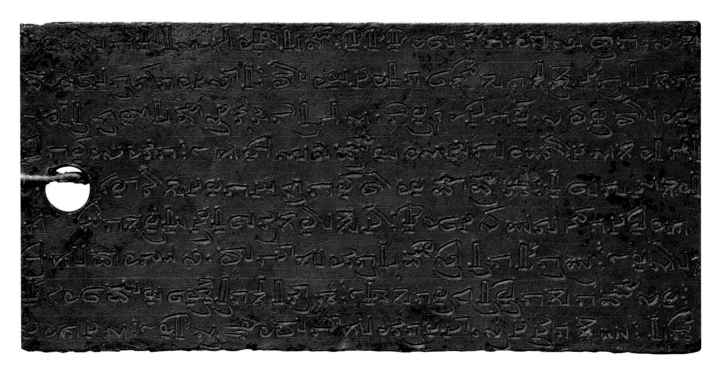

Fig. 2. Copper plaque (20 x 9 cm), engraved in *Tamil* script, the text being in Tamil and Sanskrit. The document consists of five plaques threaded together, and is a deed recording the granting of three villages to a college of scholars by King Nṛpatuṅgavarman (*ca* 850–875 CE). Ms. Indien 574, Bibliothèque Nationale de France, Paris.

inscriptions carved in rocks and on pillars by order of Emperor Aśoka. He issued proclamations in the first person to the subjects of his empire, which were inspired by Buddhist morality (Fig. 3). Paradoxically, these inscriptions are not in the "classic" mode of ancient Indo-Arian, later to be called Sanskrit, which had, however, already attained its definitive form by the fourth century BCE. Rather, they are composed in various vernacular languages of the Mauryan empire, which held sway over practically the whole of the Indian subcontinent: "vulgar" languages of the Middle-Indian type, or Prakrit (from the Sanskrit *prākṛta*, "original, natural"). Aśoka's inscriptions had recourse to two Indian scripts that continued to be used, irregularly, in subsequent centuries and are written in the form of syllables that are clearly separated from one another: *Brāhmī*, written from left to right, and *Kharoṣṭhī*, written from right to left. Inscriptions apart, the first known manuscripts are not in Sanskrit either; nor do they belong to the religious domain of Brahmanism but to that of Buddhism: these are manuscripts written in *Kharoṣṭhī* on birch bark (Fig. 4), the most ancient of which date back to the first decades of the Christian era, and come from Gandhāra (Salomon, 1999). The enormous corpus of the texts of the Veda ("Knowledge") in ancient Indo-Arian, assembled over a

period of around a thousand years (1500–500 BCE), has not been preserved through ancient written documents, unlike the collections of hymns, ritual formulas, theological commentaries, and technical treatises that make up the referential stock of Hinduism and Buddhism. The most ancient manuscript of a Vedic text yet found is from the fifth century of the common era, and most Vedic manuscripts are even more recent, dating only as far back as 1000 (Fig. 5). This is no accident. From the very moment of their formulation, the Vedic texts were memorized and their oral transmission has continued up until the present day because it is one of the sacred duties of the Brahmins, the caste charged with the task of preserving the Veda by reciting it. The continuity of this tradition has not been interrupted by technical progress or the widespread diffusion of books that were copied and then printed. The Veda is an oral library, and the Brahmins are living editions of its texts, the authenticity of which can be checked by comparing the versions of several narrators. The supreme "Knowledge" that makes it possible to know the world and to act upon it is transmitted, through a process of reciting and listening, from generation to generation, thus restoring its original resonance. The sacred Vedic texts constitute a revelation disclosed to the ear, literally a "hearing" (*śruti*). From the

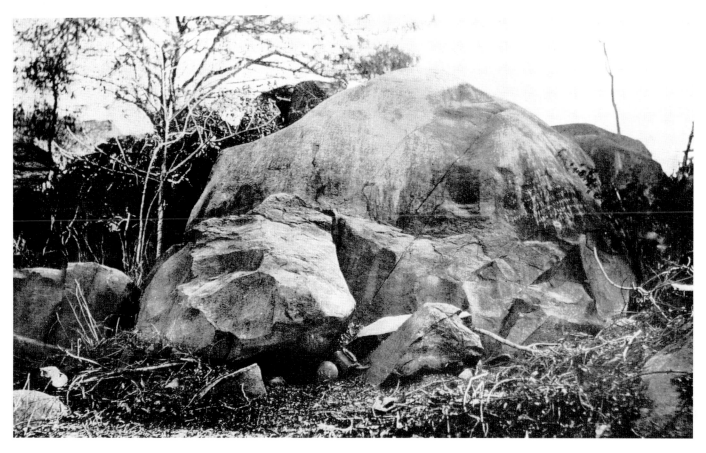

Fig. 3. A rock in Girnar (Junagadh district, Gujerat, Republic of India), bearing an inscription in *Brāhmī* script (see Fig. 7). The photograph was taken in 1869 (according to E.J. Rapson, *Ancient India from the Earliest Times to the First Century AD*, Cambridge University Press, 1916, pl.1).

Fig. 4. Detail of a fragment of a manuscript on birch bark, the text being in Gandhari and the script *Kharoṣṭhī*. It is a commentary on a collection of Buddhist stanzas. Fragment 9 (original 14 cm wide). Kharosthi Collection, British Library, London. (*Cf.* Fig. 8 and Salomon, 1999, pp. 28–29, 47).

Fig. 5. *Śatapatha-Brāhmaṇa*, Mādhyandina recension, Section 13: *Aśvamedhakāṇḍa.* A bound book consisting of paper leaves (19 x 9.5 cm) from Calcutta (sixteenth or seventeenth century). Rough *Nāgarī* script, typical of the careless style of Vedic manuscripts: irregular size of the characters, lines not parallel; divisions indicated in red chalk. Emphasis is indicated by semi-circles in red under the characters. Certain syllables, especially at the end of a phrase or section, are marked with a red vertical stroke above the line. Ms. Sanscrit 171, fol. 33v, Bibliothèque Nationale de France, Paris.

Vedic period, techniques were developed to preserve its texts in their oral form, with a high degree of phonetic precision. This was necessary to preserve the integrity and efficacy of the Veda since the texts are always used in ritual. Such being the conditions of Vedic transmission, writing was unnecessary; in fact, Brahmanic literature on the whole attaches little importance to scriptural activity, whereas it exalts the power of the spoken word. The latter is deified from the beginning in the most ancient Vedic texts, but the ancient narratives tell us nothing about any mythical origin of writing. No hero performs the act of writing. The famous scene in the prologue to the great Hindu epic, *Mahābhārata*, shows the god Gaṇeśa writing down the text of the epic dictated by the sage Vyāsa, but this is a case of a later addition. In the case of the Veda, the absence of writing borders on a prohibition, though it is never expressed as such in the Brahmanic texts: the temptation of the written word must at all costs be prevented from interrupting the transmission from master to pupil— the very foundation of social order. From an Indian point of

view, one does not truly possesses a text until one has "swallowed" it, until one has learned it by heart.

In the most ancient form of Indo-Arian, the language of the Veda, there is no verbal root signifying "to write." The Sanskrit verb *likh-* (TO WRITE)—which is the base of such derived forms as *lekha* (WRITTEN DOCUMENT, MANUSCRIPT, MESSAGE), *lekhaka* (SCRIBE), *lekhana* (WRITING), *lekhanī* (CALAMUS), *likhita* (WRITTEN) etc.—only appears belatedly in this sense. In Vedic this root (*likh-/rikh-*) signified to graze, tear, or score a surface, and in its form with the initial *r*- may be linked to words in other Indo-European languages referring to the notion of tearing up, splitting, digging a furrow, drawing a line, etc. The term for "letter" (*varṇa*) had originally nothing to do with writing. It first designated a category of sound and was a term in phonetics, a science that developed in Vedic times. However, the most ancient term referring to a written document appears in the work of the grammarian Pāṇini (fourth century BCE, at the latest) and in the inscriptions of Emperor Aśoka (at least a century later): *lipi* is in fact a borrowing from an East Iranian

word, equivalent to the Old Persian *dipi* (WRITING, INSCRIP-TION): the liquid initial may have been influenced by the roots *likh-* (TO ENGRAVE) or *lip-* (TO COAT). The word subsequently served as a base for terms referring to a scribe: *lipikara*, *lipika*, etc. Giving the root *likh-* the definitive meaning "to write" by no means excluded permanent reference to the act of cutting into or carving out a surface, or to associated notions of PAINTING or DRAWING.

Following the example of the Veda, other sciences committed their fundamental texts to memory, the only means of preserving them eternally, in contrast to books, which could be destroyed or spoiled, or could create the possibility of dispensing with a teacher or master. All branches of learning, whether mundane or erudite, followed this principle even after the practice of writing had become widespread. In literature, the most elaborate poetry must be savoured by listening to it. Texts in verse are recited in public, in the course of literary contests that are veritable "oral examinations." This preference for the spoken as opposed to the written word was taken up by heterodox religious communities, both Buddhists and Jains, even though they had established their corpus in writing at a time when the Vedic tradition was still an entirely oral one. It is generally recognized that the written composition of a corpus of Buddhist texts was only accomplished in the first century BCE. Previously, the teachings of the Buddha had been preserved orally, on the model of the Veda (and doubtless using analogous techniques) and subsequently the texts continued to be recited as well copied in writing. The establishment of a written corpus did not put an end to transmission of the texts by memorizing them, and what is more, this corpus did not include all the texts of Buddhism. A large number of texts had still not been set down in written form. In the domain of edifying stories, the manuscripts of the first centuries of the common era provide an outline plot for the narrator to develop in front of the audience of believers. The spoken word has always been considered superior to the written word, even in a worldly context.

In fact, the Indian attitude toward writing has always been contradictory: writing is no stranger, but it is not to be entrusted with the treasures of knowledge and religion. Sanskrit literatures for long avoided any recourse to written expression. We find in them very few descriptions of the practice of writing, unless it be that of letters, which play a certain part in narrative and dramatic literature. But such letters are messages that are by their very nature transient, like those of merchants, secretaries, spies, lovers, etc. The attribution of the invention of writing to the god Brahmā, the creator of the world, is not based on an ancient myth, and only appears in recent texts. In painting

and sculpture, his wife (or daughter) Sarasvatī, the goddess of knowledge and eloquence, is regularly portrayed with a book in her hand because there is no other way of physically representing the manifestation of speech. Sarasvatī replaced Vāc, the Vedic goddess "Speech," whose name is based on the root *vac-* (TO SPEAK). The use of the book as a symbol reflects the somewhat late evolution in attitude toward the written word and the ambiguity of the root *pāṭh-*, which had the primary meaning TO RECITE and secondary meaning TO READ. Such mentions of written documents in texts of the Brahmanic tradition by no means compensate for the general lack of interest and the recurring disparagement of writing expressed in numerous proverbs, such as: "Knowledge put in a book is wealth handed over to a stranger." Nevertheless, in the post-Vedic period of Classical India, writing was considered to be an art with which a gentleman ought to be acquainted: it formed part of the education of princes, even if the truly erudite were masters of the spoken word. For example, Raghu, the son of a king, at the start of his education, "entered into science by an apprenticeship in writing, as one enters the sea by the mouth of a river" (Kālidāsa, *Raghuvaṃśa*, III.28). Memorizing things was a specifically Brahminic art, and other social classes could not avoid having recourse to books and writings in general, for practical reasons, and to gain access to the increasingly diverse forms of knowledge that lay outside the sacred sphere.

We find lists of the different scripts only in Buddhist and Jain texts: their historical value is difficult to assess because they give stereotypical numbers. For example, chapter 10 of the *Lalitavistara*, the legendary biography of the Buddha, informs us that, during his childhood, he was acquainted with sixty-four different scripts (Fig. 6). This passage is not earlier than the fourth century of the common era: apart from *Brāhmī* and *Kharoṣṭhī*, the list contains names that cannot be clearly related to scripts known from other sources. The terms refer to regions, peoples, or graphic characteristics of scripts, and even to gods and other supernatural beings. This type of list simply indicates an interest in writing outside Brahminism (Fig. 5). A Jain documents lists eighteen scripts, including the Greek alphabet as well the above two, but tells us that eighteen (a conventional number) varieties of *Brāhmī* exist, which suggests that the term ended up by referring to writing in general, as "the art of Brahma." The history of Indian scripts must be based on the documents themselves and not on vague and rare mentions of them in literary texts. In India, writing seems to have been repeatedly consigned to oblivion, with the renewal of graphic systems and regular borrowing of foreign codes as a corollary.

Fig. 6. A Gandhāra Relief from the Landi Kotal area of Pakistan (height: 24 cm). It represents the "writing lesson" recounted in chapter 10 of the *Lalitavistara.* The seated figure with a halo, in the centre, is the Bodhisattva (the future Buddha), who is beginning to write in *Kharoṣṭhī,* from right to left, on a board placed on his knees. On the boards, held by two other figures (on the right, the schoolmaster Viśvāmitra), one can make out the *arapacana* syllabary in *Kharoṣṭhī* script. (See R. Salomon, *Journal of the American Oriental Society* 113 [1993]: 275.) Hirayama Collection, Institute of Silk Road Studies, Kamakura, Japan.

II. AN INVENTORY OF SCRIPTURES

Taking a long view, the history of writing in India can be summed up as the history of the script written from left to right in Aśoka's inscriptions. From that period on, this script, conventionally called Brahmi (Fig. 7), became the norm for the whole of India, except for the northwestern provinces of the empire, where *Kharoṣṭhī* was used. The (undeciphered) script of the Indus Valley belongs to an earlier epoch than Vedic civilization and the implantation of Indo-Arian forms of speech in the Indian subcontinent (see section IV). This script flourished for several centuries before its tradition disappeared completely; it lies entirely outside the system of all other Indian scripts. The history of writing in India is characterized not only by its diversity but also by its discontinuity, in contrast to the remarkable continuity of the graphic systems of Europe, the Latin and Cyrillic scripts, which can readily be related to the Greek alphabet from which they are derived and whose tradition has never been completely lost. In India there is no primary script from which all the others are descended in linear fashion. The importance of *Brāhmī* is real, but it must be seen in relation to the whole. Even if this script predominates in Indian paleography, to confine oneself to a study of Brahmanic Hindu India would result in a distorted perspective of a place that has imported and consumed many scripts over time, scripts that were once learned then discarded and replaced by others. Among these were the Greek alphabet after Alexander's conquests; the Aramaic alphabet, used when northwest India belonged to the Persian empire; the scripts of Pahlavi and Avesta, used by the Parsees and Zoroastrians who emigrated to India; various sorts of Arabo-Persian scripts, which were much used from the ninth century and for the transcription of Indo-Arian languages like Sindhī, Kāśmīrī, or Urdu; and lastly, the Latin alphabet, which was introduced by the Portuguese and English, was employed first by the colonialists and then by the Indian administration, and was used in addition to transcribe languages without any script or literature (like Koṅkanī). Over the long term, however, it appears that scripts derived from *Brāhmī* ‹have been (and are still) used to transcribe the major languages—Indo-Arian as well as Dravidian (apart from the few exceptions already mentioned)—of the Indian subcontinent and Indianized Asia. Yet the ancient form of Brahmi had already evolved to such an extent by the beginning of the common era that it required the efforts of nineteenth-century philologists (James Prinsep, 1799–1840, in the first place) to decipher what had become unintelligible to Indians.

Varieties of *Brāhmī*

One of the first problems, even today, concerns the nomenclature and the precise number of these scripts. The Indian paleographic literature contains lists that vary in length and content, depending on the criteria adopted for classification: a given script is in fact merely a cursive variant of another, which is used in a particular region or by certain professions. The constitution of the Republic of India recognizes fifteen official languages, and eleven scripts are used by the public authorities, the press, and publishers in the different states. Among them, two are foreign imports: the Latin script (for English) and the Arab script (in its Persian form, complemented with diacritic signs). A complete overview of Indian scripts cannot confine itself to the frontiers of the Indian Republic but must take into consideration areas that have been influenced by Indian civilization: Tibet and the countries of central Asia (Xinjiang) and southeast Asia. For the sake of simplicity, we shall list twelve scripts: these constitute distinct codes, each of which has to be learned in its own right. While these scripts eventually prove to be related when they are traced back to their ancient forms, knowledge of one does not bring with it knowledge of another because each one constitutes an integral system, and their forms have evolved to the extent of obliterating their common origin.

The name *Brāhmī* is usually explained by a fairly late tradition that attributes the invention of writing to the god Brahmā—a tradition that was reported by Chinese and Arab travelers during the course of the first millennium of the common era. But writing plays no part in ancient Indian mythology, and it is unlikely that, in Buddhist or Jain circles, the script used would have been given a name that referred to a deity of a religion that eschewed the written tradition. It is more probably to be seen as a reflection of linguistic polarization. In ancient India, all correct and purified language refers to Sanskrit, the language of culture, the language of the Veda that members of the Brahmanic caste memorized and recited. The term *Brāhmī lipi* (Brahmanic script) originally signified the transcription of *Brāhmī* in the sense of "sacred speech" (deified as another name for Sarasvatī), the language of Brahmā, and therefore Sanskrit, the language of the cultured Brahmins of the northwest of the Indian subcontinent. By extension, the term was applied to all scripts written from left to right, including even those recording canonical texts—those of the Buddhists and Jains—composed in languages other than the "perfect" Sanskrit language. These canonical texts, subsequently completely or partially Sanskritized, were originally written in "vulgar" Prakrit languages. Modern philology has chosen to apply the name *Brāhmī* to the pan-Indian script of

Aśoka's day and its regional variations down to the end of the Gupta period (sixth century CE). The term is also used for the central Asia scripts derived from it. Later, scripts of the same origin are designated in descriptive or, more often, geographical terms. The designations of intermediate forms of script that pre-date the modern varieties of *Brāhmī* have for long remained loose, although classification by dynasties has now been replaced by a terminology based on regions (Dani, 1986). The form of the characters immediately makes it possible to differentiate these scripts into two groups: those of the north and those of the south. The northern scripts are more angular, and their letters made more complex by the use of ligatures, whereas the southern scripts are more rounded, and their letters, while simpler in structure, are more difficult to tell apart.

THE SCRIPTS OF THE NORTH

The most famous is *Nāgarī* the "urban" script, (from the Sanskrit for "town," *nagara*), the common name for which, *devanāgarī*, only appeared in modern times, in the seventeenth century (Fig. 5). It probably emerged in the ninth

Fig. 7. Part of an inscription on a rock at Girnar (Junagadh district, Gujarat), in *Brāhmī* script, showing the sixth, seventh and eighth edicts of Aśoka (After *CII* 1 [1969]:14).

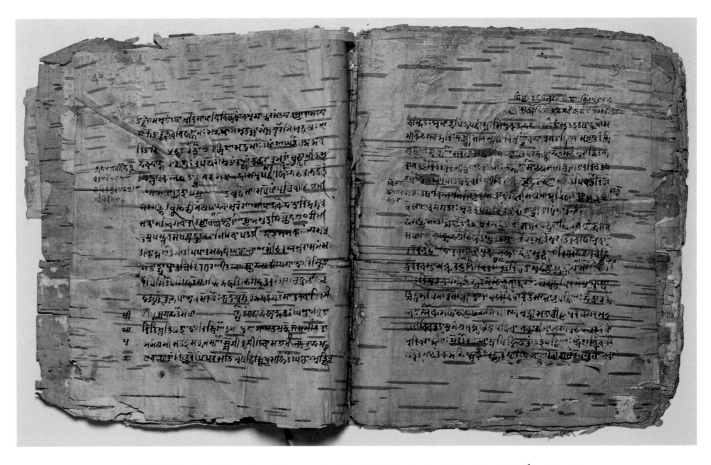

Fig. 8. *Mārkaṇḍeya-Purāṇa.* One of the sacred books of Hinduism, in Sanskrit, written in the *Śāradā* script on sheets of birch bark, bound together as leaflets (approximately 22 x 32 cm). Originally from Kashmir and possibly eighteenth century. Sanskrit ms. 375B, fol.4b-5a, Bibliothèque Nationale de France, Paris.

century CE and attained what was virtually its modern form around the year 1000, when it succeeded *Siddhāmātṛkā* (see below). It is used to write Sanskrit as well as other vernacular languages, principally Hindī and Marathi. Some variants are peculiar to the Marathi community (including a cursive form, *modī*, which is only used for writing the vernacular). The *Nāgarī* encountered in Jain manuscripts is characterized by the diversity of its ligatures and its calligraphic refinement (Fig. 23). In its diffusion, *Nāgarī* benefitted from the prestige of Sanskrit and the spread of printing. It has superseded regional scripts and virtually attained the status of the national Indian script for writing Sanskrit.

Śāradā, which may be traced back to the tenth century (Fig. 8), has been supplanted by *Nāgarī* and the Arabo-Persian script in Kashmir and in northeastern Punjab; it survives in a mutilated variant form, *Ṭākarī* (called *dogrī* in Jammu), which is used commercially in the regions of the northwest. At present, Punjabi, the language of the sacred

books of the Sikhs, is written in the Gurumukhi script, another literary variant of *Śāradā*.

Bengālī is employed for the official language of West Bengal and Bangladesh, and also for Assamese; *Maithilī*, one of its close variants (also established in final form in the seventeenth century), is used in the Mithila region. These scripts are the products of regional differentiations in *Nāgarī*.

Other modern scripts have originated from *Nāgarī* in forms that were more or less cursive at the outset: *Gujarātī* for the language of Gujarat, and *Oṛiyā* used on the coast of Orissa.

In Nepal, the current script is *Devanāgarī*, which can be found in an adapted form in recent manuscripts. The most ancient Nepalese manuscripts used a complicated and refined form of script that the Chinese called Siddham ("successful", an auspicious word placed at the beginning of text). The Arab geographer, Al-Bīrūnī (eleventh century) called it *Siddhāmātṛkā* (the term *mātṛkā*, which means

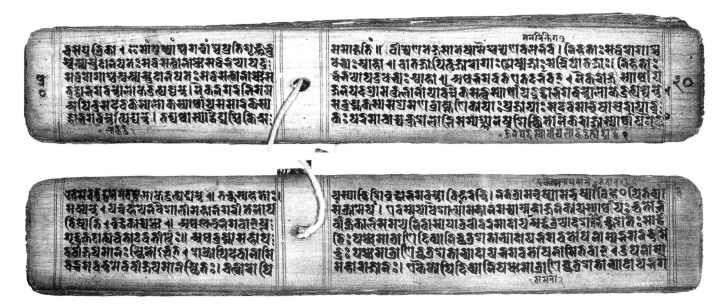

Fig. 9. A Mahāyāna *sūtra*, called the "Five Protections" (*Pañcarakṣāsūtrāṇi*), teaching charms against snakes, demons, illnesses, etc. The book consists of 140 palm leaves (30 x 5 cm) with six lines on each surface. A vertical ruling separates the side margins and the area around the hole through which the binding cord is threaded. The Buddhist text is in Sanskrit and the script is ancient Nepalese (*Nepālākṣara*), derived from *Siddhamātṛkā*. Originally from Nepal, dated 1141. Ms. Sanscrit 67, fol. 19b-20a, Bibliothèque Nationale de France, Paris.

mother or grandmother, was applied to a magic diagram, and later to a collection of characters). This type of script was widespread over the whole of northern India in the eighth century (Fig. 9), and it was exported to central Asia, China, and Tibet. At first used to write Sanskrit texts, it subsequently served to transcribe local languages.

A characteristic of *Devanāgarī* found in most of the scripts outlined above is the "gallows" pointing toward the left, beneath which hangs the appropriate sign for each character. This upper horizontal line acts as a kind of measuring rod (in Sanskrit, a *mātrā* originally meant "measure" and also denotes a musical or metric unit) and probably resulted from the enlargement of the upper ends of the "poles" of the gallows. In a calligraphic or printed text, these rods touch without blending together, but in a rapidly written form they may be represented by a single stroke, which often corresponds to one reading unit, as a result of the unifying phonetic phenomena of "liaison" (*sandhi*). Nevertheless, this feature, though dominant, is not invariable. In the *Oṛiyā* script the *mātrā* has developed into the form of a large convex hook, a kind of umbrella, whereas *Gujarātī* has suppressed the *mātrā*. The cursive forms of *Nāgarī* in use in north India have also dispensed with it, as in the case of *Kaithī*, for example, which is practiced specially by the caste of *kāyath* "scribes" (*kāyastha* in Sanskrit), or *Mahājanī*, which is used by merchants and bankers. The forms of the *mātrā* provide a criterion for distinguishing between the various kinds of *Brāhmī* in time and space.

THE SCRIPTS OF THE SOUTH

The three principal graphic types correspond roughly to the major Dravidian groups: Telugu, *Kannaṛa* and Tamil; this specialization occurred in literary circles and coincided with linguistic differentiation. However, these scripts could also be used to transcribe Sanskrit, which was used everywhere as the language of erudition. It should also be mentioned, in passing, that some scripts, including *Nāgarī* in modern times, were imported from the north.

The Telugu and *Kannaṛa* scripts (used in Andhra Pradesh and Karnataka, respectively), are rather similar and derive from types used in Cālukya inscriptions to the east and west of Dekkan (sixth to ninth centuries), which are a continuation of those of the Pallava dynasty (fourth century onwards). In Telugu, the *mātrā* became an obtuse arc, open at the top. These two forms of script assumed their present form during the fourteenth and fifteenth centuries.

Further to the south, the Tamil kingdoms developed their own types of script from the Cera dynasty on (third to fifth centuries, its kingdom covering present-day Kerala). In the

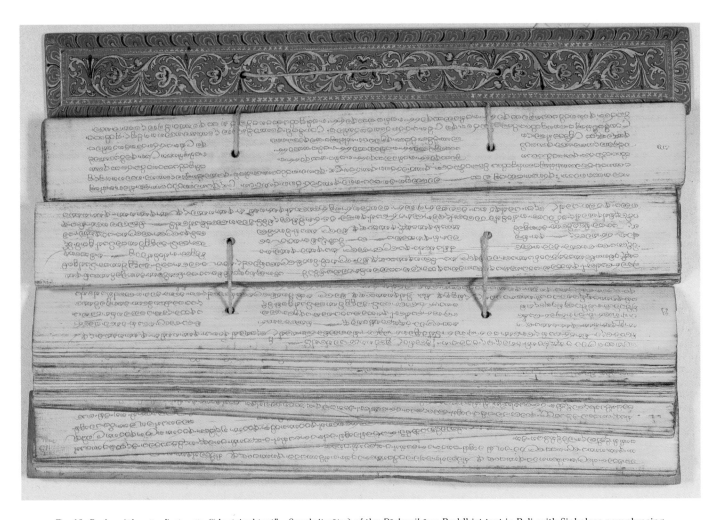

Fig. 10. *Brahmajālasutta*, first *sutta* ("doctrinal text" = Sanskrit *sūtra*) of the *Dīghanikāya*. Buddhist text in Pali, with Sinhalese paraphrasing.
The book consists of 124 palm leaves with seven lines on each side. Eighteenth-century Sinhalese script.
Pali ms. 57, Bibliothèque Nationale de France, Paris.

east they developed Grantha (a word meaning "book" in Sanskrit), which is now only used for writing Sanskrit, and Tamil (Fig. 2), which from the eighth century on differentiated itself from Grantha and is now only used for writing the Tamil language (Tamil Nadu). To the west (Kerala), they used the *Malayāḷam* and the *Tuḷu* scripts, which are also related to the Grantha script. The modern forms of Tamil and Grantha date back to the same period as the Dekkan scripts. A third type is represented by the *Vaṭṭeḷuttu* "round" (cursive) script, attested from the eleventh century on, that was considered as a vulgar, simplified form of classical Tamil but is more likely to be a separate development from the most ancient form of *Brāhmī* in the Tamil region.

On the island of Sri Lanka, three official languages coexist: English, Tamil, and Sinhalese, each employing its own graphic system. Sinhalese is a language of the Indo-Arian type (not Dravidian) and is written in a script of the same name (Fig. 10). The writing is related to ancient Grantha, but displays some calligraphic development (thick and thin strokes).

It is not possible here, even briefly, to retrace the steps by which the differentiation of the *Brāhmī* script came about. Reference manuals provide more or less detailed accounts, along with tables of the characters (Bühler, 1896, with a portfolio of 17 plates; Filliozat, 1953; Dani, 1963; Salomon, 1998, pp. 7–71 and, in particular, the differentiation table for the character *ṇa*, p. 33). In the Mauryan period, the script appears fully developed, in a uniform way, throughout the whole of India, having been propagated by the royal chancellery. It seems to have evolved fairly slowly until the beginning of the common era. Around that time, a reinforcement of the tops of the "poles" in the characters begins to appear:

Fig. 11. Fragment of a poplar-wood sheet of the manuscript of the *Udānavarga* from Subashi, near Kucha.
A hole is pierced on the left side of the oblong sheets, as for books written on palm leaves or paper
(*poṭhi* format). The *Udānavarga*, a Buddhist text in Sanskrit very popular in central Asia, is a collection
of stanzas corresponding to the Pali *Dhammapada*: this copy may be dated *ca* third to fourth century CE.
Fragment 5 of the *Udānavarga* on wood, Ms. Pelliot Sanskrit, Bibliothèque Nationale de France, Paris.

in manuscripts written with an inked calamus, the point of departure of the letters tends to be more pronounced. The resulting form is imitated and exaggerated in the format of the inscriptions. In the centuries that followed this pattern led to different forms of *mātrā*: points, triangles, squares, rectangles, bars, arcs, and so on. Another dominant tendency appears during this period: the characters are made more symmetrical and are all written more or less within a quadrilateral space. To the south, two scripts (including that known as Bhaṭṭiprolu) stand out by reason of adaptations linked to the transcription of Dravidian languages and the replacement of certain consonantal signs. Above all, they seem to have abandoned the implicit principle of notating the vowel /a/ after each consonant. This innovation, which avoided ligatures and tended toward a strictly alphabetic script, was not followed up in the development of southern *Brāhmī*. During the course of the first three centuries of the

common era, the regional differentiations became more pronounced, and certain characters were completely modified, sometimes by inversion. The crucial period was that of the Gupta era (fourth to sixth centuries), which witnessed the distinct separation of northern and southern forms, and the consolidation of regional varieties in west, east, and central India. Toward the end of the sixth century, the Gupta script of northern India evolved into a distinct script, the *Siddhāmātṛkā*, the use of which spread to a large part of India, in order to transcribe Sanskrit. Its spread prefigured that of *Nāgārī*. It is distinguished its angular appearance, with a sharp point in the bottom right-hand corner of its characters. The vocalization signs are heavily emphasized (Figs. 9 and 22). Outside India, the Gupta type of writing served as a basis for scripts that were used to transcribe Sanskrit (Figs. 11 and 12) and the languages of Buddhism in central Asia, in the oases around the

Fig. 12. Leaf of a paper manuscript of the Sanskrit *Udānavarga*, written in the *Brāhmī* script of northern Turkistan (early
seventh century CE), a script widely used in the Kucha, Agni, and Turfan regions and formerly called "Slanting Gupta."
From Dunuang, in *poṭhi* format, with a hole for the binding thread on the left-hand third of the leaf. There are six lines
per side and traces of ruling. Ms. Pelliot Sanskrit, Ud. 1, fol. 21v, Bibliothèque Nationale de France, Paris.

Fig. 13. Part of an inscription in *Kharoṣṭhī* script on a rock in Shahbazghari (Peshawar district,
North-West Frontier Province, Pakistan). Twelfth edict of Aśoka (After *CII* I [1969]: 64).

Taklamakan desert (in present-day Xinjiang), until the Islamic conquest (Sander, 1968). In the eighth century, the *Proto-Śāradā* style took shape in the far northwest, where it continued to be practiced in scripts that remained within the same regional framework. In the south, two groups stood out: one in Dekkan and one in the Tamil peninsula. From the year 1000 CE on, the scripts of various groups assumed their modern forms. Finally, Indian scripts spread into southeast Asia during the first centuries of the common era, mostly in styles based on southern forms, in particular, the Grantha of the early Pallava dynasty. The local varieties are distinguished by the different ways in which their curved strokes developed. They were used to transcribe Sanskrit and the languages of the local populations.

The limited rivalry from *Kharoṣṭhī*

A script very different from *Brāhmī*, written from right to left, is found in Aśoka's inscriptions. The difference in the use of these two scripts is clearly regional: *Kharoṣṭhī* was confined to edicts on rocks in the far northwest (Fig. 13), while *Brāhmī* spread throughout the whole Mauryan empire. The area in which it was used initially was the former Gandhāra, which stretched over a triangular shaped area on both sides of the frontier between Afghanistan and present-day Pakistan and included Bamiyan to the west and Gilgit and Taxila to the east. This script is thus linked, through Aśoka's inscriptions, to the northwestern Prakrit spoken in this region, for which modern scholars have suggested the name Gandhari. This language differs from all the other Prakrits—vernacular languages deriving from

ancient Indo-Arian—on account of several dialectal features that isolate it from the rest of Middle Indian. *Kharoṣṭhī* remained the principal script of the northwest of the subcontinent, under successive empires centered on Gandhāra, throughout the centuries of foreign domination (Indo-Greek, Indo-Scythian, Indo-Parthian, etc.) that followed the Mauryan empire. Thanks to political expansion, its use spread to neighboring regions: north India and Bactria, especially under the Kushan empire (*kuṣāṇa*). During this period, Gandhāra, under the protection of "barbarian" rulers, became an important center for the propagation of Buddhism. Buddhist communities collected and copied texts written in Gandhari and transcribed in *Kharoṣṭhī*, so that this script accompanied the expansion of Buddhism toward central Asia, in the Tarim Basin (present-day Xinjiang), and even in China. In India itself, it went out of use at the latest around the year 400 CE, and in central Asia after the seventh century, at which time it is still attested by wooden tablets from the Kushan region. Its decline in India from the third century CE onward was due to the transfer of political power from the north to the east, after the end of the Kushan empire. For several centuries, *Kharoṣṭhī* has been known through secular as well as religious documents, and a continual cascade of archaeological discoveries confirms that it was extremely important during the centuries preceding and following the beginning of the common era. In addition to engravings on coins (often in several scripts), it figures in votive inscriptions on reliquaries, on bas-reliefs, and on other objects connected with Buddhist civilization in the region. *Kharoṣṭhī* was destined to follow Gandhari as an international language for commercial as well as religious exchanges. Around the

Fig. 14. Poplar-wood tablets from Niya (third century CE), with an economic text in the *Kharoṣṭhī* script. The tablets were bound, and the confidentiality of the whole document guaranteed by a seal. Archaeological Institute of the Xinjiang Uighur Autonomous Region (Urumqi), China.

third century CE, numerous economic and administrative documents from the kingdom of Shan-shan (Kroraina)—on the southern fringe of the Tarim Basin, between Khotan and Loulan—were written in *Kharoṣṭhī* on wood or hide and transcribe a Gandhari partly influenced by the local language (Fig. 14). *Kharoṣṭhī* was also the medium for the literary use of Gandhari in Buddhist texts. The part played by Gandhari in the scriptural development of Buddhism is demonstrated by the first translations of Buddhist texts into Chinese and by the documentation of manuscripts copied on birch bark leaves: recent finds have added to the *Dharmapada* (a collection of Buddhist stanzas) that was brought back from the Khotan region in 1892 by the Dutreuil de Rhins mission (Fig. 15), and probably dates from the second century CE (see Salomon, 1999). These manuscripts from the Buddhist Dharmaguptaka school are for long texts, in the form of scrolls, influenced, perhaps, by Hellenestic models.

The name *Kharoṣṭhī* is a loose term, and has been the subject of diverse explanations: besides the transcription *Kharoṣṭhī* one finds such forms as *Kharoṣṭī, Kharoṣṭrī, Kharostrī*. It is the second script mentioned in the list of the

Fig. 15. Section of a scroll of the *Dharmapada* ("Hemistiches of the Law" = Pali *Dhammapada*) from Khotan, a Buddhist text in the Ghandhari language and *Kharoṣṭhī* script. The birch-bark leaves are stitched together by the side margins; the lines of writing are parallel to the lower side, and not arranged in vertical columns parallel to the line followed in rolling and unrolling the scroll. Ms. Pali 715A, Bibliothèque Nationale de France, Paris.

sixty-four scripts of the *Lalitavistara* (section I), and the name won recognition in paleographic literature for the script of documents in Prakrit from the northwest. Different forms and characters appear in Buddhist texts, and the original form cannot be reconstituted with certainty. It is probably a case of the Sanskritization (cf. *kharoṣṭha,* DONKEY'S LIP, *kharoṣṭra,* DONKEY (AND) CAMEL, *kharaposta,* DONKEY'S SKIN) of the name of a place or person that was presumably not Indo-Arian. The connection with Sanskrit *khara* (DONKEY), is only a popular etymology. A connection with the name of the Indo-Scythian King Kharaosta, a fairly important ruler (at the end of the first century CE) who figures on coins and in inscriptions dedicated to the lion of Mathurā, is plausible, and the most ancient form would thus be *kharostī*. The name would therefore be much later than Aśoka's inscriptions. In contrast to *Brāhmī, Kharoṣṭhī* displays the cursive appearance of a script written in ink with a calamus. The distinctive strokes of the characters tend to be placed more toward the top, and not at the bottom as in *Brāhmī*.

Kharoṣṭhī was easily exported because it remained relatively simple and informal. It retains the characteristics of a rapid script, adapted to commerce and administration. The spelling is imprecise, but *Kharoṣṭhī* has been adapted to deal with the transcription of consonants resulting from phonetic changes, and the numerous regional variations in Gandhari. It was used, rather belatedly (second and third centuries CE), to transcribe Buddhist texts in Sanskritized Gandhari, and even those in Sanskrit. Nevertheless, *Kharoṣṭhī* was not able to resist for long the growing Sanskritization of Buddhist literature, for which *Brāhmī* provided a medium that was both more precise and more stable in terms of its graphic aspect.

III. THE COMMON SYSTEM OF ANCIENT INDIAN SCRIPTS

The two principal Indian scripts, *Brāhmī* (with its derivatives) and *Kharoṣṭhī*, display a common and regular structure. Each simple graphic sign represents a syllable: either a vocalic segment (single vowel or diphthong), or one or more consonants followed by the (brief) vowel /*a*/, this vowel always being final; there is no syllabic character transcribing a sequence that terminates in a consonant. The term *akṣara* (syllable) designates both the phonic segment of the chain of speech and the corresponding character. The syllable was the primordial unit identified by the first philologists and phoneticians working from the oral texts of Vedic hymns, the quantitative meter of which was based on the number of syllables and the alternation of long and short syllables. The term was from the beginning imbued with a mystic aura inseparable from reflection on the

spoken word: *a-kṣara-* is a derivative, with privative prefix, of the root *kṣar-* (meaning to flow away, pass away, or perish), which signifies literally "that which does not pass away," hence "an imperishable [segment of discourse]," "a primitive element" of the stanza and, by extension, of whatever is articulated. This conception was deeply rooted in the linguistic conscience and in grammatical analysis, and was extended to the elaboration of the graphic system. This system with its syllabic units gives pride of place to syllables beginning with a consonant: in each sign, the consonantal element (C) constitutes the essential part, and the (brief) vowel /*a*/ is inherent, without being indicated independently. This zero indication of the vowel in syllables of the type C*a* corresponds to its high frequency in the language: in fact, it has been calculated that this vowel provides almost one-fifth of the phonic inventory of a text in Indo-Arian. The other vowels are indicated by diacritical signs added to the basic character (Fig. 16). The traditional script of Ethiopian (Geez) resorts to a similar process. The principle of the Indian system leads to the necessity for a series of special characters to transcribe the syllables, which consist simply of a vowel (V) or a vocalic segment, and which occur essentially at the beginning of a word; these signs cover all the vocalic segments that have the value of a syllable and therefore diphthongs as well as single-sound vowels. Purely vocalic characters, which seem analogous to those of the Greek alphabet, serve to fill up a gap in the system and do not have the same status as vowels in a strictly alphabetic script. A further complication engendered by the principle of *akṣara* lies in the transcription of groups of consonants and the final consonants of a sequence. Every group of consonants is represented graphically by a ligature; in this sign the consonantal elements were originally simply superimposed on juxtaposed without any alteration to their independent forms. With the passage of time, they underwent more or less important modifications, and this made it necessary to learn the special ligatures that are very frequent in scripts descended from *Brāhmī*. In *Kharoṣṭhī* the ligatures are much less numerous because the forms of speech it transcribed had introduced simplifications in the consonantal groups of ancient Indo-Arian, which, on the contrary, were preserved in Sanskrit. *Kharoṣṭhī* is thus less complex graphically than *Brāhmī* and may reflect a more primitive stage of the *akṣara* system of writing. In the ligature *tva*, the signs *ta* and *va* are combined, and this combination brings with it the suppression of the vocalism [*a*] inherent in the first sign. The result is a sequence CC*a*, which is considered to be a "simple" *akṣara,* although it is graphically complex. The upper or anterior sign of a ligature should be read first, even in *Kharoṣṭhī*, which is, however, written from right to left.

In *Brāhmī* as in *Kharoṣṭhī*, the liquid [*r*] in a group (*rCa, Cra*) is given a special transcription. The ligatures of *Brāhmī* can transcribe groups of up to three consonants. Simple *akṣara* are called *mātṛkā* (mothers), because they make it possible to produce the others by adding secondary signs representing a characteristic of the vowel (such as its length, the diacritical sign for a long vowel always being a modification of that for the corresponding short vowel), a vowel other than /a/ after a consonant (for instance, *ki* instead of *ka*), or the absence of a vowel after a consonant. A single consonant—that is to say, one bereft of the following /a/ vowel—is transcribed by adding a secondary sign, called *virāma* (cessation), to the *akṣara*. The subtraction of the inherent /a/ is indicated by an oblique stroke beneath the consonant or quite simply by placing the sign slightly below the line. This takes place when a consonant occurs as an absolute final without being linked to the beginning of the next word, as happens at the end of a sentence or line of verse. Additionally, but rarely, the *virāma* is used to disconnect a complex ligature in *Brāhmī*. Apart from such an exceptional situation, the *virāma* serves therefore simultaneously as a diacritical sign for *akṣara* and punctuation, as a consonant is normally followed by a pause when it occurs as an absolute final.

The Indian system of writing hardly lends itself to the usual typology of phonetic scripts, which makes a rigorous distinction between syllabary and alphabet and considers the latter to be an "advance" on the former. One might say that this system combines the advantages of a syllabary and an alphabet. In fact, it is a more realistic representation of language than an alphabet since each sign represents a pronounceable segment of the speech chain. There is no representation of isolated consonants (C), which, for the most part, are not pronounced in isolation: in the spoken language, an occlusive is only audible if it is followed (CV) or preceded (VC) by a vowel. Nevertheless, progress in phonological analysis had already been made beyond the level of the syllable, and the graphic system for *Brāhmī*, like that for *Kharoṣṭhī*, bears witness to this. The constitutive elements of the syllable are distinguished graphically. Vocalizations other than /a/ are obtained by adding a diacritical sign to the basic character. But this graphic *addition* corresponds to a phonetic *substitution,* according to a process described by Indian grammarians, who effectively came close to the structuralist notion of the "minimal pair." In ancient *Brāhmī*, the modification of a vocalism was obtained by adding a more or less simplified form of the vocalic character employed to the absolute initial (*ke* = *k(a)* + *e*). In the course of time, the diacritical modification of the basic *akṣara* lost all resemblance to the written form of the independent vowel. The zero transcription of the final vowel *-a* in a syllable was thus replaced by another vocalic sign. Moreover, the system solved the problem of transcribing groups of consonants more simply than other syllabic scripts. Let us take, for example, an initial or final sequence, *sto*. In strictly syllabic scripts, it is imperfectly transcribed by *so-to* (cf. Linear B), or *Vs-to* in a system that contains signs to transcribe sequences with a final consonant (VC or CVC). The Indian method consists of returning *sto* to its simple form *sta*, itself resulting from *s(a)* + *ta*. Consequently, this system presupposes an analysis of the chain of speech in terms of consonants and vowels. The script is syllabic in its form but alphabetic in its principles: it consists of an alphabet with zero (or implicit) transcription of the internal vowel /a/ and is therefore probably derived or adapted from a consonant-based alphabet, if one subscribes to the loan theory (see section IV).

The order of the letters corresponds to that of the phonemes—a significant characteristic that sets it apart from the succession of letters in alphabetic scripts. The most complete presentation of the system is provided in the grammars of classical Sanskrit, to which the signs of the *Nāgarī* (descended from *Brāhmī*) correspond (Fig. 17). It consists of forty-six phonemes (*varṇa*) arranged in a logical sequence, which are recited in that order by students and set on the page in the form of a rational table. This ordering of the letters reflects a classification of the sounds that dates back to the Vedic period—in fact, to the phonetic treatises that were drawn up to establish the correct pronunciation of the Veda. The inventory opens with the nine vowels (each brief vowel being followed by the corresponding long one), followed by the four diphthongs: *a, ā, i, ī, u, ū, ṛ, ṝ, ḷ* (the last two never occur at the beginning of a word; the long variant of the liquid vowel has only a theoretical existence), *e, ai, o, au* (diphthongs classified according to tone: *e* <* [ay]

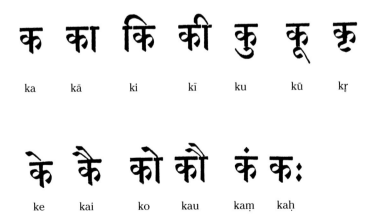

Fig. 16. Example of vocalizations and modifications of the *akṣara ka.* The sequence is *ka, kā, ki, kī, ku, kū, kṛ, ke, kai, ko, kau, kaṃ* (with *anusvāra*), *kaḥ* (with *visarga*).

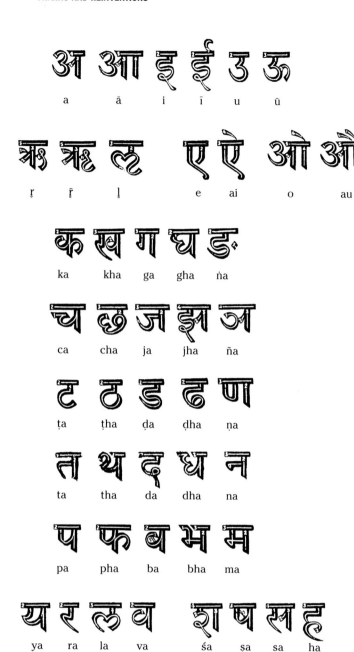

अ	आ	इ	ई	उ	ऊ
a	ā	i	ī	u	ū

ऋ	ॠ	ऌ	ए	ऐ	ओ	औ
ṛ	ṝ	ḷ	e	ai	o	au

क	ख	ग	घ	ङ
ka	kha	ga	gha	ṅa

च	छ	ज	झ	ञ
ca	cha	ja	jha	ña

ट	ठ	ड	ढ	ण
ṭa	ṭha	ḍa	ḍha	ṇa

त	थ	द	ध	न
ta	tha	da	dha	na

प	फ	ब	भ	म
pa	pha	ba	bha	ma

य	र	ल	व	श	ष	स	ह
ya	ra	la	va	śa	ṣa	sa	ha

Fig. 17. Table of characters of the *devanāgarī* in a school textbook. The numbers show the order in which the strokes of the characters should be written. The horizontal rod (*mātrā*) is always written last. From Judith M. Tyberg, *First Lessons in Sanskrit Grammar and Reading* (Los Angeles, East-West Cultural Center, 1964), pp. 4–5.

and *o* < * [aw] are long vowels resulting from the monophthongization of diphthongs with a brief first element). Then come the consonants. In the first place, the twenty-five occlusives, classified by "five groups of five," each "group" (*varga*) corresponding to a point of articulation, ranging from the back to the front of the pharyngo-buccal canal:

gutturals, palatals, cerebrals, dentals, and labials. The enumeration of each group follows its distinctive mode of articulation according to the phonological correlations: simple voiceless [– voiced – aspirate], voiceless aspirate [– voiced + aspirate], simple voiced [+ voiced – aspirate], or voiced aspirate [+ voiced + aspirate], terminating in a nasal, negatively opposed by the four preceding phonemes. The list is thus: *ka, kha, ga, gha, ṅa ; ca, cha, ja, jha, ña ; ṭa, ṭha, ḍa, ḍha, ṇa ; ta, tha, da, dha, na ; pa, pha, ba, bha, ma.* The occlusives termed "aspirates" are always marked by a single sign, which corresponds to the phonetic reality. In the second place are the four semi-vowels, known in Sanskrit as *antaḥsthā* (intermediaries) because of their fricative articulation, which have a smaller closure than the occlusives: *ya, ra, la, va.* It will be noticed that the order is different from that expected according to the corresponding vowels (*i, u, ṛ, ḷ*), which should be **ya, va, ra, la.* In the third place are the three (voiceless) sibilants and the aspirate which together form the group of "spirants" (*ūṣman*): *śa* [palatal], *ṣa* [cerebral], *sa* [dental], *ha* [voiced glottal aspirate]. The alphabet possesses two further signs, which correspond to supplementary sounds: a point marked above the character indicates the nasalization of the preceding vowel, called an *anusvāra* (transcribed *ṃ* or *ṁ*), of which *anunā*sika (transcribed *m̐*) is a rare variant; two points added on indicate the *visarga* ("escape") (transcribed -*ḥ*) by which is meant a voiceless breathing at the end of a word, followed by a resonance of the tone of the preceding vowel. In certain lists, the segments *aṃ* and *aḥ* figure after the vowels and diphthongs as though they constituted modifications of the fundamental vocalism [*a*]. The last consonantal sign, the aspirate *ha* is sometimes followed by the ligature *kṣa*, which represents a fairly frequent sequence in Sanskrit. These diverse variants in the fundamental alphabet have in common the recitation of the graphic signs and not the pure phonemes. Indeed, it would be possible to pronounce the continuous phonemes (semi-vowels and fricatives) without making them follow the vowel /a/. One observes here a to and fro movement between speech and script. The phonological foundations for the constitution of the list of sounds certainly promoted the development of a graphic system based on the syllable and its analysis in terms of vowel + consonant. But it is probable that visual transcription influenced the oral teaching of the sounds: reading is integrated in recitation, where it has a reduced role. The list may be shortened (for example, by omitting to note long vowels) or extended (by adding indicating the nasalization of vowels or enumerating all the possible vocalizations of consonants). Theory concerning the language begins with an orderly list of its phonemes: indeed, a

"catalog of letters" (*akṣara-samāmnāya*) precedes Pāṇini's grammar. But this special alphabet, destined to be learned by heart, condenses all the sounds of the language into fourteen groups of letters, according to an order inspired by grammatical rules and by recourse to a system of referring to a series of sounds by virtue of the consonantal markers inserted in the list. These markers are like boundary signs that allow the grammarian to cite—in a process of "condensation" (*pratyāhāra*)—all the units of a group by using the syllable of the initial term followed by the final marker of the group. Pāṇini's alphabet introduces these modifications into the purely phonetic alphabet through inversion and repetition.

Apart from this "rational" alphabet, which was arranged according to articulative characteristics, and perfectly reflected in scriptures of the *Brāhmī* type, other classifications of letters probably existed that reflected other preoccupations. One famous example is provided by the syllabary called "*arapacana*" after its first letters: *a-ra-pa-ca-na*. This syllabary is known through numerous Buddhist texts in Sanskrit and other languages (Tibetan, Chinese), and even through statues (Fig. 6). Contrary to the Sanskrit system, it is not a complete list of sounds according to a phonological order: in the list of forty-two syllables, many *akṣara* of the canonical list are missing, while it contains a dozen *akṣara* composed in the form CC*a* (like *kṣa, jña, sta,* etc.), of which neither the inclusion nor the order of presentation can be justified on phonetic grounds. Moreover, the only vowel recorded is /a/, as the first sign in the syllabary. It has been demonstrated, in particular on the basis of inscriptions, that this syllabary was composed around the beginning of the Christian era, in the region of Gandhāra, based on the *Kharoṣṭhī* script (see Salomon, 1990), and that it transcribed the syllables of the local Prakrit. The order of the syllables is not phonetic, nor does it reflect the order one would expect (*a-ba-ga-da,* etc.) from a semitic prototype (see section IV) of *Kharoṣṭhī.* For the time being, the most likely hypothesis is that the selection and order of these syllables originally reflect a mnemonic process, based on an acrostic principle: the syllables began the first words (or key words) of sections (verses or paragraphs) of a Buddhist text considered to be fundamental. In order to memorize the content and order of the text, the words were learned in a fixed order, and then these words were reduced to their initial syllables. The syllabary *arapacana* would thus probably be the result of applying the process of condensation, very frequent in India, based in this case on the corpus of a text that had previously been divided into distinct parts while retaining an awareness of their logical sequence.

IV. PREHISTORY AND PROBLEMS CONCERNING ORIGINALITY OR BORROWING

The Indian world discovered writing shortly after the ancient civilizations of the Middle East, during the pre-Vedic period (that of the civilization of the Indus), between 2600 and 1800 BCE .This urban civilization, in commercial contact with the Middle East as well as central Asia, has left no trace in the texts of the Vedic hymns, composed by the bards of the "*Ār(i)ya*" tribes (according to the name they gave themselves, and which is preserved in the Sanskrit *ārya*), whose language belonged to the Indo-Iranian branch of the Indo-European linguistic family. This population settled in the Punjab, the country of the "Seven Rivers," which was in fact that of the Indus civilization that had declined and disappeared before the new invaders arrived. There is no consensus as to when or how the *Ār(i)ya* Indo-Iranians arrived in their two principal regions, from which they were to launch their subsequent territorial expansion, the high Iranian plateau in the case of the Iranians, and the Indus basin in the case of the Indo-Arians. The most ancient point of departure for the (oral) composition of Vedic poetry is usually set around 1500 BCE, partly on the basis of the existence in the Middle East (and in particular in the language of the aristocracy of the kingdom of Mitanni) of Indo-Arian words, including technical terms, a list of names of gods, and proper nouns corresponding to Vedic nomenclature and phraseology. Along with Indo-Arian languages, Vedic social and religious organization penetrated the Punjab before spreading to the whole of north India. One observes that the Indus script (of which the most recent document dates from around 1600 BCE) was lost with the rest of that civilization: it was only rediscovered at the end of the nineteenth century. The majority (sixty per cent) of its extremely numerous written documents (around 4,200) consists of seals cut in quadrangular pieces of soapstone. Other materials that are well represented include rectangular copper tablets, which must have been used in ritual or magic practices. Cylinders of clay have been found, printed with seals; they were used to seal up goods. Ninety per cent of the seals carry a written text accompanied by a very "naturalistic" representation of an animal, which contrasts with the geometrical lines of the script (Fig. 18). No texts have been found that might be, according to their structure, either inventories or accounts: these were doubtless written on perishable materials (palm leaves, for example), as was the case later, in India. The Indus script has not been deciphered, and it is not connected to any known script; already in 2600 BCE, it appears to be completely standardized, even if several

Fig. 18. A seal from the Indus Valley (in color) and its imprint, originating from Mohenjo-daro. From Jagat Pati Joshi and Asko Parpola (eds), *Corpus of Indus Seals and Inscriptions*, vol. 1: *Collections in India* (Helsinki: 1987); *Annales Academiae Scientiarum Fennicae*, Series B, vol. 239 / *Memoirs of the Archaeological Survey of India*, no. 86, M-18A, p. 377.

signs possess variants. The direction of the script may vary in the most ancient documents. Later, the direction from right to left triumphs. It is probable, considering the commercial routes, that in India the idea of writing came from regions lying more to the west, but one may recognize an autonomous development based on pictograms. The number of clearly distinguishable signs (between 200 and 450) suggests that it is a case of a logographic script in which each sign represents a word or a morpheme of one or more syllables, as in Sumerian or in Proto-Elamite. The number of signs is too high for a syllabic script. The language it transcribed is unknown, although the hypothesis that it is a form of Dravidian has been regularly revived (see Parpola, 1994). It seems hardly likely to be an Indo-European language. Deciphering it is made almost impossible by the absence of any bilingual element (whether direct or indirect) and the brevity of the documents, which on average consist of five signs but often of only one, the longest text consisting of twenty-six signs. The geometric design of the characters does not allow easy identification of any initial pictographic value. Nevertheless, as most of the documents from the Indus are seals, some of which were found in Middle Eastern countries with which there was maritime contact, it is legitimate to compare their content with that

of the abundant Mesopotamian seal inscriptions. It is likely that the Indus seals also bore names and official titles, and that the animals portrayed had a propitiatory value. The horse is the only notable absentee in this bestiary, which corresponds to the enduring realities of the Indian world.

Although writing was known in the west of the Indian world as early as the third millennium BCE, in synchrony with scriptural development in the great civilizations of the Middle East, we know nothing about the presence of writing in India between *ca* 1700 and 270 BCE (that is to say, before Aśoka). Does the Vedic silence on writing and the almost total absence of written documents before the Mauryan period imply a long period of agraphia? After more than a century of research on the problem, two tendencies emerge. First, a new "invention" of writing was made under the Mauryan empire, perhaps only by scribes of Aśoka's time. Consequently, truly Indian scripts—*Brāhmī* as well as *Kharoṣṭhī*—do not date back further than the fourth century BCE. Second, despite the absence of a well documented written tradition, it seems difficult to imagine that the Indian world could have been totally ignorant of writing, for several reasons: the development of grammatical analysis at the end of the Vedic period; the needs of commerce and of the royal administration of a large territory; and the structures of the two scripts in question, which do not ideally reflect the phonological classification worked out by the Vedic phoneticians, and perfected by Pāṇini. There is archaeological evidence to support this second line of thought: *Brāhmī* characters in graffiti have been found on ceramic fragments from Anuradhapura (Sri Lanka), which have been dated definitively from between the sixth and fourth centuries BCE. All other evidence is vague, ambiguous, and open to interpretation according to one or other of the hypotheses. Indications given by Greek travelers and historians have the advantage of being dated, but they are not always clear, except insofar as it is known that the "laws" (*nómoi*) of the Indians, public and private alike, were not written down. This fits in with the tradition of Vedic oral transmission and memorization and all the norms of social, moral, and ritual organization given in the text of the *dharma*, a term which can be imperfectly translated as "law." However, Nearchus, a resident of northwest India around 325 BCE, observed that the Indians wrote missives on strips of cotton fabric. This practice is usually associated with the *Kharoṣṭhī* script, but it could equally apply to Aramaic writing as Aramaic was still being used in the area, which had for long been under Achaemidan control. Two decades later, the Seleucidan ambassador Megasthenes, while traveling in northeast India, noted that in the capital of the Mauryan empire the Indians "did not know the characters of script" (*grámmata*). But it is difficult to know

whether this observation is a generalization or whether it applies only to the judicial procedure that is the context of the remark: the code and judgement were outside the realm of writing. In the Pali Buddhist canon (Theravāda), there are, in contrast with the Vedic texts, numerous references to script used for private purposes and in official correspondence, but the texts in question are relatively recent, and it is unlikely that they were recorded before the Mauryan era. Early uses of the verb *likhati* and noun *lekhā* refer to engraving or drawing rather than to script, in accordance with the Vedic texts. Moreover, there is constant use of the expression that Buddha's teaching was "heard" by his disciples: it is possible that the oldest texts in the canon were compiled from memorized versions of the Master's word, again according to the Brahmanic model. Buddha himself was opposed to the idea of the sacred tongue (*chandas*) being exclusive, or a Brahmanic prerogative, and recommended the transmission of his "law" (Pali *dhamma*, equivalent to the Sanskrit *dharma*) in the vernacular. However, competition with Brahmanism is evident in the appropriation by Buddhist circles of many aspects of Vedism, according to deep-rooted tendencies of Indian thought—predominance of the oral over the script, a taste for grammatical analysis and etymology, and so on. The evidence provided by Pāṇini's grammar is ambiguous, and all the more so as his dates are not known with any certainty, even if they cannot possibly be later than the mid-fourth century BCE (about one century before Aśoka). The word *lipi/libi* (mentioned in Rule III.2.21) can refer to script, according to the commonly accepted interpretation, but its reference to painting cannot be entirely excluded. If it does refer to script, it could be Aramaic just as well as *Kharoṣṭhī* (or an early form of it), for tradition sets Pāṇini's place of birth and activity at Salatura in Gandhara (present-day Lahore, in Pakistan), an area that was part of the Achaemidan empire and that carries the same uncertainties with regard to its script as Nearchus' evidence. The problem of Pāṇini's dates is intimately linked with that of incomplete knowledge of scripts at the end of the Vedic period: if Pāṇini were several generations later, he would be contemporary with the composition of late Vedic texts, which were written down in some form. In none of these documents is there any positive trace of the existence of the *Brāhmī* script before the Aśoka inscriptions, leaving aside the Anuradhapura graffiti. Following strictly empirical methods, the most recent works of synthesis on the history of Indian scripts (see Hinüber, 1989, and Falk, 1993) tend to date the extensive use of writing, particularly *Brāhmī*, as early as the third century BCE. They propose that *Brāhmī*, a more recent script than *Kharoṣṭhī*, was the result of an order from the chancellery of the Emperor Aśoka in about 260 BCE for its use in recording the languages spoken in areas of his empire that lay outside the northwest provinces. In the northwest, *Kharoṣṭhī* could be used; its origins in Aramaic are not in any doubt. The theory, then, is that a pan-Indian script was expressly created by the political power structure after a long period of purely oral transmission more or less equivalent to the Vedic period. But if one considers the general arguments and the history of Indian grammar, this theory is not entirely convincing. It is difficult to believe that, in a totally "illiterate" society, it would be possible to develop economic exchange, to found powerful and prosperous kingdoms, to attain a high level of intellectual achievement, and to do so before the founding of the Mauryan empire and as early (fifth century BCE at the latest) as the time of the Buddhist preachers (Siddhārtha, alias Śākyamuni) and Jain teachers (Mahāvīra). Moreover, writing was widely used by Middle-Eastern traders in contact with Indian traders. The northwestern provinces annexed to the Persian empire set the example of the utility of script for the purposes of government. It is true that the fundamental texts of religion and law would always be committed to memory, but writing could be used for private messages, inventories, administrative reports, and other purposes, which were noted on organic materials (wood, fabric, leaves) that perished in the Indian climate. Indeed, recourse to writing was allowed where it did not contravene memorization or break the direct link of transmission from master to disciple. A limited use of writing is therefore conceivable as early as the end of the Vedic period (sixth and fifth centuries BCE). During this period, technical subjects (ritual, astronomy, grammar, law) were taught in the form of *sūtra*, short phrases that were intended to be easy to memorize. These aphoristic "rules" were stringed together, as the term *sūtra* (with a primary meaning of "thread") indicates in the treatises that made systematic use of recurrent phrases. Pāṇini's grammatical formulary, which includes about four thousand rules, is written using this model. Nevertheless, Pāṇini occupies a position somewhere between the oral and the written. His treatise in eight chapters, the *Aṣṭādhyāyī*, is written for learning by heart to be recited at great speed, but the lists of morphemes include phonetic markers on the syllables (suffixes and flexional endings) that are taken from verbal and nominal paradigms and probably classified in chart form. Pāṇini's grammar gives rules for the correct formulation of phrases and presupposes a parsing of inflected words into roots and affixes. This form of analysis was rigorously precise, and its only equivalent is to be found in Western twentieth-century structuralism. According to Indian grammarians themselves, it called for procedures of segmentation and commutation, which in turn drew on the

comparison of many phrases for which at least some visualization of messages was required. This argument does not question Pāṇini's own knowledge (or that of his predecessors and his disciples) of a vast amount of textual matter, without necessarily having recourse to books. Students of Brahmanism were trained using highly developed techniques in the memorization and recitation of works containing thousands of pages of transcription. Pāṇini quotes many Vedic texts. He could probably find colleagues to recite interesting passages of works that he did not know himself. Comparison with other civilizations suggests that grammatical research is tributary to the fixing of texts in written form and the listing of words. It would indeed be possible for several narrators in collaboration to extract lists of unusual words and interesting structures from works learned by heart. But could they go further and make a complete morphological analysis, with root and chain of suffixes, without a minimum of written records? How would it be possible to keep all the permutations of nominal and verbal forms, fundamental and substituted, "in one's head"? The teaching of grammar was intended to provide a reference, and it is natural that its definitive form should have been oral and that the temporary instruments of its elaboration should have been destroyed. The power and prestige of oral tradition were such that, in the formative period of secondary disciplines of the Veda, all "science," including phonetics, etymology, and grammar, should be subservient. It is worth noting that the "reading in words" (pada-pāṭha) of Vedic texts, where the form of words without liaisons is reconstructed, was transmitted orally, at the same time as the transmission of the continuous text (saṃhitā), with the marking of junction phonetics (sandhi). Again, it is difficult to conceive that such a "double edition" of long texts could have been set out, almost to perfection, without at least the temporary aid of script. As knowledge of the rules of sandhi, along with the correct pronunciation of the texts, was part of the teaching of the Vedic schools, it was ascribable to the oral teaching reserved for Brahmans. But it is difficult to date the fixing of doctrines of treatises on phonetics later than the sixth century BCE. The same goes for the analytical text of the earliest collection of Vedic hymns (the Ṛgveda Saṃhitā). Unravelling the history of script in Indian culture owes most of its difficulties to the fact that grammar, which everywhere else was associated with the existence of a written system for the notation of messages, was here integrated with the oral tradition. It has been noted that the order of the Indian syllabary generally reflects Pāṇini's teaching, but that does not necessarily imply that writing was completely posterior to the classification of sounds. Indeed, a script conceived in its entirety by a grammarian would be more faithful to

phonological theorization. Kharoṣṭhī is not in question here as it does not distinguish between short and long vowels. But in early Indo-Arian, the opposition between them is phonological. This distinction is shown in the Brāhmī script, but one might have expected a more systematic method of marking, in the graphic form of the consonants, the distinction (also phonological) between sonority and aspiration, or at least a greater resemblance between consonants of the same order. The study of all the characters shows that the grammarians did indeed (although not completely) rationalize a group of signs of an earlier syllabary, which could not be Kharoṣṭhī because of the difference in the graphic forms. Moreover, in certain cases, the classification of sounds seems dependent on the graphic forms, as in the case of semi-vowels, which are placed between the occlusives and the fricatives, and on the same plane as the two liquids without their affinity to corresponding closed vowels (/i/ and /u/) being recognized. Another argument resides in the fact that Kātyāyana, a Dekkan grammarian contemporary with Aśoka, made a detailed commentary on Pāṇini's rules of grammar. He had not received the text by direct oral transmission and had to reason out certain indications that, in recitations of the original formulary, would have been expressed by meta-linguistic phonic means (accent and nasalization). Consequently, the written transmission of Pāṇini's text in the third century presupposes an earlier Brāhmī institution as a privileged means of notation for the language in the northwest, which was to become proper Sanskrit. All these observations suggest that Aśoka's Brāhmī was elaborated not suddenly and definitively, as by decree, but in stages from a non-Kharoṣṭhī syllabary, which existed before Pāṇini's grammatical theorization and which was in use, at least in some rudimentary form, at the end of the Vedic period.

The question of the date of appearance of the two Indian scripts has no definitive answer. But it should not be confused with the separate problem of their precise origins, although many authors have mixed the two aspects of the debate. The foreign, indeed Semitic, origin of Kharoṣṭhī has long been recognized, and was definitively proved by Bühler in 1895. The direction, from right to left, and the general resemblance with Aramaic script are added to the fact that the area of early Kharoṣṭhī use corresponds almost exactly to the region occupied by the Persian empire, where Aramaic was used as the language of exchange and administration. The Aramaic script of the empire was adapted for the notation of the local language, a form of Prakrit called Gandhari, to the benefit of the enduring ties between the Satraps and the Indian elite. The long-term existence of these relations is proved by the bilingual versions (Prakrit/Aramaic) in Aramaic script, of Aśoka's edicts.

From the point of view of paleography, most characters in *Kharoṣṭhī* are clearly derived from Aramaic models, either directly (for example, *ba < bet, na < nun, ya < yod, ra < resh*) or by inversion or some other slight modification (for example, *la < lamed, pa < pe, ka < kaf, kha < qof*). However, several suggested equations between *Kharoṣṭhī* and Aramaic remain to be clarified in order to determine at which stage in the evolution of Aramaic cursive script these characters were borrowed.

The syllabary does not include any specific signs for isolated vowels but represents them using the character bearing the same diacritic signs as those used to vocalize consonants. In the early form of *Kharoṣṭhī* the length of vowels was not differentiated in the script: such notation, influenced by *Brāhmī*, became more regular in documents from central Asia and when *Kharoṣṭhī* was used to record Sanskrit. The *Kharoṣṭhī* syllabary is therefore a development of a Semitic type of consonantal alphabet in which the notation of the vocalized *-a* inherent in the consonants (statistically the most common timbre in Indo-Arian) is implicit. The morphologic structure of Indo-Arian, which is different from that of the Semitic languages, necessitated the addition of extra signs to mark the other vocalizations. This consonantal system, with the implicit vocalized *-a*, presented few problems for notating a form of Middle Indo-Arian that did not possess many different orders of consonant groups: the geminated consonants were recorded using the simple consonant. On the other hand, it would have been inadequate for recording Early Indo-Arian and so-called "classical" Sanskrit. The implicit vocalization *-a* of the consonant is also a characteristic of the *Brāhmī* script, which makes the placement of its origins in a Semitic alphabet a feasible proposition. But in fact the origins of *Brāhmī* are open to discussion because its relationship to Semitic writing is not as clear as *Kharoṣṭhī*'s. There is no religious motivation for the direction of the script, so this cannot be used as an argument. Reversal of the direction of the script is quite common—as witnessed, for example, in boustrophedon and in Greek and Ethiopian compared with their Semitic models. The theory of the indigenous origin of *Brāhmī*, recently defended once again by Indian researchers, considers that Indian script developed independently from all other civilizations where writing was known, from the pictogram stage to the alphabet, or that *Brāhmī* was invented *ex nihilo* by the grammarians of the Mauryan empire, using simple geometric shapes. This last idea rests on the monumental aspect of Aśoka's *Brāhmī* inscriptions, which could be due to the normalization of a less formal script (Fig. 19). The discovery (from 1920 onward) of written documents in the Indus valley gives some credibility to the Indian invention theory. But the

Fig. 19. Detail from the beginning of an inscription on a pillar at Delhi-Topra, north side, lines 1–12. The spaces separate words grouped by syntax and meaning, or, less frequently, isolated words. Facsimile of the rubbing. See Klaus Ludwig Janert, *Abstände und Schlussvokalverzeichnungen in Asoka-Inschriften* (Wiesbaden: Franz Steiner Verlag, 1972), p. 213.

obvious similarities between the Indus valley characters and some *Brāhmī* characters cannot give weight to the argument until the phonetic values of the Indus signs have been established, as these similarities may be due to chance. On the other hand, the Semitic origin theory for *Brāhmī* is generally accepted in the West, although there are great differences of opinion on which Semitic alphabet is the ancestor of Indian script. This hypothesis, generally accepted as the most likely, has not been checked systematically. The main idea is to establish a derivative relationship between *Brāhmī* and Semitic script, as has been done for the Greek and Phoenician alphabets, but this project has not yet been completed. From a structural point of view, it is certain that the Semitic theory is the most convincing. Apart from diacritic signs being used to indicate vocalization of consonant characters with the inherent *-a*, retroflex consonant characters (a particularity of Indo-Arian phonology) can also be formed from the dental forms, whose Semitic origin is plausible. Moreover, three

characters for aspirated consonants do not follow the normal pattern of being modifications of their non-aspirated equivalents: *kha*, *gha*, and *tha* bear no resemblance to *ka*, *ga*, and *ta*, but they could derive from the Semitic characters for *qof*, *ḥet* and *ṭet*, respectively.

There are several versions of the Semitic hypothesis; in recent times, it has been combined with the theory that *Kharoṣṭhī* is earlier than *Brāhmī* (Falk, 1993). This theory suggests that *Brāhmī* was deliberately created in Aśoka's time as a script derived from *Kharoṣṭhī* and strongly influenced by Greek for its direction, for the notation of long vowels, and even for certain characters. Yet the (defective) notation of long vowels using the Greek alphabet combines the notion of timbre of the voice with the notion of quantity, whereas the character used for long vowels in *Brāhmī* is perfectly systematic and accords with the phonology of the language. Above all, however, the differences between *Brāhmī* and *Kharoṣṭhī* signs are greater than their resemblances, which precludes the former being derived from the latter. The idea of a southern origin among the early Semitic scripts that developed from the Sabean type of alphabet can be supported by the clear similarity between several of the characters and by the direction of the script from left to right. But these similarities can also be explained by separate development. The link with a northern alphabet of the Phoenician type had already been defended more successfully in the mid-nineteenth century, and was discussed in depth by Bühler (1895), who dates the borrowing at the latest to *ca* 800 BCE, in (unconscious) symmetry with the invention of the Greek alphabet. This theory suggests a certain number of manipulations (total or partial inversion), some of which seem to be arbitrary, and which provide explanations for fewer than half the characters in the *Brāhmī* script. The link with Aramaic, a more recent northern alphabet, was an early suggestion that remains in need of thorough verification. The resemblance of the graphics is greater than with Phoenician and the idea can be supported from the foreseeable influence of Aramaic in the Indian area of the Achaemidan empire. Nevertheless, it remains to be proved that *Brāhmī* and *Kharoṣṭhī*, which show little resemblance in their written forms, are two independent developments from the same Semitic prototype. *Brāhmī*, which marks long vowels and groups of consonants, appears to be an improvement that was well adapted to early Indo-Arian, unlike *Kharoṣṭhī*, which was limited to the notation of the vernacular in one geographical area. Perhaps the first lineaments of *Brāhmī* should be placed before the formation of *Kharoṣṭhī*, even if Aśoka's *Brāhmī* is later than Gandhara *Kharoṣṭhī*. In conclusion, the most plausible hypothesis suggests that *Brāhmī* is a script that was adapted, rather than derived, from a Semitic alphabet, probably Aramaic, by scholars who were well aware of phonetic elements of Sanskrit, which are more evident in *Brāhmī* than in *Kharoṣṭhī*. This does not exclude a certain degree of polygenesis in that some characters could have been specially created to complete the chart of characters borrowed from the Aramaic alphabet.

V. SYMBOLISM AND ESTHETICS

In his early edicts, the Emperor Aśoka records that he ordered this legal text (*dhamma-lipi*) to be engraved (*likh-*) "so that it would last for a long time." Indeed, a message cut in stone was more durable than one written on a perishable surface. It is possible, and even probable, that he was alluding to the existence at the time of a "drawn" script—one not engraved—on other, less durable materials. It is also probable that the renown, throughout the Orient, of inscriptions on rocks made by the Achaemidan kings (Darius, Xerxes, etc.), engraved between the sixth and the fourth centuries BCE, may have inspired Emperor Maurya with the idea that stone was the ideal material for royal proclamations (Fig. 20). In the Indian context, this was a major innovation: the expression of the law (*dhamma*, Middle Indian equivalent of the Sanskrit *dharma*) was entrusted to writing and no longer to the spoken word. This idea was in opposition to that of eternal knowledge, the Veda, entrusted to a unique language, which was itself conceived as eternal. This ideological about-turn in relation to the Brahmanic tradition is probably inseparably linked to Buddhism and, more widely, to all movements questioning Hindu orthodoxy. It has been mentioned (in section I) that, according to the Hindu tradition, writing was valued less than the spoken word, whose perfect transmission is a pledge of eternity. By analogy, the message inscribed in lasting fashion in stone was endowed with the same virtues (authority, fidelity, permanence) as the word of the Veda; the readers of Aśoka's edicts, in the different languages of his empire, could always hear the king's word, as it was when he dictated it to his scribes. Competent officers were responsible for reading the texts aloud to illiterate subjects viewing them. The essential difference between this and the text of the Veda remained the fact that the latter was increate and already in existence before being received by those who, on hearing it, were responsible for its transmission. It is not the Brahman who speaks but the Veda, which is heard through his mouth. Indeed if the spoken word is linked to breath, and therefore to life, it would seem that written word is linked to another dimension of the essential existence that is the body. Aśoka's written message was an integral part of his royal body and of the power that he held personally. It is not

sufficient to say that the written word is endowed with the same force as the spoken word simply because the one is the transcription of the other.

While Buddhism continued to attach great importance to the recitation of Buddha's words, it also gave value to the written word, and not only through the rather mundane cult of the book. Merit could be stored up by copying or possessing books and therefore justified the sumptuous transcriptions of the canons. The written text itself was also bestowed with the sacred. Manuscripts that were no longer in use because new copies had been made, or because they had suffered damage, were not thrown away: they were sealed in earthenware casks and buried, in the same way as human remains (ashes or bones). Finds in the Gandhara and in central Asia attest this (see Salomon, 1999, pp. 77–86). A text was considered as a relic: in Sanskrit, once the Buddha's Law (*dharma*) was written down, it was identified with the body of the Buddha's Law (*dharma-kāya*). This practice is similar to institutions in other civilizations, notably the guenizah, a storeroom adjoining a synagogue for books that are no longer in use, originally to prevent the destruction of the divine word; old copies of the Qur'an are treated in the same way in mosques. Such respect for the written word is also an aspect of Tibetan and Chinese practices. In Indian civilization, the "dead book" could receive the same treatment as the body of a dead person. There is probably a connection between this practice and the custom of placing complete and intact written texts in the reliquary in a *stūpa*, or more commonly in a sanctuary. Texts containing Buddha's word are called *dharma-śarīra* "bodily relics of the Law." Buddha is present wherever there is a copy of his teachings, whether it is recited or not. This principle is affirmed in the soteriological phase of Buddhism, the Mahāyāna. From a Western perspective, it confirms the association between the written word and the body.

The art of calligraphy is not unknown in Indian civilization, but it is more prevalent in Buddhist and Jain manuscripts. In India calligraphy never attained the artistic status it held in China, in the Islamic world, or in the Middle Ages in Europe (Salomon, 1985). Beautiful writing was concerned more with layout on the line or on the page than with the shape of each letter. Only the mystic syllable *oṃ* is the object, in some of the post-Vedic mystic circles of Hinduism, of speculation on its written form, which was venerated in its own right as the reflection of the phonic form of this exclamation. It is in fact the ending of the word, the nasal resonance which is used as a basis for mediation, via its graphic elements: a half-moon (the lower half of a circle) below a dot. The dot is a minimal graphic mark, which is also used to note, in the ordinary alphabet, a minimal

Fig. 20. Detail from a pink sandstone pillar (upper part polished) from Delhi (Topra). From Amulyachandra Sen's *Aśoka's Edicts* (Calcutta: The Indian Publicity Society, 1956).

Fig. 21. Leaf from a fifteenth-century illustrated manuscript of the Jain *Kalpasūtra* in Sanskrit. The *devanāgarī* script is very clear
(black, or occasionally red). The illustrations are on the right side of the leaves on two levels. *Top*: on the right, a crouching astrologist dips his stylus in
an inkwell, watched by the other figure sporting a beard and black hair. *Bottom*: two astrologists converse, the one on the left holding a scroll, probably
with writing on it. For a general description, see Nalini Balbir, *Bulletin d'Etudes indiennes* 2 (1984): 17–39.
Ms. Sanskrit 1453, fol. 33A, Bibliothèque Nationale de France, Paris.

phonic element: the nasalization of the vowel it marks. Beyond this mystic equivalence between the universe and a drop of ink, the shape of the characters was not developed in the same way as in other traditions. In illustrated manuscripts (Fig. 21), text and illustration are quite separate, unlike in Irish medieval manuscripts for example; there is no development of "capitals" at the beginning of a chapter, no drawing included within the letters, and no ornamental or figurative extension of the letters, in spite of poets' analogies in which strokes are compared to scratches, blots, or garlands of plant growth. These metaphors did not inspire a visual transposition in the formation of the letters, apart from epigraphic examples, where there is the possibility of extending stems and diacritical markings in the form of a flourish. This tendency to expand the letters reached a peak in the north, from the seventh to the ninth centuries CE. Indian calligraphy was overtaken by Islamic calligraphy *ca* 1000 CE. In general, the most elaborate examples are to be found in signatures and royal panegyrics (Fig. 22). Religious texts were not written in an ornamental style. In extreme cases of ornamentation

the signs become illegible, lose their phonetic values, and adopt pictogrammatic qualities: this is "decorated *Brāhmī*" with squat rectangular letters, or "shell" (*śaṅkha*) writing, where the letters tend to take the form of shells. These two special forms of script were used for several centuries for signatures, but not for the preceding text. The inscriptions are often accompanied by auspicious drawings (*svastika*, *triratna*, wheel, lotus, animals of various sorts). At the beginning of manuscripts or engraved texts there is often a loop symbol that can take variety of forms and that is read as *siddham* ("success"), as in the recitation of the text. These drawings do not have highly developed ornamentation and are never entwined with the text itself.

The use of writing never lost its primary and practical aim, to be immediately legible. To this end, the scribes used contrast between the line and the material, notably the dense black color of the writing on a light—sometimes lightened—background. They also took advantage of the effect of the parallelism present in the form of the letters and the regularity of the upper line maintained by an impeccable procession of "gallows" (*mātrā*)—the bar or

hook that was used in the formation of each letter. The parallelism is reinforced with the triangular or rectangular shape of the supports which are characteristic of the common forms of *Brāhmī*. In a text intended for didactics, the variation in height of the lines is sometimes used to distinguish between the main text and commentaries. The gloss may be written around the principal text in the form of a frame or arborescence (Fig. 23). The distinction between the basic text and the commentary (or notes) is also shown by the alternate use of black and red ink. Punctuation takes the form of dots or vertical bars that separate different sections of a text, or different verses, which are often numbered. Reading is only possible if the letters are clearly distinguishable from the background: this preoccupation is apparent in engraving as well as writing in ink. An unusual form of writing is found on manuscripts on palm leaves: the letters are lightly "engraved" by means of a stylus with a metal point to mark (but not tear) the support, and subsequently inked to make them legible. The engraving process being blind, regularity of gesture is essential: in order to see what he had written and be able to make corrections, the copyist spread coal dust on the engraved leaf. A Sanskrit term could be used to express the effect and intent of the text: it had to be "bright" or "striking" (*citra*) to the eye, and the lines of the script must strike the observer like a shadow falling on a bright sunlit surface. As a noun, *citra* denotes a "painting" or "picture." As an adjective it can also be translated as "multicolored, colorful, spattered, varied" and refers to the contrast in color or brightness. It is associated with various technical terms used in drawing and painting. The term in question is part of the name of a holy figure, Citragupta, secretary or clerk to Yama, the god of death. Citragupta makes a careful record of men's actions, and the reckoning justifies the destiny of the dead in the cycle of reincarnation. In Citragupta's register a careful balance between good and bad actions is preserved in all its "brightness." His name has the meaning of guardian of the *citra*, of the diversity of behavior, as it appears clearly in the written record. Writing is irrefutable, like the shadow of the body, which is an integral part of the human being. It is

far more than just the simple reflection of the spoken word; because it has been written down, it means that something was said or done at a particular moment. The preoccupation with the clear layout of writing or engraving is shown by the margins, spacing between lines, and punctuation at the end of paragraphs and chapters. In poetical texts, layout has priority over the correspondence between a line of poetry and a line of writing. The spaces in the written text are not necessarily intended to indicate a pause in the reading aloud: they have a different foundation in the knowledge of the language and its grammar. However, the layout of lines of script in a "picture" (*citra*) has a particular application, which expresses the Indian conception of beautiful writing: it consists in placing the letter according to a design, which does not necessarily correspond to an ordinary line of script, but which is in itself significant. A first example is provided by grammatical inscriptions from Ujjain, Dhar, and Un in Madhya Pradesh (*CII* VII(2), no. 25–27n pp. 83–89, pl. XXVII–XXX) which include basic notions of Pāṇini's grammar (list of phonemes and affixes) within the framework of "configuration of the serpent" (*sarpa-bandha*) graphics. Their exact date is unknown, but the carefully engraved *Nāgarī* script shows eleventh to twelfth century designs. The inscription from Ujjain (Fig. 24) is the best preserved and commemorates the restoration of a temple by King Naravarman. This famous poem, which plays on the two meanings of the word *varṇa* (sort, category), praises the king and his father, as protectors of the castes (the four *varṇa*) and the teaching of the sciences, grammar being the most important, represented by a list of letters (*varṇa*). Their power is symbolized by its instrument, whose design is dedicated to them: a "dagger in the shape of a serpent made of letters" (*varṇa-nāga-kṛpāṇikā*). In the poem a linear list of the phonemes is included, and there is a second list of phonemes in the drawing of the serpent, which starts at its wide head, shaped like the blade of a dagger. The intersections of the coils of the serpent mark the edges of boxes, as in the method used for other grammatical inscriptions: an obvious example is the neat list of the twenty-five occlusives

Fig. 22. King Harsa's signature on a copper plate from Bānskherā (district of Shāhjajānpur, Uttar Pradesh), 628 CE. Sanskrit text in *Siddhāmātṛkā* script. From *Epigraphia Indica* IV (1896–1897), Calcutta, no. 29, pl. 20 opposite p. 210, Archaeological Survey of India.

(see section 3) which was set out in the easily visualized form of a chart in five lines and five columns (= 5 locations x 5 modes of articulation). Nominal and verbal flexional endings are shown in a logical order, in the thirty-nine boxes that form the end of the serpent's tail, where the characters on both sides of the curve are always written in the same direction: the twenty-one (3 x 7) nominal endings are read from bottom to top, and the eighteen (2 x 3 x 3) verbal endings follow on after the curve and are read from top to bottom. This document therefore constitutes a table of phonemes and morphemes, making use of spatial representation to aid memorization. Grammatical knowledge is expressed in the orderly presentation of symbols learned by rote: they are written down using the letters of the alphabet or with one-syllable conventional terms.

Reducing the basics elements of the language to monosyllables makes for easier memorization, and they can be transposed simultaneously into script. Another example of a series of syllables presented in chart form is shown in a form of classical Sanskrit poetry that could be called "figurative poetry" (*carmen figuratum*): the declaimed text is intended to represent an object. This style, called *citra*, appears in learned poetry from the fifth century CE onward. (Lienhard, 1984, pp. 150–158, and 1996). It is based on forms of repetition that are commonly found in Sanskrit poetry and were originally used in Vedic poetry, such as alliteration, rhyme, and restriction in the choice of consonants. The constraints are similar to those used the literature of many different cultures, ancient and modern, and recall, nearer home, the Oulipo games. In terms of sound, these constraints are often significant: repetition is used to recall the radical of a keyword, or to suggest an essential idea, while the absence of such consonants may also be evocative, as in the famous seventh chapter of the tale of Daṇḍin. In this poem Prince Mantragupta's narrative contains no labial consonant because his lips have been damaged by an excess of intense love-play. As well as the phonic effect, the repetition of consonants or syllables produces visual impressions: the message loses its strictly linear character. Reading the syllables following both the horizontal and vertical line produces geometrical figures (*bandha*), several of them bearing names which are also to be found in military textbooks: the text advances like the divisions of an army, or like the pieces on a chessboard.

Other examples show the syllables taking the shape of an object, often a weapon (sword, spear, or arrow): this method is a transposition of the archetypal metaphor of speech, seen as a well aimed arrow that strikes its target. The thirty-two (4 x 8) syllables of the following verse from the *Kāvyālaṃkāra* (v. 12) by the ninth-century poet Rudraṭa, are presented in linear transcription (*māhiṣākhye*

raṇe 'nyā nu sā nu nāneyam atra hi / himātaṅgād ivāmuṃ ca kaṃ kampinam upaplutam) laid out in the shape of a "spear." The syllables are read starting from the center along the surfaces of the object, following the arrows, and return to the starting point (Fig. 25). The verse closes in on itself, both in its oral form and in the written version. The voluntary repetition of the syllables *hi*, *nu*, *taṃ* and *kaṃ* aims to limit the contours of the object. To be fully appreciated this poem should be read and visualized: the reader is rewarded for his effort by the poet's virtuosity and discovers the hidden design in the succession of visible syllables. The underlying designs always evoke the success of a project, or a form of perfection: they double the auspicious nature often present in the text itself. In another verse of thirty-two syllables (4 x 8), the listener may be alerted by

Fig. 23. Folio from a Jain text in Prakrit, *Catuḥśaraṇa*, with a commentary in Sanskrit
written in smaller characters. Undated *devanāgarī* script.
Ms. Leumann S 310, fol. 1A, Bibliothèque Nationale Universitaire, Strasbourg.

the repetition of the syllable *yā*, which appears at the beginning and end of each of the four lines: *yāśritā pāvanatayā yātanacchid anīcayā / yācanīyā dhiyā māyāmāyāsaṃ stuta śriyā*: the positioning of this phonic effect makes the design of an eight-petal lotus flower (Fig. 26), where the eye leaves and returns to this same syllable several times. The text is an appeal to a goddess who has the power to end torment and to chase illusions away. The name of this poetic genre can be understood by reference to the sense of "chart" of the noun *citra*, mentioned above. But there is also the visual application of the adjective *citra* in the sense of "striking"—this quality is primarily that of the phonic effects of poetic ornamentation, and it is shown clearly by the letters representing the sounds in question. Beyond the realm of literature, Indian culture included a visual art form

of the syllable, whose magical aspects are renowned: the insertion of syllables or of formulae in the diagrams used as talismans or mantra. These ritual and mystical uses of script also spread to India's neighboring countries.

To conclude, the Indian world used script in similar ways to the early civilizations of Europe and Asia, even if the chronology of its development contains gaps and particularities. However, at different stages in its history, writing was in competition with the spoken word and was often even supplanted by it. It is therefore all the more interesting that graphic signs did not just reflect speech but also became endowed with a power of their own, in literature as well as in religion. Even in a civilization that privileges the powers of speech, writing was not always perceived as a simple substitute for the spoken word.

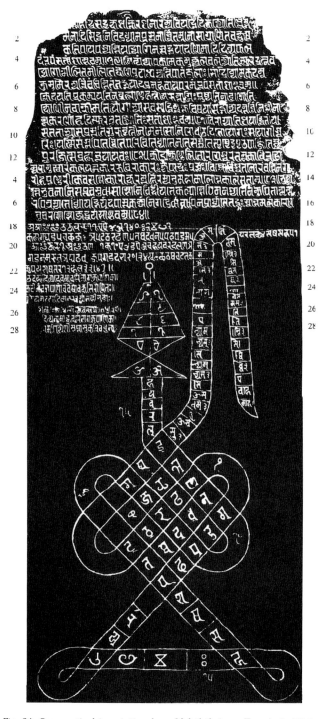

Fig. 24. Grammatical inscription from Mahākāleśvara Temple in Ujjain. Sanskrit text in *Nāgarī* script (From *CII* VII(2), pl. 27).

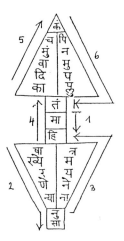

Fig. 25. Poem in the shape of a spear: the arrows show the order in which the syllables must be read. Diagram from Lienhard, (1996), p. 49. See also Lienhard (1992), pp. 211–213.

Bibliography

ALLEN, William S. *Phonetics in Ancient India* (London: Oxford University Press, 1953).

BÜHLER, Georg. *Indische Palaeographie von circa 350 a. Chr. – circa 1300 p. Chr.* (Strasbourg: Karl J. Trübner, 1896). English translation by J. F. Fleet [Bombay, 1904], with revised notes: *Indian Palaeography from about BC 300 to about AD 1300,* with life sketch of Georg Bühler 1837–98 by F. Max Müller and introductory note by J. F. Fleet (Patna, 1897).

BÜHLER, Georg. *On the Origin of the Indian Brāhma Alphabet,* 2nd edition (Strasbourg: Karl J. Trubner, 1898); *Together with two Appendices on the origin of the Kharoṣṭhī alphabet and of the so-called Letter Numerals of the Brāhmī.* Reprinted (Varanasi: The Chowkhamba Sanskrit Series Office, 1963).

CII I = *Corpus Inscriptionum Indicarum*, vol. I: *Inscriptions of Aśoka.* New edition by E. Hultzsch (Oxford: Clarendon Press, 1925; reprinted New Delhi: Archaeological Survey of India, 1969).

CII VII(2) = *Corpus Inscriptionum Indicarum* vol. VII, part 2: *Inscriptions of the Paramāras of Mālwā, Chandrāvatī, Vāgaḍa, Bhinmal & Jalōr,* ed. Harihar Vitthal Trivedi (New Delhi: Archaeological Survey of India, 1978).

DANI, Ahmad Hasan. *Indian Palaeography* (Oxford: Clarendon Press, 1963; 2nd edition, Delhi: Munshiram Manoharlal, 1986).

FALK Harry. *Scrift im alten Indien. Ein Forschungsbericht mit Anmerkungen* (Tübingen: Gunter Narr Verlag, 1993).

FILLIOZAT, Jean. "Paléographie." In L. Renou and J. Filliozat, *L'Inde Classique. Manuel des études indiennes*, vol. II (Paris/Hanoi, EFEO, 1953; reprinted, Paris, 1985), pp. 665–712.

HINÜBER, Oskar von. *Der Beginn der Schrift und frühe Schriftlichkeit in Indien* (Stuttgart: Franz Steiner Verlag, 1990).

LIENHARD, Siegfried. *A History of Classical Poetry: Sanskrit – Pali – Prakit* (Wiesbaden: Otto Harrassowitz, 1984).

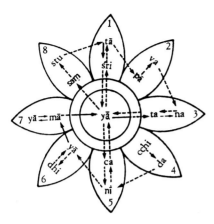

Fig. 26. Drawing suggested by the syllables of a verse of a sanskrit poem. The layout of the verse brings the eye regularly back to the center. Drawing taken from Lienhard, 1984, p. 156.

LIENHARD, Siegfried. "Carmina figurata dans la poésie sanskrite." *Bulletin des études indiennes* 10 (1992): 203–214.

LIENHARD, Siegfried. *Text-Bild-modelle der klassischen indischen Dichtung* (Göttingen: Vandenhoeck & Ruprecht, 1996).

PARPOLA, Asko. *Deciphering the Indus script* (Cambridge: Cambridge University Press, 1994).

PINAULT, Georges-Jean, "La tradition indienne." In Sylvain Auroux (ed.), *Histoire des idées linguistiques, vol 1: La Naissance des méta-langages. En Orient et en Occident* (Liège/Bruxelles: Pierre Mardaga, 1990), pp. 293–400.

SALOMON, Richard. *Indian Epigraphy. A guide to the Study of Inscriptions in Sanskrit, Prakit and the other Indo-Arian languages* (New York/Oxford: Oxford University Press, 1998).

SALOMON, Richard. *Ancient Buddhist Scrolls from Gandhara. The British Library Kharoṣṭhī Fragments* (London: British Library, 1999).

SALOMON, Richard. "Calligraphy in Pre-Islamic India." In Frederick M. Asher and G. S. Gai (eds), *Indian Epigraphy. Its bearing on the History of Art* (New Delhi: Oxford University Press and IBH Publishing Co./American Institute of Indian Studies, 1985), pp. 3–6 and 4 plates.

SALOMON, Richard, "New evidence for a Gandhari origin of the Arapacana syllabary." *Journal of the American Oriental Society* 110 (1990), 255–273.

SCHARFE, Hartmut. *Grammatical Literature* (Wiesbaden: Otto Harrassowitz, 1977).

SIRCAR, Dines Chandra. *Indian Epigraphy* (Delhi: Motilal Banarsidass, 1965; reprinted 1996).

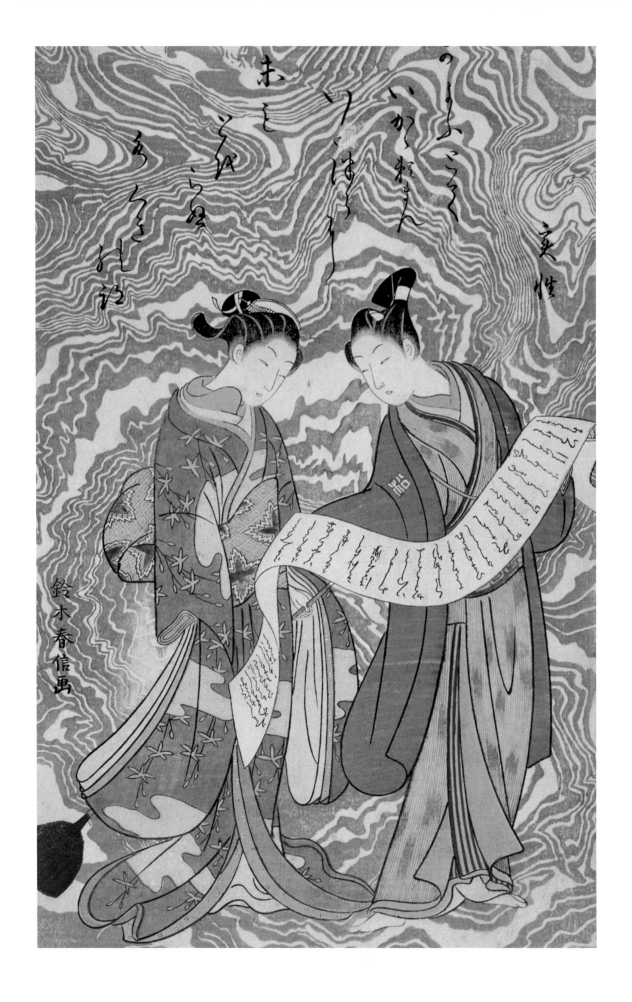

WRITING IN JAPAN

Pascal Griolet

Japanese writing presents a particularly rich and complex structure that is at once fragile and flexible. Every major historical event or social upheaval has modified both its overall structure and its practices to some extent.

I. THE INTRODUCTION OF CHINESE WRITING

Writing entered Japan via the Korean peninsula at the beginning of the common era (Fig. 2). Chinese chronicles that refer to the archipelago provide the first transcriptions of Japanese words (for the most part names of places, persons, or titles) according to the system that represents foreign languages by using Chinese graphic signs purely as syllables (thus provisionally setting aside their inherent meaning). But the choice of phonetically appropriate characters was not always innocent, and those chosen to indicate the inhabitants of the archipelago was clearly pejorative: the character *wa* in *Wajin* (倭人 = *Woren* in Chinese) is equivalent to DWARFS through a graphic artifice, doubtless based on the pronunciation of the word that the Japanese used to refer to themselves: *wa, ware* (ME, I).

In the middle of the fourth century, the Korean peninsula split into three rival kingdoms. Refugees, prisoners, and hostages from the continent settled in Japan, bringing with them a variety of new techniques, including writing.

Fig. 2. A gold seal, discovered in 1784 on the island of Shiganoshima in the Bay of Hakata. It appears to correspond to the one that, according to the Chinese chronicles, the Emperor Guangwu presented to a delegation from Japan in 57 CE. A five-character sigillary inscription states extremely concisely that the Han emperor recognizes—as a vassal—the sovereign of the Na of the country of the Wa. The first character, Han, takes up a third of the square on the right-hand side. The four other characters share the remaining space. Fukuoka Museum.

Hereditary scribes came into being, and an embryonic administration was formed. But, as writing spread into the interior of the country, so the vernacular, the language of the inhabitants of the archipelago, increasingly influenced written Chinese, which nevertheless remained the norm. Evidence for this is provided by inscriptions from the fifth and sixth centuries engraved on sword blades or on the backs of bronze mirrors. The Japanese names on them are sometimes rendered phonetically in the middle of Chinese text and sometimes, when their meaning can be analyzed, translated into Chinese. There are many indications that the Japanese language is surfacing in these inscriptions, which are often Chinese only in appearance. From a calligraphic point of view, they are often clumsily engraved, and some of the characters are truncated. Chinese seems already to have become a foreign language for their authors.

Fig. 1. Suzuki Harunobu (1724–1770), *Mitate Kanzan Jitoku zu*. This woodblock print of a young man unrolling a love letter in front of a young girl is a conventional allusion to an ancient Chinese pictorial theme, that of the two hermits Hanshan and Shide. The first always holds a text containing universal wisdom in his hand, while the second sweeps away the dust of worldly cares with his broom. As background to this caricature (*mitate*), a poem written in *kana* glorifies the importance of beautiful writing. Inv. EO 1682, Musée des Arts Asiatiques Guimet, Paris.

Continuing troubles in Korea caused a fresh and final great wave of immigrants in the sixth century. Large numbers of scholars and craftsmen then took refuge in Japan, and monks and nuns introduced a new religion, Buddhism.

II. THE CHINESE TEXT AS THE LANGUAGE OF POWER

On the threshold of the sixth century, the Japanese authorities had acquired a certain mastery of written Chinese and could weigh its words. Japan claimed to be a civilized land and, confronting the Chinese court, asserted itself by assuming the title *Riben guo*, 日本国, which is pronounced in contemporary Japanese *Nihon* (or *Nippon*) *koku*, LAND OF THE RISING SUN. In addition, the term *wa* assumes a different graphic form and appears in a nobler version of the homophone HARMONY: 和 .

In 604 Japan endowed itself with a sort of written constitution, The Seventeen Rules of Good Government (*Jūshichijō kenpō*), a magnificent document composed in the Chinese "parallel prose" style. A century later, a batch of administrative regulations written in Chinese was also promulgated. These were reproduced in a large number of copies, and the regional authorities were provided with oral commentaries. Censuses of the population were carried out regularly, both for taxation and civil registration purposes. In this way the written document established its authority, and its production very soon attained considerable proportions: the archives of the "Citadel of Peace," *Heijō-kyō*, better known by its vernacular name, Nara, which was the imperial capital from 710 to 794, may have amounted to 12,000 paper items, not to mention the thousands of tablets that continue to be discovered by archaeologists. All this was largely the result of the labors of the tens of thousands of civil servants who administered the country.

From the end of the seventh century on, elites were formed under the direction of members of the immigrant community. An Office of Higher Studies (*daigaku-ryō*) admitted four hundred boys from the high ranks of the nobility, while outside the capital, provincial institutes (*koku-gaku*) were established. The students who enjoyed the privilege of admission to these centers devoted themselves heart and soul to reciting and to copying, reading, writing, and explaining texts in a language that was foreign to them. Everything had to be learned by heart. Only after the texts had been memorized were "lessons" given on their meaning.

But Chinese was not only the language of administrative protocol, it was also that of literature and poetic expression.

As poetry was considered to be the "guide of the nation" (*keikoku*), it bore paramount testament to the virtue of a government, or the grandeur of a reign. The Japanese taste for Chinese poetry has never diminished since then.

III. THE APPROPRIATION OF WRITING: FROM THE DEGRADATION OF CHINESE TO THE EMERGENCE OF JAPANESE

In Japan's relations with its neighbors the Chinese written language constituted a kind of shield to protect its place in the region, behind which and sheltered by, breathed the vernacular language which signaled its presence from time to time. From the second half of the fifth century onward, the number of phonetic transcriptions of Japanese proper nouns that have come down to us continually rises. At times one detects an increase in the use of characters referring to honorific terms that are characteristic of the language of the archipelago.

A stone inscription drawn up in the eastern regions (south of the present town of Takasaki) illustrates this evolution: dated 681, it disregards Chinese entirely and sets each character separately according to Japanese word-order (but without indicating the syntactic elements, which have no Chinese equivalent). Was its author, a monk who lived in a very remote region, really so ignorant of Chinese or did he simply not bother about it— perhaps because he carved this inscription in memory of his own mother, as the final words show?

母 為 記 定 文 也

(mother—for—record—fix—text—is)
Haha (no) tame (ni) shiru (shi) sada (muru) fumi nari
THIS IS A TEXT FIXED IN WRITING FOR MY MOTHER

This short passage reads quite naturally according to Japanese word-order, by making a word from that language correspond to each character. Given in parentheses are the syntactical elements (particles or verbal endings) that are not indicated and must therefore be guessed.

IV. THE POWER OF SACRED TEXTS

The form of Buddhism that was originally introduced into Japan attaches considerable importance to incantatory magic, on the one hand, and to the practice of copying out sutra on the other. While the latter are known through Chinese translations, the *dhāranī*, or esoteric formulae that make it possible to act on the phenomenal world,

Fig. 4. *Hyakumantô darani* (the "*dhâranî* distributed among a million pagodas"). The beginning of one of the scrolls that is preserved in a pagoda. These texts are one of the most ancient of the world's printed documents that have been passed down to us. Tôyô bunko.

Fig. 3. *Hônen shônin eden* (detail), thirteenth century. Monks are proceeding to a ceremony for the copying of sutras, destined to be buried in the earth. They are wearing masks so as not to sully the documents with their impure breath. The miniature canopies, placed above the sutras, testify to the solemnity of the occasion. Chion-in Monastery.

were transcribed phonetically from Sanskrit, with varying degrees of accuracy. This acknowledgment of the fundamental power of the vibrations of the sacred word gave rise in China itself to the development of the first studies of phonetics and provided Japan with models for transcribing the vernacular language.

Copying out the sutras for oneself (Fig. 3)—or paying to have them copied—constituted an offering that was considered as the source of the greatest benefit to one's country, to one's clan, or to oneself, as it provided protection from all ills or dangers, both in this life and in future lives: each character contained the sacred word of the Buddha, a fragment of the infinity of buddhahood.

The Nara period—that is to say the eighth century— was the golden age of state Buddhism. Emperor Shômu (701–756) and his wife, the empress Kômyô (701–760), were consumed with an ardent faith and had a gigantic cosmic Buddha in golden bronze erected. The empress founded a service for the copying of the sutra, employing more than two hundred copyists. The whole Buddhist canon—that is to say the whole body of sacred texts— was copied several times over. The monasteries were then founded in each province—some for monks, others for nuns—and charged with conserving copies of the sutra written in golden characters on violet paper and also with performing a solemn reading of them at regular intervals.

The couple's daughter, the empress Shôtoku (718–770), also attached great importance to Buddhism. In 764, in

order to ward off a spell, she ordered the wood-cut printing of *dhâranî* and the production of a million copies (Fig. 4) of them. These sheets, which were two and a quarter inches high and nearly eighteen inches long, were to be rolled up and placed in little wooden pagodas, before being distributed among the great monasteries.

Manuscript copies of sutras retained their importance during subsequent periods. When a deceased person was laid to rest, it was sometimes the practice to collect his letters, glue them together to make a scroll, cover the characters with mica powder and inscribe a sacred text on the top. It is sometimes possible to read what the deceased wrote underneath the characters of the sutra. Occasionally, his letters were recycled to make fresh paper which was grey because of the ink contained in it, and in which the ashes from his cremation might be inserted (the ashes visible to the naked eye in the texture of the paper are actually incense).

The nobles readily performed offerings of printed passages of sutras. One of the greatest figures of classical

Fig. 5. Scrolls of buried sutra and the bronze case that contained them. These were discovered near the walls of the Hakusan sanctuary at Hachiôji in the suburbs of Tokyo, where they had been buried in 1154.

Japan, Fujiwara no Michinaga (966–1027), had a thousand copies of the Lotus sutra made. But it was he who, in 1007, initiated the ritual of burying manuscript copies of sutras enclosed in protective cases, rather like promises for times to come or messages for future Buddhas (Fig. 5). This practice spread throughout the country until the middle of the twelfth century, then diminished until its disappearance in the middle of the thirteenth century. The phenomenon appears to have been linked to the belief in the coming of an "Age of the Final Law" and the end of the power to save conferred by the teaching of Sākyamuni Buddha.

The end of the capital Heian's brilliant period is noted for its superbly decorated copies, including those of the Lotus sutra, which were sprinkled with delicate cut-outs of gold and silver leaves. These were presented as an offering around 1164 by the whole Taira clan, which, after attaining great heights of power, perished in its entirety at sea during a famous naval battle in 1185 (Fig. 6). Sharing the task of copying made it possible to forge a link for the future between those who had taken part in it and the Buddha. During this period, copies were also made on booklets that opened out in the shape of a fan (Fig. 7). As a backdrop to

Fig. 6. Frontispiece and beginning of chapter XII, entitled *Daibadatta-bon*, of the Lotus sutra, copied out by the Taira clan (*Heike nōkyō*). Particular importance was attached to this chapter, which explains how it is possible for women to attain buddhahood in this life. In the lower part of the frontispiece, the daughter of the Dragon King may be observe emerging from the ocean to present an offering to the Buddha. Itsukushima Sanctuary, Hiroshima.

Fig. 7. *Senmen hokekyō*, a copy of the Lotus sutra on fan-shaped booklets. Early twelfth century. Tokyo National Museum.

the text, they displayed landscapes and typical scenes of the everyday life of the nobility or the common people—as though the text of the sutra covered and penetrated the whole of this illusory world. The columns of characters are not parallel, but concentric, and the size of the characters diminishes progressively as they descend the page.

V. THE QUEST FOR A NATIONAL WRITTEN LANGUAGE

The Nara period is noted for three works that make it stand out in the course of Japanese history: first and foremost, the *Kojiki* (Record of Ancient Times), completed in 712, is a mythological and historical account based on sources transmitted orally. In the introduction, the scholar in charge of drafting it gives an account of the difficulties that he encountered in drawing up the written version of this narrative. The "translation," 訓 (*kun*), which is based on the equivalence of meaning between the vernacular vocabulary and Chinese written characters, retains no trace of the pronunciation and may furthermore not correspond exactly to the original meaning. On the other hand, the "phonetic transcription," 音 (*on*), aims to make the Chinese characters correspond as far as possible to Japanese syllables but suffers, in his view, from a major handicap: lengthiness, which is contrary to the esthetic of Chinese writing and its propensity for ellipsis and concision.

For example, the proper noun *Amekuni*, (THE COUNTRY [*kuni*] OF HEAVEN [*ame*]), transcribed phonetically, requires four characters: 阿米久爾 (*a.me.ku.ni*). Translated, two suffice : 天国 (HEAVEN, COUNTRY), but this written form may be read differently, in the Chinese fashion, and does not guarantee a faithful pronunciation of the name. Thus, for the written form of EMPEROR, 天皇, the reader does not know whether to read it according to the Chinese pronunciation (*tennô*) or as Japanese (*mikoto*). Finally, the eight characters in the phonetic transcription 比里爾波之彌己等 (*hi.ro.ni.ha no mi.ko.to*) THE EMPEROR (*mikoto*) OF THE (*no*) VAST GARDEN (*hironiha*) are reduced to four in translation: 広庭天皇 (*hiro.niha [no] mikoto*).

The drafter finally adopts a compromise solution: some passages are translated, others are transcribed (in particular, poems and names). Still others are a mixture of the two processes. Ambiguities are removed by adding little notes and by dividing the columns in two, as illustrated in the name *Ame no toko tachi (no) kami*, THE DIVINITY THAT STANDS ETERNALLY UPRIGHT IN HEAVEN (for convenience, the example is here given horizontally):

天之常立神

The first two characters are read as translated into Japanese (*ame no*, OF HEAVEN), as is the final *kami*, DIVINITY. But, doubtless because of possible ambiguities, the notes explain that the third character should be read as *toko*, ETERNITY, and the fourth as *tachi*, UPRIGHT. This system makes it necessary to write the same thing twice, and, in a way, heralds the process, still in use today, of using *furigana*, little syllabic signs at the side of the Chinese characters, to indicate their pronunciation.

This text, which was long to remain unknown, is eight years older than the thirty volumes of the *Nihon shoki* (Annals of Japan), which were completed in 720 and written in Chinese with the exception of names and poetic songs. This work was to enjoy a much greater diffusion.

Finally, the *Man.yô-shû* (Myriad Leaves), a poetic anthology completed between 759 and 770, later gave its name to the collection of phonetic characters used to describe the poems, the *man.yô-gana*, so called to distinguish them from the purely phonetic syllables that appeared subsequently. A large proportion of the 4,500 poems in this anthology are transcribed using one Chinese character per syllable. But one finds various other methods used, and the same word may appear in very different graphic forms: *aki* (FALL), appears in "translation" as the character 秋 or as the two characters 秋時, THE FALL SEASON, but also in several phonetic forms that correspond to the two syllables *a.ki* (安伎, 安吉 or 阿伎), as well as in a more surprising form that incorporates the Chinese character for METAL, 金, one of the five universal elements which, according to Chinese tradition, is associated with this season. One may also observe numerous mirror effects between the characters and words, like *kohi* (LOVE), indicated by two characters used phonetically, but which together also mean TO SUFFER FROM SOLITUDE: 孤悲. Finally, the use of innumerable characters derived from the homophones of numbers bears witness to the widespread use of multiplication tables: the word *nikuku* (DIFFICULT) a compound homophone of TWO (*ni*, 二) and NINE TIMES NINE (*kuku*, 九九) is indicated by 二八十一 which reads: TWO [and] EIGHTY-ONE (i.e. nine times nine). This extraordinary variety of graphic forms testifies to the playful spirit which the Japanese managed to introduce into their painful apprenticeship of Chinese writing.

The phonetic notation of the *senmyô* ("orders" from the emperor to his subjects) and the *norito* (oral "addresses" to the gods) marked a new step by indexing Chinese characters used phonetically in order to distinguish them from the meaningful forms. In these texts, which were intended to be read aloud in solemn fashion, the words are often written in Chinese following the Japanese word-order, while characters that were used purely phonetically (often

written in smaller script on the right) indicate elements that had frequently been neglected hitherto—the grammatical particles and verbal suffixes. This is how one of the imperial orders, dated 757, begins:

天皇我大命良末等宣布大命乎衆聞食倍止宣

This phrase—in which we have transcribed the phonetic elements in bold type—should be read as follows: *Sumera **ga** ohomikoto**ramoto** notamafu ohomikoto **wo** shū kikitama**he to** notamahu* (Hear, O people, the order formulated by the noble word of your sovereign!).

This process of binary opposition between the "capital" and the "lower case" for texts that had to be read without any hesitation or error marks the beginning of the practice of separating the Chinese characters from the syllabic signs (to indicate the syntactic elements) that was to become widespread in subsequent times.

VI. CONFUSION AND DISORDER IN PRONUNCIATION

The imperial residence moved away from Nara in 794, at a time of profound changes in Japanese society and the Japanese language. The ruling power distanced itself from the over-powerful monasteries and took drastic measures in an effort to regain control. It decreed strict rules for the ordination of monks, among which was the insistence on the correct pronunciation of contemporary Chinese—northern Chinese, the official language of the Sui (589–618) and Tang (618–904) dynasties—as it was taught in the Office of Education by Chinese masters. Ancient pronunciations, which had arrived from Korea and South China in earlier times and then spread through the monasteries, were condemned. Several imperial decrees to this effect were promulgated.

The new pronunciations were, however, the prerogative of a cultured elite that did not succeed in imposing it generally. For one thing, the communities of Buddhists could not abruptly abandon traditions that had been handed down from master to disciple, and for another, the

desire for linguistic reform came up against the passive resistance of the language itself, whose ancient borrowings had become deep-rooted in its speakers.

From then on, therefore, the two broad strands of pronunciation borrowed from Chinese continued to exist side by side: the ancient *go-on*, "the Wu pronunciations," and the new *kan-on*, "the Han pronunciations." Later, other pronunciations from the *Sō-on* (Song China) were introduced by Zen monks, but they were limited to particular circles and to a few words. Even today, instead of there being a single pronunciation per character, most characters possess two, three, or more, and the choice between them is made on a word by word basis according to usage. Each character, in addition to its different translations into Japanese (known as *kun.yomi*, "translated reading" or "reading according to the meaning"), was henceforth read differently according to the context, as illustrated in the following two examples (which correspond to the information provided in contemporary dictionaries of Chinese characters used in parallel with language dictionaries):

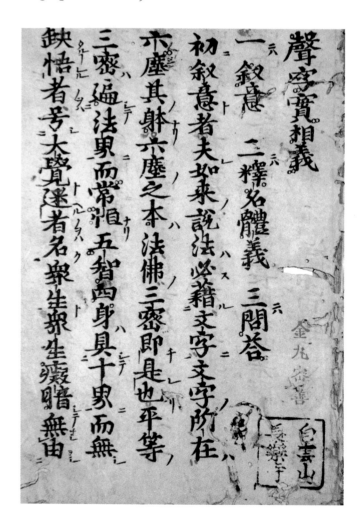

Fig. 8. Manuscript copy of the *Shōji shissō gi* (Treatise on the Voice the Sign and Reality) by the monk Kūkai (774–835), founder of the esoteric school Shingon. In this text an internal link is established between the written sign, language, and the essence of the universe. Written signs, like the sounds of the voice, are the expression of the teaching that is provided constantly by the great cosmic Buddha. Shown here is the beginning of the treatise, written in Chinese, which, to facilitate an oral reading in Japanese, has been annotated using *katakana* placed between the lines on the right of the Chinese text and diacritic signs indicating the reading order on its left. Red marks indicate the proper tone of the Chinese characters. Edo period, Zentsū-ji Monastery.

行

1. *on.yomi*, pronunciations of Chinese origin (with an example for each case)

go.on	**shū*gyō***	修行	PRACTICE AUSTERITY
kan.on	***kō*i**	行為	ACTION
sō.on	**angya**	行脚	PILGRIMAGE

2. *kun.yomi*, "translated readings"

| (1) ***iku/yuku*** | 行く | TO GO |
| (2) ***okana*u** | 行う | TO ACCOMPLISH |

重

1. *on.yomi*

| go.on | ***jū*yō** | 重要 | IMPORTANT |
| kan.on | **ki*chō*** | 貴重 | PRECIOUS |

2. *kun.yomi*, "translated readings"

(1) ***e***	重	LAYER, THICKNESS
(2) ***omo*i**	重い	HEAVY
(3) ***omo*tai**	重たい	PONDEROUS
(4) ***kasa*neru**	重ねる	PILE UP
(5) ***kasa*naru**	重なる	BE PILED UP

VII. ANALYTICAL TOOLS AND THE ADVENT OF *KATAKANA*

At the same time as the authorities tried to lay down rules for the pronunciation of written texts, they issued decrees urging novices not to be content with reciting the sutra by heart but to study their meaning in depth and to be able to explain it. It was then that various tools were created for translating Chinese into Japanese.

A system of markers was perfected, the *kun ten*, or "translation points," which were added to the texts, making it possible to read them directly in Japanese, rather than in the Chinese order. The signs in effect encourage the reader to proceed back and forth in a particular sequence, skipping certain sections before returning to them subsequently. The system was at first used by a minority before being adopted more generally: up until today, a traditional exercise in Chinese studies consists of taking a "bare text" and correctly placing the "translation points" necessary to translate it into Japanese.

The most ancient annotations of this kind that have come down to us date back to 783, the eve of the establishment of the Heian capital. On a document entitled *Kegon-kyō kanjō ki*, a commentary on the *Sutra of Flowery Ornamentation*, signs were added, either in black or vermilion, making it possible to obtain the Japanese word order for the Chinese text.

Fig. 9. Detail of a ceremonial Buddhist protocol. The first line is written in characters called, in Japanese, *bonji*, which come from *Siddham*, one of the Sanskrit forms of writing. Shown here are the formulae to be uttered during the ceremony. *Katakana*, in smaller writing to the side, indicate the exact pronunciation of these signs, which few people could read with any degree of certainty. Edo period, Zentsū-ji Monastery.

In order to make clear the syntactical relationships indicated in Japanese by particles or suffixes, markers were added at precise points in the ideal square in which a Chinese character was written. This form of annotation is called *wokoto ten*, literally "the points [that mark the particles such as] *wo* [attached to nouns, and the elements such as] *koto* [attached to verbs]." This system of annotation is particularly complex, all the more because it is not a uniform one but varies from monastery to monastery (there may be as many as a hundred different systems, most of which were conceived between the ninth and twelfth centuries). Underlying this complexity, apart from a preoccupation with remaining faithful to what a master had handed down, one may discern an ever-growing predilection for secrecy in respect to the traditions of each school.

It was in this context that one of the two Japanese syllabaries, the signs called *katakana*, literally, "pieces" (*kata*) of "borrowed signs" (*kana* or *kanna*), made its appearance. These are Chinese characters used

Fig. 10. *Sunshôan shikishi*, traditionally attributed to Ki no Tsurayuki, but estimated to have been written out in the eleventh century. On the page is a poem in *kana*, selected from the *Collection of Ancient and Modern Poems*. The first part is set on the lower right-hand side, and the second part on the upper left-hand side. The two groups of graphs form a staircase down to the last line, which consists of a single character. This work was originally part of a notebook, the leaves of which were subsequently cut out by collectors for mounting on scrolls that they put on the wall to contemplate during tea ceremonies. MOA Museum of Art, Shizuoka.

phonetically, with only a part of the original Chinese graph retained. The word *kana* probably derives from *kara no na*, which originally meant something like "signs (*na*) whose pronunciation has been borrowed (*kari*) but their meaning dropped," as opposed to signs taken in their entirety (*mana*, "the veritable signs").

Here are two examples of the forming of *katakana*:
Original Chinese character:

曽 (*so*, ALREADY) 奴 (*nu*, SLAVE)

Phonetic usage (*man.yô-gana*):

曽 (denotes the syllable *so*) 奴 (denotes the syllable *nu*)

Katakana:

ソ (upper part of the character) ヌ (right-hand part)

The earliest *Katakana* are found in the great monasteries at the end of the Nara period (end of the eighth century). At

Fig. 12. An official document called *nyôbô hôsho* (Imperial Instruction for Women). This one was not composed by a lady of the court but by the emperor himself. It was the emperor Gonara (1496–1557) who, by this document, written in 1550, presented the Nishi hongan-ji Monastery with the *Anthology of the Thirty-six Immortals of Poetry*. The letter consists of two leaves that were subsequently mounted on a scroll. It is written in the *gankô-yô* style ("flight of wild geese") and is made up of twenty-one returns. Nishi hongan-ji Monastery.

first they appear as additions between lines, but soon they become mixed with Chinese characters in the body of the text itself, as seen in a document entitled *Tôdai-ji fujumon-kô*, which consists of notes written between the end of the eighth century and the beginning of the ninth century in preparation for an oration. The indications in *katakana* aim to facilitate the public reading of a text that is profoundly Chinese in its structure. Placed after the Chinese characters, they sometimes signal their pronunciation, but without the later refinement that would distinguish between *furigana* (which give the pronunciation or the meaning of the Chinese characters) and *okurigana* (*kana* joined to the Chinese characters to indicate the variable endings of Japanese words).

These signs, which may be described as stenographic, as they made it possible to take down dictation rapidly, became a generally used form of writing in the middle of the tenth century: among the inscriptions discovered behind the wooden ceiling of the five-storied tower of the Daigô-ji monastery are three poems, written in *katakana*, probably by craftsmen during the tower's construction, which was completed in 951.

VIII. *HIRAGANA* AND THE EMERGENCE OF THE *WABUN* JAPANESE STYLE

Unlike *katakana*, which were a product of the monasteries, the signs known today as *hiragana*, "the simple *kana*,"

originated in the bosom of the aristocracy and spread in particular among the ladies of the nobility. While the former are truncated signs, crutches of a purely utilitarian nature, the latter are bound up with the elegance of cursive calligraphy.

In the first place, it was a form of writing that was reserved for official use and for private correspondence. If a few examples have come down to us, it is because they figure on the reverse side of paper that was re-used for official documents and subsequently preserved in archives. When one ran short of paper, one stuck together bits of used paper, re-trimming them to form an even surface. On the back of Buddhist or administrative texts, fragments of letters have been found whose beginnings or endings are often missing. This form of epistolary communication, which escaped from the complex conventions of Chinese, went hand in hand with a cursive script that was simpler and quicker to write. These cursive signs—called *sô* (grasses) at that time—spread during the ninth century and gave rise to a truly Japanese syllabary, which

Fig. 11. *Inaba no kokushi no gean shihai monjo.* The most ancient document on paper to display the characteristics of feminine writing. The letter begins (at top right) with the words: *ito mezurashiku towasetamaeru/ yorokobi o namu kikoesase* (I was very happy that you favored me with your visit.) This fragment has been preserved because the other side of it was used to copy out an official document, which was then stored in the archives. Shôsô-in.

Fig. 13. Model of a letter in a very scattered page-setting (ōchirashi gaki) from a letter-writing manual, edited in 1882, *Onna yōbun takarabako* (The Precious Casket of Feminine Correspondence). Small marks (with added Arabic numerals) indicate the order of writing or reading this letter of congratulation. Private collection.

constituted an appropriate field for the art of calligraphy. In contrast, the *katakana*, would remain a body of purely utilitarian signs.

Here are two examples of the formation of *hiragana*:

Original Chinese character:

曾 (*so*, ALREADY) 奴 (*nu*, SLAVE)

Phonetic use (*man.yō-gana*):

曽 (denotes the syllable *so*) 奴 (denotes the syllable *nu*)

Hiragana:

そ (cursive graph) ぬ (cursive graph)

Japan then turned in on itself, after a long period that had been marked by the production of a considerable number of texts in Chinese. Because of the prevailing troubles in China diplomatic missions from there came to an end. These had been regularly sent to the Tang court and had for several centuries nourished Japan with novelties from the continent.

An incomplete letter, which seems to have been written by a woman between 931 and 938 (Fig. 11), displays some

distinctive new features: the brush-strokes are extremely fine, and the signs are linked together in a continuous movement of the brush, which seems only to leave the page to reload with ink. Neither the verticality nor the parallelism of the columns is respected strictly. One may already observe therein certain liberties taken in the domain of graphic expression that were to become more widespread in the following centuries, such as a very broad and tall *mu* sign in the exclamatory particle *namu*. In other letters, one notices the deliberate prolongation of the sign *shi*, し (a characteristic of *kana* calligraphy), doubtless due to the vertical shape of this sign. With a negligence that may or may not be feigned, the author does not begin her lines at the same level, but descends lower and lower. This apparent clumsiness was later to be asserted in its own right.

In contrast to the square style of Chinese writing—which, by its regular pattern of squares, comes close to the principles of architecture—writing in *kana* conjures up the disorder of Nature and, from this point of view, approaches the art of gardens.

The name *chirashigaki* was given to a particular way of "dispersing" the lines, instead of arranging them from right to left, so that it is no longer clear where the beginning or the end is, or in what order the whole is to be read. Originally, usage dictated that one should begin writing in the middle of the sheet. If there was not enough space, one returned to the right margin, called the *sode*, "the sleeve" (the left margin being called the *oku*, "the back"). If space was still lacking, one wrote on the upper border, the *ten*, "heaven," and then on the lower one, the *chi*, "earth." Such disorder subsequently became an art. Reading this sort of letter was like going through a labyrinth. Nevertheless, accounts of the time that refer to *chirashigaki* underline the undoubted charm of this style, which was considered as eminently feminine.

This sophisticated jumble was to become a calligraphic tradition: when the columns begin at the same height but are not in line below, they are in the "wisteria style" (*fujibana-yô*). When they are aligned below, but uneven above, it is a case of "stones piled up" (*tateishi-yô*). Finally,

Fig. 15. *Matsuzaki Tenjin engi* (detail), 1311. In the residence of a lord, a reclining lady is writing a letter. In the sixteenth century, the Jesuit missionary Luis Frois was struck by the way that Japanese frequently, as here, wrote holding the paper in their hands. Hōfu Tenmangu Monastery, Yamaguchi.

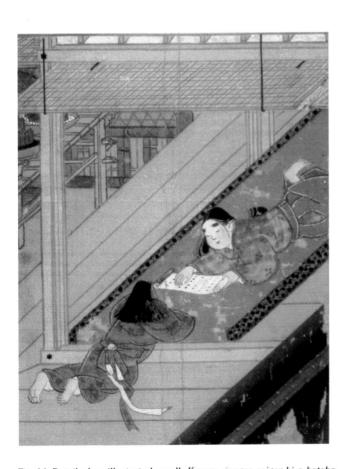

Fig. 14. Detail of an illustrated scroll, *Kasuga gongen reigen-ki e kotoba*, 1309. Two little girls, lying on the ground, chat in front of a scroll held by one of them. Is it a letter or a story? The regularity of the signs adumbrated on the document call to mind Chinese characters rather than *kana*. Imperial Palace, Sannomaru Shōkanzō.

groups of two or three short columns that do not begin at the same level but cascade ever further downward may be dispersed across the sheet in a style known as "the flight of wild geese," *gankô-yô* (Fig. 12).

Originally, this evolution of the cursive signs seems to have been linked to the sessions of poetic jousting which secretaries, appointed for the occasion, were charged to record. From 905 on, the *kana* acquired official recognition with the *Kokin waka-shū* (Collection of Ancient and Modern Japanese Poems). This poetic anthology had been ordered by the emperor Daigo (885–930), who himself

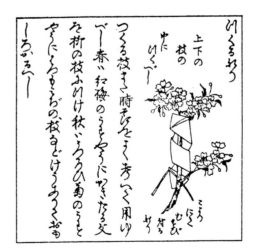

Fig. 16. *Usuyō irome* (range of colors of fine papers), 1826. Tsukuba University Library. Letter attached to a flowering branch. The text accompanying the drawing explains how to harmonize the color of the papers with the choice of branches according to the season.

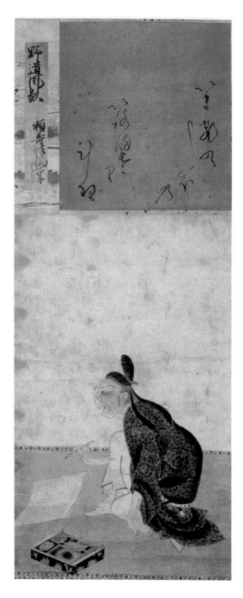

Fig. 17. Portrait of Ono no Michikaze, attributed to Raiju, thirteenth century. Michikaze, a legendary figure in Japanese calligraphy, is here depicted as ready to begin writing, with a sheet of paper placed on the floor, his ink-stand to his left, and one knee drawn up. This was the position taken up by scribes in readiness to record the emperor's wishes on the spot. Imperial Palace, Sannomaru Shōzōkan.

has handed down a remarkable example of "wild cursive" calligraphy, a style in search of spontaneity and improvisation that forsakes the regular square framework in its headlong pursuit of total freedom of space. In this "wild cursive" form—the fashion for which goes back to early eighth-century China and Zhang Xu, who was known as "the drunken madman"—the calligrapher abandons himself to a kind of dance, and the act of calligraphy becomes a spectacle in itself.

The compiler of this collection, Ki no Tsurayuki (868–945), is also considered to be the founder of Japanese prose. The introduction to the anthology begins as follows:

やまとうたはひとのこころをたねとして

よろつのことのはとそなりける [...]

Yamato-uta wa hito no kokoro o tane to shite yorozu no koto no ha to zo narikeru . . . (The song of Yamato takes root in the emotions of man and spreads them out like leaves in myriads of words . . .)

Tsurayuki was a scholar who had been nurtured on Chinese poetry. In 935, he wrote a prose text entitled *Tosa nikki* (Daily Notes from Tosa) entirely in Japanese, with notes in *kana*. He took care to refer in the very first phrase to the femininity of the style, as men normally wrote their journals in Chinese. Whereas we call these signs *hiragana* today, at the time they were called *onna-de*, "women's hands." As women did not have to compete for a career in administration, they did not need to study Chinese. Accounts of the period suggest that it was not considered desirable for a woman to appear learned in the subject. On the other hand, they were expected to know by heart all the "Ancient and Modern Poems" of the Japanese tradition.

Feminine journals were to herald the golden age of Japanese literature. Court ladies devoted their free time to filling notebooks with them, or reading accounts written using *kana*. Unfortunately, none of the latter has come down to us in its original form.

This advance in the use of *kana* led to a reduction in the number of signs used to indicate Japanese syllables: whereas there were around a thousand phonetic signs (*man.yô-gana*) in the eighth century, by the middle of the eleventh century these had been reduced to several hundred, and by the end of the twelfth century to about a hundred. The number remained high because it was considered good taste to use different signs to indicate the same syllable (the reduction of *kana* to a single sign per syllable only came about in 1900). Below are some of the different signs used to denote the syllable *su* (along with an indication of the Chinese character from which it derived):

Epistolary communication constituted an art in its own right. Amorous encounters often began with an exchange of poems. One had to choose the sheet of paper with the greatest care, and harmonize its colors with the season. The folded letter, sometimes wrapped in another piece of different-colored paper, was tied to a branch (blue paper for

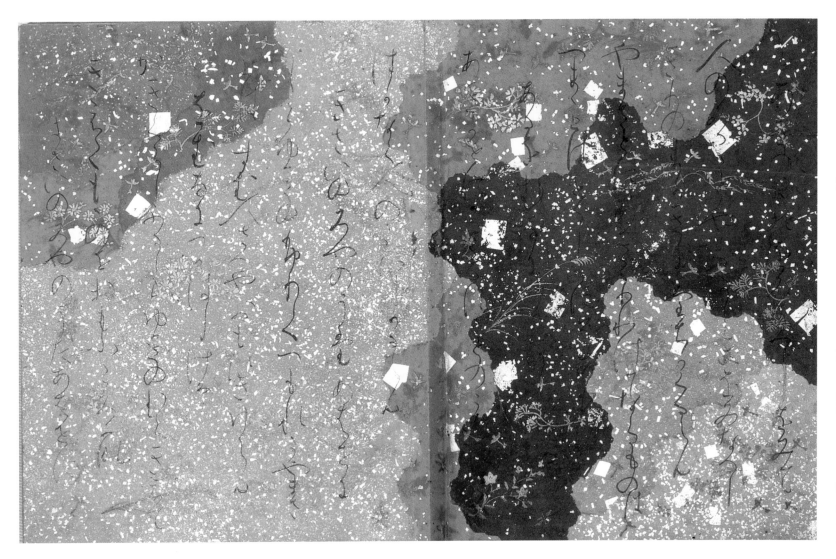

Fig. 18. *Sanjūrokunin-shū* (Anthology of the Thirty-six Immortals of Poetry), poems of Tadamine. Early twelfth century. Nishi Hongan-ji Monastery.

a willow branch, green for an oak, purple for a maple, white for an iris bulb) and might be entrusted to a graceful child instead of a messenger. The note could be rolled up very delicately and hidden beneath the petals of flowers (Fig. 16). To prevent it being seen by other people, it might even be written with the pointed end of a writing instrument and no ink. None of these splendid notes, which are mentioned over and over again in accounts of the time, has come down to us, because of their private and intimate nature. The descriptions given of them suggest that the whole process of writing and its accessories formed part of the art of seduction: women sometimes wrote their messages on scented sheets of paper that they always carried on their person, and a note from a beloved could be the first evidence of feelings of intimacy on the part of one who has

hitherto only been glimpsed through window blinds.

The great calligraphers of the time, such as Ono no Michikaze (894–966) (Fig. 17) or Fukiwara no Yukinari (972–1027) established a classicism whose elegance was to stand as an incontrovertible model for subsequent periods, even if it eventually declined into the rigid and fastidious formalism of various rival schools.

Of the numerous masterpieces of the period, the early twelfth-century *Sanjūrokunin-shū* (Anthology of the Thirty-six Immortals of Poetry), which was discovered in 1896 in the archives of the Nishi Hongan-ji monastery, constitutes one of the peaks of calligraphy in *kana* as well as of the art of paper-making (Fig. 18). Hundreds of poems are disposed on sheets of shimmering tinted paper, which have all been either colored beforehand or painted, sometimes sprinkled

with different substances (mica, gold, silver). Often the sheets consist of pasted papers made up of strips that have been torn out or cut diagonally: in the thirty or so notebooks that have been preserved no two pages are identical. The written strokes are extremely fine when the background is light, and become thicker on entering the darker areas.

It was in a Buddhist treatise dated 1079 that there appeared for the first time a poem entitled *Iroha-uta* (Colors), in which each of the 47 syllables of the Japanese of the time appears only once :

いろはにほへと
Iro ha nihohe to Even if the colors are fragrant

ちりぬるを
chirinuru wo they fade in the end.

わかよたれそ
wakayo tare so What is there then in this world

つねならむ
tsune naramu that is permanent?

うゐのおくやま
uwi no okuyama The deep mountains of vanity

けふこえて
kefu koete I cross today,

あさきゆめみし
asaki yume mishi renouncing superficial dreams,

えひもせす
ehi mo sesu no longer surrendering to their drunkenness.

This poem, shown above in *hiragana* (but it could equally well be given in *katakana*), was to act as an aid for those initiating themselves into the first steps of writing, as well as for classifying words in dictionaries. In the same period there also appeared a logical presentation of the sounds of the Japanese language, doubtless borrowed from *siddham*, one of the Sanskrit scripts that was studied in monasteries: the present form of the "table of fifty sounds," *gojûon-zu*, is given below in *katakana* (but it could equally be in *hiragana*), and should be read from left to right:

These two presentations of the syllabic signs (*Iroha-uta* and *gojûon-zu*) correspond to the constitutive syllables of pure Japanese, *yamato kotoba*. In addition combinations of these signs are used for representing syllables that derive from Chinese, as well as diacritic signs to distinguish voiceless consonants from voiced consonants.

	A	I	U	E	O
	ア a	イ i	ウ u	エ e	オ o
K	カ ka	キ ki	ク ku	ケ ke	コ ko
S	サ sa	シ shi	ス su	セ se	ソ so
T	タ ta	チ chi	ツ tsu	テ te	ト to
N	ナ na	ニ ni	ヌ nu	ネ ne	ノ no
H	ハ ha	ヒ hi	フ fu	ヘ he	ホ ho
M	マ ma	ミ mi	ム mu	メ me	モ mo
Y	ヤ ya		ユ yu		ヨ yo
R	ラ ra	リ ri	ル ru	レ re	ロ ro
W	ワ wa	ヰ (wi)		ヱ (we)	ヲ wo

IX. THE SYNTHESIS OF STYLES AND THE SPREAD OF MIXED WRITING

From the end of the tenth century, monks turned to a wider public and had recourse to a form of writing that combined the Buddhist lexicon and the Japanese language, blending in the process Chinese characters with *kana*. This trend appears in the *kanahôgo* (Buddhist sermons written in kana). The most ancient of these is surely the *Yokawa hôgo* through which the monk Genshin set forth in the simplest possible terms the "Pure Land" doctrine of re-birth. In the realm of literature, the movement is best illustrated by the *Konjaku monogatari-shû* (Stories from the Past), a collection of anecdotes that dates from around 1120.

In 1192, power was seized by the warriors who established their government at Kamakura, far from the imperial capital. Writing according to the Chinese model (*kanbun*) remained the official written language, but it drifted away from the rules of Chinese syntax. It was in this debased form (*hentai kanbun*) that the fifty-one articles of the collection of laws on which the new regime was founded—the *Goseibai shikimoku* (List of Rules for What Constitutes the Good and the Bad)—were formulated in 1232.

If the Heian period was marked by the appearance of a truly Japanese style, associated with the use of *hiragana* by the ladies of the court, it was above all male writings that spread, blending Chinese vocabulary with the Japanese

language, while relying on the crutches provided by *katakana*. The Japanese style, which reserved a privileged position for the expression of feelings and avoided terms borrowed from Chinese, did not correspond to the sensibilities of the newly dominant classes, at least not outside of poetic expression.

Most of the great reformist monks of the Middle Ages wrote learned treatises in Chinese, but they spread their doctrines among the population in the simplest possible form, in line with the search in religious matters for an "easy practice" that would give priority to faith over studies. As an example one may quote this passage taken from the *Ichimai kishōmon* (Vow Written on a Single Sheet), a kind of testament written two days before his death by Hônen (1133–1212), the founder of the movement known as Jōdo-shū, the "School of the Pure Land":

Whoever shall place his faith in calling on the Buddha, even though he may have deeply studied the law taught during his life [by the Buddha Shakyamuni], should consider himself as someone stupid and totally illiterate, like a nun or an ignorant monk. Without behaving like a learned person, he should devote himself solely to calling on the Buddha.

念仏を信ぜん人はたとひ一大の法を能々
学すとも一文不知の愚どんの身になし
て尼入道の無知のともがらに同じくし
て知者のふるまひをせずして唯一向に
念仏すべし

Here the Sino-Japanese terms of Buddhism blend with everyday words of the Japanese language. Chinese characters blend with the Japanese syllabary, not as *katakana* but as *hiragana*. Was this due to the high number of women among his followers?

The *Hôjô-ki* (Notes from my Monk's Cabin), which is one of the masterpieces of Japanese literature, was written in 1212 by Kamo no Chômei (1155–1216), a member of the nobility who chose to live apart from society (Fig. 20). This text, whose central theme is the impermanence of things, was written blending *katakana* and Chinese characters.

In about 1220, the monk and poet Jien (1155–1225) wrote, partly in the same form, a work in which he reflected on the history of Japan. He justifies his use of simple, popular language by underlining the fact that his contemporaries are no longer capable of understanding

Fig. 19. Wooden statue of the monk Kûya (detail), by Kôshô, thirteenth century. The monk Kûya (903–972) kept repeating incessantly the formula *Namu Amida butsu*, which allows—as long as one has repeated it sincerely at least once—entry to the Pure Land of Amida Buddha (Amitābha). The six syllables *na-mu-a-mi-da-butsu* emerging from his mouth are immediately transformed into as many Buddha figures. Rokuharamitsu-dera Monastery.

texts in Chinese, and he maintains that those who are attached to it are often motivated by pure pedantry.

Thus it was that from the troubled period of the Middle Ages on, several forms of writing coexisted in Japan: Chinese (*kanbun*), debased Chinese (*hentai kanbun*), Sino-Japanese (*wakan konkô bun*) and pure Japanese (*wabun*), with all sorts of interference between these stylistic formats, which differ visually from one another in terms of the amount of space occupied by the Chinese characters. Peasants, when they had to write, very often had only *katakana* at their disposal: it was in that form that a complaint against the despotism of a governor was drawn up in 1275.

Peace only returned to the country with the beginning of the Edo period (1603–1868), which witnessed an extraordinary advance in xylographic publishing (Fig. 21). The wide circulation of popular literature, written in *kana* and abundantly illustrated, is directly linked to the efforts that were made in the field of education: elites were taught in institutes of higher learning (of which more than two hundred were schools of fiefdoms) that based their programs on Chinese studies, which then experienced a resurgence of interest. Popular schools (estimated at more than 30,000 at the beginning of the nineteenth century) provided children with the rudiments of writing and arithmetic (Fig. 22).

Fig. 20. The most ancient manuscript of the hōkoji, *Notes from My Monk's Cabin*. The beginning of this work is very well-known: *Yuku kawa no nagare wo taezu shite, shikamo moto no mizu ni arazu...*, "The waves of the river never stop, and yet it is never the same water..." Daifukukō-ji Monastery.

X. MODERN TIMES

The opening up of the country to exchanges with the West were to shake the very foundations of traditional learning: Chinese studies lost their pre-eminence and Western studies required a knowledge of European languages. At the same time, it was thanks to the Chinese lexicon that the mass of new terms or concepts then introduced were able to be analyzed and translated.

During the Edo period there had been many differences in usage and it had not been possible to speak of a unique written language. But now the way forward imposed a standardization that was occasionally brutal and was partly based on the language of the ancient warriors. The typography that was now becoming standardized fixed the forms of the signs, whereas ancient writing had always left a margin of tolerance in the way one drew them. Schools also imposed a fixed pronunciation where previously the signs could be read fairly freely as long as the meaning was understood.

It was under the American occupation in the aftermath of the Second World War that new measures were applied to achieve simplification, in particular, a reduction in the number of Chinese characters used in bureaucracy, the official adoption of certain simplified forms, and a limitation in the number of alternative readings. The drafting of the new constitution (1946) officially recognized the use of *hiragana* alongside Chinese characters. Until then, official writing had married the latter with *katakana*, and *hiragana* had been confined to literature and less important writings. Horizontal writing became standard for official documents and the majority of school textbooks, but vertical writing was retained for literature, magazines and newspapers. Moreover, horizontal writing changed direction: it had traditionally been orientated from right to left, but from one day to the next it switched to move from left to right.

XI. WRITING TODAY

An official list of 1,945 current Chinese characters lays down the framework for current usage in education, the government and the daily press (see page 141). But actual usage often goes outside this framework, above

Fig. 21. Examples of metal type cast in 1607 on the orders of the Shogun. Typography techniques had been introduced first by Jesuit missionaries, then as spoils of war from a military expedition in Korea. Despite the production of some very fine typographical characters, the irregularities of *kana* writing, the close link between text and image, and the value attached to the handwritten outline of signs, caused xylographic printing to be more highly prized throughout the whole Edo period. Toppan insatsu Collection.

all because of proper names, which are not covered by the list: the most widely used computer standard today uses a database of 6,355 Chinese characters (a somewhat conservative total in view of the fact that recent surveys estimate the number at 64,000!—see Fig. 23).

While the *hiragana* constitute the basic syllabary, *katakana*, rather like our italics, set off transcriptions of foreign names and numerous borrowings from foreign languages, as well as certain particular terms such as the onomatopoeias that are so common in Japanese. The Latin alphabet is also used for certain abbreviations, or for the benefit of foreigners, or sometimes to produce an unexpected visual effect.

Chinese characters—logographic signs—perform a dual function: they are used to denote the lexical units borrowed from Chinese and their equivalents or translations in the Japanese vernacular. From a lexical point of view, the overwhelming majority of nouns that are encountered in newspapers are Sino-Japanese, while the Japanese language defends itself well in the verbal and qualificative categories. The lexical units of Sino-Japanese are in theory denoted through Chinese characters that remove the ambiguities of the innumerable homophones with which they are riddled, and the purely syntactic elements are denoted in *kana*. Japanese lexical units enjoy a certain freedom of choice: they may be written either in *kana* or in Chinese characters, but it is sometimes possible—despite

Fig. 23. The scholar Morohashi Tetsuji (1883–1982) in front of the thousands of index cards that he needed to edit the first great dictionary of Chinese characters, the *Daikanwa jiten*, in thirteen volumes containing 49,902 characters. The enterprise began in 1921. The first volume appeared in wartime (1943), and the rest between 1955 and 1960.

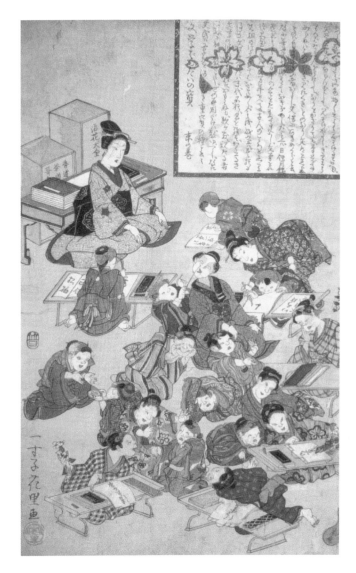

Fig. 22. Issunshi Hanasato, *Bungaku bandai no takara, sue no maki*, ca 1845. Popular schools (*terakoya*) disseminated the rudiments of knowledge. This print, entitled "Letters are an eternal treasure," shows a school for young ladies. At the top, a pupil is reciting her lesson in front of her teacher. On the boxes behind her are the words: "The Complete Art of Flowers. Treatise on the Way of Perfumes, on the Way of Tea, and on the Way of Songs..." Near the schoolmistress, another pupil, seen from behind, concentrates on copying out her piece of model writing, and, on the same level, a young lady is helping a very young boy to hold his brush. Lower down, assistants are looking after little girls in joyful disarray.

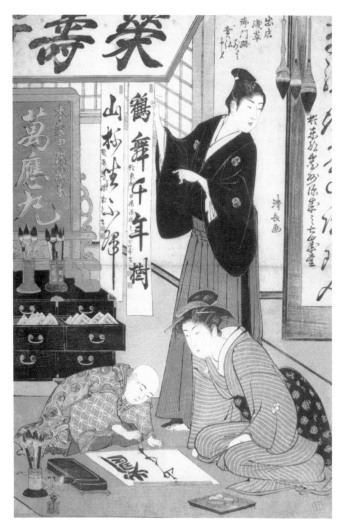

Fig. 24. Tōri Kiyonaga, *Genseishi no sekigaki* (The Child Calligrapher), 1783. Seen through the window of a store in Asakusa, a child exceptionally gifted for calligraphy gives a public demonstration of his talent. His work is subsequently hung up to be admired by all.

Fig. 25. In 2000, during the great national festival of the three Asakusa sanctuaries, numerous amateurs of tattooing were present. The man pictured here has the Sanskrit letter *a* resting on a lotus tattooed on the top of his head. This sign, which is supposed to contain the whole universe, is frequently used in esoteric meditation practices.

the official curbs that have been introduced—to choose between several different characters according to their subtle nuances. For example, the word *aoi* (BLUE) may be written without the slightest ambiguity in its naked simplicity in *hiragana* as あおい, but it is generally adorned with a Chinese character together with its ending *i*: 青い. When this word is associated with paleness, one may also encounter another Chinese character 蒼い. In order to convey the clearness of blue (as in the sky), it is possible to choose a rarer character still: 碧い. Whereas Western spelling systems impose a "standard," Japanese often has a degree of freedom in the way it "adorns" its words graphically.

Since the 1970s, Japanese writing has managed to climb onto the bandwagon of information technology, despite the difficulties it had had in negotiating the age of the telegraph and the typewriter. Now the graphs of thousands of signs are memorized in microprocessors that can be held in the palm of the hand and increasingly sophisticated software programmes convert data recorded phonetically—from a simple alpha-numeric keyboard—in sequences of characters that mix and match the different types of sign in current use. At present, there is a growing discrepancy between the increasing use of rare characters that make recording information easy and the decreasing use of handwriting. Will the widespread use of computers and the abandon of the intensive practice of handwriting result in the loss of the hand's ancestral memory?

The 1,945 Current Japanese Characters Learned at School

First Year in Primary School (80)

一右雨円王音下火貝学気休玉金九空月犬見五口校左三山四子糸字耳七車手十出女小上人水正生青石赤先千川早草
足村大男竹中虫町天田土二日入年白八百文本名木目夕立力林六花森

Second Year (160)

引雲園遠黄何夏家科歌画会回海絵外角楽活間岩顔帰汽記牛魚京強教近兄形計元原言古戸午後語交公工広考行高合
国黒今才細作算姉市思止紙寺時自室社弱首秋週春書少場色食心新親図数星晴声西切雪線船前組走多体台谷知地池
茶昼朝長鳥直通弟店点電冬刀東当頭同道読内南肉馬買売麦半番父風分聞米歩母方北妹毎万明鳴毛門夜野友曜用来
理里話羽弓光矢太答

Third Year (200)

悪安暗委意医育飲院運泳駅央横屋温化荷界開階寒感漢館岸期起客宮急球究級去橋業局曲銀区苦具君係軽決血研県
庫湖向幸港号根祭坂皿仕使始死詩歯事持次式実写主取守酒受州拾終習集住重宿所暑助勝昭章乗植深申真神身進
世整全想相送息速族他打対待代第炭短談着柱注丁帳調追定庭鉄転登都度島投湯等動童農波配倍畑発反板悲皮美鼻
筆氷表病秒負部服福物平返勉放面役油有由遊予様洋葉陽落流旅両緑礼列練路指者商昔題笛豆箱品味命問薬羊和員

Fourth Year (200)

愛案以位囲胃衣印栄塩億加果課芽改械害各覚完官管観関願希旗機季紀議救求給挙漁競共協鏡極訓軍郡型景芸欠
結健建験候功康航差最材昨刷察参散産残司史士氏試児治辞失借種祝順初焼照省象賞臣成清静席積折節説戦
浅選然倉争側続卒孫帯隊単置貯兆低停底的典伝徒努党働得特毒熱念敗博飯費飛必標票不付夫府副粉兵別変辺便
包法望牧末満未脈民無約勇要養浴利料良量輪類令例冷歴連労老録英街喜泣径好告菜札周松笑唱巣束達仲灯梅陸器

Fifth Year (185)

圧易移因営永衛液演往応恩仮価河過賀解快格額刊幹慣基寄規技義逆久旧居許境興均禁句群経潔件検険減現限個故
護効厚構耕講鉱混査再妻際災際在罪財雑賛酸師志支資似示識質舎謝授修術述準序承招証常情条状織職制勢性政精
税績責接設絶舌銭祖素総像増造則測属損態貸退断築張提程敵適統導銅徳独任燃能破判版犯比肥非備俵評貧婦富
布武復複仏編弁保墓報豊暴貿防務迷綿輸余預容率略留領券眼益桜飼製夢可枝確

Sixth Year (181)

異遺延我拡革株貴疑供勤敬系憲権絹己誤后孝皇穀済策蚕私至視詞収宗就衆従純処諸除仁推聖誠宣専創蔵存尊著賃
展討堂届難認納派拝奮陛補盟訳欲律臨論穴巻干割城宇灰映沿閣看簡危机揮胸郷筋警激紅骨冊姿誌磁射опера射尺署将傷
障城蒸針垂寸盛洗染善奏窓装層操臓宅担探誕段暖値忠庁頂潮背肺俳班晩否批秘腹並閉片宝暮訪亡忘棒枚幕密模郵
優幼翌乱卵覧裏朗呼劇源厳鋼刻困砂座裁若吸降樹縦縮熟泉宙痛糖乳脳

The remaining 939 current characters (learned in middle school or high school)

壱翁介壊且勧喚款欽奇糾拒凶叫緊掲撃侯錯軸勺爵釈需称称診帥枢畝是措俗堕妥耐怠但奪弾駐朕珍奴謄弐婆爆伐卑
幣弊傍坊妨膨慢眠黙匁僚療累隷惑雷嫌陳畳鉛押狭靴玄御込緒紋丈寝掃馱袋棚杯符払帽戻稲奥汁沢丹壁隅漫霧
隣皆乾喫丘軒頃咲寂渋吹燥滞稚途突猫苗墨茂離郎腕�虜逝脱遣驚掛越載傘依彫援汚沖暇較
岳環監況響慎恵剣幻孤江洪郊豪鎮歳斜秀魔症震鮮疎隷端秩抽彫徴津逓督縄伴被避普封幅噴崩与揚頼濫子劣陰
煙欧含及継互悟項婚崎惨旬徐睡遂跡潜礎癖即択沈閲般殻乏糧恋柔威刈勘詰絞網荒舟豚泊忙網涼鋭菓彩床粧
酔籍廷盗濃描浜翼履陵露絡酪猿渦涯垣缶渓渓蛍嫌溝蛇塾唇杉仙栓濯挑眺釣塚漬泥洞溺肌鉢扉泡俸堀岬竜枠
楼郭享亭譲巡贈託換召沼超嬢詔謙蓄為亜阿哀握慰尉伊緯維逸芋姻韻詠疫悦閲炎宴謁縁逮捕凹凸殴憶乙虞佳架
華稼寡箇蚊雅餓怪戒拐誘怖塊懐劾概疑隔獲嚇括喝渇滑褐轄甘汗肝冠陥没患貫緩艦鑑頑企岐忌軌祈
既飢鬼幾棋基輝騎宜欺偽儀戯擬犠菊吉却脚虐朽窮巨拠距斤狂峡挟恭脅矯仰暁凝斤菌琴謹襟吟駆愚偶遇掘屈繰
勲刑茎契慶携憩鶏迎傑倹兼圏堅献賢繭懸弦弧枯雇顧鼓顧呉娯悟孔巧甲坑攻抗拘肯恒香貢控慌硬酵稿衡購拷
剛克酷獄昆恨紺魂懇墾唆唆詐砕宰栽債催削剤崎索酢搾撮桟傘旨伺刺肢施嗣雌賜璽漆遮蛇邪
酌朱狩殊趣寿儒囚臭愁充銃獣叔淑粛瞬旬殉循潤遵庶如叙升匠抄尚昇渉訟掌晶焦硝奨詳彰礁鐘冗浄剰壌錠醸
殖飾触嘱辱伸辛侵娠振浸紳刃尽迅甚陣尋薪慎審炊粋衰穂錘随崇据枢据姓征斉牲逝婿誓斥析隻惜拙窃摂占践銃
遷繊禅漸繕租阻粗訴塑双壮荘捜挿桑喪葬僧遭槽霜憎促賊堕胎泰替滝拓諾濁胆淡嘆鍛壇恥致遅痴畜逐窒嫡衷弔帳
跳懲勅鎮墜坪呈邸偵貞帝訂逓堤艇締摘滴摘迭哲徹撤殿斗塗到凍唐桃透悼陶塔搭棟痘筒踏騰胴峠匿篤屯鈍曇軟
尼尿妊忍寧粘悩把覇廃培陪媒賠伯拍迫泊舶縛髪抜罰閥帆販搬煩頒範藩蛮盤妃彼披疲被碑罷裂尾微匹泌姫漂賓頻
敏扶怖附赴浮腐膚賦譜侮舞伏覆沸紛墳丙併柄塀幣偏遍浦舗募慕簿芳邦奉抱胞倣峰砲飽褒縫肪冒剖紡謀朴撲奔
翻凡盆麻摩磨魔埋膜又抹魅妙矛娘銘滅免妄盲耗猛紋厄躍諭愉癒唯幽悠猶裕雄憂融誉庸揺溶踊窯擁謡抑裸羅欄虜
寮厘倫涙塁励鈴零齢麗暦烈廉錬炉浪廊楼漏湾還怒瀬瓶違穏禍慨核閑薫顕痙紫愁翻醜醸俊准宵肖衝抵排輩慎柳吏
痢硫粒隆猟霊盾該脂

THE WRITING IN THE PICTURE

Jacqueline Pigeot

What makes the painting opposite (Fig. 1) so eye-catching is the sumptuousness of the material—gold and silver—and the boldness of the composition: an enormous moon, reclining in the midst of wild leaves (pampas grass *susuki*), fills up the whole surface of the rectangle. On this "background painting" (*shita-e*), which is possibly the work of the great Tawayara Sôtatsu (?–1643), Hon.ami Kôetsu (1558–1637) has inscribed the calligraphy of a classical poem (*waka*) by Fujiwara no Hideyoshi (1184–1240), which figures in the section entitled "Journey" of the famous *New Collection of Ancient and Modern Poems* (*Shinkokin-shû*):

Saranu dani / aki no tabine wa / kanashiki ni
Matsu ni fuku nari /Toko-no-yama kaze

"Even without that, sleep, when traveling in the fall, fills one with sadness,
And now too the wind of Mount Toko can be heard blowing through the pine trees."

In the poem, there is neither moon nor pampas grass. Could it be that there is some mismatch between the picture and the text? In fact, both conjure up the fall: the word appears in the poem, and the two motifs presented in the picture are traditionally associated with that season in poetry. Moreover, the tormented lines of the grasses, and perhaps also those of the calligraphy, slanting to one side, convey the visible effect of the wind where the poem evokes the sound of its moaning. Pampas grass is also associated, throughout traditional literature, with deserted, inhospitable or even lugubrious places that, to the traveler, convey a feeling of desolation.

Thus Kôetsu was looking for a complementary link between the motifs of the picture and the poem.

Nevertheless, the reader is aware of the discrepancy between the different esthetic parts: the painting, dazzling and extremely decorative, contrasts with the poem, which confines itself to the register of confidences and discretion. Could Kôetsu have intended, in choosing this ostentatious painting as backing for such a measured poem, to display through a dreamlike vision the anguish of a traveler all alone in the night?

Fig. 2 shows a print signed (bottom right-hand corner) by "Tori Kiyohiro," an artist who was active in the middle of the eighteenth century. Two girls are playing ball, one catching hold of the other's wrists, under a willow tree. Everything in the picture, with its greenish-blue tones, combines to evoke a world that is young and fresh: the leaves of the tree are only just in bud, the girls are youthful, the design of their kimonos features plum flowers and *hago-ita* rackets (a game played at New Year, at the beginning of spring according to the old calendar). One should add that the willow is, according to the Chinese poetic tradition adopted by the Japanese, a common metaphor for feminine grace, so the tree and the two figures are in perfect harmony. Similar juxtapositions are found in other prints of that period.

But a brief poem, a sort of *haikai* runs across the picture: its design begins at the top right, loses itself among the branches of the willow (above the faces of first one girl and then the other) and reappears at the bottom left. The verse contributes another harmonizing element to the three pictorial motifs, one that is based on verbal associations:

Nagemari no
ito mote tsunagu
yanagi kana

"The willow threads tie themselves to those of the ball that is thrown."

The ball (*mari*) is in fact made up of colored threads bound tightly together; and in Japanese poetry the fine, delicate branches of the

Fig. 1. *Susuki ni tsuki.* Painting attributed to Tawaraya Sôtatsu with calligraphy by Hon.ami Kôetsu. Gotoh Museum, Tokyo.

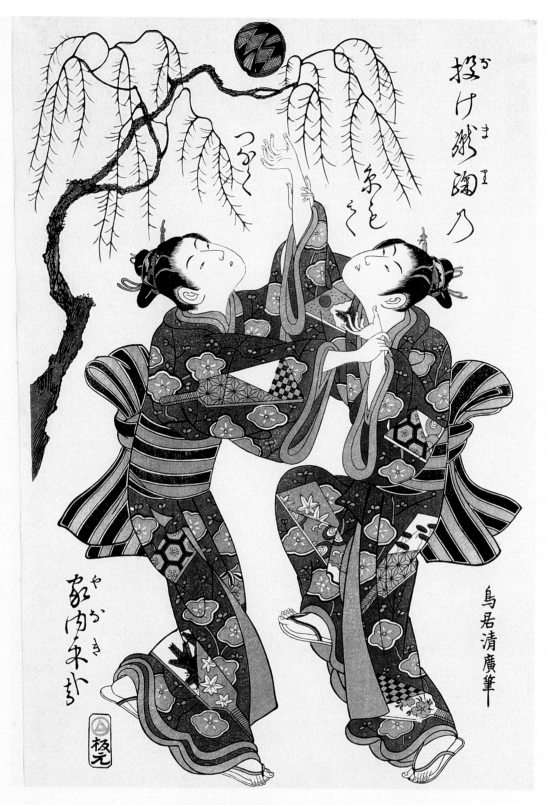

Fig. 2. Print by Tori Kiyohiro. Private collection.

willow were from the earliest times called "threads." It is possible, moreover, that another verbal association is superimposed on the first: the verb *tsunagu* can mean "to knot," "to tie together" (thus belonging to the network of words associated with "thread"), and also "to join." Does it not here evoke the gesture of the little girl entwining her arms with those of her companion? The threads of the ball, the willow branches, the girls' arms—all are thus in harmony with one another,

Verbal associations and pictorial combinations, both heirs to a long tradition, converge in this modest print. They give it its dynamism, each of the three motifs casting attention back to the other two, as though in a game of ball.

PICTURES IN WRITING

Marianne Simon-Oikawa

Among the many writing games (*moji asobi*) recorded in Japan is one that is noted for both its discretion and its longevity: the *moji-e* (picture in writing). Practiced especially during the Edo period (1603–1868), this genre consists of figures composed entirely or partially of written characters, either *kana* or *kanji*. Most often the artwork represents a figure whose outline is made up of all the signs that make up that person's name, cunningly disguised as part of the clothing. These pictures are typical of their period. Produced by means of woodblock engraving, and sold in the form of books or as isolated prints, they bear witness to the emergence of a popular sector of society, born at a time of peace and economic prosperity, and in search of distractions not only at the theater or other places of entertainment but also in the world of printing and pictures.

More than sixty years after Enkatei Yoshikuri's 1685 *Collection of Pictures in Writing* (*Moji-e tsukushi*) was published, an anonymous sequel appeared that took up the same theme—the small urban trades that were thriving at the time. It testifies both to the success of *moji-e* and to its links with popular culture (Fig. 1). Each picture is composed of a little everyday scene that presents familiar characters, like the monkey man (*saru mawashi*) or the firework maker (*hanabi uri*), in the form of *moji-e*. A very clear visual hierarchy is established between the *moji-e* itself (a tabular composition of thickly written characters), the title of the picture (which, on one side of the image, takes up in linear fashion the name of the trade in less heavy strokes), and the text (generally the words uttered by the participants), which are disposed around the picture in thinner strokes still.

Hanasanjin (1790–1858), a disciple of the humorist and man of letters Santô Kyôden, gathered together a little collection of eighty-three vignettes in which the figures are entirely composed of the written characters that form their names, to the exclusion of any other characters or brush strokes, with the occasional exception of

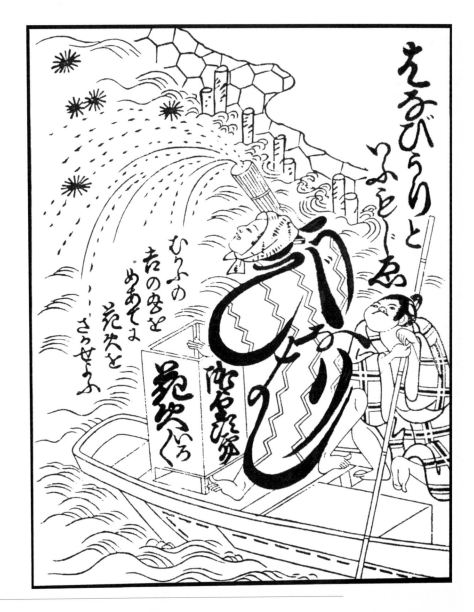

Fig. 1. "The fireworks." From *Shin.moji-e tsukushi* (New Collection of Pictures in Writing), anonymous, 1751–1764. Central Library, Tokyo.

foot of the god lies an almanac indicating the date of the print's publication. The most spectacular element in this picture is the god's attire, which consists not of plain lines but of signs reading: "An unparalleled provider of prosperity, Ebisu's shop" (*fukutoku no oroshidon.ya ka Ebisu dana*). The lithe lines, inherited from calligraphy, reduce the disparity between the big square Chinese characters and the undulating flow of the Japanese syllabic signs. The usual order for reading Japanese characters—from top to bottom, and from right to left—is not entirely respected. The numbers in the explanatory panel at the side of the picture indicate the sequence in which the signs should be put together to form the phrase.

The disposition of the signs on the page and the effort required to reconstitute the text concealed in the god's clothes bring into question the legibility of these prints. As if to facilitate the task, however, the artist has written the whole phrase legibly above the head of the god, like a caption. But such provision has probably been inspired as much by the artist's desire to show off his virtuosity as by any concern to be understood by the reader. In fact the picture functions as a puzzle: the viewer must find within the figure the characters that have been given to him in advance, and so admire the skill with which the artist has managed to conceal them.

Fig. 2. "The Heron" and "The Old Woman." From *Dôke hitofudegaki* (Pictures Drawn with a Single Continuous Brush Stroke), by Hanasanjin, 1848–1858. Inagaki Collection.

three dots to suggest eyes and mouth. Poets, historical figures, divinities, dancers, and ghosts, but also a bag, a heron (*sagi*), or an old woman (*toshiyori*) pass before the eyes of the would-be decoder, who is bemused by this unadulterated *moji-e* that hides its inventiveness behind a mask of nonchalant ease (Fig. 2). For example, above the heron the artist has commented, "Anyone can draw a heron like this quite easily." Mostly, however, the figures lack the accessories that would make them readily identifiable, and they can be truly understood only after their accompanying text has been deciphered. When recourse to words is needed in order to fully appreciate what the image shows, that is the point at which pictures in writing have reached their limit.

At New Year, merchants would buy pictures of good omen—like the one reproduced opposite (Fig. 3)—to decorate their houses. Gathered together around the god Ebisu, the divine protector of commerce and the home, is a collection of several traditional New Year symbols: the pine, the crayfish, and the strip of prayer paper. At the

Bibliography

EXHIBITION CATALOG: *Egakaretamoji/kakaret e, kaika to moji* (Painted Writings/Written Pictures, Text and Imagery) (Hakodate: Hokkaido Museum, 1989).
EXHIBITION CATALOG: *Moji-e to e-moji no keifu* (Genealogy of Pictures in Writing and Picture Writing) (Tokyo: Shoto Museum, 1996).
INAGAKI. *Shin.ichi. Edo no asobi-e* (Puzzle Pictures of the Edo Period) (Tokyo: Tokyo Shoseki, 1988 and 1993).
SIMON, Marianne. "Un cas particulier d'estampes ludiques: les images en écriture de l'époque d'Edo." *Extrême-Orient Extrême-Occident* 20 (1998): 111–133.
SIMON-OIKAWA, Marianne. "Quelques exemples de *moji-e* dans deux recueils de petits métiers de l'époque d'Edo." *Japon pluriel 3, Actes du colloque de la Société française d'études japonaises* (Paris: Philippe Picquier, 1999), pp. 397–406.
——. "L'écriture du bonheur; divinités populaires et images en écriture au Japon (XVII–XIX siècles)." *Ebisu* 23 (Tokyo) (Spring/Summer 2000): 57–93.
TAKASHINA, Shûji. "Le mot et l'image dans l'art japonais." *Le siècle du design, Art-info: présent et futur*, exhibition catalog (Paris: Maison de la culture du Japon à Paris, 1997), pp. 9–17.

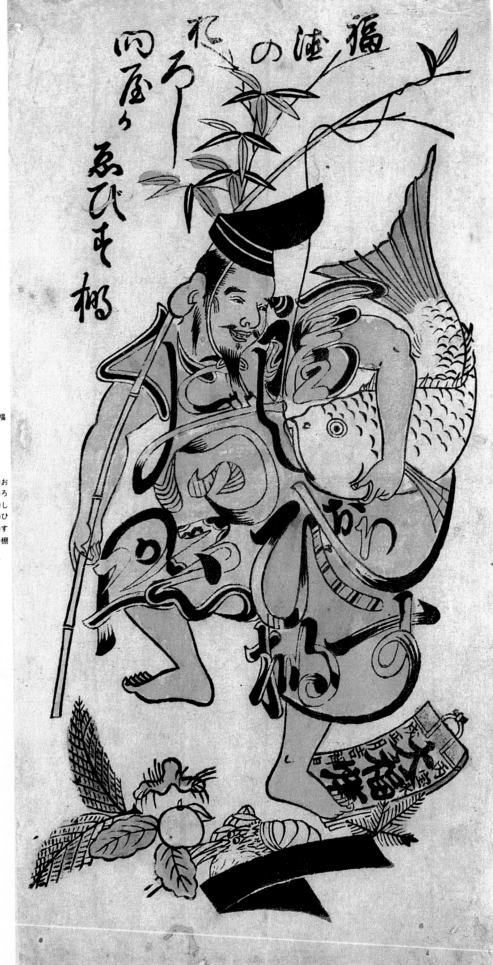

Fig. 3. Picture of Ebisu for the New Year, 1706. Monochrome print with colored brushwork additions. Honolulu Museum.

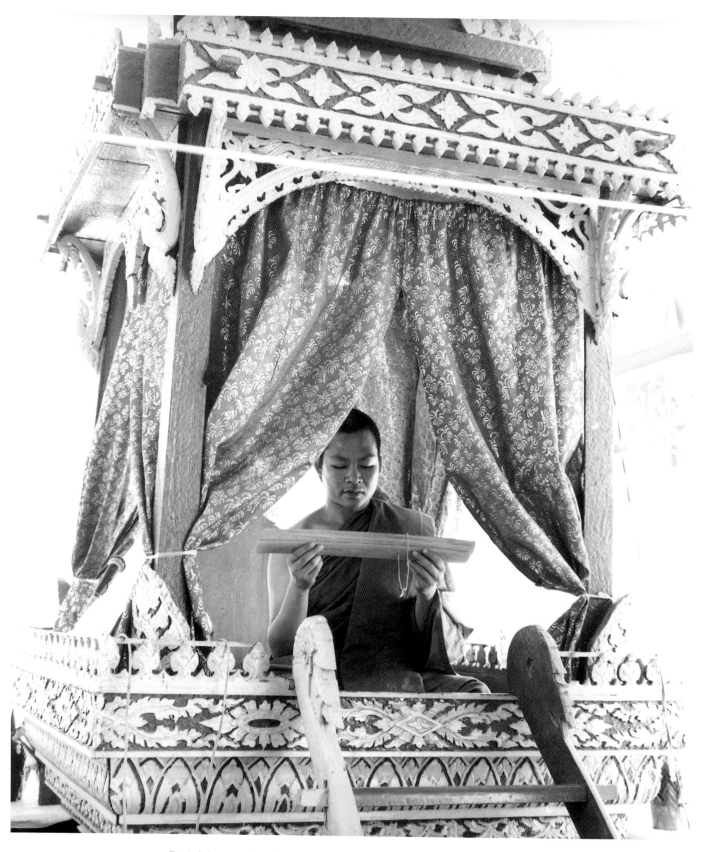

Fig. 1. Solemn reading of a text tracing back one of the former lives of the Buddha
in front of a crowded congregation at Vat Ong Teu, Vientiane (Vianchang), for the feast of "*Boum Phra Viet.*"
The manuscript is engraved on Latania leaves, the writing surface most widely used in the Indo-Chinese peninsula.
The monk is perched on a richly decorated pulpit designed to provide shade during the reading of the teaching.

BUDDHIST WRITINGS IN SOUTHEAST ASIA

Catherine and François Bizot

Like the Indian writing from which they are derived, the scripts of Southeast Asia, which arrived in the region in the first centuries of the common era, are based on a phonetic analysis of the language that classifies the consonants in five *vagga* according to an order strictly defined in relation to their points of articulation (Diagram A). Each consonant is pronounced with an inherent vowel. The basic unity of the writing is thus the syllable. Vowels *per se* do not, strictly speaking, exist (except as initial vowels); vowel-signs appear only as appendages to consonants, placed in front, above, below, or to the right of them, as a vowel may consist of a combination of several signs arranged around the consonantal backing.

1	2	3	4	5	6	7
ꖶ	ꖝ	ဟ	ꪀ	ꀀ	ꪁ	ก
ꖚ	ꖞ	ꘙ	ꀁ	ꀁ	ꪂ	ข
ꖲ	ꖟ	ꀂ	ꀃ	ꀂ	ꪃ	ค
ꖳ	ꖠ	ꀄ	ꀅ	ꀄ	–	ฆ
ꖴ	ꖡ	ꀆ	ꀇ	ꀆ	ꪄ	ง

Diagram A. Consonants of the first *vagga* (gutturals): 1. Pallava (South India), 2. Mul (Cambodia), 3. Môn/Burmese, 4. Tham/Yuon (Laos/Lanna), 5. Fak Kham (Thailand), 6. Lao (Laos), 7. Siamese (central Thailand).

Unlike India, which concentrated all the creative powers of religion and magic on the spoken word, it was on the syllabic letter that the Southeast Asian countries projected those mystic values, which make it a manifestation of supreme reality. In this respect they inherited the Vedic ideology, developed in particular by the Tantric philosophies, in which the phoneme is considered to be both a divine representation and a cosmic principle, and they transposed this representation into their writing. Without going so far as to develop a Buddhist tradition of calligraphy like that of the Chinese and Japanese, who used the Indian "Siddham" writing in much the same spirit as they treated ideograms, the Indo-Chinese placed letters at the center of ritual and symbolic manipulations, making them appear to be the primordial factors of all creation.[1] Myths ascribe the origin of the world to knots of consonants: all phenomena are born from concentration on letters. The visualization of syllables also allows the latent presence of the Buddha to be revealed.

A basic element in the education of a young monk is the study of the alphabet, with its multiple combinations of

Diagram B. Letters of the primordial *mantra*, NA MO BU DDHA YA arranged according to the image of a fetus growing in the womb. Khmer manuscripts.

consonants and vowels. It is a reflection of the consciousness that writing is the most precious manifestation of the teaching. Traditionally, the list of letters is learned like a litany, which the student copies out, prefacing it with the conventional salutatory formula: *namo Buddhaya siddham*, "Homage to the Buddha, Perfection" (Fig. 2), which recalls

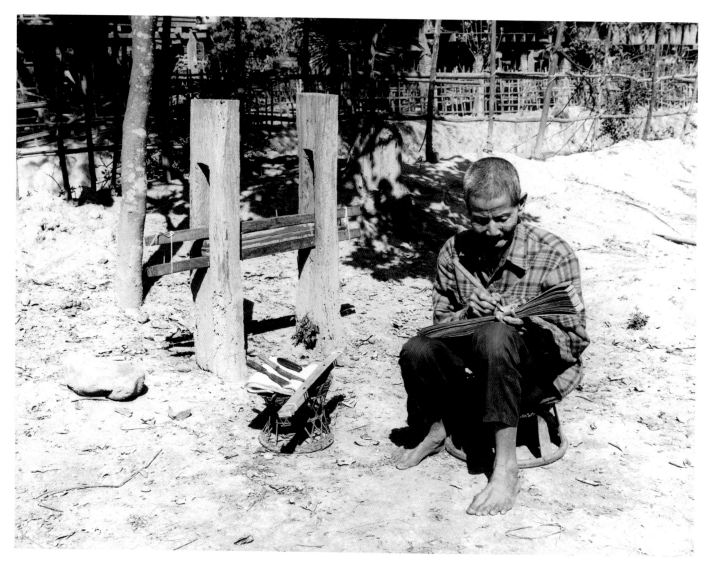

Fig. 2. A scribe pursuing the Indian tradition of engraving manuscripts on the leaves of the Latania tree (*Corypha Lecomtei*), a type of palm.
He is surrounded by traditional writing instruments.

the "Siddham" alphabet of the Chinese. In Southeast Asia, this kind of writing spread at first among the population as a way of transcribing Pali, the liturgical language of the Theravada communities, which was considered to have been the actual language in which the Buddha had preached. Apart from scholars, however, most adepts of the Lesser Vehicle knew it either not at all or very little and had to assimilate the mantras and ritual formulas more or less mechanically, like sequences of sacred syllables, whose shapes they could not touch. It was thus the need to restore the correct pronunciation of Pali that made the letter a concrete and valid link with tradition.

It was not until around the fifth and sixth centuries, when they were beginning to form themselves into organized states, that indigenous populations like the Mons and

the Khmers found it necessary to modify Indian writing to adapt it to the phonetics of their own languages. In the interests of the Buddhist religion, they undertook a whole-scale vulgarization of the literature so that it could be used to instruct village communities and to publish commentaries in the vernacular languages. To be sure, they constantly refer to the Pali canon through systems of references and quotations, but these are combined with an abundance of legends and narratives from the local mythology, which had been handed down orally for centuries. Whereas the first writings of an Indian type imported into the region by the Brahmans could not have enjoyed a wide circulation outside the elites directly concerned (the hymns and prayers are addressed only to the gods, and the inscriptions on monuments only to posterity), it is likely

that by this time the use of the alphabet was becoming more common and the tradition of the copyists had made considerable progress.

For centuries in Southeast Asia, copyists raised in monasteries have been engraving—on latania leaves, and according to strict rules—manuscripts faithfully reproduced from earlier copies, which serve as models (Figs. 2 and 3). Sometimes they cannot understand the meaning, concentrating their efforts on each letter, but they aware that they are performing a supremely pious act: the engraving of a text from the Buddhist canon. In enacting this ritual, not only are they, as the colophons almost always say, "perpetuating the religion" according to an unbroken succession which guarantees its validity, but they are also giving physical substance to the *dhamma* (the "teaching"), each syllable of which is conceived as an image, and even a manifestation, of the Buddha.

Doctrinal texts are treated as relics. As such they are venerated just like sacred "images," as are all statues, the stupa, and other representations of the Buddha. Hence there is a series of analogies between the elements composing a manuscript and the body of the person meditating, modeled on the archetypal image of the fetus in gestation in the womb (the believer creates a new, pure body within himself, a Buddha body, on the basis of the literal elements of the doctrine). The different parts of the manuscript (characters, leaves, strings, materials) are compared to the organs of the fetus (primordial constituent parts, limbs, umbilical cord, skin).

This is why the supreme merit for a Buddhist consists in presenting the monastery with "the offering of a *dhamma*," a manuscript that itself, alone, represents the whole of the Buddhist doctrine. This offering generally consists of a copy of a text or an order for one from a specialist (Fig. 2), or even the reading of a text during a ceremony or a festival (Fig. 1).

An examination of ancient texts dating from before the modern reforms of writing reveals that the prevailing tendency among copyists was to concentrate signs in combined graphic units (the final consonant of a monosyllable, or the second syllable of a word, being grafted either onto or underneath the initial consonant). This leads to ambiguities in the reading that oblige Western readers, used as they are to linear alphabetic writing, to perform constant visual gymnastics. It is thus not entirely true to say that one reads from left to right, as those who have described these scripts have too readily asserted. From a letter there always emerges a syllable, which itself can produce a word. Moreover, because of the symbolic nature of syllables a whole phrase may be born from a single letter, and a poem from a mantra (for example, *Ratanamala*). This efflores-

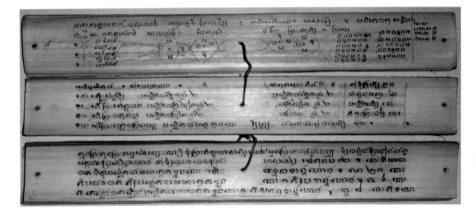

Fig. 3. Manuscript on a latania leaf. The letters are usually engraved over five lines with a metal-pointed stylus, and coated with lamp-black. The bundles are planed, pierced with two or three holes, and joined together with a string that passes through either the left-hand or the central hole to form a volume of a variable number of leaves.

cence of the syllabic element is latent in all the religious writings of the region. Those of the northern part of the peninsula (Tham writing in Laos, Thai khun in Burma, Thai lu in China, and Yuon in Lanna) have particularly developed this combinatorial tendency, creating abbreviations and stylized signs that cannot be explained as the simple joining-up of letters bound together by virtue of the cursive nature of the script. Rather, they are the result of a genuine desire to place the letter in a space that allows it to command attention as an independent graphic whole.

The division of Pali formulas into simplified graphic units led, in the same way as the tendency to isolate and concentrate syllables, to manifold manipulations in which the letter was incorporated into the composition of tables and coded combinations of signs that conferred invulnerability and supernatural powers. These same compositions were used in protective diagrams—or *yantra* (Fig. 4)—that combined letters and figures, and were composed not for reading but for their magical power, which was based on the sacred nature of the letter.[2] Such diagrams might be drawn on shirts or headscarves, engraved on metal tablets for use as amulets, or tattooed on the skin. They became very popular throughout Southeast Asia. Whereas in China the whole of written art focused on calligraphy, in the Indo-Chinese peninsula it seems to have found expression more in ingenious patterns and in the stylistic arrangement of its compositions.[3]

What emerges in particular from the photographs shown here is that the peoples of Indo-China, proceeding from a conception of writing as a scholarly instrument reserved for the grammarians and priests of the elite—in exactly the same way as the canonical language—were led by their

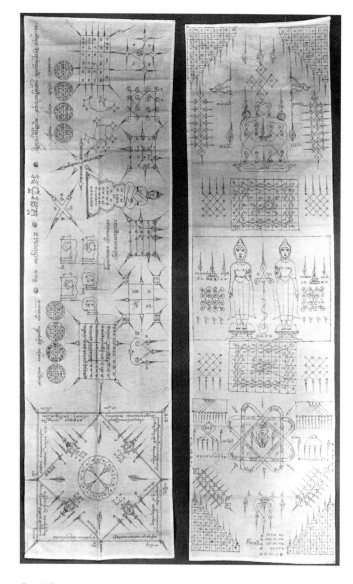

Fig. 4. Protective scarves covered with *yantra*. The two central statues of the Buddha, supporting the protective spirits Neang Chek-Neang-Cham, are the pivot around which are arranged coded strapwork and diagrams, composed for the most part of letters and names of the Blessed One. Northern Pagoda of Angkor Wat, Cambodia.

pragmatism and by their own cultural past to develop mystical practices that implied not so much a knowledge of the sacred language as a recognition of the elements of those combinations of letters on which they relied in their rituals, their prayers, their meditation exercises, their healing operations, and their magic.

Notes

1. Becchetti and Bizot, 1998.
2. Becchetti, 1991.
3. Becchetti and Bizot, 1998.

Bibliography

BECCHETTI, C. *Le Mystère dans les lettres* (Bangkok: Edition des Cahiers de France, 1991).

———. "Une ancienne tradition de manuscrits au Cambodge." *Recherches nouvelles sur le Cambodge*, published under the direction of F. Bizot, *Études thématiques* no. 1, École Française d'Extrême-Orient (Paris, 1994).

———. (in collaboration with F. Bizot). "Une écriture codée des noms du Bouddha." *L'Écriture du nom propre, Actes du colloque* (L'Harmattan, 1998).

BIZOT, F. *Les Traditions de la pabbajjoe en Asie du Sud-Est, Recherches sur le bouddhisme khmer,* IV (Göttingen, 1988), Abhandlungen der Akademie der Wissenschaften in Göttingen, Philologisch-Historische Llasse, Folge 3, Nr. 169.

———. "Ratanamala. La Guirlande de joyaux." *Textes bouddhiques du Cambodge* n° 2, Publication du Fonds pour l'édition des manuscrits, École française d'Extrême-Orient (Paris-Chiang Mai-Phnom Penh, 1993).

BÜHLER, J. G. "Indian Paleaography." In J.F. Fleet, *The Indian Antiquary*, vol. 33, 1904 [prev. publ. in germ. Strassburg, 1896]

CHHABRA, B. CH. *Expansion of Indo-aryan culture during Pallava rule (as evidenced by inscriptions)* (Behli, 1965).

CŒDÈS, G. *History of Thai Writing.* (Bangkok, 1924) (in Thai).

DAMAIS, L. C. "Les Écritures d'origine indienne en Indonésie et dans le Sud-Est asiatique continental." *BSEI*, vol. XXX, 4, 1955, p. 365-382.

FERLUS, M. "Les circonstances de l'introduction de l'alphabet tham lanna." First franco-thai symposium on ancient Thai history from its origins to the fifteenth century (Bangkok: Silpakorn University, 18-20 July 1988).

———. "Langues et écritures en Asie du Sud-Est (les écritures d'origine indienne et leur adaptation aux langues de l'Asie du Sud-Est continentale: les consonnes)." The 21st International Conference on Sino-Tibetan Languages and Linguistics, University of Lund, Sweden, 7-9 october 1988.

FÉVRIER, J. *Histoire de l'écriture* (Paris, 1995), p. 334-375.

FILLIOZAT, J. *L'Inde classique* (Paris, 1953), p. 665-702.

FINOT, L. "Recherches sur la littérature laotienne." *BEFEO*, vol. XVIII, 5, 1917.

GAGNEUX, P. M. "Sur un mode particulier d'acquisition de mérites dans le Laos ancien: l'inscription des images du Bouddha (données épigraphiques)." *ASEMI*, vol. VIII, 1, 1977, p. 93-102.

———. "Les écritures lao et leurs évolutions du xve au xixe siècles." *ASEMI*, vol. XIV, 1-2, 1983, p. 75-86.

JACQUES, C. *Angkor* (Paris, 1990).

KONG KÉO VIRAPRACHAKS. *Seven hundred years of Thai writing.* (Bangkok: Silpakorn University, 1988), 80 pages.

LAFONT, P. B. "Les écritures 'tay du Laos." *BEFEO*, vol. L, 2, 1967, p. 367-393.

———. "Les écritures pâli du Laos." *BEFEO*, vol. l, 2, 1961, p. 394-405.

SINGARAVELU, S. "Note on the possible relationship of King Rama Khamhaeng's Sukhodhaya script of Thaïland to Grantha script of South India." *JSS*, vol. LVII, 1, 1969.

STEVENS, J. *Sacred Calligraphy of the East,* new ed. (Boston & Shaftesbury, 1988).

VIMOLKASEM, K. *L'Écriture "fak kham" dans les inscriptions du Nord.* (Bangkok: Silpakorn University, 1983) (in Thai).

———. *L'Expansion de l'écriture Fakkham*, Advanced Studies Diploma thesis (EPHE, 1992).

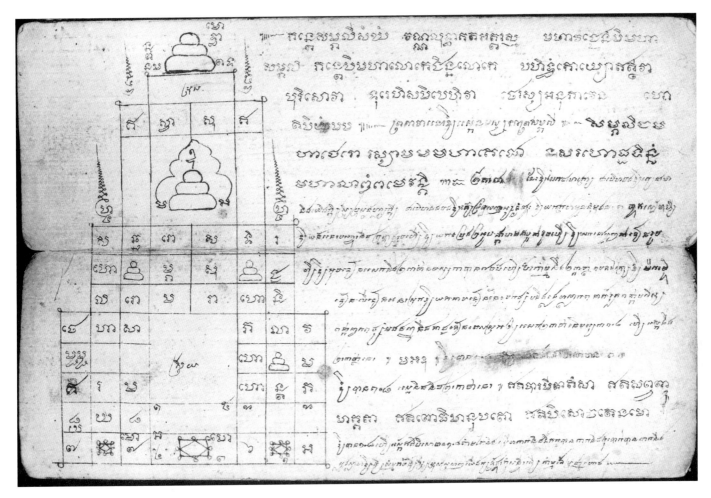

Fig. 5. Khmer manuscript on paper, called *kramn* (the bark of *Streblus asper*), folded like an accordion. This type of medium, less formal than latania leaves, has often been used as notebooks by the specialists of the cult (*acary*) for recording extracts of the liturgy, indications concerning ceremonies, outlines of initiation practices (rites, meditations, etc.) or magic (divination, medicine, etc.). The double page of this manuscript reveals two systems of writing which exist side by side in a space that was originally set aside for a linear text but has been invaded by esoteric combinations. The diagram, composed of letters and figures enshrined in a frame, straddles the two leaves. Two styles of writing appear in this text: the round writing (*mul*) to transcribe the Pali, and the cursive writing (*jrien*) for the glosses.

THE KOREAN ALPHABET

Daniel Bouchez

Korean is written using an alphabetic script, known today as *han'gûl*, which originally consisted of twenty-eight letters but has now been reduced to twenty-four (fourteen consonants and ten vowels). It replaced a previous system of Chinese characters that were used either semantically or phonetically. The alphabet's invention is first recorded in 1444, and it was presented in its final form by King Sejong in 1446. It was issued with an explanatory document (Fig. 1) that set out directions for its use and the principles underlying its creation, which were essentially those of Chinese phonology adapted to the Korean language. Chinese phonology distinguished only two elements in a syllable: its initial (consonant) and its "rhyme" (vowel with or without a final consonant). Initial consonants were classified according to their points of articulation into ten categories, which were themselves divided according to secondary characteristics. The Korean system retained nine of these categories, and each category has an "entirely clear" (voiceless) sound with its own corresponding simple graphic sign. These basic symbols were given an emblematic value (as explained in the document of 1446), indicating the position of one of the speech organs involved in the phonation. This simple sign serves as the basis for all the characters in the same category, as shown by a lengthening, or the addition of a stroke to indicate an aspiration, or a reduplication to indicate a hardening of the sound through emphasis.

When it came to the "rhyme," the Koreans made a distinction between the medial sound (vowel) and the final sound (consonant). By identifying the latter with one of the initial sounds and specifying that it would be written in the same way, they showed that they were aware of the interaction between vowel and consonant. The sign for the six basic vowels consists of a stroke and/or a dot. The stroke is vertical in the case of what are termed open vowels [a], [∂] and [i], horizontal for closed vowels [o], [u] and [ɨ]. The absence of a dot—since transformed into a dash perpendicular to the stroke—or its presence, on the right or left of a vertical stroke, above or below a horizontal stroke, differentiates the vowels. Vertical vowels are placed on the right of the initial consonant, horizontal vowels beneath them.

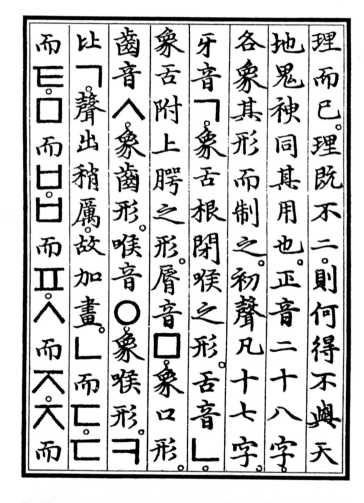

Fig. 1. Page from an edict promulgating the alphabet in 1446. The text in columns 4 and 5 (from the right) reads: "The molar sound [k] is in the shape of the root of the tongue closing the throat, the lingual [n] represents the shape of the tongue touching the upper palate, the labial [m] depicts the shape of the mouth."

관계를 가지고 있어서, 전편과 속편이 이질적이지 않을 수 있는 좋은 예이다. 윤·하·정 세 가문의 남녀가 서로 얽혀 있는 무척 복잡하면서 흥미로운 양상을 전편에서 한차례 다룬 다음에 속편에서 다음 세대의 사건을 취급할 때에도 같은 방식을 그대로 이어 세 가문 이대기로 205책이나 되는 2부작을 완성했다. 〈엄씨효문청행록〉은 그 가운데 윤씨네와 사돈이 되는 또 한 가문의 내력을 서로 관련되는 맥락에서 설정했으니, 아직은 이름만 알려진 그 속편과 함께 크게 보아 단일 작품군 안에 든다.

비슷한 성향을 가진 여러 작품에서 볼 수 있는 인물·사건·수법 등을 두루 모아들여 잡다하면서도 통일성 있는 구성을 갖춘 것이 대장편을 이룩한 비결이다. 몇 백 명에 이르는 등장인물이 벌이는 무척 복잡한 사건이 작품을 계속 확장시켰지만, 기본 양상은 새롭지 않고 흔히 볼 수 있던 방식으로 되풀이되었다. 천상에서 하강했다는 남성 주인공은 뛰어난 재능을 발휘해 가문의 위세를 더욱 높이고 성현의 가르침을 돈독하게 실행해 지배체제를 재확립하는 것을 사명으로 한다고 설정해놓았다. 그러면서 천정배필을 만나 혼사를 이루기까지의 장애를 다루고, 동성간의 질투에 의한 모함, 이성을 강압적으로 차지하려는 데서 생기는 파란을 문제삼았다. 세상에는 요사스러운 인물이 적지 않고, 무슨 도술을 써서 얼굴이나 마음을 바꾸어놓는 짓도 하기에 파란이 중첩된다는 것으로 흥미를 돋우면서, 세상이 타락될수록 질서를 되찾는 데 더욱 힘써야 한다고 했다.

〈완월회맹연〉(玩月會盟宴)은 180책이나 되어 단일 작품으로서 가장 방대한 분량이다. 오늘날의 단행본으로 열두 권이나 된다. 작품 본문에서 〈맹성호연〉·〈양씨가록〉·〈정씨후록〉 등 여덟 종이나 되는 속편이 있다고 했는데, 아직 발견되지 않았다. 그런 속편들까지 합치면 더욱 놀라운 거작이다. 송대 정명도(程明道)의 후손이라 한 정한이라는 인물이 명나라 때 산중에서 성리학에 힘쓰다가 황제의 간절한 부름을 받고 세상에 나와 최고 지위에 올라 부귀를 누리면서, 가문을 번성하게 해서 사람이 누릴 수 있는 모든 이상을 실현했다는 것이 기본 줄거리이다. 정한의 생일날 달 구경하는 자리에 모인 친지와 문하생들이 각기 자기 자손을 소개하

Fig. 2. Korean text of 1954, written vertically, from right to left, with numerous Chinese characters.

Fig. 3. Korean text of 1994, written horizontally, with very few Chinese characters added in parentheses.

Yodization is indicated by doubling the dash, diphthongization (which has become umlauting), by the addition of the vertical stroke, the sign of the [i], as yodization and diphthongization can be combined. The initial [w] sound is written with an [o] when it occurs before [a] and with a [u] before the other vowels.

Han'gûl is not a linear script. It is syllabic as well as alphabetic. Each syllable is composed in an imaginary square, in which the letters are written from left to right and from top to bottom, the eventual final consonant being placed beneath the initial and the vowel. The absence of an initial consonant is compensated for by the use of a valueless character.

G. Ledyard has recently demonstrated the link between the invention of this alphabet and the spread of alphabetic writing in Asia. Korean phonologists knew and used the Tibetan *hP'agspa* alphabet, invented in 1269 to transcribe the languages of the Mongol empire. Five categories of initial sounds are common to the two alphabets. In four of the five, the basic Korean character appears to be a simplified form of the *hP'agspa* sign.

The use of the alphabet spread slowly and did not prevail until the end of the nineteenth century, following the renunciation of classical Chinese as the literary and administrative language. The use of Chinese characters to write terms of Chinese origin in a Korean text is now rare; they are called on only where necessary. The spelling that was laid down in 1930 privileges etymology over pronunciation, and subsequent modifications have not altered this tendency. The horizontal script, written from left to right, has increasingly supplanted the ancient vertical one.

VIETNAMESE SCRIPT AND SOCIETY

There have been two scripts in the history of writing Vietnamese: the *nôm*, which is no longer used, and the *quô'c ngû'*, which is in current usage.

The characters of *nôm* were modeled on Chinese around the twelfth century and may be divided into two types, simple and complex.

1. Simple characters have been borrowed directly without modification from the Chinese to convey a Vietnamese word that is either a homophone or a paraphone:

Character	Pronunciation		Meaning	
	Sino-Viet.	*nôm*	Chinese	*nôm*
卒	*tô't*	*tô't*	soldier	good
買	*mài*	*mâ'y*	buy	some

2. Complex characters consist of two elements, one semantic and the other phonetic: the first is generally a Chinese radical, the second a Chinese homophone or paraphone:

Fig. 1. The biography of Emperor Tu'-Du'c engraved on stone.

Character (*nôm*)	Semantic element	Phonetic (Sino-Viet pron.)
伵 *tô'* SERVANT	亻 MAN	四 *tû'*
刮 *chém* TO CUT	刂 KNIFE	占 *chiêm*

Despite its appearance, *nôm* is above all a phonetic script that is based on what is known as Sino-Vietnamese pronunciation—that is to say, the pronunciation of Chinese characters by the Vietnamese. For them, Chinese is a dead language, and the words they borrowed, cut off from their Chinese source since the tenth century when Vietnam became independent, have become bound by the phonetic rules of Vietnamese.[1]

It was with A. de Rhodes' edition of the *Dictionarium anna-miticum, lusitanum et latinum* (Rome, 1651) that the alphatebic script *quô'c ngû'* first appeared, but its present form was fixed by another clergyman, J.-L.Taberd, in his *Dictionarium anamitico-latinum* (Serempore, 1838). *Quô'c ngû'* comprises 44 signs, of which 27 are consonantal, twelve vocalic and five tonal. All exist already in the Latin alphabet, except the letters *đ, ă, ơ, ư*. One must distinguish the different tonal signs placed either above or below the vowel in the following examples: *ma* (GHOST), *mà* (BUT), *má* (CHEEK), *mạ* (SOWING), *mả* (TOMB), *mã* (HORSE).[2]

Nôm took the syllable as the operative phonetic unit for graphic representation. This resulted in a multiplicity of characters: in a non-exhaustive index published in 1976 in Hanoi, 8,187 were registered. As *quô'c ngû'* relies on the analysis of phonemes it uses a small number of signs. When it comes to learning the language, *quô'c ngû'* is distinctly more economical than *nôm*.

Throughout its existence, *nôm* has never played an important role. Indeed, although Vietnam rid itself of Chinese occupation in the tenth century, it kept Chinese as the official administrative language. Thus Vietnamese, and consequently *nôm*, was only of secondary importance.

Fig. 2. Two pages from the *Manual of Five Thousand Characters* by Nguyen-Ngoc-Xuan, published in Hanoi in 1929, for the use of Vietnamese learning Chinese. The large characters correspond to Chinese words, with the Sino-Vietnamese pronunciation transcribed in *quô'c ngû'* alongside. The little characters are in *nôm*; they give the Vietnamese meanings of the corresponding Chinese characters. Their pronunciation is transcribed in *quô'c ngû'*.

Nevertheless, the replacement of *nôm* by *quô'c ngû'* in the middle of the nineteenth century, encountered strong resistance from the Vietnamese. *Quô'c ngû'*, imposed by the new French colonial administration, was identified with Catholicism in a country that practiced mainly Buddhism and Confucianism. Above all, it heralded the loss of national sovereignty and the decline of a traditional culture of which the literati, steeped in Chinese studies, were the most ardent defenders.

The last civil service examinations of the Imperial Court of Vietnam in which Chinese played a prominent part were held in 1919. But already in 1907, literati were actively working to spread a new culture for which one of six proposals was the use of *quô'c ngû'*, rightly considered to be an efficient weapon against illiteracy. This was a turning point for the romanized script. The coming of *quô'c ngû'* signalled both the rise of a new generation of intellectuals, educated in Franco-Vietnamese schools, and a profound transformation of society.

Notes

1. See Nguyen (1978) for a detailed study.
2. See Haudricourt (1949) for a complete table.

Bibliography

DE FRANCIS, J. *Colonialism and Language Policy in Vietnam* (La Haye: Mouton, 1977).

HAUDRICOURT, A.-G. "Origines des particularités de l'alphabet vietnamien." *Bulletin Dân Viêt Nam* 3 (1949): 61–8.

MASPERO, H. "Etudes sur la phonétique historique de la langue annamite. Les initiales." *Bulletin de l'Ecole française d'Extrême-Orient* 12/1 (1912).

NGUYEN, P.P. "A propos du nôm, écriture démotique vietnamienne." *Cahiers de Linguistique Asie Orientale* 4 (Paris: CRLAO, 1978).

PRINTING AND THE REPRODUCTION OF THE WRITTEN WORD IN THE FAR EAST

Jean-Pierre Drège

In the Chinese world, the word "printing" covers two techniques that are, in fact, rather different—xylography and typography. But whereas in Europe the former enjoyed only limited diffusion and the latter provoked a veritable revolution, in China and East Asia it was virtually the reverse phenomenon that was produced.

BIRTH OF XYLOGRAPHY

Official Chinese historical sources agree in situating the birth of the technique of reproducing the written word by xylography in the middle of the tenth century, when the imperial administration of the Posterior Han, followed by the dynasties that succeeded it, had the Confucian classics printed between 932 and 953. In fact, the process was not really new, as it had probably already existed for at least two hundred years. This double origin reflects the two different objectives of this method of production at the times when it was first brought into use. In official circles, engraving the classics on wood was considered as no more than an economical substitute for engraving them on stone. Here, the aim was not to accelerate the diffusion of the Confucian doctrine but, above all, to establish correct versions of the texts that could be transmitted without error. Xylography thus came to replace the more ancient technique of the ink rubbing, which had appeared perhaps as early as the fifth century but had certainly been in use since the seventh century. The process consisted of placing a sheet of damp paper onto a hollowed-out inscription so that the paper penetrated into the hollows, then inking the

Fig. 1. *Dharani*. Tenth-century xylography from Dunhuang. MG 17688, Musée Guimet, Paris.

Fig. 2. *Shangshu* (Book of Documents). Classic engraved on stone *ca* 240–248. Fragment of rubbing. Ecole Française d'Extrême-Orient, Paris.

sheet by rubbing or using a pad so that the engraved signs—whether writing or images—would appear in white on a black background. Thanks to this technique, it was possible to make an exact copy of both the works of calligraphers and the texts of the Confucian canon (Fig. 2). The possibility of any error in copying was thus excluded. The influence that the rubbing technique exerted on xylography was very real, but it was not due to any logical development in the technical aspects of the process, as xylography, unlike ink rubbing, depends on an engraving that is both inverted and raised in relief. It was, rather, part of an intellectual process that handed down and perpetuated an ideal.

The other origin of xylography undoubtedly stems from the technique of seal engraving and seal impressions. From ancient times, seals were cut in reverse on materials as diverse as jade, metal, ivory, or wood. First they were printed in clay in order to seal and authenticate documents, then they were inked up with a cinnabar-based paste and applied to paper. Even though the inscriptions consisted generally of only a few characters conveying personal names, the Buddhists seized on this technique to carve images that could then easily be printed in large numbers. They thus proceeded to reproduce images of little Buddhist figures, almost mechanically, in thousands, in the same way that they tirelessly repeated magic formulae to gain reward or, occasionally, simply to get out of trouble. The most ancient printed texts that have come down to us are products of this process of multiplying the same images and charms. It was probably at the end of the seventh century or during the first half of the eighth century that the cutting of longer texts became more commonplace. Their printing was only made possible by reversing the process: whereas the inked xylographic stamps were pressed hard on the paper, now the sheets of paper were placed on the inked plate. Rubbing the back of the paper with a pad helped to make the sheets adhere more closely to the plate, and it became possible to print a large surface in one go. Nevertheless the first extant printings are still in small format. These are the little scrolls of *dharani* that the empress Shotoku had printed in Japan between 764 and 770. One hundred thousand, perhaps a million, of these *dharani* may have been printed at that time. These are the most ancient dated printed texts to have been found so far, and they show the striking progress that xylography made after its birth in China, when it very soon spread to Korea and Japan, both of which were then heavily influenced by China. The technique has left early traces in both Japan and Korea, where a small sutra—printed perhaps around the middle of the eighth century—was discovered in 1966, but it is scarcely found in China itself before the second half of the ninth century. By that time, however, the xylographic process had been fully developed and perfected:

the manuscripts cave at Dunhuang (on the borders of China and Central Asia) has yielded a copy of the Diamond Sutra, engraved in 868, that is a complete printed work, embellished with a frontispiece that is also printed. From that time on, the Buddhist scriptures were mass-produced by xylographic techniques, and the old system of copying was abandoned without regret.

FROM MANUSCRIPT TO PRINTED PAGE

The response to the newly emerging xylographic printing process reflected the dual advantages that Chinese xylography itself possessed by virtue of its technical properties. On the one hand—and contrary to claims that are sometimes made—it enabled the Buddhist desire for mass production to be satisfied. Woodblock printing was relatively inexpensive as it generally used the wood of the pear tree (or other fruit trees) and it also permitted printing on a large scale, insofar as there was no danger of the plates becoming prematurely worn out. Thus we know, thanks to printed Buddhist works from the sinicized Dangxiang (Tangut) kingdom of the Xixia (1032–1227), that such editions might run to as many as fifty thousand copies. On the other hand, woodblock printing met the requirement for faithful reproduction of an original model. Unlike typographical compositions, which must be disassembled after use so that the characters can be re-used to set up fresh type, the engraved wooden plates may be kept intact for further printings. And these may be made in small quantities as and when there is a demand for them. The plates may also be hired out or sold, and they can be repaired should they become damaged or worn-out.

The xylographic technique seems to belong to the tradition of manuscript copying (indeed to be a continuation of that process), but at the same time it appears to depart from it in subtle measures that are not easy to gage (Figs. 3 and 4). The same is true of the script that xylography did not really modify. Just as the engraver working in stone could faithfully imitate the wildest strokes of calligraphy, so he could, when working in wood, use his chisel to reproduce the blank spaces on a page of manuscript. The original model is in fact directly transferred onto the woodblock plate to be cut without recourse to the engraving of separate, identical characters. Variations in the forms, styles and proportions of the writing can be reproduced unchanged, even if the spontaneity is lost. It is possible to combine different elements in a single engraving without encountering any problems concerning their height or typesetting. Scripts that are distinctly different, such as the regular Chinese one and the Brahmanic Sanskrit, can be brought together. What is more,

one can make light of the constraints of linearity and compose a text vertically just as easily as horizontally, even with an alphabetic script such as for Sanskrit or Tibetan; indeed, one may even cast it in the form of a circle (Fig. 1). Yet this wide range of possibilities was not always exploited. Most of the time, and especially at the beginning, no attempt was made to make the printed book look distinctly different from a manuscript book (the same would happen in Europe some centuries later). The layout of the text remained the same, and the regular style of the script employed by the copyists for works in libraries, whether Buddhist or Confucian, was retained without modification. The apparent standardization of the xylographic script in the Song dynasty (960–1279) in fact reflects a normalization of the script that had taken place in the Tang dynasty (618–907) and was inherited from the court calligraphers whose styles had been adopted. This normalization was reinforced when calligraphy was introduced as a subject in official state examinations.

The freedom that xylography offered by comparison with typographic printing is particularly evident in the illustration of books. Texts and pictures are engraved on the same woodblock plate, often by the same engraver. As this method was easy to employ it resulted in an abundance of illustrations, unhindered by the problems associated with the simultaneous use of wood and metal in Europe. Here again, xylography should be seen as part of a process of evolution rather than one of radical change. The pictures used to illustrate manuscript works could be transposed without modifying either their form or their layout, whether they occurred separately from the text, as in the case of frontispieces, or were interspersed within the text itself. This contributed to the perpetuation of the practice of placing pictures in sequence above the text, in the top half or third of each leaf, thus allowing a more or less simultaneous understanding as well as a parallel reading of both text and illustrations. In the same way, the practice was continued of cutting up the text into passages separated by illustrations that summarize a particular section or introduce it. The fresh contribution made by xylography in this area resulted from the distribution of illustrations throughout texts in a variety of formats that facilitated the diffusion of technical works, whether they dealt with ritual material (Fig. 5)—which was of paramount importance—or pharmacopeia.

TRANSFORMATION OF THE BOOK

An important turning point in the evolution of the book, signaling the passage from manuscript to printing, was the change in the form of the scroll and its eventual abandonment in favor of collated leaves. This transformation took

Fig. 3. (top) *Guanyin jing* (Sutra of Guanyin). Ninth-century manuscript from Dunhuang. 8210 / S.4031, British Library, London.

Fig. 4. (bottom) *Guanyin jing* (Sutra of Guanyin). Ninth- or tenth-century xylography from Dunhuang. 8210 / P13, British Library, London.

Fig. 5. Xylography of *Xinding Sanlitu jizhu* (Illustrations of the Three Rituals). New annotated edition by Nie Chongyi (Zhenjiang fuxue, 1175). National Library of China.

books frequently resulted in a smaller format than the scrolled versions, but the change from a book that was unrolled to one whose pages were turned entailed other consequences. With scrolls, the cutting-up of text had been quite unnecessary; the discourse was very often continuous, without indentation, division into paragraphs, or punctuation. At best, commentaries on the text were inscribed in smaller characters in double columns. One could write the copy on a scroll that had already been set up, but even if it had not, the risk of mislaying some of the inscribed sheets was slight as there was only one copy involved. With books on the other hand, the difficulties in assembling the material became significantly greater when printing, one after the other, dozens or hundreds of different pages from a single work. It then became necessary to indicate in each case the page and chapter number, and even the title of both the work and the chapter. These annotations also contributed to the changes that took place in the appearance of books and the way they were used.

The delay in the spread of xylography in Confucian circles—by comparison with those of Buddhist activists when the technique first appeared—was made good from the ninth century onward. The expansion of the civil service competitive examinations, urban development, and the economic transformations that occurred at this time all boosted a veritable explosion in the process of reproducing and, above all, of disseminating the written word. Changes in the physical presentation of the book, particularly the addition of points of reference, and the reduction of the cost of books (which was significant, even if difficult to evaluate precisely) also had an influence on the sales of books and on the attitude of their readers. The obsolescence of the copyist's role transformed reading habits. Pedagogues, confronted with the popularization of the printed book in the eleventh and twelfth centuries, and fearful that intellectual impoverishment would ensue, reveal the advent of new forms of behavior: a decline in the custom of learning by rote that the rarity of manuscripts had necessitated; the practice of accelerated, perhaps silent, reading; and the habit of disconnected, utilitarian reading, in search of examples and quotations, to the detriment of absorbing and ruminating over texts. All this, according to the literati, induced in students a detached attitude toward books and a deterioration in their studies; but such claims are extremely difficult to verify.

The acceleration in the spread of xylography that took place in China during this period had repercussions in neighboring countries, which were then dominated to a large extent by Chinese culture. Empires like those of the Qidan, the Nüzhen and the Dangxiang (Tangut), by virtue of their ties with Song China, all benefited from xylography: some using the Chinese language, others using both Chinese and

place in the eighth century, at about the same time as the appearance of xylography. The paper scroll, which had been in use since at least the first century of the common era, had little by little replaced silk scrolls and bamboo strips. Given the considerable number of Buddhist manuscripts brought into China for translation, it was probably the influence of Indian books made from palm leaves that prompted the Chinese to cut up paper leaves, fold them and assemble them. The book then took on a variety of forms, the most common of which were screens of different sizes, and bindings resembling our codices. Such a sophisticated type of binding was to decline fairly rapidly, insofar as its complex forms were concerned, for the simple reason that only one side of the leaves was printed. Use of the rubbing brush made double printing impossible. This is why the "butterfly" binding finally limited itself to a series of leaves folded in two, with their blank *verso* sides glued together, without insetting or binding in stitched books. Later, blank pages were avoided by joining the leaves (after they had been turned over) at their edges rather than at the fold. Paginated

Fig. 6. *Wenxin diaolong* (The Literary Mind and the Carving of Dragons) by Liu Xie (465–522). Xylography in five colors, engraved by Ling Yun of Wuxing, *ca* 1628–1644. National Central Library, Taipei.

their own recently created script, based on Chinese characters. Further to the west, in the thirteenth century, the Uygur (Uighur) kingdom in the Turfan region was also using xylography. The latter had already, as we have seen, long since penetrated the Korean kingdom of Silla (668–935) as well as Japan. The vehicle of this diffusion was, of course, Buddhism, which encouraged its followers to repeat the words of the Buddha endlessly, not only to spread their message but also to prevent them from disappearing, by enshrining sutra, like holy relics, in pagodas or statues. In all the countries that it reached, xylography established itself quite spectacularly.

The technique of xylography had already been perfected by the ninth century and, without subsequently undergoing any radical changes, was to dominate the Chinese world until the nineteenth century. A few improvements and additions would ensue, in particular with the remarkable progress in book illustration and the blossoming of colored printing. The amount of illustration in printed books increased markedly in the sixteenth century, with the rise in the number of books destined for art lovers as well as of art books to which painters themselves contributed. It was then that pictures began regularly to spread over a whole or double page. Printing was henceforth no longer merely a means of reproduction but a vehicle for artistic expression in its own right. And color gave it an additional creative value. The use of black and red ink had originated with manuscripts; in printing, little by little, blue, red and yellow came into use for the coloring of commentaries and glosses (Fig. 6). At the end of the sixteenth century, five colors were

used in the printing of art books, ink albums, model paintings, writing paper, works of cartography, etc. The process used was that of "plates in series," by which each color corresponded to a different plate. The number of books published was limited, but they display an important technique that was later to be transmitted so successfully to Japan.

MOVABLE TYPE

Shortly after its adoption in scholarly circles, xylography found itself confronted with numerous experiments in printing with movable type. The first attempts date from the beginning of the eleventh century, when a certain Bi Sheng cut characters in clay that he baked before assembling them on an iron dish and setting them with wax and pine resin. During the same period, or soon after, the idea also emerged (inevitably, perhaps) of cutting out characters that had been engraved on woodblocks and printing them in various compositions. Instead of cutting identical characters over and over again, it became possible to re-use them. The fact that the characters of the script were not joined together but were set apart from one another as distinct units may logically have favored such an initiative. The advantages of typography may seem to us to be enormous and even obvious; but not to the Chinese. In fact, whereas a printer's case contains only a relatively limited number of typographic elements, the Chinese script, with its several thousand different characters, poses almost insuperable problems for a typesetter. It was as though a Western typographer had to have at his disposal as many characters as there were words in the language. Making a selection from among

Fig. 7. Fourteenth-century revolving case. In sixteenth-century xylographic edition of Wang Zhen, *Nongshu* (Book of Agriculture).

Fig. 8. *Shiqishi zuan gujin tongyao* (Extracts from the Seventeen Dynastic Histories). Korean xylography, 1412. National Library, Seoul.

several thousand elements is costly in terms of time, filing systems, and personnel. The ingenious invention of the revolving case, devised by Wang Zhen in the fourteenth century, only partly solved the problem (Fig. 7). Another obstacle was undoubtedly the relative fragility of wood as a material. Although it was entirely suited for the cutting of block plates, when it was used to make separate typographical elements that required frequent handling it was much more liable to wear and even breakage. Perhaps paradoxically, typography confers no advantages as far as the running-off of impressions is concerned. In fact, the flexibility provided by the possibilities of infinite reprinting from woodblock plates has no equivalent in printing from movable type. The run has to be fixed once and for all and must be completed before the type can be used again. This is an important consideration, as decisions must be taken before it is known how rapidly the books will sell or whether provision has been made to keep unsold copies in good conditions; typography is not a good technique for long-term projects. If one examines the many different typographical ventures that have taken place in China, one realizes that they were often responses to particular needs, as for example the printing of official texts in the gazettes published by the Qing dynasty imperial administration or

the printing of genealogical registers for clans. In both cases the quantity of different characters to be used was rather limited—much more so than in works of literature, or those dealing with other subjects. To a lesser extent, the fact that China did not perfect a system of die and matrix may have acted as a brake on the development of typography. Repeated attempts to print with movable characters aimed rather at solving the problems posed by the material from which they were made: wood, terracotta, tin, or bronze. Specialists have sometimes wondered whether the bronze characters used at the end of the fifteenth century (by the Hua and An families of private printers in the Jiangsu region) or, later, in the eighteenth century (by the imperial administration in publishing a vast encyclopedia of ten thousand chapters, the *Gujin tushu jicheng*) were engraved or cast. But there is no technical information to provide confirmation that they were cast. In this respect, Chinese typographers—at least those of the fifteenth and sixteenth centuries—seem not to have known about the fairly successful experiments that were performed in Korea, especially during the first half of the fifteenth century (Fig. 8). These were state-sponsored, as only the government had large supplies of copper at its disposal. The technique was not far removed from that of the Europeans in its conception: engraving with a chisel on hard wood, the creation of a sand-cast matrix, and the casting of characters in a mold by hand with a mixture of copper, tin, and zinc. Even though typography did not maintain its hold in Korea beyond the fifteenth century, it enjoyed a certain success in Japan during the first half of the seventeenth century. But the Japanese preferred to use wood rather than bronze and followed the technique used in China. Once again, however, the processes of printing with movable type remained considerably less important than the technique of woodblock printing. The survival of a such a simple process, which for long blocked the progress represented by typography in European eyes, has led to an unfortunate tendency in some circles to accuse the Chinese cultures of immobility. This notion was reinforced by the fact that Western techniques, such as electrotyping, which had only just emerged in the West, were adopted in China and Asia from the middle of the nineteenth century onward. But it forgets the real success of xylography, which, being better suited to the Chinese script, made possible the diffusion of ideas and writings just as

Fig. 9. *Tangshi huapu* (An album of Paintings for Tang Poems) by Huang Fengchi and Cai Zhonghuan. Xylography engraved by Wang Shiheng. Huizhou, late sixteenth to early seventeenth century. Peking Library.

effectively as typography in Europe. As far as the quality of printing is concerned, particularly of illustrated books, even if the woodcut does not achieve the same precision as copperplate engraving or etching, the degree of expression and refinement attained by engravers and printers in the sixteenth and seventeenth centuries is certainly not inferior to that of their European counterparts. At the same time, xylography was able to leave the oriental taste for the handwritten script and calligraphy undiminished (Fig. 9).

Bibliography

CARTER, T. F., and L. C. Goodrich. *The Invention of Printing in China and its Spread Westward* (New York: Ronald Press, 1955).
TSIEN TSUEN-HSUIN. "Paper and Printing." J. Needham (ed.). *Science and Civilisation in China*, vol. 5 (Cambridge: Cambridge University Press, 1985), p. 1.

THE JAPANESE PRESS

Cécile Sakai

During the course of the twentieth century, newspaper reading in Japan has become a collective and systematic exercise, as evidenced by an exceptionally large circulation. Consider a few data for the four principal newspapers: the *Yomiuri* has a world record circulation of 10.2 million copies for its morning edition and 4.2 million for its evening edition; the *Asahi* has 8.2 million and 4 million, respectively; the *Mainichi*, 3.9 million and 1.7 million; and the *Nihon Keizai*, 3 million and 1.6 million. The market penetration rate for the 122 daily papers is 576 copies per thousand inhabitants, or 1.16 papers per household (statistics for 1998). These newspapers thus create an omnipresent textual environment that constitutes a veritable cultural code.

The main press arrived on the scene during the Meiji era (1868–1912) as part of the move toward westernization and modernization that characterized that period. Newspapers provided the means to spread not only news but new ideas and political policies, as well as light relief in the form of popular serials that were sometimes read aloud in family circles. In other words, just as in Western countries earlier in the nineteenth century, newspapers espoused the cause of "reading for all."

At present, however, the most noteworthy feature of the Japanese press is the method by which it delivers its content to its readers, 93 per cent of whom are subscribers. Morning and evening alike, the dailies are dropped into letter-boxes, establishing a habit of reading at home that rotates among different members of the family, at definite times, and above all regularly, since it does not depend on an act of purchase. Often, a second daily paper or a magazine will be bought from a kiosk for reading on the long journey to work.

Subscription also rests on a decision on the part of the reader, but its effects are longer-term, and so the press engages in fierce competition and insistent attempts to win custom by all means fair or foul. In short, methods of acquisition play a fundamental role in the power of the press, which moreover is made up of multimedia groups involving periodicals, publishing houses, television channels, cultural bodies, and even sports teams. A veritable strategy of encirclement is thus brought to bear.

A common feature of the major Japanese newspapers is that they publish information that is apparently neutral, reliable and little marked by political considerations—even if (or perhaps because) it is essentially a question of governmental policy. Articles are rarely signed, but some columns demonstrate a real interest in everyday life, describing locally organized events, provincial festivals or cooking recipes. Japanese dailies are characterized by a display of uniformity and anonymity on the one hand, and an exhibition of material culture on the other; they convey a consensual vision of the world that is textually based. Thus, journalistic writing in Japan has preserved a social function, a universal combination of both general and specific information, sometimes serious and sometimes light-hearted, all of which, when put together "cements conviviality".

Nevertheless, this strong circulation has been stagnant for several years—evidence that it has reached its saturation point. The fax, the Internet, and new technologies have all called into question the classic networks for distributing information. It may very well be that the Japanese press is on the threshold of a veritable revolution in its practices—one that is surely a threat to its very existence.

Bibliography

SEGUY, Christiane. *Histoire de la presse japonaise* (Paris: POF, 1993).

Fig. 1. The front page of the April 13, 2001 edition of *Asahi shinbun*. In "large A2" format, like all the national dailies, the presentation is dense and austere. However, the page retains its readability, thanks to the gradation of the headlines, typographic variation, and the interplay of vertical and horizontal lines.

The Asahi Shimbun

朝日新聞

2001年（平成13年）4月13日 Friday　Issue No. 41332

自民総裁選　4氏届け出

経済策　違い鮮明

小泉氏「改革」

亀井・橋本・麻生氏「路線継承」

米機乗員、ハワイへ

解放問題　聴取後、本土帰還

中国　機体、即時返還応ぜず

セブン—イレブン
小売業トップに

売上高、ダイエー30年ぶり転落

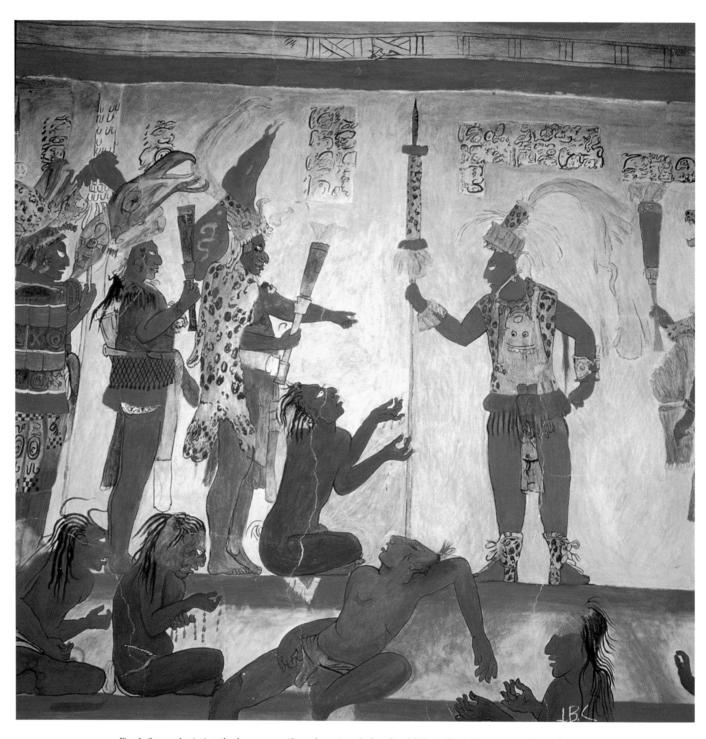

Fig. 1. Scene depicting the human sacrifice of captives before Lord Yahaw Chan Muwan on a flight of steps.
Fresco from Room 2 at Bonampak, 791 CE.

MAYAN SCRIPT AND SOCIETY FROM THE SECOND THROUGH THE TENTH CENTURIES

Michel Davoust

Mayan script is one of the greatest artistic and cultural achievements of the society that created it. It is also one of the most complex scripts of pre-Columbian America, resembling Egyptian hieroglyphics, and it has proved particularly resistant to attempts at deciphering it, especially when the texts do not relate to chronology.

In the mid-nineteenth century, American and European explorers penetrated deep into the tropical forests of Guatemala and the Chiapas in Mexico, in search of ancient lost cities. The most famous of these explorers were the American diplomat John Lloyd Stephens and the English artist Frederick Catherwood. Between 1839 and 1841, they discovered the sites of Copan and Palenque, publishing a famous account of their voyages, *Incidents of Travel in Central America, Chiapas and Yucatan,* in 1843. The book contains the first faithful reproductions of the glyphs on the steles of Copan (Fig. 2) and panels from the Temple of the Cross, the Temple of the Foliated Cross, and the Temple of the Sun, at Palenque.

The script is linked to a civilization that developed between the third and the tenth centuries CE in south-eastern Mexico, especially in the Yucatan Peninsula and the Chiapas Highlands. Traces have also been found in Guatemala in the jungle region of Peten and the volcanic Highlands, as well as in what is now Belize (formerly British Honduras). Mayan society was semi-urbanized, living in numerous stone cities surrounded by a complex of temples, courtyards, palaces, and ball-game courts.

The tombs of the rulers contained multicolored vases and codices that were placed beside the body of the deceased. Hieroglyphic signs were painted in a cursive style on the vases, many of which were unearthed during archaeological digs or when tombs were plundered. The codices or books of hieroglyphics did not survive in the

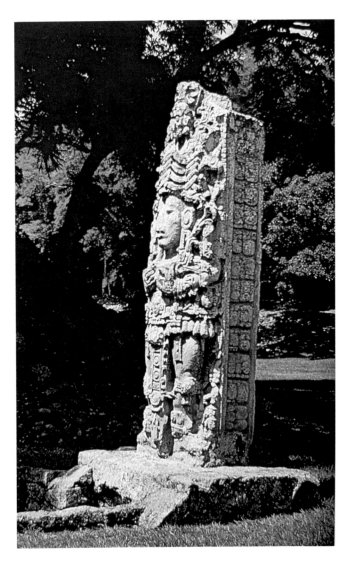

Fig. 2. Stele A (dated 731) at Copan, representing the ruler Waxaclahun u bah Kawil, dubbed "Eighteen moles."

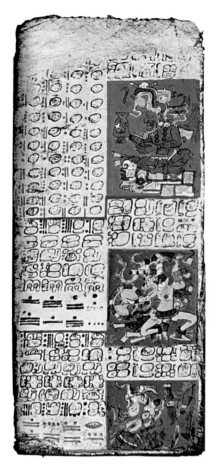
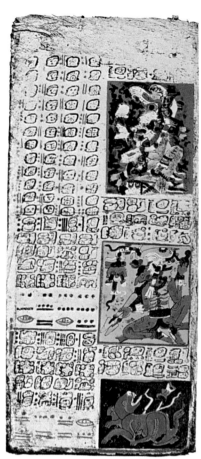

Fig. 3. *Dresden Codex*, pages 46–47. The cycle of Venus with two aspects of the goddess Venus using her javelin to pierce two gods, Kawil and Bahlam, representing two constellations.

hot, humid tropical climate. Four codices have been preserved, three in the libraries of Dresden, Madrid, and Paris, and one in a private collection. These date from the postclassical period, that is to say from the thirteenth century in the case of Dresden (Fig. 3) and from the fifteenth century in the cases of the Paris and Madrid codices. The fourth, called the *Codex Grolier*, was only discovered in 1971 by Professor Michael Coe of Yale University and is now owned by a Mexican collector, Josué Saenz. Carbon-dating analysis gives it a thirteenth-century origin. All these codices were compiled in the Yucatan region.

The hieroglyphic script is also carved or engraved on stone monuments, steles, and altars placed in courtyards facing the temples or on the steps of the flights of stairs leading to temples built on several platforms, such as the Great Staircase of Copan (Fig. 4). The script can also be found on lintels over temple or palace doorways, the most elaborate being those of Yaxchilan. Finally, writing also covers the panels on the far walls of temples, as in the temples of the Cross, the Foliated Cross, and the Sun in Palenque.

The earliest dates at which these monuments could have been built are 292 CE for stele 29 at Tikal to 909 CE for monolith 101 at Tonina.

WHICH LANGUAGES DID THE MAYAN SCRIBES SPEAK?

The area covered by this extinct civilization is today inhabited by people who speak a language that belongs to the Mayan group. Nearly five million people still speak the twenty-eight languages of this family, which were recorded

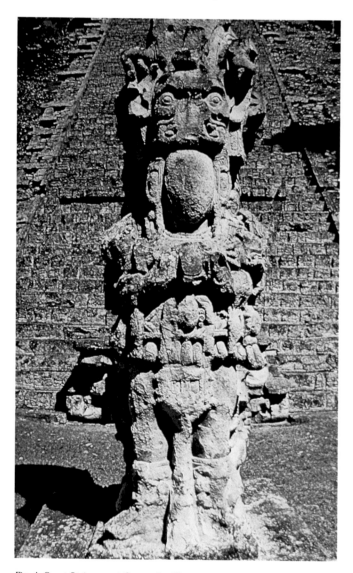

Fig. 4. Great Staircase at Copan. Its 63 steps are covered with nearly 2,000 glyphs and lead up to stele M., dated 756 CE, on which the ruler Butz'Yip Chan Kawil is represented. He had no doubt commissioned the stairs and the hieroglyphic text relating the genealogy and main events of the history of Copan from 593 through 756 CE.

by the Spaniards in the early sixteenth century. The Yucatecs, the largest group (665,000), still live near the sites of Chichen Itza, Coba, and Xcalumkin in northern Yucatan. The Itzas, of whom only 500 are left, live on the shores of Lake Peten near Tikal. Nearly 600 Lacandon Yucatecs are forest dwellers who live near the sites of Bonampak and Yaxchilan in the Usumacinta Valley. The 100,000 Chol Palencano live in villages near Palenque in Chiapas and the 30,000 Chorti remain in the Copan region of Honduras.

Recent successful attempts at deciphering the glyphs of the months confirm the presence of the Chol group from the third through the tenth centuries in the Usumacinta region and in Peten along the banks of Rio Motagua. These are also the sites of the great cities that flourished when Mayan civilization was at its zenith.

Although the Yucatecs still seem to live in northern Yucatan, it is difficult to determine the linguistic frontier between the two groups, which seems to have moved over time.

LOGOSYLLABIC SCRIPT

There are four different ways of recording speech as script: logographic, logosyllabic, syllabic, and alphabetic.

If a script contains a very small number of signs (around thirty), the script is alphabetic. If it contains between thirty and a hundred signs, the script is syllabic. If the number of signs is several hundred, the script can be said to be logo-syllabic, but if there are several thousand signs, the script is probably logographic.

The number of signs used in Mayan script varies between 900 and 1,200, so it must belong to the family of logosyllabic scripts. These include classical Egyptian (734 signs), Hittite (497 signs) and Sumerian (598 signs, written in cuneiform).

It has long been known that Mayan script took the form of glyphs carved in rectangular blocks. Each glyph consists of a central graphic element surrounded by minor elements known as affixes. Their position is specified by the name given to them—prefix, suffix, postfix, etc. There are also three types of signs:

— a symbolic type (a three-pointed bar for the figure 8, or a four-petaled flower symbolizing the sun to represent the word "day," *kin*)

— an anthropomorphic head in profile representing the corn-god for the figure 8 and the head of the sun-god for the day, *kin*).

— an anthropomorphic figure (the same number 8 is represented by the whole corn-god *Maize* and the day, *kin*, by the complete sun-god.

The glyphs can be combined in glyphic groups, phrases and texts. These texts can be read from left to right and from top to bottom, like Latin and Greek scripts.

In 1962, the British archaeologist Eric Thompson created a list of 862 signs found in the texts of three of the codices, as well as on monuments and vases. The present author believes, however, that there could be as many as 1,200 signs in the language, thanks to the discovery of new texts on monuments and ceramics. These signs may either represent logograms indicating consonant–vowel–consonant (CVC), roots or syllabic signs indicating phonetic values of the consonant-vowel (CV) type.

THE STAGES OF DECIPHERING

Unfortunately, unlike the archaeologists who deciphered Egyptian and Hittite scripts, archaeologists exploring the Mayan civilization did not discover any bilingual texts. Furthermore, the Spanish conquistadors never annotated a Mayan codex as they had done with certain Aztec codices, in

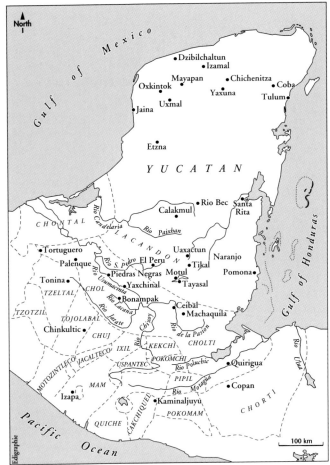

Archaeological and linguistic map of the Mayan region divided into the sixteenth-century linguistic regions (after a drawing by P. Mathews).

which the Spanish translation was written next to the glyph. Diego de Landa (1524–1579), the second Spanish bishop of Yucatan, did, however, write an ethno-historical treatise entitled *The Relation of Things of Yucatan* at the end of which there is a calendar of the glyphs representing the 18 months—each having 20 days—with their names in Yucatec, and a 27-letter pseudo-alphabet that he claimed was part of a syllabary. Some of these signs do, in fact, have the syllabic values of *cu, ku, ca, ka, ti* and *ma.* Similarly, at the beginning of each glyph of a month there are additional phonetic signs, indicating the Mayan Yucatec name of the Chol month of origin. Thus the first month, *pop*, is preceded by the syllabic form: *Po-p(o),* clearly indicating the Yucatec reading as *Pop* and not the Chol name of *Kanhalab.*

From the sixteenth through the eighteenth centuries, Spanish clerics suppressed the hieroglyphic script, though they compiled grammars and dictionaries in Mayan languages, mainly Yucatec, Cholti, Tzeltal, and Quechua Cakchiquel. In the villages of Yucatan, the Mayan Indians continued to write in their own language but used the European alphabet. They wrote about the ancient codices that had been destroyed, about the chronicles of religious ceremonies, the story of their ancestors, and forecasts of the *Katun* or periods of twenty-years.

It was not until the early twentieth century that Americans and Europeans became interested in the inscriptions on monuments and the codices. They made copies of the inscriptions, especially at the sites of Palenque and Copan.

In 1860, Brasseur de Bourbourg, a French priest officiating at Rabinal in the Guatemalan Highlands, discovered documents that were an important source of information about the Mayans. They included the *Popol Vuh* manuscript, written in Quiché and relating the Mayan myths about the creation of the world and the four dynasties of Utatlan, the ancient Quiché capital. Bourbourg visited Madrid where he saw the Diego de Landa manuscript and its pseudo-alphabet. He also examined the *Troano Codex* that belonged to a member of the Spanish Royal Academy of History and realized that it was the first part of another codex, the *Codex Cortesianus*, owned by the Madrid Library.

Then in 1869, Léon de Rosny, a professor at the School of Oriental Languages in Paris, found the *Codex Perez*, named for its former owner, in a trash can at the Bibliothèque Nationale de France!

At the turn of the nineteenth and twentieth centuries, some North American and German researchers, including Cyrus Thomas, Eduard Seler, Paul Schellhas, and Ernst Forstemann, tried to decipher the Mayan calendar, namely, the dates, days, months, and other time periods, as inscribed on monuments and written in codices. In addition to the photographs and drawings of inscriptions produced

by the Austrian Teobert Maler and the British archaeologist Alfred Maudslay, several lists of signs were compiled by the American William Gates (1931), the German Gunter Zimmermann (1956), the Russian Yuri Knorosov (1963), and the British Eric Thompson (1962).

In the 1950s and 1960s, three major breakthroughs occurred in attempts to decipher the glyphs.

In 1952, Yuri Knorosov, a linguist working in Leningrad, Russia, recognized the syllabic nature of Mayan writing. He worked out that the system of signs used the CV type of syllable, as well as CV–C(V) in which the second vowel was silent. Thus, the glyph representing a dog consists of two signs representing the sounds *tzu* and *lu*, producing *tzu-l(u) tzul* (dog).

In 1958, the German archaeologist Heinrich Berlin identified a glyph symbol that was specific to each important site that he visited in Mexico, and in 1960, Tatiana Proskouriakoff, a Russian archaeologist living in the United States, identified the name-glyphs of seven rulers at Piedras Negras. Then in 1962 and 1963, she identified the names of several noblemen at Yaxchilan. She also deciphered the glyphs for the birth dates, the date of accession to the throne, and the dates of death associated with each king. This enabled her to reconstruct part of the genealogy of the kings at these two sites.

As a result of this discovery, American researchers and I were able to identify a series of genealogies of the rulers of the cities of Quirigua, Palenque, Naranjo, Copan, Chichen Itza, and Tikal. In 1975 and 1976, I also reconstituted the dynasty of the first rulers of Palenque, in parallel with the work of Linda Schele and P. Mathews. During this period, I attempted to reconstruct the dynasty of twelve of the kings of Copan, based on a study of the sides of the Q altar. Then, in 1977, I deciphered the name-glyphs of nine dignitaries of Chichen Itza, as well as various glyphs referring to male and female historic figures, noblemen, vassals, sculptors, and captives.

READING MAYAN SCRIPT

At first, the name-glyphs of the kings could not be read phonetically, so they were referred to by a number, a letter of the alphabet, or a name in the researcher's own language. These included "Jaguar-Bird" at Yaxchilan, "Snake-Jaguar" at Palenque and "Sovereign A" at Tikal. In the same way, title-glyphs accompanied the name-glyphs of these notables. The former were identified by Tatiana Proskouriakoff who recognized that, in the case of a noblewoman, a female head in profile is preceded by an upturned vase on which the day, *kin*, is marked. The event

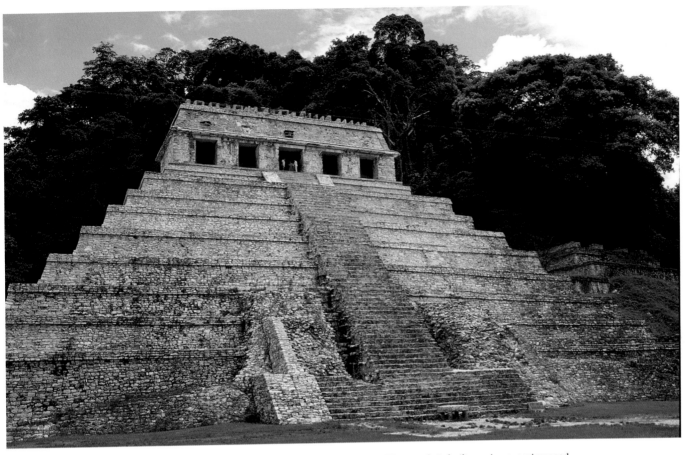

Fig. 5. Temple of the Inscriptions at Palenque (general view). The temple is built on nine superimposed platforms connected to the ground by a flight of steps. There are five doors in the facade. The temple contains the funerary vault of king Hanab Pacal who died in 683 CE.

glyph is a glyph representing a verb, following the date and preceding the name-group in an intransitive sentence of the type: date–verb–subject.

In the phonetic approach to writing, two schools of thought long prevailed. The first supported the logographic hypothesis of Eric Thompson and Thomas Barthel, who believed the logograms represented the signs for whole words, as in Aztec and Chinese script. Consequently, Eric Thompson read the glyph for "drought" as KIN-TUN-HAAB-*il*, in which each graphic element corresponded to a phonetic root of the CVC type, and graphic affixes represented morphemes, such as colors, or grammatical suffixes like *-il* in the above example. Syllabic signs were used infrequently.

The second, or logosyllabic, school adopted Yuri Knorosov's morpheme and syllabic theory, which interpreted the logographic signs as a syllabic system in which the vowel of the second syllable was silent.

In 1978, in a thesis devoted to Mayan script, John Justeson, an American epigraphist from Stanford University, introduced the idea of phonetic complements.

A Mayan grammar has recently been produced through the successive studies made by the American researchers Linda Schele (1982), Barbara MacLeod (1983), and Victoria Bricker (1986).

PRINCIPLES OF MAYAN SCRIPT

Most researchers currently agree that Mayan script is mainly logosyllabic, with the addition of phonetic signs, semantic determinatives, and a table of about 84 syllabic signs of the CV type. The script employs three types of signs, the logogram, the syllabogram, and a phonetic addition or affix.

The logogram is a morpheme to which both semantic and phonetic values are attached. For instance, the logogram depicting a four-petaled flower, the symbol of the sun, represents the sound *kin*, meaning "sun" but also "day," "time," or "time period." Such logograms are often roots of the CVC type.

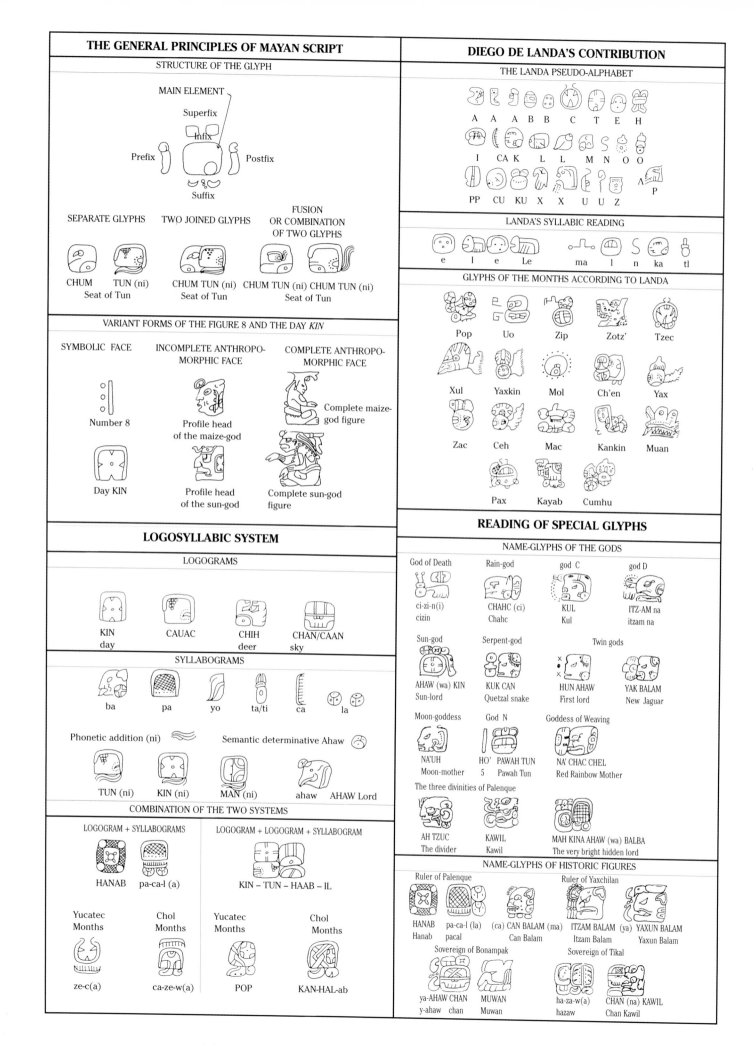

THE GENERAL PRINCIPLES OF MAYAN SCRIPT

STRUCTURE OF THE GLYPH

MAIN ELEMENT

Superfix

Infix

Prefix

Postfix

Suffix

SEPARATE GLYPHS

TWO JOINED GLYPHS

FUSION OR COMBINATION OF TWO GLYPHS

CHUM — TUN (ni)
Seat of Tun

CHUM TUN (ni)
Seat of Tun

CHUM TUN (ni) — CHUM TUN (ni)
Seat of Tun

VARIANT FORMS OF THE FIGURE 8 AND THE DAY KIN

SYMBOLIC FACE

INCOMPLETE ANTHROPO-MORPHIC FACE

COMPLETE ANTHROPO-MORPHIC FACE

Number 8

Profile head of the maize-god

Complete maize-god figure

Day KIN

Profile head of the sun-god

Complete sun-god figure

LOGOSYLLABIC SYSTEM

LOGOGRAMS

KIN
day

CAUAC

CHIH
deer

CHAN/CAAN
sky

SYLLABOGRAMS

ba

pa

yo

ta/ti

ca

la

Phonetic addition (ni)

Semantic determinative Ahaw

TUN (ni)

KIN (ni)

MAN (ni)

ahaw — AHAW Lord

COMBINATION OF THE TWO SYSTEMS

LOGOGRAM + SYLLABOGRAMS

LOGOGRAM + LOGOGRAM + SYLLABOGRAM

HANAB — pa-ca-l (a)

KIN – TUN – HAAB – IL

Yucatec Months

Chol Months

Yucatec Months

Chol Months

ze-c(a)

ca-ze-w(a)

POP

KAN-HAL-ab

DIEGO DE LANDA'S CONTRIBUTION

THE LANDA PSEUDO-ALPHABET

A A A B B C T E H

I CA K L L M N O O

PP CU KU X X U U Z Λ P

LANDA'S SYLLABIC READING

e l e Le ma l n ka tl

GLYPHS OF THE MONTHS ACCORDING TO LANDA

Pop Uo Zip Zotz' Tzec

Xul Yaxkin Mol Ch'en Yax

Zac Ceh Mac Kankin Muan

Pax Kayab Cumhu

READING OF SPECIAL GLYPHS

NAME-GLYPHS OF THE GODS

God of Death

Rain-god

god C

god D

ci-zi-n(i)
cizin

CHAHC (ci)
Chahc

KUL
Kul

ITZ-AM na
itzam na

Sun-god

Serpent-god

Twin gods

AHAW (wa) KIN
Sun-lord

KUK CAN
Quetzal snake

HUN AHAW
First lord

YAK BALAM
New Jaguar

Moon-goddess

God N

Goddess of Weaving

NA'UH
Moon-mother

HO' PAWAH TUN
5 Pawah Tun

NA' CHAC CHEL
Red Rainbow Mother

The three divinities of Palenque

AH TZUC
The divider

KAWIL
Kawil

MAH KINA AHAW (wa) BALBA
The very bright hidden lord

NAME-GLYPHS OF HISTORIC FIGURES

Ruler of Palenque

Ruler of Yaxchilan

HANAB
Hanab

pa-ca-l (la)
pacal

(ca) CAN BALAM (ma)
Can Balam

ITZAM BALAM
Itzam Balam

(ya) YAXUN BALAM
Yaxun Balam

Sovereign of Bonampak

Sovereign of Tikal

ya-AHAW CHAN
y-ahaw chan

MUWAN
Muwan

ha-za-w(a)
hazaw

CHAN (na) KAWIL
Chan Kawil

TITLE GLYPHS OF HISTORIC FIGURES

CHAHC TE'	KAWIL (la)	ya-AHAW (wa) TE'	ah KIN (ni)
Chahc Te'	Kawil	y-ahaw te'	ah kin
The Chach tree	Kawil	Lord of the Tree	The Priest

ah CH'UL NAH	CH'UL AHAW	HOY-al CH'UL NA'	u (ca) CAN
ah ch'ul nah	Ch'ul ahaw	hoyal ch'ul na'	u can
He of the divine house	Divine lord	Divine mother consort	His/her guard

u ba-c(i)	ba-te	ah tz'i-b(a)	u wo-ho-l(i)
u bac	bate(l)	ah tz'ib	u wohol
His captive	Warrior	The scribe	His scribe

ah BIH	ah tz'u-l(e)	ah pi-tz(i)	za-hal(a)
ah bih	ah tz'ul	ah pitz	zahal
The traveler	The stranger	The ball-player	Vassal

RELATIONSHIP GLYPHS

yi-cha-n(i)	yi-ta-h(i)	i-tz'i(n) WINIC	u ma-m(a)
y-ichan	y-itah	itz'in winic	u mam
His mother's brother	His sibling	Younger brother	His maternal grandfather

u HUN-TAN (na)	u BAH u CH'AM (ma) AK	u zi-h(i) u lo(t)CH'AM(ma)
u huntan	u bah u ch'am ak	u zih u lot ch'am
He takes care of	She harvests with her tongue	He is born of the harvest of (his parents)

VERB INFLEXIONS ON MONUMENTS

Free pronoun	Prefix pronoun	Verb root	Root suffixes: transitive intransitive	Transitive root suffixes	Intransitive root suffixes	Positional root suffixes
U	Y(o)		-ah	-aw	-tah	-Wan
	Y(i)		-i	-ab	-Nah	-Lah
	Y(a)			-al	-ah-ih	
				-ih	-tal	-hal
					-Pah	-lah
					-Bah	-Wan-i
Gender Ah						-Lah-i

SIGNS AND GLYPHS OF ANIMALS AND PLANTS

BALAM	YAX BALAM (ma)	ba-la-m(a)	tzu-l(u)
	Yax Balam	balam	tzul
Jaguar	New Jaguar	Jaguar	Dog

WAH (wa)	u ca-ca-w(a)	NAHB	YAX TE'
wah	u cacaw	nahb	yax te'
Tortilla	His cocoa	Water lily	Ceiba tree

SIGNS AND GLYPHS FOR MAN-MADE OBJECTS

CH'UL NAH	PITZ NAH	yo-to-t(i)	u LACAM TUN (ni)
		y-otot	u Lacam Tun
Divine house (temple)	Ball-game house	His house	His stele

po-p(o) tz'a-m(a)	HOK	u tu-p(a)	yu-ch'a-b(i)
pop tz'am		u tup	y-uch'ab
The throne of natte	Sacred package	His pendant	His vase

SIGNS AND GLYPHS REPRESENTING PARTS OF THE HUMAN BODY

AHAW	NA'	CHOC	TZAC
Lord	Mother	To scatter	To seize, ward off

		Lock of hair	Drops of blood
TZ'IB	CHUM	UH	CH'UL
To write	To rule	Moon	Divine

READING OF GLYPHIC TEXTS

TEXT OF DRESDEN CODEX, p. 65b

1st verb	Complement of place	Subject	1st object	2nd object	2nd verb
(a) AYAN (na)	ta-CAB (ba)	CHAHC(ci)	OX OC WAH	BOLON WAH (wa)	u HANAL
AYAN	ta cab	Chahc	ox oc wah	bolon wah	u hanal
is	on the ground	Chahc	many tortillas	nine layers of tortillas	his food

EPIGRAPHIC TEXT AT PALENQUE: 96 GLYPHS PANEL

Date	1st verb	1st title	Name of person
BOLON IK HO'KAN-a-zi(ya)	CHUM-LAH ta-AHAW-el	ya-AHAW TE'	MAH KINA a-cu-l(a)
Bolon Ik Ho'Kanazi	chum-lah ta ahaw-el	y-ahaw te'	Mah kina Acul
9 Ik 5 Kanazi	Ruled in the fiefdom	The lord of the tree	Very brilliant Acul

2nd title	Patronymic name	2nd verb	2nd subject
ah na-b(i)	CH'UL AHAW BAC	u bu-chi-hi	ZAC nu-c(u) NAH
ah nahb	Ch'ul Ahaw Bac	u buch-ihi	Zac nuc nah
He of the water-lily	The divine lord Bac	She settled	The large white house

Name of House E in the Palace of Palenque

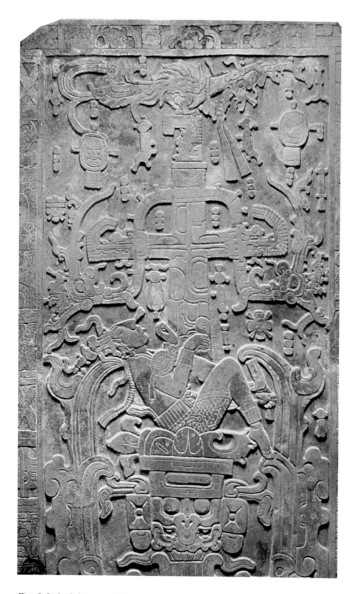

Fig. 6. Lid of the sarcophagus in the Temple of the Inscriptions at Palenque. It represents the dead king Hanab Pacal climbing down the cosmic tree to the underworld, represented by the white skeletal jawbones of the first serpent Zac Bac Nah Chan.

The syllabogram or syllabic sign is a composite sign representing a syllable consisting of a consonant and a vowel of the CV or VC type. It is based on a CVC logogram in which the second consonant is weak, as in *h, ', w* and *y.* Thus, the syllable *chi* is based on the logogram CHIH (deer) and the syllable *ca* on the logogram CAY (fish).

A syllabic sign is often placed as a postfix or suffix to indicate the sound or part of the sound represented by the logogram with which it is associated. Thus, the phonetic complement *ni,* represented by the affix of a mammal's tail, indicates the following logographic sounds: *tun* (a period of 360 days), *kin* (day, sun), or *man* (vision).

To make matters even more complicated, Mayan script also contains numerous allographs (different signs representing the same spoken words or syllables). For instance, the syllabic value *ca* may be represented by nine different signs. This duplication is a function of a writing system that consists of an affix and a main element or anthropomorphic head, but it could also be due to regional variation or result from the medium on which the script is written (a monument, vase, bone, jade, codex, or fresco). It may even be due to the way the signs evolved over time.

In recent years, several syllabaries have reflected a proto-Chol phonological system consisting of twenty consonants and five vowels. These have been devised by Peter Mathews (1984), David Stuart (1987), Nikolai Grube (1989), and myself (1989), and the most recent syllabary created by Linda Schele, Professor of Art at the University of Austin, Texas (1996), indicates 75 sounds represented by 171 signs.

In my book *Mayan Writing and Its Deciphering* (1995), I presented a table of 84 syllabic sounds represented by 425 signs.

DECIPHERING THE NAMES OF GODS, HISTORIC FIGURES, ANIMALS, AND PLANTS

This syllabary now makes it possible to read a large number of different glyphs, such as those representing the days and months, the cycle of the moon, and points of the compass. It is also now possible to read in the codices the name-glyphs of the various gods, such as the god of death *Cizin,* the rain-gods *Chahc* or *Chahac,* the sun-god *Ahaw Kin*, the moon-goddess *Na' Uh* (Mother moon) and the twin divinities *Hun Ahaw* (First lord) and *Yax Balam* (New Jaguar). Monuments feature the names of the three main divinities written on the central panels of the Temple of the Cross, the Temple of the Foliated Cross, and the Temple of the Sun. These are dedicated, respectively, to *Ah Tzuc* (the divider), *Kawil* (the abundance of food) and *Ahaw Balba* (the hidden lord).

Another line of inquiry has been the identification and the subsequent phonetic reading of the name-glyphs of historic figures, such as the names of the rulers of Palenque *Hanab Pacal* and *Can Balam* (Figs. 6 and 7), *Itzam Balam* and *Yaxun Balam,* the rulers of Yaxchilan, *Yahaw Chan Muwan* of Bonampak (Fig. 1), and *Hazaw Chan* of Tikal. These names are often accompanied by titles that are indicative of the social hierarchy in the classical Mayan period (third through tenth centuries CE), and religious titles such as *Chahc Te'* (the Chahc Tree) and *Yahaw Te'* (The Great Tree) with whom the sovereign identified, as shown on the stele. This is also

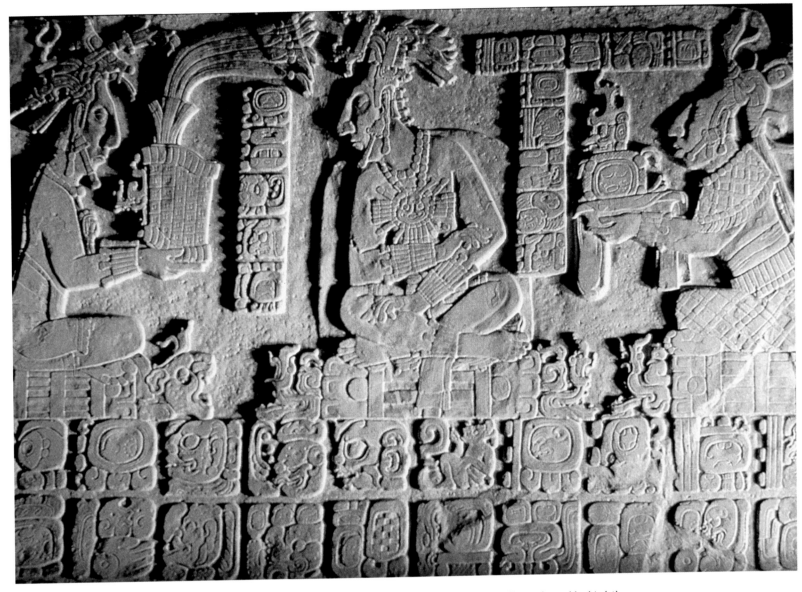

Fig. 7. Panel of Ruz 1 at Palenque. The king, Kan Hok Chitam, is represented seated on a throne of bone, framed by his father, Hanab Pacal, on the left and his mother, Na' Ahaw Ts'ac, on the right, upon his ascension in 701 CE.

the name of the ceiba tree (which is still the sacred tree of the Lacandon Indians), *Ah Kin* (the priest), and *Ah Ch'ul Nah* (he of the divine house).

The titles of commoners include *Ah Tz'ib*, the scribe. The lintels over the doorways of Chichen Itza feature the titles *Ah Beh* (the traveler) and *Ah Tz'ul* (the stranger). In 1987, the young American epigraphist, David Stuart, identified the title *Ah Pitz* (the ball-player). More recently, Nikolai Grube of Bonn University, Germany, identified the title *Zahal* (vassal), which is lower in the hierarchy than *Ahaw* (lord). Finally, the title *Ah Pol* (the sculptor), which I identified at Yaxchilan, is a title given to a captive called "Shield-Jaguar."

In the same way, glyphs of relationship have made it possible to reconstruct the genealogical tree of the rulers of the principal sites. Thus, the ruler *Hanab Pacal* of Palenque had an elder son, *Can Balam* ("Serpent-Jaguar"), and a younger son, *Kan Hok Chitam* ("Precious Pecari Knot") (Fig. 7). The glyphs of animals and plants have been identified on monuments and vases such as *Balam* (the jaguar), *Til* (the tapir), *Tz'i'* (the dog), *Kuk* (the quetzal), and *Moo'* (the macaw).

As for plants, there are the corn stalk *Nal,* the cocoa tree *Cacaw,* the water-lily *Naab,* and many names of trees such as *Yaxche'* (the name of the ceiba tree in Yucatec) and *Chac Te'*

(the mahogany tree). The tropical fauna and flora of central America thus feature prominently in Mayan script.

The names of Mayan monuments such as palace, temple, ball-park, house, stele, altar, and sarcophagus, and architectural features such as staircase, door, lintel, and platform have also been identified.

Signs and glyphs may represent the names of smaller objects associated with the religious, civil, and military power of the king, such as the throne, the sacred package, the headdress, the scepter or lance, the ax, and the shield. Signs and glyphs representing parts of the human body were also used. The position of hands, in particular, represents a whole code of gestures (see my book, 1995).

Nikolai Grube has also found a glyph representing dance (*akot*) and the various names of dances that are engraved on monuments or painted on vases. The dances of the "precious maize"and the "red dwarf" are recorded on the lintels of Yaxchilan. and the "dance of the serpent" is mentioned on a neighboring site.

The creation of a complete grammar of the script, similar to that produced by Champollion for Egyptian hieroglyphics, thus becomes a definite possibility. As early as 1986, the American linguist Victoria Bricker created an initial short grammar through studying the noun and verb inflexions in Yucatec and Chol Mayan and comparing them with those in the texts of the codices and monuments. It should also become possible to transcribe phonetically the entire hieroglyphic texts of the codices, monuments, and vases.

As in the case of other ancient scripts, researchers are all coming to the same conclusion regarding the phonetic reading of these texts, and it has been possible to decipher Mayan script to a large extent, thanks to the collective effort of colleagues in several disciplines.

Bibliography

BRICKER, Victoria. *A Grammar of Mayan Hieroglyphs*, Middle American Research Institute Publ. 56 (New Orleans: Tulane University 1986).

COE, Michael D. *Les Mayas: mille ans de splendeur d'un peuple* (Paris: Armand Colin, 1987).

———. *Breaking the Maya Code* (London: Thames and Hudson, 1992).

DAVOUST, Michel. *Le Déchiffrement de l'écriture Maya: Bilan et perspectives*, 6 vol. thesis, École des Hautes Études en Sciences Sociales (Paris: 1987).

———. *L'Écriture Maya et son déchiffrement* (Paris: Les Presses du CNRS, 1995).

———. *Un nouveau commentaire du codex de Dresde: Codex hiéroglyphiques maya du XIVe siècle* (Paris: Les Presses du CNRS, 1997).

KNOROSOV, Yuri V. *The Writing of the Maya Indians*, chaps. 1, 6, 7, 9. trans. Sophie Coe, 1963. (Cambridge, Mass.: Peabody Museum of Archaeology and Ethnology, 1967).

LANDA, Diego de. *Relacion de las cosas de Yucatan* (Mexico: Porrua, 1966).

MARTIN, Simon, and Nikolai Grube. *Chronicle of the Maya Kings and Queens. Deciphering the Dynasties of the Ancient Maya* (London: Thames and Hudson, 2000).

SOUSTELLE, Jacques. *Les Mayas* (Paris: Flammarion, 1982).

STEPHENS, John L. *Aventures de voyage au pays Maya*, vol. 1, Copan 1839 (Paris: Pygmalion, 1991).

THOMPSON, Eric J. *A Catalog of Maya Hieroglyphs* (Norman, Okla.: University of Oklahoma Press, 1962).

NAHUATL SCRIPT

Marc Thouvenot

Nahuatl script[1] is that which was used by Nahuatl-speakers at the time of the Spanish conquest of Mesoamerica, in which a key event was the fall of Mexico-Tenochtitlan in 1521. The geographic center of use of this writing system was the Mexican Valley, and its best known users were the Aztecs. The script resembles Mixtec, and there are major similarities between the two, to the extent that, according to several authorities, certain documents (the Borgia group in particular) contain writings in both scripts.

So how is it that the Nahuatl script has not been deciphered, even though it has been known in the West since the first day Europeans (the Spanish) set foot on the Mexican shore? This seems all the more surprising when we consider that we have contemporary reports about it; that, since the nineteenth century, a number of studies have been made of it; that, for the last thirty years (thanks to the efforts of Joaquín Galarza), new life has been breathed into research into it; and lastly that, at the turn of the twentieth and twenty-first centuries, some of the codices—"codex" being the name usually given to books in traditional scripts—have been published along with the research.

The answer is simple. There currently exists no dictionary worthy of the name that could supply a key to the elements of which this writing consists, and we do not have any means of swiftly looking up the sound value (or values) represented by a particular sign, nor of finding how many times it occurs, and even less of identifying the contexts in which these signs are found. We do not know the syntax of the images or even the direction in which the glyphs should be read.

Our ability to read the signs is therefore very limited, and consequently, the general conclusions that we can draw about this script are tentative and are tempered by a profound ignorance. This is not the place to discuss the limitations of the system but rather to explain some of the potential points of interest that we are currently capable of detecting.

The reason why we know so little about Nahuatl script is due to a variety of factors. The most important, in the view of the author, is due to our own conception of script *per se* and the eradication of traditional native scripts.

Our subconscious view of writing is shaped by our own experience thereof, as well as by what has been written about it over the centuries and also by the work of linguistics experts. These influences converge in the same direction and tend to make us claim that script is a univocal system for fixing units of language. Writing is thus a mere reflection of the spoken language.

This ideology has a very simple consequence: namely, that many experts in Central American culture believe that, of the Aztec images, only those which have by convention been referred to as glyphs (and especially where they refer to names of people or places) are a form of writing. Experts in scripts go further and consider that the symbols that appear in the codices or on other media are not a form of writing at all but are merely "precursors."

This disregards the fact that by the early sixteenth century people were able to write not only in their traditional script but also in the Latin characters taught to them by the Spanish clerics. Clearly, they considered the two writing systems as being equivalents of each other. Here, for example, is what a Nahuatl Indian called Chimalpahin says about the books of his ancestors, the codices: "The story of the customs of the people and the genealogical history of their royal family is written in black and in color. They are laid upon paper as signs. They will never be erased nor forgotten, but will always be preserved." When an author

speaks of a book he is writing in Latin characters, he shows the same care to preserve and transmit knowledge: "… and to prevent it disappearing or being forgotten, once again, I check, I renew, and arrange it in a book."[2]

This shows that the point at which the two systems of writing converge need not be sought in the relationship with a language—in this case Nahuatl—but in a means to an end, that of preserving and transmitting information.

The second reason why we know so little about Nahuatl is the eradication of the traditional script. This took three forms—destruction, silence, and replacement.

Destruction by fire was systematic. The Spanish priests believed that all these documents were the work of Satan, but their actions did not stop there. After destroying most of the written words, they fostered the creation of several new codices in order to use any of the content that might help them in their missionary work. They then proceeded to create conditions whereby the native script could not be revived from the ashes. They did so first by ensuring that silence prevailed in regard to the script, a systematic behavior observed by the Franciscan Bernardino de Sahagún (Sahagún worked with the Indians to create the of *Florentine Codex*, considered to be a sort of encyclopedia of Aztec civilization). They also destroyed knowledge of the script by their teaching activities—another very important missionary task—in which they substituted their own Latin script, a script which, in the context of their absolute political domination, could not have failed to establish itself.

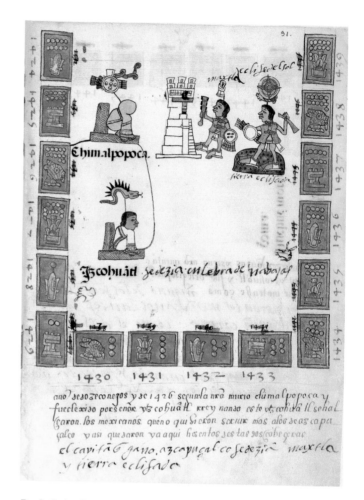

Fig. 2. *Codex Telleriano-Remensis*. No. 385, fol. 31r, Bibliothèque Nationale de France, Paris.

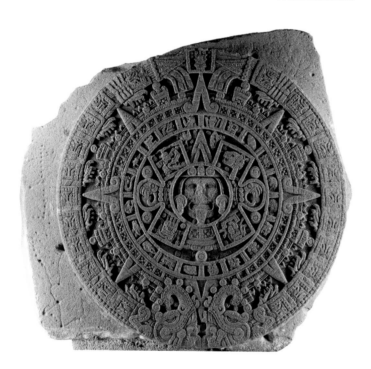

Fig. 1. Sundial. Museo Nacional de Antropología, Mexico.

It would appear, however, that civilian society had a slightly different attitude to that of the clerics. In fact, documents written in the traditional native script were accepted as legally valid by the courts and are accepted as such to this day.

The result of the ruthless suppression of Aztec script can be seen from the statistics. At the time of writing, about three hundred pictographic documents are scattered throughout the world, preserved in a large number of libraries. Only a handful of them (five or six) escaped the *autos-da-fé*; all the rest were produced after the Spanish conquest. The number has increased slightly over the years with the discovery of new codices, mainly among native communities who have preserved them, conscious of their historic and legal value.

In addition, there were sculptures (Fig. 1), frescoes, some ceramics, artifacts made of feathers, etc. Even though the Aztecs preferred to write on "paper," whether the native amatl paper, European paper, cotton fabric, or

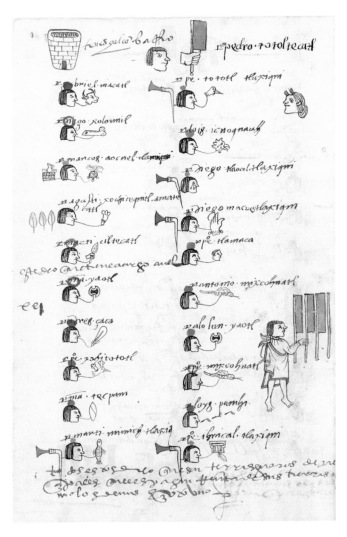

Fig. 3. *Matrícula de Huexotzinco*. No. 387, fol. 780v, Bibliothèque Nationale de France, Paris.

Fig. 4. Plan of an estate. No. 34, Bibliothèque Nationale de France, Paris.

prepared animal skins, writing appeared on every medium that proved receptive to legible inscription.

THE SUBJECT-MATTER

The codices that are still in existence[3] can be classified into various types of subject-matter that throws light on the preoccupations of the Nahuas, in direct or indirect response to Spanish prohibitions or pressures at the time when they were written. Codices of a legal or economical nature (Figs. 3, 4, and 5) represent 40 percent of the documents. Historical and political essays (see Figs. 2 and 8) account for 34 percent of them, and religious writings (Fig. 6) for 12 percent. There are also two scientific documents, the *Codex Badiano* (Mexico) and the *Florentine Codex* (Fig. 7). Those that are believed to be precortesian

are, on the other hand, all of a religious nature. As a consequence, neither their distribution after the Spanish Conquest (closely linked to the colonization of the Nahuas) nor the small amount (five or six documents, five of which are from the Borgia group) of pre-Conquest data enables us to discover the most frequent use to which the native script was put. It is therefore important to learn from the writings of educated Aztecs. One such, Alva Ixtlilxochitl, wrote:

They had specialist writers for each type of subject. Some were chroniclers, classifying things that happened every year, stating the day, month, and time. Others recorded the genealogy and lineage of the kings, lords, and nobles, entering the births and crossing out the deaths. Yet others were responsible for painting demarcation lines around territories and signposts in towns, provinces, villages, and other

Fig. 5. *Matrícula de Tributos*. Codices 35–52, fol. 9r, Tepequacuilco. Biblioteca Nacional de Antropología e Historia, Mexico.

places, and for recording the condition and distribution of land, what it consisted of, and to whom it belonged. Others worked on the books of laws, rites, and ceremonies that were in use at the time when they were unbelievers; and the priests of the temples concerned themselves with their idols and their idolatrous doctrines, the feasts of their false gods, and the calendars. And finally, the task of the philosophers and sages in their midst was to draw and paint all their knowledge, old and new.[4]

Both the wide range of subject-matter that Ixtilxochitl recorded and the few documents that have been preserved indicate that the subjects that were written about under Spanish pressure were much the same as those about which the Indians traditionally wrote.

THE IMAGES THAT MAKE UP THE SCRIPT

The following examples show that the images that appear in the documents are of three types. First there are human and divine figures—shown either in full or in part. Then there are glyphs, and finally there are graphic or plastic links between the two. The figures and the elements of which the glyphs consist are all conventional figurative images.

The glyphs

The glyphs[5] are graphic units that are basically identifiable thanks to the space that surrounds them. They can be distinguished from the figures by the fact that their constituent elements do not necessarily create a realistic image (unlike the anatomically correct figure elements). On the basis of their graphic characteristics, the glyphs fall into five main categories:

1) The *anthroponyms* (names of people) have two characteristics. First, they are always linked to the upper part of a human or divine figure (headdress, cloak fastening, or arm), and second, they are often smaller than the other glyphs with which they may be connected. This first class is subdivided into individual, collective, locational, and functional anthroponyms.

2) The *toponyms* (place-names) are larger than the anthroponyms and are often represented separately—that is, without a graphic link to the context. They may be attached, however, by a link or by contact with the lower part of a person (leg, foot, or seat).

3) The *enlarged glyphs* are of ample dimensions. This is because they are supposed to represent elements of the landscape. Examples are the glyphs representing a lagoon

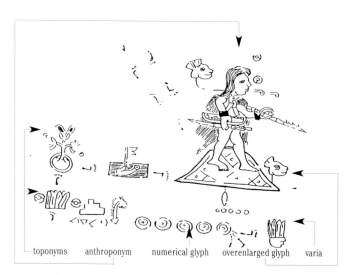

toponyms anthroponym numerical glyph overenlarged glyph varia

Diagram 1. Plate 1 (010) of the *Codex Xolotl*

or a mountain range that features in almost every plate in the *Codex Xolotl*.

4) Glyphs representing *numbers* may be temporal glyphs, glyphs of tribute, glyphs of measurement, or any glyph whose main function is numerical.

5) The *varias* are those glyphs that do not fall into any of the previous categories.

Proper identification of the class to which a glyph belongs is important for a correct reading of the script. It also enables us to understand, in particular, the space-saving strategies employed by the *tlacuiloque* or painter-scribes.

Almost all the glyphs consist of a number of elements. An element may be defined as the smallest graphic that has a characteristic shape shared by two or more different glyphs or parts of a glyph, whose other parts have already been identified as elements, or it may be the color of a graphic if it is not the color conventionally used for it.

These elements transcribe the sounds of the language which represents its various units. These units may be syllables, roots, or words. The agglutination of these units make it possible to read the words or phrases thus written.

Reading depends on a precise analysis of the glyphs because the various elements contain subtle differences that make it possible to distinguish them. Table 1 shows various different elements, all of which use a "volute."

The elements are very flexible so that they can be adapted to the various contexts in which they are used. Thus, the element *chalchihuitl*, "jade" (Table 2), may take on very different forms, depending on the way in which it is used. In most cases, the elements reproduce only one sound, but there are some that represent a variety of sounds, as for example the element *mitl*, "arrow" (Tables 3 and 4). This element can be used to transcribe ten different sounds, which are identifiable from the different ways in which the element *mitl* may be portrayed (drawn in part or in whole, horizontally, vertically, or at an angle, etc.) and the way in which it relates to the other elements.

In more than 75 percent of cases, a sound is represented by a single element, but some sounds can be represented by various elements.

Finally, in a relatively few cases, elements are combined in order to annotate a sound that is different from that represented by each of its components separately. An example is the glyph read as *chichimecatl* (Table 3). It consists of the elements *mitl*, "arrow," and *tlahuitolli*, "bow," neither of which would alone produce *chichimecatl*. It is the combination of both that produces this reading.

Table 1

ELEMENT				
NAME	*popoca*	*tlatoa*	*zozoma*	*cuecuenoti*
SOUND	*popoca*	*nahua*	*zozo*	*cuecueno*

Table 2. *chalchihuitl* element = jade

Codex Mendoza, f. 3v.	*Codex Telleriano-Remensis*, f. 12v.	*Codex Magliabechiano*, pl. 29.

Table 3. *mitl* element = arrow

REF.	X.050.G.23	X.040.G.13	X.030.E.15	X.020.D.58	X.070.D.26
GLYPH					
READING	*acamapichtli*	*tenancacaltzin*	*chichimecatl*	*mamalhuazco*	*totomihuatzin*
SOUND	*aca*	*cacal*	*chichimecatl*	*mamalhuaz*	*mi*

Table 4. *mitl* element = arrow

REF.	X.050.H.29	X.010.I.03	X.050.A.59	X.100.D.28	X.101.F.17
GLYPH					
READING	*temictzin*	*mitl*	*tenanmincatzin*	*tencoyomitzin*	*tlacochcalco*
SOUND	*mic*	*mitl*	*min*	*ten*	*tlacoch*

Fig. 6. *Codex Borbonicus.* fol. 34, Bibliothèque de l'Assemblée Nationale, Paris.

Human and divine figures

No one doubts the fact that the glyphs, whose elements represent sounds, can be read. This is not true for the figures and graphic links, and scholars have produced two different trends of thought. The majority believe that the figures are not to be read but must be interpreted; others consider that the figures consist of elements similar to those encountered in the glyphs and that they should therefore be read. This second theory, a totally new one, is that proposed by Joaquín Galarza. According to the first group, there would be total independence from any particular language, whereas for the second group, there would be a close relationship between the figures and the language. Since there is currently insufficient research on the matter, it is difficult to validate Galarza's theory. On the other hand, it is possible to discount the first theory.

The *Codex Xolotl* provides several examples showing that the elements of which the figures consist could be used in exactly the same way as the glyphs. The fact that

the same proper name, *Cuacuauhpitzahuac*, can be written either as a separate glyph with a graphic link or by a glyph associated by contact with a figure shows that, at the very least, the figures might have the same value as the glyphs and that these elements merely need to be "activated" in order to reveal the sound they represent.

Diagram 2. X.050.G.38: *Cuacuauhpitzahuac* Diagram 3. X.060.F.34: *Cuacuauhpitzahuac*

The *Codices Matritenses* also contain examples of the close relationship in Nahuatl of the elements that make up the figures. The books contain several lists of rulers, including two lineages, that of the *Chichimeca* and that of the *Acolhuachichimeca*. The two lists are graphically distinguished from each other by the fact that in one list the rulers are depicted with a bow and arrow placed in front of them, a combination that is traditionally read as *chichimecatl*, whereas in the other, an arm in the anatomically correct position is holding the bow and arrow:

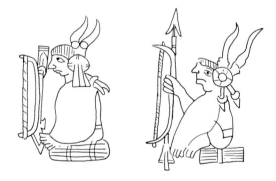

Diagram 4. Codices Matritenses, f. 52r: *Chichimecatl* (title), f. 53r : *Acolhuachichimecatl* (title)

This apparently minor detail makes sense when one realizes that the sound of the element *maitl*, "hand, arm" is known to be *acol*. So the arm represents the sound *acol*, its position is probably the possessive suffix *hua*, and the bow-and-arrow combination make *chichimecatl*. The whole word

should thus be read as *acol-hua-chichimecatl*, the title of this person.

This is one of many examples. It is not enough to prove that all the elements of a human figure should be read in the same way as those of a glyph, but it does at least show that all the images in the codex should be analyzed in the same way, by seeking first to determine their various constituent elements and establishing the possible relationship with the spoken Nahuatl language.

The links

Numerous and diverse graphic links are used to connect the main elements, the glyphs and the figures, to one another. They are used to link glyphs to glyphs, figures to figures, or glyphs to figures. The links may take several forms: straight lines, dotted lines, footsteps, paths, links in various colors, and so on.

These links may be read, but their extensive use can be explained mainly by the possibility they afford of developing the writing in every direction (and even three-dimensionally). Unlike our own script, Nahuatl writing has no linear extension. Its elements develop in space quite freely, but, as a result, it requires the use of the link to structure the whole and indicate the preferred order of reading.

The plastic links are part of this structuring process, and they express the way in which the various images are arranged in relation to each other. This creates new graphic units, groups of glyphs and figures, making stories from sets of groups.

The reading of Nahuatl texts written in the codices suggests (though so far this is only a theory that still needs to be tested) that in addition to the strict relationship that existed between a set of elements (glyphs or figures) and a unit of the Nahuatl language, other, more flexible, relationships existed alongside them, as part of a semantic structure dictated solely by the images. Aztec script sometimes seems to play with these two sets of sounds and meanings simultaneously in order to fulfill its function of preservation and communication. The transcription of the sounds is only used when it is deemed necessary, but otherwise the reader seems to have been given a certain freedom of interpretation. Freedom does not mean that the signs could be ready in any way at all, but that the structure of the codex might permit a number of different readings as to form, which would nevertheless be identical as to content.

Here is an example of how a small fragment from Plate 6 of the *Codex Xolotl* could be read:

Nican ipan in <u>motlahtocatlalli</u> *in* **tlacatl** *in* ***itoca*** **Ix***tlil***xochi***tzin* **Ome Tochtli, tlatoani.** *Yc* <u>motlallico</u> *in* **petlapan** *in* **icpalpan**. *Auh inin* **Ix***tlil***xochi***tzin* *in*

Fig. 7. *Codex Florentine*. Ms. Med. Palat. 220, c. 214v, Biblioteca Medicea Laurenziana, Florence.

<u>quimocihuati</u> ***itoca*** **Matlalcihua***tzin*. *Auh* **omentin** *in* <u>quincauhtia</u> **ipilhuan**, *inic ce itoca* **Nezahualcoyo***tzin* **Acolmiz***tzin*, *inic ome* **cihuatl** *itoca* **Tozquen***tzin*.

[**Bold** indicates single explicit sounds; *italics*, implicit sounds (imposed by the language); ***bold + italics***: sounds inferred by the graphic context; <u>underlined</u>: multiple sounds inferred by the graphic context.]

It was at this time that the man named Ixtlilxochitzin Ome Tochtli was installed as ruler.

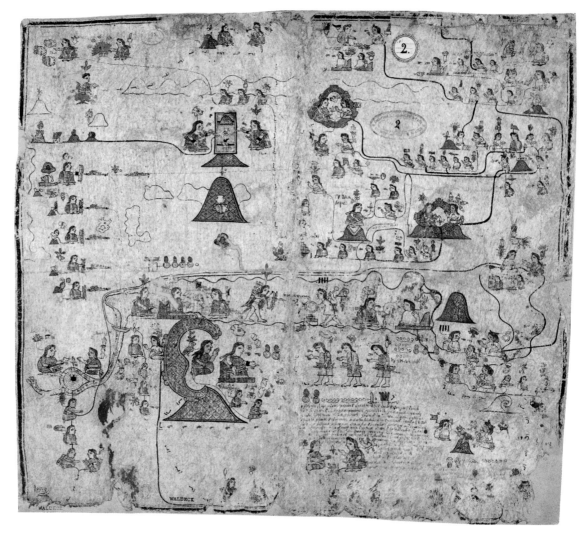

Fig. 8. *Codex Xolotl.* No. 1-10, Plate 2, Bibliothèque Nationale de France, Paris.

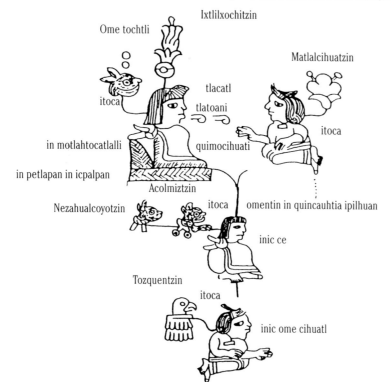

Diagram 5. (left) Plate 6 of the *Codex Xolotl* (detail).

He came to sit on the mat, on the seat [= to govern]. And this Ixtlilxochitzin took a wife by the name of Matlalcihuatzin. And they left two children. The first was named Nezahualcoyotzin Acolmiztzin, the second, a woman, had the name of Tozquentzin.

This is just one of a number of possible readings, since the purpose of the script was to record and convey the content and not the language itself "word for word." An other possible reading of the above images could be as follows:

Nezahualcoyotzin Acolmiztzin was the first of two children of the ruler named Ixtlilxochitzin Ome Tochtli who had married a woman named Matlalcihuatzin. His younger sister was called Tozquentzin.

Notes

1. This text owes much to the exchange of correspondence between myself, Michel Launey of the University of Paris IV and Ma. del Carmen Herrera M. (DL-INAH).

2. *Ynin altepenenonotzaliztlahtolli yhuan tlahtocatlaca-mecayonenonotzaliztlahtolli, in tliltica tlapaltica ycuiliuhtoc, machiyotoc amapan, ayc polihuiz, ayc ylcahuiz, mochipa pieloz* and *Auh ynic amo polihuiz, ylcahuiz yn, ynic oc ceppa, ye no nehuatl axcan nicneltilia, nicyancuilia, niccenteamoxtlalia.* Translation based on: Rubén Romero Galván, *Octava Relación, obra histórica de Domingo Francisco de San Antón Muñon Chimalpahin Cuauhtlehuanitzin, Introducción, estudio, paleografía, versión castellana y notas de José Rubén Romero Galván* (Mexico: UNAM, Instituto de Investigaciones Históricas, Serie de Cultura Náhuatl, Fuentes, 8, 1983), and Jacqueline de Durand-Forest, *L'Histoire de la vallée de Mexico selon Chimalpahin Quauhtlehuanitzin (du XIe au XVIe siècle)* (Paris: L'Harmattan, 1987).

3. John B. Glass, "A survey of Native Middle American pictorial manuscripts," in *Handbook of Middle American Indians*, vol. 14 (Austin: University of Texas Press, 1975), pp. 3–80 [p. 39]. The codices are owned by Mexico and the Distrito Federal (Mexico City) as well as by the Mexican States of Guerrero, Hidalgo, Morelos, Puebla, Tlaxcala, and Vera Cruz. The codices of the Borgia group have been added. For this reason, several documents written in a language other than Nahuatl may well have been introduced.

4. *"Tenían para cada género sus escritores, unos que trataban de los anales poniendo por su orden las cosas que acaecían en cada un año, con dia, mes y hora. Otros tenían a su cargo las genealogías y descendencias de los reyes y señores y personas de linaje, asentando por cuenta y razón los que nacían y borraban los que morían, con la misma cuenta. Unos tenían cuidado de las pinturas de los términos, límites y mojoneras de las ciudades, provincias, pueblos y lugares, y de las suertes y repartimientos de las tierras, cuyas eran y a quién pertenecían. Otros, de los libros de las leyes, ritos y ceremonias que usaban en su infidelidad ; y los sacerdotes, de los templos, de sus idolatrías y modo de su doctrina idolátrica y de las fiestas de sus falsos dioses y ± calendarios. Y finalmente, los filósofos y sabios que tenían entre ellos, estaba a su cargo el pintar todas las ciencias que sabían y alcanzaban."* Ixtlilxochitl, Alva, *Obras Históricas, Edición por Edmundo O'Gorman*, vol. I (Mexico, UNAM, Instituto de Investigaciones Históricas, 1975), pp. 527–528.

5. All the information about the glyphs and their constituents is based on a study of the *Codex Xolotl*, and it is highly likely that some of the characteristics mentioned are specific to the document.

Bibliography

ANDERS, Ferdinand, Jansen Maarten, and Luis Reyes García. *El libro del Ciuacoatl, Homenaje para el año de Fuego Nuevo, libro explicativo del llamado Códice Borbónico* (Mexico: Fondo de Cultura Económica, 1991).

———. *Los templos del cielo y de la obscuridad, Oráculos y liturgia, libro explicativo del llamado Códice Borgia* (Mexico: Fondo de Cultura Económica, 1993).

BERDAN FRANCES, F., and J. de Durand-Forest. *Matrícula de Tributos* (Mexico: Museo Nacional de Antropología, 1980), nos. 35–52.

DIBBLE, Charles E. *Códice Xolotl.* Preface by R. García Granados. (Mexico: UNAM, Instituto de Investigaciones Históricas, 1951).

GALARZA, Joaquín. *Lienzos de Chiepetlan* (Mexico: MAEFM, 1972).

———. *Codex Mexicains. Catalog. Bibliothèque Nationale de Paris* (Paris: Société des Américanistes, 1974).

———. *Estudios de escritura indígena tradicional AZTECA-NAHUATL* (Mexico: Archivo General de la Nación, 1979).

———. *Codex de Zempoala* (Mexico, MAEFM, 1980).

———, and A. Monod Becquelin. *Doctrina christiana, le Pater Noster* (Paris: Société d'Ethnographie, 1980).

KARTTUNEN, Francis. *An Analytical Dictionary of Nahuatl* 2nd edn (Norman, Okla.: University of Oklahoma Press, 1991).

PREM, Hanns J. *Matrícula de Huexotzinco (Ms. mex. 387 der Bibliothèque Nationale Paris)*, Einleitung Pedro Carrasco (Graz: Akademische Druck-u. Verlagsanstalt, 1974).

QUIÑONES KEBER, Eloise. *Codex Telleriano-Remensis, Ritual, Divination, and History in a Pictorial Aztec Manuscript*, E. Le Roy Ladurie (intro.). M. Besson (illus.) (Austin: University of Texas Press, 1995).

SAHAGÚN, Fray Bernardino de. *Códice Florentino. El manuscrito 218-220 de la colección Palatina de la Biblioteca Medicea Laurenziana* (Florence: Giunti Barbéra & Archivo General de la Nación, 1979).

THOUVENOT, Marc. "L'écriture nahuatl." *L'Aventure des écritures* (Paris: Bibliothèque Nationale, 1997), pp. 71–81.

———. "Amoxcalli, publication du Fonds mexicain de la Bibliothèque Nationale de France en cédéroms." *Journal de la Société des américanistes* 84/3 (1998): 51–70.

———. "Valeurs phoniques and unités de langue dans les glyphs des codex Xolotl and Vergara." *Amérindia* 23 (1999, Paris): 67–97.

———. *Codex Vergara and Santa Maria Asunción: Dictionnaire des éléments constitutifs des anthroponymes and toponymes*, CD-ROM (forthcoming).

VALLE, Perla. *Códice de Tepetlaoztoc o Códice Kingsborough* (Mexico: El Colegio Mexiquense, 1994).

A MIXTEC MANUSCRIPT

A QUESTION OF PERSPECTIVE

Martine Simonin

The Mixtec writing system, like the Central American scripts, produced numerous and wide-ranging documents and treatises on a variety of topics, including genealogies, histories, geographies, and details of disputes over land. Unfortunately, they were systematically destroyed by the Spanish conquistadors and clerics who regarded them as heretical, so few have survived. Those that were fortunate enough to escape this wholescale destruction are mainly scattered throughout European and American libraries.

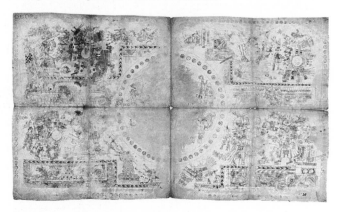

Fig. 1. The Aubin Manuscript No. 20 , Department of Oriental Manuscripts, Bibliothèque Nationale de France, Paris.

That is the case with the Aubin Manuscript No. 20 (Fig. 1), which originates from Mixteca, a region that lies west of the Mexican state of Oaxaca. It is currently preserved in the Department of Oriental Manuscripts of the Bibliothèque Nationale in Paris, France.[1]

This magnificent original document, measuring 36 by 20 inches, is written on tanned deerskin and consists of five "tableaux-scenes" arranged in staggered rows. Its eventful history—it passed through various private collections (Boturini, Aubin, then Goupil) before reaching the archives of the Paris library on January 13, 1898[2]—is typical of the destiny of such documents.

Quite apart from the content, the format of this document illustrates the originality of Central American art and illustrates one of its basic principles, known as "native perspective." This is a device that uses the projection, superimposition, and intersection of various plans within the space of the manuscript in order to put these planes "into perspective" and create plastic and semantic links between them.

The state of preservation of the lower right-hand scene in the manuscript in the Léon y Gama copy (Fig. 2) makes it possible to get to the heart of this system of spatial writing, while restricting the investigation to the arrangement of the planes in this "tableau-scene." The arrangement is based on the use of various plastic levels, defined by the relationship between content and sequence and dealing with such major themes as Time, Place, War, and Religion.

The theme of Time is divided into two differently shaped areas, corresponding to different subject-matter. The first, in which the days are counted, represents a period of 52 days. This sequence, ringed by a red line, defines the time-frame of the scene. It consists of the date, "5 grass," written in full, [3] and 51 red "ring-units" facing it. The second is a single date that, by its size and position between the human figures, is on a more advanced plane It consists of the numeral "1" and an eagle's head.

The following theme, Place, combines three subjects that are also incorporated, from the furthest plane to the closest plane to the reader. The furthest plain (the path) links the middle plane (the scene of conquest) to the closest plain (the ceremonial center).

This last plane contains two human figures, who stand facing each other. Their position situates them thematically so that neither dominates the other. Yet two themes emerge from their attributes. The person on the right carries attributes of a religious nature, while the one on the left bears the trappings of a warrior.

It is the spatial composition within these planes, the way they overlap by superimposition and crossing, that determines the succession of planes and themes in space and that defines the order in which they should be read. In traditional native perspective, the

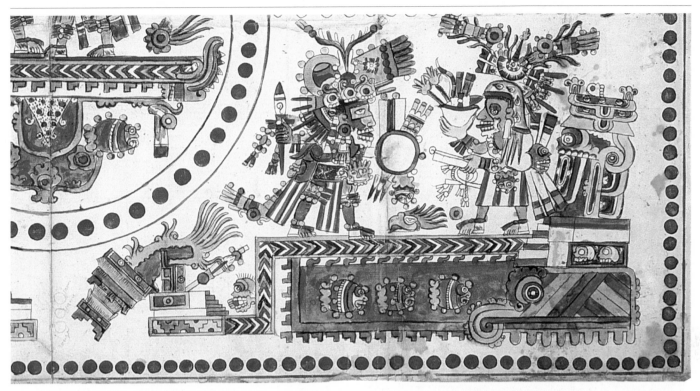

Fig. 2. Copy No. 21 by Léon y Gama of the Aubin Manuscript No. 20. Detail of the lower right scene. Bibliothèque Nationale de France, Paris.

richest element thematically is also the largest in size. It is always nearest to the reader and reveals the direction for reading the themes. The plastic transcription of the succession of planes in space in this scene respects this convention and follows the order: (1) human figures (war and religion); (2) ceremonial center (place); (3) scene of conquest (geography); (4) path (place); (5) commemorative date (time); and (6) chronological dating (time).

This rapid overview of the Mixtec writing system shows that this first descriptive reading is a concise rendering of the plastic organization of space in this "tableau-scene," and that, by decompartmentalizing the themes, it produces a dynamic view of an image that at first sight looks very static.

Notes

1. The Bibliothèque Nationale de France also possesses Léon y Gama's copy, No. 21.
2. See Martine Simonin (1996), vol. 1, p. 13.
3. The date was erased on the original and was not reproduced in the copy.

Bibliography

CASO, Alfonso. "El culto al sol; notas a la interpretacion de W. Lehmann." *Traducciones mesoamericanistas*, vol. 1 (Mexico: Sociedad mexicana de Antropologie, 1966), p. 177–190.

———. *Reyes y Reinos de la Mixteca* (Mexico: Fondo de Cultura Económica, 1979).

DALHREN DE JORDAN, Barbro. *La Mixteca su cultura e historia prehispanicas* (Mexico: Imprenta universaria, 1954).

GALARZA. Joaquín. *Amoxtli in Tlacatl, El libro, El Hombre, Códices y vivencias* (Mexico, 1992).

SIMONIN, Martine. "Le Manuscript Aubin no. 20, Codex Mexicanus no. 20 (Fonds mexicain de la Bibliothèque Nationale). Manuscript mixtèque préhispanique." Doctoral thesis, Paris, EHESS, 1996.

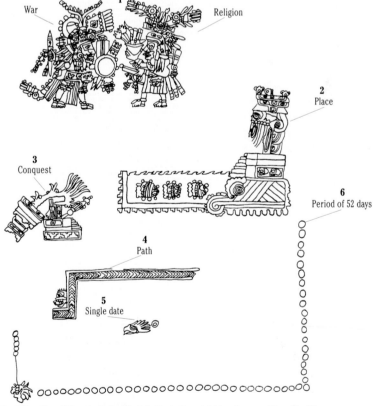

Fig. 3. Drawing of the principal subjects in the bottom right-hand scene of Copy No. 21 of the Aubin Manuscript No. 20.

THE PERUVIAN QUIPUS

Danièle Lavallée

The Peruvian Incas are often referred to as a society that did not write, yet a number of theories have been proposed, including the theory that the *tocapus*, the multicolored geometric patterns used to decorate Inca textiles, were in fact ideograms. None, however, has ever been proven or validated.

Yet the powerful Inca empire, based on carefully planned economic management, could not have existed without an efficient accounting and data-recording system. Such a system did exist, in fact, and it used the *quipu*, a word which means account, number, and knot in Quechua. Although it was not a script in the strictest sense of the word—for the *quipu* did not record the sounds of the language—it was, as several recent studies have shown, a true "visual language."

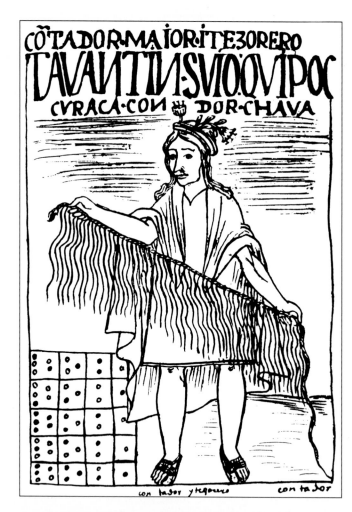

Fig. 2. Illustration from G. Poma de Ayala F., *Nueva Coronica y buen gobierno* (Paris: Institut d'Ethnologie, Musée de l'Homme, 1936).

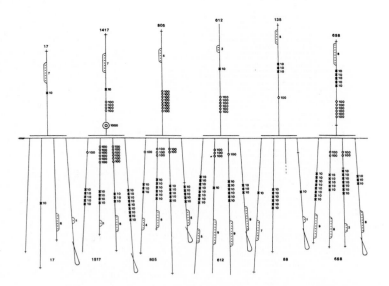

Fig. 1. Diagram of *Quipu* B8713. American Museum of Natural History in New York. (Redrawn by Locke, "The Ancient Peruvian Knot Record," *American Anthropologist*, 1912).

Thanks to descriptions left by Spanish chroniclers, it has been known since the sixteenth century that *quipu* was based on the decimal numbering system. In 1912, L.L. Locke became the first European to work out how the system operated.

A *quipu* consists of a main cord, from which secondary cords hang on which there are a number of knots. Some of these knots may have other, smaller cords attached to them. The main cord may vary in length from a few inches to over a yard, and the number of secondary cords may number eight to ten for small *quipus*, and up to as many as a thousand. for large ones. The knots themselves are of three types: plain (a single knot), double (a pair of knots), and composite (consisting of multiple knots spiraling along the cord). A single knot = 1, a double knot = 2, a triple knot = 3 and so on up to 9, the zero being indicated by the absence of a knot. The position of these single or complex knots on the cord indicate a numerical order of units, tens, hundreds, thousands, or tens of thousands, and the corresponding groups of knots are separated by a space of predetermined length (Fig. 1). The groups that belong to the same order are always placed at the same level on the secondary cords, those closest to the main cord representing the highest numbers. In order to decipher the *quipu* the main cord had to be held taut horizontally, so that the knots of the same numeric order would be aligned with one another. Here is a real example that Locke noted: at the lower end of a cord (representing the units) was a knot consisting of five turns; there was no knot in the middle range (that of the tens); and there were eight single knots at the upper end (that of the hundreds); the number recorded is thus 805.

The *quipus* thus recorded the results of calculations made on a type of abacus consisting of a frame or box containing pebbles or grains of corn. The quantities recorded could refer to property or people. The largest *quipus* might be used for keeping government accounts, but the smallest might represent the property or members of a single family.

The type of "product" to which a *quipu* referred also needed to be known, and this is where the extra-numeric factor comes in, expressed by the color of the cords, which were usually made of cotton, more rarely of wool. In the simplest case, each cord was of a single color, of which eight have been found, but a single cord could be braided using threads of various colors, or consisting of sections of different colors. There were thus infinite color variations that could be used to convey the message, and this is an aspect of the *quipus* that has not yet been deciphered. All that is known is that, according to the chronicler Garcilaso de la Vega, the yellow may have represented gold in "financial" *quipus* (and corn in the "agricultural" quipus), white may have signified silver, red, "warriors," etc.

The creation, archiving, and reading of these clever recording instruments was in the hands of special officials known as *quipucamayoc* (he who is in charge of the knots). A *quipu* was only completely intelligible to the person who made it, because the meaning given to the colors, and even the direction in which the threads were twisted, could be specific to each *quipu*. The idea that a *quipu* could be "read" is an illusion, but in the hands of trained experts who could memorize the traditions and historic events, the *quipus* could be extremely useful memory aids.

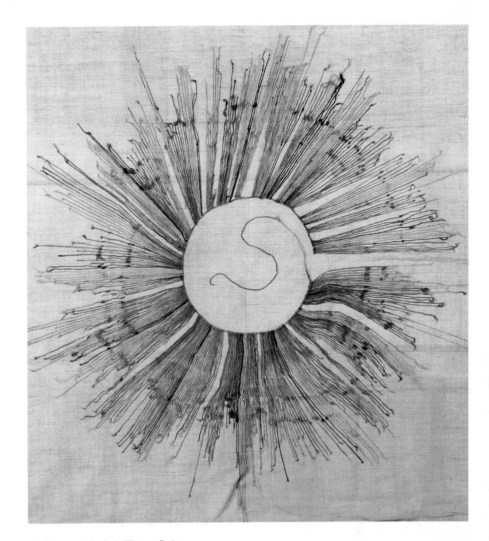

Fig. 3. A *quipu*. Musée de l'Homme, Paris.

Bibliography

ASCHER, M., and R. Ascher. "Numbers and relations from ancient Andean quipus." *Archive for History of Exact Sciences* 8/4 (1972): 288–320.
——. "El quipu como lenguaje visible." H. Lechtman and A.-M. Soldi (eds.), *La tecnología en el mundo andino* (Mexico: Universidad nacional autonoma, 1981), pp. 407–431.
LOCKE, L. L. "The Ancient quipu, a Peruvian knot record." *American Anthropologist* 14 (1912): 325–332.
NORDENSKIÖLD, E. "The secret of the Peruvian quipus." *Comparative Ethnological Studies* 6/1 (1925): 1–37.
RADICATI DI PRIMEGLIO, C. "L'interpretazione del quipu." L. Laurencich Minelli (ed.), *I regni preincaici e il mondo inca* (Milan: Jaca Books, 1992), pp. 190–192.

RONGO-RONGO:
THE EASTER ISLAND SCRIPT

Michaël Guichard

The script used on Easter Island, known as Rongo-Rongo or Rongorongo, is one of those that remains to be deciphered, having been the subject of controversy for more than a century. This is the "script" of a Polynesian people that became isolated from the rest of the world on a tiny island in the Pacific Ocean.

First of all, doubts were raised as to whether the signs on the Easter Island tablets were, in fact, an actual script. There was a widely held opinion that Rongo-Rongo does not consist of text as such but merely represents a system of mnemonics. Researchers currently favor the theory that it is a true script, even if no one agrees on the nature of its essential characteristics.

Then there is the problem of the source material. The authenticity of Easter Island inscriptions and the veracity of eye-witness accounts collected in the nineteenth and early twentieth centuries, which give valuable information about the practices connected with Rongo-Rongo, continue to raise difficult questions. There is still much discussion over whether a particular document is a forgery or whether a particular custom, as described by an elderly native of the island, is genuine. Thomas Barthel relegated several museum pieces to the rank of mere curiosities by demonstrating their lack of authenticity, naturally calling into question earlier interpretations made on the basis of these forgeries.

This situation is the result of the tragic end that the "civilized" world reserved for this Pacific island. Easter Island did not enjoy a good reputation with sailors in the eighteenth century, and this spared it from colonization until the mid-nineteenth century. However, it was then that passing ships, whalers or slave-ships, began to attack the natives. During one single expedition, hundreds of Easter Islanders were captured and torn from their island homeland to be sold into slavery. They included all of the elite, especially those Maoris who were the repositories of their ancient culture.

The handful of survivors who managed to make it back to Rapa Nui (their own name for the island) brought death to their fellow islanders because they carried diseases that had been hitherto unknown. This caused an irreparable break in the thread of tradition.

By the time enlightened Europeans began to exhibit an interest in the Easter Island culture, it was already dying. The last old people whose ear lobes were lengthened and pierced in the same style as the famous Easter Island statues, known as *moaïs*, died in the early twentieth century. Christian missionaries then extinguished whatever was left of Easter Island culture and tradition.

The belated European interest in the Rongo-Rongo "writings" at least made it possible to salvage something which no longer had any meaning for the natives themselves and was thus threatened with disappearance. The first tablet to attract the attention of Father Jaussen, the true "inventor" of Rongo-Rongo, was one that had been reused for winding a hank of hair that the Easter Islanders had given him as a gift.

The sudden interest in Easter Island caused the rapid dispersion of documents throughout the world. The main collections of tablets are currently to be found in Rome, in the British Museum in London, in Vienna, in the Smithsonian Institute in Washington, D.C., in the natural history museum of Santiago, Chile, and in Hawaii.

Only twenty-five authenticated documents escaped destruction. They were written on a variety of media, including a stick and two pectorals shaped like the head of a rooster, which are covered in signs. All the rest of the Rongo-Rongo is written on *kahau*, "tablets of the bards," irregularly shaped blocks of wood. A few stone tablets may be authentic. For Easter Islanders, wood was a valuable material, the island having been denuded of trees. The French admiral, Abel Dupetit-Thouars, who sailed to Rapa Nui in 1838, related that the natives who came on board ship were constantly asking for wood. Some researchers believe that the wood on which the inscriptions were written was driftwood from wrecks. Archaeology has shown, however, that at one time the island was covered in vegetation. The toromiro tree, whose wood was used to make the tablets, disappeared through excessive use. The fact that it was used for writing shows how important Rongo-Rongo was considered to be.

The tablets are completely covered with finely engraved signs, leaving no empty space, and this was at one time held to be a proof that

Rongo-Rongo could not be considered a script but merely a decorative art. Barthel listed 595 basic signs and, taking the variations into account, 1,400 glyphs. In fact, the number of signs varies depending on who wrote them; a researcher recently reduced the number to 200.

The glyphs look like pictograms, which one author has compared to the script of the Indus, another form of writing that has not yet been deciphered. It consists of stylized representations of birds, fish, plants, various parts of the human body, and geometric patterns.

On the only engraved stick that we know of, the signs are arranged in a spiral pattern, whereas on the tablets, they are aligned regularly from left to right. However, the tablet must be turned upside down at the end of each line, because odd lines are written one way up and even lines are written the other way up, on the boustrophedon principle.

The signs are written with varying degrees of skill. The "crude" style is attributed either to a deterioration in writing skill or its "democratization." This theory presumes that the writing developed into a linear form, of which two variations have been distinguished, *ta'u* and *va'e-va'e*.

The difficulty of deciphering is not due to lack of knowledge of the language, which is known since the inhabitants of the island have not died out completely; the problem lies in the way in which it was annotated. It might have been a syllabic script or an ideogrammatic script, a sort of hieroglyphics. These theories contradict the way in which the script was previously interpreted, when it was believed that even if certain signs represented a whole word, Rongo-Rongo was merely a sort of memory prompt to help with the recitation of traditional chants of the kind that existed in the islands of Polynesia.

One thing is certain: the content of the Rongo-Rongo *kahau* is of a religious nature, consisting of ritual chants, mythical tales or "genealogical" lists. The "text" on the wooden script, for example, is punctuated by pairs of vertical lines. Within these divisions, there are at least three signs, one of which is almost always considered to

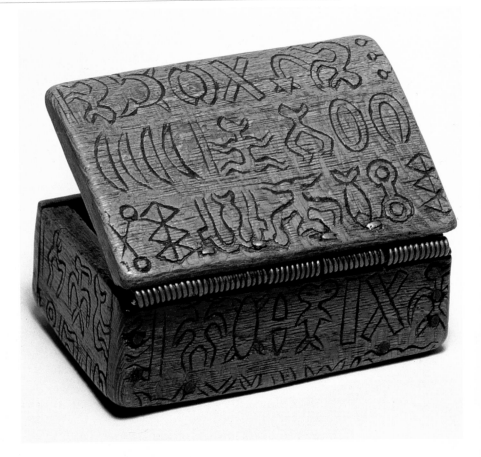

Fig. 2. Box inscribed in Rongo-Rongo, reused as a tobacco-box. Inv. 62.47.5, Musée de l'Homme, Paris.

Fig. 1. Print of signs carved in stone.

represent a phallus, the symbol of sexual congress. It thus appears to be a genealogical recitation parallel to an Easter Island chant listing forty-two sexual unions.

The date of these texts remains uncertain. The oldest manifestation of the act of writing by Easter Islanders is preserved in a document recording the capture of the island by the Spanish in 1770. The document is signed at the bottom in Rongo-Rongo by three Easter Island dignitaries. It is interesting to note that the signs are arranged vertically. According to the islanders, the founder of their civilization reached the island with sixty-seven tablets of the tradition, which would place the arrival of writing on the island in the sixth century CE. The number of tablets preserved on the island was certainly considerable by the mid-nineteenth century because Father Eyraud, the first missionary, noted in 1864 that all the sections of the island possessed tablets. He was also the first European to mention the tablets, but he seems not to have realized the importance of what he was seeing:

The small significance that the Islanders accord these tablets leads me to suppose that the characters, even if they are probably a script in principle, are simply a custom that they continue to preserve, without really taking account of it. In fact, they have no idea of how to read or write.

II. ALPHABETS AND DERIVED SCRIPTS

AEGEAN SCRIPTS
OF THE SECOND MILLENNIUM BCE

Jean-Pierre Olivier

INTRODUCTION

As the third millennium BCE drew to a close in Crete and a new millennium dawned, two scripts were created: Cretan hieroglyphic and Linear A. These were simple syllabaries, each consisting of a hundred or so signs of the consonant + vowel (CV) type. They developed on the fringes of the Assyrian and Egyptian empires, benefitting from Cretan insularity in order to distance themselves from the cumbersome logosyllabic scripts of the mainland.

Hieroglyphic was confined to central and eastern Crete and ceased to be used as an administrative script in the mid-seventeenth century BCE. Linear A, which has been found throughout the island and in the Aegean Basin, fell into disuse in the mid-fifteenth century BCE. Prior to this, in circumstances that remain unclear, Linear A developed into Linear B; the latter (found in Crete at Knossos and Chania, and on the Greek mainland in the palaces of Mycenae, Midea, Pylos, Thebes, and Tiryns) disappeared around 1200 BCE under Mycenaean rule. The syllabic script survived only in Cyprus, where it was adopted before the end of the first half of the second millennium BCE in a so-called "Cypro-Minoan" version that in turn produced the Cypriot syllabic script.

The fact that the origins of Cretan hieroglyphic and Linear A are obscure should come as no surprise; this is almost always the case with such early forms of writing. And the reasons for developing a script suitable for recording accounting transactions in an expanding society are not difficult to fathom. But why two scripts should have been created, and why they subsequently coexisted (even in the same archives, written on the same media, and dealing with the same subjects) is more puzzling. As far as is currently known, the two scripts do not appear to have had a common ancestry, nor was one derived from the other.

Yet for at least three hundred years both were used on an island only 200 miles in length which does not appear to have experienced immigration after the turn of the millennium. Two different languages may have been in common use—something that archaeology would not necessarily reveal—but even that does not provide a complete explanation; for example, why is hieroglyphic alone found on seals?

The development of Linear A into Linear B (based on an "archaic" precursor that has been lost but whose rounded forms indicate that it was usually written on a flexible medium) is more easily explained. It is because it was required to transcribe a different language—Greek. About twenty of the old signs were discarded and another fifteen introduced, leaving a shared base of seventy signs. In theory, this should be helpful for attempts to decipher the script because some signs that used the same shape might still be used to represent the same sounds. But which sounds? The classic Cypriot syllabary, deciphered in the 1870s, was used, like Linear B, to annotate Greek. The scripts share

Aegean scripts in the north-eastern Mediterranean.

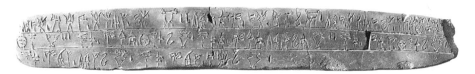

Fig. 1. Clay tablet from Pylos inscribed in Linear B; 25.2 x 3.6 x 1.5 cm. NMA 641, National Museum of Athens.

around ten signs that look the same and reproduce the same sound, and this enabled Linear B to be deciphered in 1952 by Michael Ventris. Yet, in the current state of documentary evidence, this is not enough to solve the problem, let alone to go back as far as Linear A.

Although both the classic Cypriot syllabary and Linear B have been deciphered, that is first and foremost because a relatively large amount of material existed and it had been used to record a known language. Furthermore, there were several digraphic texts, written in both the classic syllabary and an alphabetic script, which helped in the decipherment of the classic Cypriot syllabary, and there existed at least one "pseudo-bilingual" text which was useful for confirming the decipherment of Linear B. The clay tablet from Pylos known as the "tripod tablet" (Fig. 1) bears a mention of the

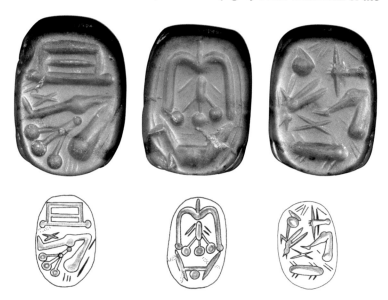

Fig. 2. Three-sided prismatic seal of green jasper, engraved with Cretan hieroglyphic; 0.9 x 1.15 cm. N 3444, Cabinet des Médailles, Bibliothèque Nationale de France, Paris.

word *ti-ri-po* = τρίπους, "tripod," followed by a drawing of a vase standing on three feet (in three places in line 1), and the words "vase with four handles" (in two places in line 2), "vase with three handles" (lines 2 and 3)," and "vase without handles" (line 3) are followed respectively by drawings of vases with four, three, and no handles.

No such clues are provided for Cretan hieroglyphic, Linear A and Cypro-Minoan, which cannot be read today because they transcribe languages that are unknown.

CRETAN HIEROGLYPHICS

Cretan hieroglyphic script was given its name by its discoverer, Arthur Evans, the excavator of spectacular finds at Knossos. In fact the script is a syllabary, though it must be admitted that this was by no means obvious in the early part of the twentieth century. Although the script is no longer considered to be a hieroglyphic one, the name has stuck, for lack of a suitable alternative.

The corpus of the script consists of just over 1,700 signs (found on some three hundred objects), a number that more or less corresponds to the number of typographic characters in thirty lines on this page (for comparison, Ventris had about thirty thousand signs available to him when he deciphered Linear B). The documentation we have available is divided more or less equally between archives written on *unbaked* clay (as with all the scripts discussed in this section, except for the Phaistos disk) and those written on seals, usually made of stone, to which should be added about twenty or so other items—mainly inscriptions on vases, mostly engraved, but some painted. The archives and seals shared ten or so groups of signs, and this would seem to be enough to suggest that they formed a consistent whole, even though the basic forms of the accounting documents (which hardly changed from hieroglyphic through Linear B) and engraved seals (which only existed in the time of the first palaces, *ca* 1900–1700 BCE) are not identical. It should be noted in passing that the imprints of seals, whether hieroglyphic or not, are never found on basic administrative documents (the "four-sided bar" or "double-edged blade" in hieroglyphic, the tablet in Linear A or B); these clay documents were no doubt of such minor importance that they did not need to be authenticated. This leaves to the imagination, then, the huge quantity of material that must have been written on organic matter and is lost for ever.

Shown here are two hieroglyphic documents engraved on stone: a three-sided prismatic seal (Fig. 2) and an inscription on a large "libation vase" (Fig. 3).

They are different in every respect. The written components of the seal are contained within the oval field of each of the three faces. To achieve the desired harmony, the engraver not only moved certain signs or altered their scale but also added "filler" or "decorative" elements (modest ones in this case): on the α side the signs are juxtaposed, on the β side they are superimposed, and on the γ side they are scattered at random. Starting from the "initial cross,"

Fig. 3. Blue limestone vase from Malia engraved in Cretan hieroglyphic; height: 44 cm; length of the inscription: *ca* 19 cm.
HM E 415, Herakleion Archaeological Museum.

the inscription can be unfurled in four different ways without there being any clue as to the direction in which the signs are to be read. Since this group of signs remains unknown in the current state of research, this does not help us understand the document. It is indeed a script, but one that owes more to tradition and decoration than to the efficient conveying of information in an administrative capacity. It could only be read by someone who knew the "relevant" groups of signs).

By contrast, the sixteen signs inscribed on the vase (Fig. 3) constitute the only example of a monumental inscription in Cretan hieroglyphic, not so much because of their size (they are not particularly large) but on account of their linearity. They appear to have a top and bottom and a right and left (apart from which, the three recurring signs have the same outline). Only the absence of punctuation is a potential source of confusion. It is easy to tell that the text is read from right to left (the mouth of the vase is on the right in the photograph), but there is nothing else to assist with reading; since no single group of three signs appears in the body, there is no indication of how the signs should be divided up into "words."

These two documents are not particularly typical of the existing data, but they illustrate some of the difficulties that confront the modern researcher who attempts to study this script.

LINEAR A AND LINEAR B

Linear A

Linear A was probably created after Cretan hieroglyphic and shares only twenty or so signs with this script, although the numbering systems, which consist of the juxtaposition of simple decimal elements, are almost identical. Linear A and Cretan hieroglyphic have both been found on non-administrative media, such as stone or clay vases. The latter are mostly engraved but sometimes painted. Inscriptions are also found on walls and metal objects. Only about a hundred or so such inscriptions have been found, whereas 1,500 administrative records have been discovered on clay tablets.

The 7,500 signs presently known in Linear A, along with their various combinations into groups, are sufficiently well known to researchers to have enabled Louis Godart to identify in 1981, within a few minutes, one authentic text in a group of ten hoaxes that the present author had carefully forged as having the most credibility. The text in question consisted of eighteen signs inscribed on a gold pin (Fig. 4) that turned up in the antiques trade. Yet none of the signs in this group was known at the time; it was the inimitable "melody" of the sign-groups that led to the identification.

Linear A has been found all over the Aegean, in Cythera, Kea, Miletus, Melos, Samothrace, and Santorini, and it was clearly the script used by the Minoan thalassocracy, but it

Fig. 4. Gold pin of Cretan (?) origin, inscribed in Linear A; actual length: 11 cm; length of the inscription:
ca 3.6 cm. HNM 9675, Haghios Nikolaos Archaeological Museum, Crete.

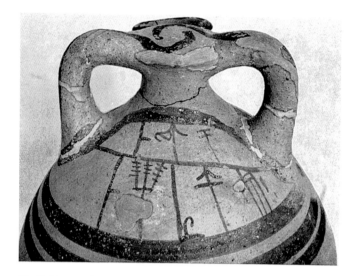

Fig. 5. Clay amphora from Eleusis (Attica) with painted Linear B inscription; height: 41 cm; max. length of the inscription: about 15 cm. Eleusis Museum.

did not disappear from religious and private use when Crete was invaded in *ca* 1450 BCE by the Mycenaeans whose used the Linear B script. This confirms that its use was not reserved for a scholarly caste. The most recent evidence of this script consists of eight signs painted on a statuette found in a private house and dating from *ca* 1380 BCE. It would appear to contain a "votive offering formula," since the same wording has been found on several "proto-hieroglyphic" seals dating back to the third millennium BCE. This fills a gap in knowledge, but nothing more can be inferred from it other than the survival of an ancient scriptural and religious tradition.

Linear B

Although Linear B has been found on more than five thousand documents, it is almost entirely confined to clay tablets (even though the writing must have been used on organic materials that have not survived). Of the inscriptions that have been found on other supports, only two or three short inscriptions painted on small drinking vessels could be described as private; the 175 or so inscriptions on large amphorae used for storing oil are of an administrative nature (see below). Historically, this implies that literacy became less universal and was thenceforth restricted to the upper echelons of the bureaucracy. In the case of a palace such as that of Pylos, in which most of the tablets date from the same period, this means that thirty or so "writers on clay" were employed, who were educated administrators rather than professional scribes.

The theory has even been proposed that most of the inscriptions on the amphorae were copied down by illiterate potters who did not bother to organize the space on which the inscription appears, since they did not know the phonetic value of the signs they were tracing.

In contrast, Fig. 5 shows an inscription painted on a amphora by a "literate person" (Fig. 5), but one who was certainly no artist (as witnessed by the proportions of the letters, the clumsiness of the central dividing line, and the way it accidentally brushes against the last sign). He was nevertheless able to write Linear B without confusing the syllabic order and without distorting the shapes. In short, here was a person delivering a clear, precise message. The first line indicates the provenance of the amphora (it was found in Attica but bears a place-name from central Crete) and the second names the person in charge of production (and/or shipping) of the vase (and/or the oil). The whole operation (or merely its author?) is described as "royal" by the final monosyllabic abbreviation, framed by two punctuation marks, as proved by archival documents that are quite unambiguous.

CYPRIOT SCRIPTS

Syllabic script disappeared from Greece with the destruction of the Mycenaean palaces in the late thirteenth century BCE, but it survived in Cyprus as late as the Hellenistic period (in the late third century BCE), where a form of Linear A had been in use since the sixteenth century BCE or even earlier. During this fourteen-hundred year period the syllabary changed between five and ten times, though the precise number is difficult to determine because no one has yet mastered the 3,000 signs of Cypro-Minoan and the 14,000 or so signs of classic Cypriot (the dividing line between them is said to fall in the eleventh century BCE). The origins of the Cretan scripts are equally obscure, and their relationship with the Cypriot scripts has not been clearly established, but the texts have almost all been published, with photographs and drawings, and their chronology is fairly certain; this is not the case with the Cypriot scripts (which even extended as far as Ugarit on the coast of modern-day Syria). Only the classic Cypriot syllabary, which was deciphered in the late nineteenth century—it was used to transcribe the Greek of the Mycenaean colonists who settled on the island in the twelfth century BCE—has been given close attention.

Here, we shall focus on two representative examples of these Cypriot offshoots. The first one (Fig. 6) shows the lower left quarter of the back of a rather large clay tablet measuring about 22 cm in height. It is part of a group of three fragments of opistographic tablets in the shape of a cushion (and thus of the eastern type), found at Enkomi,

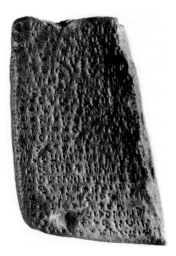

Fig. 6. Fragment of clay tablet (side B) from Enkomi inscribed in Cypro-Minoan; 8.5 x 12.1 x 3 cm. AM 2336, Musée du Louvre, Paris.

Cyprus, and dating from the late thirteen or early twelfth centuries BCE. These tablet contain about 1,300 signs; the uniform syllabary of this group is sometimes called "Cypro-Minoan II," and consists of about sixty signs (whereas the "general syllabary," which is more extended, both diachronically and geographically, has between 90 and 100 signs). The right-facing text is divided into two or three columns, and the words are separated by punctuation marks. Although they contain running text rather than inventories and are carefully inscribed and paginated, these tablets were not fired intentionally, exactly as their Cretan counterparts from which they are differentiated by the angular outline of the characters, in which some scholars have detected the influence of cuneiform writing. The content is unknown because the script, which was used to transcribe an unknown language, cannot be read. At best we can only try to guess at the sound values for the dozen or so signs that are similar to those in Linear B and classic Cypriot.

The other tablet (Fig. 7) shows side A of a wonderfully preserved inscription in the classic Cypriot syllabary. It is a bronze tablet from Idalion, which was engraved between 480 and 470 BCE; the left-facing text records an agreement in Greek between Stasikypros, king of Idalion, and the physician Onasilos and his brothers concerning the medical attention given to the wounded when the city was besieged. The inscriptions on both sides are of almost equal length and contain 1,028 signs and 232 punctuation marks. Among them are abbreviations for monetary values, followed by numerals (I, II, and IIII)—these can be identified on the sixth, thirteenth, penultimate, and last lines. The fact that the signs were written on metal had little effect on their shape. They are mostly found engraved on stone, but also, more rarely, as painted inscriptions. Syllabic writing had become archaic by this late date, so it is not surprising that the writing was rather conservative in style.

It is unfortunate that knowledge of the Cypriot syllabaries should have made so little progress, for the island of Cyprus was a real "script laboratory," not only in the second millennium BCE, during which several syllabaries may have evolved and influenced one another, but also during the first millennium when at least four systems of writing existed simultaneously: classic Cypriot syllabary (used to transcribe Greek as well as "Eteo-Cypriot," which was just one of the languages spoken in the second millennium BCE); cuneiform script; the Phoenician alphabet; and the Greek alphabet.

THE PHAISTOS DISK

The Phaistos disk dates from about 1700 BCE (Figs. 8 and 9). Found in 1908 at the site of the first palace of Phaistos, it is a unique document in the history of writing in that, at the time of its unearthing, its script did not resemble anything that was then known. Even now, a century later, this situation has scarcely changed.

The clay disk was stamped in relief using punches that were probably made of metal—gold has been suggested—in view of the sharpness of the imprints; the signs are written in a spiral pattern between pairs of lines that are demarcated into 61 frames or boxes. There are 242 marks on the disk. The boxes probably contain words (some are repeated), written in a simple syllabary of the open type (the groups consist of between two and seven signs and there are 45 different signs). It is reasonably certain that

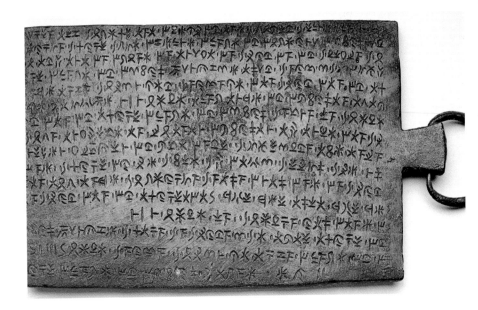

Fig. 7. Bronze tablet from Idalion (side A) engraved in classic Cypriot script; 21.4 x 14 x 0.4-6 cm. No. 2297, Cabinet des Médailles, Bibliothèque Nationale de France, Paris.

Fig. 8. Phaistos disk, side A; diam.: *ca* 16 cm; thickness: 1.6-2.1 cm. Herakleion Archaeological Museum.

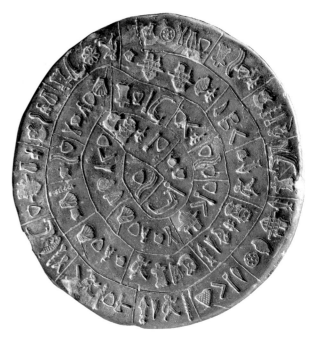

Fig. 9. Phaistos disk, side B; diam.: *ca* 16 cm; thickness: 1.6-2.1 cm. Herakleion Archaeological Museum.

the syllabary must have numbered between 50 and 60 signs in total (the only feature that it has in common with Cretan scripts, all of which are syllabic), that side A should be read first, and that the disk should be read starting from the outside and finishing at the center.

The object was not a matrix and the text had to be read directly from the clay, so the disk cannot be compared with seals bearing one or more signs in Cretan hieroglyphic script whose purpose was either to mark the property or indicate authenticity, or to affix a "stamp" containing a fairly short word of generally between two and six signs.

There is no known equivalent of the manufacturing technique. It was not until the invention of movable type in the last years of the fourteenth century CE that anything similar was used (although combining elements of loose type on a temporary basis in order to mass-produce a set of characters is very different from stamping out individual characters one by one, using single punch-letters that cannot be combined).

The maker of the disk had certainly a model, but could not avoid making about fifteen mistakes, which left their mark on the clay. There is no denying the pleasing esthetic effect that this technique produces; furthermore, the Phaistos disk had been deliberately fired, which is evidence that it was considered to have some value. In this respect, it differs fundamentally from most of the documents written on clay that have been found in Crete and in Cyprus. This detail alone would be enough to suggest that it was not an accounting item.

The object is not of Cretan origin, regardless of what has been written about it, since the shape of the signs in *no way* relates to those of Cretan hieroglyphic or Linear A.

As regards the style and choice of theme, it is very difficult to link them to the Minoan iconography. Indeed, there is not one typically Cretan character on the disk. For instance, there is no double ax or bull's head (signs used in all three scripts). Only the ship could be said to look vaguely "Aegean." Unfortunately, on the basis of a single sign, the disk has been variously identified as "Philistine"—from the "feathered head" worn by Philistine warriors and represented on the walls of the temple of Ramses III at Medinet Habu (*ca* 1160 BCE)—and as "Lycian" (from the wooden scaffolding that is also found carved in stone on the walls of Lycian tombs in the Hellenistic period).

Even if this artifact does not constitute "an astonishing anticipation of printing," as has been claimed rather too enthusiastically, it does present some intriguing paradoxes. By no means the least of these is the fact that its text is destined to remain undecipherable for as long as the disk remains the only example of this particular script.

Bibliography

CHADWICK, J. *The Decipherment of Linear B* (Cambridge, 1970).
GODART, L. *The Phaistos Disk. The Enigma of a Script* (Herakleion, 1995).
MASSON, O. *Les Inscriptions chypriotes syllabiques. Recueil critique commenté* (Paris [1961], 1983).
OLIVIER, J.-P. "Cretan writing in the second millennium B.C." *World Archaeology* 17 (1986): 377–389.
PALAIMA, Th. G. "Cypro-Minoan scripts: problems of historical context."*Problems in Decipherment.* Y. Duhoux, Th. G. Palaima and J. Bennet (eds.) (Louvain-la-Neuve, 1989), pp. 121–187.

THE ORIGIN OF THE WESTERN SEMITIC ALPHABET AND SCRIPTS

André Lemaire

The western semitic scripts of the ancient Near East were the first to have limited the number of their constituent signs to a mere thirty or so, most of them consonants. They are now known by the term "alphabet," a word derived from the names of the first two signs of the traditional order of the letters, as taught in the Levant. This primitive alphabet, which dates from the first half of the second millennium BCE, is the basis for the "Canaanite" and Ugaritic scripts of the second half of the second millennium BCE, and the later Phoenician, Philistian, Hebrew, Ammonite, Moabite, Edomite, and Aramaic scripts, as well as the earliest south Arabian scripts of the first millennium BCE. Toward the end of the ninth century, the Greeks borrowed and adapted the Phoenician alphabet and subsequently transmitted it to the Etruscans and Latins. In the Near East, the Philistian, Ammonite, Moabite, and Edomite scripts disappeared in the sixth century BCE at the same time as the kingdoms that used them, while Phoenician and paleo-Hebrew continued in use until the first centuries of the common era. At the time, however, various forms of Aramaic script were the most widely used, especially in manuscripts and as inscriptions on funerary monuments. Only the Aramaic script survives to this day, in evolved and adapted forms, especially as "square" Hebrew writing but also as Syriac and Arabic scripts.

THE ORIGINS OF THE ALPHABET

The first evidence for an alphabetic script was found in two adjacent regions, northern Sinai and Palestine. In the Sinai peninsula, about forty so-called "proto-Sinaitic" inscriptions dating from *ca* 1850–1500 BCE, have been found carved on rocks or stone slabs, sometimes next to inscriptions in Egyptian hieroglyphics (Fig. 1). In Palestine,

Fig. 1. A proto-sinaitic inscription reading LB'LT, found on a sphinx, *ca* 1800(?) BCE. No. 41748, British Museum, London.

small, often fragmentary, inscriptions have been found that date from the seventeenth through the fourteenth centuries BCE.

Clearly, the first alphabetic script emerged because the Semitic tribes of the region frequently encountered Egyptian hieroglyphics, a writing system that included some

Fig. 2. Cuneiform lettering textbook from Ugarit, thirteenth century BCE. AO 19992, Musée du Louvre, Paris.

twenty alphabetic signs, mainly for the purpose of transcribing foreign names. Consequently, the shapes of the twenty-seven or so alphabetic signs used in proto-Sinaitic inscriptions are visibly inspired by hieroglyphics, though they do not represent the same sounds. Their phonology can be deduced from the word that the pictogram represents in western Semitic languages.

For instance, the sign representing the head of an OX ('aleph in western Semitic) was used to transcribe the consonant that languages using Latin script represent with the symbol ' (a silent guttural or glottal stop). The pictogram showing a schematic representation of a HOUSE (bayit in western Semitic) denotes the consonant B. Similarly, the horizontal wavy line of the pictogram for WATER (mayim in western Semitic) is used to indicate an M.

As in western Semitic languages, consonants play a crucial role in indicating the basic semantic field. The first alphabetic scripts were purely consonantic—as are, for the most part, Hebrew and Arabic to this day.

SEMITIC SCRIPTS OF THE FOURTEENTH AND THIRTEENTH CENTURIES BCE

The defeat of the Hyksos ca 1525 BCE and the conquest of Palestine by the New Egyptian empire did nothing to assist the spread of the new writing, "the script of the vanquished," especially since it had to compete with the two dominant, traditional scripts, Egyptian and cuneiform. Egyptian (in both its hieroglyphic and its hieratic forms) was the language of the victors, and cuneiform was an

international script for which there is much evidence of extensive use in the Near East from the eighteenth and seventeenth centuries BCE.

The Tell el-Amarna letters are proof that in the Near East the scribes of the period used cuneiform and, later (ca 1300? BCE), a cuneiform adaptation of linear writing, another alphabetic script, that came into use in Palestine, Phoenicia, what is now the Beqaʿ Valley of southern Lebanon, southern Homs, and as far away as Cyprus.

The largest amount of evidence currently available for the use of cuneiform comes from Ras Shamra, on the coast of northern Syria, the area once known as Ugarit. Here, a thirty-character alphabet, in which each consonant had an attached vowel sound ('a, 'i, and 'u) was officially adopted by the local royal administration. French excavations begun in 1930 at Ugarit and neighboring sites have uncovered around two thousand inscriptions of this type, mainly on clay tablets, of which an example is shown in Fig. 2. The horde included at least 800 financial texts, 170 mythological texts, 80 items of correspondence, and about 20 school exercises as well as textbooks for teaching the alphabet. It should be stressed, however, that in Ugarit itself, the number of syllabic cuneiform tablets (mainly in Akkadian), far exceed that of alphabetic cuneiform tablets.

Fig. 3. Arrowhead inscribed in ancient Phoenician, eleventh century BCE. AO 18849, Musée du Louvre, Paris.

Whether in its abbreviated (22-letter) or extended (30-letter) form, the use of alphabetic cuneiform ceased with the disappearance of the Levantine civilization that had created it in the Late Bronze Age; that is to say, it did not survive the invasion of the Peoples of the Sea ca 1180 BCE.

"NATIONAL" SCRIPTS IN THE ELEVENTH TO SIXTH CENTURIES BCE

After a Dark Age, the Late Bronze Age civilization was replaced by the so-called Iron Age, during which the linear alphabet of the Late Bronze Age spawned several new scripts in tandem with the creation of various independent political entities. Starting from the same base, the letters gradually diverged from their original

shape to reflect the regional scribal traditions of the numerous royal administrations that used different languages or dialects. Depending on the language, various so-called "Canaanite" scripts have been found for the Phoenician, Philistian, Hebrew, Ammonite, Moabite, and Edomite languages, and there were also the Aramaic and south Arabian scripts.

Fig. 4. Inscription on the sarcophagus of King Ahiram of Byblos, *ca* 1000 BCE. National Museum, Beirut.

"CANAANITE" SCRIPTS

Phoenician script

Phoenician culture developed along the Mediterranean coast of the Levant north of Mount Carmel, in the city-states of Tyre, Sidon, Byblos, and Arwad. There is plenty of evidence of Phoenician script dating from the eleventh century BCE in the form of inscribed arrowheads (Fig. 3) and various royal inscriptions from Byblos, including the sarcophagus of King Ahirom (or Ahiram) dating from *ca* 1000 BCE (Fig. 4). A few inscriptions on jars of a slightly later date confirm the use of cursive writing using red or black ink (late ninth and eighth centuries BCE). Several rather crudely inscribed gravestones bearing the name of the deceased have been found in cemeteries in Tyre and Akhziv, which show that the script had spread by the seventh century BCE.

During this period, Phoenician script was often used outside the confines of Phoenicia. It can be found on objects made in Ur (Lower Mesopotamia) and Crete, and especially in the Phoenician "colonies" of Cyprus, Malta, Sicily, Sardinia (the ninth-century Nora inscription), southern Spain (as far as Cadiz) and North Africa, where for a time, Carthage, the center of the Punic civilization, vied with Rome for control of the Mediterranean. A few inscriptions dating from the sixth through the fourth centuries BCE have even been found in Egypt, linked to Phoenician trading posts.

The most surprising phenomenon is the use of Phoenician in royal inscriptions in countries where it was not the language of habitual use. This was the case in the small Aramean-Louvite kingdom of Samal (Zencirli)—which existed east of the River Amanus in central Turkey in the second half of the ninth century BCE—and the kingdom of Que in Cilicia where, in the eighth through the seventh centuries, bilingual inscriptions in Phoenician and Louvite were found at Karatepe. These are the longest inscriptions in Phoenician known hitherto.

The use of Phoenician by a people who spoke Louvite, an Indo-European language, no doubt facilitated the transmission and adaptation of the Phoenician alphabet to the Greek-speaking world, which would originally have used it as a means of transcribing local proper names with a basic guide to their pronunciation. Even though the exact date and place of this adaptation is still in dispute, it is likely to have taken place in the second half of the ninth century BCE. Letters used to denote Phoenician gutturals that were redundant in Greek were appropriated to transcribe vowels whose annotation is indispensable for understanding a text written in an Indo-European language.

Philistian script

The Philistian script is a direct descendant of the "Canaanite" script that was used at the end of the Late Bronze Age. It developed in the five kingdoms of the

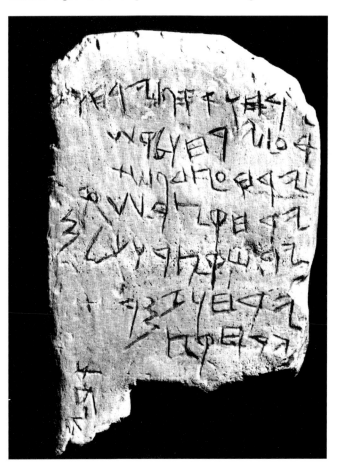

Fig. 5. Tablet found at Gezer, Levant. Istanbul Museum, Istanbul.

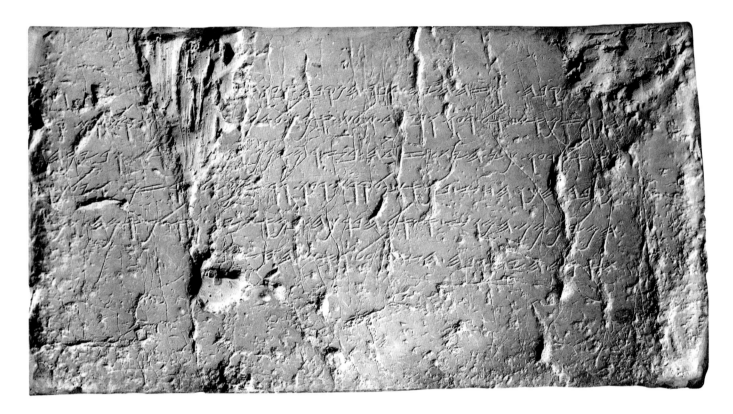

Fig. 6. Inscription from the Siloam Canal in Ancient Hebrew (molding), dating from 715–701 BCE. AO 1310, Musée du Louvre, Paris.

Philistine plain: Gaza, Ashkelon, Ashdod, Gat, and Ekron (currently in Israel, between Tel-Aviv and the Egyptian border). The Gezer tablet (Fig. 5), is probably written in Philistian script. It shows an agricultural calendar dating from the tenth century BCE and may well have been a lesson in learning to write on a stone tablet.

Paleo-Hebrew script
Further inland, in what is now Jordan, and along the banks of the river Jordan, lay the kingdoms of Israel to the north and Judah to the south, originally a single kingdom under King David and King Solomon. For the purposes of royal administration, they adopted the local "Canaanite" script and soon developed it into a cursive style, mainly by the extension and incurving of the vertical strokes, a feature of scripts of the second half of the eighth century BCE (Fig. 6).

No long royal inscriptions carved in stone have been found from the kingdoms of Israel and Judah. On the other hand, numerous ostraca, seals, stamps, and bullae, as well as a few funerary inscriptions and graffiti carved on rock, plus numerous inscriptions on vases or weights, are proof that the script was in widespread use.

Even though the caves of the Judean desert have thus far yielded only a single papyrus from the time of the kings

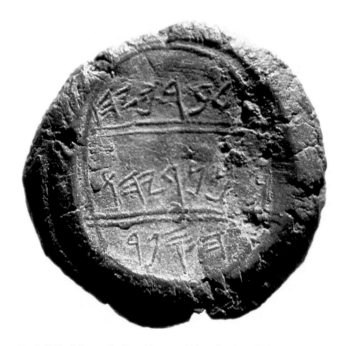

Fig. 7. Bull of the scribe Barukh, son of Neryahu. Israel Museum, Jerusalem.

Fig. 8. Ammonite inscription from the citadel of Amman. Department of Antiquities, Amman, Jordan.

(and even this is a palimpsest), the text of the Hebrew Bible—as well as traces impressed on the back of most of the bullae dating from the late eighth century BCE through 587 BCE (the year when Jerusalem was captured for the second time by Nebuchadnezzar)—shows that most of the writings of the period (letters, administrative documents, property titles, literary texts, etc.) were produced on papyrus or leather. Books—in the form of scrolls—and property deeds were written out by a scribe (*sofer*) who was also a notary. One of the most famous was Barukh, son of Neryahu (Fig. 7). As an employee of Jeremiah he drew up the contract of sale of a field to his cousin (Jeremiah 32), as well as scrolls of oracles (Jeremiah 36).

Ammonite script
The Ammonite kingdom was founded in Transjordan in the eleventh century BCE but only became a neo-Babylonian province in 582 BCE. The capital, Rabbat-Ammon (now Amman), has yielded a fragment of an inscription in stone (Fig. 8). Ammonite script is also known from a hundred or so inscribed seals and is similar to Phoenician and the Aramaic script that followed it, on account of its many straight, vertical strokes.

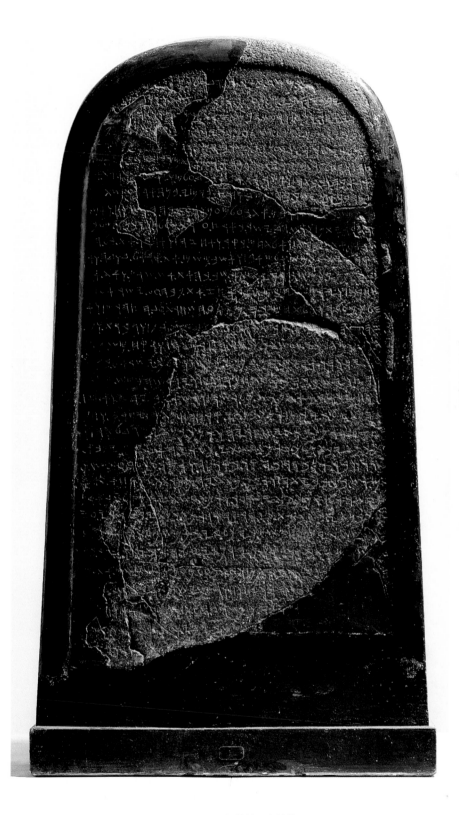

Fig. 9. Stele of Mesha, king of Moab, *ca* 810 BCE. AO 5066 and 2142, Musée du Louvre, Paris.

Fig. 10. Edomite ostracon from Horvat 'Uzza. Courtesy Israel Antiquities, Jerusalem.

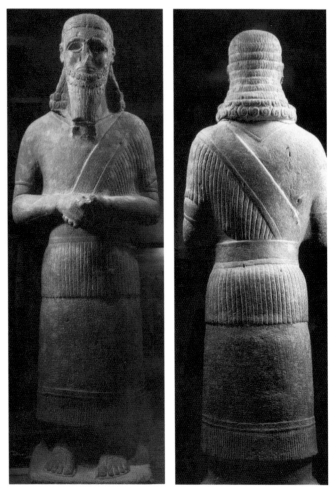

Fig. 11. Aramaic inscription, one of two languages on the back of a statue from Tell el-Fekheriyeh, late ninth century BCE. Damascus Museum, Syria.

Moabite script

The kingdom of Moab lay east of the Dead Sea and developed its own culture and religion before it ended in 582 BCE. During the reigns of Omri and Ahab (881–853 BCE), it was a vassal of the kingdom of Israel, and its scribal tradition was thus very similar to the Hebraic tradition, as can be seen, for example, in the stele of Mesha, king of Moab, which was probably engraved in 810 BCE (Fig. 9). The script later departed from this style, enlarging the heads and shortening the vertical strokes, finally opening up the heads, no doubt under the influence of Aramaic.

Edomite script

The kingdom of Edom once occupied the mountainous region southeast of the Dead Sea. It only became independent *ca* 845 BCE (II Kings 8: 20–22), gradually extending west of the Arava desert, and later into the Negev desert (597 BCE) and the southern Judean Hills (587 BCE), before its destruction in the campaign of Nabonides (early 552 BCE). The kingdom controlled the trade in incense to the Mediterranean, and its scribal tradition seems to have been influenced by Moabitic script, Philistian script, and, from about 600 BCE, by Aramaic script. Edomite script is known from several ostraca (Fig. 10), seals, and bullae. It is typified by the way the *dalet* is written upside down to make it easier to distinguish from the *resh*, since the two letters look so similar in Phoenician and paleo-Hebrew.

ARAMAIC SCRIPT

Perhaps from the eleventh century, but certainly from the second half of the ninth century BCE, alphabetic script was used in the royal inscriptions of the various Aramean kingdoms that occupied what is now Syria (from the Middle Euphrates to the Khabur). A bilingual royal inscription written in Assyrian and Aramaic, was found near the source of the River Khabur at Tell el-Fekheriyeh. It dates from the second half of the ninth century BCE but is written in an older script (Fig. 11). The fragmentary stele found at Tel Dan (Fig. 12), near the source of the Jordan, dates from the same period and shows how Aramaic script was used in the administration of Hazael, the great King of Damascus (*ca* 845/841–805/803 BCE).

Also from the Kingdom of Damascus, at Deir 'Alla in the central Jordan Valley, are some early eighth-century BCE inscriptions written in ink on a limewashed wall. Although they were found as fragments, they were restored so extensively that it was possible to identify them as an extract from the "Book of Balaam, son of Beor, the man who saw the gods" (Fig. 13). This is the same Balaam who is the

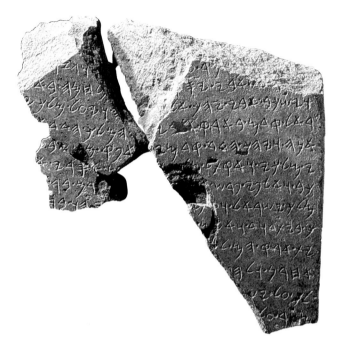

Fig. 12. Inscription of Hazael found at the Tel Dan Excavations.

main character in the biblical story in Numbers 22–24. These inscriptions are probably a Hebraic adaptation of an ancient Aramaic literary tradition. Indeed, the inscriptions are arranged in columns inside a frame, the title and important passages being written in red ink (the headlines), while the rest of the text is written in black ink. They represent a copy of a manuscript that would originally have been written on papyrus or leather.

During the same period (the first half of the eighth century), Aramaic was used for various royal inscriptions in stone, commemorating the deeds of the kings of Samal (Zencirli) and Hamat (Afis), as well as for treaties with the kingdom of Arpad (inscriptions found at Sfireh).

In the second half of the eighth century BCE, all of the Aramean kingdoms were absorbed into the Assyrian empire, which thus became an Assyro-Aramean empire. Although Aramaic script was no longer used in monumental royal inscriptions, it did not disappear completely because it was still used frequently by the Assyrian administration, which often employed both an Akkadian scribe to write cuneiform on a tablet and an Aramaic scribe to write on papyrus or leather, or even on a wax-coated wooden diptych.

The use of Aramaic as the language and script of royalty and for international communication continued under the neo-Babylonian empire from 605 through 539. The evidence for this is contained in several Aramaic tablets and a letter in Aramaic written on papyrus and addressed to the pharaoh Nekao by a minor king of southern Palestine, *ca* 605–603.

SOUTH ARABIAN SCRIPT

The origins of south Arabian script remain mysterious and controversial. Although the chronology of south Arabian inscriptions dating from the start of the common era is known with a fair degree of certainty, the age of those dating from the first millennium BCE remains less certain. Depending on the archaeologist or epigraphist consulted, the dating of the oldest inscriptions can vary from the end of the second millennium BCE all the way to the sixth century BCE.

South Arabian monumental inscriptions are typified by their geometrical shape. The letters consist of circles or semi-circles and right-angles. They are taller than they are wide, and a long vertical line separates the words. As with

Fig. 13. Inscription on plaster at Deir 'Alla from the "Book of Balaam" (top of combination II). Department of Antiquities, Amman, Jordan.

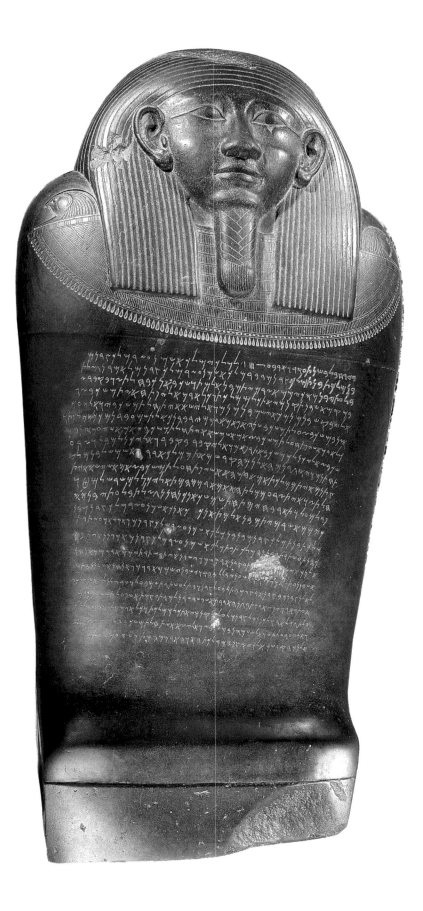

the western semitic scripts of the second millennium BCE, the earliest south Arabian inscriptions could be written from right to left, from left to right, and even in each direction alternately (known as *boustrophedon*). There was a preference for right-to-left writing, though this did not become definitive practice until a few centuries before the start of the common era.

South Arabian script ceased to be used some time after the emergence of Islam. The new religion created an expansion of the Arabic language and script, which was itself a development of the Nabatean script (see p. 213).

SEMITIC SCRIPTS UNDER THE PERSIAN EMPIRE (539–332 BCE)

For just over two centuries, the Near and Middle East were ruled by the same political entity, the Persian empire, which stretched from Asia Minor to the Indus river. This vast empire included numerous nations that used a variety of languages and scripts, although the king of kings did not apparently seek to unite them, an almost utopian situation. The Persian administration used the various local languages and scripts, but to facilitate communication it naturally tended to favor languages and scripts that were simple and easy to use and already had some degree of international diffusion, such as Aramaic. For this reason, the Aramaic script at this period is called "Empire Aramaic" and was used alongside the local scripts in places as far apart as Asia Minor, Egypt, along the banks of the Indus river, and even in Persepolis, in the heart of Persia itself.

Empire Aramaic has been found on numerous ostraca and bullae in the Levant, as well as on the papyri discovered in a cave at Wadi Daliyeh in the desert north of Jericho (Fig. 15). Along the Mediterranean coast, Phoenician remained the official language of the vassal kingdoms of Tyre, Sidon, Byblos, and Arwad, as well as of certain parts of Cyprus. In the interior, the confederation of the Arab nations of Qedar used Aramaic script for short inscriptions in Aramaic or northern Arabic, alongside northern Arabian and southern Arabian scripts (Teimanite, Lihyanite and Minean). In the little province of Judea, literature probably continued to be copied in paleo-Hebrew, but probably in around 398 (the date of Ezra's mission), Aramaic script (square Hebrew) began to be used for the transcription of biblical texts.

Fig. 14. Inscription by Eshmunazor of Sidon. AO 4806, Musée du Louvre, Paris.

Fig. 15. Papyrus no. 1 found in Wadi Daliyeh (335). Rockfeller Archeological Museum, Jerusalem.

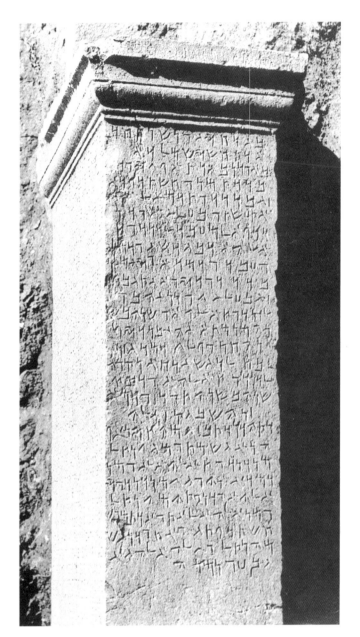

Fig. 16. Aramaic text from the trilingual inscription at Xanthos (337).

The linguistic and scriptural situation in Asia Minor at the time was particularly complex. Empire Aramaic only achieved dominance in Cilicia. There is good evidence that it was used throughout almost the whole of Asia Minor, but alongside local scripts and languages, including Lycian, Carian, Lydian, and Greek, a language that gradually came into widespread use from its beginnings on the Ionian coast. The evidence for this plurilingualism lies in the existence of a number of bilingual, and even trilingual, inscriptions, such as those on the stele of Xanthos that

promulgates a religious "law" in Lycian, Aramaic, and Greek (Fig. 16).

Despite its geographical expansion, Aramaic remained almost uniform throughout the whole empire, with regard to both its language (with the exception of several borrowings from local languages) and its paleography (both the cursive and monumental scripts). There were merely a few, perfectly understandable borrowings from the vocabulary of ancient Persian. This uniformity was both possible and necessary thanks to the use of Aramaic by the Persian chancellery

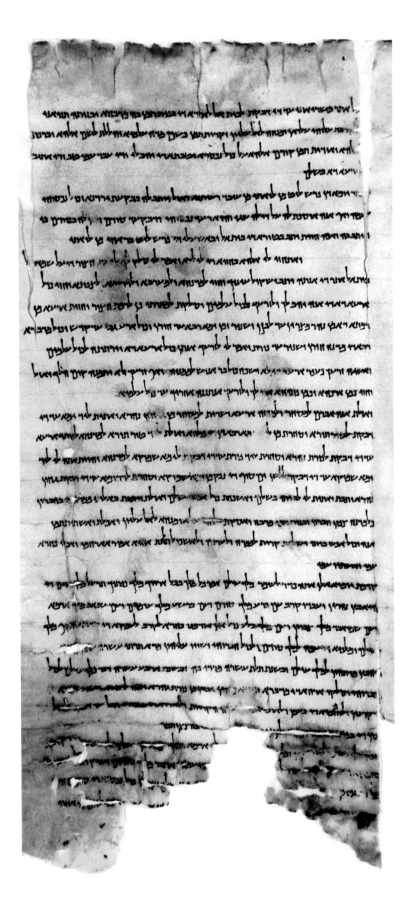

for the constant stream of correspondence it conducted with the diverse parts of the empire and especially the successive capitals.

SEMITIC SCRIPTS FROM ALEXANDER TO CONSTANTINE (334 BCE–324 CE)

Alexander the Great's conquest did not suddenly change the cultural situation in the Near and Middle East. The dates on legal documents written in Aramaic simply ceased showing the year of the reign of Darius III and began to state the year of Alexander's reign instead. Alexander could even be said to have been "the last of the Achaemenid kings." The wars of the Diadochs, Alexander's successors, however, broke up the empire, which split into various hellenistic kingdoms with a troubled history. Under such conditions, the use of Aramaic declined except in regions in which a semitic language was spoken.

In the west, in Asia Minor, Aramaic continued to be used until the start of the common era, but only in Cappadocia and Armenia. In Egypt, it is only found in a few inscriptions on papyrus or on pottery dating from the third century BCE.

Aramaic continued to be used in the east during the third century BCE, as evidenced by the five Asoka inscriptions (*ca* 274–237 BCE) found in Afghanistan and northwest India. This same king is better known for the forty or so inscriptions found in the local language, *Brahmi*, a syllabic script which, according to some scholars, may have been an adaptation of the Aramaic script created in the sixth century BCE. *Kharosthi* script, used mainly for Bactrian, was used from the second century BCE to the middle of the fourth century CE and is probably another adaptation of fifth-century Aramaic script.

From 247 BCE, the northeast and then the east of the former Persian empire was occupied by the Parthians and the Arsacid dynasty. The Parthian empire (until the second century) and its successor, the Sassanid empire (226–640), prevented the eastward expansion of the Roman empire. Aramaic was no longer spoken in the region, but *Pehlevi,* an adaptation of Aramaic script, was used to transcribe the local languages (Pahlavik and Parsik).

In countries in which a semitic language was spoken, Aramaic was able to resist the spread of Greek, but the diversified political situation soon led to the development of national or regional scribal traditions. A distinction is usually made between western and eastern Aramaic.

Fig. 17. Column from the Aramaic Apocrypha of Genesis. Israel Museum (The Shrine of the Book), Jerusalem.

Western Aramaic

In the south, *Nabatean* script was used, as this was the official language of the kingdom of Petra that covered an area from southern Palestine through southern Syria. The majority of the population probably spoke Arabic. Nabatean script is well known from the first century BCE to the third century CE, through several thousand inscriptions, most of them votive or funerary, or mere graffiti. It was used in this region concurrently with the north Arabian scripts of the nomads, Thamudean and Safaitic, as shown by the thousands of graffiti found in the plains and the desert. The script survived the Roman annexation of the Nabatean kingdom in 106 CE and is probably the writing on which modern Arabic script is based.

In Palestine, *Judeo-Aramaic* was used on many inscriptions carved in stone, especially on ossuaries and above all in the manuscripts found at Qumran (Fig. 20), Murabba'at and other caves in the Judean desert. The same script was commonly used to transcribe Hebrew text, hence the name "square Hebrew," since most of the letters could be written within a square.

The oasis of *Palmyra,* in the center of the Syrian desert, had its hour of glory under Queen Zenobia, but was finally conquered by Rome in 272 CE. Its economic and cultural importance as a transit point for caravans is conveyed through the 2000 or so monumental inscriptions (most of them funerary) dating from the first through the third centuries CE (Fig. 18). Aramaic script of the Persian era was developed here into an attractive, regular and rather mannered monumental script.

Eastern Aramaic

The city of *Hatra* lies around 30 miles northwest of Assur. It flourished at around the same time as Palmyra and was the capital of a city in Upper Mesopotamia. It has yielded about 350 inscriptions, most of them carved in stone and dating from the first through the third centuries CE. Even when engraved in stone, Hatrian writing has a cursive look that makes it hard to read.

Further to the west, but still in Upper Mesopotamia, the kingdom of *Edessa* (now Urfa) developed its own tradition of writing, known as *Ancient Syriac*, and known through several hundred inscriptions. When the king of Osrhoene converted to Christianity in the second century CE, an important and lasting literary tradition was born, most of it exegetic and theological, produced by such theologians as Bardaisan (Bardesanes) and Tatian.

Throughout this period, Phoenician script gradually fell into disuse. The *Phoenician* language and script appear to have been used until the start of the common era, but Phoenician script alone was still used on the coinage of the

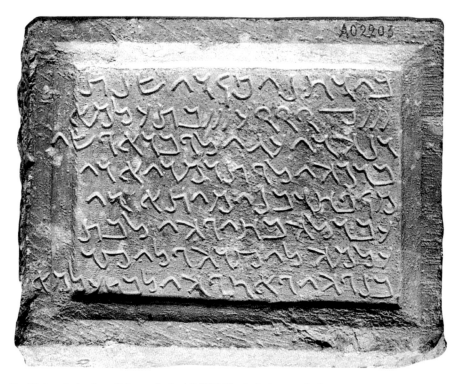

Fig. 18. Inscription from Palmyra, Syria. AO 2203, Musée du Louvre, Paris.

second and third centuries BCE. The start of this period is marked mainly by the expansion of *Punic*, as the Carthaginian empire expanded. It is well represented by inscriptions on funerary steles (Fig. 19) and on coins displaying an attractive monumental script. At the same time, a *neo-Punic* cursive script developed that was later used on monuments in North Africa and Tripolitania, until the start of the third century CE.

Paleo-Hebrew (see above) developed slightly differently. It disappeared from daily use during the Persian era, while being partially maintained through the copying of biblical texts and on some coins of the fourth century BCE. The Hasmonean renaissance of the second century BCE was marked by a certain revival of this archaic script, which was used to emphasize Jewish statehood. It was always employed for inscriptions on Hasmonean coinage, and on the coins of the First Jewish Revolt (66–70 CE) and the Second Jewish Revolt (132–135) against the Romans, then sporadically in the copying of biblical manuscripts, especially when writing down the Tetragramnon (the name of God). The revival of the Hebrew language was based, however, on writings in square Hebrew (Judeo-Aramaic—see above), and this was the script used for the earliest texts in the Rabbinic tradition, in particular the Mishna, created in the early third century CE.

During this period, the *Samaritans* developed their own version of the Paleo-Hebrew script that they used to copy the

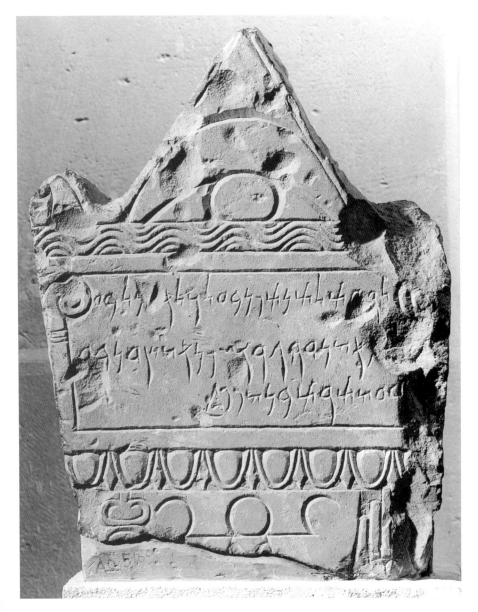

Fig. 19. Punic stele from Carthage. AO 5169, Musée du Louvre, Paris.

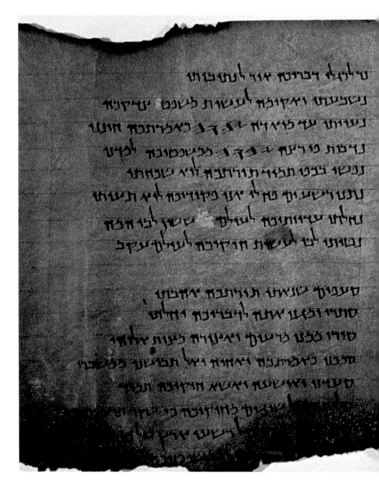

Pentateuch (the Five Books of Moses, which they recognized as the only canonical books of the Bible) as well as other manuscripts belonging to their tradition.

THE BYZANTINE ERA (324–*ca* 638 CE)

This period saw the conversion to Christianity of the population of the Near East, under the auspices of the Byzantine emperors. It was therefore accompanied by the spread of Greek into general use. Western semitic scripts were threatened with extinction, but their use continued in two forms:

1) *Syriac,* which was used in the theological academies of Edessa and Nisibus, in the writings of Ephrem of Nisibus and Aphraate, who used a script known as *Estranghelo*; and

2) *Hebrew*—basically *square Hebrew*—which was used for Hebrew and Aramaic texts in the Rabbinic tradition, notably for the Jerusalem and Babylonian versions of the Talmud, while the Samaritans continued to use their own script.

VII. FROM THE ARAB CONQUEST (*ca* 638) TO THE PRESENT DAY

After the Arab conquest, the use of western Semitic scripts was almost exclusively confined to a religious context.

Syriac is associated with Eastern Christianity, whose missionaries took it with them as far as India and China. Variations of the script, known as *Serto* and *Nestorian*, developed from the sixteenth century and were mainly used in Syria and Iraq by Christians.

Samaritan continued to be used by the small and dwindling community of Samaritans who, by the twentieth

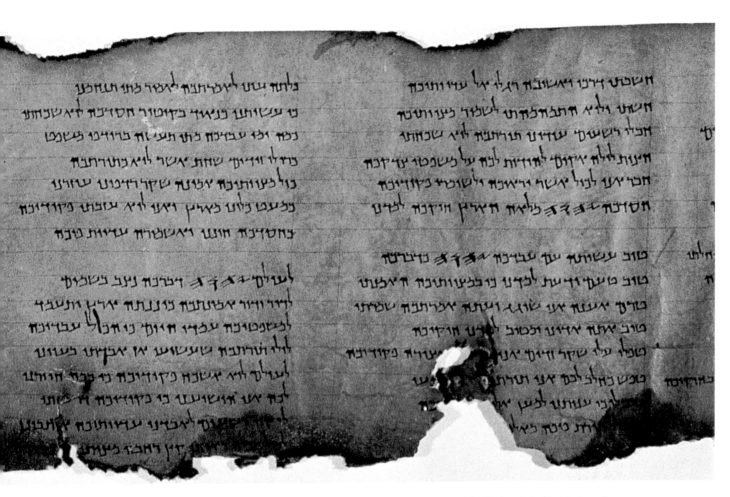

Fig. 20. Fragment of a scroll of the Psalms found at Qumran. Israel Museum (The Shrine of the Book), Jerusalem.

century, numbered only a few hundred living in Nablus on the West Bank and Holon in Israel.

Square Hebrew continued to be used in the Bible, religious teachings, and inscriptions (mainly funerary monuments). However, several types of cursive script for Hebrew developed over time. The best known is Rashi script, so-called because it was used for "Rashi's" commentary in the first book ever printed in Hebrew (Reggio di Calabria, 1485).

The nineteenth-century revival of the Hebrew language and the creation of the modern Jewish state in 1948, with Hebrew as its official language, widened the status of its script as a purely religious form of writing and brought it into general use as the official, public script in Israel (in daily newspapers, for instance). The cursive, handwritten modern Hebrew script uses characters that look very different.

Thus, apart from Syriac and Hebrew (square or Samaritan), many of the alphabets used today, especially Greek, Latin, and Arabic, whether directly or indirectly, are based on western semitic scripts.

Bibliography

AMADASI GUZZO, M. G. *Scritture alphabetiche* (Rome, 1987).
BAURAIN, Cl., C. Bonnet, and V. Krings (eds). *Phoinikeia Grammata* (Liège/Namur, 1991).
FÉVRIER, J. G. *Histoire de l'écriture* (Paris, 1984).
LEMAIRE, A. *Les Écoles et la formation de la Bible dans l'ancien Israël* (Orbis Biblicus et Orientalis 39) (Fribourg/Göttingen, 1981).
NAVEH, J. *The Development of the Aramaic Script* (Jerusalem, 1970).
——. *The Early History of the Alphabet: An Introduction to West Semitic Epigraphy and Palaeography*, 2nd edn, (Jerusalem-Leyden, 1982, 1987).
OUAKNIN, Marc-Alain. *Mysteries of the Alphabet*, trans. Josephine Bacon (New York, 1999).
PECKHAM, J. B. *The Development of the Late Phoenician Scripts* (Cambridge, Mass., 1968).
SASS, B. *The Genesis of the Alphabet and its Development in the Second Millennium B.C.* (Ägyptes und Altes Testament 13) (Wiesbaden, 1988).
——. *Studia alphabetica* (Orbis Biblicus et Orientalis 102) (Fribourg/Göttingen, 1991).
VIERS, R. (ed.). *Des signes pictographiques à l'alphabet* (Paris-Nice, 2000).

THE *ALEPH* OF THE KABALISTS

Charles Mopsik

The Kabala (also: Kabbalah or Cabbala) is an esoteric form of Jewish thought that emerged in southern France in the late twelfth century. It continued to develop in Spain (Catalonia and Castile) and spread across the Mediterranean basin into Eastern Europe and the Near East. In its approach to biblical texts and canonic tradition as far as a study of writing ideology is concerned, the Kabala enjoyed a rather unusual status in addition to its customary role. The prohibition against making concrete representations of the Divinity—one that is universally observed in the practice of Judaism—was circumvented by the kabalists, who used the letters of the Hebrew alphabet for a special purpose. Since the sacred texts consisted of combinations of these letters, the texts themselves were considered to be the transmutation of the Word of God into the tangible form of script, and thus the only raw material that, in the expert hands of the "knowers of truth," could be used as a visible manifestation of God. Alone or in combination, they could be used to create concrete or abstract representations in order to produce a visual dimension of what had only been granted for the purpose of reading.

Writing arranged in the shape of a drawing but without being lost therein, a conceptual representation that can be memorized and is the image or pale imitation of the sublime reality, becomes a holy place for the manifestation of the invisible. It refers to an object that is absent, invisible, through the meaning it conveys when read and understood conceptually and through the imagination. Yet, through its arrangement and organization on the page, it also provides a tangible glimpse of a fragment of the celestial world, one that is both derived from divinity and a complete encapsulation thereof.

From among the many examples of the dual use of writing in this extensive and still largely unexplored body of kabalistic literature, we chose a page illustrating a chapter (called "Gateway of the Order of the Disposition [of the *sefirot*]") of the book Pardes Rimonim (The Pomegranate Orchard), written in 1549 by Moses Cordovero "in the unequaled sum that he has compiled in the city of Safed (Upper Galilee)." The book was first published in Cracow, Poland, in 1592.

The author offers three representations of the structure of the *sefirot* (the emanations, in the form of spheres or numbers, which together constitute the whole of the celestial world) by embellishing the first letter of the alphabet, *aleph*, in various ways. The kabalist explains:

Concerning the form of the sefirot, I mean the order in which they are arranged, there are numerous ideas, and the kabalists have designed shapes for them, that they call "trees" [and draw] on large pieces of parchment. Some have chosen to draw them on the basis of the shape of the *aleph* (T) and for this purpose they have subdivided the top of the letter into three, the first part corresponding to the Supreme Crown, the right-hand side to Wisdom, the left hand side to Intelligence. The line positioned below the *yod* (h) [the top of the right-hand vertical] is the *vav* (U) of the *aleph*; the tip is called Grace, the left-hand top is called Power, and the central part is called Beauty. From its haunches and below, the right-hand side is called Victory and the left-hand side represents Majesty. That which is between them is the Foundation, and the lower tip represents Royalty.

The shape is shown in Fig. 1. Furthermore, they sought to inscribe[1] human forms in the upper part of the drawing of the *aleph*, in order to suggest that they create a perfect unity. Although the ten sefirot are spoken of as if they were separate

from each other, they combine into a perfect whole. And this is manifested in the very shape of the aleph.

The first aleph (facing page) is drawn so as to represent the human form schematically, a reflection of Superior Being (the manifestation of God) whose shape provides the structure for the ten emanations. The lateral extremities of the letter form the fingers (the five fingers and toes on the left and right) on the basis of a formula to be found in the *Sefer Hayetsira* (The Book of Creation) (chap. 1 § 3). The letters placed within and around this *aleph* are the initials of the ten *sefirot*.

The second *aleph* (below) represents this system of emanations through the four letters of the Tetragramnon (the sacred name of God,

yod, heh, vav, heh) each of which refers in turn to one or more *sefirot*.

The third and last *aleph* is also a schematic representation of the system of sefirot, the letters that are included being their initials, but the emphasis here is not on their anthropomorphic arrangement, or on the symbolism of the letters of the Holy Name, but on the open character of the structure of the emanations. The *aleph* is open at the top, to indicate that the first sefira, the keter (crown) is not the primary Cause, but that it is surmounted by a "single Lord" who prevails and spreads his existentiating influence over the whole set of emanations; this "single Lord" is usually referred to as the Eyn Sof or Infinite. The aleph is also open at the bottom to indicate that the purpose of this whole arrangement is to guide the inhabitants of the world below, and that its function of mediation consists in assuring the passage of the influence emanating from the Infinite toward his creations.

Note

1. The Hebrew word used could equally well be translated as "to write." Writing and artistic representation are inextricably linked here.

Fig. 1. Page from *Pardes Rimonim* (The Pomegranate Orchard), Noses Cordovero, Cracow, 1592.

Bibliography

BILSKI, Emily. *Golem!* (New York, 1988).

CORDOVERO, Moses. *Pardess Rimonim* (The Pomegranate Orchard) (Jerusalem, 1962).

IDEL, Moshe. *Language, Torah, and Hermeneutics in Abraham Abulafia* (New York, 1989).

——. *Golem: Jewish Magical and Mystical Traditions on the Artificial Anthropoid* (New York, 1989).

LIEBES, Yehudah. "The seven doubled letters, BG"D.KFR"T: On the doubled resh and the background of the Sefer Hayetsira." *Tarbiz* 61 (1992): 237–247.

LIPINER, Elias. *The Metaphysics of the Hebrew Alphabet* (Jerusalem, 1989).

OUAKNIN, Marc-Alain. *Mysteries of the Kabbalah*, trans. J. Bacon (Abbeville Press, 2001).

SCHOLEM, Gershom. *Major Trends in Jewish Mysticism* (New York, 1995).

WOLFSON, Elliot. *Through a Speculum that Shines, Vision and Imagination in Medieval Jewish Mysticism* (Princeton University Press, 1994).

——. "Letter symbolism and Merkavah imagery in the Zohar." M. Hallamish (ed.). *Alei Shefer–Studies in the Literature of Jewish Thought Presented to Rabbi Dr. Alexandre Safran*, (Jerusalem, 1990), pp. 195–236.

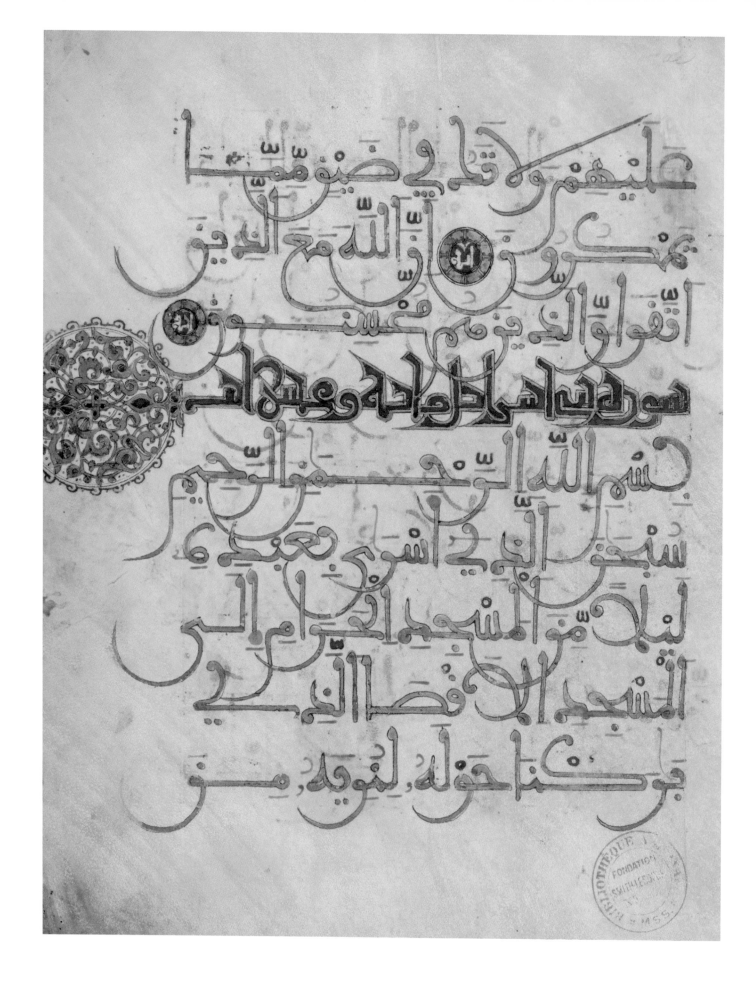

ARABIC SCRIPT

François Déroche

The history of Arabic script is a fascinating one. Arabic is the baby sister of the Semitic alphabetic systems of writing, in which only consonants and long vowels are annotated. It first emerged in the ever-changing desert, at the gates of the sedentary world of the Fertile Crescent. This partially explains the uncertainty that surrounds its birth. The witnesses have dispersed and later accounts are contradictory, but the script's general appearance has something in common with Syriac, although there are also occasional convergences with Nabatean. The search for its origins is also complicated by the fact that it has a very long history behind it. Its extensive use is witnessed by the shape of letters that have been reduced to a few simple lines or loops, joined together to suggest they were the cursive form of an ancient script. Such simplification and economy, along with its origins in the Aramaic branch of Semitic alphabets, make it fairly ill-suited to render the Arabic language. If twenty-eight phonemes were to be transcribed using only eighteen signs, diacriticals would be needed urgently to distinguish between letters that used the same shape to represent more than one sound.

Yet this worn and apparently deficient script has come to have equal status with the great calligraphic traditions of the Far East. Its flexibility may well have constituted a major asset that artists exploited to the fullest advantage. Within a civilization that forbids human or animal representation, writing came to occupy pride of place in Islamic art, to the extent that any discussion of Arabic script is invariably devoted almost exclusively to calligraphy. This is strangely paradoxical, considering that there is no specific term for "calligraphy" in Arabic, the word *khatt*

meaning writing in general. Does this mean, perhaps, that writing has no real existence, unless it is calligraphic?

When the script first appeared, in the time of the prophet Muhammad, it was fairly crude in appearance. The oldest documents reveal irregularities that no doubt stem from its mainly practical function as a tool for everyday use. Within the primitive community known as a "People of the Book" (*Ahl al-Kitâb*), the importance of transcribing the text of the Qur'anic revelation introduced changes whose significance would gradually became clearer. The revealed word spread very quickly through the mold of writing, and the Arab conquests of the seventh and eighth centuries CE accelerated the process of Arabization and extended the use of Arabic script. While this expansion was taking place, and to meet the needs that it created, the script was transformed so as to give it an appearance better suited to its sacred task and the new power of the Muslim empire. The decision of the Umayyad caliph 'Abd al-Malik (in the late seventh century CE) to make it the script used by his chancellery no doubt accelerated this process, as evidence shows in the form of manuscripts, coins, and inscriptions. These documents reveal that a major effort was being made to render the Arabic alphabet into a set of regularly-shaped and elegant letters. The early *hijâzî* script was first made uniform. It was soon replaced by a flowering of ancient Abbasid scripts; the first generation of scripts were works of art (Figs. 2 and 3) that are traditionally but incorrectly known as Kufic. This style became the script used in official documents but emerged later than than the cursive style that gradually changed through everyday use. Its esthetics were built on its heavily horizontal components,while the vertical strokes gave the script a rhythmical appearance. This contrasts with the more dynamic appearance of the new trend that emerged in the late eighth century CE,

Fig. 1. Page from the Qur'an (*sura* XVI: 12 – XVII: 1). Thirteenth or fourteenth century CE. Ms Smith-Lesouef 217, fol. 1r, Bibliothèque Nationale de France, Paris.

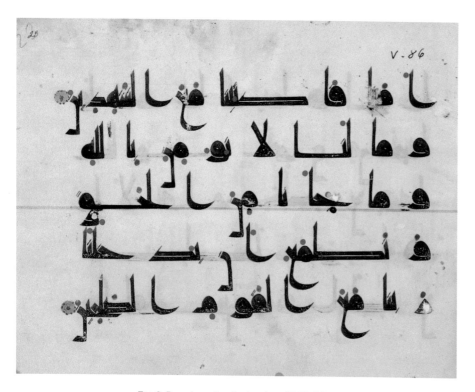

Fig. 2. Page from the Qur'an (*sura* V: 83–84). Nineteenth century CE. Ms. Arabe 350, fol. 23r, Bibliothèque Nationale de France, Paris.

initially as a modest book script. By the tenth century CE, it had become the latest style that, with certain modifications, would be embraced by the whole Islamic world. Each of these two trends had a relatively brief existence and their survival was only artificially ensured through the decorative use of the script (Fig. 1, line 4) right up until the age of printing, and then into the computer age.

This whole period, and the golden age of the Abbasids in particular, was marked by an intense graphic creativity and an extension of the palette available to scribes and copyists (Fig. 4). Contact with other communities that had their own scripts—Jews, Christians, or Manicheans—probably produced emulations that were beneficial for the Islamic world. The specialist terminology and the utensils—from parchment to the reed calamus—were ancient borrowings from neighboring populations. On the other hand, various groups of Muslim practitioners of writing played an active part in the creative process. This leads to the conjecture that the secretaries of the chancelleries played a crucial role in this rexpect. Aphorisms from this period demonstrate that writing was required to identify with the ruling power and show that administrative procedures had already been introduce that would later develop fully into the Ottoman *tughras*. The innovations introduced by the scribes of the various administrations appear to have been welcomed

in other circles and contributed to the development of new styles right up to the nineteenth century. In the eighth and ninth centuries, the final rules were laid down that were to govern the script through its later history. They included the principles of functionality—whereby a style of writing corresponds to a specific use—and derivation, which makes it possible to extrapolate new graphic forms as variations on the basic script.

Calligraphic art moved in a variety of directions, depending on need and on the medium used for the writing. These included calligrammatic devices, the use of color and gilding, elongations of letters, contrasts between thick and thin lines, the development of decorative tips on exaggerated upstrokes (Fig. 8), etc. The decorative possibilities of the script, whether or not they were associated with arabesques or geometric compositions of an abstract nature that were permitted by official art, gradually conquered the Islamic word. Anyone visiting a Muslim country—even one that does not use Arabic script for its own language—can still see the evidence to this day. Buildings (Fig. 5) and objects of stone (Fig. 4), metal (Figs. 6 and 8), brick, or textile (Fig. 7), were used as media for texts whose symbolic value is often decisive. The main concern of the artists who created these writings does not appear to have been readability, because the place in which they were written, their ornamental transformation, and even the content of the text made deciphering difficult if not superfluous (Fig. 5). Certain words, or groups of words, fraught with religious

Fig. 3. Plate decorated with script, Ninthtenth centuries CE. AA 96, Musée du Louvre, Paris.

Fig. 4. Funerary stele, dated 1183 CE. © 2002 Museum of Fine Arts, Boston.

significance acquired an almost ideogrammatic value. These are distinguished by the use of specific shapes of letters and they are always represented everywhere in the same way. Ibrahim Izquierdo, a Moor who emigrated to Salonica, Greece, and who spoke Spanish much better than Arabic, would write the word *Allâh* in Arabic letters even within a text that he wrote in Castilian Spanish.

The break occurred in the tenth century. For the first time, the graphic unity of the Muslim world was split with the emergence in the Muslim West (the Maghreb and Spain) of its own specific form of writing—*Maghribi*. Simultaneously, changes occurred in the East, the nature of which are still obscure. However, the tenth century is dominated by the figures of two prestigious calligraphers, the Vizier Ibn Muqla and Ibn al-Bawwâb, both of whom will always be known for having profoundly changed the practice of calligraphy in the Islamic world. The changes were both technical and theoretical. At this period, geometry became the foundation of graphic art, the letters being ideally defined in relation to a circle of which the vertical stroke of the *alif* represented the diameter. Was this the work of Ibn Muqla? Nothing is certain, except that from this period onward, the so-called "cursive"

Fig. 5. Doorway decorated with writing in the Mosque of Ince Minareli. Thirteenth century CE, Konya, Turkey.

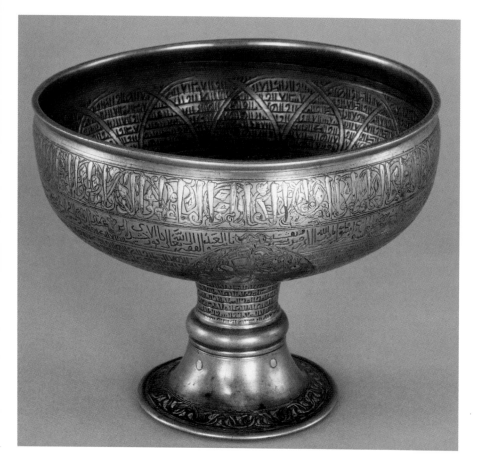

Fig. 6. Chalice said to possess magical powers. Second half of the thirteenth century CE. Private collection.

It should come as no surprise that the commonest such style is called *naskhi*, meaning "the writing of the copyists." The flowing strokes and speed of writing made possible with Arabic script must be largely responsible for the extraordinarily large number of books written from the ninth century CE onward. This was also encouraged by the fact that paper was now widely used and it was a much less expensive material than papyrus or parchment. Despite the importance given to the oral transmission of knowledge in the Islamic world, the written word was also used extensively (Fig. 13). Thanks to their indefatigable efforts, authors and copyists enriched the libraries that flourished almost everywhere, in mosques and palaces, among wealthy bibliophiles and within institutions of learning such as the *madrasa*; the texts proudly listed the incredible wealth contained in these diverse collections that did not merely contain books in Arabic. In the tenth century, Persian (Farsi) began to be written in Arabic characters, and in the eleventh century, Turkish followed suit. To overcome its deficiencies for this purpose, Arabic script was extended and adapted for writing many other languages that, like Persian and Turkish, did not belong to the Semitic group.

The victorious entry into the Islamic world of successive waves of peoples from central Asia was to change forever the way in which Arabic script was written and practiced. The bitterest blow was delivered in the thirteenth century, when Baghdad was captured by the Mongols in 1258 CE. One consequence of this (and other traumatic events) was the considerable exploitation of Arabic script for magical purposes, such as forecasting the future, interpreting current events, or attempting to change their course, all of which were attempted through the science of letters. The text of the Qur'an occupied a central place in these operations, but any letter of the alphabet had a role to play (Fig. 6). In truth, there was nothing surprising about this. Understood as an integral part of the divine scheme of things, Arabic script, the writing to which the sacred text had been consigned for

styles predominate. Their flowing strokes (Fig. 9) were the result of standard practice of the time, as described previously and illustrated by manuscripts written on papyrus from the seventh century onward. The widespread literacy and the fact that large sectors of Muslim societies were able to write in the Middle Ages certainly contributed to the official triumph of this script that is still in use to this day.

Fig. 7. Inscription on textile from the Fatimid period. Qatar Museum.

all eternity on the "closely guarded tablet" (Qur'an, LXXXV: 22), was vested with supernatural powers based on the close relationship generally accepted to exist between writing, concept, and sound. Each sign of the alphabet, once fixed on the medium, conveyed its own power, and this property had been used in amulets for a long time, whether as scrolls or clothing that combined verses from the Qur'an with magic spells or diagrams (Fig. 11). New practices emerged in the thirteenth century, such as potions for which the recipe required the ingestion of various edible substances after first using them as ink with which to copy a particularly efficacious Qur'anic verse.

Far removed from these practices of the common people, the heterodox thinkers envisaged the possibility of deciphering divine creation. In the beginning, there was the calamus, the

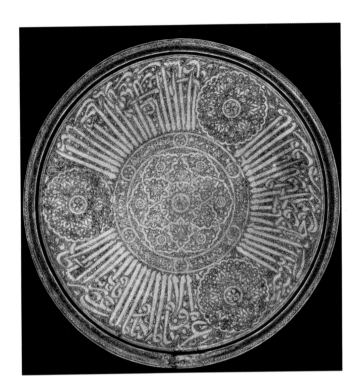

Fig. 8. Metal tray made in Egypt for a Yemenite ruler between 1321 and 1363 CE. Musée du Louvre, Paris.

Fig. 9. Qur'an from Egypt. Late fourteenth century CE. From the collection of Prince Sadruddin Aga Khan.

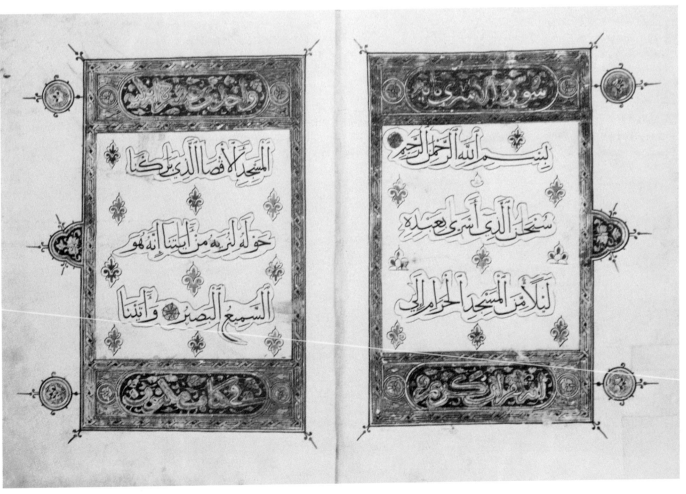

Fig. 10. Pages from the Qur'an (*sura* XVII: 1). Eighteenth century CE. Ms. 1588, fol. 1b–2a, The Chester Beatty Library, Dublin.

of the divine spark within man. Another technique that was greatly favored during the Ottoman period consisted of recourse to the ancient numerical values of the letters of the Arabic alphabet. This type of equivalence was reinforced by the fact that the *alif*, the first letter of the alphabet and initial of the name of *Allah*, was equivalent to "1". By converting a word into the sum of the numbers represented by each of its letters, a total was obtained that could be compared to other numerical values obtained in the same way. Writing thus functioned in the second degree since it made it possible to decipher the secrets of the universe, and reveal connections between realities that appeared to be remote from each other but were actually related, thus disclosing their ultimate secrets. This became part of the magic practiced by the common people, as mentioned above.

These speculations concerning the power of Arabic script were not the only result of these upheavals. The script's position changed substantially in relation to power and more generally throughout society. During the early centuries, it had imposed itself at the same time as the religious message propagated by the Arab conquerors, but the new rulers of the Middle East received it from those whom it had recently subjugated. Thus, in the thirteenth century, the use of different languages by the Ilkhanid chancellery coincided with the emergence of specialists in writing alone, it having been reduced to the role of an instrument. It is quite possible that the downgrading of the scribes to mere copyists, subordinate to those who gave them the work to copy, caused them to react adverseley. This produced a culture specific to the calligraphers that flourished in the Ottoman and Indo-Persian civilizations. From ancient times, a technical expertise developed

agent of this creation, through which the written word could be read—literally—via the intermediary of the Arabic alphabet. Speculation of this type was rife among the Hurufis, for example, a sect that emerged in fourteenth-century Persia. Their founder identified the four letters of the name of Allah in the human face and saw in this the proof

Fig. 11. Qur'anic micrography (Turkish?). Eighteenth century CE. Qatar Museum.

around the practice of writing. The choice and size of the point of the reed-pen was the subject of detailed recommendations. This knowledge was accompanied by general notions of the history of Arabic script; these would produce an official history of the script that emphasized its continuity from the days of the Prophet to the present time, by means of edifying anecdotes that added to the prestige of those who practiced writing as their trade. A crucial role was played by the great calligrapher, Yâqût al-Musta'simi. According to a legend redolent with symbolic meaning, he took refuge in a minaret and calmly performed calligraphic exercises while the Mongol hordes devastated Baghdad. On the other hand, the practice of calligraphy was enhanced and legitimized by the borrowing of some of its terminology from the Islamic religious sciences with which it is associated—after all, was not the primary mission of writing to transmit the text of the Revelation? Scribes and calligraphers were the repositories of a great treasure that they guarded jealously; they were advised to perform a ritual purification before they began their work of copying.

Beginning in the thirteenth century, the fragmentation of the Muslim world as far as writing was concerned increased considerably. Just as in the Muslim West a separate identity had established itself quite early on so that a North African hand would be immediately recognizable, other regions developed styles that clearly showed their differences. The most important is indisputably the style known as *nasta'liq*, created in Persia in the late fourteenth century, which remained closely associated with the dissemination of Persian culture (Fig. 12). It is noteworthy that this style was much better adapted esthetically to the annotation of Persian than it was to Arabic. In the Arab-speaking world it was given the name "Persian writing." The writing style known as *sini* was typically used by Chinese Muslims who may have been influenced by the writing style of the majority Han Chinese (Fig. 10), and the *bihari* style of Northern India. In sub-Saharan Africa, *sûdânî* is different again from the writing style of the Maghreb. Some uses of writing are typically regional, such as Ottoman compositions in which writing is used to mimic the shape of an object or human figure, a use that would amaze a reader from the Arab world.

While these developments revived the practice of writing, another movement was at work that attempted to codify and rationalize it. Depending on the location, a list of five, six, or seven well-defined scripts was compiled that would form the officially permitted repertory. The tradition that prevailed consisted of six styles and is credited to the famous Yâqût; these were the styles of which the Ottomans claimed to be the heirs and which they were instrumental in imposing. They liked to recall

Fig. 12. Page of Persian calligraphy. Sixteenth century CE. Inv. 1971-107-/287, © Musée d'Art et d'Histoire, Geneva.

that "the Qur'an was revealed in Mecca, recited in Cairo, and copied in Istanbul." One name stands out, that of Sheikh Hamdullah (late fifteenth to early sixteenth century CE). The Ottoman calligraphers of later centuries claim him as their mentor. A school of style was established; the transmission of skills had to comply with strict rules and a diploma was granted to graduates, that contained a reminder of the spiritual heritage and the rights and duties of the recipient.

The written works reflect developments in the various regions of the Muslim Orient. According to literary sources, from the very beginnings of Islam, the calligraphers created

Fig. 13. *The Epistles of the Sincere Brothers* (Baghdad, 1287 CE): the authors in the company of a copyist.
Ms. Easd Ef. 3638, fol. 3v, Süleymaniye Library, Istanbul.

models that the stonemasons (Figs. 4 and 5), decorators, and mosaicists (Fig. 14) reproduced in durable materials. This aspect of their work became prominent in recent times and the biographies of the artists tend to dwell on it. In general, however, the copying of manuscripts tended to be of less importance than in the past, possible due to an economic downturn. It may also have been due to the introduction of printing, which only reached the Arabic-speaking world in the first half of the eighteenth century, and was at first treated with great suspicion. On the other hand, calligraphic compositions, modest substitutes for inscriptions, were very much in favor, as were smaller compositions, destined to enrich the albums of the collectors (Fig. 12). In fact graphic

creations gradually began to cater for these two markets, both of which were less restrictive and less bound by onerous rules.

Printing profoundly changed the Arabic and Islamic culture of writing, since in daily use, it introduces a uniformity that has significantly impoverished choice. *Maghribi*, for instance, is seriously threatened with extinction. Calligraphy today is experiencing a search for its own identity, between respect for a rich and prestigious heritage and a search for new forms. Artists and the public are often at odds, especially as the image has conquered contemporary Muslim societies and now occupies a place that it never had in the past.

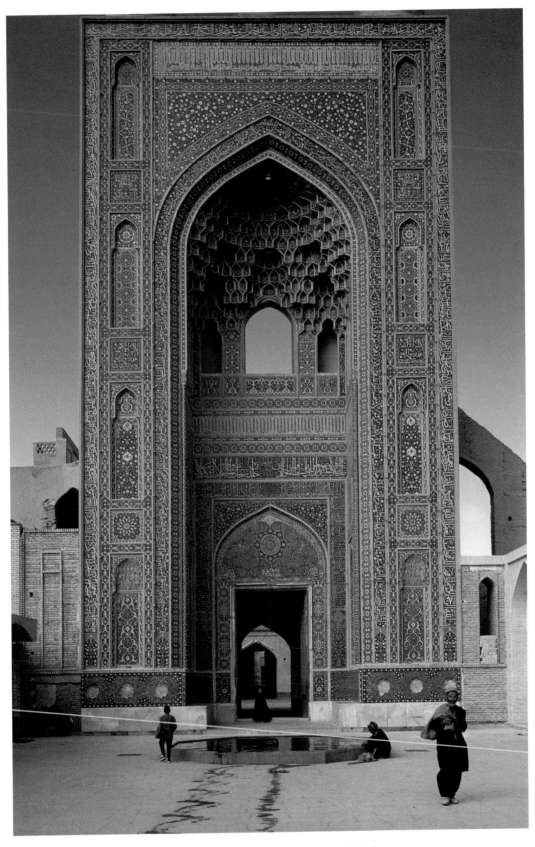

Fig. 14. Decorated wall of the Great Mosque, Yazd, Iran.

WRITINGS IN THE MARGINS
OF ARABIC MANUSCRIPTS

Jacqueline Sublet

The two documents shown on pages 229 and 230–231 are extracts from manuscripts of the twelfth and thirteenth centuries CE (sixth and seventh centuries of the Hegira), preserved in the Asadiyya Library in Damascus, Syria. One is a literary treatise by a ninth-century author (third century of the Hegira), the other is an anthology of traditions handed down from the time of the Prophet of Islam and written down some time during the tenth century (fourth of the Hegira).

The inscriptions in the margins and on other blank areas of pages in the original manuscripts are proof that the text, whether it consisted of "sacred" writings, such as the traditions (*hadîth*) handed down from the earliest days of Islam (Fig. 1), or "profane" texts, such as a literary treatise (Fig. 2), had been transmitted orally (read aloud by revered scholars), listened to by those who attended their readings, and heard by those who came to acquire the right to transmit them in their turn. The chains of transmission thus constituted guaranteed the authenticity of the texts repeated in this way. Arabic is a language in which only the consonants and long vowels are written; the short vowels are not transcribed. Reading aloud makes it possible to vocalize the words correctly and avoid confusion or distortions of meaning. As in other civilizations, the tradition of inherited oral transmission existed long before the Islamic period.

During the medieval period, before the introduction of printing, manuscripts were rare items that had to be shared. Educated people, both men and women, read or listened attentively to the reading of texts and wrote their name and the nature of the transmission in the margins and blank spaces, using a standard phraseology for such activities as hearing the reading performed by a master, listening, or reading by a third party, and dictated as follows: "I have read in the presence of a particular master who himself received the text from a particular scholar," or "I heard a particular scholar read the text to me and he has given me permission to transmit it." These sessions took place in mosques, teaching establishments, gardens, and private homes. Some of the scholars listed the names of their children next to their own in the certificates of transmission. Pregnant women attended the sessions so that the unborn child could participate in the stream of transmission that ran through the Muslim world, the *dâr al-Islâm,* the territory within which Islam was the law. Travelers "in search of knowledge" (*fî talab al-'ilm*) would halt at the home of a recognized master, and the pious would undertake long journeys just to be able to read or hear a famous text from the chain of trustworthy guarantors who conveyed its knowledge. The transmitters would add to their own name—a composite name bearing their life-story—the name of the place at which they stopped to rest. They also wrote their name in the margins of the manuscripts to indicate that they had received "permission to transmit" (*ijâza*). The identity of these scholars and the routes of their journeys were the subject of the huge number of biographical lists created in the ninth (3rd) century to preserve the memory of this extraordinary transmission movement.

The manuscripts are more often written on paper than on parchment. The names written in the blank space around the text (margins, the bottom of pages, and pages originally left blank) recall the presence of scholars grouped around the manuscripts in order to see and touch them, read them and listen to their content.

The first document is extracted from a volume containing a literary text: "The Book of Silence and Good Usage of the Language" (*Kitâb al-samt wa-adab al-lisân*), preserved in the Zâhiriyya Fund of the Asad Library in Damascus under reference *'umûm* 31. It consists of forty-seven folios and was written by Ibn Abî d-Dunyâ, who lived in the ninth (3rd) century at the court of the Ummayad princes of Damascus. The certificates of transmission, written in Damascus, date from the late twelfth (6th) and early thirteenth (7th) centuries.

Folio 47 verso (right-hand page):

1. At the top of the margin, there is a statement that "the volume in its entirety was constituted as part of the *waqf* (religious legacy). (See document 2, inscription 10.)

2. The end of the text has a colophon attesting to the fact that this is indeed the end of the work. The copy is undated and the name of the

scribe does not appear. The margin contains corrections to the text.

3. A first audition certificate dated 561 AH (1165 CE).

Folio 48 recto (left-hand page):

4. A second audition certificate of the same work, dated Damascus, 602 AH (1205 CE).

5. Reading certificate dated 608 AH (1211 CE).

6. Reading certificate dated 612 AH (1215 CE).

7. Reading certificate in the Damascus mosque dated 615 AH (1218 CE).

The second document represents folios 38 verso and 39 of the manuscript that bears the reference *Majmû* 75 of the Zâhiriyya Fund of the Asad Library in Damascus; the manuscript consists of 191 folios of several pamphlets bound together. These are collections of traditions or *hadîth* received and transmitted by Iraqi scholars from the tenth century CE (fourth century of the Hegira) through the twelfth century CE (sixth century of the Hegira) in learned circles in Damascus.

Folio 38 verso (right-hand page): *Amâlî al-Mahâmilî*. "Dictation taken from the scholar al-Mahâmilî." These are traditions collected by a Baghdadi scholar who died in 941 CE (330 AH). It is the last page, originally left blank, of a pamphlet of thirteen folios with its three inscriptions as follows:

a) A scholar accompanied by his children and several companions says: "I have read this text several times under the direction of our master who received it from Shahda daughter of Ahmad." There follows a chain of transmitters and the date 652 AH (1254 CE); the place is not indicated but it was probably Damascus.

b) Certificate of authentification: a scholar of Iraqi origin certifies

(here and in seven places in the manuscript) that all that is written in it is true.

c) Audition certificate written by the same hand and bearing the same date—671 AH (1272 CE)—naming the same place, the Damascus mosque, as that stated on the left-hand page (see no. 10 below). The wavy line around the inscription indicates the development of the word *sahîh* "authentic," which had already been used in a different form in the preceding inscription.

Folio 39 recto (left-hand page): title page of a collection of traditions gathered by another Baghdadi scholar, Ibn Bakhît ad-Daqqâq, who died in 983 CE (372 AH). The title is surrounded by various inscriptions:

1. "Six folios"(the number of folios of which the collection consists).
2. "Reading aloud of the booklet in full, in Damascus," and a signature.
3. An invocation and a signature.
4. "4 *qirch*" (the price of the booklet).
5. Below the title *Al-juz' al-thânî min hadîth Abî Bakr Muhammad b.'Abd Allâh b.Muhammad Ibn ad-Daqqâq 'an shuyûkhihi*: "Second part of the traditions that Ibn ad-Daqqâq received from his masters." This is followed by three names, two men and Shahda, daughter of Ahmad (her name is mentioned five times in this document), as trustworthy scholars who collected and transmitted the text. Then comes the name of a scholar who received the three recensions (*riwâya*), and a name accompanied by religious formulae so that God's blessing should be upon him and the Muslim community.
6 and 7. Two audition certificates (*sami'tuhu*)—"I have heard this text"—and "audition" (*samâ'*) with signatures.
8. Written vertically on the right: a scholar states that he heard the owner of the text read it in full. The reading took place in the presence of an emir and his son, as well as another companion. The accuracy of the lesson was confirmed by a person from al-Andalus (Spain) at the beginning of the month of Jumâdâ I of the year 624 AH (1226 CE), in the Damascus mosque.
9. A reading certificate is framed in the center of the page: "I have read this from beginning to end under the direction of a certain master who had it from Shahda daughter of Ahmad: the reading began on Thursday, 13 Jumâdâ II, 623 AH [June 11, 1226 CE] at the Damascus mosque." It is followed by a signature and a religious formula.
10. Two overlapping inscriptions on the left:

Vertically: "I have read under the supervision of a certain person who received it from Shahda daughter of Ahmad. All this is authenticated and declared valid (*thabat*), Friday 18th of the month of Sha'bân of the year 671 AH [March 10, 1273 CE] in Damascus." Followed by a signature.

Horizontally: Written across the audition certificate is the inscription: *waqf mu'abbad* ("perpetual religious legacy"). This means that the pamphlet had become part of the *waqf* or religious legacy and was destined to be preserved in a library, the cost of borrowing it to be assigned to a teaching foundation or charity.

11. Transmitted by Shahda daughter of Ahmad, dated 624 AH (1226 CE), and performed at Jabal Qâsiyûn near Damascus.
12. Seal of the Zâhiriyya Library, Damascus.

من عبد الله الحميد وليته طالبه طالعه البقا الحسن

ابو عبد الله الحسين نما بمعبار الحاكم

ولا ابا معتى فطرة و بخلصه

به لبيع ومر و تبا مر و كتبة ومم

تعلمت على اس لطيف حاننت

مسلمه بعنا

اسا مع

معلا عبد

حد العراقي

الامام العالم نخر الدين اي

اءه يا من بهذه الورقه

لر ابو الحسن علي حصن

ر ابو عبد الله محمد مسفو

نخوله خامس عشري

الد ڡانى عر سبو

روا ابه ابي بكر احمد بن المبشر

روا ابه ابو النعالي ياس بن بند

روا ابه السمعه العالمه نخرا

سماع لعبد الرحمن بن ابرهيم نز احمد

و سا مر العلون

و صلى الله س

Fig. 1. The Gortyn "Law-Code" consists of a lengthy text regulating the inheritance of property. It was engraved in the fifth century in this Cretan city and consists of 12 columns, each of more than fifty lines, arranged in *boustrophedon* style.

THE GREEK ALPHABETS

Catherine Dobias-Lalou

The alphabet was not the first system of writing used for transcribing the Greek language. The syllabic system that preceded it and was used in the Mycenean palaces (see pages 197ff) seems to have disappeared with the Myceneans themselves. Yet, in Cyprus, an island at the edge of the Greek world, another syllabary emerged, one that, though rather different from the Mycenean system, was probably related to it. The Cypriot syllabary was in use from at least the eleventh century BCE and for most of the first millennium BCE. It was used to write the local Greek dialect and another language that has not yet been identified and is known as "Eteo-Cypriot." The island was a real language laboratory for the eastern Mediterranean; Cypriot syllabic writing existed in parallel with the Phoenician script (which was used to transcribe the Phoenician language) and, from the sixth century BCE, with the Greek alphabet, which was used to transcribe the form of Greek language known as *koinè*. This Greek alphabet was simply the Phoenician alphabet with some adjustments (made a few centuries earlier) to the phonetic requirements of Greek.

The place and the time of the loan are the subject of great controversy, but the place is unlikely to have been Cyprus, despite the favorable conditions that existed on the island. As for the date, there is good evidence to suggest that it is fitting not only with the age of the oldest documents written in alphabetical Greek but also with the time at which the Greek alphabet was in turn passed on to other nations, especially to the Etruscans in Italy. The data converge and make it possible to claim that the Greek alphabet, subject to a few variations, was created in the mid-eighth century BCE. It is very difficult to pinpoint the gestation period. For one thing, there is nothing to prove that the loan took place at a single time and place. Its adoption in Greece appears to have occurred in several regions simultaneously. It has been suggested that the place of initial contact with the alphabet (before it was adapted) was northern Syria (then Phoenicia, now mostly Lebanon) where the Greeks had established colonies.

Each sign in the alphabet is an instrument joining an outline and a sound, and each has a name. The right-to-left direction used for writing in the Canaanite country was not considered necessary by the Greeks. In ancient times, they sometimes wrote from right to left (Fig. 6), sometimes from left to right, flipping asymmetrical signs by 180 degrees. They also alternated the direction, a practice known as *boustrophedon* (meaning "like a plow-ox that turns" at the end of a furrow—Fig. 1). Eventually, the left-to-right direction was adopted exclusively. The Greeks retained the traditional order of the letters as well as most of their names, which refer to the shape of the letter. These were transposed into Greek with the addition of a final *a*, so that *bet* became *beta* and *dalet* became *delta*. The adapters used the twenty-two signs of the Canaanite alphabet, in which only consonants were noted down. To make them suitable for transcribing the Greek language, vowel signs had to be included. Two types of operation thus needed to be performed: retaining the most suitable signs for the notation of the Greek consonants, and assigning graphemes for the vowels. Initially, none of the twenty-two signs was rejected: all were used forming the Greek letters from *alpha* to *tau*. The subsequent additions to the alphabet are the result either of variations based on some of the signs in the first set or of newly created symbols. At first, Greek vowels were roughly indicated, the initial set of five signs rendering neither the different lengths of vowels nor the opposition between more or less open vowels, which however is meaningful in numerous dialects. Consonant

Fig. 2. Ceramic ostraca, several of which bear the name of Themistocles.

signs were thus converted to represent A, E, I, O and a new sign, Y, added at the end of the alphabet.

Most of the consonants had comparable phonemes in Canaanite (semitic) languages. Letters that were considered to be redundant functioned as doublets. For instance, the Canaanite system contains four sibilants, but Greek only has a single, ordinarilly unvoiced one. The Greeks thus reassigned the redundant signs, altering their original names and sound values. One of the four sibilants that had originally competed with *sigma* (under the Greek name of *san*) was eventually abandoned. The oldest Greek alphabet also contained a sign known as *qoppa* that was used equally with *kappa* to render the dorsal /k/. Even though the stock of available letters was surplus to requirements, there was no way of annotating two Greeks aspirated occlusives /kh/ and /ph/ (the sound /th/, however, was represented by the Phoenician emphatic dental). The combinations ΠH and KH were used for as long as the letter H was the grapheme for the aspirative H. Later on, the addition of *phi* and *chi* met the need. Despite the adoption of a monophonematic principle, three letters denoted diphonematic signs: *zeta*, which represented a

pair of consonants only at certain periods and in certain dialects; *xi*, which was one of the sibilant signs in the Canaanite repertoire; and *psi*, a Greek addition designed to be used as the counterpart of *xi*. The last letter of the classic alphabet, *omega*, is due to the need to annotate the long *o*. The sign H eventually became available in certain dialects, following the disappearance of the aspiration, and was reassigned to annotate the long *e*.

There was thus an initial period lasting several centuries during which local—or epichoric—alphabets offered certain differences between them, both in the shape of some letters and in the sound attributed to them. During this period, much effort was invested in adapting the graphic tool to a developing phonological situation. A fixed and uniform spelling eventually developed, starting in the late fifth century BCE. The model was supplied by Ionia in Asia, and gradually spread throughout the regions, although it was not perfectly adapted to all the dialectical variations. In Athens, for example, the adoption of "Ionian letters" for writing official texts was decided by a vote passed in 403–402 BCE, the same year in which the democratic institutions were restored—an excellent indication of the institutional status of writing.

Writing had a vital political function in that it enabled each individual to learn about the decisions taken by the state, reminding each member of the city that he was both the originator and the addressee of the decision taken. Writing developed in tandem with the concept of the city-state, in which a body of literate civilians—whose knowledge of reading and writing was indispensable to the functioning of the institutions of the state—replaced the formula of a king surrounded by a council of elders. We have a good example of that in Athens, where the procedure known as "ostracism" was designed to prevent the return of tyranny. Once a year, on a fixed date, each citizen could write on a potsherd (*ostracon*) the name of the public figure who, in his opinion, had excessive influence in the city-state. If more than six thousand votes were cast for the same person, that person was banished from Athens for ten years (Fig. 2).

Publicly displayed notices also played an important role, whether they were exhibited temporarily on panels of lime-washed wood or permanently by being engraved on a stone tablet or bronze plaque fixed to a support. In many of the city-states, honorific decrees conferred awards and privileges on those who had given help to the state, which would culminate in the decision to "have the present decree engraved on a marble stele and placed in the most prominent position of the *agora* (marketplace)." Sometimes it was also specified that this public display might encourage other benefactors to come forward.

Other official decisions were engraved and placed in the sanctuaries. If the deed in question involved several cities, it was generally stipulated that the most important sanctuary in each of them would receive an engraved copy of the order; often an additional copy was to be deposited in a great temple visited by all the Greeks. In addition to this informative function, the display of the document was intended to place the decision under the protection of the gods—an indication of the importance of the relationship between writing and religion. Holy places, belonging to the gods, offer protection from seizure of people or property (hence the etymology of the adjective *asylos*). Thus, when a human undertaking is put in writing and deposited with the gods, there ensues some form of guarantee. An example is the acts of enfranchisement of slaves that are preserved in sanctuaries; in some temples, such as at Delphi, the deed is formulated like a contract of sale from the master to the god. The fictitious party to the contract, latter, being a warrant, is at the same time the repository of the deeds that are engraved on the walls of the various buildings within the temple complex (Fig. 3).

Writing had yet another function within the religious context, in that it could be used to record a sacrificial offering in the sanctuary. Of course, the simple gesture of depositing a valuable object could be enough, yet from the dawn of writing and even on the humblest artifacts, there are innumerous examples of engraving an explanation for the sacrifice. Countless vases have been found on which graffiti were clumsily scratched with a sharp metal point, including as a minimum the name of the divinity, the name of the offerand, and often the reason for making the sacrifice. This might be the fulfillment of a vow (*euche*), first fruits, a tithe, or a share of booty (Fig. 4). Obviously, these messages were also intended to be read by visitors to the sanctuary, especially when a victorious general used it as an opportunity for reminding all concerned of his conquests. The humbler dedications clearly aim to reinforce the mysterious relationship between the faithful and the object of his devotion through the intangible link created by letters and words.

This leads us to the magical properties of writing. Sometimes, letters are arranged in incomprehensible sequences, or texts are written in what is clearly a code. The *defixiones*—curses or imprecations—are easier to understand and were designed to cast a spell on their remote victim. They are small tablets made of lead, this being a material with magical properties. Once certain rites had been performed and the curse had been read aloud, the tablets were rolled up and buried in the ground where the forces of the underworld were supposed to be effective. This is how writing was used as a vector of communication, but not, in this case, for publication—quite the opposite.

Fig. 3. Acts of enfranchisement engraved on a supporting wall of the temple of Apollo in Delphi.

Fig. 4. Golden bowl dedicated to Zeus in the sanctuary of Olympia by the sons of Kypselos, tyrant of Corinth, as part of the spoils of war (mid- to late-seventh century BCE): "The Kypselides have dedicated [this object] that comes from Heraclea." © 2002 Museum of Fine Arts, Boston.

Fig. 5. Mosaic from the Temple of Hermes in the Gymnasium quarter of Cyrene, Libya. The inscription concerns an offering from the slave Januarius to the god who ensured the victory of his master, Ti. Claudius Jason Magnus. It is known that the latter, who hailed from a prominent Cyrenaean family, was a victor in the Olympic stadium in 189 CE.

Fig. 6. Rhodian drinking vessel of the late 8th century BCE. The bowl has a graffito scratched from right to left reading: "I am the cup of Korakos, son of [...]." Inv. 10151 (*Inscriptions from Lindos*, 710), National Museum of Denmark, Copenhagen.

Writing was used to communicate not only with the supernatural powers but also with posterity. The function of memory, handed down from prehistoric times through the oral tradition, is much more safely preserved through writing. With a few minor differences, there is almost universal agreement that the *Iliad* and the *Odyssey,* in the state in which they have come down to us, can be linked to the introduction of alphabetic writing in Greece. Henceforth, literature would either be produced in writing or not at all.

A funerary monument sometimes consisted merely of a stone set up to indicate the burial site (*sema* = "sign," as well as "tomb"). But the inscription on a tombstone helped more and more to identify the deceased and ranged from a simple name to a full record, often in the form of a short poem, the epigram. Such formulae as "Hail, passer-by!" or "This stele indicates to passers-by my name, the name of my father, and my homeland," or "His mother had this monument erected in memory of her son for the generations to come," were typical epigrams.

In the Greek city-states, the man responsible for drawing up public deeds and recording them in the archives—the official who today would be known as a registrar or clerk of the court—was given various names, many of which are illuminating. The most common were based on the root that also produced the verb *graphein* ("to write," but etymologically derived from "to scratch"); the writing medium would have been stone, ceramic, metal, wood, or leather. *Graphos* is also the word used for an outline made-up by other means on other media—a stylus on wax or an inked calamus on parchment or papyrus. The mark thus produced may be figurative, decorative, or symbolic. The verb has the double meaning in Greek of "to write" and "to paint." The man responsible for written texts in the city-state was a *grapheus* or *grammateus*, the latter being derived from *gramma*, meaning letter or traced sign. In other city-states, the memory function was considered the most important, and he was known as a *mnamon* (memory man). An inscription found in 1970 in the Cretan city of Lyttos uses a different title, that of *poinikastas* (the two verbs for memorizing are *poinikazen* and *mnamoneuen*). Taking account of dialectical peculiarities, the word is derived from the adjective for "Phoenician"—*p(h)oinikos.* The names of two products imported from Phoenicia passed into the Greek language on the basis of this derivation: purple dye and the letters of the alphabet. As for the name of the official in charge of the archive, I believe it to be a lexeme with a dual meaning: he was the man who had mastered Phoenician letters, but he was also responsible for engraving inscriptions, which were made more readable by the addition of a red coating in the hollows of the letters.

He thus had the duty of writing the characters and enhancing them, for writing was not merely a matter of attaching a message consisting of conventional signs to a medium, it also involved creating a work of art. Inscriptions were designed to harmonize with the medium on which they were written—namely, a carved, painted, hammered, or other prepared surface (writing painted on vases is discussed on pages 241–243 and writing on coinage is on pages 254–255), to say nothing of manuscripts. Captions or other messages associated with the artistic program were often incorporated into mosaics (Fig. 5). Stonework or metal objects were treated similarly. An object's "message" was often conveyed linguistically by the simple expedient of the "speaking object." The words might have been owner mark's, such as graffiti scratched on a cup ("I am the cup of Korakos"—Fig. 6), or the commemoration of a sacrifice indicated by the words "Megaris dedicated me to Hera," or a combination of both types of message on a tomb: "I am the monument of Glaukos, son of Leptines; the children of Brentes offered me."

Visually, the inscription needed to harmonize with the other elements in the monument. The position it occupies on the block of stone is part of the overall design that combines a generally flat surface with mouldings, a pediment, sculptures, and paintings. The majority of tombstones, whose esthetic qualities are based on the association between the sculpture and the engraving, were also decorated with colored paintings, as is proved by an exceptionally well-preserved item from Demetrias in Thessaly (Fig. 7). On coins, the legend is an integral part of the whole design (Fig. 8).

Fig. 7. Funerary stele from Demetrias in Thessaly (third century BCE). The deceased (identified by the inscription "Demetrios son of Olynpos") is shown sitting on a stool; in front of him is a little table separating him from a smaller figure, that of a slave. The scene is painted, as is the moulded decoration, and the pediment and the engraved letters are picked out in blue. Volo Museum.

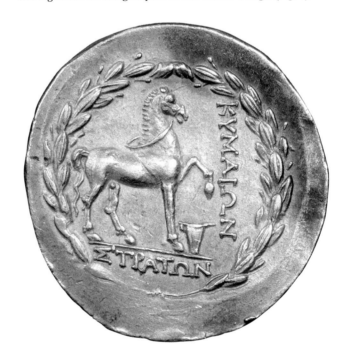

Fig. 8. Reverse of a second-century BCE silver tetradrachma from Kymaea in Asia Minor. Inside the circular field defined by a laurel wreath, a bridled horse stands facing right, pawing with its front left foot while a vase has been placed in front of its front right foot. Parallel and at right angles to the two axes of the animal's posture, two words are engraved: the vertical "of the Kymaeans" indicates the city that issued the coin; the horizontal "Straton" is the governor of the mint's name. No. R 2085, Cabinet des Médailles, Bibliothèque Nationale de France, Paris.

The internal arrangement of the inscription was designed to produce a harmonious impression overall, even if making part of the information less clear. After all, the classic Greek alphabet did not contain enough letters to represent certain vowel sounds. Nor did the incribed words bear any accents, which are nevertheless significant in the Greek language. The point at which a word begins and ends is rarely indicated. From the first short, hesitant inscriptions to the lengthy documents of the classical era, there is a progression, especially with regard to the overall visual impression obtained prior to the reading. The shape of the letters, when subjected to the requirements of large-scale reproduction, was systematized and regularized, and the space allotted to the inscription was entirely occupied by the letters. In the oldest inscriptions certain words or groups of words could be separated by dots, but this system was soon abandoned. The letters were then arranged in rows from one margin to the other. The ends of the lines did not necessarily coincide with the ends of the words, or even with the ends of syllables. The internal organization of the text could only be indicated by its arrangement in columns, or, more rarely, when it started on a new line, reinforced occasionally by a double space between the lines or, instead of a space, the placing of a stroke next to the margin (*paragraphos*). The ornamental function of writing culminated in the so-called *stoichedon,* a fashionable device in Athens in the fifth and fourth centuries BCE. The letters, which completely fill the space allotted for the text, are aligned both horizontally and vertically in a grid prepared by a stone-cutter who drew faint guidelines of which a few traces still linger (Fig. 9). When this arrangement was not used (certain letters, such as the *iota,* being narrower than others) the vertical alignment was irregular with respect to the horizontal spacing.

For several centuries, only one type of character existed, and it changed only in response to requirements of regularity and symmetry (and a few dictates of fashion). Only a very practiced eye could detect the minute details that characterize the work of a particular stone-cutter or studio. If an engraver wanted to indicate a significant difference in style between one part of an inscription and another, all he could do was to play with the white spaces and the respective sizes of the letters from one line to the next. The shapes of the letters are almost identical wherever they are found, even when traced on papyrus with a calamus (Fig. 10). But the multiplicity of flexible media resulting from the introduction of parchment would later favor the emergence of cursive lettering for use in handwriting. These new forms of the letters were on echoed inturn stone when, during the imperial era, the first premises appeared of what, for modern readers, is the

Fig. 9. Collective funerary stele of soldiers of the Athenean tribe of Erechtheis, who died during the campaigns in 459 BCE. After three lines of heading in characters of two different sizes, the names are engraved in three columns, each arranged in a *stoichedon*. Ma 863 (Nointel marble), Musée du Louvre, Paris.

Fig. 10. Papyrus used for writing exercises *ca* 160 BCE, preserved among family papers in Memphis, Egypt.
The exercise consisted in writing the seven vowel signs in columns, then creating syllables by adding
successive consonants from the alphabet attached to each of the vowels.
Ref. I.P.Z. 1, 147, National Museum of Antiquities, Leiden, Netherlands.

difference between capital letters and small letters, or upper case and lower case.

Before showing this type of variation, writing consisted of an immutable set of characters that were taught and learned as a multipurpose tool. Education began with the "master of letters" (*grammatodidaskalos*), who taught the children of freemen. The students memorized the letters in the conventional order and learned how to use them. They practiced by tracing letters and syllables before moving on to writing whole words, then sentences.

Learning the letters meant not just learning how to read and write but also how to count, because the letters were also used to signify numbers. Various systems were used at first, of which two will be mentioned here. The first rests on the acrophonic principle, noting units with the shape of a lance I, Π for five (*pente*), Δ for ten (*deka*), H for a hundred (*hekaton*), X for a thousand (*chilioi*). Monograms were used for more complex numbers (for example, combining *pi* and *delta* to produce fifty). The other system, which eventually prevailed, used the sequence of the complete alphabet to transcribe the nine units, then nine tens, then nine hundreds. Thus, the number 329 was written in retrograd order, with *tau*, *kappa* and *thèta*: ΤΚΘ. The alphabet used for the purpose was of Ionian origin and had twenty-seven letters. It thus did not exactly match the alphabet used in Athens, which had twenty-four letters. The *digamma*, a letter representing the former consonant /u/, between *pi* and *rho*, was in sixth position. The letter

qoppa was used for 90, and the last letter of this alphabet, *sampi* (which followed *omega* and was used in Ionian to represent the fricative /ts/) had the numerical value of 900. This distortion is not without parallel. Apparently, in other regions, in the time of the epichoric alphabets, an alphabet might be copied using characters that were no longer in use. On the contrary, the classic Athenian 24-letter alphabet was used to number the verses of the *Iliad* and the *Odyssey*. Letters were also used for other classification purposes: to number the divisions of the civil administration, to identify the various seating areas of the auditorium in a theater, and as keys to fitting stone blocks together during construction.

The loan made by the Phoenicians to the Greeks had in turn counterparts. The most lasting example was that of the epichoric alphabet of Euboea, brought to Italy by Greek colonists who settled in Pithekoussai, now known as Ischia. The oldest Greek inscriptions are found there, and archaeologists date them from between 750 and 725 BCE, as on the famous "Nestor's cup." It was by this route that the Greek alphabet entered Italy. I should mention another loan here, but one that was temporary. The Gauls, who had established relations with the Greeks of Massalia (now Marseille in France), made their first foray into writing by using Greek letters. A few inscriptions in Gallic, written in Greek letters, have survived especially in Provence (Fig. 11). The Latin alphabet was later preferred, but the Latino-Gallic script retained two Greek letters, Θ and X,

Fig. 11. Dedication from Glanum (second to first centuries BCE) in Gallic, using Greek script, to the divinities known as the "Glanic mothers" (after the Glanis river), based on a formula that was well known in pre-Roman Gaul. Collections and Archives of the Hôtel de Sade, Musée du Site archéologique de Glanum, Saint-Rémy-de-Provence.

Fig. 12. Graffito on an *oenochoe* (wine-jug) in the geometric style found near the Dipylon Gate in Athens (730–720 BCE). The inscription on the band at the base of the handle reads. "That out of all the dancers who today produces the most graceful performance, he..."; what follows is rather controversial since it does not match metrically or grammatically. National Museum, Athens.

This joyful exercise of metric and graphic improvisation, that may have been inspired by an existing poem, ended abruptly when the author ran out of space (Fig. 12). This is excellent proof, if any were needed, that writing was not something that always had to be taken seriously!

to represent phonemes that had no equivalent in the Latin alphabet.

This brief survey of the uses of alphabetic writing perhaps gives an impression that at first stage knowledge of writing might have been reserved for a privileged class that enjoyed religious or political power. However, this does not seem to have been the case. Almost all the major categories of inscriptions supplied by classic epigraphy are represented in the far less abundant material from the earliest period. The oldest documents include some that are singularly frivolous in nature, such as the aforementioned "Nestor's cup," or the oldest inscription found in Athens, a wine-jug found near Dipylon, on which someone who was just learning to write has mentioned a dancing competition.

Bibliography

BAURAIN, C., C. Bonnet, and V. Krings (eds.). *Phoinikeia grammata. Lire et écrire en Méditerranée* (Liège/Namur, 1991).

DETIENNE, M. (ed.). *Les Savoirs de l'écriture en Grèce ancienne* (Lille, 1992).

EASTERLING, P., and C. Handley (eds.), *Greek Scripts. An Illustrated Introduction* (London, 2001).

GUARDUCCI, M. *Epigrafia greca*, 4 vols. (Rome, 1967–1978).

——. *L'Epigrafia greca dalle origini al tardo Impero* (Rome, 1987).

HEUBECK, A. *Schrift* (*Archaeologia Homerica*, X, 3) (Göttingen 1979).

JEFFERY, L. H. *The Local Scripts of Archaic Greece.* A.W. Johnston (ed.) 2nd ed. (Oxford, 1989).

PESTMAN, P. W. *The New Papyrological Primer* (New York, 1990).

POWELL, Barry B. *Homer and the Origin of the Greek Alphabet* (Cambridge, UK, 1991).

SASS, Benjamin. "On the origin and early history of the Northwest Semitic, South Semitic and Greek alphabets." *Studia alphabetica* (Friburg/Göttingen, 1991).

SWIGGERS, Pierre. "Transmission of the Phoenician script to the west." Daniels/Bright S.261-270, 1996.

INSCRIPTIONS ON GREEK VASES

François Lissarrague

In ancient Greek, the verb *graphein* meant both "to write" and "to draw." Starting in the eighth century BCE, the geometric period, the elements that covered the surface of vases were mainly graphical. The geometric patterns that give their name to the period more closely resemble ideograms than painted figures. Art of this type, which aims not to represent the figures mimeticaly but to produce schematic elements (warriors, chariots, horses, birds) soon included writing alongside the figurative elements.

In the so-called proto-Attic phase,at a time when painted figures were no longer used as part of a geometric pattern and became more

diversified through the variety of the incised motifs used, the expression of movement, and the variety of gestures,the vase-painters continued to use various ornamental patterns (flowers, rosettes, chevrons) that added an esthetic quality to their work; they then added words which oriented the eye in the image and gave names to the figures portrayed.

As soon as the Attic style began to develop its characteristic use of black figures (*ca* 630 BCE), what appears to our modern eye to be a double level—image and writing—is not separated by the vase-painters. The two levels of the graphic merge into one (Fig. 1). Interestingly, the inscriptions do not all face the same way, and, as in

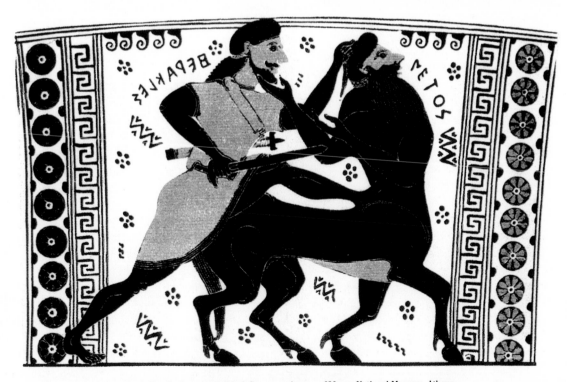

Fig. 1. Detail of proto-attic black figure amphora, *ca* 620 BCE. National Museum, Athens.

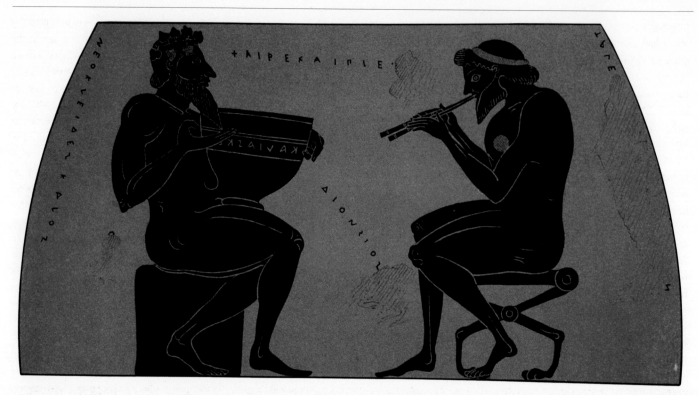

Fig. 2. Detail of an Attic black figure *oenochoe* (wine-jug), *ca* 540 BCE. Antikensammlung, Berlin.

the case of ancient inscriptions on monuments, writing was not required from the outset to run horizontally from left to right; this only became the norm in the fifth century BCE. The vase-painters wrote their inscriptions in various directions, and often the direction is significant.

The type of inscription that is found on vases also varies within the same image. There is a good example on a small oenochoe (wine-jug) in the Berlin Museum (Fig. 2). The scene represents two men who sit facing each other. They are naked, as if attending a banquet. The one on the left is playing the double *aulos* pipes; the man on the right has a large vase on his lap and wears an ivy wreath. At eye level are the words CHAIRE KAI PIE ("Rejoice and drink"). This formula is often encountered in isolation on drinking-vessels, in the absence of any figures, and it is interpreted as a salutation from the vessel to the drinker. Here, the inscription, placed between the two facing figures, takes on the aspect of the opening words of a dialogue, that places the scene within the context of a banquet.

Further down, the name of the man carrying the vase is written obliquely: DIONSIOS. This is not the god Dionysos, but the name of an ordinary mortal, Dionysios—Denis, in fact. The musician is not named. The surface of the vase in his back is damaged but enough letters remain, written vertically at the edge of the scene, to identify the signature of the potter: TALE[ides epoiese]N ("Taleides made it"). Symmetrically on the right, the following inscription runs the length of the frame: NEOKLEIDES KALO ("Neocleides is handsome"). This name in this form is found on other vases; it does not refer to the figures represented but to a young man famous for his beauty. There are a number of acclamations of this type, praising the looks of a particular young man—more rarely those of a young woman. The practice is known from inscriptions on media other than vases, in the form of graffiti, and was very much in line with the homoerotic culture of the ancient Greek world. On vases, the inscription is addressed to the circle of drinkers, in a symposion, a place where men gathered to share wine and sing lyrical songs of a romantic nature. On the vase in question, a final inscription is found on the side of the krater on Dionysios's lap, stating KALIASK[alos] ("Kalias is handsome"). Visually, it echoes the previous inscription. Kalias, like Neocleides, is praised on the vase, but not so prominently. This vase thus offers a complex array of inscriptions that links various names and identities, naming one painted figure (Dionysios), commemorating the potter (Taleides), and celebrating the beauty of the young men Neocleides and Kalias. These various statements are supplemented by a legend inside the scene itself, a toast between the drinkers, the trajectory of which signifies for the reader that it has been spoken aloud between them. This last inscription adds sound to the image, as does the representation of the aulos, a musical instrument so frequently encountered at banquets.

In parallel to the diversity of the types of inscription whose linguistic content is linked to different planes, the position of the inscriptions within the image has a special importance. Some inscriptions (the signature, the acclamation) frame the scene, whereas others (speech, the name of the subject) occupy the space between the figures and create visual links between them.

Similar effects can be found, with interesting variations, on a

lecythos, a tiny perfume vase (Fig. 3). It predates the drinking vase by about half a century and is now in the Lyon Museum, France. At this date, *ca* 490 BCE, the painters of vases regularly placed inscriptions inside the images. Although this use of writing was almost commonplace, it was not compulsory and some painters never used the device. Others, on the other hand, acquired an amazing mastery of calligraphy. On the Lyon vase, for instance, there are two types of inscription. The first, carefully placed from left to right, is placed beneath the figure represented, between two lines of black glaze that separate it from the image, forming an ornamental band in symmetry with the checkerboard pattern that runs along above the image. The letters are spaced regularly, and the vase needs to be turned to read the inscription: KORONE KALE PHILO ("I love the beautiful Korone"). This declaration is addressed to a young woman. The formula is rare in the feminine, as is its position on the vase. It is hard to be absolutely positive, but this arrangement would suggest that it was commissioned from a craftsman who copied the words dictated by his customer.

What makes this even more likely is the fact that the other inscriptions, on the body of the vase, are of a different order. The scene represents a chariot alongside which a man is walking while playing on a lyre. At the head of this little procession is a doe. The man is probably Apollo, the musician-god. A series of letters runs from the face of the charioteer to the heads of the horses; other groups of letters, written vertically, occupy the spaces between the horses' legs and Apollo's back.

These letters, thickened but legible (VTSOI are among the characters that can be read) make no sense; they are mere series of signs that are repeated horizontally as STOVTIS, SOVTIS, though not a single coherent word emerges from them. Their function appears to be restricted to filling the field of the image to suggest a verbal transaction that is left open, and is up to the initiative of the reader-viewer. The signs give the image a voice, in accordance with the presence of the lyre and Apollo's singing, but they do not transcribe any musical or linguistic content.

The painter cannot be said to have been illiterate, because he was able to reproduce the praise of Korone and the usage would seem to indicate a relative familiarity with writing. The painter writes because this graphic tool enables him to obtain a certain visual effect. There is no reason, however, to radically contrast an oral culture and a written culture. What is represented here is a mixed state and varying degrees of mastery of writing, in which the letter is used merely as an element of decoration.

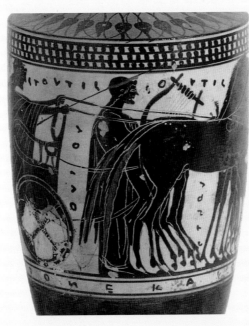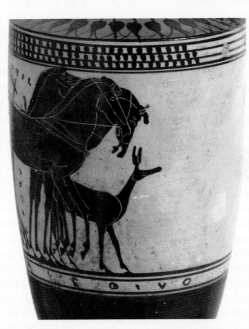

Fig. 3. Details of an Attic black figure *lecythos*, *ca* 490 BCE. Musée des Beaux-Arts de Lyon.

Fig. 1. *The Baker and His Wife*, a painting from Pompeii. The woman holds a stylus and writing-tablet, and her husband holds a scroll. First century CE. Muzeo Nazionale, Naples.

THE SCRIPT OF ANCIENT ITALY

Dominique Briquel

The Greeks began to colonize Italy in the early eighth century BCE. A group of Chalcidians (citizens of Chalcis in Euboea) settled on the island of Ischia, then known as Pithecusses, and in around 750, they founded Cumes, the first Greek city in Italy. A fragment of iron ore from the island of Elba, found in archaeological excavations on Ischia, reveals the reason for the Greek wanderings. They were looking for metals—iron and copper—which were in short supply in their own land but which Etruria possessed in abundance, mainly in what was called "the mining district," the island of Elba and the mainland coast facing it. By settling in Campania, on the fringes of the Etruscan world, they were able to trade with the Tuscan aristocrats who controlled the wealth. Yet there was no true colonization as such: the Greeks established trading-posts in Tuscany, but they did not found cities or subjugate the native inhabitants as they would later do in southern Italy or Sicily. When confronted with the Greeks, the Etruscan world safeguarded its cohesion and strengthened its own national identity. This was a strictly commercial arrangement, and these barbarians were not about to let themselves be dominated by the sophisticated Hellenes.

Yet the Etruscans were attracted by the trappings of the civilization that these newcomers brought with them. From the eighth century BCE, the tombs of the Tuscan aristocrats, and later those of the wealthy in neighboring provinces such as Latium, were laden with riches that must have been obtained in exchange for the local metal. There were Greek vases, some geometrically patterned, others in the oriental style; there were huge bronze cauldrons, like those described by Homer; and there were silver vessels, and gold and ivory jewelry, some of it from Cyprus or the Syrian coast. All this is evidence from beyond the grave of the luxurious lifestyle of the native aristocraty. Their lives were modeled on the

innovations from beyond the sea. They even began to banquet in a reclining position, like the Greeks, and to drink wine, a practice hitherto unknown.

The novelties also included writing. The first Etruscan inscriptions appeared *ca* 700 BCE, almost simultaneously in the two great southern metropolises of Tarquinia and Caere. They were written in the script of the Greeks of Chalcis who lived in close proximity with the Etruscans. The Tuscans made a few minor modifications to adapt the alphabet to their own language. For instance, *gamma*, the third letter of the Greek alphabet, a voiced occlusive /g/, became our letter C, an unvoiced occlusive /k/, because Etruscan did not contain the phoneme /g/. The Greek alphabet, as amended by the ancient Tuscans, would later be transmitted to the other peoples of the Italian peninsula. This explains how our modern, Latin-based script contains a C in place of the *gamma* of the original Greek script. The Etruscans occupied a dominant place in Italy at the time, and it is from them that writing spread to the other nations, especially the Latins.

During the earliest stages of the history of writing in Italy, a knowledge of reading and writing was a clear sign of prestige. Several of the excavated tombs of the wealthy in Tuscany contained writing instruments inscribed with alphabets. This shows the occupant to have been "literate" in the true sense of the word: he knew his letters in a society that still contained very few people who knew how to read, and thus was able to claim a superior culture. For instance, a princely tomb dating from 650 BCE in Marsiliana d'Albegna contained a tablet with an alphabet written along its upper edge (Fig. 2)—early evidence of what would remain one of the commonest writing materials in the Roman world, a wax-coated tablet on which letters were engraved with a stylus. But this tablet is a luxury item made of ivory and decorated with a lion in oriental style. Writing is thus

Fig. 2. Writing-tablet from Marsiliana d'Albegna, engraved with an alphabet, *ca* 650 BCE. Inv. no v. 93480, Museo Archeologico, Florence.

associated with the luxurious and exotic lifestyle of the Italian aristocracy.

Waxed tablets were not the only surface on which writing was inscribed. A tomb in Caere of roughly the same era produced a little bottle in *bucchero* (the luxury ceramic of the Etruscans), inscribed with an alphabet and syllabic exercises of the *ba be bi bu, ca ce ci cu* type (Fig. 3). It served as an inkwell, an accessory for another of the materials used for writing at that time in Italy, the "linen books" mentioned by Latin authors. These books were made from fabric that was written on with a brush and then folded. The inkwell shown here is noteworthy since it uses shapes for M and N that have not been found elsewhere. The aristocrat wanted to be accompanied to the grave by the object that attested to his outstanding achievements and singled him out not only for his mastery of writing—something that was still exceptional at the period—but also for the fact that the shapes of his letters were unique to himself.

Thus, when writing was first introduced, it played the role of affirming social prestige, and this is confirmed by the existence of pseudo-inscriptions by people who pretended that they could read and write—an easy thing to do in a society that was so largely illiterate (Fig. 4). In fact, writing was to some extent monopolized by the nobility. The script did not present any major difficulty. It was alphabetic and thus contained a limited number of signs, so it did not require a lengthy apprenticeship. Consequently, it did not result in the creation of a specialist cast of scribes. The aristocracy used writing for its own purposes. A great many of the oldest inscriptions, dating from the seventh century BCE, accompany the magnificent gifts which these aristocrats presented to one another, in the style of the

Fig. 3. *Bucchero* inkwell from Caere (Ceveteri), found near the tomb of Regolini-Galassi, inscribed with an alphabet and syllabic exercises. Late seventh century BCE. Inv. no. 20349, Museo Gregoriano Etrusco, Vatican Museums.

Fig. 4. *Impasto* vase with pseudo-inscription found at Tarquinia. First half of seventh century BCE. Inv. no. 732, Museo Nazionale, Tarquinia.

heroes of the Homeric epic. Such an inscription would commemorate the giver and the recipient and constituted an important element in these aristocratic exchanges of presents. Sometimes writing was inscribed on the luxury item itself, as in the case of the golden fibula now in the Louvre Museum in Paris (Fig. 5). The goldsmith produced the inscription with the same delicate granulation technique that he used for the decoration.

Inscriptions commemorating aristocratic gifts and the alphabets that accompanied princes to their graves disappeared after the sixth century BCE. This was hardly surprising, since a knowledge of reading and writing could not remain the prerogative of a narrow, socially dominant sector of the population for ever. Vases covered in writing have been found in quite modest tombs, and the craftsmen signed the goods that they made. The nobility could no

longer claim to be exceptional in their literacy or signal their social standing in this way. Furthermore, there is evidence that writing was taught outside the sphere of the families of the nobility and that it became part of the fabric that was used to build up the city. One of the earliest tangible manifestations of this affirmation of the city, over and above the family groups who lived in it, was the construction of temples, an activity that appears to have begun in the sixth century. These temples, with their outbuildings and associated personnel, produced veritable schools of scribes—if only to enable the faithful to leave votive offerings inscribed with their names.

One such "writing studio" existed in the sixth century BCE at Veii, attached to the temple of Portonaccio. This is where the famous terracotta *acroteria* (statues that stand beside the pediment) representing Heracles and Cerynia's doe were produced. A northern variation on Etruscan script, dating from the fourth to third centuries BCE, was found in the province of Veneto, and it is one of the best

Fig. 6. Bronze plaque imitating a writing-tablet and bearing a dedication, an alphabet, and writing exercises, originating from the sanctuary of the goddess Reitia at Este. Fourth to third century BCE. Inv. no. 16000, Museo Nazionale Atestino, Este, Italy.

Fig. 5. Gold fibula from Chiusi, 625–600 BCE. Inv. no. Cp 282/Bj 816, Musée du Louvre, Paris.

Fig. 7. Inscription on the *lapis niger* (black stone) in the Roman Forum, mid-sixth century BCE. Foro Romano, Rome.

Fig. 8. Bronze tables from Gubbio, second century BCE. Palazzo Comunale, Gubbio, Umbria.

examples. The excavations at the sanctuary of the goddess Reitia, in Este, yielded dozens of votive offerings involving writing, in the form of reproductions of tablets and styluses (Fig. 6). The divinity (who was the local equivalent of the Greek and Roman goddesses of wisdom and the arts Athena and Minerva), was the patroness not only of writing but also of the study of writing. The tablets are covered with alphabets and writing exercises, evidence of the role the community attached to this sanctuary and its priests in the teaching of the young Venetians. It is even conjectured that the English verb "to write" derives from the same root that gave the name Reitia.

There is nothing as eloquent in Portonaccio, but it has been noted at least that the votive offerings made in a local workshop use a special form of writing, involving a system of punctuation and a sibilant sign in the form of a cross. This is proof of its uniqueness. Yet unlike the alphabet found in the aristocratic tomb in Caere (which dates from the previous century), these offerings are not from the nobility. The entire citizenry considered the sanctuary as collectively theirs, and through it they expressed their community's individuality. These special features are generally found only in inscriptions discovered at Veii, whereas other cities had their own distinctive characteristics. For example, in Caere, the two

sibilants in the language were often distinguished by placing an S next to three dashes and a *sigma* next to four dashes, a peculiarity unique to this city.

From this time on, the forms of writing of which we are aware passed from the privileged prerogative of the aristocracy into general use by the citizenry. It was the city's means of expression and was at the service of its people. A statistic from Roman history may provide the best illustration. One of the stages that marked the slow progress of the Roman plebeians toward winning equal rights with the patricians, who tended to monopolize (if not abuse) political power, occurred in 450, with the display of the Law of the Twelve Tables. It is so-called because it was presented and offered for public perusal on the bronze tables displayed in the Forum. The citizen was thus protected from arbitrary rulings by judges and given the

Fig. 9. Detail of the triumphal Arch of Titus in the Roman Forum, showing an inscription dating from shortly after 81 CE. Foro Romano, Rome.

opportunity of seeing whether those judges were applying the law. Of course, the public display of a regulation is not a democratic process in itself. One of the oldest inscriptions discovered buried in the ground in Rome dates back to the sixth century BCE. It is the so-called *lapis niger* (black stone), which takes its name from the black pavement that had covered it since the end of the republican era. As far as can be judged, it simply fixes ceremonial rites associated with the ancient altar beside which it was discovered (Fig. 7). But the way in which the writing is used, and perhaps also the form of the stone, which is shaped like a tombstone or milestone, reinforces the impression of an edict set in stone, of a law fixed by a king—the *rex*, whose name appears in the text.

Note that in this case, the inscription does not appear to have been created for the purpose of being read. It is

arranged vertically, the lines running in alternate directions in the *boustrophedon* system where the end of a line is continued below it on the same side, reversing the direction of reading. The wording covers all four sides of the stone, and this would have made it even more difficult, if not impossible, to read. What counts most in the end is the presence of lettering, regardless of the content of the message it is supposed to convey. It is what the letters symbolize that matters.

The Twelve Tables changed the very meaning of writing. They themselves have disappeared, but one can get an idea of them through documents from the impressive series of seven large bronze tables, dating back to the second and first centuries BCE, which were found in the Umbrian city of Gubbio (Fig. 8). They are written in the local language and use the local writing style (only the two most recent are in

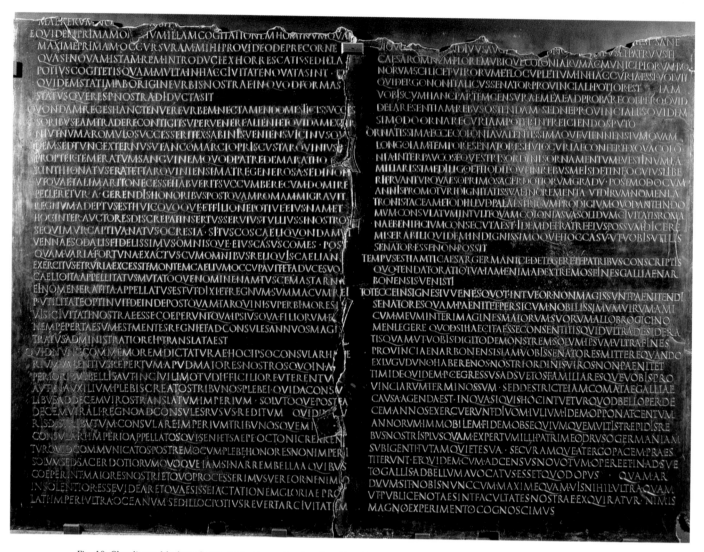

Fig. 10. Claudian table from Lyon, dating from shortly after 48 CE. Inv. no. Br 2, Musée de la Civilisation Gallo-romaine, Lyon.

Latin script). They contain religious precepts, laying down the ritual order for ceremonies held in the city. Legibility was imperative from now on. This sort of text was designed to be read, responding to the express wish of the people to have the law made public.

It would be simplistic, however, to link the use of writing merely to the publicity that it gives a text and to the process of democratization. The Latin inscriptions on many of the monuments in Rome date from the imperial period and are clear celebrations of the emperor. They are destined to perpetuate his glory and thus set him apart from the common mortal, giving him a godlike status, at least after his death. Thus, the inscription over the Arch of Titus in the Forum in Rome, built after the emperor's death in 81 CE, proclaims to the world, in handsome, carefully ordered capital letters, "the divine Titus, son of the divine Vespasian" (Fig. 9).

It is remarkable that this celebration of a ruler who was henceforth to preside over the destiny of the empire should be responsible for the misappropriation of republican forms of written proclamation. Much has been made here of the sovereignty of the Roman people who insisted on the public display of official texts on a bronze table. At first glance, the famous "Claudian Table of Lyon," found on Fourvière hill near the place where the delegates would assemble from the various cities of Gaul, seems to conform to this model (Fig. 10). The imposing bronze plaque commemorates the decision taken by the Senate, under the emperor Claudius in 48 CE, to open its ranks to the notables of this province. But it is no longer stamped with the seal of senatorial approval, the assembly's imprimatur in republican times. What has instead been engraved for posterity is the ruler's discourse, which

Fig. 11. Sarcophagus of Lucius Cornelius Scipio Barbatus, consul from 298 BCE.
Inscription dating from the mid-third century BCE. Vatican Museums, Rome.

preceded the decision. The discourse is recorded by Tacitus; the ruler used it to persuade the appointed city fathers, somewhat reluctantly, to recruit from further afield. The traditional medium on which republican laws had been written was thus adapted for use by the new form of power.

The break with republicanism was not as great as it might seem. The Roman republic, like its Italian counterparts, remained very undemocratic despite gradual plebeian encroachments. Its rulers were recruited almost exclusively from the narrow circle of leading families, whether they had originally been patrician or plebeian. Even under the Republic, one of the basic functions of writing, at least in its public applications, was to celebrate the glory of great men, and thus generally to honor the members of families who shared glory and high office.

Polybius, writing in the second century BCE, emphasized the importance of funeral services which were the occasion for listing the great achievements of the deceased and, by association, those of his ancestors. Epitaphs engraved on tombstones fulfilled the same function more permanently. The tomb of the Scipio family found on the Appian Way contained imposing sarcophagi that bore paeans of praise to each of the deceased. Lucius Cornelius Scipio Barbatus, who was consul in 298 BCE, is described in saturnine verses as "a brave and wise man whose nobility was equal to his courage, who was your consul, praetor, and city father, who captured the cities of Taurasia and Cisauna in Samnium, subjected the whole of Lucania, and brought back hostages" (Fig. 11). Note that this is addressed to the *populus Romanus,* who was invited to read these lines and marvel at the exploits of his noble scion.

Fig. 12. Latin inscription by Paulus Emilius on a plinth of King Perseus at Delphi, erected in front of the Temple of Apollo, 167 BCE.

Yet in the aristocratic republic that was Rome, the affirmation of the *res publica* went hand-in-hand with that of great men. One notable example is the inscription that Paulus Emilius, who overcame Perseus, king of Macedonia, at the Battle of Pydna in 168 BCE, had engraved on the plinth that the king had erected in the Hellenic sanctuary of Delphi. It proudly celebrates this appropriation of the monument of a conquered king: "Paulus Emilus, Imperator, has taken [this plinth] from King Perseus and from the Macedonians" (Fig. 12). The inscription is written in Latin in large, square characters in a location where the only language spoken was Greek. The letters appear to crush the Greek text that also appears on the stone, written in smaller letters. It is the very symbol of Rome's seizure of the Hellenic world, which was finalized with this victory.

Many of the inscriptions left by the Romans have a public, political nature, but these people did not spend all their lives in the public sphere—what they called the *negotium*. There was also its opposite: *otium,* or leisure. It was to this sphere that culture belonged, where writing was put to a very different use. Of course, much less is known about this personal aspect of literacy. Unlike the great official, or at least commemorative, inscriptions (such as epitaphs), that were designed to last and were therefore inscribed on stone or metal, this other writing was written on perishable materials which, with a few exceptions, have not survived. The fate of Herculaneum and Pompeii, buried under ash and lava when Vesuvius erupted in 79 CE, has provided a glimpse of the amount of material that must have disappeared. It is only in this region that parchment documents have been recovered. Skins prepared using a technique developed in Hellenistic Pergamon, as well as papyrus imported from Egypt, supplanted the ancient "linen books" and the wax-coated tablets as writing surfaces. The tablets were the commonest writing materials and were used for the myriad needs of everyday life, at work or in private, by anyone who could write. For cultural and literary purposes, though, parchment was mostly used.

Much has been written about literacy in the Roman world, and in the absence of any possibility of producing even approximate statistics, one can only offer impressions. It would seem, however, that the Romans were less illiterate than has long been thought. Many of them, boys and girls,

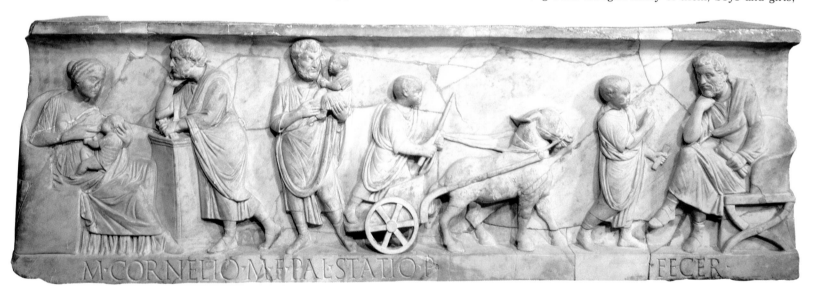

Fig. 13. Sarcophagus of Marcus Cornelius Statius, as schoolmaster and student, second century CE. Musée du Louvre, Paris.

attended elementary school run by a *magister ludi* (headmaster), whose main function was to teach letters—reading and writing—hence his other name of *litterator* (Fig. 13). He was a craftsman who was a permanent resident of the city, sometimes assisted by the civic authorities or by the emperor. The *magister* dispensed knowledge that no longer had to be sought in the temples, as had previously been the case. Those who could went on to attend high school or *grammaticus*, where they were taught literature. Even higher education was available from the *rhetor*. At the very least, everyone had a basic knowledge of writing and some notion of how it opened up a whole field of knowledge.

It is therefore not surprising that so many funerary images consist of a representation of the deceased surrounded by writing implements. Already in Etruscan funerary monuments (generally dating back to the second century BCE) it is not unusual for the effigy that lies on the top—reclining on its side in the banqueting position—to be holding a writing-tablet (Fig. 14) or a parchment scroll (Fig. 15) instead of the customary banqueting paraphernalia of chalice and paten. This was supposed to spell out how cultivated the deceased was. The sarcophagus of Laris Pulenas (in Tarquinia) features a long inscription recalling the fact that he was a diviner and wrote treatises on Tuscan religious knowledge. Significantly, it is recorded on the noble and literary material of parchment rather than the wax tablet that was used for more mundane purposes. Among Romans, this same desire to depict the deceased (or a living person) as a *litteratus*—"lettered" in the widest sense but also in its original meaning of "able to read"—produced similar representations. Here again, Pompeii has some interesting examples. For instance, a couple chose to decorate the wall of their house with their portraits, the wife holding a double tablet in her left hand and bringing a stylus to her lips with her right hand, while the man clutches a parchment scroll in his left hand, a sign of his appreciation of the literature written on this medium (Fig. 1). Did they have plenty of time for such intellectual pursuits? It is unlikely. They were both bakers, and their tablets, like those of the banker, Jucundius, which were found intact in the ruined city, were mainly used for keeping accounts rather than for recording their musings. But perhaps in their eyes, knowing how to read and write placed them in the same cultural community as Cicero or Pliny the Younger who never traveled without their writing instruments. This is a far cry from the situation that existed around 700 BCE, when only a few aristocrats were able to dazzle their illiterate friends with their knowledge of writing. Yet even at this late stage, the ability to read and write was still the best way of achieving social status.

Fig. 14. Alabaster cinerarium of Setre Cneuna with a figure holding a double writing-tablet, *ca* 100 BCE. Inv. no. 334, Museo Guarnacci, Volterra.

Fig. 15. Sarcophagus of Laris Pulenas holding an open parchment scroll containing his epitaph. Late third century BCE. Inv. no. 9804, Museo Nazionale, Tarquinia.

INSCRIPTIONS ON COINAGE

Michel Amandry

Some mid-fourth century BC tetradrachms from Clazomenes in Ionia are of special interest. An inscription, ΘΕΟΔΟΤΟΣ ΕΠΟΕΙ (*Theodotos epoei*)—which appears next to the full-face head of Apollo, whose flowing hair is crowned with a laurel wreath—confirms the identity of the coin's engraver, Theodotus. The use of the word EPOEI on coins has been found only once elsewhere, at Cydonia in Crete, on tetradrachms bearing a similar inscription: ΝΕΥΑΝΤΟΣ ΕΠΟΕΙ (*Neuantos epoei*).

(*Apatorios eglupsen*). The use of the word ΕΓΛΥΨΕΝ is even more specific and links the gemstones with the coins that were produced by the same craftsmen/artists. For instance, Phrygillos, who worked in last third of the fifth century BC, signed a carnelian engraved with a figure of Eros and a chalcedony scarab featuring Heracles absconding with the Delphic tripod, as well as tetradrachm coins struck in Syracuse.

In early 281 BC, the armies of Seleucos and Lysimachus, Alexander's two surviving generals, met west of Sardos on the Plain of

Fig. 1. Clazomenes. Luynes 2582, Cabinet des Médailles, Bibliothèque Nationale de France, Paris.

The signatures of engravers are rare, especially because they were considered artisans, rather than artists. That the name was written out in full and, moreover, on the "heads" side of the coin, was surely a great privilege. Theodotus seems to have enjoyed a long career, as coins he made were struck during the reigns of three magistrates, Pytheos, Heracleides, and Mandronax. At around the same period, staters struck at Soloi in Cilicia bear the inscription ΑΠΑΤΟΡΙΟΣ ΕΓΛΥΨΕΝ

Kouroupedion. Seleucos's victory (though shortlives—he was assassinated in late summer of that year) was celebrated in Pergamon with the remarkable issue of tetradrachms, the reverse of which features an Indian elephant—the animal that was largely responsible for his triumph (Fig. 2). The inscription ΒΑΣΙΛΕΩΣ ΣΕΛΕΥΚΟΥ (*Vasileos Seleukou*) is accompanied by two symbols, a star and an anchor, referring to the allegedly divine origin of the Seleucid dynasty.

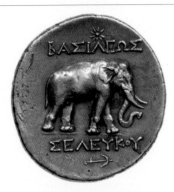

Fig. 2. Pergamon Seleucos. Luynes 3265, Cabinet des Médailles, Bibliothèque Nationale de France, Paris.

The inscription is in the genitive case, the word ΝΟΜΙΣΜΑ, *nomisma*, being understood. It should thus be read as (ΝΟΜΙΣΜΑ ΤΟΥ) ΒΑΣΙΛΕΩΣ ΣΕΛΕΥΚΟΥ, coin of King Seleucos. The inscription refers to the issuing authority. From the second century onward, various epithets were added to the sovereign's name (*philopator*, *soter*, etc.).

It is always difficult to identify the mint at which royal or imperial coinage was struck because so many were active at the same time. In some cases, an abbreviation or symbol solves the problem. In France, for instance, between the reigns of Charles VI and François I, the mint was indicated by means of secret dot placed beneath a letter in the inscription. Under François I, letters of the alphabet were used to represent the various mints throughout the kingdom. Paris was designated by the letter A. For coins issued by a city, the identification of the mint is generally a simple matter and is shown as an abbreviation, or occasionally an initial; sometimes the letter is broken, sometimes it is complete.

Fig. 3. Confederation of Athena Iliados. FG 688, Cabinet des Médailles, Bibliothèque Nationale de France, Paris.

On some coins, the name of the divinity surrounds his or her image. Thus tetradrachm coins of the Hellenistic period show a standing Athena holding a lance, with an owl at her feet and with the inscription ΑΘΗΝΑΣ ΙΛΙΑΔΟΣ, *Athinas Iliados* (Fig. 3). These are the coins of the Athena Iliados Confederation, the confederation of cities that worshiped Athena Ilias of the Troades. They are not the coins of the city of Ilion, however, because such coins would be

inscribed ΙΛΙΕΩΝ (Ilieon). The tetradrachms showing Artemis the huntress and inscribed ΑΡΤΕΜΙΔΟΣ ΠΕΡΓΑΙΑΣ (Artemidos Pergaias) probably come into the same category. They are coinage issued by a confederation of several cities who shared a place of worship.

The name in the genitive on the reverse of the coin—in this case ΜΗΤΡΙΚΗΤΟΥ (*Mitrikitou*)—is no doubt the name of the judge who ruled the confederation. But if so, what is the meaning of the monogram in the background on Athena's left? It is probably a proper name, perhaps that of a second judge (but which one?), or a liturgist.

Fig. 4. Pergamon Caracalla. FG 1379, Cabinet des Médailles, Bibliothèque Nationale de France.

Under the rule of Caracalla, (211–217 AD) Pergamon issued massive bronze coins on the reverses of which is a reference to the Emperor's visit (Fig. 4). The three temples and the inscription ΕΠΙ ΣΤΡ Μ ΚΑΙΡΕΛ ΑΤΤΑΛΟΥ ΠΕΡΓΑΜΗΝΩΝ ΠΡΩΤΩΝ Γ ΝΕΩΚΟΡΩΝ (*epi str M Kairel Attalou Pergaminon proton G neokoron*) are enlightening as to the administration of the city and its attitude to the imperial religion. The name M. Caerelius Attalos in the genitive, preceded by ΕΠΙ, signifies the name of the magistrate who ruled the city at the time of Emperor Caracalla's visit to Pergamon in 214–215. However, the name on the coins could also be that of the person responsible for minting them or of a liturgist—a wealthy citizen who contributed to the cost of minting the coin and who, for a given period of time, had responsibilities equivalent to those of a magistrate. The emperor came to the Asklepieion for treatment, and the city claimed the honor of being the f irst in Asia to be thrice neocorite. A neocorite city contained a temple dedicated to the cult of the emperors and Pergamon had built a temple for each neocory (Augustus, Trajan, and Antoninus).

Bibliography

CALLATAŸ, F. de. "Un tétradrachme de Lysimaque signé au droit et la question des signatures d'artistes à la période hellénistique." *Rev. Arch.* 1/95, 23–37.

FORRER, L. "Les signatures de graveurs sur les monnaies grecques." *Revue belge de numismatique* LIX (1903): 271–302 and pl. VIII; 419–434. *RBN* LX (1904): 5–40; 117–154; 241–276; 389–408. *RBN* LXI (1905): 5–30; 129–154; 283–311; 387–436. *RBN* LXII (1905): 5–38; 117–153.

GAUTHIER, P. "Légendes monétaires grecques." J.-M. Dentzer, P. Gauthier and T. Hackens (eds.). *Numismatique antique. Problèmes et méthodes* (Nancy-Louvain, 1975), pp. 165–179.

JAMESON, R. "L'œuvre de Théodote à Clazomène." *Revue numismatique* (1906): 249–252 and pl. X.

Fig. 1. *The Gospel of Ējmiacin* (*erkatʿgir*). Armenian manuscript written in upper case, fol. 54: "The Adoration of the Magi."

CHRISTIAN ALPHABETS OF THE CAUCASUS

Albanian, Armenian,

and Georgian Scripts

Jean-Pierre Mahé

In his description of Transcaucasia, Strabo (XI) states that this isthmus, which lies between the Black Sea and the Caspian Sea, was divided into three principal nations: the Iberians, the Armenians, and the Albanians. This corresponds roughly to today's Eastern Georgia, Armenia, and Azerbaijan (Fig. 2). Those three nations spoke languages that were quite different from one another and that belong to separate language families. Armenian is an Indo-European language, Georgian belongs to the south Caucasian group, and Albanian is a northeastern Caucasian tongue. The historic circumstances and the date at which all three languages were written down happen to coincide.

Attached to the Roman world through Pompey's conquests, Caucasia (comprising Iberia, Armenia, and Albania) officially converted to Christianity under the reign of the Emperor Constantine. The bible was translated into the local languages during the following century, and the first evidence of the respective scripts appears in the fifth century CE in a Christian context.

A clear relationship between the three alphabets is evident from the outward appearance of their most ancient forms (Figs. 3, 4, and 5). But while the Albanian alphabet contains fifty-six graphemes, Armenian has only thirty-six, and Georgian thirty-seven. As far as the order of the letters

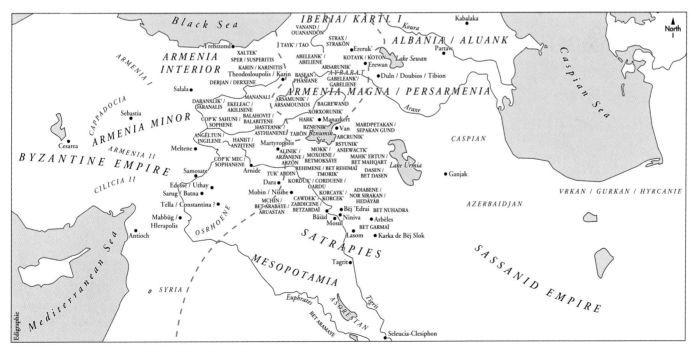

Fig. 2. Map of the Christian Caucasus at the beginning of the fifth century CE (R.H. Hewsen).

be impossible to convert the rural population thoroughly to Christianity without access to an Armenian translation of the Scriptures. With the consent of the king and the patriarch, he experimented unsuccessfully with a system of writing adapted for Armenian by a Syrian bishop named Daniel. Then, realizing that a number of letters were lacking in this foreign alphabet, he devised his own characters, the inspiration for which came from Edessa, where he had been staying during the course of his studies. He transcribed the Armenian version of the Book of Proverbs and asked Rufin, a Greek calligrapher from Samostatis, to perfect the design of the lettering. He then returned to Armenia where he translated all the books of the bible between 404 and 406.

As for its phonological content, the Armenian alphabet consists thirty-six letters and is based on the Greek alphabet with some additional letters. Although twenty-two Greek letters for which there is an Armenian equivalent appear in roughly the same order as they do in Greek, the fourteen additional letters that have no Greek equivalent have been inserted into the body of the alphabet in places that are more or less appropriate for the sound they represent. The alphabet begins with *a*, the initial letter of the name of God (*Astuac*), and ends with *k'*, the initial letter of the name of Christ (*K'ristos*). It consists of four series of nine letters that also serve as numeric symbols for the numerals, units, tens, hundreds, and thousands.

As for the shape of the letters, the capitals or upper case (*glxagir*), also called *erkat' agir* ("writing with an iron burin"), are the oldest type and are divided into two groups (Fig. 1). The letters that appear to be based on uncials are derived from a cursive Greek alphabet of the fourth to fifth centuries CE; they seem to be grouped graphically into sets of five. Those letters that have no equivalent in Greek are of an original design based on the sounds they represent. For instance, in the fricatives, the sibilants contrast with the palato-alveolar fricatives by having closed, as opposed to open, loops; the voiceless letters are closed at the top and the voiced letters are closed at the bottom. The aspirated letters are hooked.

The alphabet is thus based on a careful philological analysis, each letter representing a separate phoneme. Yet it cannot be considered to be completely phonetic because the simple *l* and the velar *ł* are conditional variants of the same phoneme, and the vowel *u* is annotated using the digraph *ow*, a result of Greek influence.

The oldest inscription in the Armenian language is to be found in the church at Tekor (or Digor) and dates from *ca* 480. The peculiar shape of certain letters makes it possible to recognize fragments of the oldest manuscripts as dating from the fifth to sixth centuries CE. The first complete manuscript, the Vehamor Gospel, dates from the

Fig. 3. The Albanian Alphabet. Manuscript of Ējmiacin, no. 7117, fol. 142.

is concerned, all three are clearly derived from the Greek alphabet, although the Albanian and Armenian ordering is different from the Georgian.

The origin of the Armenian alphabet is the least obscure of the three. The historian Koriwn attributes its creation, *ca* 400 CE, to a certain Maštoc', who died *ca* 439 and whose biography he wrote between 443 and 451. The same individual was called Mesrop or Mesrovb by later historians; his name appears as Mastrovb in an eleventh-century colophon, and as Mastoubios in Photius's *Bibliotheca*.

According to his biographer, this scholar was first employed as a translator of Greek by the royal chancellery, but later became a monk. He soon concluded that it would

ARMENIAN ALPHABET

Order	Greek	Armenian Upper case	Armenian Lower case	Name	Numeric value	Transliteration
1	α	Ա	ա	այբ	1	a
2	β	Բ	բ	բեն	2	b
3	γ	Գ	գ	գիմ	3	g
4	δ	Դ	դ	դա	4	d
5	ε	Ե	ե	եչ	5	e
6	ζ	Զ	զ	զա	6	z
7	η	Է	է	է	7	ē
8		Ը	ը	ըթ	8	ə
9	ϑ	Թ	թ	թո	9	t' (th)
10		Ժ	ժ	ժէ	10	ž
11	ι	Ի	ի	ինի	20	i
12	(λ)	Լ	լ	լիւն	30	l
13		Խ	խ	խէ	40	x
14		Ծ	ծ	ծա	50	c
15	κ	Կ	կ	կեն	60	k
16		Հ	հ	հո	70	h
17		Ձ	ձ	ձա	80	j
18	λ	Ղ	ղ	ղատ	90	ł
19		Ճ	ճ	ճէ	100	č
20	μ	Մ	մ	մեն	200	m
21		Յ	յ	յի	300	y
22	ν	Ն	ն	նու	400	n
23	ξ	Շ	շ	շա	500	š
24	ο	Ո	ո	ո	600	o
25		Չ	չ	չա	700	č' (čh)
26	π	Պ	պ	պէ	800	p
27		Ջ	ջ	ջէ	900	ǰ
28	ρ	Ռ	ռ	ռա	1000	ṙ
29	σ	Ս	ս	սէ	2000	s
30		Վ	վ	վեւ	3000	v
31	τ	Տ	տ	տիւն	4000	t
32	(ϱ)	Ր	ր	րէ	5000	r
33		Ց	ց	ցո	6000	c' (ch)
34	υ	Ւ	ւ	հիւն	7000	w
35	φ	Փ	փ	փիւր	8000	p' (ph)
36	χ	Ք	ք	քէ	9000	k' (kh)
37						
38						

GEORGIAN ALPHABET

Order	mrglovani	k'utxovani	mqedruli	Name	Numeric value	Transliteration
1	Ⴀ	ⴀ	ა	ანი	1	a
2	Ⴁ	ⴁ	ბ	ბან	2	b
3	Ⴂ	ⴂ	გ	გან	3	g
4	Ⴃ	ⴃ	დ	დონ	4	d
5	Ⴄ	ⴄ	ე	ენ	5	e
6	Ⴅ	ⴅ	ვ	ვინ	6	v
7	Ⴆ	ⴆ	ზ	ზენ	7	z
8	Ⴡ	ⴡ	ჱ	ჰე	8	ē
9	Ⴇ	ⴇ	თ	თან	9	t
10	Ⴈ	ⴈ	ი	ინ	10	i
11	Ⴉ	ⴉ	კ	კან	20	k'
12	Ⴊ	ⴊ	ლ	ლას	30	l
13	Ⴋ	ⴋ	მ	მან	40	m
14	Ⴌ	ⴌ	ნ	ნარ	50	n
15	Ⴢ	ⴢ	ჲ	ჲე	60	y
16	Ⴍ	ⴍ	ო	ონ	70	o
17	Ⴎ	ⴎ	პ	პარ	80	p'
18	Ⴏ	ⴏ	ჟ	ჟან	90	ž
19	Ⴐ	ⴐ	რ	რაე	100	r
20	Ⴑ	ⴑ	ს	სან	200	s
21	Ⴒ	ⴒ	ტ	ტარ	300	t'
22	Ⴓ	ⴓ	ჳ	ჳე	400	w
23	Ⴧ	ⴧ	უ	უნ	—	u (ow)
24	Ⴔ	ⴔ	ფ	ფარ	500	p
25	Ⴕ	ⴕ	ქ	ქან	600	k
26	Ⴖ	ⴖ	ღ	ღან	700	γ
27	Ⴗ	ⴗ	ყ	ყარ	800	q'
28	Ⴘ	ⴘ	შ	შინ	900	š
29	Ⴙ	ⴙ	ჩ	ჩინ	1000	č
30	Ⴚ	ⴚ	ც	ცან	2000	c
31	Ⴛ	ⴛ	ძ	ძილ	3000	ʒ
32	Ⴜ	ⴜ	წ	წილ	4000	c'
33	Ⴝ	ⴝ	ჭ	ჭარ	5000	č'
34	Ⴞ	ⴞ	ხ	ხან	6000	x
35	Ⴟ	ⴟ	ჯ	ჯარ	7000	q
36	Ⴠ	ⴠ	ჴ	ჴარ	8000	ž
37	Ⴤ	ⴤ	ჰ	ჰაე	9000	h
38	Ⴥ	ⴥ	ჵ	ომ(ჰოე)	10000	ō

Fig. 4. Armenian alphabet (after A. Meillet, *Altarmenisches Elementarbuch*, 1913, pp. 8–9).

Fig. 5. Georgian alphabet (after Ak'ak'i Schanidse, *Grammatik der altgeorgischen Sprache*, 1982, p. 17).

N.B. the ʽ (spiritus asper) indicates aspiration, whereas the ʼ (apostrophe) indicates stabilization.

Fig. 6. Armenian manuscript in lower case (*bolorgir*). *Reader of King Het'um II*, 1286 CE: "Jonah ejected from the whale." No. 979, fol. 200v, Yerevan, Matenadaran.

late seventh or early eighth century CE, earlier than the Gospel of Queen Mlk'ē (862).

Insufficient documentation exists to enable a precise dating of the creation of the various types of lower-case or small letters. *Bolorgir* (round writing) appears for the first time in a colophon dating from 999 CE (Fig. 6). *Słagir* (pointed writing), incorrectly referred to as *sełagir* (oblique writing), can be found from the eleventh century CE. Morphologically, it derives from *notrgir* (notary script) though, paradoxically, there is no record of the latter prior to the fifteenth century (Fig. 7). The present cursive form is based on *słagir*, the printed lower-case form on *bolorgir*.

There are several forms of illuminated letter (*p'aṙagir*, the writing of glory), some decorated with flowers (*calkagir*), others with birds (*t'ṙč'nagir*). Before the eleventh century, biblical texts were only copied in capital letters, lower-case letters being used for secular purposes. Abbreviations, which were initially reserved for holy names, are surmounted by a line called a *patiw* (honor), and for practical reasons their number increased considerably before the eighteenth century. Ligatures also appeared in epigraphic texts. The Armenian alphabet was used to transcribe Mongolian (thirteenth century), Turkish (fourteenth to nineteenth centuries), Kurdish (fifteenth century), and Qipčak, a turkic language spoken in the Ukraine (sixteenth and seventeenth centuries).

According to Koriwn, Maštoc' also invented the Albanian alphabet *ca* 423. He was assisted by a scholar named Benjamin who spoke the local language. The script was diffused on the orders of King Arsvał and it enabled the Patriarch Jeremiah to translate the bible into his own native language. The script disappeared without trace until the discovery in 1937 of a fifteenth-century Armenian manuscript that contained a copy and an explanation of several foreign alphabets. The script attributed to the Albanians contained fifty-two letters that were reproduced with their names in Armenian. The underlying phonological structure of the alphabet was based on Udi, a language of the Lezghian subgroup of the Daghestan group of Caucasian languages that, in 1978, was still spoken by 6,900 people in Azerbaijan and Georgia. The close relationship between the Udis and the Albanians had been noted by Pliny the Elder (*Historia Naturalia* book VI: 15). In 1947–1952 several short inscriptions engraved on stone were discovered in Azerbaijan, from which it was possible to recognize thirty-six of the fifty-two letters in the Armenian manuscript, with certain variations. Even more recently (November 1996), Z. Aleksidze discovered two tenth-century palimpsests in the basement of the Church St. George, on Justinian's wall in the Monastery of St. Catherine in the Sinai Peninsula. The underlying text, a lectionary, contained 350 columns of text in Albanian script. The inventory of signs makes it possible to identify fifty-four or fifty-six of the graphemes, whose shape coincides with those of the inscriptions but differs in many respects from the Armenian manuscript. The latter can thus be seen to contain a number of errors, both phonetic and graphic. The titles of the extracts from the bible were identified, so the text will soon be fully deciphered.

The general style of the letters is similar to that of Armenian and Georgian upper case, and the *u* is also represented by a

Fig. 7. Armenian manuscript written in cursive script (*notrgir*). *Vita Patrum*, 1625 CE, Jerusalem no. 23, p. 541: "Saint Simeon Stylites."

digraph. As for the sounds represented by the characters, the list of letter names given in the Armenian manuscript suggest that the Albanian alphabet is completed by additional letters inserted in a Greek-based alphabet in much the same way as the Armenian one. It is therefore quite possible that both scripts were created by the same author, as claimed by Koriwn.

The Georgian alphabet consists of thirty-eight letters of which the first is *an* and the last is *hoe*, corresponding to *alpha* and *omega* in the Greek alphabet. While the Greek-based letters occupy positions 1 through 25, the fricatives and palato-alveolar fricatives that are specific to Georgian occupy positions 26 through 37. Thus, unlike the Armenian and Albanian alphabets, where the additional letters are interspersed among the Greek-inspired letters, the Georgian alphabet (like the Coptic alphabet, among others) juxtaposes the new letters without mixing the two heterogeneous groups of characters. Furthermore, Georgian replaces the *digamma* and *koppa* (in positions 6 and 18 respectively) of the Ancient Greek alphabet, with the letters *v* and *ž*. This suggests that Georgian is based on a different version of the Greek alphabet from that used by Armenian and Albanian, one in which the position of the Ancient Greek letters in question was still occupied by the symbols for the numbers 6 and 90.

According to Koriwn, the Georgian alphabet was also invented by Maštocʻ, with the help of a local interpreter called ˤala. It is difficult, however, to accept this evidence unreservedly. If Maštocʻ had had a local source of information, would it have been sufficient for an Armenian scholar to do what he had done with Albanian and produce a phonological analysis of a language he probably did not speak (despite the fact that most of the consonants are fairly similar to those of Armenian)? Furthermore, why would he have used a radically different system for incorporating the additional Georgian letters than the system he had used for the additional Albanian letters? And why would he have used a different version of the Greek alphabet? On the other hand, Koriwn provides the authenticated evidence of a contemporary who normally only stated facts that had been confirmed by his master's entourage. The text could be read to mean that Maštocʻ

Fig. 8. Inscription in Georgian upper-case letters (*aso-mtavruli*), monastery of Bir el-Kutt, near Bethlehem, fifth century CE.

Fig. 9. Georgian *mqedruli* lower-case printed version of "The Rooster and the Pearl," *Aesop's Fables*, Venice, 1859 CE.

made some contribution to the completion or improvement—even if only stylistically—of a pre-existing script.

Despite the assertions of the eleventh-century chronicler Leontʻi Mroveli, it is unlikely that this script dates back as far as the reign of King Pharnabazes I (fourth to third centuries BCE). The author is probably referring to the use of Aramaic in the Royal Iberian chancellery in that distant period. There is no evidence for the existence of the Georgian alphabet before the fifth century CE. It may well have been a recent invention when Maštocʻ first met ˤala. In any case, it would be hard to date its introduction earlier than the conversion of the country to Christianity in the fourth century CE.

The oldest examples of Georgian church (*xucuri*) capitals (*asomtavruli*) (Fig. 8), also known as round script (*mrglovani*), are in inscriptions from the Palestine (fifth century) and eastern Georgia (sixth century—Fig. 10). Each of the letters fits into a square and the whole system is based on a combination of nine elements. Fragments of palimpsests exist, dating from the fifth and seventh centuries. The Georgian book of readings found in Sinai dates back to 862 CE. Even in the absence of a colophon, the dating of documents is facilitated by the phonetic development of personal affixes. Thanks to changes in spelling, it is easy to differentiate between *xanmetʻi* texts (fifth to seventh centuries), *haemetʻi* texts (seventh to ninth centuries), and classical texts (ninth to twelfth centuries).

The church lower-case style, known as *nusxuri* (copying script) or *k'utxovani* (angular script), first emerged in the ninth century. It uses a single character to represent the diagraph *ow*, pronounced *u*. In the eleventh century, a secular script called *mqedruli* (warrior or knight's script) was created, and it is on this script that printed letters and modern cursive are based (Fig. 9). It has no capital letters and there is little difference between script and printed characters; the letters are rarely joined. However, until the late nineteenth century, liturgical books were printed in the church script using both upper-case and lower-case letters.

Initial letters decorated with geometric or plant patterns are generally more restrained in Georgian than in Armenian manuscripts. As early as in the oldest texts, abbreviations are used extensively, even for purposes other than the transcription of holy names.

The three Christian alphabets of the Caucasus were thus created at around the same time, in similar political and cultural climates. They fulfilled the religious needs highlighted by Koriwn in his *Life of Maštoc'*. As for the order of the letters, Georgian differs from the other two, but all three present a remarkable stylistic convergence in the shape of the capital letters. However, the history of the three scripts subsequently diverged as a result of their different circumstances. Albanian disappeared in the eighteenth century, the victim first of the supremacy of the Armenian church, which opposed the local Chalcedonism, and subsequently of the Muslim invasions. During its three centuries of existence, no lower-case letters were created for it. The religious schism of 610 divided Georgia, with its Chalcedonian form of Christianity, and Armenia, which was anti-Chalcedonian. Georgia developed lower-case letters that increasingly diverged from the main alphabetic style common to all three languages.

Fig. 10. Votive inscription in Georgian capital letters (*aso-mtavruli*) from the early sixth century CE. Church of St. Zion of Bolsini, consecrated in 493 CE.

Bibliography

ABRAHAMYAN, Ašot G. *Lettres et art de l'écriture chez les Arméniens* (Erevan, 1973), pp. 347–361.

ABULAJE, Ilia. *Examples of Georgian Script: Paleographic Album*, 2nd edn (Tiflis, 1973).

AČAṘYAN, Hračʿya. *Armenian Characters* (Yerevan, 1984).

ALEKSIDZÉ, Zaza, and Jean-Pierre Mahé. "Manuscrits géorgiens découverts à Sainte-Catherine du Sinaï." *Comptes rendus de l'Académie des Inscriptions et Belles Lettres* (1995): 487–494.

——. "Découverte d'un texte albanien: une langue ancienne du Caucase retrouvée." *Comptes rendus de l'Académie des Inscriptions et Belles Lettres* (1997): 517–532.

——. "Le déchiffrement de l'écriture des Albaniens du Caucase." *Comptes rendus de l'Académie des Inscriptions et Belles Lettres* (July 6, 2001).

BOEDER, Winfried. "Versuch einer sprachwissenschaftlichen Interpretation der altgeorgischen Abkürzungen." *Revue des études géorgiennes et caucasiennes* 3 (1987): 33–81.

CREISSELS, Denis. *Les Langues d'URSS. Aspects linguistiques et socio-linguistiques* (Paris, 1977).

DONABÉDIAN, Patrick. "Une nouvelle mise au point sur l'Albanie du Caucase." *Revue des études arméniennes* 21 (1988–1989): 485–495.

DUMÉZIL, Georges. "Une chrétienté disparue: les Albaniens du Caucase." *Journal asiatique* 232 (1940–1941): 125–132.

FROUNDJIAN, Bedros. *Armenische Abbrevationen* (Berlin, 1965).

GAMKRELIDZE, Thomas V. *Alphabetic Writing and the Old Georgian Script* (Tbilisi, 1989).

MAČʿAVARIANI, Elene. *The Graphic Foundations of the Georgian Alphabet* (Tbilisi, 1982).

MERCIER, Charles. "Notes de paléographie arménienne." *Revue des études arméniennes* 13 (1978–1979): pp. 51–58.

MOURAVIEV, Serge N. "La forme interne de l'alphabet albanien." *Le Museon* 93 (1980): 345–374.

——. "Les caractères daniéliens. Les caractères mesropiens." *Revue des études arméniennes* (1980): 55–111.

——. "Valeurs phoniques et ordre alphabétique en vieux géorgien." *Zeitschrift der deutschen morgenländischen Gesellschaft* 134 (1984): 61–83.

——. "Page d'histoire de la phonétique ancienne. La forme externe de l'alphabet asomtʿavruli en tant que modèle graphique de la structure différentielle des phonèmes du vieux géorgien." *Proceedings of the Eleventh International Congress of Phonetic Sciences*, vol. 3 (Tallinn, 1987): 198–201.

OUTTIER, Bernard. "Le vocabulaire religieux en oudi." In C. Paris (ed.), *Caucasologie et mythologie comparée* (Paris, 1992), p: 331–333.

ŠANIDZE, Akʿakʿi. "L'alphabet des Albaniens du Caucase découvert récemment et son importance pour la science." *Bulletin de l'Institut Marr de langue, d'histoire et de culture matérielle* 4/1 (1938): 1–68.

SCHULZE, Wolfgang. *Die Sprache der Uden* (Wiesbaden, 1982).

TSERETʿELI, George. *The Most Ancient Georgian Inscriptions from Palestine* (Tiflis, 1960).

YOVSEPʿEAN, Garegin. *Armenian Paleographic Atlas* (Vałaršapat, 1913).

Fig. 1. The Kiev Missal, parchment, from the tenth to eleventh centuries.
П. 328, fol. 1v, Library of the Ukrainian Academy of Sciences, Kiev.

CYRILLIC SCRIPT

Vladimir Vodoff

Constantine (Cyril in religious writings, d. 869), "the Philosopher" (meaning "the learned"), and his brother Methodius, archbishop of Moravia (d. 884) were commanded by the Byzantine Emperor Michael III and the patriarch Photius to assist Prince Rostislav of Moravia in his desire to see his people converted to Christianity, but in their own language. This would remove them from Latin and Teutonic influences. Just as the language used for these translations—Old or Church Slavonic—was an artificial creation based on the dialects heard by the two missionaries in the region of their birth (Thessalonia and its surroundings), the alphabet, known as "Glagolitic" but originally known as "Cyrillic," was apparently created by Constantine/Cyril. This is the script used in the Kiev Missal (Fig. 1), a sacred Latin text translated into Old (Church) Slavonic. As for the alphabet from which the missionary drew his inspiration, was it the Hebrew alphabet? Or Greek cryptography? The question remains open. The name "Glagolitic" (*glacolica* from *glagol*, "verb"), only appeared in the late Middle Ages, in Croatia, where the priests who used the Slavic liturgy were called *glagoljaši*, "those who speak [the local dialect]."

This alphabet consisted of forty signs that rendered Slavic phonology quite accurately. As in Greek, the letters also had a numeric value. The originality of the alphabet seems to have hindered its diffusion since it had to compete with the Greek and Latin alphabets that had a long written tradition behind them. The Slavic nations who owed allegiance to Rome gradually adopted Latin as the language of liturgy and literature, later borrowing its alphabet to transcribe their own languages (Polish, Czech, Slovak, Croatian, and Slovenian). The nations that remained in the Byzantine orbit—the regions that correspond to modern Bulgaria, Macedonia, Serbia, the Ukraine, Belarus (Byelorussia), and Russia—abandoned Glagolitic in favor of an alphabet that more closely resembled Greek and is now known as "Cyrillic." Glagolitic persisted in the western Balkans, and continued to be used in Macedonia until the eleventh century, in Serbia until the twelfth century, and in certain parts of Croatia until modern times. As yet, there is no convincing explanation for the traces of Glagolitic discovered by epigraphers among eastern Slavs.

The Gospels copied for Ostromir (Fig. 2), a lieutenant of Izjaslav Jaroslavič, Prince of Kiev who held court at Novgorod, is the oldest codex preserved in the eastern region and one of the oldest to have been written in the Cyrillic alphabet. Although this alphabet inherited the former name given to Glagolitic, it was actually created long after the death of Constantine/Cyril and Methodius by disciples of the Thessalonian brothers who found refuge in Bulgaria at the court of Tsar Simeon (893–927). The modern Cyrillic alphabet is more or less a hybrid of the original Slavic alphabet (Glagolitic) and the Greek alphabet, which was widely used in Bulgaria—a country whose elite had adopted Byzantine Christianity, giving it access to Greek culture.

In practical terms, of the forty-three letters (all of which also have a numerical value), twenty-four are borrowed directly from the Greek alphabet, others are modified Greek letters, and the rest are descended from Glagolitic. Several were created by making ligatures between existing letters (for example by linking **i** with a vowel). Early Cyrillic manuscripts contain some abbreviations, like the Greek and Latin texts of which they are a translation, but these are limited to holy names. There is also a notable tendency to reproduce the superscript signs used in Greek, as well as

Fig. 2. The Ostromir Gospel, parchment, 1056–1057 CE. F.П.I. 5, fol. 2; John I: 1–7, National Library of Russia, St. Petersburg.

occasional accents, and the "soft sign" above the initial vowel of a word.

This alphabet was used initially for Old Slavonic, especially in Bulgaria, then in the various local adaptations of this scholarly language (Slavonic), and later in countries of the Greek Orthodox faith to transcribe their local languages. The religious and cultural community that these countries constituted in medieval Europe is sometimes known as *Slavia orthodoxa*.

The adaptation of Old Slavonic to the local dialects produced certain modifications in the language that transferred themselves to the lettering. Thus the nasal vowels / ǫ / and / ę / were respectively replaced by /u/ and /'a/, causing the letters Ѫ and Ѭ to disappear, while the Ѧ and Ꙗ henceforth competed with Ꙗ to produce either /ya/ or /'a/.

The most formal Cyrillic lettering, like the Greek on which it is based, is known as uncial (*ustav*). As can be seen

The script remains uncial but the letter is less careful than that of the Ostromir Gospel, hence his designation as "popular." The letters no longer rest on the lower horizontal line but appear to be suspended from the upper line; they are irregularly drawn. It is quite possible that this script was influenced by Glagolitic, which remained in use in Macedonia until the late eleventh century.

The *Guide Book* (Fig. 4) reproduces the start of the long version of *Pravda russkaya* (*Russian Justice*), the oldest collection of laws known to the Eastern Slavs (the long version dates only from the thirteenth century). This text also constitutes one of the oldest examples of the use of Old or Church Slavonic, the language of religion and scholarship, to transcribe the vernacular.

In this late manuscript, the writing has evolved somewhat. The uncial has become a semi-uncial (*polu-ustav*), the letters are more irregular and often asymmetrical (the letters **Б**, **В**, **К**, and **Н**, for example).

Fig. 3. Dobromir Gospel, parchment, twelfth century. Ms. Slave 65, fol. 4; Mark X: 52 to XI: 6, Bibliothèque Nationale de France, Paris.

in the example shown here, it is a precise, regular block style, most of which fits between two horizontal parallel lines. The Ostromir Gospel is one of the handsomest examples of a manuscript written in uncials or indeed of any manuscript in the whole of *Slavia orthodoxa*.

The Dobromir Gospel (Fig. 3) was copied out in Bulgaria by a priest called Dobromir (except for a few later folios that are fourteenth-century additions from Serbia). Most of the manuscript is preserved in St. Petersburg in the National Library of Russia (Q.п.I.55); twenty-three folios are in the Monastery of St. Catherine on Mount Sinai (no. 43) and there are two in the Bibliothèque Nationale in Paris (Slave 65, fol. 3–4). It is written in Bulgarian Middle Slavonic. The difference between this version of Slavonic and Eastern Slavic Slavonic (commonly known as "Russian Slavonic") is in the characters, which include nasal vowels, but the confusion between the two ultra-short vowels / ĭ / (= Ь) and / ŭ / (= Ъ) caused the second of these graphemes to disappear. For the same reason, the etymological hard /y/ is rendered as ЬІ and not as ЪІ.

Fig. 4. *Kormčaja kniga* (Guide Book), compilation of canonic and civil law, written on paper, mid- to late-fifteenth century CE. From the St. Sophia cathedral in Novgorod, no. 1173, fol. 402; the beginning of *Pravda russkaja* (*Russian Justice*), long version, National Library of Russia, St. Petersburg.

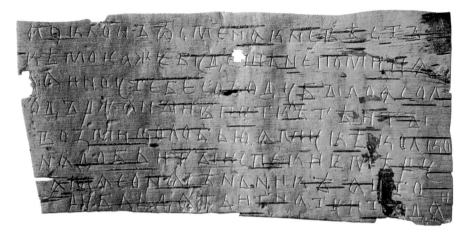

Fig. 5. Note on birch bark concerning domestic matters, late fourteenth century CE. No. 363, Novgorod Museum.

Superscripted letters, generally final consonants, have become more numerous and they have lost the tilde that was placed on top of them.

The Cyrillic alphabet itself only underwent a few modifications. These were generally the result of changes in the language, the most important of which involved the disappearance of the ultra-short vowels /ŭ/ and /ĭ/ in the weak position and their replacement by /o/ and /e/ in the strong position. However, the script does not really convey this change. The Ь or "soft sign" was retained to indicate a softening of the previous consonant, and the Ъ or "hard sign" was used to indicate the end of a word or even the end of a closed syllable. The arrival in the fourteenth and fifteenth centuries of Balkan priests who were fleeing the Turkish invasion explains various modifications linked to the development of the southern Slavic languages, such as the substitution of Ы for ЪI. Yet, in general, Cyrillic lettering changed little. This situation would persist until modern times because handwritten documents continued to predominate, not only because the Balkans were under Ottoman rule but also because in Russia the communities of Old Believers rejected the printed books produced by the official Russian Orthodox church.

Hundreds of texts inscribed on birch bark, for the most part fragmentary (Fig. 5), have been found buried in the earth in Novgorod and, to a lesser extent, in other cities of Russia, Belarus, and the Ukraine. They are generally brief notes, discarded by their recipients once they had been read, and they by no means constitute a structured archive. But the location in which they were discovered makes it possible to link them with a particular piece of urban real estate whose owner may even be identifiable. The content of the document may be an indication of the sender's occupation, or it may involve a landlord and concern the management of an estate covering the vast tracts of land ruled by the oligarchic republic of Novgorod. The language of these notes is not characteristically Slavonic and is not composed of legal formulae. It thus provides valuable evidence of the language as it was spoken in the Novgorod region in the Middle Ages.

The script used in these documents is very much dictated by the material employed for the writing. The need to carve the letters on wood gave the semi-uncials a more angular shape. It is also perfectly possible that the use of wood, necessitated by the late introduction of paper, may have delayed the development of a cursive script among the eastern Slavs.

Paper was first introduced in the fourteenth century but continued to compete with parchment and birch bark. However, paper encouraged the development of a cursive style of writing. From the sixteenth century, cursive began to be used predominantly in diplomatic papers, charters, and

Fig. 6. Record of a debt from the peasants of the village of Koževnikovo to the treasurer of the monastery of St. Savior at Priluki, near Vologda. Paper, 1608. P.M. Stroev Collection, no. XVII, 19, Institute of Russian History of the Russian Academy of Sciences, St. Petersburg section.

Fig. 7. Ivan Fedorov. *Alphabet Primer*. L'viv (L'vov, Lemberg), Ukraine, 1574.

Предлагаемая вниманию читателей книга представляет собой описание грамматического строя русского литературного языка середины XX в. Пятнадцатилетие, отделяющее эту книгу от академической «Грамматики русского языка» (1952—1954), ознаменовалось появлением как у нас, так и за рубежом большого количества работ, посвященных общим вопросам грамматической теории и описанию отдельных сторон грамматического строя русского и других славянских языков. За это время были пересмотрены многие освященные традицией решения, накоплены новые материалы. Все это сделало актуальной задачу такого описания русской грамматической системы, которое бы отразило развитие теоретических поисков и собственно исследовательской работы за истекшие годы. Кроме того, необходимо было удовлетворить давно назревшую потребность в относительно компактном описании грамматического строя русского языка в его с о в р е м е н н о м с о с т о я н и и.

По своим задачам, характеру описания материала и по самому этому материалу «Грамматика современного русского литературного языка» отличается от предшествующих описаний.

Известно, что уже для «Грамматики» 1952—1954 гг. те требования жанра, которые традиционно предъявляются к академической грамматике — общедоступность изложения, отсутствие гипотетических решений, непререкаемость рекомендаций, опирающихся на классические образцы литературной речи, строгая и исчерпывающая кодификация норм,— остались в значительной степени идеальными. Однако известно также, что составители и редакторы этой книги в своей работе руководствовались именно этими задачами и требованиями: по своему замыслу «Грамматика» 1952—1954 гг. была описательной и строго нормативной. Задачей возможно полной грамматической характеристики русского литературного языка как языка национального в ней определилось широкое понимание границ современного языка — от Пушкина до наших дней; частые исторические справки, иллюстрации из языка писателей допушкинской поры еще более расширили эти границы, отодвинув их к концу XVIII — началу XIX в.; из сокровищницы языка классиков черпались образцы, предназначенные иллюстрировать современные нормы и современное употребление.

«Грамматика современного русского литературного языка» ставит перед собой другие цели. Эта книга не может служить всеобъемлющим справочником. Она прежде всего отражает поиски «модели описания». Ее цель не в том, чтобы дать исчерпывающий свод действующих грамматических правил (хотя во многих главах читатели смогут заметить стремление к полноте описания), а в том, чтобы показать языковые явления в системе, последовательно разделяя аспекты формы и ее функции (назначения, употребления). Авторы стремились к разграничению разных ступеней грамматической абстракции, т. е. к рассмотрению грамматических явлений с точки зрения лежащих в их основе абстрактных схем (образцов), их принадлежащих языку регулярных реализаций (манифестаций) и их употреблений; при этом в самом описании функциональный аспект подчинен аспекту формальному.

Fig. 8. Modern Cyrillic script: page 3 of the Introduction to a Russian grammar published in Moscow in 1970.

the various registers of the Moscow civil authority (Fig. 6). The shape of the letters, which had become fixed in the semi-uncial style, gradually became distorted and the number of superscripted letters increased. Nevertheless, the Cyrillic alphabet *per se*, as used by the eastern Slavs since the eleventh century, did not undergo significant changes.

Printing did not emerge until relatively late in the sphere of eastern Slavic influence. The first printed books using Cyrillic characters were produced in Lithuania in the sixteenth century. One of the earliest printers was Ivan Fedorov. In 1564, he even succeeded in publishing a printed book (an epistolery) in Moscow, but he was soon forced to flee to L'viv (L'vov, Lemberg) in the Polish Ukraine, where he published his Alphabet Primer (Fig. 7).

The primer reproduces the letters of the Cyrillic alphabet in their uncial form, just as in the West, incunabula were being printed in Gothic letters. These characters, in which the holy names are abbreviated, were used in Slavic printing until the late seventeenth century and well into the

eighteenth century for books of a religious nature. Even today, the characters continue to be used in books of liturgy published by Slavic Orthodox churches that follow the Byzantine rite.

In modern times, the Cyrillic alphabet used in Russia has undergone two important alterations. The first occurred in 1710, at the initiative of Peter the Great. In all secular publications, the old Cyrillic alphabet was replaced by a civil Cyrillic alphabet: the shape of the letters was modernized and made to look as far as possible like those

— 136 —

Па он брже ситну књигу пише,
Те је шаље Анђелијну Вуку:
„Богом брате, Анђелијну Вуче! 135
„Немој мени ђецу поморити,
„Поморити и глади и жеђу;
„Пустићу ти брата Милутина."
Ал' Вук бану књигу отписује:
„Господине, бане Задранине! 140
„Не ћу теби ђецу поморити:
„Нема њима од злата бешике,
„Него им је дрвена бешика,
„Два комада јелова дрвета;
„Нема њима меда ни шећера, 145
„Нит' им има ране материне,
„Но им има скроба овсенога,
„И дебела меса овнујскога;
„Ал' ти ћеку ја послати не ћу,
„Док ми не даш брата Милутина, 150
„И узањга три товара блага;
„Јер су скупља два банова сина
„Од једнога сужња из тавнице."
Када бану ситна књига дође,
Те он виђе, што му књига каже, 155
Од ина се њему не могаше,
Већ он пусти сужња Милутина,
И даде му три товара блага,
Те поврати до два своја сина.

— 137 —

24.
Опет Вук Анђелић и бан За-
дранин.

Вино пије бане Задранине
Усред Задра на бијелој кули,
С баном пије тридесет Задрана;
Кад се бане накитио вина,
'Вако оде њима бесједити: 5
„Чујете л' ме, тридест ђеце лудо!
„Оћу једну чету покупити,
„Добру чету три стотин' Задрана,
„Шњоме ћу се, ђецо, подигнути,
„Спустићу се низ приморје равно 10
„До бијела села Челебића,
„А до куле Вука Анђелића,
„Б'јелу ћу му кулу поварати,
„Вјерну ћу му љубу заробити,
„Погубићу Мића Анђелића, 15
„Мила брата Анђелијна Вука,
„Пак ћу отле чету повратити
„У Удбињу у Турску крајину,
„Не би л' кака роба заробио."
Што је бане пијан говорио, 20
То тријезан бане учинио:
Он подвикну на граду тобуије,
Опалише дванаест топова,
Бане просу рушне по калдрми,

Fig. 9. Two pages of modern Serbian Cyrillic. In Vuk Karadžić, *Narodne srpske pjesme*, vol. IV (Peć, 1833), pp. 136–137.

of the Latin alphabet. Some of the letters borrowed from Greek that were superfluous to requirements in Slavonic languages were removed (ξ, ψ, ω). On the other hand, a breve was introduced over the "i" (И = /i/) to represent /iy/ at the end of a syllable (Й, or *i kratkoc*); the letter Э was gradually introduced to annotate the /e/ in foreign words, as distinct from the /'e/ or /ye/, written as **Е** or **e** in Cyrillic. The alphabet was reformed yet again in 1918, on the basis of proposals that had been made over the years by linguists such as A. A. Šakhmatov. More letters were discarded, such as θ, Ѵ and also I and Ѣ, these last two being pronounced identically to И and Е. The "hard sign" Ъ (*tvyordyi znak*) was no longer added at the end of a word. The final version of the alphabet can be seen in Fig. 8.

A similar reform took place in Bulgaria in 1945. In the wake of these changes, Macedonian was also modernized and given the status of a valid written language in its own right. In practical terms, each Slavic language uses a slightly different version of the Cyrillic alphabet, due to differences in the phonetics, the medieval written tradition, and the initiatives of nineteenth- and twentieth-century reformers. The differences are greatest in Serbian.

After four centuries of Ottoman domination in the Balkans, when few books were published in Slavonic using the Cyrillic alphabet, spoken Serbian was codified by the philologist and ethnographer Vuk Karadžić (1787–1864) [Fig. 9]. As in Russia, the shape of the Cyrillic letters was modernized, and letters that were no longer needed for use in modern speech were discarded. On the other hand, the Ћ (*ć* in Croatian), which represented the /č'/ sound—as distinct from the /č/ Cyrillic Ч—was retained, and so too were the Џ and the Ђ, which rendered /dž/ and /dž'/ respectively. An important innovation was the introduction of the German /j/, which made redundant the compound letters formed by means of a ligature between and **i** and another vowel (as in the Russian Ю).

Unlike most Slavic languages, the Serbian alphabet is not only phonological but also phonetic. The same consonant may be rendered in different ways depending upon its position, whether it precedes a vowel or a voiceless consonant. For instance, there is **Срб, Срба**, but the adjective is **српски** (*Srb, Srba, srpski* in Croatian). Each grapheme of Serbian has its exact equivalent in Croatian, a Slavic language that uses the Latin alphabet, supplemented by a number of diacritical signs.

Bibliography

Belorusskij prosvetitel' Francisk Skorina i načalo knigopečatanija v Belorussii i Litve (Moscow, 1979).
ČEREPNIN, L. V. *Russkaja paleografija* (Moscow, 1956).
DVORNIK, F. *Les Légendes de Constantin et de Méthode vues de Byzance* (Prague, 1933).
——. *Byzantine Missions among the Slavs: SS. Constantine-Cyril and Methodius* (New Brunswick, New Jersey, 1970).
DŽORDŽIĆ, P. *Istorija srpske ćirilice* (Belgrade, 1971).
KARSKIJ, E. F. *Slavjanskaja Kirilovskaja paleografija* (Leningrad, 1928).
NAHTIGAL, R. *Slovanski jeziki* (Ljubljana, 1952; Russian translation, Moscow, 1963).
NEMIROVSKIJ, E. A. *Načalo knigopečatanija na Ukraine, Ivan Fedorov* (Moscow, 1974).
——. *Vozniknovenie knigopečatanija v Moskve, Ivan Fedorov* (Moscow, 1964).
VAILLANT, A. *Textes vieux-slaves, 1. Textes et glossaire, 2. Traductions et notes* (Paris, 1968).
VODOFF, V. "Les documents sur écorces de bouleau de Novgorod." *Journal des savants* (1966): 193–233; (1981): 229–281.

RUNIC SCRIPT

François-Xavier Dillmann

THE BEGINNINGS OF RUNIC SCRIPT:
A FIBULA FROM THE TOMB OF A WOMAN IN
HIMLINGØJE II, SEELAND ISLAND, DENMARK

Runic, the writing system used by the Germanic peoples, first made its appearance at the beginning of the common era. The oldest known inscriptions have been found in Denmark, where they were engraved on weapons and various objects in daily use that had been buried in peat-bogs. They were also found on jewelry discovered in the graves of the wealthy. An outstanding example of the latter is the third-century tomb of Himlingøje II, found in 1949 on the island of Seeland (Fig. 1).

The shape of most of the runes is clearly inspired by Latin characters, and this would seem logical in view of the influence of Roman civilization in Scandinavia—and especially Denmark—during the first centuries of the common era. The order of the runes differs substantially, however, from that of Mediterranean alphabets. It begins with the signs representing the sounds /f/, /u/, /þ/, /a/, /r/, /k/, hence the name *futhark* that has been given to this script. The oldest Runic scripts, dating roughly from the end of the second century to the middle of the eighth century, used twenty-four letters.

Runes were usually carved on wood, bone, or metal, and could be written from left to right as well as from right to left and sometimes as a *boustrophedon*. The earliest Runic inscriptions are usually quite short, consisting of just a few words that should often be interpreted as the name of an individual. That is the case, for example, with the fibula found in the rich grave of a woman in Himlingøje. Unfortunately, the inscription has been damaged, but the following sequence of runes can be read: ...**[w]iduhuda**R. It is highly likely that they represent the name of a man,

Fig. 1. Fibula belonging to Himlingøje II (detail). National Museum of Denmark, Copenhagen.

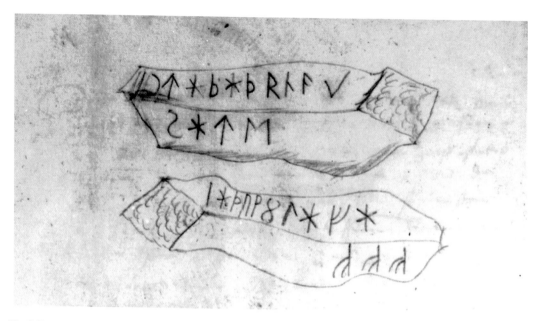

Fig. 2. Drawing on the Gummarp Stone. Jon Skonvig manuscript, fol. 13v, Det Arnamagnæanske Institut, Copenhagen.

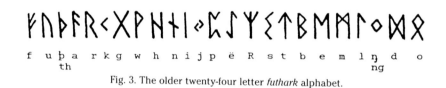

f u þ a r k g w h n i j p ë R s t b e m l ŋ d o
 th ng

Fig. 3. The older twenty-four letter *futhark* alphabet.

f u þ ą r k h n i a s t b m l R

f u þ ą r k h n i a s t b m l R

Fig. 4. The younger sixteen-letter *futhark* alphabet: upper row, the "normal runes;"
lower row, the "short-branched runes."

f u þ a r k g w h n i j p ë R s t b e m l ŋ d o
 th ng

Fig. 5. The medieval runes: the sixteen-sign *futhark* alphabet and additional signs.

After James E. Knirk, "Runes and Runic Inscriptions." Phillip Pulsiano (ed.),
Medieval Scandinavia, An Encyclopedia (New York/London: Garland Publishing, 1993).

the composite *Widu-hundaʀ*, whose literal meaning is "Dog of the Wood" (possibly a term for "Wolf") or "Snow-fox" and which appears to be a metaphor for the name of the engraver of the text (or the author of the inscription, "the master-of-the-runes"), or for the jeweler who made the pin, or even for the man who gave it to the deceased.

THE STONE OF GUMMARP (BLEKINGE PROVINCE, SWEDEN): THE IDEOGRAPHIC USE OF RUNES IN THE MEROVINGIAN PERIOD

Not only are the runes classified in a different order from that of the Mediterranean alphabets, they have another peculiarity in that their names also have a meaning. Thus, according to several medieval manuscripts, the rune þ, representing the sound /th/ (voiceless interdental aspirant, pronounced similarly to the soft /th/ in the word *thin*), had the name of *þurs*, meaning "giant." Consequently, a conceptual meaning was sometimes attached to the various Runic signs, so that the rune þ might, in certain circumstances express a magical intention (an evil one, in this instance) by the writer of the inscription, because the name *þurs* had the reputation of "harming women," as stated in Norwegian and Icelandic Runic poems.

As a result, while the runes were usually used for writing messages of all types, both secular and sacred or mystical (like the characters in other phonetic scripts), they were sometimes credited with having their own magical powers arising from the names they bore and the symbolic properties attributed to them. Thus, the generic name for these signs (the Nordic word *rún*, derived from the proto-Germanic **rūnō*) itself means "secret, mystery," and the ancient Scandinavians are known to have attributed a divine origin to these characters. This is shown in two similar Swedish inscriptions that date from the seventh and ninth centuries respectively and two verses from a famous Eddic poem (the *Hávamál*) transmitted through a thirteenth-century Icelandic manuscript.

The inscription engraved *ca* 600 on the Gummarp Stone (Fig. 2) in Blekinge, a province that runs along the southern coast of what is now Sweden, offers a highly plausible example of the ideographic use of runes. The text reads:

hAþuwolAfA sAte stAbA þria f f f

If the inscription is considered to be complete[1] and the first name is in the nominative, it should mean: "Haduwolf has placed three signs **f f f**." If the text is considered to be fragmentary and the name of the person is in the accusative it could mean: "[In memory of] Haduwolf, [N] has placed three signs **f f f**." The triple engraving of the rune **f** can be explained in the present context by the desire to reinforce

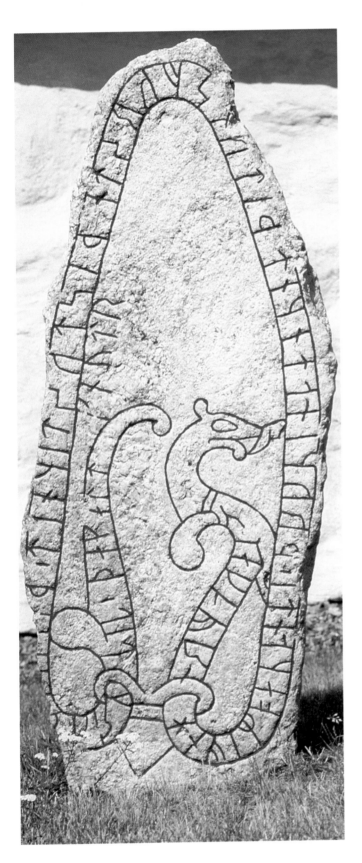

Fig. 6. The Yttergärde Stone, Uppland province, Sweden.

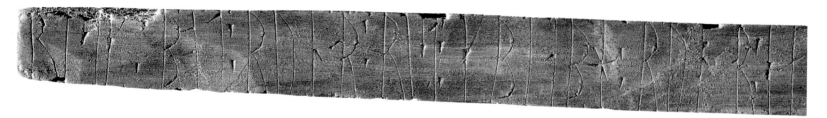

Fig. 7. Runic stick discovered in Bergen, Norway.

the conceptual importance of the sign (which means *fehu*, "wealth" in proto-Nordic), so that the entire inscription appears to be a magical spell or religious incantation.

A FUNERARY INSCRIPTION IN MEMORY OF A VIKING WHO DIED FAR AWAY: THE YTTERGÄRDE STONE, UPPLAND PROVINCE, SWEDEN

Runic script in Scandinavia underwent a great reforme due to the radical changes in the phonetics of proto-Nordic that occurred in the seventh and eighth centuries. The runes gradually disappeared from mainland German-speaking areas in the seventh century and from England in the ninth century, mainly as a result of the conversion of the inhabitants to Christianity. The old twenty-four letter *futhark* was replaced by a sixteen-letter *futhark* (Fig. 4). The new alphabet was used to engrave many inscriptions in Denmark, Norway (including the Norwegian colonies in the North Atlantic), and above all Sweden. In this country, the custom arose of erecting a "runestone" to the memory of the deceased, and this became very popular, as witnessed by the three thousand or so monuments of this type listed throughout the provinces of Sweden. There is a particularly high concentration in the region of Lake Mälaren, and in the province of Uppland, around the pre-Christian sanctuary of Old Upsal.

The runestones were generally cut from granite or gneiss, and often decorated with a long snake coiled around the edge of the monument, its body forming a ribbon that frames the inscription, as can be seen on the Yttergärde Stone, which stands 68 inches high (above the ground) and 22 inches wide (Fig. 6).

The Yttergärde inscription was probably engraved during the second quarter of the eleventh century and reads from right to left (beginning from the snake's head), then from left to right (in the last part, in the serpent's tail). It commemorates a Swedish viking named Ulf, who lived in

the early eleventh century and went on several military expeditions to England, especially those led by the famous chieftain Thorkel the Tall and the future ruler of the Anglo-Danish empire, King Knut the Great, whose name is engraved here outside the snake's body, just above its tail (**knutr**).

THE RUNIC STICKS OF BERGEN AND TRONDHEIM, NORWAY: MARKS OF OWNERSHIP, COMMERCIAL RELATIONS, AND MAGICAL AND RELIGIOUS BELIEFS

Despite the fact that Runic script was closely associated with ancestral beliefs, it was not entirely replaced by the Latin alphabet, even when Scandinavia had been converted to Christianity. For several centuries thereafter, the runes continued to be used regularly in various social circles, as can be seen from several impressive archaeological discoveries that were recorded in the second half of the twentieth century in the cities of Bergen and Trondheim in Norway. These are mainly wooden sticks or wands discovered in the old quarters of these two port cities. Around six hundred were found in Bergen and a hundred or so in Trondheim. They were engraved with inscriptions that varied in length from a few words to several sentences.

It appears that some of them were used as labels or markers because they consist of a possessive verb and a proper name that no doubt corresponds to the name of the owner of a bale of merchandise to which these wooden sticks were attached. Others contain messages that shed a great deal of light on the economic history of the kingdom of Norway, as well as on the history of Scandinavian literature and the study of magical and religious beliefs.

Some of these wands contain fragments of Latin (for instance, the following quotation from Virgil: *Omnia vincit Amor, et nos cedamus Amori*) and others reproduce lines from the Eddic lays, such as those on the wooden wand dating from the late fourteenth century that is reproduced

here (Fig. 7). The inscription begins with a sentence that exactly matches a passage from an Eddic lay (**ristek : bot : runar : rist : ekbiabh : runar**, meaning "I engrave the runes of healing, I engrave the runes of safekeeping..."). It ends with a curse, the language of which matches that of a famous strophe in the corpus of the Icelandic mythological poems or sagas known as the Edda.

Note

1. The stone has been known since the early seventeenth century (the inscription was copied by the artist Jon Skonvig *ca* 1627 at the request of the Danish scholar Ole Worm). It was moved to Copenhagen in 1652, but it disappeared in the great fire that ravaged the Danish capital in 1728. For more information about the text quoted here, see the works mentioned in n. 63, pp. 71–72, of the author's article quoted in the bibliography, "Les runes dans la littérature norroise," in *Proxima Thulé* II (1996).

Bibliography

ANTONSEN, E. H. *A Concise Grammar of the Older Runic Inscriptions* (Niemeyer, 1975).

DILLMANN, François-Xavier. "Les runes dans la littérature norroise. À propos d'une découverte archéologique en Islande." *Proxima Thulé* II (1996): 51–89.

DÜWEL, Klaus. *Runenkunde*, 3rd edn (Stuttgart, 2001).

ELLIOTT, Ralph W. V. *Runes, An Introduction* (Manchester, 1959).

HAGLAND, Jan Ragnar. "Les découvertes d'inscriptions runiques de Bergen et Trondheim. Marques de propriété, relations commerciales et croyances magico-religieuses." *Proxima Thulé* I (1994): 123–134.

JANSSON, Sven B. F. *Runes of Sweden.* Trans. Peter Foote (Stockholm: Gidlunds, rpt. 1997).

KNIRK, James E., Marie Stoklund, and Elisabeth Svärdström. "Runes and Runic Inscriptions." Phillip Pulsiano (ed.), *Medieval Scandinavia. An Encyclopedia* (New York/London, 1993), pp. 545–555.

KRAUSE, Wolfgang. *Runen* (Berlin: Walter de Gruyter, rpt. 1993).

MOLTKE, Erik. *Runes and Their Origin. Denmark and Elsewhere.* Trans. Peter G. Foote (Copenhagen: The National Museum of Denmark, 1985).

MUSSET, Lucien. *Introduction à la runologie* (Paris: Aubier-Montaigne, rpt. 1976).

PAGE, R. I. *An Introduction to English Runes*, 2nd edn (Woodbridge, 1973).

STOKLUND, Marie. "Les découvertes d'inscriptions runiques de Nydam." *Proxima Thulé* III (1998): 79–98.

OGAMIC SCRIPT

Pierre-Yves Lambert

Ogamic (or Oghamic) inscriptions on stone are the first documents in the Irish language and date mostly from the fifth to the eighth century CE.

At first glance, the script appears to be based on an cyphened alphabet. Each letter is written using a certain number of notches (one to five) cut into a stone, running along a central axis formed by the vertical or horizontal edge of the stone (Fig. 3). The notch may take one of four forms: a perpendicular line to the right of the axis (or beneath it); a perpendicular line to the left of it (or above it); a diagonal line crossing the axis; or a shorter slit on the edge of the stone. The fourth type was sometimes replaced by a vertical line. The various types of notches, repeated between one and five times, thus

Fig. 1. Tables of the Ogamic alphabet, showing the vertical (epigraphic) arrangement and the horizontal (manuscript) arrangement.

made it possible to transcribe twenty letters. The sounds were classified, depending on the type of notch associated therewith, into four families or *aicme* (Table I).

An Irish grammar, known as *Auraicept na n-Eces*, "The Manual of the Scholars," provides the names of the various letters of the Ogam. The names themselves are the names of trees (in a manner similar to the Germanic runes). The names of the first, second and fifth letters of the first series are known in the Ogamic alphabet as *beithe-luis-nin* (birch, sorbus, ash [?]).

The names of the letters include several archaic words such as

ceirt for the letter Q, itself an archaism, since the labio-velar sound / k^w / had been simplified into / k / even before the earliest manuscripts were written in Old Irish in the seventh century CE. The word MAQQI, "the son of" (the genitive singular), which occurs frequently in Ogamic funerary inscriptions, corresponds to the Old Irish *maic* / mak'k' / (using the geminate-palatal / k /). This example demonstrates that in the language of Ogamic inscriptions, a distinction still existed between the velar consonant / k / and the labio-velar / k^w /, and that Irish words still had their final syllables.

Four hundred or so Ogamic inscriptions are known, of which about fifty have been found in Great Britain. Of the 350 in Ireland, the vast majority are from the southwest, and especially from County Kerry (Fig. 3). Of those in Great Britain, many are bilingual, consisting of an Irish inscription in Ogamic and a Latin inscription in Latin letters. These bilingual inscriptions were found in South Wales, Cornwall, and Devon and date from the late fifth and the sixth centuries CE. A few Ogamic inscriptions found in eastern Scotland have not been deciphered but are probably written in Pictish. The inscriptions on stone are generally memorial stones; by necessity, they are limited to a few words, in which the name of the deceased is written in the genitive case: "[stone] of N son of N'."

In addition to these carved inscriptions, Ogamic was also used on jewelry and other objects, such as a silver pin found at Ballyspellan, a triangular bronze basin from East Kilgulbin, and a bone thimble and a piece from a wooden loom found at Littleton Bog, Leigh. Ogamic often appears in the margins of manuscripts from the ninth century onward. Irish scribes would pass the time by writing their names, or the date, or by making malicious remarks in Ogamic. They would

Fig. 2. Saint-Gall MS 904, p. 204, upper margin: LATHEIRT "drunkenness" or "drunkard." Sankt-Gallen Abtei, der Bibliothekär (Herre J. Duft), Sankt-Gallen, Switzerland.

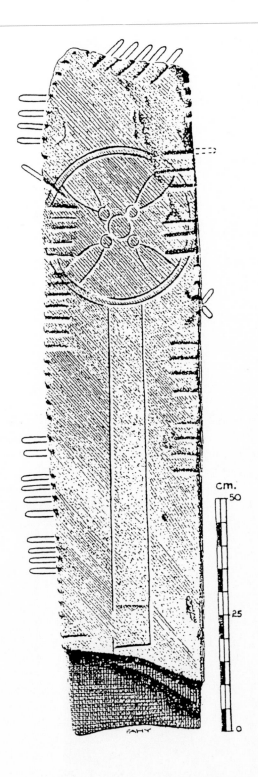

cm.

50

25

0

Fig. 3. Late Ogamic inscription on a tombstone (BECCDINN MACI RITTECC). Church Island.

write Ogamic in the form of dashes on either side of a straight line, representing the edge of a stone (Fig. 2).

The Irish grammar mentioned above contains a list of fictitious ogams, complicated variations on the system described above. Either the names of the letters must be sought in areas outside the botanology (one thus obtains an "Ogam of the stones," an "Ogam of the pigs," etc.) or the shape of the letter must be altered by adding something to it, for example, by using two, three, or four axes on which to make the marks.

The scribes probably invented the additional five signs (*forfeda*) that appear only in the hand-written ogams (except for three late examples of carved stone inscriptions). The *forfeda* were used to write diphthongs.

The Ogamic alphabet presents a number of problems. First, there are problems of structure: three letters H, Z, and NG, respectively called *huath* "hawthorn", *straiph* "blackthorn" and *getal* "reed (?)," have not been definitively interpreted. In fact, since none of these three letters were usually found at the beginning of Irish words, it is hard to know their phonetic value; one recent hypothesis identifies the letter *getal* with an ancient labio-velar sound, the voiced aspirated Indo-European $*/g^{u}h/$ simplified to $/g^{u}/$.

Secondly, the alphabet is hard to read: it is difficult to isolate two successive letters belonging to the same series. For example the five notches that represent Q could also be interpreted as four notches (C) plus one notch (H). Recently, VEQREQ was reread as FECHRECH, *Fiachrach*.

Finally, the origin of Ogamic is still controversial. Literary traditions indicate that the Ogams were used as magical incantations and for warding off evil spirits. Ogamic was used not only for inscriptions on tombstones but also for signs on frontier posts or as warning signs. The original technique was almost certainly based on "notching"—marking numbers on a wooden stick by cutting a number of notches in it. But no one knows what model was used in order to divide the letters into classes. It may well have been the Latin alphabet that, with certain adjustments, was the basis on which this script was devised.

Bibliography

BINCHY, Daniel A. "The background of Early Irish literature." *Studia Hibernica* (1961).

CARNEY, James. "The invention of the Ogom cipher." *Ériu* XXVI, (1975), pp. 53–65.

DIACK, F. C. "Origin of the Ogam alphabet." *Scottish Gaelic Studies*, 1929.

LEHMANN, Ruth. *Ogham: The Ancient Script of the Celts* (Lincoln, 1989).

MACALISTER (R.A.S.). *Corpus Inscriptionum Insularum Celticarum* 2 vols. (Dublin, 1945; 1949).

MACFHEARAIGH, Criostoir. *Ogham: An Irish Alphabet* (Indreabhán, Co. na Gaillimhe, 1996).

McMANUS, Damian. "Ogam: archaizing, orthography, and the authenticity of the manuscript key to the alphabet." *Ériu* XXXVII (1986), pp. 1–31.

——. *A Guide to Ogam* (An Sagart, Maynooth, 1991).

SIMS-WILLIAMS, Patrick. "The additional letters of the Ogam alphabet." *Cambridge Medieval Celtic Studies* 23 (Summer 1992), pp. 29–75.

——. "Some problems in deciphering the early Irish Ogam alphabet." *Transactions of the Philological Society* 91 (1993), pp. 133–180.

VENDRYES, Joseph. "L'écriture ogamique et ses origines." *Études Celtiques* IV (1941–1945), pp. 82–116.

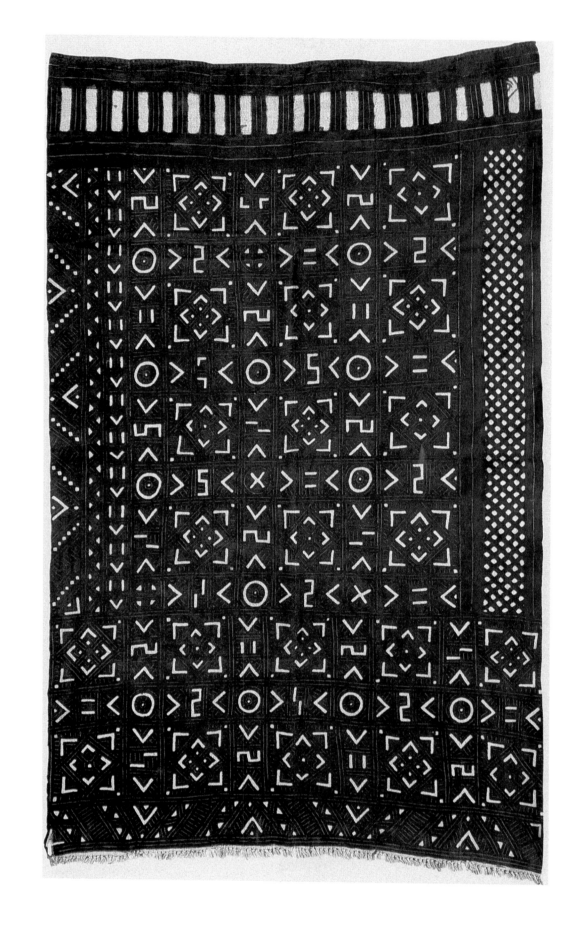

THE SCRIPTS
OF SUB-SAHARAN AFRICA

Jean Boulègue and Bertrand Hirsch

BORROWED SCRIPTS

The advent of trans-Saharan trade and the incursions of Islam brought writing and the Arabic language simultaneously into the Sahara and the Sahel. It is significant that the oldest Arabic document found in sub-Saharan Africa should be a commercial one, a bill of exchange written, according to the geographer Ibn Hawqal, by a merchant from Awdaghust in 971 CE. In the following decades, several inscriptions in Arabic, most of them on funerary monuments, were engraved in the region of the Niger river bend at Gao and Kukiya, the capitals of a Sahalian state whose people converted to Islam at an early date. Inscriptions produced by the Ifoghas have also been found in the neighboring mountain range of Adrar. It was the continuation of an epigraphic tradition in Tifinagh. The oldest inscription, on a rock near Es-Souk, merely proclaims: "It is the year 404 [1013–1014]." Through its reference to an abstract date that did not match the local calendars, this graffiti is evidence that the writer believed in the universalism of Islam.

This universal culture existed alongside the local, oral tradition, until at least the nineteenth century in Muslim black Africa, an area stretching from just south of the Sahara to the very tip of the continent and along the east coast. Jack Goody has used the term "restricted literacy" to describe the situation in which only a minority can read and write. This situation is by no means confined to Africa, but here, the oral tradition did not wither or decline with the introduction of writing. In fact it remained the commonest vehicle for transmitting important areas of knowledge, and not only to those who belonged to the lower orders. For

instance, Alvares de Almada (who came from the Cape Verde Islands) noted that in the sixteenth century, in what is now Senegal, Arabic script was most frequently used for the making of amulets whereas the historical information he collected had been transmitted orally. This division persisted into the nineteenth century. Written output was used primarily for religious purposes, magic and divination, while history and current events were passed on by word of mouth. In many of the societies that had converted to Islam, written and oral knowledge were used in similar ways. Books were rare and valuable (paper was imported, but inks of various colors were made locally). They were treated with respect, even those other than the Qur'an. There were schools for Islamic studies, where students started by learning how to read and write, and the fact that this had to be done through Arabic entailed a break with everyday usage. Yet the oral tradition too was taught in schools by reputable masters; it required a long initiation period and serious study. As with book-learning, the recitation of stories was entrusted to an educated minority. Neither the written nor the oral culture (which were by no means compartmentalized) took precedence over the other: they were two separate, albeit complementary, strands and they acted as rivals, the clerics in opposition to the aristocracy.

The use of the Arabic alphabet to transcribe an African language began only relatively recently. In East Africa, the first texts written in Swahili date from the eighteenth century. In West Africa, there is no evidence of a written form of Hausa or Fulani until the early nineteenth (or possibly late eighteenth) century. It is attested to in a religious context, in what is now Guinea, by Thierno Samba Mombeya, a Muslim intellectual. In the kingdom of Kongo (today's Angola), whose people converted to Christianity, the use of Portuguese from the sixteenth century onward

Fig. 1. Pictograms on a cotton rug. These *Bogolan* patterns were used by the Pagnes of Mali. Former collection of Charles Ratton.

Fig. 2. Sorabe: the first page of the Oslo A6 manuscript. Ethnographic Museum, Oslo.

was the equivalent of the use of Arabic in other regions, but it was never used for transcribing the local languages.

The case of Madagascar is thus all the more remarkable. Arabic characters were adopted for writing Malagasy quite soon after the first contacts were made with Muslim merchant ships and with early converts to Islam among the Antemoro on the southeastern coast of Africa. The oldest manuscript in existence cannot be dated with certainty, but it is probably sixteenth-century. Manuscripts written in the combination of Arabic and Malagasy known as Sorabe are written on local paper and are leather-bound (Fig. 2). Antemoro paper, made from bark pulp treated with a decoction of rice, was described in the seventeenth century and is still used today. The ink was made from the wood of a certain tree. Most of the Sorabe manuscripts deal with religious practices, divination, and magic. A few are historical. The writing tradition was in the hands of specialists (scribes and witch-doctors) who maintained it until the present day, despite the loosening of the ties with Islam. However, it rarely spread beyond aristocratic circles and beyond the Antemoro region. The Merina monarchy of the high plateaux became interested in this form of writing in the eighteenth and early nineteenth centuries, King Radama I had Antemoro secretaries and was initiated into their knowledge. Yet when, in 1825, he had to decide on the official alphabet to be used for writing Malagasy he pronounced in favor of the Latin characters suggested by Protestant missionaries.

INVENTED SCRIPTS

Paradoxically, it was at the places and the time in which the two borrowed writing systems (Arabic and Latin) were in use that African writing systems first emerged. Furthermore, these systems were sometimes more complex than the existing alphabets because they were usually syllabic and even, at first, logographic. The oldest of them is Vai, the language of the Liberian, coastal-dwelling tribe of the same name, whose script was invented *ca* 1833. Then came the Bamum system in the western Cameroons, invented in the late nineteenth century (Fig. 3). Others followed until as recently as the 1960s. They were divided into two language groups, both in West African. One covered the Mende linguistic group, spoken from Mali through Liberia, and associated language groups. The other group extended to southern Nigeria and west of the Cameroons.

The inventor was often a well-known figure. Momolu Bekele, who invented Vai writing, had been inspired by an expert in African languages, the Reverend S.W. Koelle, whom he met in the mid-nineteenth century. Bamum script was devised by the sovereign, Njoya, himself, and the story is recounted in a Bamum book. In both cases, the invention was presented (as were most of the others) as the result of a dream or revelation. Such an explanation accounts for the originality of the invention, and it can be clearly seen that these scripts owe nothing to the Arabic and Latin alphabets other than to have served as examples or as a stimulus. The inventor of the N'ko alphabet, created in 1949 to transcribe Malinke, did not claim to have been inspired by a dream but asserted that he deliberately chose to create new characters that were neither Latin nor Arabic (although the influence of both of them is detectable in some of the letters).

Yet how could these signs have been invented from scratch? Gérard Galtier has demonstrated that there are resemblances in the western set of characters, in which the Mende language group predominates, between the Masaba syllabary (created in western Mali in 1930) and the Vai syllabary (from the edge of the Mende region), as well as between Masaba, Vai and far older ideograms used in the same area, especially those used by the Komo secret society. It can thus be theorized that the recently invented scripts were inspired by these local pictographic codes. The similarities are not very numerous, however. Perhaps when ancient systems were drawn upon, it was generally in order to find inspiration rather than to adopt precise elements.

Fig. 3. Bamum manuscript. Musée de l'Homme, Paris.

This inspiration may also have come from the decorative patterns used in African applied art.

The Bamum system was originally logographic. Initially it contained 510 signs that represented words. Most were figurative, but they also had a phonetic value. A semantic marker was used to differentiate between homonyms, in the form of an "honorific" preceding the word belonging to the "noblest" category. The phonetic possibilities of the system were very soon exploited by combining monosyllables using the rebus principle. At first, this was applied to proper names only. Njoya made several modifications to his script, and in 1910, he produced a syllabary of only eighty-two signs. This development was facilitated by virtue of the fact that European paper, ink, and writing instruments had been introduced in 1903. In the early years, wood or bark had been used for writing, the ink being made from a liana vine.

The new script came into general use, a development that Njoya had not wanted originally. He once said, "I shall create a book that will speak without being heard," believing that writing would guard the secret of his power more closely than oral transmission. A number of schools were opened, but at the same time, Njoya invented a secret code of language and script reserved exclusively for use by himself and his entourage.

The purposes for which these scripts were employed varied considerably. In the Bamum kingdom, writing was part of the power structure from the outset and was used to compile royal messages. Njoya subsequently created a civil service, a registry of births and deaths, and a land registry. It is significant that the first book written in Bamum is a code of royal etiquette.

The Vai syllabary is mainly employed by traders for their own use, with English as the language for communicating with the outside world, and Arabic being reserved for religious purposes. The Masaba syllabary is used by farmers, although the Latin and Arabic alphabets are also widely used. N'ko is used by traders, teachers, and Muslim clerics; it is supported by an association that produces a newsletter. Surprisingly, many of the populations affected by the new scripts had already been converted to Islam at the time their own writing systems were being developed. It seems that the invention of a script satisfies a profound desire for an African identity.

CASE STUDY: SCRIPTS IN ETHIOPIA

In ancient Ethiopia, two types of writing were generally used by the scribes, Ethiopic itself and Arabic script.

The former emerged on the high northern plateau of Ethiopia and is indisputably derived from the ancient consonantic alphabet of southern Arabia. It may have roots going as far back as the fifth century BCE, since traces of the earliest south Arabian epigraphic inscriptions in Ethiopia appear to date from this period. The context is not well known, but there is evidence of trading in both directions among the populations that faced each other on either side of the Red Sea (Fig. 4). The writing system is derived from southern Arabian cursive scripts and was used to transcribe the Ethiopic languages that belong to the Semitic language family, and especially Geez, the language used in the kingdom of Axum that dominated the region between the first and the fifth centuries CE (Fig. 5).

The most interesting documents in this respect are the gigantic royal inscriptions engraved on stone, particularly those near Axum. One of the most famous of these recounts the story of a military campaign conducted by King Ezana. The text is written in Geez but in two different scripts, an Ethiopic script without vowels, consisting of twenty-six consonants, and a south Arabian script. It is also translated

Fig. 5. Epigraphic inscription in Geez and Ethiopic letters engraved on a rock near the city of Axum. The text states that it is the boundary marker between two territories.

into Greek, which serves as proof that several writing systems and languages, including Greek, existed simultaneously, at least among the elites. It was during this period, the mid-fourth century CE, that Ethiopic was vocalized and converted into a syllabary consisting of 182 signs, combining the twenty-six consonants with seven orders of vowels. The basic shape of the letter, representing the vocalization of a short *a* vowel is called the Geez order, and it alters, on the basis of strict rules, to represent combinations with the six other vowels.

This same King Ezana converted to Christianity, a religion that in the subsequent centuries brought writing into more widespread use with the translation of the Septuagint version of the bible into Geez by Ethiopian scribes. Other religious texts were also copied and distributed in manuscript form. Most of the existing Geez manuscripts that were written in Ethiopic script do not date further back than the thirteenth or fourteenth centuries. It is thus quite difficult to work out the paleographic development of the language in earlier times.

The introduction of Arabic script is proportionate to the Muslim presence in Ethiopia, which began in the late eighth century on the coast of the Red Sea and the offshore islands. Thanks to the Muslim tombstones that bear Arabic inscriptions, the spread of Islam and the use (albeit restricted) of the Arabic language and script on the high plateau can be traced. At first it followed a north–south axis, through Enderta, Wollo, and Choa, later spreading into the eastern and southern regions, including the Chercher plateau (Fig. 6). Many manuscripts have been found that were written in Arabic, especially historical chronicles. One of the oldest texts describes the dynastic succession in the

Fig. 4. Stone plaque bearing an inscription in the Sabean language and script. Found at Gobochela, south of Axum.

Muslim kingdom of Choa since the tenth century. The Ethiopian Muslim kingdoms probably reached their zenith between the thirteenth and sixteenth centuries, when the arrival of scholars and clerics from the Muslim Arab world caused the Arabic language and script to flourish among the educated elite of these kingdoms. Land grants from Christian Ethiopian kings have been found that were written in the Arabic language and script, evidence of the cultural exchanges that existed on the high plateau between populations of different beliefs who spoke different languages (Fig. 7).

Yet the development of the two scripts is very different. Ethiopic is linked to the political and cultural expansion of the Christian kingdom and thus emerges as the script of the "conqueror." It was used to transcribe the most important of the eighty languages spoken in Ethiopia, including Tigrinya, Gurage, and Oromo, and in recent times it has become a symbol of national identity, whether accepted or disputed. The Ethiopic script as a means of writing the Geez language is strongly identified with Christian sovereignty. On the other hand, the European missionaries who arrived in the nineteenth century preferred to use the Latin alphabet to

Fig. 7. Rare example of an Ethiopian manuscript of the gospels written in Geez and containing a land grant in Coptic and Arabic (left-hand folio). The land grant is attributed to King Dawit (1378/80–1413) and concerns the Bethlehem church at Lalibala, where the manuscript is preserved.

translate the bible into Ethiopic languages that as yet had no written form. The systematic expansion policy of Ethiopic script was encouraged by the Ethiopian monarchy during the twentieth century, as well as by its successor, the Marxist military DERG regime. Since 1991, when a federalist regime came to power, there has been a choice of writing systems. Some groups, the Oromo for instance, chose to transcribe their language using the Latin alphabet rather than Ethiopic script, as a way of distancing themselves from the central power and the "dominant culture."

Arabic script is generally linked to the use of the Arabic language and has been preserved by a small fringe group of Ethiopian Muslim scholars. However, there are manuscripts written in Harari, a semitic language spoken mainly in the area of the city of Harar, that use the Arabic alphabet; nor should it be forgotten that during the Middle Ages, Arabic was spoken by certain Christian monks, especially those who had come from Egypt, and who used to translate Arabic religious texts of the Coptic church, into Geez.

Consequently, from the late thirteenth century onward, when the seat of Christian power moved south to the lands of Amhara and Choa, the scribes continued to use Ethiopic script, not only so that they could perpetuate the manuscript tradition in Geez, the sacred language used for biblical texts, but also so that they could transcribe the vernacular of the new rulers of the Christian lands. The transcription of names into Amharic, another Ethio-semitic language, in fact required the conversion of several signs to annotate seven consonants that did not exist in Geez. This altered syllabary, which contains 231 letters, became the true national script when modern Ethiopia was founded in the nineteenth century.

Fig. 6. Arabic inscription on a tombstone (eleventh century, CE) of Quiha from Enderta, Tigré province.

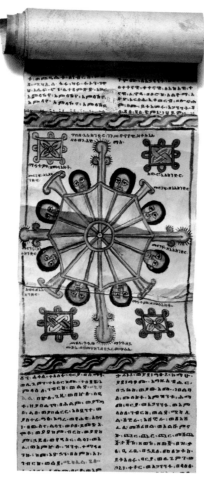

Fig. 8. Parchment protective scroll amulet, with illustration linked to the legend of Alexander, dating from the late nineteenth or early twentieth century. Ms. or. Éthiopie 420, Bibliothèque Nationale de France, Paris.

In a land that remained essentially rural, the prestige acquired by those who had mastered reading and writing is readily understood. At the interface between the masters of the written word and the peasantry, a new, specialist category developed, that of the *dabtara*. These were laymen who sang in church choirs. They could read and write, had a passing knowledge of Geez, and were thus able to meet the local demand for protective scrolls—amulets that were worn around the neck, contained images and writing, and were alleged to be therapeutic (Fig. 8).

In the complex relationships that were woven around literacy and orality, Christian Ethiopia presents an interesting case. There were the "traditionalists" who were masters of literacy within a culture that remained essentially oral. The written texts were created first and foremost to be read and publicly commented on, either in church as sermons to the congregation or at court for the benefit of the king. On the other hand, the prestige of the written word was such that a number of stories transmitted orally were based—or would later be based—on a written original. The importance of the Bible in the construction of the culture of Christian Ethiopian cannot be underestimated. It was the basic text upon which all the rest, as far as the Christians were concerned, could never be anything other than a vast gloss.

Bibliography

BEAUJARD, Philippe. "Islamisés et systèmes royaux dans le sud-est de Madagascar. Les exemples antemoro et tanala." *Omaly sy anio* 33–36 (1994), pp. 235–286.

BENDER, M. L., et al. *Language in Ethiopia* (London, 1976).

BERNAND, A., A. J. Drewes, and R. Schneider. *Recueil des inscriptions de l'Éthiopie des périodes pré-axoumite et axoumite* (Paris: Picard, 1991 -2000).

CERULLI, E. *Studi etiopici. I: La lingua e la storia di Harar* (Rome, 1936).

COHEN, M. *Traité de langue amharique (Abyssinie)* (Paris, 1936).

DALBY, David. "The historical problem of the indigenous scripts of West Africa and Surinam." Dalby (ed.), *Language and History in Africa* (London, 1970), pp. 109–119.

DUGAST, I., and M. D. W Jeffreys. *L'Écriture des Bamum. Sa naissance, son évolution, sa valeur phonétique, son utilisation* (Dakar: IFAN, 1950), p. 109.

FARIAS, Paulo de Moraes. "The oldest extant writing of West Africa: medieval epigraphs from Essuk, Saney and Egef-n-Tawaqqast (Mali)." *Journal des africanistes* 2 (1990), pp. 65–113.

GALTIER, Gérard. "Un exemple d'écriture traditionnelle mandingue: le masaba des Bambara-Masasi du Mali." *Journal des africanistes* 57/1–2 (1987), pp. 255–272.

GOODY, Jack (ed.). *Literacy in Traditional Societies* (Cambridge University Press, 1968).

TARDITS, Claude. "L'écriture, la politique et le secret chez les Bamoum." *Africa* (Rome, 1991), pp. 224–239.

UHLIG, S. *Äthiopische Paläographie* (Stuttgart, 1988).

For the development of Ethiopic in ancient times, see the numerous articles by R. Schneider, especially those published in *Annales d'Éthiopie.*

Until the twentieth century, writing was the prerogative of an elite of clerks who specialized in the use of Geez and were well versed in the holy scriptures. Geez remained the language of high culture and the liturgy and was used to compose and to translate religious texts (the latter mainly from Arabic via Egypt). Thus, in Ethiopia, Geez had a similar role to Latin in medieval Europe, though Geez was confined to the monasteries, the courts of kings, and the nobility. Not until the nineteenth century did Amharic became a written and cultural language. The two dominant figures, the *masters of the written word,* were the monk and the court chronicler. Ethiopian monasticism emerged in the latter days of the kingdom of Axum and played a vital role in the spread of Christianity, the transmission of texts, education, and the teaching of reading and writing. Until modern times, the main monasteries had their own scribes who were specialists in the preparation of parchment and the manufacture of codices. The royal court also supervised this valuable instrument of good government. From at least the mid-fifteenth century, the *sahafi taezaz* (chronicler) was responsible for recording the great deeds of his sovereign, and there were scribes whose duties included corresponding with the outside world.

III. THE IMAGE IN WESTERN WRITING

WRITING IN THE MIDDLE AGES

Michel Parisse

Although medieval sources exhibit highly numerous forms of writing, varying with time and place, one script can nevertheless be acknowledged to have prevailed for nearly four centuries, to the extent of dominating all the others. It is called "Carolingian minuscule," from Carolus, the medieval name of King Charlemagne, under whose reign it was developed. Inspired by various styles then in use, it rose along with the European expansion of the Frankish empire and continued to mature until the moment when changes in both usage and style triggered the rapid, bursts of development that characterized it during the final three centuries of the Middle Ages. Since this chapter can hardly aspire to cover the entire field of these medieval scripts, it will focus on the central period, running from the imperial coronation of Charlemagne (800) to the rise of the University of Paris (thirteenth century).

THE RISE OF COPYISTS' WORKSHOPS

Some clarification and qualification of two often repeated ideas is required: the first is that Charlemagne "invented" schools, and the second is that Carolingian script arose at Corbie in northern France in the late eighth century.

Charlemagne's reign has been sufficiently studied to permit a more accurate description of his efforts in the realm of schools and writing. His qualities as a statesman are indisputable. He is often said to have been uncultured because his biographer, Eginhard, reported that at the end of his life Charlemagne tried to learn the alphabet. This overlooks the fact that political genius can be found among monarchs who do not display marks of culture but who are perfectly able to understand the value of a policy that favors intellectual activities even though they do not

themselves master them. Right from the start of his reign, Charlemagne went often to Italy and surely recognized its cultural as well as its political wealth. On the death of his most beloved wife, Hildegard, in 783, not only did he sponsor the drafting of the *Gesta episcoporum Mettensium*— a history of the bishops of Metz featuring a forebear, Arnulf, and his family—but the writer commissioned by Charlemagne (or his closest adviser, Bishop Angilramn of Metz) was a Lombard, Paul the Deacon. This occurred at a time when the Carolingian government was opening itself to the outside world, most clearly through expansion into Saxony, yet in fact extensively in every direction, including northern Spain, the Anglo-Saxon lands, Bavaria, and Italy. The Frankish king, realizing the importance of writing, wanted a refined language and proper books, and he therefore promoted an increase in the number of teaching institutions.

A detailed capitulary of regulations, drafted in 789 and known as the *Admonitio generalis,* contained all the measures that led to the subsequent cultural boom (Fig. 1). To simplify somewhat, we might say that a concern for the political unification of the Frankish world was spurred by the diversity of the regions governed and first called for the religious and liturgical unity that had already begun in the days of Saint Boniface and Carloman and was then pursued under Pippin the Short and Chrodegang (Bishop of Metz from 742 to 766). To achieve this it was necessary to Romanize the form of worship and, therefore, the books required by the liturgy. This cultural campaign began slowly in the final decade of the eighth century, and its various manifestations were reflected in the rise of the palace school that drew intellectuals from England, Spain, Italy, and Aquitaine, in the importation of Roman manuscripts, and in the founding—within religious communities, monasteries,

Fig. 1. This capitulary of 789 CE, titled *Admonitio generalis*, is considered to be the founding text of the Carolingian Renaissance and was written in a script that remained common until the end of the eleventh century. Ms. 1202/501, fol. 1r, Stadtbibliotek, Trier.

Fig. 2. Roman writing bequeathed to the Franks a fine script with rounded forms called uncial, both upper- and lower-case. The shape of most Roman letters was retained, as seen in this detail from the *Concilia minora Galliae*, seventh to eighth century CE. Ms. Phill. 745, fol. 111v, Berlin.

and chapter-houses—of schools where respect for the Latin language was taught (Figs. 2 and 3). Pupils had to learn grammar (the first of the liberal arts), to speak decently, and, thanks to those skills, to copy books correctly and disseminate them. This thrust triggered what has rather misleadingly been called the Carolingian Renaissance but was really only the Franks' dawning awareness of the heavily Romanized culture of nearby lands. Writing played a key role in that development.

The other commonly stated idea that needs qualifying concerns the supposed emergence of Carolingian script at the monastery of Corbie in the late eighth century. Why should it have arisen at Corbie in particular? People had never stopped writing and copying books—there is no doubt about that—but letters traced by a hand that wrote without halting led to texts that were hard to decipher. Meanwhile, on the fringes of the Frankish world, from Benevento to Canterbury, people were acquiring a taste for

Fig. 3. This *Epistle of Paul to the Thessalonians* reveals some of the special features of the script used in the British Isles in the eighth century. Note the *s*, for example, that appears twice in the name "Silvanus" on the second line. Werden an der Ruhr. Ms. theol. lat., fol. 366, fol. 69r, Berlin.

Fig. 4. A monastic scriptorium carried out all the tasks of a printer and publisher, delivering completed books with carefully arranged pages and colorful decoration, as seen in this ninth-century *Psalter of Saint Gall.*

a minuscule script that featured distinct, Roman-style capitals. Large angular or semi-angular letters—indeed even rounded, or uncial, hands—thus steadily gave way to smaller letters that imitated the form of capitals, taking less room on writing surfaces where space was at a premium. This minuscule script reached the Franks through imported books and was used to inform the entire kingdom of the measures taken at the general assemblies held in spring, such as the one that issued the *Admonitio* in 789. Now, it happened that the monastery in Corbie, Picardy, was very precocious in the production of books copied in this small hand, and its monks were given the main credit for inventing it. Although this religious community was indeed located at the intersection of different cultural currents, from which it could profit to teach its scribes another script, the new trend must nevertheless have been slower and more diffuse than suggested by surviving manuscripts from the period.

SCRIPTORIA

A plan of the Swiss abbey of Saint Gall (or Sankt Gallen) locates the copyists' workshop, or scriptorium, right next to the church. Such detailed information remains all too rare, yet there is absolutely no doubt about the existence of these rooms where monks kept their writing equipment and spent long hours copying books that they had borrowed or were commissioned to produce. The hard work continued even in cold weather, as one poor monk described, when hands became numb and ink froze in the inkwells, although the warming room and the chapterhouse were just a few steps away. Starting in the ninth century, these scriptoria produced hundreds of liturgical books, bibles (in whole or in part, in the form of psalters and Gospels), and countless commentaries on Holy Scripture, on the prophets, on certain psalms and on each Gospel; monks also copied many books by the Fathers of

the Church as well as works by classical authors from the days of the Roman Republic and Empire (Cicero, Tacitus, Livy, Lucretius, Ovid, Horace, Virgil, and many others). If the term "Carolingian Renaissance" refers to the dissemination of classical authors, as was later the case in the later Renaissance, then the term is justified; but that is not the way it has been employed by historians, who use it above all to refer to a revival of intellectual activity and scholarship. As fate would have it, however, there was in fact a close link between the two "Renaissances": the later humanists, when rejecting the barbaric, Gothic script of the late Middle Ages, supplied printers with model letters taken from works by Latin authors, a script they thought authentic but which in fact was Carolingian. Thanks to this misconception by humanists, today we still use a "roman" typeface directly derived from a script established in the late eighth century.

In employing the term scriptorium to refer to a monastic workshop, we have given it a more general meaning as the site of a special way of writing, decorating, and producing manuscripts. Hence we speak of the scriptoria of Tours, Reims, Metz, Saint-Amand, Fulda, Reichenau, and Saint Gall (Fig. 4) to refer to places of production characterized by a specific way of tracing certain letters, of depicting scenes from the life of Christ, of choosing colors, and of laying out historiated initials and full pages.

Miracles of Saint Paul of Verdun (late ninth century)
I heard someone recount a miracle most surprising and strange, which happened when the prior of the place, the monastery of Saint Paul, gave him some quaternions to copy (for he was a scribe). He said that one day, when the heat of midday gave way to shadows, he went outside to do the work he had begun; that evening, he was called to supper. If he failed to arrive quickly, if the hour and repast were over, in vain would he have sought what was offered. At once, therefore, he abandoned his writing tool, the quaternion, and the book he was copying, carelessly left open. He went to sup and, as happens in such circumstances, downed more glasses than customary; overcome by the sleep that brings forgetfulness, he was taken to his bed by his dining companions. He fully profited from his night's rest, not waking a single instant, until the next day's dawn lit the dark woods and hills. While he was thus asleep, during the first nocturnal vigil there all at once began a downpour of rain that lasted until the end of night, even unto destroying orchards and ruining crops, say those who witnessed it. Awakening to all the clamor, the scribe realized that he had caused more loss than gain for the monastery. Worried on his own account, and alarmed at the loss caused to the monastery (for he had no means to pay it

back), he hastened to the spot where he would surely see the damage caused by his negligence. Reaching the spot, he saw two contrary wonders: the quaternion on which he was writing was full of water, but the open book was so spared that not a drop of the downpour had fallen on it.

– Joseph van der Straeten, *Les Manuscrits hagiographiques de Charleville, Verdun et Saint-Mihiel, avec plusieurs textes inédits* (Brussels, 1974), pp. 138–139

A SCRIBE'S TOOLS

The writing done by a scribe required the convergence of three elements: parchment, pen, and ink.

Throughout the Middle Ages, parchment was the writing surface *par excellence*. The use of papyrus—sheets made from an Egyptian plant, aligned and glued together to make wonderful, widely exported scrolls—had become increasingly rare in the early centuries following the classical period. By late antiquity, skins were coming into use. It was at Pergamum that people first developed what would be called "stuff from *Pergamentum*," or parchment. The skin of a calf or a sheep would be meticulously scraped to remove the hair on one side and the flesh on the other, soaked in an alum solution to prevent it from rotting, then stretched, dried, scraped, smoothed, polished, and finally cut according to requirements. Parchment-makers produced material that could be more or less white, more or less fine; the output of highly skilled craftsmen was of admirable quality. Today specialists can tell whether the skin came from a goat, still-born lamb, or sheep. Connoisseurs can, at the very least, distinguish by touch and sight the hair side from the flesh side, the latter having a paler color and softer surface. This difference in appearance would become important when a book was being prepared.

It was the Romans who invented the book (*codex*) that progressively replaced scrolls (*volumen*). They already used wax-covered tablets of wood, which they would bind together to make a kind of "book of wood"; by replacing these tablets with sheets of parchment, then folding and stitching the sheets, they devised the true book, discovering its numerous advantages. Scrolls did not totally disappear, however, and paintings of the evangelists at work always show them writing on a scroll. Craftsmen at a Carolingian monastery would supply the scribe with sheets of parchment, which he would cut, fold, and gather to produce volumes of greater or lesser dimensions, although always one of several standard sizes. An entire sheep skin, folded once, yielded giant books more than two feet high and nearly sixteen inches wide, some late eleventh-century examples of which survive; at the same time, the format

A scribe consumed many quills and often had to resharpen them; his left hand would constantly hold a knife, with which he would also keep the parchment flat or scrape away some unfortunate mistake (Figs. 5 and 6).

Ink still had to be made, however. Even though widely known techniques existed, everyone had his own recipe. The basic ink was black or brown, with more or less carbon-black or acid. It should neither run nor, once dry, corrode the parchment. The use of overly acid ink sometimes produced letters that came off the parchment while leaving a highly visible mark. The best inks have retained an amazing freshness down to the present, as black as the day they were used; others have faded or taken on a less attractive brownish color. When necessary, of course, scribes knew how to make colored inks, notably red, green, and blue, in complement to the painted illustrations.

WRITING

A scribe placed the ball of his hand on the parchment and traced the letters one by one. Each letter had a generally consistent *ductus* (traced form), but this did not prevent significant variations in form (Fig. 7). A letter was composed of

Fig. 5. *Bede writing* (672–735 CE). The scribe is writing in an already manufactured book; in his right hand he holds a quill and in the left a knife to sharpen the pen and to scrape any mistakes off the parchment. Ms. Yates Thompson 26.f.2, British Library, London.

might be as small as six inches by three inches. The beauty of the book required that special care be taken to make sure that facing pages came from the same side of skin (hair or flesh).

Having prepared his parchment, the scribe then took up his pens. The term stylus, occasionally applied to this tool, recalls the earlier use of sharpened reeds; the term pen here refers to the shaft—or quill—of a feather. The English word "pen" derives from the Latin word for a wing feather, *penna,* while the French term "plume," derives from *pluma,* the name for a smaller feather. The preferred quills came from large birds, especially geese and ravens; particularly valued was the leading feather of the left wing, for the curve of the quill was best adapted to writing by right-handed scribes. Once the lower shaft was trimmed, the point was skillfully shaped, split, and sharpened so that it would retain enough ink to write several letters in a row.

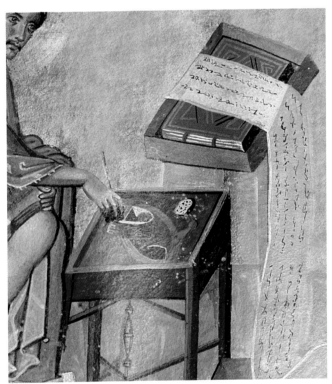

Fig. 6. Thanks to paintings of the evangelists at work—here, Saint Luke—we now have many pictures of medieval scribes, though perhaps somewhat idealized. Ms. 56, National Library, Athens.

several strokes of the pen, running from top to bottom or left to right, or perhaps even diagonally (though it was not possible to scribble arabesques or to go back and forth in any direction at will). Léon Gilissen has carefully demonstrated how letters were drawn, revealing the series of strokes that yielded the calligraphy of a stable hand. Since a letter was a well-defined form, known to all, decipherable by all, and reproduced in the same way by all copyists, texts were as uniformly readable as printed books are today. The choice of letters, their standardization, and the fact that they were clearly separated from one another meant that writing was somewhat similar to printing in its rigor and repetitiveness, indeed in its lack of inventiveness. Scribes nevertheless enjoyed enough freedom to leave their own "mark" or take certain initiatives, making it possible today to assign a text to a given scriptorium (as so admirably demonstrated by Bernard Bischoff, the most remarkable paleographer and connoisseur of Carolingian

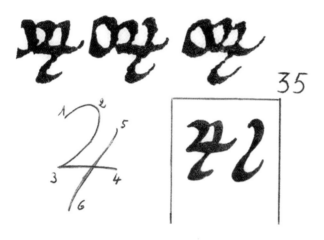

Fig. 7. An illustration of *ductus,* the way to trace a letter. Here the genitive plural ending *orum* is abbreviated to a symbol that the scribe makes with three distinct strokes of the pen (1 to 3, then 3 to 4, then 5 to 6). The pen can be drawn easily only from top to bottom or left to right.

manuscripts, able at a glance to date a work to within twenty-five years). Hence rigor existed, but so did particularities.

The alphabet adopted by the Carolingians is the same one, with only a few exceptions, as the roman typeface used today by printers. Only a few letters require comment. There were at least two ways of tracing an *a;* the shaft of a *d* could be vertical or diagonal; a *g* was probably the letter in which scribes best expressed their inventiveness, in its lower loop; the letter *r* long retained a tendency to descend below the base line; an *s* was made with two strokes, like an *f* (the double curve used for capitals was only adopted later); the letter *t* was so short that it was often confused

with *c.* Capital letters displayed greater authority, as seen in the double paunch of *B,* the belly of *D,* the angular strokes of *F, L, T* and *X,* the bars of *M, N,* and *V,* the large loop in *P.* Ligatures sometimes linked one letter to the next, especially *st* and *ct,* but other combinations existed, notably with the letter *r.* Scribes were also able to play with rustic capitals, or with uncial and half uncial forms.

A Carolingian scribe's hand carefully traced strokes from top to bottom; since the attack of the pen was thicker on top than on the bottom, this created a veritable club-like shape. Firmly maintaining the point at the same angle through curved strokes created thin and thick sections on ascenders and descenders (more commonly known as loops and stems).

In the early days of Carolingian script, scribes were primarily concerned to trace each letter; although letters touched, one letter was never drawn as an extension of the previous one—they remained distinct. Words therefore followed one another without being clearly separated; a break, or small white space often occurred between words, of course, but this was far from being the rule. Some texts display lettering as dense as a Roman epitaph. Only a careful reading out loud makes it possible to understand the text, the eye being unable to decipher with the ease normally afforded by a clear separation of words. Reading, in fact, was done out loud, in a murmur or boldly, depending on whether one wanted to avoid bothering a neighbor or hoped that distinct articulation would stave off distraction.

Starting in the tenth century, a new practice involved creating greater spaces between letters, to make reading easier. Then, a century later, letters were brought closer together and words became clearly distinct; "ocular" reading began to replace oral reading. In the twelfth century, the quality of writing yielded perfectly legible manuscripts, with tightly spaced letters and clearly spaced words.

During this time, the use of punctuation became widespread. Although fairly basic, it was not without significance, as the study of certain scribes' writing shows. A capital letter sometimes cued the eye to the start of a sentence. To allow readers to take a breath, a period would be placed, mid-height, to suggest a pause. Then came the semi-colon, reversed in relation to the modern one, with its comma angling to the upper right above the period. Finally, question marks made their appearance. The process was complete by the twelfth century.

One practice unfamiliar to today's readers, however, was the use of abbreviations, which continued to expand throughout the Middle Ages. Initially involving only ten per cent of words, abbreviations wound up being applied to some fifty per cent of all words, even exceeding this proportion in

allowing a copyist to save space—and perhaps time— they also embodied an entire system of writing, learned along with the basic forms of letters. The use of abbreviations was a profoundly original aspect of medieval writing. Although they make decipherment more difficult for the uninitiated, there is comfort to be taken in their relative standardization of use, whose keys need merely be learned.

PAGE LAYOUT

Mindful of their readers, medieval scribes took care with the layout of the page, marking it out, signaling starting points, indicating flow, using capitals and headings,

Fig. 8. This ninth-century evangelistary, or compilation of Gospels to be read during the mass, is particularly legible, although the words are not yet distinctly separated from one another. *Prüm Evangelistary,* Ms. lat. theol. fol. 733, fol. 28r, Berlin.

Fig. 9. Note the careful layout and writing in this ninth-century charter delivered by Ernaud, Bishop of Le Mans. The personal intervention of certain witnesses is indicated by the sign of a cross and the addition of their appellations between the lines. Nouv. Acq. lat. 2588, item 1, Bibliothèque Nationale de France, Paris.

notes made by scholars—as is the case today with notes taken by students. Leaving aside a ligature as dense as & (for the letters *et,* meaning "and"), which could even be used in the middle of words such as *pr&ium* and *p&cator* (for *peccator,* via confusion between *t* and *c*), the most frequent early abbreviations concerned terminal *us* and *er,* certain doublings of *m* and *n,* a tilde over *p* to indicate *pre,* a bar on the stem of *p* to indicate *per,* or a loop on that same letter to signify *pro.* Around 800, the terminal *ur* in passive forms began to be abbreviated. After 1050, the number of abbreviations suddenly increased, affecting more and more words. This was also the period when scribes began placing an accent over a doubled *i,* to avoid confusion with *u,* and when they started using a dash to indicate a word-break at the end of a line.

These abbreviations were so deeply rooted in writing that they survived in early printed books. Far from simply

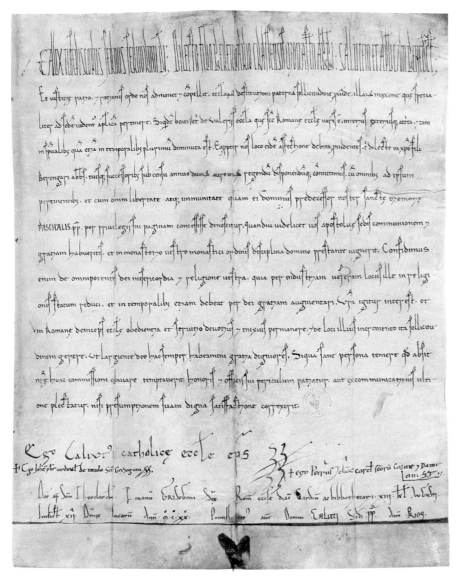

Fig. 10. To prevent forgeries, papal bulls adopted a strict format, as seen in this bull delivered by Calixtus II to Abbot Béranger of La Grasse, dated July 20, 1119. Collection Baluze 380, no. 14, Bibliothèque Nationale de France, Paris.

columns and illustrations (Fig. 12). First the margins and lines had to be defined, by ruling vertical and horizontal lines either on the verso (with the aid of a dry point, which left a ridge in the parchment) or on the recto (with ink or lead point). In this way they could justify both right- and left-hand margins, and obtain uniform spacing between lines and identical page height. They would arrange the text either in long lines or in columns. Major divisions of the text would begin with a capital letter, often bold, or with an elaborate initial decorated with foliage, figurative image, or tracery. To make it easier for the reader to identify various sections, some scribes began using running headers. Here and there room would be set aside for illuminations, the scribe leaving the artist the required space and guiding him with indications in smaller writing. Such painting could be of various dimensions: small (initials), middling size (occupying part of a page), or large (a whole page). When a miniature illustrated the text, it was placed as close as possible to the relevant passage, thus playing on the relationship between word and image.

Layout assumed new importance with the invention and development of commentaries in the form of marginal glosses (Fig. 11). This practice concerned Holy Scripture as well as textbooks on grammar or law—in short, any text where a commentary proved necessary. In such cases the text under discussion often occupied a small part of the page and was written in rather large lettering; the surrounding commentaries would be written in a markedly smaller hand. A symbol placed in the text would refer to a counterpart in the marginal gloss where the commentary on that passage was located. The reader could thus shift easily from text to gloss and vice versa. Some scribes achieved quite elaborate results from this interplay.

COMPLETING THE BOOK

Once the writing was done—once the colophon had been inscribed, in which the copyist expressed in a few words or lines his joy at having finished—the book had to be completed with a sturdy binding. Gatherings (or quires) of two, three or four folded sheets—binions, ternions or quaternions—were bound together, then a strong tie was inserted in the wooden boards that protected front and back. A piece of leather sheathed it all, making a fine, uniform cover. The correct binding order of the respective

Fig. 11. A manuscript offered to the Abbey of Clairvaux by Cistercian Cardinal Pierre de Bar, thirteenth century. The main, central text is surrounded by commentary in the form of a gloss; here there are two layers of commentary. A cross-referencing system makes it possible to shift from text to commentaries.

Columna I

Benedic? uiela z. Sep
eccla spe sci munere fe
cundatur. z altis? ad lucē
pariam deecēdibus su
cedunt ut xpiani no
mē maneat in cretuti
z marē sistant de noua
pgenie in senecture su
a osoleden sūt. Hereo?
ibz? qi pnnarrhes z ppbe
tis successus eū igēdie z apsi. v̄ā. q
putabis ruis uax sunt tibi filii.

In suu suo. z c. Qn e. c.
per legem gignere ū po
nuit. p ppbetas ministe
cium susceptis sub ue
lamine figuratū porta
bat occultum. z num
as sungebatur officio
qi matre carebat pui
lega.

Hec se gna. De
can se guardes filii inde
tsep. ad ddi. vnde cognos
cis qi totus diuine iure
no legit ad xpm tendit
qui natiue est de semie
dauid. ut illi ad uiceni
pōtent legis gestario
nem in eo manisestet.
finis a legis xpс ad ius
ticiam ōi credē. Als legi
si iacob de mea matrix
xpс aut nō ausertur
septis de iuda z dux de
fe. ef. do. ne. qui mue.
tē. d̄a xpс de semine
uida. Ad dā dicui t.
de suum uenui ad po
nam sē sedem uui.su
archaril ceuculu genere
ad despensanone diũ uti
sui nix.

Columna II

sent pui nouissimu
z no. pri. thamar sp
cōmitans in amari
tudo meresa. ere san
gennū z nom z btiū
nuitauit. que sunt in
j dolarnal seat z amal
ta in puia sir dilligeb
pulchri.

nectiue. de ninru ein tua nat est qui te dilign
z multo tibi melior est qi si sep
rem haberes filios. Sumptū qi
noemi pueru posuit in sinu su
o z nutricis ac getule officio su
gebatur. Viane aut mulieri
ogitulabant ei dicentes. Nat
est filii noemi. vocauerūt qi no
men eū obeth. Hic est pater ysai
patris dauid. Hee sunt ge
nerationes phares. phares ge
nuit esrom. Esrom aut genuit
amminadab. Amminadab genuit
naason. Naason genuit salmon.
Salmon genuit booz. Booz ge
nuit obeth. Obeth genuit ysai.
Ysai genuit dauid regem;

Columna III

iiii. Dixcerit qi que
lieres ad noemi
Benedict? oñs qui nō est passu
ut deficeret successor familie
tue z uocarit nomen eū in israel z habeas
qui esoletur aiam tuam. z nutriat se

Columna IV

donec steralis pepit
plurimos. z qi multos
jai. fi. fit. ēst.

Elin fi. rui. lui. fi. z c.
multerudinē. L. eor
qui in tieū. z. leges
corrina nutriebān
nur. qn. L. nō credite
nunt uerbū oñis. z
molauert filios suo
z fi. sui dem. z tuno
xpm accepert z occi
dect. z apros ysci
as fu

Hee sūt ge.
z t. Spirituali? capta
generatione demō
stratur. Obeth ui ser
uitus interpr. z sai.
mistic saminū uni
mensil. dauid ma
nu fortis uel desidera
bilis. Qui ū seruite
deo seruit. sacrestiū
illi grata z suaui
sint eotus sacrestiū
p opa mrtiri z deo
nis studui inpenent
sit qi roborātur her
z deuotione desidera
bilis est z deo placens.

[Lower section — historiated initial and text below]

...uil dissciile sit faic nō posimi aubare. nec ōi faciū. Nam neq nob aliqo impuni
... abemre sine est. z magnitudo horui inpositi ma cernes pemit. ut ante sub saice tū
... iuersum sir q sernaual. Aceduunt ad hoc inuice suida qui onne qo sanbral erpbendendol
... puenit. z inteuoil mea se asia repugnantie publice lecerint. z occulte legum mini tu
... lamare compellar. z dicene. oile lubera aiam mea a laber. tui. z a tua. tu. Tercius aut est qi
...semp scribens z imp resernens ut elabe uixil z bester ubos de beheeo miserant. qi nō habeicis gratia z lau
... na uolumina. aut quicqd illud est qo a nos uiceat nō satian ab alis exponend sir. seusstra z tir qui
... dauium neq aliqo sanguido serre rui obeli. cenente cōnente z. stiqs obseruo mi oben z gramare
... tibie ut pui ueta lectione seram hbos sui osstecunt in pubbisi. ne ssuedoosis eotos ingeniat. uuen q eor
... suptusi qui nudicare tui de aliis. z: ipa saeere niem nonert. Stqi z lisis sr qui by mia ū desplacent bos scribe
... ray comptel. admouentus ut beheeli noia euret gode in hoc uolumine copat est delinita z p puctuail.

Fig. 12. Vernacular French increasingly found its way into manuscripts in the thirteenth century. The careful hand makes it easy to read. *Conseil de guerre de Pierre de Fontaine.* Nouv. Acq. franç. 10685, fol. 73, Bibliothèque Nationale de France, Paris.

gatherings was assured by the use of a few words (called a signature) at the end of each quire, indicating the initial words of the next one.

In certain cases, metallic clasps held the book shut, thereby preventing the parchment from buckling. That completed the work on ordinary books, sometimes known by the color of their covers (the "white book" at the abbey of Saint-Denis, for example). Highly precious books, however, were confided to a goldsmith who enriched the cover with ivory, gemstones, and costly metalwork. The craftsman might hollow the central section of the top board in order to insert a plaque of ivory depicting a religious scene. Or he might place cabochon-cut stones on the four corners, or attach small metallic figures. Precious bindings were primarily given to the most important liturgical books, known as sacramentaries and evangelistaries (Fig. 13).

Some scriptoria were highly reputed for the quality of their work and would produce numerous copies of the same book. Thus, in France, Tours produced many bibles at the instigation of Abbot Alcuin and his successors, filling orders from rich or powerful patrons, and Saint-Amand specialized in sacramentaries. Further east, the scriptorium at Reichenau produced Gospels. These multiple copies, however, should not be perceived as the equivalent of modern mass publishing.

A book was a valuable addition to a monastic library. It might be chained down in the church, to prevent it being moved or stolen, or it might be placed flat in an *armaria* (chest) under the control of an *armarius* (librarian), to whom the monks applied for books. The Rule of Saint Benedict, for that matter, required them to read throughout Lent. One monk would read out loud in the refectory while his companions dined (as is still the case today); sometimes he might finish reading a text that had not been completed in church. The lives of the saints enjoyed a privileged status, as did books of commentaries. Manuscripts thus played a major role in the life of religious communities.

CHARTERS

Custom has established a distinction within medieval sources between manuscripts (by which is meant books) and "diplomas" or charters, a generic term used to cover individual, practical texts such as deeds, endowments, confirmations, judgments, agreements, and other documents issued by lords, bishops, abbots or other generous donors. These charters were drafted in tens of thousands all across Europe, their number notably increasing from the twelfth century onward. Their distribution is highly variable.

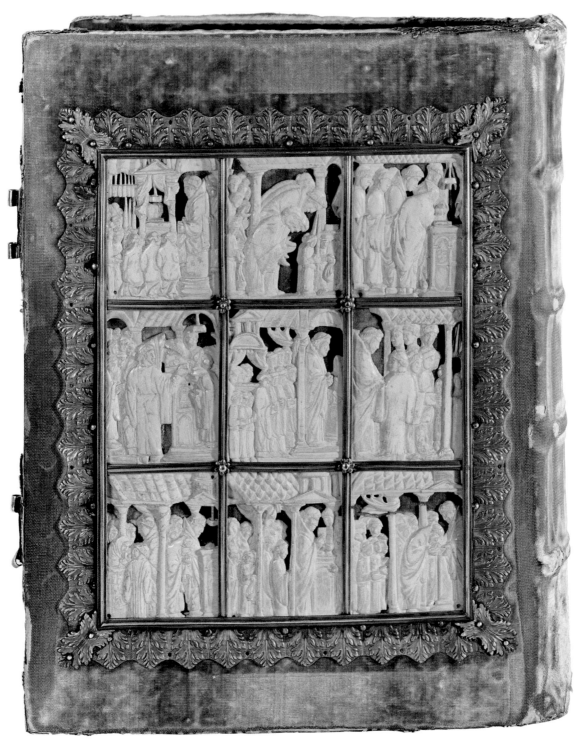

Fig. 13. The upper board of the binding of the *Drogon Sacramentary*, 850–855.
Ivory and silver. Ms. Lat. 9428, Bibliothèque Nationale de France, Paris.

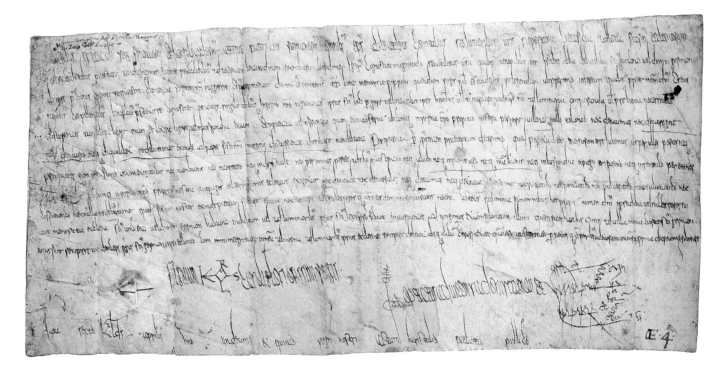

Fig. 14. A charter issued by Charlemagne to the Abbey of Saint-Germain-des-Prés, 779. In the eighth century,
the hand used for charters was difficult to read, yet it was retained to lend great solemnity to this type of document
(note the vertical extension of letters). K7, no. 2r, Musée de l'Histoire de France, Paris.

In medieval days, it was usual for archivists in churches, monasteries, and chapter-houses to store separately documents that recorded their most important privileges, the most glamorous being royal charters and papal bulls. These documents were drawn up in the royal or papal chancery, or else in the monastic workshop when the beneficiary enjoyed the possibility of preparing the document that would then be transmitted for validation. The realm of charters is as varied and dense as that of books, and there can be no question of dealing with it in detail here. I would just like to make a few remarks.

The first concerns the script, or hand, that has been called charter hand (or diploma hand) as opposed to book hand. This distinction arose at the very time that the Carolingian minuscule was developing. Whereas capitularies, annals, and treaties were written in clear, discrete minuscule letters, charters issued by Charlemagne's chancery continued to employ a presentation and script similar to Merovingian diplomas (Fig. 14). A large parchment would be used, and the text would run horizontally across the longest side. The first line would be composed of very tall, thin, tightly spaced letters that were difficult to read. The next line, separated by a wide space, featured fine, often contorted letters with elongated ascenders and

descenders. This charter hand lacked the simplified, round form of book hand.

The persistence of this tradition may seem surprising, but the truth is that the use of charters was quite different from that of books and other texts intended for wide dissemination. People probably wanted to retain a somewhat mysterious—and certainly solemn—air to documents issued by the king, a solemnity further stressed by chancery marks and monograms, not to mention the all-important seal. Even when the hand employed for royal charters slowly began to approximate the one used for books, nothing was changed in terms of external presentation, which functioned as a guarantee of authenticity. A real break only occurred with the Capetian dynasty, whose charters were more like ordinary texts, while nevertheless retaining a few features of other charters.

These documents, stored with infinite care in a chest after having been folded to protect the text, provided the crucial proof of the rights and possessions of the church that held them. As a precautionary measure, they were sometimes copied onto another support, and these duplicates might be gathered into a collection of charters known as a cartulary, making them easier to consult with other documents on the same subject without having to remove

the originals from their store. If necessary, the original parchment would be displayed to an assembly and read out loud (texts were sometimes composed in rhymed prose). In case of doubt it would be examined by specialists, when it would be compared with other documents and its seal and symbolic signs would be scrutinized. The more handsome the document, the more sure its impact: noteworthy was a text well arranged across its surface, enhanced by a first line of tall letters, with capitals beginning each sentence or highlighting certain names (especially those of patron saints), adorned with decorative loops and arabesques, endowed with a royal monogram, imperial notary's symbol (say, a beehive), or papal *Rota*, accompanied by a list of witnesses (in lines or columns), with the date perhaps transferred to the terminal position, and with an affixed or dangling seal (Fig. 15). Like churches, towns soon became attached to their "charters" and "privileges," especially charters of freedom or franchise. A more common procedure was adopted for ordinary diplomas, simple notices and announcements hastily drafted on a piece of parchment sometimes awkwardly cut.

The papal chancery issued bulls drafted according to similar principles. Pope Leo IX, who was familiar with the Germanic court, established more precise rules for bulls (Fig. 10). Many bishops, who had charters and bulls in their church archives, copied them in turn, drawing up particularly magnificent documents, many examples of which survive from the ninth century onward, notably in the region between the Loire and Rhine rivers. Other, lesser, criteria were adopted in southern administrative lands; beyond the Rhine the practice of fine charters lagged somewhat behind.

Studies of the paleography and diplomatics of the various royal, imperial, papal, and episcopal chanceries of the central Middle Ages have made a major contribution to our knowledge of the institutions, practices, and attitudes of the period, drawing special attention to the titles borne by issuers, to preambles, to the lists and arrangements of witnesses, to types of seals, and to the formal wordings of curses ("If any man oppose this gift, he will incur the wrath of Almighty God and will burn in hell with Dathan and Abiram and Judas the traitor"). Charters have become historical documents that specialists continue to study in order to come up with new finds. I will refer to one example, the so-called Liège hand, to illustrate the interest of such research.

ADORNING CHARTER HAND

A German scholar was the first to be struck by the original adornment of charters issued in the Belgian town of Liège in the eleventh and twelfth centuries. He noted in particular

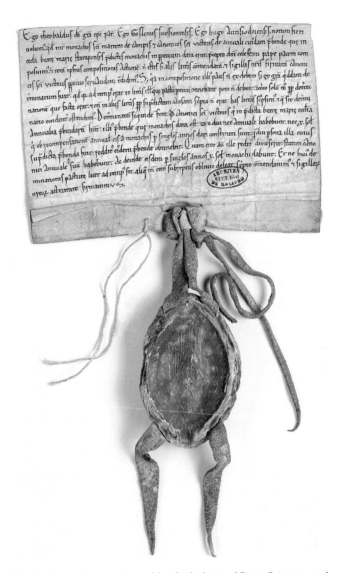

Fig. 15. A joint document issued by the bishops of Paris, Soissons, and Auxerre, relating to a dispute between Saint-Martin-des-Champs and Saint-Victor (1144–1151). A charter was only valid if it had an official seal; here only one of three remain. L. 900, no. 16, Archives Nationales, Paris.

the many loops that scribes added to the ends of the strokes of the letters *s* and *l*, by extending tracery back toward the left (Fig. 16). It was not a question of drawing attention to certain words but merely of decorating the spaces between the lines. At the same time, tildes and other marks of abbreviation assumed unusual scope. Jacques Stiennon then re-examined this issue in the desire to discover whether there existed a "province of the Liège hand." After selecting three criteria—the serpentine swirl of loops, the special spring-like shape of the letter *g*, and the elegant lengthening of the abbreviation for *us*, he began combing archives throughout Europe and learned that this decorative approach was in fact widespread and not

Fig. 16. Details of a charter issued by Thierry, duc de Lorraine, to the chapter of Saint-Dié in 1114.
The scribe was a remarkable calligrapher, displaying great confidence and elegant pen-strokes.
Note, in particular, the gratuitous series of loops above *canonicus,* as well as the original handling of the *g*
(in *rogatu*). G. 248, Archives Départementales des Vosges.

therefore specific to Liège. To a certain extent, he agreed with Hajnal's conclusions on the unity of script across European schools. Yet it is possible to draw further conclusions from Stiennon's study—it revealed not only the influence of the papal chancery on episcopal chanceries in terms of layout and decoration but also the apparent unity of script in Cistercian monastic workshops. The same observations always recur: realms of similar hands existed, charters were solemnized, chanceries mutually influenced one another. As far as what we still call, for the sake of convenience, the decorative Liège hand, its exceptional exuberance clearly reached a region vaster than the province of Liège alone, one that harks back to the former kingdom of Austrasia; this means that the features studied by Stiennon were most common and most spectacular within the area from Soissons to Cologne, from Utrecht to Toul, in Lotharingia (roughly equivalent to the Netherlands, Belgium, Luxembourg, Lorraine, Alsace, and northwest Germany), and east of Champagne. So the idea of a larger "province" of writing is not totally null and void.

A final point worth examining concerns certain notable changes in the eleventh century, when writing suddenly took on greater importance. After roughly 1050, the number of charters grew steadily, generated initially by the bishops, followed in the next century by secular authorities, and finally by all kinds of other people. Special attention has been brought to bear on the archives of monasteries caught in the battle of investitures and the implementation of feudal structures, a period when solid, ample archives were required to consolidate estate claims. That was when old privileges, becoming illegible, were recopied, when cartularies and briefs were compiled, when certain documents were grouped into dossiers, when claimants went regularly to Rome to obtain sweeping confirmations of property, or to recover or obtain new churches unjustly controlled by laymen. As people began writing more, charters evolved: lists of witnesses lengthened, documents were increasingly adorned with a seal or ornate lettering, the use of abbreviations suddenly expanded, and other minor practices emerged (see above). Overall, a rather sudden transformation occurred

Fig. 17. Detail of a cartulary from the commandery at Éterpigny, 1285.
This scribe writes in an equally confident hand, but instead of tracing letters one by one he links them all, accentuating the tall, bold strokes.
This is cursive script. Nouv. Acq. lat. 927, fol. 1, Bibliothèque Nationale de France, Paris.

around 1060–1080 that paved the way for a twelfth century rich in charters, preserved in the collections of the new religious orders (Cistercian, Premonstratensian, and other canons regular) as well as chapter-houses, military orders, and traditional Benedictines. Each order constituted, or reconstituted, archives that are now priceless sources of information for historians. Manuscripts did not undergo a similar change at this time, but continued on their already steady path. In the realm of books, the main new arrival was the cartulary, a collection of copies of original charters to be preserved; such books established a bridge between charters and manuscripts.

THIRTEENTH-CENTURY DEVELOPMENTS

It is obviously presumptuous to attempt to cover the evolution of texts and writing in the West by following only the broad lines, given that there were so many nuances and variations in application. This description of thirteenth-century developments is therefore subject to caution. The most striking novelty was nevertheless the growing use of vernacular languages. In France, of course, by the late eleventh century the type of epic poem known as the *chanson de geste* was composed in the local language, which began to make its way into manuscripts, something that

had occurred much earlier in the Anglo-Saxon and Germanic worlds. When it came to charters, the vernacular arrived later—it began in the second half of the thirteenth century, taking another half century to reach German lands; a different time-scale operated for Italian, Occitan, and Spanish.

A second novelty concerned the shape of letters. Rounded forms dominated until the middle of the twelfth century, when curves broke into angles. Making a connection with the pointed arches of Gothic architecture which were simultaneously replacing round, Romanesque arches, specialists labeled the new script "Gothic." J. Boussard has shown that it may have originated in a way of cutting the quill's writing edge obliquely (as seen in old metal nibs), which made it easier to broaden some strokes and to narrow others, transforming a round letter *o* into a square one, for example. Not everyone is convinced by this explanation; indeed, thin and thick strokes already existed and, furthermore, this new pen would not have permitted the next stage, that of cursive script (Fig. 17). Twelfth-century letters were tightly spaced, and the base of one anticipated the beginning of the next. Soon the pen was no longer lifted, and the link from one letter to another was made. Equally soon, the liberated hand began to flow from one letter to another without stopping at all, extending with a slight stroke the stems and tails that sloped more and more.

The spread of schools, the founding of universities, the increase in the number of students, and the need to distribute books in greater numbers all put pressure on the traditional practices of monastic scriptoria where time mattered little. Workshops were established to facilitate the dissemination of basic texts and invented an assembly-line method of working: the book to be copied was unbound and assigned quire by quire to various scribes, each of whom, working on his own, reproduced the model by carefully respecting text, spacing, and layout. The copied quires were then taken to the binder and assembled for a buyer. Thus arose the systems of *pecia*, or piece-work, without which universities would have suffered a drastic lack of books.

Parchment continued to be consumed in vast quantity, and the major monastic suppliers were joined by parchment sellers in the university towns of Paris, Bologna, and Oxford. Finally, paper arrived in Spain from the East via the Muslims, but only slowly made its way into Western chanceries—it was not yet considered sturdy enough for items designed to last. The day of paper's rise was not far off, however.

THE END OF THE MIDDLE AGES AND THE BIRTH OF PRINTING

The eleventh century had witnessed changes of detail in scripts and saw the emergence of copies, briefs, seals, and systematic archiving. The following period was one of increased religious activity, with the birth of new orders eager for charters and confirmation of privileges, even as towns also began multiplying. The slow transformation of chapter schools into communities of students and masters—that is, universities—plus the increasing control wrested by town burghers over municipalities and urban society, and the consolidation of secular and ecclesiastical territorial power, all created the conditions for a sharp rise in writing and books.

The steep increase in the number of charters has already been mentioned. The few authorities entitled to validate such documents were joined or represented by officials, notaries public, and sworn clerks. Scribes were everywhere: in castles, in provincial headquarters, in mayoral offices, in monasteries, in priories. The widespread custom of keeping accounts and opening registers soon favored, for economic reasons, the greater use of paper in order to save parchment for rarer items (continuing to use skins as the main writing surface would have led to the massacre of herds of livestock).

Books were required for teaching, for reading, and for collecting by patrons—ever more books. Churches brought

Fig. 18. The detail of a manuscript from the Abbey of Marchiennes, 1305, displays the same features as the charter in Fig. 17, here applied to a book hand. Note the concern for a legible layout, as well as the refined capital. Nouv. Acq. fr. 21287, pièce 12, Bibliothèque Nationale de France, Paris.

Hence the fine, rounded letters of Carolingian minuscule became more pointed and slanting. Many scribes remained attentive to traditional practices, but circumstances no longer favored a slow, steady pace.

Just then the difference between charter and book re-emerged (Fig. 18). Charters became smaller in format, placed more text on a given surface, tightened spacing, abbreviated words, and eliminated any text judged pointless (for example, preambles and lists of witnesses). Lay people, municipalities, and princes established archives in turn, opening registers, account books, and cartularies—all books that constituted, as mentioned above, a new category halfway between charters and manuscripts.

their old books up to date and revamped liturgical texts by having them redecorated in the reigning fashion. Burghers wanted to have their own little libraries composed of prose novels, verse romances, books of hours, histories, and chronicles. Gone were the days of clerical and monastic exclusiveness as libraries spread and grew (their swelling catalogs now provide information on their varied content). Art patronage became common; although not every example can be mentioned here, one man's name has gone down in history in this respect—Jean, duc de Berry (died 1416), whose illuminated books simultaneously represented a form of wealth and a sign of cultivation (Fig. 19). Exhibitions in recent decades have amply shown the splendor of German, Italian, and Spanish manuscripts, prefiguring the imperceptible shift from painting on parchment to painting on wood, then canvas. A given artist could change from one medium to another. This movement affected all of Europe, which was busy reading and writing. Everything that museums now display to represent the late Middle Ages—triptychs, painted panels from the fourteenth and fifteenth centuries, frescoes—tends to foreground books, for instance an open book on a stand before the Virgin when visited by the archangel Gabriel, or a volume placed in the hands of a donor.

Handwriting assumed hundreds of forms. The trunk represented by the Carolingian minuscule blossomed into a thousands fronds and leaves like a palm tree or papyrus. On the one hand, the old script survived, barely modified— sometimes rigidified—as its strokes thickened. It sought refuge in luxury manuscripts, in the huge graduals and antiphonaries set on high stands amid the monks' choir stalls, or else it closed ranks in the columns of breviaries and, above all, chronicles. On the other hand, the emergence of cursive script opened the way to every invention; handwriting altered as a function of the dynamics of the pen, becoming smaller (sometimes tiny), formed of short lines and curves that made the original letters hard to recognize. One need merely look at the "unintelligible" marginal notes of Thomas Aquinas, or the scribblings of notaries, or an inventory compiled in some clerk's clumsy hand, or a hasty missive scrawled on a scrap of paper. And this occurred in every language, Latin sometimes remaining calligraphy's last refuge.

The subsequent reaction of humanist scholars is therefore hardly surprising: how could they revive pure

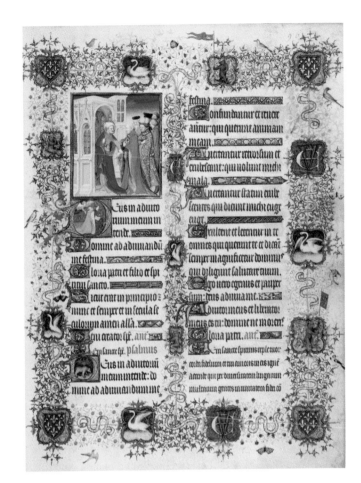

Fig. 19. Shortly before printed books arrived on the scene, the art of scribes and illuminators reached its zenith, as seen in the *Grandes Heures du duc de Berry,* completed in 1409. Here priority went to color and decoration. Books had become an item of luxury rather than work. Ms. lat. 919, fol. 96, Bibliothèque Nationale de France, Paris.

grammar, correct phrasing, and faultless speech if the handwriting itself was deficient? The problem harked back to Carolingian policies. Indeed, the revival of Latin and ancient authors led scholars back to the manuscripts of the ninth and tenth centuries, back to Carolingian script. There thus occurred a renaissance not of Roman books, but of Carolingian books. Humanistic script was one of round, separately written letters; it led to the idea of carving each letter in wood, in order to reproduce it endlessly. Printing was born.

THE BOOK OF KELLS

Jennifer O'Reilly

Insular gospel books, which were also precious liturgical objects, characteristically apply motifs from Celtic and Saxon fine metalwork to the decoration of the written word, most notably at the opening of the sacred text. The native repertoire of abstract ornament (curvilinear trumpet patterns and spirals; rectilinear fret and step patterns; ribbon and zoomorphic interlace) is combined in the Book of Kells with imports from the representational art of the Mediterranean world such as vinescroll, lions and human figures. Different categories of ornament sometimes overspill their boundaries and the framing bands which compartmentalise the design also unify it by their colour and line. The first page of St Matthew's gospel bears only two words, *Liber generationis*, yet is almost illegible (Figs. 1, 2). The circular bosses, curves and spinning spirals of *Liber* are counterpoised by the rectangular multiple frames holding *generationis*. The first syllabe, *Lib*, forms a sweeping ligature which spans the entire page and encircles the second syllable. Below, the shrunken word *gene/rati/onis* is divided into three lines with letter forms of almost runic obscurity shown in orange on purple and then in purple on orange. Such use of colour, like the decorative outlining of *Lib* and the ornamental encrustation not only of the letters but of the spaces between them, creates ambiguity between words and frames, foreground and background. The words are veiled by the ornament; discerning their form provides some visual analogy to the monastic practice of *Lectio divina* in which the reader meditatively seeks the spiritual meaning concealed beneath the literal text of the sacred word.

Mt. 1: 1-17, beginning with the words *Liber generationis*, records Christ's human lineage from the royal house of Judah. Mt. 1: 18 begins the account of the virginal conception and incarnation of Christ which reveals his divine as well as his human nature. Insular gospel books embellished this text to equal or even surpass the opening of the gospel itself. In the Book of Kells f. 34 only the first three words of Mt. 1: 18 are shown, *Christi h* (= *autem*) *generatio*. The second and third words, written in insular majuscule, the main script of

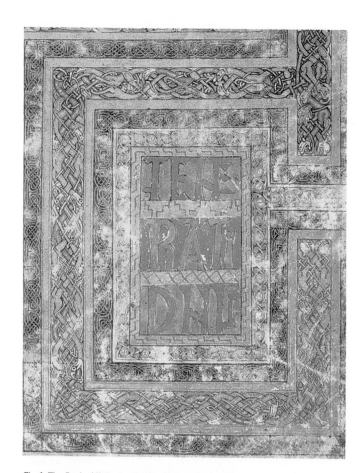

Fig. 1. The *Book of Kells*, detail of fol. 29: "*generationis*".

the manuscript, lie almost unnoticed at the bottom of the page. The Greek title Christ (Messiah) is shown through its customary abbreviation XPI derived from the Greek letters *chi* and *rho*, but is magnified so that the initial letter embraces the whole page. The arms of the *chi*

Fig. 2. The *Book of Kells*, fol. 29: "Genealogy of Christ", Mt 1: 1.

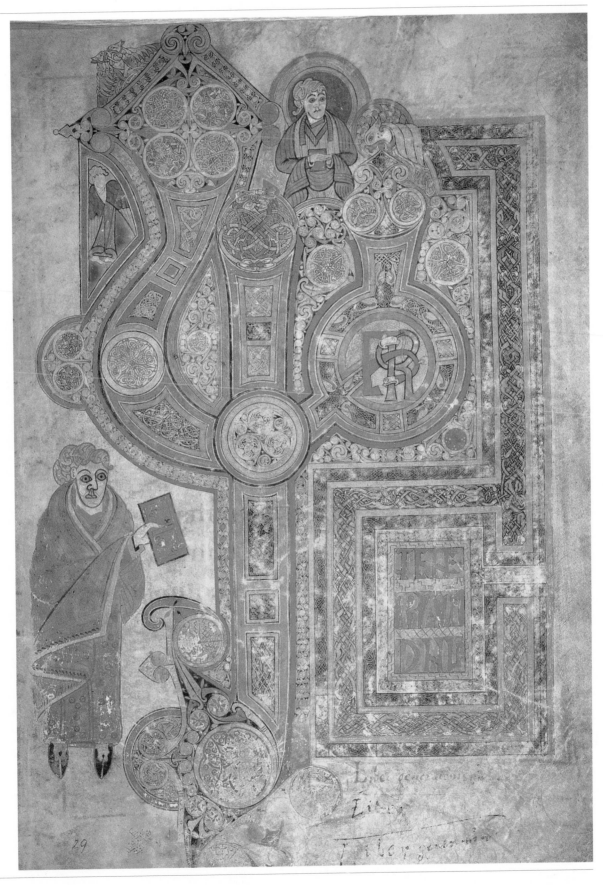

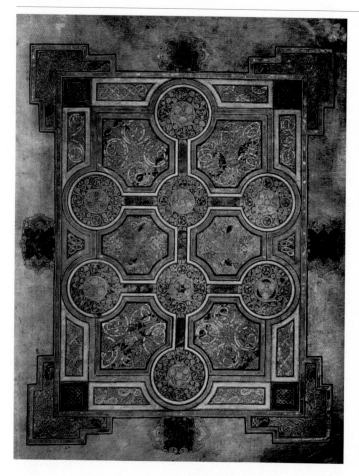 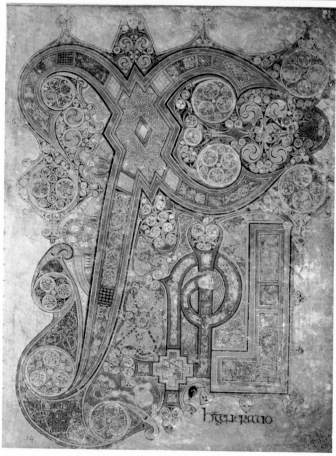

Fig. 3. The *Book of Kells*, fol. 33r and 34r. Reconstitution of the probable original layout:
the cross with the eight medallions and the chrisma page facing each other, forming a single visual composition.

radiate in four directions and whirl into spools of roundels and spirals;
the letter *rho* (p) and the Latine ending (i) stem from extensions of
a small equilateral cross. A foreshortened version of this golden cross
appears in the rhombus at the centre of the *chi*. The page is inhab-
ited by creatures of earth, air and water. Within the rhombus, which
is an image of the quadripartite cosmos, are four human figures; to
the left are moths and angels and below are cats and mice and a black
otter with a fish. The interlace ornament is formed from vine scrols
and stylized birds, serpents, quadrupeds and humans. Christ incar-
nate is here identified with the Creator-Logos. The divine Word is
revealed in a word which is hidden in the design as Christ's divinity
lies hidden in his Creation, beneath his human flesh and within the
scriptural text.

Bibliography

ALEXANDER J. J. G. *Insular Manuscripts, 6th to 9th Century* (London: Harvey Miller, 1978).

ANDERSON, George. *From Durrows to Kells, The Insular Gospel-books 650-800*, (London: Thames and Hudson, 1987).

FARR, Carol. "Lection and interpretation: the liturgical and exegetical background of the illustrations in the Book of Kells." PhD dissertation (Austin: University of Texas, 1989).

FOX, Peter (ed.). *The Book of Kells, MS 58, Trinity College Library Dublin* (Lucerne: Faksimile Verlag, 1990).

HENDERSON, Isabel. "The Book of Kells and the snake-boss motif on Pictish cross-slabs and the Iona crosses." Michael Ryan (ed.). *Ireland and Insular Art A.D. 500-1200* (Dublin: Royal Irish Academy, 1987), pp. 56–65.

HENRY, Françoise. *The Book of Kells* (London: Thames and Hudson, 1974).

LEWIS, Susan. "Sacred calligraphy: the Chi Rho page in the Book of Kells." *Traditio* 36 (1980): 139–159.

MEEHAN, Bernard. *The Book of Kells* (London: Thames and Hudson, 1994).

O'MAHONY, Felicity (ed.). *The Book of Kells. Proceedings of a conference at Trinity College Dublin, 6-9 September 1992* (Dublin: Scolar Press, for Trinity College Library, 1994).

O'REILLY, Jennifer. "The Book of Kells, fol. 114r: a mystery revealed yet concealed." R. M. Spearman and John Higgitt (eds.). *The Age of Migrating Ideas. Early Medieval art in Northern Britain and Ireland* (Edinburgh: National Museums of Scotland, 1993).

WERCKMEISTER, Otto-Karl. *Irisch-Northumbrische Buchmalerei des 8. Jahrhunderts und monastiche Spiritualitat* (Berlin: Walter de Gruyter, 1967).

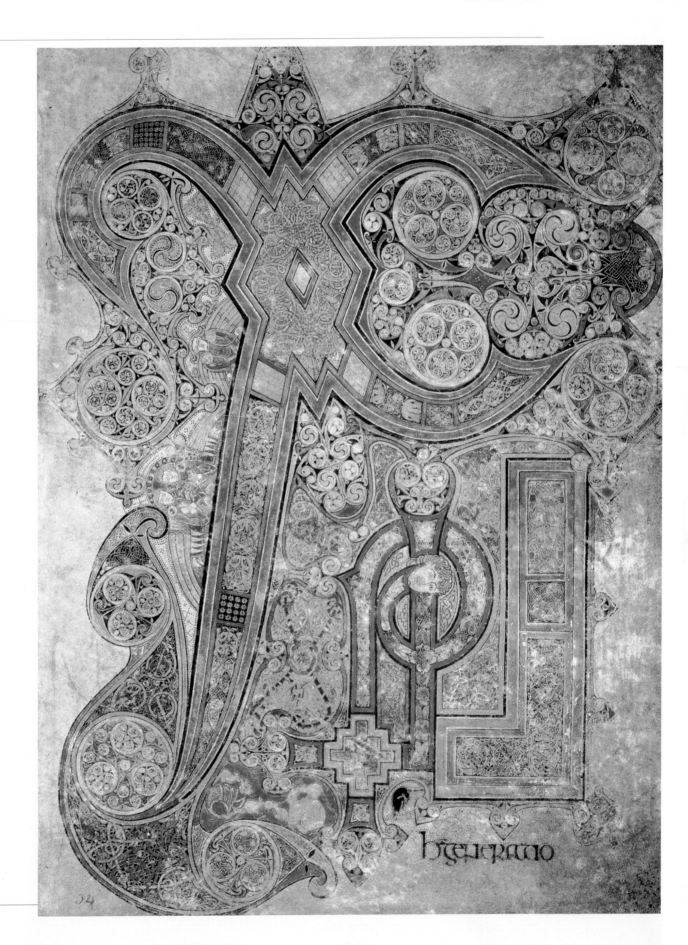

Fig. 4. The *Book of Kells*, fol. 34:
"The name of Christ", Mt. 1: 18

A MEDIEVAL STAGE MANAGING BOOK

Darwin Smith

From the late fourteenth century to the mid-sixteenth century, towns in France, Germany, and Flanders staged large-scale mystery plays. These local liturgies required months of preparation by the entire community. As celebrations of patron saints or founding myths, they were stimulated by economic—indeed political—as well as religious motivations. The *Passion of Christ,* the most frequently performed mystery play, contributed to the intense growth of Christocentric worship during that period. These huge urban events came to an end in the mid-sixteenth century, the victim of religious divisions brought about by the Reformation and of parliamentary prohibitions.

In July 1501, a week-long Passion play was performed in Mons (in modern-day Belgium). To prepare the event, the town's aldermen turned to the nearby city of Amiens for a copy of the play, from which were produced *originaux* (copies of the entire text), *parchons* (players' parts), and *abregiés* ("briefs" for the stage director). The *abregié* used at Mons comprised eight volumes (ranging in length from 56 to 116 pages), one for each day of the performance; there were two copies of each volume. This manuscript is unique of its kind in French—almost no technical documents from the Middle Ages have survived, except for a few very rare items (including, in the theatrical sphere, a notebook of special effects employed by a "master of secrets"). Apart from the *originaux* that constituted the definitive text for the performances, there also survive working copies and luxury copies made for private or public reading, for religious or meditative purposes.

Each sheet of the *abregié* was lightly folded down the middle to create two equal columns of writing; on the right-hand side were cues to the text, on the left-hand side were stage directions. Certain crucial instructions ran across both columns so that they would not be missed by the technical director.

RIGHT-HAND COLUMN:

The names of characters, written in large, *lettre de forme* script: DIEU [GOD], ADAM, EVE, LE SERPENT.

When a character appears for the first time, the name of the actor playing the role is indicated in a small cursive hand. Here LE SERPENT is followed by "*filz* [young] *Pierre Parmentier*."

Below the name of the character are given the first and last lines of each speech:

DIEU [GOD]: *Mauvais serpent et decepvable* [Evil serpent, so deceiving] . . .

The total number of lines in the speech is indicated in the right-hand margin (here, *xxxvi*), enabling the director to check the actor's knowledge of the part by counting the verses.

LEFT-HAND COLUMN:

Stage directions indicate the action or stage business that accompanies certain lines, as well as the entrances and exits of characters.

To the left of the first speech of DIEU, the directions read: *Quant il a dit "tous les jours..."* [When he says "all the days of thy life, dust shall thou eat," then the serpent slithers on his belly; and at the end God departs from them and goes to the room below Paradise, as before.]

Shorter directions are centered in the left-hand column. Next to Adam's third speech on this page, the directions read: *Il luy donne le nom de Eve*, meaning "He gives her the name [inscribed nameplate] of Eve."

ACROSS BOTH COLUMNS (just below Adam's first speech):

The abbreviation *N°* (for *Nota Bene*) is followed by important instructions to the stage manager: "During this speech, warn God, who is in the room below Paradise, to bring with him, when he returns to earthly Paradise, two angels carrying the two pelts that will have been prepared so that he can give them to Adam and Eve [to hide their nakedness]."

The synoptic page layout and the use of different scripts make it easy to monitor actors, text, and stage business all at once. The system is so perfect that it betrays a well-established tradition: the Mons *abregié* is obviously an accomplished example of the tools used in stagecraft during the golden age of grand urban mystery plays in French-speaking Flanders.

A page from a 1501 *abregié,* or manuscript of stage directions. MS. 1086, fol. 3r, Bibliothèque Universitaire de Mons-Hainault, Mons, Belgium.

Bibliography

COHE, Gustave. *Le Livre de conduite du régisseur et le compte des dépenses pour le mystère de la Passion jouée à Mons en 1501* (Paris/Strasbourg: Les Belles-Lettres, 1925).

KÖNIGSON, Élie. *La Représentation d'un mystère de la Passion à Valenciennes en 1547* (Paris: Éditions du CNRS, 1969).

SMITH, Darwin. "Les manuscrits de théâtre: Introduction codicologique à des manuscrits qui n'existent pas." *Gazette du livre médiéval* 33 (1998).

———. *Maistre Pierre Pathelin, comédie: Texte d'un recueil inédit du XVe siècle. MSS. Paris BNF fr. 1707 and 15080* (Saint-Benoît-du-Sault: Tarabuste, 2001).

VITALE-BROVARONE, Alessandro. *Il Quaderno di segreti d'un regista provenzale del Medioevo: Note per la messa in scena d'una Passione* (Alessandria: Edizione dell'Orso, 1984).

FORMS AND HISTORY OF WRITING IN ITALY

Armando Petrucci

In the last years of the eighth century BCE, the Greek alphabet arrived in the Italian peninsula and its surrounding islands and was swiftly adapted by the Etruscans to their own specific phonetic requirements, while the Etruscan alphabet in Rome and Latium generated what was later known as "Latin"—the most widespread alphabet in the world today. The standardization of writing systems in Italy took place progressively, in parallel with the political unification that Rome was engineering and was only completed during the two-hundred year period that straddled the transition to the Christian era. Thereafter, the literate inhabitants of Italy used only the Latin alphabet in its various forms, which, until the third century CE, comprised three styles of the capital letter: a cursive script, used in documents and for private purposes; book hand, or "rustic" capitals; and an epigraphic, monumental script, which was characterized by great solemnity. In the third and fourth centuries CE, North Africa introduced lower-case letters similar to those now used. Next came "new cursive" for everyday and bureaucratic use, and then an affectedly elegant elaboration of the capitals—incorrectly described as "uncial writing"—which was widely used in late Antiquity and the early Middle Ages in Italy and the rest of Europe.

The main pre-medieval lettering styles were employed in Italy until the beginning of the ninth century. In addition, cursive and semi-cursive scripts deriving from the new cursive style were widely used. In parts of northern Italy, writing styles imported from other areas of Europe were used, such as French Merovingian and insular scripts. In southern Italy—then divided between the Byzantines and Lombards until the second half of the eleventh century—a distinctive upright minuscule semi-cursive script established itself in the second half of the eighth century. Eventually it became the national script of the Lombards in the south and was therefore called "Beneventan," from the name of the capital of the area's largest principality. It was used until at least the end of the thirteenth century.

The Franks occupied the Italian kingdom in 774, and, in 800, Charlemagne constituted the Holy Roman Empire. The Frankish influence led to the introduction in central and northern Italy of the new

Carolingian minuscule script from France. In Rome and central Italy the Carolingian script adopted a flattened and sloping form, developing into a distinctive local style: "roman."

The different writing styles in the Italian peninsula between the ninth and the eleventh centuries reflect the exisiting political division, represented by a frontier line—from Rome to Ancona—that divided Italy into two linguistically distinct areas.

In the twelfth and thirteenth centuries, the administration of central and northern Italy, with its system of communes, contrasted with that of the south, which was under Norman and then Swabian rule, but the writing styles in the peninsula converged in the wake of the widespread adoption of the Gothic minuscule as a book hand and a then-developing new cursive script (*minuscola cancelleresca*, or chancery hand). In Italy, Gothic script established itself in various ways: in the north and center, from French influence and because it was used by notaries; in the south, from the Normans and the new Carthusian order; and in Bologna, as a round, compact form used for the production of university textbooks (*littera bononienis*). In late medieval Italy, the new cursive scripts were widely employed as a book hand, above all for the diffusion of the new literary texts in the vernacular. In addition to the *minuscola cancelleresca* there was the *mercantesca* (merchant hand), which was round and flattened. This script, which originated in Tuscany toward the end of the thirteenth century and then spread to northern Italy, was used by merchants, bankers, craftsmen, and city dwellers who did not know Latin, and it continued to be used for both private purposes and public documents well into the sixteenth century. Wherever this distinctive round and compact cursive writing appeared in Europe and the Mediterranean area, it clearly signaled the Italian presence.

Meanwhile, in the fourteenth and very early fifteenth centuries, a new intellectual elite, consisting mainly of notaries and clerks, formed in the largest cities of northern and central Italy. This humanist movement created a new type of culture and adopted an almost exclusively classicistic form of Latin. Along with these developments, Petrarch led

Andrea Mantegna,detail of the dedication of *The Bridal Chamber*, 1474. Fresco. Mantua, Palazzo Ducale.

a strong polemic against the scholastic book and the Gothic script; the latter was regarded as crabbed, mechanically contrived, and difficult to read, and the humanists countered it with the old Carolingian minuscule. As a result, in the fourteenth and fifteenth centuries, the *antiqua* or *umanistica* minuscule originated in Florence, inspired by the Carolingian script. It spread throughout Italy and the rest of Europe, where it became the book hand of the cultured elite and ruling classes (e.g. Medici, house of Aragon, Malatesta and Mattia Corvino).

In the second half of the fifteenth century in Milan and Rome, and then elsewhere, a second type of humanistic hand appeared, with larger, rounder letters: the *antiqua tonda*, which, with the influence of Donatello and Andrea Mantegna, was enriched with capital letters inspired by ancient Latin inscriptions. Meanwhile, in the first part of the century, several types of cursive strongly influenced by the humanistic minuscule had been developed for use as book hands. In the last thirty years of the century this type of script gave birth to a mannered yet elegant cursive hand, with a pronounced forward slope to the right. This was known as italic script, the most outstanding exponent of which was the calligrapher Bartolomeo Sanvito. Thus, by the end of the fifteenth century, Italy had provided the rest of Europe with the three principal types of letter form that are still used in printing today: the monumental capital found in inscriptions, the *romano tondo* character, and italic, introduced into typography by Aldus Manutius in 1510.

During the sixteenth century Venice and Rome continued to play an important role in the development of scripts for handwriting, printing and engraving: in treatises by the masters of writing, the manuals of calligraphy produced in Rome during the pontificate of Sixtus V, and the use of speedier forms of bureaucratic cursive scripts promoted first by Giovanni Battista Cresci and then by Scalzino. Yet within a few decades, Italy produced no new innovations in the field of writing due to a combination of factors: the decline of publishing in Italy (which continued to flourish in Germany, France, and Holland); the spread of new styles of writing (Mannerist and Baroque) in Spain, France, and the Low Countries; the creation of new Latin and Greek type in Paris, Antwerp, and elsewhere; the transfer of philological and medico-scientific research to areas outside Italy; and a period of general economic and political crisis in the Italian states. This state of affairs persisted beyond the French Revolution, the beginning of the Industrial Revolution, and the unification of Italy, all the way to the twentieth century. Several factors are responsible for the fundamental weakness in the field of writing that exists in contemporary Italian culture: a widespread illiteracy that lasted for far too long, the fragility of the culture of the elite, the absence of a modern publishing industry, and the indifference of the country's politicians to the problems of the written language. In other milieux—that is, among the semi-literate or the fringe groups of marginalized intellectuals—some attempts were made at representing the written word in innovative and original ways, but these would have disappeared if advertising had not occasionally revived them. Otherwise, people write in Italy as they do elsewhere: not inventing or proposing, but simply repeating.

Spelling in France: Texts and Style

Nina Catach

With its contrast between old forms and new ideas, the treatise by Geofroy Tory known as the *Champfleury,* published early in the Renaissance, symbolized not only the absence of French printing standards but also an immense aspiration to modernize graphic and typographic presentation (Fig. 1).

Printed like a traditional Gothic work—with archaic spellings, abbreviations, typographical errors, minimal indenting and punctuation—the book nevertheless featured fine roman letters as well as the first printed quotation marks (in the margins), probably at Tory's request.

Tory, a humanist scholar, had been a proofreader for the Estienne printshop and became a printer in his own right. After spending time in Italy, he wrote the *Champfleury* to teach French typefounders how to design and cut "roman" letters. He also discussed, for the first time, the need for accents and other signs (apostrophes, cedillas, etc.) to represent the French language. He would later apply and develop these ideas in a modest pamphlet of 1533, titled *Briefue Doctrine pour deument escrire en langaige francois* (Brief Doctrine for Duly Writing in the French Language). This little manual made a true mark on the language. In the ten years between 1530 and 1540, thanks to Tory's own example, most French printshops began following his instructions, acquiring the new characters and using them extensively. Along with Tory, these typecutters and typographers were largely responsible for a major transformation of the French language.

The young poet Pierre de Ronsard was so enthusiastic about these new ideas that his first collection of poems contained a veritable manifesto against old-fashioned spelling (Fig. 2). Without going so far as the advocates of phonetic spelling, Ronsard proposed his own

Fig. 1. The letter "V" from Geofroy Tory's *Champfleury,* or "Art and Science of the True Proportions of Antique Letters . . . Commonly Called Roman Letters, Proportioned According to the Human Body and Face" (Paris: Gilles de Gourmont, 1529). 2°. Rés. V.515, Bibliothèque Nationale de France, Paris.

AVERTISSEMENT AV
Lecteur.

I'Auoi deliberé, lecteur, suiure en l'orthographe
de mon liure, la plus grand part des raisons de
Louis Meigret, homme de sain & parfait iuge-
ment, qui a le premier osé desseiller ses yeus pour
uoir l'abus de nostre écriture, sans l'auertissement de
mes amis, plus studieus de mon renom, que de la ue-
rité: me paignant au deuant des yeus, le uulgaire,
l'antiquité, & l'opiniatre auis de plus celebres igno-
rans de nostre tens: laquelle remontrace ne m'a tant
sçeu epouanter, que tu n'i uoies encores quelques
merques de ses raisons. Et bien qu'il n'ait totale-
ment raclé la lettre Grecque y, come il deuoit, ie me
suis hazardé de l'effacer, ne la laissant seruir sinon
aus propres noms grecs, comme en Tethys, Thyeste,
Hippolyte, Vlysse, affin qu'en les uoiant, de prime
face on connoisse quels ils sont, & de quel païs nou-
uellement uenus uers nous, non pas en ces uocables
abíme, Cigne, Nimphe, lire, sire (qui uiet comme l'on
dit de κύριος changeant la lettre x en σ) lesquels
sont déia reçeus entre nous pour François, sans les
marquer de cét epouantable crochet d'y, ne sonnant
non plus en eus que nostre I en ire, simple, nice, lime.

Fig. 2. The "Notice to Readers" from Pierre de Ronsard's first collection of odes, *Les Quatre Premiers Livres des Odes* (G. Cavella[r]t, 1550). Octavo. Rés. Ye 4769 and Manuscript Department, Rothschild II.3.62, Bibliothèque Nationale de France, Paris.

system based on ancient poetic traditions. His proposals met with great success, and his sensible innovations were swiftly adopted, first by his poet friends—the Pléiade group—then by printers, and later by all creative writers of the day, ultimately resulting in what would be called "Renaissance spelling."

Ronsard's volume benefited from a fine italic typeface with handsome characters cut by the Wechels, his publishers. The poet advocated a "modernized" spelling with accents, punctuation marks, hyphens, the use of *j* for *i,* and so on. Although he respected the traditional graphic layout of the day, he dropped consonants that were silent or doubled, eliminated "Greek" letters (notably *y*, called "Greek *i*" in French), replaced terminal *x* and *z* by *s,* and systematically substituted *an* for *en.*

Ronsard's innovations, forgotten in France during the wars of religion, were taken up in the Low Countries by printers such as Plantin, Waesbergue, and Elzevier, and therefore resurfaced back home in the second half of the seventeenth century. They led, slowly and steadily, to the shift from "old-style spelling" (still followed by the Académie Française) to the current system (starting in the eighteenth century). This basically entailed renewed use of accents over vowels, which

meant dropping the silent letters that had played the same accenting role (*escole* became *école, niepce* became *nièce,* etc.)

Shortly after Antoine Baudeau de Somaize published his *Grand Dictionnaire des Pretieuses* (or *Précieuses*) in 1661, Louis de Lesclache, a fashionable lecturer and advocate of literary salons whose ideas often brought him into conflict with religious authorities, enthusiastically promoted a resolutely phonetic spelling of French. He wanted to come to the aid of "all those who do not know the Latin language but have good minds," including women, who were resolutely struggling for access to learning and for simplified spelling (Fig. 3).

Fig. 3. Louis de Lesclache's "Veritable Rules of French Spelling": *Les véritables Régles de l'ortôgrafe francéze ou l'Art d'aprendre an peu de tam à écrire côrectement* (Paris: Lesclache and L. Ronder, 1668). Octavo. Rés. X 1955, Bibliothèque Nationale de France, Paris.

LA CANTATRICE GRAMMAIRIENNE.

L'ESPRIT s'ennuie & ſe dégoûte de tout ce qui ne ſe préſente pas à lui avec les graces de la nouveauté. Ainſi nous pouvons dire qu'il en eſt d'un ouvrage comme du plaiſir : l'un & l'autre ont beſoin d'être variés pour être goûtés avec de nouveaux charmes. L'ame éprouve alors une agréable ſecouſſe qui la réveille & la rafraîchit.

« L'ennui naquit un jour de l'uniformité »

nous dit un poëte agréable. Diverſité ſera la deviſe d'une production à laquelle j'avois cru d'abord ne pouvoir ravir la monotonie qui paroiſſoit en être le partage. Je prie les dames de ne faire que de très-courtes réflexions ſur le précepte. Les chanſons qui le confirment, diront plus que le précepte lui-même. Nous avons ex-

A

Fig. 4. The title page from Abbé Louis Barthelemy's "Singing Grammarian," which taught spelling "through erotic, pastoral, rural, and anacreontic songs." *La Cantatrice grammairienne ou l'Art d'apprendre l'orthographe françoise. . .* (Geneva and Lyon: J.-S. Grabit, 1788). Octavo. X 13059, Bibliothèque Nationale de France, Paris.

"La prononsiasion des mos qui la compozent doit être la règle de l'Ortografe," wrote Lesclache ("Prununsiashun of wurds cumpozing it shud be the rool of speling"). He wanted to eliminate all etymologically based letters, to extend the use of accents, to replace *s* by *z, x* by *s,* and so on.

The illustration on the title page of his book is mannered and laden with arabesques, reflecting the taste of the day. The italic characters were of varying sizes, and both upper-case and lower-case letters had loops that closely mimicked handwriting. This baroque style contrasts sharply with the modernity and graphic simplification that Lesclache was promoting. It seems a long way from the sober forms advocated earlier by Renaissance typecutters (and later adopted again in the eighteenth century and the modern era).

Lesclache was only one of many—including Robert Poisson (in 1609), Lartigaut (1670), and Gilles Ménage—to raise the issue of spelling. The proposals contained in his book may have been too bold to gain acceptance, but his arguments would be used to defend the "new," modernized spelling initially inspired by Ronsard, which would be widely adopted by seventeenth-century writers and their successors.

On the eve of the French revolution, teaching spelling to both children and adults became a priority. Toward the end of the eighteenth century, Abbé Louis Barthelemy from Grenoble became a fashionable tutor—like Lesclache a century earlier—who counted young ladies from good families among his pupils. He authored one of the many handbooks of spelling and grammar "specially designed for ladies," each trying to outdo the others in the originality of their teaching methods. The abbé's method featured songs, some of which—rather surprisingly—were bawdy; judged to be a little too risqué, the book was published anonymously (Fig. 4).

Henceforth, however, women—who did not receive formal schooling and were not taught Latin—had to learn how to spell. And Abbé Barthelemy suggested that they do it with song. "A singing mood," he wrote, "is one of the characteristics of women: happy or sad, they are always singing. . . " He therefore proposed that they learn to use accents over letters while singing Beaumarchais' *Égarements d'Elvire* (The Error of Elvira's Ways), and learn declensions through *Nous sommes précepteurs d'amour* (We're Tutors of Love).

Yet when it came to spelling, the abbé proved to be staunchly conservative. He indignantly criticized what he called "neographs," people such as Restif de La Bretonne who wanted to "write the way one speaks" by publishing passages of the following type: "J'sentis un attendrissement *délicieus* . . . J'vis sous les arbres un *home* vêtu de noir, avec une *famme en-satin-couleur-de-tabac* . . ." ("I feel a deliteful tendernes . . . seeing a man drest in blak with a ladee beneeth the treez . . .").

This profusion of aspirations and ideas soon withered in the days of the Directorate and Empire, when there was a return to Latin and when women and spelling were both firmly brought into line once more.

Bibliography

BEAULIEUX, Charles. *Histoire de l'orthographe française* 2 vols. (Paris: Champion, rpt. 1967). On Tory, see vol. I, pp. 210–215, and vol. II, p. 19. On *Briefue Doctrine*, see vol. II, pp. 103–123.

BRUNOT, F. *Histoire de la langue française des origines à nos jours*, 15 vols. (Paris: A. Colin, 1905-1996). On Lesclache and *Les Précieuses*, see vol. II, pp. 93–123; on the late eighteenth century, see vol. VII, pp. 156–182.

CATACH, Nina. *L'Orthographe française à l'époque de la Renaissance (auteurs, imprimeurs, ateliers d'imprimerie)*. Ph.D. Thesis (Geneva: Droz, 1968). On Tory and *Briefue Doctrine,* see pp. 31–60, 459–461. On Ronsard, see pp. 108–127, 426–433.

SOMAIZE, Antoine Baudeau de. *Le Grand Dictionnaire des Pretieuses*, 3rd ed. (E. Loyson & J. Ribou, 1661).

SIGNATURES

Béatrice Fraenkel

A signature has the power to transform things. The absence of a signature—whether from a painting, a letter, or a piece of furniture—is alleged to depreciate the value of the object, to invalidate written texts. Where do signatures get their power? Is it from the written name that evokes the identity of a specific author, or from the trace of the physical gesture made by the hand attesting to an individual's presence, or from the intention thus expressed by someone who is acting deliberately?

Signing undoubtedly derives its power from a combination of these three elements, and it is this hybrid nature that makes such marks simultaneously familiar and exceptional. The name invokes an individual's social identity and genealogical position, the graphic trace incarnates the hand and body that produce it, as well as the support that receives it, and the intention to sign belongs to the realm of legal acts. So despite its modest appearance, a signature incorporates the founding principles of both individual and society.

The semiological scaffolding that characterizes signatures is the result of a long historical process that began in the sixth century and ended in the sixteenth century when signatures became mandatory.

THE LEGACY OF A VANISHED SYSTEM OF SIGNS

It was in the sixteenth century (1554) that a decree issued at Fontainebleau by the French King Henry II made signatures mandatory: "We order that henceforth all contracts and obligations, receipts and private acts bear, in addition to a notary's sign, the signatures of the consenting parties when they know how to sign or, when they know not how to sign, the signature of some other worthy man known to them, at their request." Thus a long process of transformation of signs of identity came to an end. The culmination of this process was as noteworthy for what it promoted—an autographed signature of a name—as for what it abandoned and proscribed—seals and marks. Indeed, the methods of validating a document or signing a letter varied in the Middle Ages. A signature was a mark generally used by the literate and was less employed than a seal, that glamorous mark favored by all levels of society.

INVENTING NEW SIGNS OF IDENTITY IN THE WEST

Between the sixth and the sixteenth centuries, the system of signs of identity underwent a profound upheaval. Proper names changed radically once the Latin system comprising three elements—personal name, name of the *gens* (clan) and family name—was abandoned in favor of the single-name system characteristic of

Fig. 1. A charter dated June 12, 947, bearing the monogram and seal of Emperor Otto I, next to the chancellor's drawn "beehive" symbol. Archives, Abbey of Saint-Gall.

Fig. 2. Testament of Édouard de Beaujeu, marshal of France, April 6, 1347.

Christians and Germanic peoples. Then, at the end of the Carolingian period, it became apparent that a single name no longer sufficed to distinguish individuals. Homonyms began to proliferate even as the need for identification increased when written law became more important: if a legal document proved necessary for the sale of property or the drafting of a testament or endowment, it could be difficult to individualize a subject on the basis of a proper name only. So people adopted the habit of adding an epithet to qualify overly common names. As this epithet steadily became transmittable, surnames emerged. Thus faced with new situations—the establishment of legal documents—individuals acquired a new institutional identity. Writing imposed a logic of identity which supposed that everyone could be individualized beyond the small circle of their immediate community.

IDENTITY VIA IMAGE

Another system developed alongside proper names, that of the coat of arms. Its importance was reinforced once heraldry became rampant in seals. A seal was indeed the sign of identity and validation *par excellence*. Seals dominated the system of personal marks and served as a model for the signatures used today. Kings affixed their seals to solemn acts, and princes and nobles did likewise. It was only people in the writing trades—chancellors, notaries, scribes, and monks—who signed with a written phrase, symbol, or name (Fig. 1).

A LOVE OF IMAGE AND EMBLEM: ICONIC SIGNATURES

A seal allowed everyone to express an identity not only through a name but also by a coat of arms or personal emblem. Imagery prevailed,

providing a symbolic and imaginative repertoire on which everyone could draw widely. The appeal of iconic expressions of identity is attested in testaments, a document that the testator and witnesses all had to validate with their autograph mark, as seen in the will of Édouard de Beaujeu (Fig. 2). Six witnesses signed his testament, along with the notary public and marshal de Beaujeu himself. Every type of signature figured here: the notary wrote his name, which he underscored with a bold line, not unlike a modern signature. Two witnesses drew their shields, thereby signing with their arms; another depicted a dog's head, probably derived from his seal. De Beaujeu himself signed by drawing a fine winged helmet. In the fourteenth century, then, a heraldic mentality coexisted with scribal traditions of writing names.

Yet scribes themselves also demonstrated their fascination with images and heraldry. Thus notaries public in southern France developed the *seing,* a professional mark or "sign manual" designed to validate the documents they certified. Bernard de Ferrières (1303), for example, signed with the letter B followed by a highly decorative but relatively restrained design by comparison with his colleagues Jean Poulet (1326) and Teste (1371) who boldly employed a telling rebus or canting arms that punned on their names (Fig. 4). Notaries seemingly tried to outdo one another in wit and virtuosity. Their marks represented a personal choice.

These examples make it easier to understand the difficulty encountered by the sixteenth-century lawmaker who wanted to impose written signatures and thereby eliminate all marks, images and seals. In fact, it took several decades for the alphabetic system to

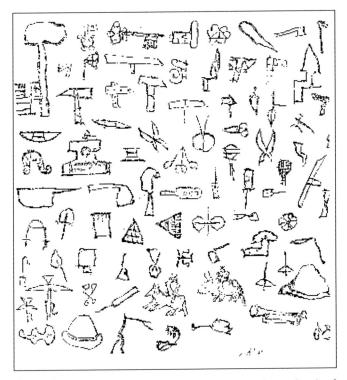

Fig. 3. Craftsmen's signatures from the sixteenth and seventeenth centuries, city of Laon, France.

Fig. 4. Notarial signatures of (from top) Bernard de Ferrières (1303), Jean Poulet (1326) and Monsieur Teste (1371). (*Poulet* and *teste* signify chicken and head in French.)

triumph over the iconic one. Numerous documents from the sixteenth and seventeenth centuries show that many craftsmen signed by drawing the symbol of their trade. Some were perhaps illiterate and therefore unable to write their names, but others chose to draw a gild emblem—hat, barrel, trumpet, and so on—rather than a surname that they felt signified little (Fig. 3).

The triumph of the written signature could be understood as symptomatic of a cultural upheaval that would slowly encompass all Western societies. Individuals entered the written world more and more profoundly, drawing from it new signs of identity, new graphic habits, new means of acting. Yet it also meant subscribing to a new discipline—when signing our name, we must always repeat ourselves—and acquiring new modes of perception: everyone would soon have their own personal handwriting, and their signature would be endowed with a special expressive function. From this standpoint, signatures have assumed their characteristic importance in alphabetic cultures whereas seals remain special signs of validation and identity in the Far East.

URBAN FORMS OF WRITING IN THE EIGHTEENTH CENTURY

Daniel Roche

For thousand of years, cities have produced and consumed writing in every possible form. Urban adoption of the print culture favored the spread of writing through the mechanical reproduction of texts, even as it disseminated new items that were easier to handle, thereby increasing the presence and use of writing. In this regard, the Age of Enlightenment inherited an accumulation of various means of written communication for which cities were the site of intense production and privileged consumption.

Three factors contributed to this increase in written forms, consolidating and increasing the impact of urbanity in the division of social and economic forces. Government and politics, by augmenting the requirements for information and the means of publishing it—in the form of posters, regulations, mandatory documents, clandestine reports and manuscripts—generated new relationships between the people and the urban ruling classes. Economics, meanwhile, developed naturally in cities because that was where, throughout all of Europe, the product of income was consumed; and the economy required daily information, evaluation, and correspondence, so that all kinds of writing—from handwritten sheets to printed documents—were generated by the vast movement of "sweet trade." Finally, the intellectual, moral, and religious capital invested in the city was being reinforced by the educational polices of Church and State, mobilizing the many manifestations of intelligence and innovation and encouraging their reproduction within society. European printers were the children of cities, and their influence grew throughout the eighteenth century along with the general increase in printed output, the acceleration of sales, and the diversification of documents (always dominated by utilitarian texts). The requirements of the new society were symbolized by the spread of newspapers, those vehicles of advertising, information, and interpretation.

Knowing how to consume and produce writing became first a necessity and then a habit for the urban population. Literacy spread from top to bottom, among women and the poor, stimulated by the

Fig. 1. Street posters and notices in an early nineteenth-century print by Charles Motte, titled *Is it Raining? Or, A Surprise!* Musée Carnavalet, Paris.

Fig. 2. Shop signs, handbills, and labels in an eighteenth-century painting by Léonard Defrance, *At the Sign of Minerva's Shield.* Musée des Beaux-Arts, Dijon.

requirements of growth. Not only did writing win out, but it produced a specific culture in which acts and behavior were based on new skills, where occasions to meet and communicate afforded even the most destitute—indeed, the illiterate—greater hope for basic cultural progress. Urban writing informed and transformed, as witnessed by various practices both personal and collective. It accumulated first of all in the home, in the form of letters and books, family papers and practical documents. It respected the hierarchy of social stations even as it somewhat transcended them in larger cities where written culture enjoyed more numerous outlets than elsewhere—including hoax and slander (quickly read and quickly tossed away), handwritten posters and printed broadsheets (scrutinized in the street), and letters of all kinds (indispensable to all).

The varied forms taken by urban writing—learned by most at school, perfected by some through calligraphic training offered by master scribes—intervened at every moment in the lives of everyone, appropriated for diverse purposes ranging from the scholarly to the scurrilous, employed by the learned and the uncultured alike. Reading and writing wove an unbreakable network of intellectual habits among people, modifying the relationship between mental capacity and material resources. They yielded goods whose use value and symbolic value strongly rivaled their exchange value. The process of disclosure at work throughout the city led to distinct practices, to increased differentiation in ways of appropriating both the written word and typographic materials. Learning to write and to read the city itself would then become not just a dream but a compulsion.

LETTER WRITING IN FRANCE IN THE SIXTEENTH TO EIGHTEENTH CENTURIES

Roger Chartier

Sitting by an open window that offers a glimpse of the city beyond the trees, a young woman bathed in soft daylight is deeply absorbed in reading a carefully unfolded letter, one that probably speaks of love. Seventeenth-century Dutch painters like Pieter de Hooch loved to portray people reading or writing a letter (as in the painting shown opposite). So did their French counterparts a century later. In these contrived depictions, epistolary communication served to convey highly intimate thoughts. Written or read in solitude, well away from prying eyes, a letter respected the privacy that bound communing souls—it brought hearts together and vanquished absence.

This image should not mislead us, however. Between the sixteenth and the eighteenth centuries, it applied only to a small fraction of actual correspondence. In fact, letters were considered to be an oratorical genre, conceived as a discourse whose divisions and tropes were fixed by the rules of rhetoric. Written to be read out loud, like poetry, and often dictated to a public writer or secretary, letters were closely identified with eloquence. Far from being associated with private composition and silent reading, letter writing was an oral exercise.

Guides to the norms that governed good epistolary practice existed in various registers, each of which presupposed specific uses and social relations. The first concerned scholastic apprenticeship, as exemplified by a treatise by Erasmus, *De conscribendis epistolis,* published in 1522 and reprinted some fifty times prior to 1540. Written in Latin, and used in schools to teach grammar and style, Erasmus's book established the model of humanist letter-writing etiquette. Another type of teaching aid consisted of anthologies of letters printed in the vernacular language. The model for such books was Italian, as acknowledged by Montaigne in his *Essays* when he wrote that, "The Italians are great printers of letters. I have, I believe, some one hundred volumes of them." In France, the publication of contemporary letters began in 1539 with Hélisenne de Crenne's *Epistres familières* (Family Epistles), followed by the correspondence of Étienne du Tronchet (1569), Étienne Pasquier (1586) and Guez de Balzac (1626).

In the seventeenth century, another type of anthology, which the French called a "secretary," featured other letters—fictitious ones—as models. The volumes most frequently reprinted included Jean Puget de La Serre's *Secrétaire de la cour* (Court Letters, 1625) and *Secrétaire à la mode* (New Letters, 1640). The letters published therein constituted examples yet also provided instructions on adapting style and layout to reflect social differences between the protagonists of the epistolary exchange. For example, a greater or lesser space between the name of the addressee and the first line of the letter indicated the exact extent of the difference in social stations and the reverence required by that difference.

By the eighteenth century, Puget de La Serre's anthologies of model letters were being sold up and down the land by book peddlers. There was a certain irony in this, since the models they provided related to aristocratic civility and life at court; and the style of the language, whether pious or flirtatious, was based on literary conventions of the early seventeenth century. Of what use, then, could such anthologies be to a colporteur's usual customers—rural merchants, craftsmen, artisans, and village worthies?

Two observations make this question all the more pertinent. On one hand, letters written by "lower-class" writers in fact display great independence from the rules advocated by the peddlers' anthologies. These letter-writers were inspired by other models, drawn from Christian spiritual tradition or from sentimental novels. And on the other hand, all those people unable to write their own letters—the illiterate and semi-literate—had to ask someone else to wield the pen. In lower-class districts of Renaissance Rome, most people who wrote letters on behalf of others belonged to the world of tradesman and shopkeepers and were therefore socially close to the population to whom they lent their writing skills.

In the seventeenth century, all those excluded from literacy—day laborers, itinerant merchants, farm workers living in or around towns, etc.—apparently had a harder time finding someone to write on their behalf. This meant they had to turn to professional scribes,

Pieter de Hooch, *Young Lady Reading a Letter,* 1664. Inv. n° 5933, Szépmüvészeti Muzeum, Budapest.

secretaries, or public writers. In Paris, public writers gathered in a few specific places—most scribes set up their desks under the arcades along the cemetery near Les Halles, the market area in the center of town, one of main places where the lower-classes mingled.

Therefore, the purchase of anthologies of aristocratic, high-society correspondence does not seem to have been driven by a desire to use them directly, at least in most cases. Reading them must have fulfilled other needs or other pleasures: for instance, to learn the hierarchy of social conditions, exemplified by the terms of address required (or forbidden)

by various social distinctions; to satisfy curiosity about a distant, exotic social world; or simply to be read as sketches of epistolary novels.

With the French Revolution, private correspondence came under tight surveillance, as though letters seized by the authorities provided the most reliable indication of their author's political opinions. Once removed from its most common function—correspondence as tool of business or bureaucratic government—letter-writing thus entered the sphere of privacy and intimacy, although a privacy that postulated, like an epistolary novel, a public gaze.

LETTER WRITING IN FRANCE IN THE NINETEENTH CENTURY

Cécile Dauphin

The diversity and scope of nineteenth-century epistolary habits accompanied the advent of long-distance and media-oriented mass communication. Letters became an everyday item thanks to the spread of literacy, the implementation of regular, country-wide postal services, the variety of materials available and the emergence of new means of transportation. Alongside the "grand" correspondence nurtured by literary criticism and various publications, letter writing became a key factor in the business world, in military life, and in family cohesion. Beyond their immediate usefulness, letters also spurred the growing taste for collecting—autographs, post cards, stamps, cancellation marks, special postmarks, writing implements, and so on.

Fig. 1. Hocquart's manual of everyday correspondence, *Le Secrétaire de tout le monde ou la correspondance usuelle* (Paris: J. Langlumé et Peltier, 1845).
Left, a drawing by Brigitte Parent based on the original vignette. Z 50546, Bibliothèque Nationale de France, Paris.

Fig. 2. Drawing by Brigitte Parent based on Person de Teyssèdre's manual of romantic correspondence, *Le Courrier des amants* (Paris: Lebailly, 1838).
Counter-clockwise, from upper left, the illustrations begin with "first meeting" and proceed through "the declaration" to "breaking off" and "making up,"
concluding (top) with the "marriage bed." Z 61508, Bibliothèque Nationale de France, Paris.

The establishment of a public service for conveying letters forged a national network based on the distance to be covered and the speed of transportation (post coaches, steam boats, and trains). The French post office vaunted its conquering image and emblematic colors in various ways: the fine uniforms worn by mailmen, who became a common sight in villages as well as cities once rural delivery was organized in France in 1830; the 1849 inauguration of a stamp whose cost no longer depended on distance (which meant that postage could be paid at the point of dispatch rather than reception); the new-year almanacs offered to families from 1855; and the increase in the number of local post offices (which, along with the school, formed the geometric locus of the end of rural isolation). Letters permeated life everywhere (Fig. 1 depicts the role played by the public services). Schools, although not shown here, also greatly helped to promote writing skills and epistolary models.

The everyday pervasiveness of letters, although not affecting everyone's existence, triggered the spread of practices long reserved to a social elite or professional writers. Completely ordinary, if relatively affluent, families would henceforth regularly exchange "news," thereby creating a realm in which to assert their identity and maintain their cohesion. Taking advantage of their writing skills, they more or less invented the specific genre of family correspondence, turning the spotlight on everyday lives that were not always so ordinary or without merit. It is noteworthy that society's imaginative bent, as reflected in illustrations in letter-writing manuals, always favored novelistic features (Fig. 2). Yet in the context of epistolary education and a popularizing mission, this staging of romance betrayed the strong tensions existing between utilitarian ends, epistolary rituals, and personal expressiveness.

Indeed, the geography of correspondence went hand in hand with the geography of business. "Humankind is surely highly affectionate,

Fig. 3. Letter from Dr. Giraudeau de St. Gervais to Monsieur Fleury, an attorney in Clermont-Ferrand, December 1, 1835. No. 8845, volume 57, Musée de la Poste, Paris.

yet that does not prevent letters of friendship from being a mere detail next to letters of self-interest," wrote Michel Chevalier. Most correspondence, in fact, related to trade, to various services, to administration, and to transactions of goods or money, even when it was interspersed with personal—sometimes intimate—comments. The arrangement of text and images basically followed advertising principles of self-display, striking the reader with a catchy phrase or image evoking pleasure or desire. Letterheads (with their printed headings and images), watermarks, and quality papers all attested to the credibility and importance of a "corporate identity" (Fig. 3). Epistolary space reduplicated the positions of distinction adopted by letter writers. Meanwhile, the printing and paper industries profited from these new utilizations.

By snatching young men from their families, the military draft—not to mention war itself—obliged them to communicate via letters. This situation constituted an event on more than one level: it was a new site for the personal appropriation of writing, it called on unusual means of transportation (carrier pigeons, balloons, aerostats, etc.), and it led to the diversification of materials and commerce. For instance, the *cantinières* (or "camp letters") that appeared during the French Revolution survived throughout the nineteenth century (Fig. 4), combining pre-printed imagery with handwritten script. The vignettes on the letterhead were initially produced by wood engravings, often hand-colored. Later, stenciling techniques made it possible to vary subjects, patterns, and colors. Such stationery was highly popular among soldiers, who often bought it from tradesmen near the barracks or from camp staff (hence its name).

Fig. 4. A *cantinière*, or "camp letter," dated May 10, 1812. PO AR 995 62, Musée de la Poste, Paris.

FRENCH AND ENGLISH PRIMERS
IN THE EIGHTEENTH AND NINETEENTH CENTURIES

Ségolène Le Men

A primer, or spelling-book, introduces the alphabet to those who cannot read, especially children. As a fundamental vehicle of written culture, it is identified with the acquisition of the rudiments of literacy, thereby turning the straightforward, technical task of learning to read into a rite of passage. The question of which words and texts were chosen to teach reading was so important that traditional primers combined reading lesson with religious instruction. During the Age of Enlightenment, however, the spread of educational methods long reserved for royalty and nobility secularized primers, which then evolved into encyclopedic volumes of childhood knowledge.

Right from the eighteenth century, "active" methods were devised, based on the picture-book approach used as early as 1658 by the Czech educational reformer John Comenius in his pioneering *Orbis sensualium pictus* (The Visible World in Pictures), a multilingual lexicon in encyclopedic form that was swiftly disseminated throughout all of Europe. Two different traditions co-existed: one for commoners—typified by *Rôti Cochon* (Pig Roast)—and the other preceptorial and aristocratic—as seen in the 1733 *Bureau typographique* (Typographical Desk) of Louis Dumas and the 1744 *Quadrille des enfants* (Children's Quadrille) of Abbé Berthaud, who combined book and educational game. Few copies of such early primers have survived (being ephemeral objects *par excellence*), whereas nineteenth-century examples are legion.

For small schools with pupils of humble background, the *Croix Depardieu* (Depardieu Cross)—a small church-authorized primer that combined teaching the alphabet with teaching the catechism—continued to be used alongside secular books without images. This type of spelling-book existed since the early days of printing and was a French equivalent of the English hornbook or battledore, a wooden tablet (or folded cardboard) with letters that introduced a series of prayers. The print quality of such books was modest—the cover would be of marbled papers or simply printed with a wood cut, usually of religious imagery (the Crucifixion, Our Lady of the Hermits), often with a link to childhood (Saint Nicholas, a guardian angel, the Madonna

Fig. 1. Thomas Bewick's *New Lottery Book of Birds and Beasts for Children to Learn their Letters by as Soon as They Can Speak* (Newcastle: printed by T. Saint for W. Charnley, 1771). The Pierpont Morgan Library, New York.

Fig. 2. Nicolas Charlet's "Moral and Philosophical Alphabet for Children Big and Small." *Alphabet moral et philosophique à l'usage des petits et des grands enfants* (Paris: Gihaut Frères, 1835). Inv. 3.4.03 / 79.06329-6, Musée de l'Éducation, Rouen.

and Child) or maternal education (the education of the Virgin). This imagery sometimes indicates the geographical origin of the primer, for example Saint Nicholas from Lorraine or a bird from Provence.

The most heavily illustrated primers, to judge from frontispieces depicting the spelling lesson, were nevertheless destined for affluent children, boarding-school pupils whose educational horizon had often included a parental—and especially maternal—introduction to the alphabet. Both in France and England, such books contained six engraved plates, including a frontispiece and a title page with vignette. The four other plates were divided into compartments in which each letter was represented by an image. The Romantic revolution of imagery within the text, one page per letter, occurred in England where Thomas Bewick, for example, used it in *A New Lottery*

Book of Birds and Beasts (Fig. 1). His primer, in the form of a book or single sheets, employed images based on the theme announced in the title: birds and four-footed animals, yet also games, the cries of urban peddlers, saints, and history. The most widely used series focused on crafts and natural history, as though respecting the tradition of the Enlightenment inherent in sensationalist pedagogy, through little books that modestly recall the encyclopedias of the age or Buffon's *Natural History*.

Whereas school textbooks were not illustrated (or else only in black and white), children's publications willingly adopted the album format, a book almost without text, based on imagery inspired by Romanticism and by lithographic series published, for example, by Victor Adam and the Bonapartist illustrator Nicolas Charlet (Fig. 2).

Fig. 3. *Kate Greenaway's Alphabet* (London and New York: George Routledge & Sons, 1885). The Pierpont Morgan Library, New York.

Starting in the 1860s, color printing was introduced in France along the lines of the English toy book, becoming widespread in the last two decades of the nineteenth century. In England, the poetry of spelling-books might be associated with nonsense humor, such as that of Edward Lear. Formats became larger in these introductory picture-books, attracting illustrators such as Walter Crane, Kate Greenaway (Fig. 3), André Hellé, and Pierre Bonnard.

Bibliography
ALEXANDRE-BIDON, D. "La lettre volée, apprendre à lire à l'enfant au Moyen Âge." *Annales* 4 (July/August, 1989).
——. "L'arbre à l'alphabet." *Cahiers du léopard d'or.*
HAVELANGE, I., and S. Le Men. *Le Magasin des enfants (la littérature enfantine de 1750 à 1830)* (Montreuil, France: Bibliothèque Municipale de Montreuil, 1988).
JULIA, D. "Livres de classe et usages pédagogiques." *Histoire de l'édition française*, vol. II (Paris: Promodis, 1988).
LE MEN, S. *Les Abécédaires français illustrés du XIXè siècle* (Paris: Promodis, 1984).
——. "L'enfance et le texte." *Le Grand Atlas des littératures* (Paris: Encyclopaedia Universalis, 1990).
WHALLEY, J. I. *Cobwebs to Catch Flies: Illustrated Books for the Nursery and Schoolroom, 1700–1900* (London: Elek, 1974).

Fig. 4. A primer published by the Falières baby-food company, illustrated by T. M. Lobrichon. Bibliothèque Municipale, Rennes.

LITERACY IN WESTERN SOCIETIES

Béatrice Fraenkel

TWO HISTORICAL MODELS OF LITERACY IN WESTERN SOCIETIES

The history of literacy in Western societies is a relatively new field. In recent years, a number of publications have challenged various preconceptions that hindered satisfactory understanding of the phenomenon. Debate has raged on many important issues such as the methods of assessing the degree of literacy in ancient societies, the reasons for the spread of literacy, and even the very definition of literacy. But everyone agrees on at least one point: achieving literacy in Western societies was a very long-term process that occurred at different rates depending on the economic development of a given region.

In the twentieth century, another model came to the fore: the swift and determined elimination of illiteracy, spurred by major revolutions and decolonization. The worldwide literacy program launched by UNESCO just after World War II was modeled on recent experiences including, inevitably, those of the USSR and Mexico.

LITERACY IN ANTIQUITY: A LIVELY DEBATE

Assessments of the degree of literacy in ancient societies long reflected widely shared preconceptions among historians. Starting from the idea that the alphabetical writing systems used by the Greeks and Romans were "simple" and therefore accessible to all, the feeling arose that these societies must have had a high level of literacy. The presence of numerous inscriptions in ancient cities seemed to confirm this impression—why, indeed, display so many inscriptions if they could not be read by a large number of people? Furthermore, it was tempting to contrast three Oriental civilizations whose writing was based on ideograms—Mesopotamia, Egypt, and China, all despotic societies where only professional scribes in powerful castes acquired the skills of literacy—with the image of Greek and Latin societies as cradles of democracy and children of the alphabet. Yet estimations made by historian

W.V. Harris in 1991 show that the Roman world, once thought to be massively literate, must have had a maximum level of literacy during the high imperial period of roughly 30 per cent of adult males.

For that matter, the very terms literacy, literate, and illiterate have led to much confusion and vagueness. There are many intermediate stages between a person who knows nothing—is totally illiterate—and one who is highly cultivated. We are indebted to medievalist Armando Petrucci for forging the concept of "semi-literate" to account for reading and writing practices in ancient and medieval societies. Knowing how to read and write thus involved distinct educations; readers were more numerous than writers, constituting a class of semi-literates who could occasionally communicate a text to total illiterates. Reading out loud, the dominant method throughout antiquity and part of the Middle Ages, thereby produced situations where contact with writing did not necessarily presuppose literacy. Furthermore, the need for a literate population was thoroughly alien to ancient mentalities.

The high Middle Ages projected the image of a society in which only clerics possessed the knowledge of a written culture entirely devoted to the glory of God. Intense preaching campaigns were aimed at making the message of Holy Scripture accessible to *illiterati*.

Starting in the thirteenth century—in the context of profound economic, political and cultural changes in the medieval West—certain groups of laymen would learn to write. Such was the case with merchants who felt the need for practical knowledge, which was limited to basic reading, writing, and arithmetic. This learning was acquired on the job, or occasionally from teachers. It was only in the sixteenth century that the transition to a fully literate society began, a process that would last several centuries.

LIMITED LITERACY IN FRENCH *ANCIEN-RÉGIME* SOCIETIES

A challenge to familiar notions and a critique of long-held preconceptions also arose from revised historical perspectives. Following a pioneering

Fig. 1. The cover of Agostino Tensini's "True Rules of Writing for Children" (*La vera Regola dello scrivere Utile a Giovani*, Bassano, *circa* 1680).

study by François Furet and Jacques Ozouf on French literacy from John Calvin to Jules Ferry, our understanding of the phenomenon of literacy changed. State, Church, and school, up till then perceived as the major movers behind the trend, were henceforth seen to be merely the means by which social demands were fulfilled.

Furet and Ozouf demonstrated the lengthy process that stretched over three hundred years in France, from the sixteenth to nineteenth centuries, as well as the various forms it took depending on sex, region, and type of terrain (city or country). The determining factor that capped all others was social development. By the seventeenth century the social elite knew how to read, write, and count. They were followed in the eighteenth century by the middle classes (merchants, traders, craftsmen, land-owning farmers) and in the nineteenth by salaried workers.

Thus, although the sixteenth century indisputably represented a historical watershed due to the Church's change in attitude toward literacy, this was not sufficient to explain the universal spread of literacy. Reformation and Counter-Reformation encouraged the extension of limited literacy only—people learned to read but not to write; boys were far more literate than girls. Yet access to writing—and more particularly the spread of knowledge to all social groups—seems rather to have stemmed from a profound social change related to a market economy that required an intensive use of written communication.

The concept of "restricted literacy," developed in 1968 by anthropologist Jack Goody, provides a better understanding of the nature of

the growth of literacy in France from the sixteenth to the nineteenth centuries. The country went from a literacy that was restricted to certain groups and certain developed regions (and further limited to men and to a certain minimal education) to a more complete, mass, nation-wide literacy.

WORLDWIDE LITERACY IN THE TWENTIETH CENTURY

The "revolutionary" model of literacy was epitomized by the Soviet policy of eliminating adult illiteracy following the revolution of October 1917. In 1919, all citizens between the ages of 18 and 50 were obliged to learn to read and write. Lenin's goal was to banish illiteracy by the tenth anniversary of the revolution. The entire nation was mobilized, volunteers were massively recruited, and schools were set up. According to official statistics, however, this goal was only reached in the late 1950s. Yet other, similar experiments confirm the possibility of a remarkable acceleration in the spread of literacy: Turkey in 1928 and Mexico in 1944 declared "war on ignorance" and seem to have won it.

UNESCO, founded in 1946, modeled its strategy for the worldwide elimination of illiteracy on these victorious campaigns. A few years later, after poor results, a change in approach became necessary. Indeed, many efforts ended in failure not only because of cultural and political resistance encountered in certain developing countries but also because once the literacy training had been completed, the local population no longer had any occasion to use their new skills. They therefore wound up forgetting them, in what is known as a return to illiteracy.

The concept of functional literacy emerged in the 1960s. The school-based model, which had never been truly challenged, was abandoned, and the needs of adults were defined from a practical standpoint—the content of lessons was supposed to fulfill their needs. This concern to rationalize teaching programs nevertheless masked the political and ethical issues behind educating adults. Paolo Freire from Brazil countered the model of functional literacy with a call for a written culture that encouraged "critical consciousness": learning to read and write must be set within the dynamics of social and cultural transformation that can help people acquire the means to critique the conditions of their existence. Literacy is motivating only if it allows people to analyze the social realities and forms of domination experienced by illiterates, and only if, in the long run, it helps to change people's lives.

In the 1980s, just when literacy in Western societies seemed total, a new issue of illiteracy arose. Certain European countries realized that a large number of adults were still illiterate. This was the case in southern Europe—Greece, Portugal, Spain, and Italy—where primary education was not made mandatory until relatively recently. Northern Europe, meanwhile, was confronted with a different phenomenon, that of inadequate skills in reading, writing, and arithmetic among people who had indeed gone to school. Illiteracy in developed societies

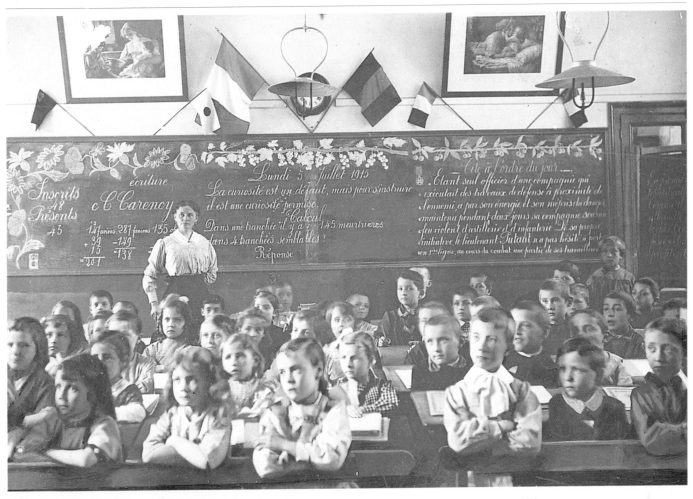

Fig. 2. Primary school in Rheims, France, on July 5, 1915. A French law sponsored by Jules Ferry in 1882
made secular primary education mandatory between the ages of seven and thirteen.
Teaching children to read was the main educational goal during France's Third Republic.

today concerns their underprivileged populations. Young people from those social groups face extensive academic failure and unemployment. The risk of social exclusion of illiterate citizens is very real. The basic skills of reading, writing, and arithmetic, which once used to suffice, are now being devalued at the expense of more selective skills and knowledge. The phenomenon of under-education, the final incarnation of illiteracy, raises questions about another aspect of literacy, namely the symbolic and mercantile value of learning. Is the social gap between the educated and the uneducated in Western societies really smaller than it was during other periods? This is a question that needs to be raised.

Bibliography

BANNIARD, M. *Viva voce: Communication écrite et communication orale du IVe au IXe siècle en Occident latin* (Paris, 1992).
CHARTIER, A.-M., and J. Hébrard (eds) *Discours sur la lecture (1880–1980)* (Paris, 1989).
——. *Compendium des statistiques relatives à l'analphabétisme* (Paris: UNESCO, 1995).
FRAENKEL, Béatrice (ed.). *Illettrismes: Variations historiques et anthropologiques* (Paris, 1993).
FREIRE. P. *Conscientisation* (Paris, 1971).
FURET, F., and J. Ozouf. *Lire et écrire: L'alphabétisation des Français de Calvin à Jules Ferry* (Paris, 1977).
GOODY, J. *Literacy in Traditional Societies* (Cambridge: Cambridge University Press, 1968).
HARRIS, W. V. *Ancient Literacy* (Cambridge, Mass.: Harvard University Press, 1991).
——. *Littératie, économie et societé* (Paris: OECD, 1995).
VALETTE-CAGNAC, E. *La Lecture à Rome* (Paris, 1997).

THE MATERIAL SURFACE
OF MODERN LITERARY MANUSCRIPTS

Claire Bustarret

Writing does not just mean making marks on a blank page, as can be discovered by examining draft manuscripts. A writer's creative activity does not only stem from a mentally prepared plan that takes shape once it is set down on paper: it also feeds on the imaginative potential of a material surface that serves as a fertile—or sterile—ground. Poet Francis Ponge suggested this image in *La Fabrique du pré* (Making the Meadow):

And furthermore . . . it must spring from the page, and that page must be brown.
. . . may that page be not so much white paper as brown earth (or: "may this sheet of white paper instantly evoke another sheet, that stretch of brown earth").

It is well known that the writing hand can scrawl things and can cross them out, but it is too often forgotten that the hand can attack the material itself—sometimes cutting a page, folding it, tearing it, pasting fragments onto it, assembling loose sheets or dismembering a notebook. In this way, paper sometimes reflects the suffering involved in creativity, as expressed by Henri Michaux: "Ferociously crossing things out with my pen, I scar the surfaces, wreaking havoc on them, like the havoc wreaked all day in me, turning my being into a sore. May this paper also become a sore!" The handwritten object resulting from such treatment—sometimes methodical, sometimes impulsive—seems to be a vestige of the multiple operations that gave birth to a given work. Carefully studied, it provides a source of hypotheses on the relationship between a piece of writing and a given space of composition. These hypotheses are

Fig. 1. Cornelis Norbertus Gysbrechts, *Trompe-l'oeil with Booklet of Drawings,* 1665. Musée des Beaux-Arts, Rouen.

based on evidence of the transformations undergone by the physical writing surface.

Writers' manuscripts have been subjected to various fates: some have been neglected, hidden, or even destroyed by authors and their entourage, others have been prized, preserved and later exhibited by heirs, collectors, and libraries. More than just the trace of a famous hand, they seem to contain the secrets behind the making of a work, triggering commercial speculation and scholarly curiosity, justifying the cultural value attached to such documents. The existence of rewriting techniques—including erasures, additions, and substitutions—is attested as far back as antiquity and appeared increasingly in the late Middle Ages and Renaissance. The concept of "autograph manuscript," meanwhile, emerged in the seventeenth century and coincided with the social recognition of "writers" who began to describe, in private letters, the material conditions of their creative work and the tools of the "trade" they employed. That was also the period when "writing" paper became an everyday item despite its high cost—manuscripts of memoir writers were still characterized by a parsimonious use of the space on a page (Fig. 2).

The singularity and variety of objects produced from tools and materials as common as pen, ink, and paper can be explained firstly by the artisanal, individual nature of a handwritten composition. The modern manuscript form is related to a private, intimate way of writing, freed from the constraints of public communication. In fact, the complexity of generative processes is such that the graphic coherence of a manuscript, resulting from dynamic inventiveness both visual and gestural, often violates rules of legibility. And the physical qualities of the writing surface and implements can influence the course of composition on a semiotic level as well as the material level. Writers are particularly sensitive,

Fig. 2. Mademoiselle de Montpensier, *Mémoires*. Fr. 6699, fol. 268r, Bibliothèque Nationale de France, Paris.

as Roland Barthes so accurately pointed out, to tactile and visual effects that vitalize their perpetual confrontation with the blank page, with the page being written by their hand, with pages written recently or long ago. Yet the very permanence and finiteness of the material writing surface seems to present a perpetual challenge. As Françoise Sagan so succinctly put this paradoxical feeling: "Public enemy number one is the paper!"

The paper used for writing is not a raw material but a manufactured product, the way parchment once was. The material aspects of manuscripts of a given period stem directly from the standard manufacturing techniques of the day (whether made by hand or by machine): the consistency of the pulp, the size and thickness of sheets, the finish and polish of the surface. Yet these aspects also reflect evolutions in taste and accompany the more or less rapid

adoption of new writing implements. Thus preference successively shifted from "Dutch" laid paper around 1750 to vellum in the early 1800s (a highly prized novelty in the Napoleonic Empire) to the French vogue around 1850 for machine-made laid paper from England (better suited to metallic nibs). We know that school notebooks, also called "rough paper," were commonly used by French writers from 1870 right up to the 1950s. Compared to earlier eras, a far greater variety of qualities became available in the nineteenth century, if only in terms of thickness (including the onion skin so prized by Balzac), texture (glossy or woven), and color. However, the use made of these materials by a writer in the heat of composition will probably defy any standard rule.

Indeed, writers will not just choose their paper from past experience but may go so far as to identify a given kind of paper with the core of a future work, as Gustave Flaubert did when he decided, after drawing up his notes on his voyage to Corsica, to set aside the remaining sheets "for [his] next trip," which would be to Egypt—ten years later. A similar identification can exist with a work in progress or one just being completed. Thus Stendhal noted in the margin of folio 272 of *The Life of Henri Brulard*, "6 March 1836/New paper/bought at C[ivit]a V[ecchi]a," whereas Victor Hugo, by way of colophon, wrote on the back of folio 481 of the manuscript of *Toilers of the Sea:* "29 April 1865: I'm writing the last page of this book on the last sheet of a batch of Charles 1846 paper. This paper was begun and finished with this book" (Fig. 3). Note the highly unusual gap of twenty years between the watermarked date of manufacture and the date of use, betraying a long period of storage first by the vendor, Bichard, then by the user, who kept his finest reams "in store"—virgin surfaces to be preserved in expectation of future composition.

The role played by the surface—the very texture of the medium—as a source of inspiration and an initial site of the desire to write certainly produces one of the key incentives—one of the most archaic motives—for writing. Asked about his "profound reasons" for becoming a writer, Jean Genet recalled a postcard addressed to a female friend:

> I didn't really know what to say. The side on which I had to write had a white, lumpy look, and that surface made me think of the snow we obviously never had in prison, made me think of Christmas, so instead of saying any old thing to her, I wrote about the quality of the card. That was it, the trigger that enabled me to write. It was probably not the motive, but that was what gave me my first taste of freedom.

Colette, meanwhile, when questioned about her use of ordinary school notebooks, dated her start in writing to an idle

Fig. 3. English machine-made laid paper watermarked "*Britannia/ C Harris/ 1846*" (which Victor Hugo wrongly quoted as "Charles 1846"). From Victor Hugo, *Toilers of the Sea.* N.a.fr. 24745, vol. 2, fol. 271 (half actual size), Bibliothèque Nationale de France, Paris.

period of convalescence, an unexpected rediscovery of childhood memory, a private pleasure scarcely clouded by the external constraint of academic obligation:

> Having found and purchased from a stationer some exercise books similar to my school notebooks, those sheets of laid paper with gray lines and red margins . . . there came to my fingers a kind of itch for the assignment and the passivity of finishing required homework . . . That's how I became a writer.

In a writer's everyday experience, it is vital to have both writing implements and paper constantly within reach— paper proves to be inseparable from an author's body. Well before bound notebooks were a common item of stationery, Jean-Jacques Rousseau decided to scribble the notes that would become the *Reveries of a Solitary Walker* on playing cards as he walked along, because they were easier to carry

and were stiffer than large sheets of writing paper. In Rousseau's footsteps, Gérard de Nerval concocted his own pocket notebook by folding into octavo format four sheets of Italian laid paper made for export, probably bought in Alexandria or Cairo, on which Nerval made notes, kept accounts, and executed hasty sketches during his trip through Egypt. Flaubert, on an outing in the forest of Fontainebleau, took notes on a little notebook no bigger than the palm of his hand. Long-distance travelers such as Michel Butor and Michel Deguy also preferred small formats, always the same, suited to the size of the pockets of their usual clothing. As Butor admitted: "It all begins with the notebook. Which is in my pocket. I'm never without a notebook, so to speak, wherever I go, since I have a jacket with a pocket and the first thing I do is put the notebook in it." Michel Deguy, meanwhile, wrote in *Au jour le jour* (Day by Day):

> I've taken to always having little orange Rhodia notebooks on me (usually the pocket-book size that fits easily into the breast pocket of my overalls), I use them width-wise to note whatever comes to mind on the train (as with this note), at the airport, in my college office, in administrative waiting rooms, or at home.

Unlike mechanical and electronic tools that theoretically impose a standardized use of paper (if only in terms of the dimensions of sheets, direction of lines and size of characters), handwriting gives an author total liberty. Everyone can dispose of the space on the page, or double page, as he or she wishes: Victor Hugo divided each sheet cleanly into two equal columns—following a venerable tradition—but his additions in smaller and smaller lettering, running diagonally and then perpendicularly, wound up filling the tiniest gaps. Raymond Roussel, like Choderlos de Laclos, used double spacing to allow room for corrections but left no margins—only to use, as Stendhal did, the entire back of the preceding page (of a bound notebook) for marginal notes (Fig. 4). Flaubert, meanwhile, who worked on large, loose sheets, completely divorced the front from the back: a page would be totally covered until all spaces and margins were saturated, then would be cleanly copied onto another sheet, the first being crossed with a large X so that the back could later be used as a new, blank page (Fig. 5). Flaubert's technique was so methodical that this double use, corroborated by the pagination, created no confusion. In fact, the visual unity of the page paced his work of composition.

The same was true for Ponge, although in a less typically hierarchical way. Beginning with an initial placement in the center, flanked by wide margins, the poet usually indulged

Fig. 4. Stendhal, *Lucien Leuwen*. Fol. 288v, Bibliothèque Municipale, Grenoble.

or even hundreds of pages. Not only can the initial arrangement and succession of sheets change, but the material units themselves may sometimes be altered by pasting or cutting. Although these transformations undoubtedly facilitate the shaping of a text, no consistent relationship can be established between a given literary form and a given type of physical manipulation. The fragmentary form, for example, may involve highly different approaches to the writing surface: Walter Benjamin tore the blank margins from various kinds of documents (letters, official correspondence, printed forms) in order to use them as portable note cards, linked virtually through a system of colored marks, whereas Vladimir Nabokov, would write sections of a novel he had already composed in his mind directly onto sequentially arranged index cards.

In general, it appears that certain writers display a selective, unadventurous behavior toward carefully chosen

Fig. 5. Gustave Flaubert, *The Temptation of Saint Anthony*. The front and back can be seen simultaneously through the paper, as can the BFK/RIVES watermark. N.a.fr. 23688, fol. 33, Bibliothèque Nationale de France, Paris.

in proliferation by zones, in which corrections and lines establishing connections and divisions grew into free figures, often punctuated by dates. The handwritten page can sometimes form material, visual, and semantic unity such a fruitful form that the author transposes it almost as is, despite technical difficulties, into typewritten form. In contrast, for the marquis de Sade the page constituted a quantitative and structural marker—very careful pagination, often doubled or tripled, took successive additions into account, each indicated by an X and preferably written in a "supplemental notebook" separate from the body of the text.

In many cases, studying page layout from a graphic, visual or conceptual standpoint can only be done by taking into account changes and transfers that run across dozens

materials to which they remain faithful—as was the case with Flaubert and Gide—whereas others, like Hugo, are happy to use any old piece of paper, saving quality laid paper for the final stages of work. The latter type of writers pick up letterheaded paper here and there, use pads and notebooks of various sizes, make notes on wrapping paper, a restaurant napkin, the back of an illustrated label, or even tear out the margin of a magazine or telephone book, as both Louis Aragon and Marcel Duchamp did. We should nevertheless be wary about establishing overly hasty typologies; manuscripts as they have been preserved often provide only a partial view—and one sometimes deliberately skewed—of the materials used.

Does the use of a given type of writing surface oblige an author to conform to a "suitable" form of writing? In leafing through Colette's exercise books, which seemed evenly filled from the first line to the last, it is of course impossible not to sense the normative (or at least inspirational) impact of the scholastic model. And yet her writing was equally fluid, continuous and "clean" when she used other types of paper; in contrast, we know that poet Paul Valéry used exercise books for anthologies of discontinuous texts. Even more than notepads, exercise books lend themselves to multiple alterations. In the hands of Proust they underwent a spatial metamorphosis that transgressed all constraints of linearity, since the writing surface grew in anarchic fashion as the writing campaigns multiplied—proliferating strips of paper, or *paperoles,* would be glued one after another along the margins (Fig. 6).

In an even more radical way—since it involved the eradication of earlier stages—Violette Leduc glued new versions on top of the old, using sheets of notebook paper of identical size. Not only did these multiple layers make the thick volume somewhat unwieldy, but the various strata, although materially tangible, remained inaccessible to the reader. Roussel, meanwhile, systematically detached the front sheets—on which he had already written—from an exercise book, thereby transforming them into so many loose sheets, then continued writing on the pages at the back which had become detached at the same time, turning them upside down. Rough drafts of his *Impressions d'Afrique* show that, unlike bound pages, loose sheets made it easy to insert additional pages and to interpolate sequences. Changes made by pasting additions were limited here to brief passages of less than one page long.

As these examples show, the type of writing surface adopted and the manipulation it undergoes vary depending on material conditions, working methods, and tools employed. Still other techniques affect the materiality of the manuscript in a less lasting way. A writer may decide to use thumbtacks or clothespins to post any preparatory

notes or previous versions of the text all around the workspace, in order to take in everything with a glance, or may temporarily gather loose sheets into a sheaf held together by a pin or paperclip. Such treatment will leave discreet but noticeable traces when the writing surface is closely examined. These ways of handling the paper either fulfill a need to visualize a work during its planning stage (Fig. 7) or execution, or else reflect a need to file already composed pages. As to destructive acts, whether occasional or systematic, their scope and seriousness can only be assessed indirectly through testimony in biographies, autobiographies, or correspondence. Apart from the stubs of pages ripped from bound notebooks and exercise books, surviving manuscripts remain silent on the most violent assaults conducted on the very substance of writing.

The wide range of specific examples encountered in modern manuscripts makes it possible to assert that a writer's choice of a given writing surface is rarely random. In order to understand that choice, though, it must be set in the historical context of paper production and standard practice of the day, as well in the biographical context of

Fig. 6. Marcel Proust's notebook of drafts for *Remembrance of Things Past*, with a strip glued onto the upper margin and cross-references noted in the left margin. N.a.fr. 16697, fol. 18v, Bibliothèque Nationale de France, Paris.

the author. Comparison of various materials used throughout a writer's lifetime makes it possible to determine their usual choices of paper and to detect any chronological development (as demonstrated by Marianne Bockelkamp's study of Diderot's papers). The functions accorded to each form of paper (notepad, exercise book, loose sheets of varying size and quality) can only be established in relation to the writing implements used, to the circumstances of composition (steady or interrupted, at home, while traveling, in exile), and finally to the various phases of genesis. That is why the concept of the "singularity" of writing techniques can apply to each work in particular rather than applying to a specific model that would remained the same for each author.

The evidence supplied by the surviving manuscripts studied to date not only alters our understanding of the texts, it also enriches our perception of writing techniques, whose variety and creativity can be surprising. The graphic environment is never neutral—a composing author appropriates it by fashioning the manuscript as he or she goes along, under the successive impulses of drafting and rewriting. These manipulations leave traces that are sufficiently coherent to enable a close examination of the object to reveal the singularity of each compositional project. Such study demonstrates the existence of a veritable visual language employed by authors, which is intricately related to the writing but was ignored for as long as manuscripts were studied solely for their relationship to the text. Yet it so happens that the making of a work calls for original, pragmatic solutions that spur writers to abandon graphic norms. The amazing diversity of those solutions underscores the extent to which the act of writing is performed not only on a verbal and conceptual level—writing inscribes itself in the spatial and visual field of a material surface that participates in the creative act.

Bibliography

ABRAMOVICI, J.-C. "Au travers des mailles du filet sadien." Sade, *Les infortunes de la vertu* (Paris: Manuscrits, CNRS Éditions, BNF/Zulma, 1995).

BEUGNOT, B., and B. Veck. "Le scriptorium de Francis Ponge." *Bulletin du bibliophile* 2 (1993), pp. 411–426.

BOCKELKAMP, M. "L'analyse bétaradiographique du papier appliquée aux manuscrits de Diderot." *Studies on Voltaire and the Eighteenth Century* 254 (1998), pp. 139–173.

BOIE, B. "L'écrivain et ses manuscrits." L. Hays (ed.). *Les Manuscrits des écrivains.* (Paris: CNRS/Hachette, 1993).

BOLLE, W. "As siglas em cores no *Trabalho das passagens* de W. Benjamin." *Estudos Avançados* 10/27 (1996), pp. 41–77.

BUSTARRET, C. "Le papier 'écriture' et ses usages au XVIIe siècle." *XVIIe siècle* 192 (1996), pp. 489–511.

——. "Les instruments d'écriture, de l'indice au symbole." *Genesis* 10 (1996), pp. 175–191.

——. "The Writing Hand in the Mirror of the Manuscript." *Word & Image* 13/2 (1997), pp. 193–203.

——. "Paper Evidence and the Interpretation of the Creative Process in Modern Literary Manuscripts." *Looking at Paper: Evidence and Interpretation* symposium proceedings (Toronto: Canadian Conservation Institute, 2001), pp. 88–94.

——, and A.-M. Basset. "Les Cahiers d'*Impressions d'Afrique*: l'apport de la codicologie à l'étude génétique." *Genesis* 5 (1994), pp. 153–166.

CHRISTIN, A.-M. "Espaces de la page." *De la lettre au livre: Sémiotique des manuscrits littéraires* (Paris: CNRS, 1989).

ERNST, P. *Les Pensées de Pascal: Géologie et stratigraphie* (Paris and Oxford: Universitas/Voltaire Foundation, 1996).

FLAUBERT, G. *Carnets de travail*, P.-M. de Biasi (ed.) (Paris: Balland, 1988).

GAUDON, J. "Carnets, liasses, feuilles volantes." L. Hay (ed.). *Carnets d'écrivains* 1, (Paris: Textes et manuscrits CNRS, 1990).

GERMAIN, M.-O., and D. Thiébaut. *Brouillons d'écrivains* (Paris, BNF, 2001).

GRÉSILLON, A. *Éléments de critique génétique: Lire les manuscrits modernes* (Paris: PUF, 1994).

HAY, L. "L'écrit et l'imprimé." *De la Lettre au Livre: Sémiotique des manuscrits littéraires* (Paris: CNRS, 1989).

Les Cahiers de Médiologie 4: *Pouvoirs du papier* (Paris: Gallimard, 1997).

PETRUCCI, A. "La scrittura del testo." *Letteratura italiana* vol. 4 (Turin: Einaudi, 1985).

PICKERING, R. *Paul Valéry, la page, l'écriture* (Clermont-Ferrand, France: Faculté des Lettres et des Sciences Humaines, 1996).

RAMBURES, J.-L. de. *Comment travaillent les écrivains* (Paris: Flammarion, 1978).

VIALA, A. "L'auteur et son manuscrit dans l'histoire de la production littéraire." In *L'Auteur et son manuscrit*, ed. M. Contat (Paris: PUF, 1991).

VIOLLET, C. "Écriture mécanique, espaces de frappe: Quelques préalables à une sémiologie du dactylogramme." *Genesis* 10 (1997), pp. 193–208.

ZERLI, A. (ed.). *L'Aventure des écritures: La page* (Paris: BNF, 1999).

Fig. 7. A page from the guideline for Chapter 89 of *Life, A User's Manual*, Georges Perec, C.N.R.S. Éditions. Bibliothèque Nationale de France, Paris.

FLAUBERT: THE LABOR OF WRITING

Pierre-Marc de Biasi

An absolute way of seeing things

Flaubert was one of the first French writers to use the verb *écrire* ("to write") in an intransitive way (meaning "to create a literary work" in the absolute sense), defining literary writing as a demanding synthesis that simultaneously involved a professional attitude (literature first, enjoyment second—maybe), an organic conception of style (a statement cannot be divorced from the way it is stated), and systematic recourse to a series of precepts. These precepts included: the evacuation of the issue of *subject* ("there isn't a subject—style alone represents an absolute way of seeing things"); Goethe's axiom ("everything depends on the conception . . . of the plan"); the necessity of a *prose ideal* ("a good prose phrase should be like a good line of verse—unchangeable"); a general problematizing of meaning and the elaboration of a non-conclusive form of tale ("wanting to conclude is foolish"); the need to remain impersonal ("one shouldn't write *oneself*") with all its corollaries; and the general relativity of viewpoints and the immateriality of writing ("the finest works are those in which there is the least material").

It was writers such as Proust who noted the originality of this system with its singularities: no quotation marks for dialogue, which was reduced to a strict minimum and tended toward indirect speech; a new realm of description modalized through focalization, often functioning as psychological analysis, multiplying macroscopic visions of details and lending worldly objects a strangely independent presence; an original use of pronouns (notably indefinite), tenses (the imperfect past), indirect style (a free indirect, hard to attribute), punctuation (dashes, pauses for breath), italics, and typographic spacing; a musical development of phrases (the oral rhythm of reading everything out loud, tracking down repetitions and assonances); the task of integrating verbal stereotypes and dispersing clichés, rigid turns of phrases, and received ideas; a systematic play on the literary and scientific intertext; and the constant incorporation of visual descriptions, etc. Flaubert's letters and manuscripts (some thirty thousand pages of notes, drafts, and documents) make it possible to reconstruct the key stages of this redefinition of literary writing that laid the foundations of the modern novel.

The moment of conception

Behind every work there was almost always an "old plan." As it resurfaced, the idea was transformed and recast into an operational project. At this initial stage, Flaubert's secret was to avoid writing—for several weeks, he would "daydream" around his subject. This stage of psychic labor resembled a guided reverie. The writer imagined the key scenes of his story, linked sequences, set the stage, chose locations, and established hypotheses about the psychology of his characters and the form of the narrative. This work of conception continued until Flaubert was able to see the "film" of his narrative unfold clearly in his mind's eye. In order to visualize it better, to send the reverie down new paths or to resolve a linking problem, Flaubert might conduct some research (reading, location scouting, interviews, museum visits) that would help him create the atmosphere, the intertext, and the historical setting. Once everything was clear, he set the main elements of his vision in a detailed but more or less abbreviated outline that he called a "scenario." This dense guiding plan might be revised but served as a constant reference during the entire writing process.

Composition: from expansion to contraction

Once the scenario was set, Flaubert first developed the narrative by letting the core images, formed during his reveries, proliferate and redeploy themselves. In this "developed scenario" stage he organized the main lines of the diegesis and perfected the articulations of the narrative, and in so doing explored vast stretches of prospective text. The style was still sub-compositional, containing parataxis and semi-formed phrases. Certain details (names of places and characters, etc.) were treated as unknowns (x, y, z). When the overall work had been signposted, Flaubert moved from the development stage to a draft—the plan was expanded page by page until it reached the scale of an enormous pre-text that explored the various possibilities of the narrative, even as sentences and paragraphs began to take shape. The manuscript pages were dense with interline corrections, the margins were filled with additions. The same

Fig. 1. File on the genesis of Flaubert's *Three Tales: The Legend of Saint Julian*. N.a.fr. 23663, Bibliothèque Nationale de France, Paris.

location at place A to place B (where they must find themselves two pages later)? Flaubert would then do some location work, following the itinerary of his characters in order to be able to write it. This "on-the-spot" documentation was motivated not by a realist's obsession with accuracy but by a need to "see" according to the specific and potentially diverging viewpoints of the characters, as though reality was observed through them, from within the novel itself. After the expanding phase of rough drafts, the writing process went into reverse. In three or four successive new versions, the novel's pre-text underwent a terrific contraction—entire pages were reduced to a few phrases or even words. This was the decisive moment of creation. Flaubert cut deep into the narrative matter: nearly 40 per cent of what was "already written" would vanish during campaigns of revision as phrases were submitted to the test of the *gueuloir* (oral reading). The work of condensation continued through various "corrected copies" until the "final manuscript" was reached. The ultimate profile of the text became more and more distinct underneath the corrections. It was this last stage of condensation of meaning that, for Flaubert, represented the synthesizing labor of style—a prose reduced to essentials, into which everything fit: the descriptive possibilities explored in the drafts, the narrative structure, the symbolic economy of the tale, the efficiency of ellipses, the memory of the intertext, the network of imagery, the problematizing of meaning, etc. In short, the published text was a complex machinery of meaning that functioned like a musical score, open to readers' own talents of reverie and interpretive creativity. Flaubertian writing integrated this virtual reader—who incarnated posterity—as one of the essential components of composition right from the start by anticipating the way his work would be received and by eliminating anything in the text that might one day cease to be readable—for Flaubert, a writer "worthy of the name" did not write for his own times, but for all readers to come, "for as long as the language shall live."

page might be rewritten ten or fifteen times. Along the way, sometimes, the writer became blocked: What do they see from the window of their carriage, these characters traveling from their current

Fig. 2. Scenario (fol. 492).

Fig. 3. Draft (fol. 411v).

Fig. 4. Corrected version (fol. 437v).

Fig. 5. Final manuscript (fol. 31 v).

Raymond Queneau: The Form and Meaning of a Manuscript

Emmanuel Souchier

A text written by Raymond Queneau in the late 1930s, *Traité des vertus démocratiques* (Treatise on Democratic Virtues), was never published in the author's lifetime. A "physico-semiotic" analysis of the text[1] when it was finally being prepared for publication[2] made it possible to glean the "formal meaning" of the work[3] and to present these literary fragments in a coherent fashion.

The developmental file contains a handwritten notebook assumed to be the original crucible of the work. The poster-like title on the notebook clearly targets Marx and Engels' *Communist Manifesto* (Fig. 1, "... final advice to revolutionaries of all countries"), and immediately affirms Queneau's intention to write a polemical article in a political register. He nevertheless hesitated over the form to give this text. His early metadiscursive notes show that he thought first of a "novel-like presentation of the article," then of a "dialogue" framed by a preface and epilogue. After a few exchanges of dialogue, however, that form was discarded in favor of fragments.

Queneau adopted the unusual practice of jotting down his ideas as they flowed, then cutting them out and sticking them down on other pages of the notebook. This technique forestalled any discursive development and underscored the stylistic impact of his method. By proceeding in this fashion, Queneau went from the noting of ideas to the shaping of aphorisms, a shaping that was also a visual enhancement. Once detached from its primal nebula, a fragment acquired semantic autonomy and called for a mode of reading more contemplative than discursive.

The most significant example can be found in Folio 9, where the phrase, "What is to be done, then? Nothing" was stuck to the top of a blank page (Fig. 2). Previously buried among a set of hastily noted comments, the slogan thus acquired a symbolic charge it originally lacked. This fragment highlights the dialectical relationships between the material form and the spirit of the text. Queneau replies to Lenin's political essay, *What is to be Done?* by a categorical "Nothing" that might be considered just a quip if it weren't also an expression of *wu-wei,* the Taoist doctrine of "non-action." Queneau counters revolutionary practice with the Chinese tradition of Taoism before going on to mention

Fig. 1. Raymond Queneau, *Traité des vertus démocratiques* (Treatise on Democratic Virtues). Manuscript folio 1 of the *Anti-Manifeste.*

Aristotle's "unmoved mover," a western version of *wu-wei.*[4] To a question of political action Queneau replies with "non-action" and "the call of metaphysics."[5]

Queneau extended this process during the typing phase of his work. In its most complete version, the *Traité* was characterized by short, concise texts set alone on independent sheets. The composition developed

Fig. 2. Raymond Queneau, *Traité des vertus démocratiques*. Manuscript folio 9 of the *Anti-Manifeste*.

around proverb-like aphorisms. The material presentation, the categorical tone of definitions, the timeless present, and the elimination of instances of utterance all recalled the universal value of the moral decree, legislative law, or wise maxim, like both the Taoist *Tao-te Ching* and the French *Declaration of the Rights of Man and Citizen,* between which the *Traité* tried to establish an ideological bridge.

Folio 9 is a synthesis of the overall approach of the *Traité*. As far as traditional political philosophy goes, it answers Lenin with the *Tao-te Ching*. From a literary standpoint, its linguistic expression takes the form of a fragment and graphically exhibits itself as a slogan around which the text is organized. The "formal meaning" is here implemented in an exemplary way. The aphorism expounds the work in the very way it is proffered—or, more exactly, effected—and spatialized, in the same way that "poetry expresses what it expresses by expressing it."[6]

A rhetorical figure of condensation, a symbolic act that shows more than it says—this ninth fragment sits alone—lofty, heralding the work even down to the relentless contradictions that prevented it from ever being completed.[7]

Notes

1. Almuth Grésillon, *Éléments de critique génétique: Lire les manuscrits modernes* (Paris: PUF, 1994), p. 37.

2. Raymond Queneau, *Traité des vertus démocratiques,* edited and annotated by Emmanuël Souchier (Paris: Gallimard, 1993). See also Emmanuël Souchier, *Raymond Queneau* (Paris: Éd. du Seuil, 1991).

3. The concept of "formal meaning" borrowed from Jacques Roubaud's *Le Fleur inverse: Essai sur l'art formel des troubadours* (Paris: Ramsay, 1986) is reinvested here with a semiological perspective, thus revealing the *interdeterminacy* of "meaning" and "form" (rhetoric, material, etc.) in a text. See Queneau, *Traité* ... (ed. Souchier), pp. 15–24.

4. Queneau used Leon Wieger's French translation of Lao-Tzu's *Tao-Tê King* (Paris: Jean Varenne, 1913).

5. Queneau, *Traité...*, pp. 127–128 and related notes.

6. "La poésie dit ce qu'elle dit en le disant." Raymond Queneau, *L'invention du fils de Leoprepes: Poésie et mémoire* (Saulxures: Éd. Circé, 1993), p. 140.

7. An infographic presentation of the documents comprising the *Traité de vertus démocratiques* was given at the Bibliothèque Nationale de France in Paris as part of an exhibition titled "L'aventure des écritures: La page" (Oct. 1999–Feb. 2000). An interactive presentation on the Internet, titled "Archéologie d'un brouillon d'écrivain," is also accessible on the website of the Bibliothèque Nationale de France at http://www.bnf.fr/pages/pedogos/queneau/index.htm.

Incipit epistola sancti iheronimi ad
paulinum presbiterum de omnibus
diuine historie libris·capitulū primū.

Rater ambrosius
tua michi munus-
cula pferens·detulit
simul et suauissimas
lras·q̃ a principio
amicicias· fide pba-
te iam fidei ⁊ veteris amicicie noua
pferebant. Uera eni illa necessitudo ē·
⁊ xp̃i glutino copulata·qñ non vtili-
tas rei familiaris·nõ pñtia tantum
corpoꝝ·nõ sbdola ⁊ palpãs adulaco:
sed dei timor·et diuinaꝝ scripturarū
studia conciliant. legim⁹ in veterib⁹
historijs·quosdã lustrasse puincias·
nouos adiisse pplos·maria trãsisse·
ut eos quos ex libris nouerant:cora
q̃q̃ viderent. Sicut pitagoras memphi-
ticos vates·sic plato egiptū ⁊ architā
tarentinū·eandemq̃ oram ytalie·que
quondã magna grecia dicebat·labo-
riosissime peragrauit· ut qui athenis
mgr erat·⁊ potens·cuiusq̃ doctrinas
achademie gignasia psonabãt·fieret
peregrinus atq̃ discipulus·malens aliena
verecūde discere·qñ sua ipudent ingeret.
Denicꝫ cū lras quasi toto orbe fugien-
tes psequit·capt⁹ a piratis ⁊ venunda-
tus·tyrãno crudelissimo paruit·duct⁹
captiuus vinct⁹ ⁊ seruus: tam̃ quia
philus maior emente se fuit·ad tytum
liuiū·lacteo eloquencie fonte manante·
de vltimis hispanie galliarumꝫ finib⁹
quosdã venisse nobiles legimus:⁊
quos ad contemplacionē sui roma nõ
traxerat·uni⁹ hois fama pduxit. Ha-
buit illa etas inauditū õnibꝫ seculis·
celebrandumꝫ miraclū·ut urbe tantā

ingressi:aliud extra urbem quererent.
Apolloni⁹ siue ille mag⁹ ut uulgus
loquitur·siue philus·ut pitagorici tra-
dunt·intrauit psas·prãsiuit caucasū
albanos·scithas·massagetas·opulen-
tissima indie regna penetrauit·et ad
extremum latissimo physon amꝵ ne
tãsmisso/puenit ad bragmanas·ut
hyarcam in throno sedentē aureo et de
tantali fonte potantem·inter paucos
discipulos·de natura·de moribᶻ·ac de
cursu dieꝝ et siderꝝ audiret docentem.
Inde p elamitas·babilonios·chalde-
os·medos·assyrios·parthos·syros·
phenices·arabes·palestinos·reuersus
ad alexandriã·perrexit ad ethiopiã:
ut gignosophistas ⁊ famosissimam
solis mensam videret in sabulo. In-
uenit ille vir vbiqꝫ q̑ disceret:et semp
proficiens·semp se melior fieret. Scrip-
sit super hoc plenissime octo volumi-
nibus·phylostratus. Cap secūdū
Uid loquar de seculi hominibᶻ·
cū aplus paulus·vas eleccõis·
⁊ magister gencium·qui de consciencia
tãti i se hospitis loquebat dicens·an
experimentū queritis eius qui in me
loquit xp̃us·post damascū arabiãqꝫ
lustratã·ascendit iherosolimã ut videt
petrū ⁊ mãsit apud eū diebᶻ quindeci.
hoc eni mistio ebdomadis et ogdo-
adis·futur⁹ gencium pdicator instruen-
dus erat. Rursūqꝫ post ãnos quator-
decim assumpto barnaba et tyto·ex-
posuit cū aplis euãgeliū:ne forte in va-
cuum curreret aut cucurrisset. Habet
nescio qd latentis energie·viue vocis
actus:et in aures discipli de auctoris
ore transfusa:forcius sonãt. Unde et
eschineus cū rodi exularet·⁊ legeret

THE RISE OF PRINTING IN THE WEST

Henri-Jean Martin

THE EMERGENCE OF PRINTING IN WESTERN EUROPE

In Western Europe, printing stemmed from a technological advance that soon outstripped its initial goals and transformed an entire civilization. It owed its success to an increasing demand for written texts. The use of writing had been growing since the eleventh century in response to the increase in economic and intellectual activity, along with the revitalization of towns and cities, all of which required ever greater quantities of books and practical documents. Above all, writing became an everyday affair starting in the thirteenth century. By the end of the fourteenth century, and even more so in the fifteenth, this trend—which had begun in Italy—accelerated in Germanic lands, which enjoyed great prosperity and boasted more and more schools and universities.

Meanwhile, Spanish and Italian merchants had introduced paper into Europe in the twelfth century. The methods for making this new medium spread across the continent in the fourteenth century. The first German paper mill appeared in Nuremberg in 1399, the year that Gutenberg is thought to have been born in Mainz.

At the same time, people had begun cutting images in relief on blocks of wood, accompanied by short texts. These woodblocks would then be printed on paper. The invention of the true printing industry nevertheless sprang from advances in metallurgy then occurring in Germany. The need for silver in this period of economic revival spurred engineers to perfect methods of extracting it from silver-bearing lead ore. Also, iron and copper mines were actively exploited, and efforts were made to mass-produce metal objects, notably in Nuremberg, whose municipal forges largely contributed to the development of new techniques.

The story of Johannes Gensfleisch, known as Gutenberg, unfolded in this context. Gutenberg's life, carefully studied by German scholars and apparently well known, still retains a measure of mystery. He came from a patrician family exiled by an urban uprising, and became an engineer like many other men at the time. He offered his services to clients among the large merchant companies, proposing to teach them new methods for cutting gemstones, for making mirrors, and for "writing artificially." Gutenberg was not the only one of his kind—for example, a certain Procopius Waldfoghel from Prague who had trained at the Nuremberg forges seems to have helped to develop, on the shores of Lake Constance, techniques for intaglio engraving on copper plates even as he studied the manufacture of astronomical clocks. Waldfoghel also sold an *Ars scribendi artificialiter* to some Jews in Avignon, probably designed for tooling book bindings, while one of his journeymen taught the art of making cannon to agents of the duke of Burgundy.

The lack of an adequate technical vocabulary means that nothing can be inferred from otherwise detailed documents concerning litigation over the printing invention on which Gutenberg worked in Strasbourg from 1438 to 1444. Yet it appears certain that he managed to print, in Mainz, a number of items in the years 1448–1453, thanks to loans from a rich merchant, Johannes Fust. It also seems that, once the invention was complete, Gutenberg swiftly found himself ousted by Fust, who preferred to cut a deal with Gutenberg's assistant, Peter Schoeffer, a former student at the University of Paris who became Fust's son-in-law and who probably perfected the mold used to cast the characters.

Fig. 1. The prologue to the so-called "42-line Bible", attributed to Fust and Gutenberg. Bibliothèque Nationale de France, Paris.

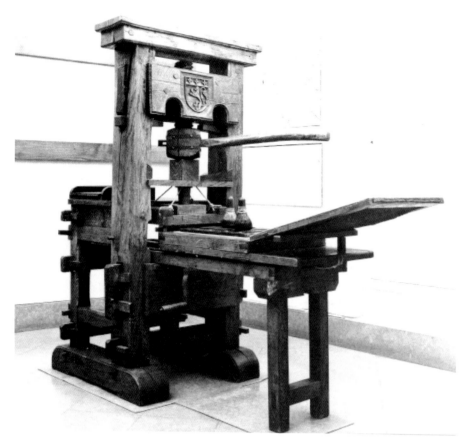

Fig. 2. A reconstruction of an early printing press based on a fifteenth-century engraving. Musée Lyonnais de l'Imprimerie, Lyon.

The members of this group printed small publications—grammars by Aelius Donatus, astronomical calendars, and letters of indulgence—before undertaking what they intended to be their masterpiece, the "42-line Bible" (Fig. 1). This large book was probably completed in 1454–1455 by Gutenberg in collaboration with Fust and Schoeffer. After this the latter two alone produced a magnificent psalter dated 1457. They thus set off to conquer a vast potential market that would soon inspire rivals and followers such as William Caxton, who probably learned the art of printing when he was working in Cologne in 1471.

EARLY PRINTERS VERSUS HANDWRITTEN MODELS

The art of typography as it emerged in the West involved simple technology that nevertheless implied certain forms of standardization. It is worth recalling that characters were made from a steel die on which a letter (or other sign) had been carved, reversed, in relief. This die was punched into a small block of copper—the matrix—where it left an

intaglio imprint, the right way around. Then the matrix was set in a mold that could be used to cast endless numbers of characters from an alloy of lead, tin, and antimony, which melted at low temperatures. Reproducing the given character in reverse, these letters could be assembled into the lines and pages (and later groups of pages) of a "form." Once covered with ink and applied with the correct pressure to a sheet of paper, the text appeared the right way around.

The press used at the time was a simple, robust instrument (Fig. 2) that could print a text correctly only if the pieces of type were of the same height (known as "height to paper") and had the same body size (or "point size"). Only the width could vary without creating problems. Moreover, the typesetter had to be able to draw the characters he needed from the case swiftly and easily. This also called for a standardization of characters.

Now, great diversity reigned among manuscripts henceforth available for mass reproduction. First of all, this diversity concerned the scripts, or style of handwriting, which varied according to region and type of book. Church books and certain bibles were written in the most solemn Gothic lettering, known as *lettre de forme* (or Textura), characterized by large vertical shafts and multiple angles resulting from the systematic elimination of curves.

Theological treatises, meanwhile, employed a less solemn, smaller and generally rounder hand (despite a certain angularity) known as *lettre de somme*. Such books employed a conventional, strikingly limited vocabulary and systematically used a series of standardized abbreviations. They followed the principle of a completely full page, no space or indentation being allowed, although margins were sometimes very wide. This layout made it difficult to get an overall vision of a text, which mattered little given that the methods of reasoning at the time were primarily analytical—the argument would be divided into segments that fit into one another according to a stereotyped construction, as meticulously stated at the head of each section of the book.

Books in vulgate languages, designed to be read in small groups of people, were laid out very differently. The text was usually divided into short chapters preceded by a summary, everything contributing to the oral reading. The script used to transcribe these works was generally a type of Gothic hand known as *lettre bâtarde* (bastard) because it was employed both for documents issued by chanceries and for literary texts. *Bâtarde* varied from land to land, obviously, since each chancery had its own script. Punctuation, meanwhile, was usually highly limited, was intended above all to guide the reader's voice, and had become somewhat fossilized.

Early printers strove to reproduce these various types of script (Fig. 3). They also initially attempted to print titles in red, which represented a highly complicated task. They were notably unable to dispense with rubricators who went through the pages of every copy, adding the many pen or brush strokes of the rubrics that guided the reader; it goes without saying that a growing number of volumes were soon being issued without this additional work, thus rendering unreadable many theological texts that piled up, unread, in libraries.

In view of these various models of writing, early attempts at innovation had been made in Italy well before printing emerged. The Italians had always had difficulty in accepting the angular, Gothic script. For their university texts—notably for law books inspired by a school of jurists in Bologna—they therefore adopted a round lettering of rather large size that was markedly different from the Parisian *lettre de somme* script. This hand became highly popular in the Romanized lands of southern Europe and was later widely disseminated through printing.

It is well known, furthermore, that the grand reform in writing was primarily the work of humanists who promoted scripts inspired simultaneously by the Roman capital letters seen on the pediments of many ancient buildings and by Carolingian minuscule script, itself more or less derived from ancient Latin lettering. The great Italian printers of the fifteenth century soon began imitating these magnificent models.

Meanwhile, in a concern to obtain the best possible versions of major Latin texts, the humanists struggled to develop coherent systems of punctuation. Paradoxically, this trend took a long time to make itself felt on Italian typography. On the other hand, scholars who sought to introduce the same texts outside Italy seemed particularly concerned to make reading easier, as was notably the case with Guillaume Fichet and Johann Heynlin in Paris, who established a very elaborate system of punctuation designed to facilitate the understanding of certain works by Cicero and Sallust. It might be wondered whether French printers' highly precocious concern to make ancient texts more comprehensible came from the fact that their work was monitored by scholars accustomed to a strictly analytical, scholastic way of thinking based on the principle that an argument had to be divided into elements constituting the units of a whole.

Fig. 3. Examples of fifteenth-century typefaces:
(a) Textura (*lettre de forme*): The Bible (Gutenberg and Fust, Mainz)
(b) "Bolognese" rotunda: (Rugerius, Bologna)
(c) French Gothic *bâtarde* (Le Rouge, Paris)
(d) English Gothic *bâtarde* (Caxton, Bruges)
(e) Roman (Nicolas Jenson)

THE TRIUMPH OF ROMAN TYPE IN WESTERN EUROPE

Right from the start, Italian-based printers published ancient classics—as well as books by Dante, Petrarch, and Boccaccio—in a humanist-inspired typeface. Two names are worth noting: the Frenchman Nicolas Jenson, who worked in Venice and developed, around 1469–1470, the roman letters to receive future consecration, and the Italian Aldus Manutius, who cut roman letters based on proportions established by artists and calligraphers using ancient inscriptions and who also created the first italic typeface. Italic type imitated the sloping, cursive hand used by the Vatican chancery, on which the humanist Niccolo Niccoli had drawn when developing a highly dense but nevertheless elegant book script. Furthermore, Aldus Manutius, who specialized in printing the Greek classics, began using a system of accents designed to aid the reading of Latin texts by indicating stressed syllables.

Three dates stand out in the printing career of Aldus Manutius. In 1494, he published Pietro Bembo's *Aetna,* the

Fig. 5. (left) Francesco Colonna's *Hypnerotomachia Poliphili* (Dream of Polyphilo), published by Aldus Manutius in 1499 in a typeface cut by Francesco Griffo. Bibliothèque Nationale de France, Paris.

Fig. 4. The beginning of the "Georgics" in Virgil's *Works,* published by Aldus Manutius in Venice in 1501. This octavo volume was the first book to use italic typeface (cut by Francesco Griffo). Bibliothèque Nationale de France, Paris.

first book to use roman type cut by engraver Francesco Griffo. In 1499, he brought out Francesco Colonna's *Hypnerotomachia Poliphili* (Dream of Polyphilo), an allegorical tale written in a language inspired simultaneously by Latin and Italian dialects. Illustrated with figures of archaeological inspiration and highly pure in style, this book employed a markedly refined typography—for instance, the typesetter disposed of several variants of certain lowercase letters, allowing him to avoid the impression of visual monotony on the page (Fig. 5). Finally, in 1501, Aldus printed the *Works* of Virgil in a small format (octavo) and

italic type, for which he received authorization from the Venetian Senate (Fig. 4).

Very soon, printers working elsewhere began using typefaces inspired by the roman letters cut in Italy to reproduce classical Latin texts. German typographers, however, who long dominated the continent and were more accustomed to the Gothic style, attempted to adapt the new typefaces to the vertical thrust of their national tradition. Encountering great difficulty in employing the new capital letters, they sometimes tried to preserve certain features of the uncial-derived capitals they had been using up until then. They also retained certain aspects of their traditional lower-case letters to produce "humanist-Gothic" type.

Roman type was long used solely for texts in Latin. It might have been expected that each nation would retain the Gothic typefaces derived from the script used in the local chancery for the publication of texts in the local language. That, however, would have meant overlooking the glamour of the classical culture and the writing that symbolized it. Thus Claude de Seyssel, a scholar from Savoy who was an adviser to French King Louis XII, proposed to his royal patron—in the preface to one of his famous translations from Greek and Latin—that French should be made a language as ordered as Latin by following the example of the ancient Romans, who themselves had looked to Greek to endow their own language with a more regular form.

The manuscripts presented to Louis XII by Seyssel were of course copied by hand in the court's Gothic script. But a revolution was stirring in the entourage of the dauphin François, the future King Francis I: the first manuscript in French to employ the new roman script was produced at the instigation of the dauphin's tutor, François Demoulins. This treatise praised Christian virtues (Fig. 6), as a kind of reply to the *Hypnerotomachia Poliphili,* which had glamorized paganism. Later, after the victory of Francis I at Marignano, Demoulins composed a dialogue between the young king and Julius Caesar that was handwritten in roman script. Above all, Demoulins presented his patroness Louise of Savoy and her daughter Marguerite of Angoulême with a series of booklets, also written in a humanistic script, explaining and defending certain exegetical theses advanced by his friend Jacques Lefèvres d'Étaples.

These books were composed at a time when Francis I hoped that one day he would rival the ancient Roman emperors, being himself a candidate for election to the title of Holy Roman Emperor. A further stage was reached in 1524, when the king's lector, Jacques Colin, had Seyssel's translations published by humanist typographer Josse Bade and several printers close to the monarchy. Such publications were most timely—the royal government, as it

Fig. 6. A treatise on virtue by François Demoulins, written in a hand inspired by the roman typeface used in the *Hypnerotomachia Poliphili* (see Fig. 4). The paintings are by Guillaume Le Roy. Ms. fr. 12247, fol. 4v, Bibliothèque Nationale de France, Paris.

moved toward an enlightened absolutism, felt the need to unify the French language, basing it on the vocabulary and pronunciation used at court and the *parlement* of Paris. Robert Estienne was therefore pursuing this same line when, in 1526, he published the first Franco-Latin grammar

Fig. 7. Diacritical marks used to indicate French pronunciation, cut for Robert Estienne's 1526 publication of *Isagoge* by the physician Jacques Dubois. Typeface attributed to Claude Garamond. Bibliothèque Nationale de France, Paris.

in France—*Isagoge* (Fig. 7), written by a well-known physician named Jacques Dubois—followed by a major lexicographical work that gave the meaning and pronunciation of words and expressions.

This trend coincided with efforts made by type cutters in the tradition of Colines, Augereau, Garamond and Granjon, whose criteria were soon adopted all across Europe. More important in this particular context, however, were theorists such as Geofroy Tory, whose famous treatise on the design of type, *Champfleury* (Fig. 8), not only provided a meditation on letters but also contributed to the development of a series of new diacritical marks, such as the cedilla.

Starting sometime around 1530, under the influence of people close to the French court such as Clément Marot,

French literary works of the new school were published in roman type with diacritical marks and, especially, accents and punctuation. These were added to the ancient alphabet in an effort to convey pronunciation better, thereby facilitating both diction and comprehension. At the same time, spelling began to be standardized despite resistance from typesetters who wished to retain a certain autonomy (particularly useful when justifying lines of type). Finally, punctuation reached its current form. As discussed below, this did not yet mean that pages had attained their modern appearance, because the concept of chapters remained poorly defined and the principle of block-like pages continued to dominate whenever prose texts were involved.

The veritable graphic revolution represented by the spread of roman typeface everywhere in France remains a surprising phenomenon, especially since Gothic *lettre bâtarde* long remained the official hand used in the French chancery. This revolution was nevertheless encouraged and carried out by the royal entourage and by humanists linked to the royal chancery. Encouraging writers and printers to abandon the familiar path of traditional Gothic lettering and ill-adapted diacritical marks led to a general revision of French linguistic norms. The change made French a "well-ordered" language and turned spelling into government business. This trend, backed by a strong central government, prefigured French classicism. At the same time, cutters of French type began imposing their norms everywhere. Such was their influence on France's neighbors that the English and Spanish adopted this type of lettering (which, it should be recalled, was used not only by the French but also—and sometimes exclusively—by the Italians).

Germany, meanwhile, took an opposite tack. Whereas the French court adopted the roman typeface for political ends, Emperor Maximilian did the contrary for similar reasons. Wanting to fuel national hostility to everything that came from Rome, and influenced by the aesthetic taste of artists in his entourage, Maximilian had an Augsburg engraver work in secret, under the emperor's supervision, to produce a Gothic type that was both elegant and refined, directly based on the script used in the imperial chancery. This typeface was used for a few private publications, the most famous of which was Pfinzing's *Teuerdank* (Fig. 9). Because Luther's movement followed this new graphic line, Germans henceforth used roman typeface only for Latin texts. Germans simultaneously tended to maintain old traditions in terms of the layout, transcription, and punctuation of printed texts. The Thirty Years' War exacerbated this lag, which was only overcome at the end of the eighteenth century.

Fig. 8. *Champfleury* by Geofroy Tory, published by Gourmont in Paris in 1529. Bibliothèque Nationale de France, Paris.

Fig. 9. Page 15 of Melchoir Pfinzing's *Teuerdank* (Augsburg, 1517). Illustration attributed to Beck. Bibliothèque Nationale de France, Paris.

TEXT AND IMAGE

Of course, the emergence of printing also led to an upheaval in the relationship between text and illustration.

Woodblock printing techniques, developed prior to typography, had stimulated the spread of booklets in which image and text were produced together in the same way and were therefore intricately linked. Attention was naturally drawn to the images; the few words engraved alongside them (or even within them) played only an explanatory role, as seen, for example, in picture bibles known as *Biblia pauperum* and in enormously popular illustrated Apocalypses (Fig. 10). In a way, it may seem regrettable that these woodcut pamphlets—rather plain in appearance yet inexpensive and easy

to understand—vanished on the arrival of typographical printing. Initially, printers left spaces for illuminators and rubricators to add their work to each copy. Later, engraved woodblocks were incorporated into the typographical composition, so that everything could be printed at the same time. Illuminators continued to be used for a time to illustrate certain luxury editions, often printed on vellum, while other editions might be colored in a production-line way, often by using stencils. Little by little, however, engravers became completely autonomous, executing black-and-white illustrations that were totally accomplished, notably thanks to increasingly sophisticated hatching techniques. Then, using very hard wood, they began engraving small vignettes with extremely fine draftsmanship.

Fig. 10. An Apocalypse scene printed from woodblocks in the Netherlands around 1450. Bibliothèque Nationale de France, Paris.

Hence it was once again possible to place an image at the center of a page, turning text back into a kind of commentary on it. A vast secular public became enthusiastic about this type of publication, giving rise to books of emblems, anthologies of heraldic devices (Fig. 11), and other biblical imagery, all of which exploited visual interplay to bring allegorical thinking to the fore. This fashion, which arose in the years 1520–1530, lasted for over a century. Moreover, the popularity of copperplate engravings—which were finer and more accurate than woodcuts, and became widespread from the late sixteenth century—required that sheets with illustrations be printed on a roller press as opposed to a letter press, leading to the increasing use of frontispieces presenting the content and meaning of the book in an allegorical way (Fig. 12).

Engraving also made it possible to represent animal and plant species—not to mention human anatomy—with greater accuracy, thereby favoring the growth of natural sciences and knowledge of the world (Fig. 13). Cartography also benefited, notably in the latter half of the sixteenth

century and first half of the seventeenth. Readers thus steadily learned to "decipher" images and "read" maps, managing to grasp a page with a synthesizing gaze that could analyze the elements of a discourse visually, rather than slowly decoding it by "listening" internally, as they still tended to do.

THE EMERGENCE OF MODERN TEXT PRESENTATION

A simple glance at the pages of books from the sixteenth and early seventeenth centuries makes it easy to measure the progress made in the presentation of printed discourse.

The difficulty of the undertaking is reflected in the history of title pages. In the early years of the sixteenth century, title pages started becoming the rule. Yet the title itself would be drowned by laudatory phrases, themselves often wrapped in a decorative framework apparently designed to

Fig. 11. "Pour un grand seigneur" ("For a great lord"), a motto and device found in Simeoni's *Devises héroiques,* a quarto volume published by B. Rouillé in Lyon, 1550.

Fig. 12. A copperplate engraving advocating the legal restoration of dueling,
used as the frontispiece to volume two of Vulson de la Colombière's *Mémoires historiques de la Noblesse*,
published in folio format by A. Courbé in Paris in 1648. Bibliothèque Nationale de France, Paris.

les autheurs. Quant aux animaux, comme beftes fauua-
ges, poiffons, & oyfeaux, noftre ifle en nourrit des meil-
leurs, & en autant bonne quátité qu'il eft poffible. D'oy-
feaux en premier lieu en reprefenterons vn par figure,
fort eftrange, fait cóme vn oyfeau de proye, le bec aqui-
lin, les aureilles enormes, pendantes fur la gorge, le fom-
met de la tefte eleué en pointe de diamant, les pieds
& iambes comme le refte du corps, fort velu, le tout
de plumage tirant fus couleur argentine, hors-mis la
tefte & aureilles tirans fus le noir. C'eft oyfeau eft nom-

*Pa, oy-
feau e-
ftrange.*

mé en la langue du païs, Pa, en Perfien, pié ou iambe:
& fe nourrit de ferpens, dont il y á grande abon-
dance, & de plufieurs efpeces, & d'oyfeaux fembla-
blement, autres que les noftres de deça. De beftes,

m

Fig. 13. A parrot, illustrated in Thevet's *Singularitéz de la France antarctique,* published in quarto by Héritiers de la Porte in Paris in 1556.

fill the entire page. Humanist printers reacted to the clutter by proposing simpler titles and playing on contrasts between black and white. But even the most famous of them were guided by purely aesthetic concerns—the idea of emphasizing key words did not even occur to them, except in the case of the word "Bible," which they would dramatically place alone in the middle of the page (Fig. 14). Meanwhile, throughout the sixteenth century many books continued to be set as dense pages with no white spacing, no ventilation. That was the case, for example, with Montaigne's *Essays,* the text of which contained no indentation or blank spacing for up to ten pages at a stretch, except when it came to quotations. On the other hand, printers and authors would often include marginal notes indicating the date or subject of the passage opposite. Sometimes illustrations might also lend breathing space and help to pace a text.

Such page layout can be explained by the fact that many texts were subdivided into nothing other than "books,"

Fig. 14. Title page from a French bible published by Jean de Tournes in Lyon in 1557, folio format. Bibliothèque Nationale de France, Paris.

MODÉLES

DES CARACTERES DE L'IMPRIMERIE,

ET DES AUTRES CHOSES NÉCESSAIRES AUDIT ART.

NOUVELLEMENT GRAVÉS

Par SIMON-PIERRE FOURNIER le jeune, Graveur & Fondeur de Caractéres.

A PARIS,

Ruë des sept voyes, vis-à-vis le Collége de Reims.

1742

Fig. 15. An example of "baroque printing"—the title page of a typographical catalog by type-founder Simon-Pierre Fournier, 1742. Bibliothèque Nationale de France, Paris.

thus imitating the works of ancient authors for whom the term "book" meant one scroll of papyrus. Occasionally, however, a publisher would insert chapters, even in a classical work, which could vary greatly in length, being no more than a few lines in certain cases. Whatever their length, chapters were not yet broken into paragraphs; even in the mid-seventeenth century, Madeleine de Scudéry and her *précieuse* set in Paris salons were still writing novels that had to be read for hours at a stretch in a murmuring voice by a reader totally immersed in the text in order to avoid losing the thread.

The situation nevertheless began to change in the late sixteenth and early seventeenth centuries under pressure from editors and the last generation of humanist printers. Wanting readers to be able to find their place in the great works of antiquity, and above all wanting to provide references that would be valid for all editions, editors began to number verses and to divide prose into numbered *capituli* of several dozen lines. Thus emerged the presentation still used today in scholarly editions. Great prose writers of the day in both England and France soon followed this example, as seen in Sir Philip Sidney's *Arcadia* and Guez de Balzac's *Le Prince.* The latter also preceded each section of his book, already subdivided into chapters, with a short summary. Then, when he had *Le Prince* reprinted, he neglected to reproduce the Roman numerals that marked

PUBLII

VIRGILII MARONIS

AENEIDOS

LIBER PRIMUS.

Aʀᴍᴀ, virumque cano, Trojæ qui primus ab oris
Italiam, fato profugus, lavinaque venit
Littora. Multum ille et terris jactatus et alto,
Vi superum, sævæ memorem Junonis ob iram.
Multa quoque et bello passus, dum conderet urbem,
Inferretque Deos Latio : genus unde latinum,
Albanique patres, atque altæ mœnia Romæ.

 Musa, mihi causas memora, quo numine læso,
Quidve dolens regina Deum, tot volvere casus
Insignem pietate virum, tot adire labores,
Impulerit. Tantæne animis cœlestibus iræ?

 Urbs antiqua fuit, tyrii tenuere coloni,
Carthago, Italiam contra, tiberinaque longe
Ostia, dives opum, studiisque asperrima belli ;
Quam Juno fertur terris magis omnibus unam
Posthabita coluisse Samo : hic illius arma,

Fig. 16. The "Didot style," as seen on the first page of Virgil's *Aeneid,* published in folio format by Didot in 1791. Bibliothèque Nationale de France, Paris.

the various *capituli,* so that each *capitulo* assumed the appearance of today's paragraphs. Descartes adopted this same presentation for his *Discourse on Method,* which was printed in Holland and constitutes, to the best of my knowledge, the first French text of philosophy printed in modern form.

French typographers slowly conformed to this new layout, which allowed readers to pause regularly and to reflect on each unit of meaning before commencing again.

Subsequently, polemicists in the latter half of the seventeenth century, notably the Jansenists, further enhanced the visualization of their texts, notably by using shorter paragraphs.

The seventeenth century produced no great engravers of type—French classicism remained faithful to Renaissance typography. At the very end of the century, engravers at the Royal Print Works in France finally produced a "royal typeface" of letters that were "corseted," so to speak, by stronger horizontal bars. Then, during the Regency and early years of Louis XV's reign, skilled artists lent a "rococo" look to the printed page by loading it with ornamental details cast in relief from molten metal (Fig. 15). This period was followed—throughout Europe—by one of simplification, associated with the names of Baskerville in England, Didot in France, and later Bodoni in Italy. The Didot family set the tone by imposing its rigid, geometric typeface (Fig. 16), which emphasized the contrast between thick and thin strokes, giving the page a quasi-military feel page perfectly suited to the illustrations that Jacques-Louis David and friends produced for certain grand, classical publications during the early Napoleonic years.

Prosperity during the previous century had nevertheless enabled Enlightenment printers to issue extensive series of documentary tomes such as the *Encyclopédie* and Buffon's *Natural History,* whose texts were illustrated by engraved plates that often held great appeal. At the same time, although on another register—that of pure book lovers—there flourished delightful little volumes with vignettes produced by a galaxy of highly specialized artists. The most famous examples of such books in France were Dorat's *Les Baisers* (Kisses) (Fig. 17) and La Fontaine's *Contes* (Tales).

At the same time, printers were greatly improving the presentation of their books. The existence of intellectual and commercial networks across Europe tended to impose the same style on all, particularly when it came to "philosophical" works. The titles of books, for example, consequently assumed their modern form, notably under the influence of British printers. Finally, the "reading frenzy" that gripped Germany was accompanied by the growing influence of roman typefaces there, halted however by a nationalist reaction during the reign of Napoleon I.

Such progress should nevertheless not disguise the fact that less carefully printed books were being produced throughout Europe. Such was the case notably with so-called chapbooks whose typography could be so hard to decipher that they were seemingly designed not so much to be read as to be re-read by someone who already knew the text perfectly well (Fig. 18).

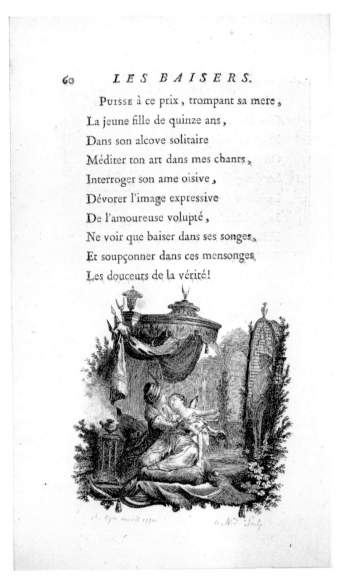

60 *LES BAISERS.*

PUISSE à ce prix, trompant sa mere,

La jeune fille de quinze ans,

Dans son alcove solitaire

Méditer ton art dans mes chanrs,

Interroger son ame oisive,

Dévorer l'image expressive

De l'amoureuse volupté,

Ne voir que baiser dans ses songes,

Et soupçonner dans ces mensonges

Les douceurs de la vérité!

I. BAISER.

LES ROSES,

OU

LA MOISSON DE VÉNUS.

UN JOUR la belle Dionée,

Dans un de ces bosquets qui couronnent Paphos,

Fit enlever le fils d'Énée,

Tandis que le sommeil lui versoit des pavots :

Fig. 17. The book as precious object—pages 60–61, with copperplate engravings after Eisen, from an octavo volume of Dorat's *Les Baisers*, published by Delalain in The Hague and Paris, 1770. Bibliothèque Nationale de France, Paris.

PRINTING AND SOCIETY

Just looking at the books produced during each period is not sufficient to appreciate the impact of the advent of printing. The impressive rise in output sparked by the new craft must also be taken into account. When it comes to incunabula, although reliable statistics in this realm are hard to offer (given all the vanished editions), several hundred thousand early volumes survive, corresponding to 27,000 to 30,000 known editions, which means that a total of fifteen to twenty million books were put on the market in the forty or so years between 1460 and 1500. Book production then increased exponentially in the sixteenth century, and 200,000 to 300,000 editions have been listed for that period. Growth continued throughout a good part of Europe in the first third of the seventeenth century, despite the ravages of the Thirty Years' War. Subsequently, the decline in Latin publications led to a rupture in the international book trade. Given a climate of recession, formats tended to shrink and booksellers reacted by also lowering the quality of their books. Nevertheless the "good years" of the seventeenth century in France—1640 to 1645 and 1660 to 1670—produced an estimated 2,000 editions. After a period of deep crisis, publication grew once again, first in Germanic countries in the early eighteenth century, then in France starting in 1720. Output would reach dizzying

Fig. 18. A little moralizing chapbook, just four pages in quarto format, published in France in the late eighteenth century. *La Bête du Gévaudan,* Bibliothèque Nationale de France, Paris.

heights in the years 1770 to 1820, when both Germany and Britain matched and then outstripped France.

Measuring the impact of printing means considering, in addition to the books that have survived, all the countless fliers and other commercial work that occupied some 50 per cent of the presses in eighteenth-century France. This figure was even surpassed in Britain with the advent of advertising.

These increases in output corresponded to a growing number of readers, as witnessed initially and most noticeably by the sale of religious texts, and then by the number of books peddled by traveling colporteurs to rural notables and craftsmen of moderate resources. Reading habits continued to evolve, and it is generally acknowledged that in the late seventeenth—and especially eighteenth—century people shifted from an intensive type of reading (where a small number of books were constantly re-read) to a more extensive one (where novelty tended to be favored).

The profession of writer also changed. For a long time, most new books were written by churchmen, jurists, or authors supported by patrons, a situation that weighed on the choice of literary genre and the inclination of published texts. In the seventeenth and eighteenth centuries, however, the sale of books began providing authors with revenues that became substantial during the Enlightenment, leading to greater independence vis-à-vis the establishment. At the same time, censorship proved ineffective in suppressing subversive texts, though this in no way means that such texts played a determining role in changing attitudes—an issue that remains entirely open.

Despite undeniable progress, the reading public nevertheless remained limited. Initially comprising a highly restricted elite of aristocrats, royal officers, and clergy, this public grew to include, broadly speaking, all men having obtained some sort of schooling, plus the wives and daughters of the privileged. In the eighteenth century, when literacy began to spread and self-taught readers grew in number, readership began to reach wider circles, although it remains to be established what those readers expected and retained from books they read.

THE INDUSTRIAL REVOLUTION AND THE BOOM IN PRINTED PAPER

There can be no question here of covering the whole history of the second Gutenbergian revolution, triggered by a revolution in communications in the nineteenth century.

A simple reminder should do: it all began with a revolution in the manufacture of paper, so essential to a society that was writing more and more, which corresponded to

Fig. 19. A mechanical press in a nineteenth-century printworks. Sketch by Paul Baudoin for a fresco in the Municipal Library in Rouen, France. Oil on wood, Musée des Beaux-Arts, Rouen.

another revolution in imagery sparked by new methods of printmaking. Lithography—whereby drawings or writing are transferred from stone to paper, requiring no special technique—constituted the first modern method of reproducing text and images in multiple quantities, and its rise was linked to the rise of advertising. Then came mechanical presses—printing machines that were more and more productive—and the mechanization of binding. Photomechanical processes that made it possible to print photographs alongside text were finally perfected in the late nineteenth century, as were the first automated typesetting machines.

It should be pointed out that this revolution did not initially concern books. In the first two thirds of the nineteenth century, mechanical presses were used above all for periodicals (Fig. 19), and sometimes for advertising. It was only around 1850 that book production truly began to take off, reaching dizzying figures by the end of the century, at least in terms of the number of publications.

The new technology produced a complete upheaval in intellectual output. During the reign of Louis-Philippe in France in the 1830s, publishers began to assume new power, calling the tune as books were "promoted" to rank of industrial product. Efforts were made to diversify the presentation of books and prices in order to reach the widest possible public. On the level of presentation of text, a new form of standardization arose. Potential readers began turning systematically to the table of contents to grasp the substance of a book, and authors duly offered a more coherent plan of the main ideas—except, of course in

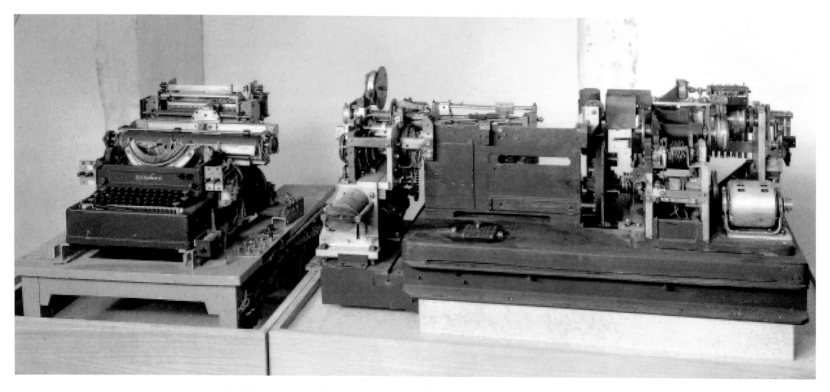

Fig. 20. A prototype of a Lumitype machine. On hitting a key on the typewriter, the corresponding character is photographed through an aperture in a spinning wheel. Today, such machines are governed by computer disks containing the text to be printed. Musée Lyonnais de l'Imprimerie, Lyon.

purely literary works such as novels, which raised different problems. At the same time, typesetters—whose numbers were increasing—had to respect stricter and stricter guidelines. Typographical innovation nevertheless grew apace during the nineteenth century, largely aimed at posters but also influencing the conception of books. Furthermore, the flexibility of new methods of illustration favored a return to imagery that ultimately led to modern comic books. The visual revolution stemming from the industrial, mass-manufacture of books went so far as to trigger numerous reactions from conservatives who, not without good reason, felt that a highly symbolic object was losing its sanctity.

The spread of literacy, the ubiquitous presence of print in society (Fig. 20), and social issues that required reflection all tended to broaden the book-reading public. Types of popular reading material grew in the latter half of the nineteenth century, then seemed to regress in the beginning of the following century during a recession that remains poorly understood. Books were still an elitist object, their reading public not being as large as periodicals, whose print-runs broke all records at the dawn of the twentieth century.

WHAT NOW?

Other articles address the revolution in the manufacture of printed documents in the second half of the twentieth century, the explosion of communications, and the globalization of information.

So from this standpoint, how should we view the future of books, at least in their current form?

Obviously, the recent emergence of worldwide information systems of unlimited power will certainly alter the parameters of the problem and challenge the role of books and traditional printed documents. It should simply be noted that dramatic declarations of the imminent demise of paper have only led—for the moment—to an increase in the latter: one only has to think of the reams of paper churned out by computers, of mailboxes stuffed with advertising, of fliers tossed away unread. Furthermore, in terms of sheer numbers, books have never done so well. Indeed, now being touted as a major advance is the imminent possibility of producing a book at home, with limited equipment, by putting into book form information drawn from the Internet.

As always when it comes to progress, in fact, the threat of overload is more worrying than that of a vacuum.

Conceived as the medium of communication *par excellence*, heir to long and varied experiments and a glorious past, the printed book—a sacred object if ever there were one, where ideas set down on paper offered everyone a chance to think critically and self-reflexively, assuming the mission of helping human thought to perfect itself—only reigned, in fact, during a relatively short period that began with Gutenberg. It took a long while to reach its final form, which distinguished it from oral discourse as far as possible. The Enlightenment represented a high point in that effort, with a final burst during the Romantic era. Already, however, the rise of newspapers announced the decline of the book. The thrust of innovation then shifted to other forms of printed material and new modes of communication that employed word and image to challenge the inventive power of books. Nowadays, Descartes would probably be a telecom engineer charged with designing ever more powerful systems, while Victor Hugo would devote at least part of his time to making television series. Consequently, today books seem threatened not so much with extinction as with loss of sanctity.

Bibliography

BECHTEL, Guy. *Gutenberg et l'invention de l'imprimerie* (Paris: Fayard, 1991).

CHARTIER, R., and H. J. Martin (eds). *Histoire de l'édition française* (Paris: Fayard-Cercle de la Librairie, 1989–1991).

EISENSTEIN, Elisabeth L. *The Printing Revolution in Early Modern Europe* (Cambridge, England: Cambridge University Press, 1983).

MAN, John. *Gutenberg: How One Man Remade the World with Words* (New York: Wiley, 2002).

MARTIN, Henri-Jean, in collaboration with Bruno Delmas. *Histoire et pouvoirs de l'écrit* (Paris: Albin Michel, 1995).

——. *Mise en page et mise en texte du livre français: La naissance du livre moderne (XIVe–XVIIe siècles)*. (Paris: Cercle de la Librairie, 2000).

A a B b C c D d G g M m N n Q q R r
Group I – Humanistic

A a B b C c D d G g M m N n Q q R r
Group II – Garaldic

A a B b C c D d G g M m N n Q q R r
Group III – Transitional

A a B b C c D d G g M m N n Q q R r
Group IV – Didonic

A a B b C c D d G g M m N n Q q R r
Group V – Mechanistic

A a B b B c D d G g M m N n Q q R r
Group VI – Lineal

A a B b C c D d G g M m N n Q q R r
Group VII – Incised

A a B b C c D d G g M m N n Q q R r
Group VIII – Script

A a B b C c D d G g M m N n Q q R r
Group IX – Manual

𝕬a 𝕭b 𝕮c 𝕯d 𝕲g 𝕸m 𝕹n 𝕼q 𝕽r
Group X – Black Letter

آپ کو 'سونوٹائپ' سشینوں کی
Group XI – Non-Latin

Fig. 1. In the early twentieth century, the plethora of available typefaces called for a classification system that would make it easier to find and identify them. The above system, named Vox after its deviser, Maximilien Vox, is based on the style and chronology of letterforms and was adopted by the Association Typographique Internationale in 1962.

THE HISTORY OF TYPOGRAPHIC FORMS IN EUROPE

René Ponot

Ever since the emergence of Carolingian minuscule script, the basic shape of each letter of the Latin alphabet has conformed to a convention consecrated by twelve centuries of use. The evolution of letterforms, both handwritten and typeset, has therefore mainly involved their non-essential features—that is to say, visual details that do not affect the interpretation of the character. These details nevertheless apply to all the letters in the alphabet and establish its style (Fig. 1).

Since the notion of a single script to be used in all contexts did not exist when Gutenberg managed to "write without a pen," he was obliged to imitate the various hands used by his local contemporaries, namely Gothic script and its derivatives, each of which had a specific social function. Gutenberg therefore designed the Textura typeface for his "42-line Bible," cursive Gothic for letters of indulgence (both mid-1450s) and Rotunda for his encyclopedic *Catholicon* (1460). Italian scholars had been the only ones in Western Europe to shun "Gothic artifice" in favor of a humanistic, neo-Carolingian book hand (the first manuscript in this hand dates from 1408). Publishers Conrad Sweynheym and Arnold Pannartz, exiled from Mainz, Germany, produced the first typographic version of this hand in 1465 at Subiaco, near Rome (hence the name "roman" given to this type by French printers in the sixteenth century). But the cutter's lack of skill in reproducing a script with which he had only recently become familiar gave his prototypes a hesitant feel. Thus French typecutter Nicolas Jenson improved on them five years later, in Venice, by eliminating every hint of Gothicism. Jenson's type would become the future standard, thanks to the Latin elegance of its forms and the masterful way its serifs stabilized the printed line. Twenty-five years would pass before this typeface was rivaled, in its refinement, by one designed by

Aldus Manutius, another Venice-based printer who worked with typecutter Francesco Griffo. At this point a watershed was reached: typographic writing asserted its autonomy by abandoning all allusion to handwriting, henceforth answering only to its own criteria. Manutius was not content with roman type alone, and in 1500 he had Griffo cut a slanting, cursive script like the hand used at the papal chancery since 1431—this type was dubbed "italic," although its capital letters remained vertical until 1540. Their model was perhaps not the finest, but it was the easiest to typeset. Furthermore, Griffo was obliged to make the tall letters, with their long ascenders and descenders, less angled than the shorter letters. It was nevertheless a popular typeface and still survives today.

In only a short while, around 1530, all of the most competent printers were using roman typeface exclusively, even for texts that had been produced in Gothic script up till then. Inspired by Manutius, Claude Garamond led the way in creating new roman characters. His name, more than any other cutter of type (except Robert Granjon when it comes to italic), best expresses the spirit of typographic creativity in Latin letterforms. Yet such letterforms were not just Latin. This should not be forgotten, for it explains why, from subtle change to subtle change and from national identity to national identity, the creative torch passed to the roman type of Van Dijk, Voskens, and Kiss in the Netherlands during the last third of the seventeenth century, thanks to their more massive letters that narrowed the eyes of short letters (a, c, e) and shortened the ascenders and descenders of stemmed letters (b, d, p). Then England came to the fore, freeing herself from typographic subservience to the Dutch, due to the efforts of William Caslon (1720) and John Baskerville (1757). Exploiting his talent as a former teacher of handwriting,

E Q R b a e g

E E E E E E E E

Q Q Q Q Q Q Q Q

R R R R R R R R

b b b b b b b b

a a a a a a a a

e e e e e e e e

g g g g g g g g

Fig. 2. Examples of letterform details on three upper-case and four lower-case letters, with the basic shape shown on the first line. Note, on each line: the various serifs (1); spurs, beaks, or brackets (5); the bowl (2) or loop (7) with an "angle of stress" that may be more or less vertical or oblique; the finials (3); ascenders (4), which may be of equal height to or taller than the capitals; the ear of the "g" (8); the height of the crossbar of "e" (6) and its length in "E"; the tail of "Q"; the crossbar of "R". These variations are complicated by contrast between the thickness of mainstroke and hairline, and by differences between bold, roman, italic and other fonts.

Baskerville launched a neo-classic style called Transitional (*Réales* in the Vox classification system—see Fig. 1), which also elegantly assimilated the style of Frenchman Grandjean—indeed, back in 1693 the French Academy of Sciences had charged the Bignon Commission with developing a geometric method of constructing letters against a squared-up background. The pedagogical goal was to stimulate type design, and this approach inspired Grandjean to design a typeface called "romain du roi" in honor of King Louis XIV (but also called Grandjean). The innovation was crucial, since for the first time typographic design abandoned the *ductus,* or physical gesture of handwriting letters, to form letters solely by their outline—the axes of letters could thus become more vertical as their attacks and terminals became more horizontal. This method, once it had sufficiently incubated, was extended by the Didot family of typecutters around 1784, creating a maximum contrast between thick and thin strokes and their filiform serifs. This "modern" (or "Didonic") typography reigned unchallenged until the "Elzevier revolution" inspired by Louis Perrin in Lyon (1854) and Théophile Beaudoire in Paris (1858) spurred a return to favor of "old style" roman type. Meanwhile, the lithographic process had been invented, permitting the printing of letters that no longer had to be cast in typographic relief. Hence the requirements of trade, the emergence advertising, and the rise of the press all combined with Romantic exuberance to create new styles, subsequently imitated by lead typefaces, for setting texts not intended to be read continuously—short texts to be noticed rather than read. In addition to "fancy" types (Manual and Script), there emerged antique and sans-serif typefaces (also called Lineal), the latter being highly popular in the latter half of the twentieth century. There also appeared "Egyptian" (Mechanistic) types, with their slab-like serifs (Fig. 2).

In the late nineteenth century, the invention of the pantograph by American Linn Boyd Benton made it possible for non-professionals to industrially produce punches and/or dies, leading to the development of automatic typefounding and type-setting machines that were five to six times faster than manual methods. The drawback was that

g g g g g

Fig. 3. Punches for letters were formerly cut from designs that were modified as a function of the body size, in an effort to retain the visual unity of characters once they were printed. Here the letter "g" has been subtly modified for 18-, 14-, 12-, 9-, and 6-point type.

1 ABCDEFGHIJKLMNOPQRSTUVWXYZ&

2 abcdefghijklmnopqrstuvwxyz

3 *ABCDEFGHIJKLMNOPQRSTUVWXYZ&*

4 *abcdefghijklmnopqrstuvwxyz*

5 LINOTYPE faces are standard throughout the world

6 *LINOTYPE faces are standard throughout the world*

Fig. 4. In manual typesetting (lines 1 to 4), upper-case roman and italic faces (1 and 3) have approximately the same spacing, whereas lower-case roman (2) requires more spacing than lower-case italic (4). In mechanical typesetting, the spacing is the same for upper- and lower-case roman and italic (5 and 6), leading to a certain degree of deformation of the characters.

the most widely used machine, the Linotype, used duplexed dies, that is to say that each die bore the same letter twice, once in roman and once in italic or bold. This required the unfortunate bastardization of all three fonts in order to give them the same spacing (Fig. 4). Around 1950, a further weakening of the typographic purity of letterforms occurred with photocomposition technology in which a single design, often established for a 10-point body size, was used for every single body size in that type; the uniform scaling of letterforms, however, actually sabotages their homogeneity unless it is accompanied by compensating optical adjustments (Fig. 3). The same is true of the process of italicizing types by slanting them, or of making condensed versions through anamorphosis, which introduces crippling deformations in the final impression. All these concessions, piling drawback upon drawback, pollute the eye, which becomes accustomed to mediocrity. Now mediocrity, like slander, never seems to go away completely, even when disavowed. And today we find ourselves confronted with the benefits and drawbacks of digital characters, although that is the subject of another article (see page 384).

VOICI UN ANGE
UN ANGE EN BLANC

UN ANGE **BLEU**
AVEC SA BOUCHE ET
SES DEUX YEUX
ET PUIS APRÈS
VOICI UN ANGE **ROUGE**

TYPOGRAPHIES FOR CHILDREN

Annie Renonciat

Even before experimental research into typography specially adapted to children's needs was first conducted in France in the late nineteenth century, the use of distinct typefaces for children's books had reflected various concerns felt by adults.

ESTABLISHING A FRENCH TYPEFACE

In 1557, Robert Granjon, a printer and bookseller from Lyon, developed a new punch that resembled everyday writing. His goal was to establish the typeface—which he called "French" as distinct from Gothic and Roman typefaces—as a national standard. Granjon first used this type for a book aimed at adults, then for another (in 1557) devoted to the "Christian instruction" of "the youth of France,"[1] followed in 1558 by a treatise on children's manners based on Erasmus (Fig. 2).[2] Next came another primer on child etiquette, written by Claude Hours de Calviac, a Protestant from Geneva, printed in Paris in 1559.[3] Henceforth it became customary to print little instructional treatises and other educational volumes in this type, soon dubbed "*civilité* (or 'etiquette') typefaces."

The fate of this cursive typeface was partly linked to its educational role—it was used as a model "for learning to shape and read handwriting rightly," in the words of Christophe Plantin in a 1564 edition of his *Book of Ecclesiastes*. Yet other considerations, both nationalist and religious, also came into play, since even though that style of handwriting was no longer used in France after the mid-seventeenth century, the typeface continued to find favor until 1860, notably in Protestant books of manners that sought

Fig. 1. Sonia Delaunay and Jacques Damase, *Alphabet* (Paris: École des Loisirs, 1970).

Fig. 2. *La Civilité puérile,* Jehan Louveau's translation of a treatise on children's manners by Erasmus (Lyon: Robert Granjon, 1588). Zentralbibliothek, Zurich.

p. 2

UNDER SEVEN.

This type may be used for books to be read by children under seven. The letters are larger than the minimum given in the typographical table. Printed from 24 Point Lining Old Style No. 5, lent by Messrs. Stephenson, Blake & Co., 33 Aldersgate St., London.

Fig. 3. A page from a 1912 report by the British Association for the Advancement of Science.

to distinguish themselves from their Catholic counterparts. Such a long life seems all the more surprising in that this typeface—attractive but not very legible—in no way fulfilled the criteria later established to help children learn to read.

THE LEGIBILITY OF SCHOOL TEXTBOOKS

Early research into typography for children sprang from health concerns. In 1881, the French ministry of public education became alarmed by the research published by an eye doctor, Émile Javal, and so it charged a committee composed primarily of medical specialists and textbook publishers to seek "the causes of the steady increase in nearsightedness among schoolchildren," and to suggest a few remedies. The committee's conclusions revealed that myopia was an acquired condition due, among other things, to overly fine typefaces used in textbooks. A second commission in 1882 confirmed the need to revamp the typefaces used in school books. It advocated use of a yellowish paper, lines of type no longer than eight centimeters (three inches), and character size no smaller than 8 points, with an additional point

of inter-line spacing. Letters had to be wide and well spaced, with no more than seven letters per centimeter of text. Javal developed all these ideas in a book on the "physiology" of reading and writing, published in 1905 (*La Physiologie de la lecture et de l'écriture*).

Research bearing on the suitability of typefaces to children's visual capacities was then carried out in Germany (Dr. Hermann-Cohn in 1883), Great Britain (E. R. Shaw in 1902, and the British Association for the Advancement of Science in 1912 [Fig. 3], J. Kerr in 1926 and C. Burt in 1959), and the United States (J. H. Blackhurst in 1927, M. A. Tinker in 1959). The design of letters was thereby revamped, the size of characters defined, and specifications for minimum line spacing and length of line established according to age; the advantages of unjustified lines for the youngest readers, as well as the need to enlarge punctuation, were also demonstrated. But experimental research only really took off in the 1970s with the first studies on children and teachers conducted in Great Britain by Lynne Watts and John Nisbet (1974) followed

A Caucus-Race and a Long Tale. 29

" Fury said to
a mouse, That
he met in the
house, 'Let
us both go
to law: *I*
will prose-
cute *you.*—
Come, I'll
take no de-
nial: We
must have
the trial ;
For really
this morn-
ing I've
nothing
to do.'
Said the
mouse to
the cur,
'Such a
trial, dear
sir. With
no jury
or judge,
would
be wast-
ing our
breath.'
'I'll be
judge,
I'll be
jury,'
said
cun-
ning
old
Fury:
'I'l
try
the
whole
cause,
and
con-
demn
you to
death.'"

" You are not attending ! " said the Mouse to Alice, severely.
" What are you thinking of ? "

" I beg your pardon," said Alice very humbly: " you had got to the fifth bend, I think ? "

Fig. 4. "A Caucus Race and a Long Tale," from *Alice's Adventures in Wonderland*, Lewis Carroll (London: MacMillan, 1865).

Winter came. The trees were bare.
Snow lay on the ground.
Hungry animals were out hunting.
It was hard to find food.
But the dormouse slept safely in his
warm nest.

Fig. 5. Sassoon Primary, a typeface specially designed for young readers by Rosemary Sassoon.

by B. Raban (1984). Whereas, in France, François Richaudeau shifted from the issue of typographic legibility to the study of the visualization of *meaning* in school textbooks, the first family of typefaces designed specifically for young children saw the light of day in Britain in 1958, thanks to Rosemary Sassoon. Sassoon Primary is a type designed to facilitate the learning of reading and writing, being slightly slanted and incorporating certain elements of handwriting that lend it a cursive, familiar feel (Fig. 5).

PUBLISHING EXPERIENCE, ARTISTIC PRACTICE

The practical experience of publishers and their desire to adapt typography to young children long predated theory. There are many examples dating as early as the eighteenth century, but the best demonstration perhaps comes from Antoine Renouard's preface to his new edition of Berquin's *L'Ami des enfants* (The Child's Friend) in 1803, in which he describes how he divided the first volume, comprising short stories and tales designed to bridge the gap between primers and full-length books, into sections with distinct typography:

The first, and shortest [section] consists of short sentences and stories of just a few lines; it is printed in large characters, and the lines are widely spaced. The second part, for use by children who have begun to read somewhat smoothly, is in characters one degree smaller, though still quite large. . .

The large, well-spaced letters and wide margins of gift books and other books read for enjoyment, less constrained by

Fig. 6. The "typographical desk" invented by Louis Dumas in 1733.

economic imperatives than textbooks, appeared better suited to the tastes and needs of children. The art of lettering blossomed in the nineteenth century, especially on title pages and covers, as well as in primers that offered fertile terrain for fanciful, decorative, historiated or personified letters. In body text, such creativity was usually limited to decorative capitals. An unusual example of typographic inventiveness in a running text occurs in the third chapter of *Alice's Adventures in Wonderland,* where a precocious "picture-poem" devised by Lewis Carroll illustrated Alice's semantic confusion between the "tail" (of the mouse) and the (mouse's) "tale" (Fig. 4).

In the twentieth century, in contrast, the almost unlimited range of characters available to typographers could be seen everywhere: in gift books, where choice of typeface could harmonize with the tale and aid its illustration; in comic books, where the art of speech balloons drew extensively on the expressiveness of printing symbols; in artist books, where typesetting echoed the images, as in Sonia Delaunay's *Alphabet,*[4] conceived jointly by typographer and painter (Fig. 1). In recent decades, illustrators of children's books have seized upon letters and subjected them to their fancy, multiplying visual effects with the aid of various methods such as stenciling, transfers, and so on.[5]

CHILD TYPOGRAPHERS

The concern to help children enter the world of writing has also spurred remarkable educational innovations. As early as 1733, the "typographical desk" developed by Louis Dumas was designed to avoid "giving children the dread of a book, which always seems too long to them, its pages too full of tiny letters." Instead, Dumas' original method involved providing them with a set of letters on cardboard, inspired by the cases of type used by real typesetters (Fig. 6). Although it aimed to promote young readers to the rank of "child typographers," this system did not allow them to print actual texts.

Motivated by a similar rejection of standard textbooks, Célestin Freinet brought a real if modest printing press into his little school in Bar-sur-Loup, France, in 1924, designed to produce texts conceived by his pupils according to the "free expression" theory. By 1926 Freinet was publishing *Enfantines,* a series of brochures written and illustrated by children. He established exchanges with various schools that produced similar material, the finest texts appearing in a "children's co-review" titled *La Gerbe,* founded in 1927. After the Second World War, veritable albums sprang from the literary, artistic and typographical talents of children

under the aegis of the Institut Coopératif de l'École Moderne, an association of activists who defended the educational method of free expression.

Very different from Dumas' costly system (reserved for highly privileged children), Freinet's press could be afforded even by poor schools—his first model, the Cinup, was initially used by merchants to print their shop labels. The method was part of a vast teaching reform movement that viewed pupils as "the prime value of the budding flower that we must bring to fruition." By teaching children to master typography, Freinet was not providing a new method of reading: when he gave the children's texts " the glamour of printing and distribution," he was seeking to more braodly transform the social system by teaching the true role of printing, viewed as a means of promoting the "mutual acquaintance of individuals, anticipating the great fraternity of peoples."

Notes

1. *Instruction chretienne pour la jeunesse de France en forme d'alphabet, propre pour apprendre les enfans tant à lire, escripre* [sic] *et lier ses lettres que congnoistre Dieu et le prier* (1557).
2. *La Civilité puérile distribuée par petits chapitres et sommaires. À laquelle avons ajouté la Discipline et Institution des enfants, traduite par Jehan Louveau* (Lyon: Robert Granjon, 1558).
3. *La Civilité Honesteté pour les enfans, avec la manière d'apprendre à bien lire, prononcer et escrire: qu'avons mise au commencement* (Paris: P. Danfrie and R. Breton, 1559).
4. *Alphabet de Sonia Delaunay: Comptines par Jacques Damase* (Milan, 1969; École des loisirs, 1972).
5. See, for example, the *Émilie* series by Domitille de Pressensé, published by Éditions G.P. in the 1970s; also *Le Livre du serpent* by Hélène Tersac, illustrated by Pier Brouet (Éditions de La Marelle, 1979), and Jean Alessandrini's recent books.

Bibliography

AUDIN, M. *Les Caractères de civilité de Robert Granjon et les imprimeurs flamands* (Antwerp, 1921).

BRITISH ASSOCIATION FOR THE ADVANCEMENT OF SCIENCE. *Report on the Influence of School-books upon Eyesight* (London, 1912). (Thanks to Nigel Roche of the St. Bride Printing Library in London for helping to locate this document.)

CARTER, HARRY, and H. D. L. Vervliet. *Civilité Types* (The Oxford Bibliographical Society, Oxford University Press, 1966).

FREINET, Célestin. *L'Imprimerie à l'école* (Boulogne: E. Ferrary, 1927).

———. "La littérature enfantine." *Résumés des communications présentées au Congrès de Cracovie 1934* (Krakow, Poland: Convention organizing committee, 1934).

JAVAL, Émile. *Physiologie de la lecture et de l'écriture* (Paris: Félix Alcan, 1905).

LE MEN, Ségolène. *Les Abécédaires français illustrés du XIXe siècle* (Paris: Promodis, 1984).

MINISTÈRE DE L'INSTRUCTION PUBLIQUE. *Hygiène des écoles primaires et des écoles maternelles: Rapports et documents présentés à M. Le Ministre de l'Instruction publique* (Paris: Imprimerie nationale, 1884).

RABAN, B. "Survey of Teachers' Opinions: Children's Books and Handwriting Styles." Dennis D. Reading, *Meeting Children's Special Needs* (London: Heinemann Educational Books, 1984).

RICHAUDEAU, François. *Conception et production de manuels scolaires: Guide pour la conception, l'élaboration, la fabrication et l'évaluation des manuels scolaires* (UNESCO, 1979).

SASSOON, Rosemary. "Through the Eyes of a Child—Perception and Type Design," *Computers and Typography* (Oxford: Intellect, 1993).

SPENCER, Herbert. *The Visible Word* (London: Royal College of Art, 1968).

WATTS, Lynne, and John Nisbet. *Legibility in Children's Books: A Review of Research* (Windsor: NFER Publishing Company, 1974).

Lettering on Posters

Anne-Marie Christin

The use of printing technology played a crucial role in the history of public notices. The new means of disseminating information offered new advantages—not found in either handwritten or stone inscriptions—to the authors of government and ecclesiastical broadsheets, doctoral theses, broadsides, and advertisements for publications and theatrical performances. Identically reproduced in an infinite number of copies, a printed poster became an objective document. Yet since each copy was placed in a particular spot, the reader still received an impression of authenticity and personal appeal. Understandably, governments swiftly adopted the medium—as of 1536, Francis I of France ordered that official decrees would be announced via posters instead of public criers—and also eventually decided to regulate its use. Thus in July 1791, for instance, the use of black ink on white paper was outlawed for private posters in France, white paper being the sole prerogative of the administration.

These features of *legibility* were not only essential to posters and their efficiency, but were also specific to them. A recruiting poster headed *Avis à la belle jeunesse* (Notice to Able-Bodied Youth) reveals that text was more important than image; the illustrations merely recalled to mind certain stereotyped figures, with no concern for realism or even visual coherence (Fig. 1). Such coherence was provided by the text alone, whose straight lines and equal margins served to orchestrate the overall composition. Yet the poster was not just a transcription of speech. The linearity of the text follows theatrical conventions designed to render the staging of the meaning clearer and more striking. Similarly, intonation counts more than actual sentences; the various sizes and types of lettering are visual transpositions of a voice that must be heard for its message to carry better. The full sentences in lower-case letters, grouped into a paragraph at the bottom, provide the additional information that explains the document and specifies it. The true announcement—the one that must impress—is presented completely differently: it has been broken down into fragments, each one of which has been enlarged and made more solemn by capital letters, generating the iconic charge

Fig. 1. Anonymous, *Avis à la belle jeunesse* (Notice to Able-Bodied Youth). Woodcut. Second half of the eighteenth century.

Fig. 2. Tony Johannot, poster for the publication of *Voyage où il vous plaira*, 1843. Lithograph.

characteristic of words removed from their surrounding context: *legion – de flandres – dragons – de par le roy* (Legion – of Flemish dragoons – by order of the King).

The first decisive mutation in posters, inspired by books, concerned the shift of structural priority from text to image. This mutation occurred in the early nineteenth century. The lithographic printing technique, invented by Aloys Senefelder in 1798, allowed artists to place illustrations within printed text in the form of vignettes, thus establishing a dialogue between image and words. At the same time, the text itself was enlivened by a new typographical expressiveness born of the spread of newspapers and the emergence of catchy advertising. These innovations permitted polyphonic literary experiments such as the one jointly attempted by writer Charles Nodier and artist Tony Johannot in their 1830 tale, *Histoire du roi de Bohème et de ses sept châteaux* (Story of the King of Bohemia and His Seven Castles— see page 379, Fig. 4).

The need to provide illustrated books with their own specific advertising led to the appearance of publishing posters. Of modest size, printed in black and white (like the books they advertised), these posters were placed in the windows of bookstores so that they could be seen from the street. Jacques Deveria produced the first one in 1828

for a version of Goethe's *Faust* illustrated by Eugène Delacroix. Such posters subsequently flourished, primarily in two types. The first was based mainly on the visual liberty of the typographical line: styles and sizes of lettering were highly contrasted, while the image remained subordinate. The second was based on the frontispiece: most illustrators—such as Grandville—took the motif of the closed door about to open onto wonders (which made a frontispiece the immediate and mysterious preliminary to the text it introduced) and transposed it to posters. Other illustrators were more aware of the fact that a poster had to beckon in the *absence* of the book itself, that it had to spur a desire for a text that could only be discovered elsewhere—in the bookstore where it was confined. The second poster that Johannot produced for *Voyage où il vous plaira* (Travel Where You Will, 1843) constitutes a remarkable example of this approach (Fig. 2). Whereas the first poster literally copied the frontispiece of the book, this one is sculpted by shadow and perspective, hollowing a deep space from the surface of the sheet. Three freakish beings in the foreground attract the gaze of passersby—yet it is not toward the book that they are beckoned, but rather into the lair of the bookstore where the book awaits. Thus literary fantasy already launches its appealing voyage.

For posters, the second half of the nineteenth century was a period of revolutions both technical and cultural. The invention of lithography at the end of the previous century had freed artists from the constraints of engraving on wood or metal. The development of chromolithography, more or less perfected by 1865, would turn posters into a true art form. This art nevertheless had a specific practical use: the industrial and commercial boom experienced by Western societies, and the concomitant spread of urban development, had turned city walls into a prized medium through which customers could be seduced and convinced to buy new products.

The artistic and popular success of posters by Jules Chéret would make these new images fashionable and appealing to collectors. But painters had already become aware that the difference between prints and posters lay less in the technique employed than in the visual goal that posters had to respect, one that was fundamentally hybrid in nature since the image could not do without a text. The discovery of Japanese prints incited Western artists to push experimentation even further. In 1869, Édouard Manet developed a Japanese-inspired "poster effect" for Champfleury's *Les Chats,* noticeable in his use of strong outlines and contrasting zones of black and white to suggest figures and in his recourse to minimal indications of perspective. But Manet's work remained that of a painter insofar as lettering was totally divorced from image. Pierre Bonnard—the "Japanizing" member of the Nabi group—seemed more sensitive to another specific feature of Far Eastern art, namely the close interconnection between writing and imagery. In theory, alphabetic writing made such a combination difficult. Bonnard nevertheless experimented with it in a poster for *La Revue blanche* (Fig. 3). The whiteness of the graphic lettering tends to make an ideogram of the literary review it advertises, its calligraphic curves participating intricately in the imagery—the letter "a"

wraps itself around the hip of the review's owner as though it were a trimming of ermine similar to the braid on her cloak.

Posters had their heyday in the first half of the twentieth century. Leonetto Cappiello developed the basic formula in 1901 with a poster for *Cachou Lajaunie*: the viewer's eye was to be drawn by a powerful image, accompanied by a brief, clearly legible text that could not be dissociated from it. In Europe, the use of photography and cinematic ideas (notably the films of Sergei Eisenstein) inspired artists who were not only determined to open avant-garde art to the general public but also hoped to develop a truly modern language of communication based on the new visual complex henceforth established by posters. This final mutation in posters, then, greatly benefited lettering, as seen in the works of El Lissitzky and Jan Tschichold. In France, artist Adolphe Mouron, known as Cassandre, developed new typefaces called Bifur (1929) and Peignot (1936).

In France, the 1930s were the great age of posters. Charles Loupot, Jean Carlu, Paul Colin, and Cassandre pushed Cappiello's intuitions to an admirable degree of abstraction and subtlety. But the growth of advertising led to the birth of professional agencies in which artistic originality had to conform to the demands of teamwork. Nonetheless, in certain fields of advertising—notably for the theater—creative inventiveness was still left to reign freely. The poster devised by Marcel Jacno for the Théâtre National Populaire (T.N.P.) in 1951 tried to wed director Jean Vilar's concept of the theater to lettering that would best convey this idea to spectators. Jacno therefore developed a new typeface called Chaillot, a rustic version—inspired by inexpensive publications—of the Didot typeface used during the revolutionary period in France. Influenced by Vilar's wish to move his entire outfit around like a traveling circus, he wrote:

I noticed costumes and sets, etc., being moved around in chests marked with the shipper's stamp. So I designed the T.N.P. logo in "stencil" lettering that modified and exaggerated certain features of Didot. I placed it in an oval that spelled out the name of the Théâtre National Populaire. The whole thing looked like an official stamp. Brochures, handbills, programs, posters, booklets, etc., were all labeled in this way.

When Vilar became head of the Avignon Festival, Jacno enriched this lettering with the three keys on the coat of arms of the city of Avignon (Fig. 4).

Bibliography

L'Affichomanie. Catalog of the Musée de l'Affiche (Paris, 1980).
BARGIEL, Réjane, and Ségolène Le Men. *L'Affiche de librairie au XIXe siècle.* Catalog of the Musée d'Orsay and the Musée de la Publicité (Paris, 1987).
BARGIEL, Réjane, and Christophe Zagrodzki. *Le Livre de l'affiche* (Paris: Alternatives, 1985).
BARNICOAT, John. *Posters: A Concise History* (London: Thames & Hudson, 1972).
CHRISTIN, Anne-Marie. *L'Image écrite ou la déraison graphique* (Paris: Flammarion, 1995).

Fig. 3. (left) Pierre Bonnard, poster for the review *La Revue blanche*, 1894, color lithograph.

Fig. 4. Marcel Jacno, poster for the Avignon Theater Festival, 1964. Color offset. Musée de la Publicité, Paris.

JACNO, Marcel. "Typographie et théâtre, une expérience." *L'espace et la lettre, Cahiers Jussieu 3* 10/18 (1977): 349-358.
MAINDRON, Ernest. *Les Affiches illustrées* (Paris: H. Launette & Cie., 1886).
———. *Les Affiches illustrées 1886–1895* (Paris: G. Boudet, 1896).
MOURON, Henri. *Cassandre* (Geneva: Skira, 1985).
RENONCIAT, Annie. *La Vie et l'oeuvre de J.J. Grandville* (Paris: ACR Édition-Vilo, 1980).

L'homme aux lunettes bleues qui se promenait nerveusement dans le couloir et qui me regardait en passant
Froissis de femmes
Et le sifflement de la vapeur
Et le bruit éternel des roues en folie dans les ornières du ciel
Les vitres sont givrées
Pas de nature !
Et derrière, les plaines sibériennes le ciel bas et les grandes ombres des Taciturnes qui montent et qui descendent
Je suis couché dans un plaid

Bariolé
Comme ma vie
Et ma vie ne me tient pas plus chaud que ce châle
Écossais
Et l'Europe tout entière aperçue au coupe-vent d'un express à toute vapeur
N'est pas plus riche que ma vie
Ma pauvre vie

Ce châle
Effiloché sur des coffres remplis d'or
Avec lesquels je roule
Que je rêve
Que je fume
Et la seule flamme de l'univers
Est une pauvre pensée...

DU FOND DE MON CŒUR DES LARMES ME VIENNENT

SI JE PENSE, AMOUR, À MA MAÎTRESSE
ELLE N'EST QU'UNE ENFANT, QUE JE TROUVAI AINSI
PÂLE, IMMACULÉE, AU FOND D'UN BORDEL.

CE N'EST QU'UNE ENFANT, BLONDE, RIEUSE ET TRISTE,
ELLE NE SOURIT PAS ET NE PLEURE JAMAIS;
MAIS AU FOND DE SES YEUX, QUAND ELLE VOUS Y LAISSE BOIRE,
TREMBLE UN DOUX LYS D'ARGENT, LA FLEUR DU POÈTE.

ELLE EST DOUCE ET MUETTE, SANS AUCUN REPROCHE,
AVEC UN LONG TRESSAILLEMENT À VOTRE APPROCHE;
MAIS QUAND MOI JE LUI VIENS, DE-CI, DE-LÀ, DE FÊTE,
ELLE FAIT UN PAS, PUIS FERME LES YEUX — ET FAIT UN PAS.

CAR ELLE EST MON AMOUR ET LES AUTRES FEMMES
N'ONT QUE DES ROBES D'OR SUR DE GRANDS CORPS DE FLAMMES,
MA PAUVRE AMIE EST SI ESSEULÉE,
ELLE EST TOUTE NUE, N'A PAS DE CORPS — ELLE EST TROP PAUVRE.

ELLE N'EST QU'UNE FLEUR CANDIDE, FLUETTE,
LA FLEUR DU POÈTE, UN PAUVRE LYS D'ARGENT,
TOUT FROID, TOUT SEUL ET DÉJÀ SI FANÉ
QUE LES LARMES ME VIENNENT SI JE PENSE À SON CŒUR.

Et cette nuit est pareille à cent mille autres quand un train file dans la nuit
— Les comètes tombent —
Et que l'homme et la femme, même jeunes, s'amusent à faire l'amour.

Le ciel est comme la tente déchirée d'un cirque pauvre dans un petit village de pêcheurs
En Flandres
Le soleil est un fumeux quinquet
Et tout en haut d'un trapèze une femme fait la lune.
La clarinette le piston une flûte aigre et un mauvais tambour
Et voici mon berceau
Mon berceau
Il était toujours près du piano quand ma mère comme Madame Bovary jouait les sonates de Beethoven
J'ai passé mon enfance dans les jardins suspendus de Babylone
Et l'école buissonnière, dans les gares devant les trains en partance
Maintenant, j'ai fait courir tous les trains derrière moi

Bâle-Toumbouctou
J'ai aussi joué aux Courses à **Auteuil** et à **Longchamp**
Paris-New-York
Maintenant, j'ai fait courir tous les trains tout le long de ma vie
Madrid-Stockholm
Et j'ai perdu tous mes paris.
Il n'y a plus que la **Patagonie**, la Patagonie, qui convienne à mon immense tristesse, la **PATAGONIE** et un voyage dans les mers du Sud
JE SUIS EN ROUTE
J'AI TOUJOURS ÉTÉ EN ROUTE
JE SUIS EN ROUTE AVEC LA PETITE JEHANNE DE FRANCE
LE TRAIN FAIT UN SAUT PERILLEUX ET RETOMBE SUR TOUTES SES ROUES
LE TRAIN RETOMBE SUR SES ROUES
LE TRAIN RETOMBE TOUJOURS SUR TOUTES SES ROUES

« Blaise, dis, sommes-nous bien loin de Montmartre? »

Nous sommes loin, Jeanne, tu roules depuis sept jours
Tu es loin de Montmartre de la Butte qui t'a nourrie du Sacré-Cœur contre lequel tu t'es blottie
Paris a disparu et son énorme flambée
Il n'y a plus que les cendres continues
La pluie qui tombe
La tourbe qui se gonfle
La Sibérie qui tourne
Les lourdes nappes de neige qui remontent
Et le grelot de la folie qui grelotte comme un dernier désir dans l'air bleu
Le train palpite au cœur des horizons plombés
Et ton chagrin ricane...

« Dis, Blaise, sommes-nous bien loin de Montmartre? »

Les inquiétudes
Oublie les inquiétudes
Toutes les gares lézardées obliques sur la route
Les fils téléphoniques auxquels elles pendent
Les poteaux grimaçants qui gesticulent et les étranglent
Le monde s'étire s'allonge et se retire comme un harmonica qu'une main sadique tourmente
Dans les déchirures du ciel les locomotives en furie
S'enfuient
Et dans les trous
Les roues vertigineuses les bouches les voix
Et les chiens du malheur qui aboient à nos trousses
Les démons sont déchaînés
Ferrailles
Tout est un faux accord
Le *broun-roun-roun* des roues
Chocs
Rebondissements
Nous sommes un orage sous le crâne d'un sourd...

« Dis, Blaise, sommes-nous bien loin de Montmartre? »

Mais oui, tu m'énerves, tu le sais bien, nous sommes bien loin
La folie surchauffée beugle dans la locomotive
La peste le choléra se lèvent comme des braises ardentes sur notre route
Nous disparaissons dans la guerre en plein dans un tunnel
La faim, la putain, se cramponne aux nuages en débandade
Et fiente des batailles en tas puants de morts
Fais comme elle, fais ton métier...

« Dis, Blaise, sommes-nous bien loin de Montmartre? »

Oui, nous le sommes, nous le sommes

VISUAL POETRY, PAINTERS' BOOKS

Anne-Marie Christin

The Greek alphabet carried the visual parsing of a written text to an unprecedented degree of rationality. In so doing, however, it rendered obsolete the very principle behind writing. Indeed, unlike its predecessors, which had allowed readers to reconstruct a text based on optical clues arrayed across a given surface, the new system required readers to complete a veritable task composed of three unrelated steps: first, vowels and consonants had to be graphically identified, then they had to be grouped into syllables, and finally the text had to be comprehended on hearing a succession of syllables. The alphabetic method of understanding a written text was no longer a kind of reading—it was more like decoding. And the signs it established as models were signs that intrinsically lacked the very essence of what they were supposed to convey—a certain verbal signifier. As a code for a sound, a letter of the alphabet is in fact a mute sign.

The history of the literary use of that alphabet has therefore taken two opposing directions, depending on whether writers wanted to mitigate the system's failings by reinventing, in their own way, a measure of the visual intelligibility required for reading it, or whether they wished, on the contrary, to exploit the enigma specific to the signs it engendered by creating a kind of fragmentary storehouse of the music of a language that could be uttered without necessarily being understood.

The importance placed by Western civilization—at the very moment it invented the alphabet—on the notion of representation or "mimesis" was behind an interpretation of letters that, although fundamentally mistaken, nevertheless held considerable appeal. People thought that although letters expressed no verbal meaning in themselves, as visual figures they were nevertheless charged with an analogic meaning. This interpretation provoked numerous debates, the first of which was recorded in Plato's *Cratylus*. Cratylus defended the theory according to which a letter reflected a sound in nature (thus allowing names to represent the things they designated) against Hermogenes, for whom letters were merely a convention. The origin of this theory should probably be sought in the assimilation the Greeks felt they could make between the alphabet and hieroglyphic writing—which on first sight appeared to be a collection of figurative images—even though they could no longer comprehend the hieroglyphic system (and perhaps this alone accounts for their misconception). This supposition is all the more legitimate in that the Greeks were also indebted to Egyptian civilization for a different, more subtle approach to writing, a thoroughly pertinent one that survived into the early nineteenth century via the art of committing to memory. Ancient treatises on rhetoric devoted their final sections to "artificial memory," a technique based on the selection of "striking images" designed to symbolize the arguments of a speech, great importance being placed on the "location" of those images. The goal of the method was to allow a speaker to memorize the stages of a speech one after another by mentally following an itinerary through a familiar space, in which were placed, by convention, the images symbolizing each argument. Quintilian later replaced this system with a more abstract approach, yet one that made the principle more intelligible: he advised orators to remember a speech by visually recalling the places on the tablet where the speech was written—that is to say, the positions of margins and "spaces" as well as the graphic arrangement of lines and the identity of words.

Fig. 1. Blaise Cendrars and Sonia Delaunay, poem on the Trans-Siberian train, entitled *La Prose du Transsibérien et de la petite Jehanne de France* (detail), 1913.

Fig. 2. Simmias of Rhodes, *The Ax*, French translation from the *Analecta veterum poetarum graecorum* (Strasbourg: Argentorati, 1772–1776).

century acquired a taste for these devices, for the development of printing provided the opportunity for feats of typography, yielding many examples such as the wine-bottle poem attributed to Rabelais, *Dive Bouteille*. Shaped verse increasingly appeared throughout Europe from the seventeenth to the nineteenth centuries, usually produced for humorous or satirical ends.

The *Carmina figurata*, composed by Rabanus Maurus in the early ninth century (Fig. 3), is closer to the cryptic treatment of letters authorized by Semitic alphabets (due to their simultaneously consonantal and semantic structure, and as demonstrated by kabalistic practice). These poems play on the alignment of letters not so much to form figures but rather to glorify the esoteric value of their message. The work of Maurus requires the reader's gaze to follow the grid letter by letter until a phrase is recognized, in such a way that the figures can only be perceived within a text that is itself massive and continuous, in which the figures remain tightly imbedded.

Fig. 3. Rabanus Maurus, *De Laudibus sanctae crucis* (Pforzheim, 1503).

From Hellenistic antiquity to the contemporary period, all literary and poetic creativity involving the visibility of letters has privileged one or the other of these interpretations. Simmias of Rhodes, a poet of the fourth century BCE, is thought to be the author of the first "shaped verse" through three of his poems—*Wings, The Egg,* and *The Ax*—which combine the variable length of the lines and the linear constraint of the alphabet to display the shape of the title-object in the course of reading (Fig. 2). The sixteenth

In the fifteenth century, the invention of engraving provided images with previously inconceivable means of dissemination, spurring artists to envisage their contribution to books in a new way. Subjecting letters to a typographic mold, meanwhile, would shatter the tradition—born of age-old handwriting habits—that connected each letter to its neighbor by a subtle network of ligatures. This isolation sparked new hypotheses about supposed significations of the alphabet, such as those of Geofroy Tory, who sought to find in the structure of letters the proportions of the human body, the very proportions assumed to reflect the order of the world. Above all, however, printing granted the apparently neutral elements of the page—all those "blank" spaces between letters and lines—a physical identity equivalent to the one possessed by the letters themselves. It was thus that the technical constraints of printing turned the absence of a textual sign (or character) into a full-fledged sign.

Only later in the story, however, did authors and poets become truly aware of this phenomenon and the new expressive possibilities that it offered. Francesco Colonna's 1499 publication of *Hypnerotomachia Poliphili* (Dream of Polyphilo)—in which Aldus Manutius, with extremely rare artistry, was able to wed the typography of page layout to the beauty of illustrative imagery—remained practically without issue until the middle of the eighteenth century, when Laurence Sterne conducted an original literary experiment by combining letter with image in *Tristram Shandy* (1760). Under the inspiration of Sterne's novel, in 1830 Charles Nodier and Tony Johannot published their *Histoire du roi de Bohême et de ses sept châteaux* (Story of the King of Bohemia and His Seven Castles). This was a work not just for two voices, but for three, since the typographer's creativity was as crucial as that of writer and illustrator, whether by stressing the text's expressive intent through evocative line arrangement, by underscoring the humor of a vignette (of, say, a fanatical, lanky character) through word-breaks that defy meaning, or by illustrating a striking phrase through a special font or monumental letter (Fig. 4).

The emergence in the West of a literature that sought to privilege the visual aspect of a text over its oral fidelity was decisively confirmed by Stéphane Mallarmé's 1897 publication of *Un coup de dés jamais n'abolira le hasard* (A Throw of the Dice Will Never Abolish Chance). This version, which appeared in the literary review *Cosmopolis*, was just a provisional sketch of the final project, not published until 1914 (Fig. 5). As Paul Valéry pointed out, Mallarmé had "studied very carefully (even on posters and in newspapers) the proportion of white and black areas created by the positioning of the characters—the comparative intensity of typefaces."

Fig. 4. Charles Nodier and Tony Johannot, *Histoire du roi de Bohême et des ses sept châteaux* (Paris: Delangle, 1830).

The only "novelty" for which the poet claimed credit, however, was in "the spacing of the reading." Indeed, he asserted that "the spaces take priority; they strike first." This innovation probably sought, initially, to introduce certain visual effects into the writing. But in so doing it fundamentally challenged the principles of literary creativity. Mallarmé not only granted "initiative to the words," to use one of his phrases, but by proceeding thus he also delegated that initiative to the reader: the reader alone determined the value, at the moment they were scanned, of those spaces scattered across the page like so many fragments of mute thought.

Himself a typographer of books, Pierre Reverdy claimed to use the blank spaces of the page to invent a form of lyric poetry that was purely written. The second, 1945, version of *Les Ardoises du toit* (Slates on the Roof), better planned than that of 1918, revealed his strategy: the reader was personally implicated in the spatial evaluation of the text, inciting him or her to supply those meanings on which the "blanks" remained silent; these blanks thereby introduced a temporal and affective dimension that amplified the resonances of the sensorial "present" time of reading. Guillaume Apollinaire, placing his work under the sign of painting (for *Idéogrammes lyriques,* the first version of the *Calligrammes* published in 1918, took as its epigram Correggio's exclamation, "I, too, am a painter") revived the

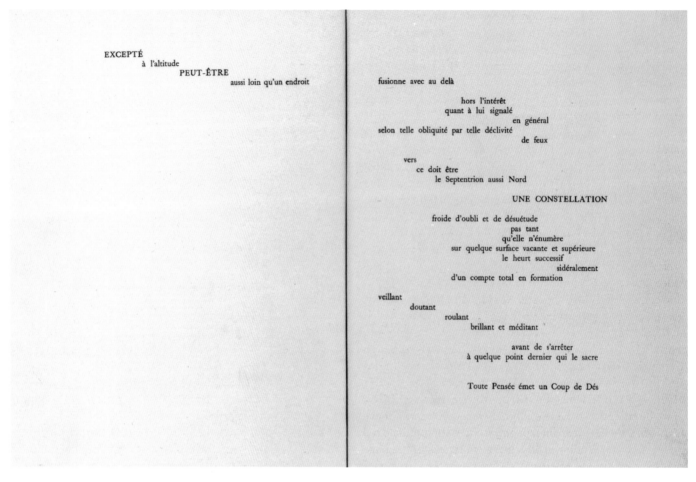

Fig. 5. A double page from Stéphane Mallarmé's *Un coup de dés jamais n'abolira le hasard.*

ancient tradition of "shaped verse" (Fig. 6). But he was also inspired by the "Simultaneist" creations of his futurist friends, with their call to "liberate words," as Marinetti put it. During the next two decades, artists and poets assiduously committed themselves to this liberation, either out of concern to break the academic structure of texts or else in order to create styles of lettering better adapted to modern requirements, as witnessed by the creative work of Velimir Khlebnikov, El Lissitzky (Fig. 7), Kurt Schwitters, Jan Tschichold, and A. M. Cassandre. The resulting literary experiments took highly diverse forms. Yet all were characterized by an urgent desire to lend an international dimension to this creativity, for a number of reasons: artists rejected the national cultures that war had stripped of credibility and prestige; they could finally and deliberately call for an ideographic writing that was plurilinguistic in its very principles; and a growing number of writers were fascinated by the multiple ambiguities, both graphic and aural, of letters.

The most ambitious of these experiments attacked the text as such. Inaugurated by Ezra Pound and James Joyce, they continued in the writings of Raymond Queneau and William Burroughs. Starting in the 1950s, the lettrist movement, concrete poetry, and *spazialismo* all felt that the "letter" was the best medium for giving radical form to the cultural deconditioning they advocated. Art by the likes of Eugen Gomringer from Switzerland, the Noigandres group from Brazil, Ian Hamilton Finlay from Scotland, Jiri Kolar from Czechoslovakia, Carlo Belloli from Italy, and Pierre Garnier from France explored the spatial effects of printing into order bring forth new figures or original meanings. They were joined by a few Japanese artists—Kitasono Katsue, Seiichi Niikuni—who, following their example, sought an original interplay of ideograms within Japan's own system of writing.

The silent revelations spawned by illegible writing led Henri Michaux and Christian Dotremont, meanwhile, from poetry to drawing, from text to painting. As painter-poets,

they occupy the extreme boundaries of an art which, having already in the nineteenth century broken away from the tradition of the "illustrated book," gave birth to the "painter's book." The term fully conveys the contempt felt by book-lovers for works in which painters, far from remaining content with the subordinate role they were strictly assigned, sought to assume a place equal to that of writers; they intended to provide a *visual reading* by an image-maker, not just the modest, imitative adjunct normally expected of them. That is why these painters' most wholehearted collaborators were writers who, like Mallarmé and André Gide, categorically rejected the pernicious artlessness of so-called "literal" illustration.

The history of posters unfolded in parallel to the history of painters' books. The roots of both can be traced to a French edition of Goethe's *Faust,* for which Delacroix provided lithographic illustrations and for which Devéria produced the first publicity poster in 1828. Although the public gave it a poor reception, Goethe was enthusiastic about the book. By the end of the century, painters who had learned the truly hybrid art of posters could give full scope to the art of illustrated books: Manet (*Le Fleuve* by Charles Cros, 1874; Mallarmé's translation of Poe's *The Raven*), Maurice Denis (André Gide's *Le Voyage d'Urien,* 1893), Pierre Bonnard (Verlaine's *Parallèlement,* 1900). In these works, image and text interpenetrate, creating a dialogue between line and color in which the whiteness of the page plays the role of intermediary and amplifier. The creativity operates on several concomitant levels—a musical creativity, one might say—which, rather than leading to a synthesis between visual and literary themes, maintains a simultaneously spatial and temporal distance between them, since it occurs during the reading itself; it makes evident a dominant graphic continuity (through the recurrence of motifs or a simple constancy of style), yet one that nevertheless remains ungraspable, so attached is it to its textual surroundings. The dialogue could be made even bolder, as splendidly demonstrated by Sonia Delaunay and Blaise Cendrars in 1913 with *La Prose du Transsibérien* (Prose of the Trans-Siberian), a poem "drenched in light" in the words of Cendrars, transforming the book into a strip six and a half feet long, composed of four glued sheets and designed to unfold in the Chinese manner (Fig. 1). Here typography and illumination demonstrated a shared concern to exalt the text's visual aspects: over ten different typefaces and characters were used, paragraphs were justified so as to compose a painting, and the play of "simultaneous contrasts" freed color from all illustrative dependence.

The initiative for such creative projects would soon devolve, in imitation of Ambroise Vollard (who was behind

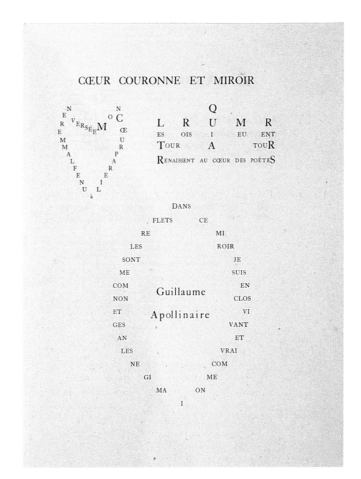

Fig. 6. A poem titled "Heart, Crown, and Mirror," from Guillaume Apollinaire's *Calligrammes* (Paris: Mercure de France, 1918).

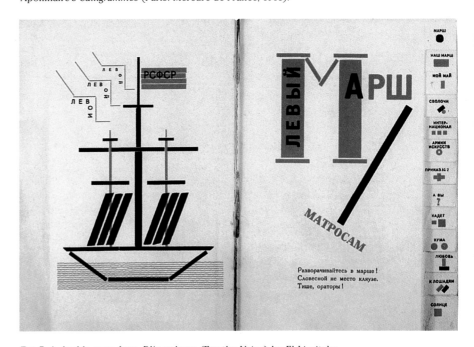

Fig. 7. A double page from *Dlia golossa* (For the Voice) by El Lissitzky and Vladimir Mayakovsky (Berlin, 1923).

Parallèlement), to publishers of books or reviews who were also art connoisseurs. Artists in their own way, these publishers arranged encounters between writers—past or present—and painters who could exalt a text in their own way. Thus appeared, to speak only of the first half of the twentieth century, Kahnweiler's 1909 edition of *L'Enchanteur pourrissant* by Apollinaire and Derain, Skira's 1931 publication of *The Metamorphoses* by Ovid and Picasso, and Tériade's 1948 edition of *Le Chant des morts* by Reverdy and Picasso (Fig. 8). In the maiden whiteness of books, renewing the ancient traditions of ideogrammatic cultures, image and text have finally come totally together once again.

Bibliography

CHAPON, François. *Le Peintre et le livre, l'âge d'or du livre illustré en France, 1870–1970* (Paris: Flammarion, 1987).

DOTREMONT, Christian. *Traces* (Brussels: Jacques Antoine, 1980).

GARNIER, Pierre. *Spatialisme et poésie concrète* (Paris: Gallimard, 1980).

MALLARMÉ, Stéphane. *Un coup de dés jamais n'abolira le hasard.* Edited and introduced by Mitsou Ronat, produced by Tibor Papp (Change errant/d'atelier, 1980).

MARTIN, Henri-Jean, Roger Chartier, and Jean-Pierre Vivet, "Histoire de l'édition française," *Le Livre concurrencé,* vol. IV (Paris: Promodis, 1986).

MASSIN. *La Lettre et l'image: La Figuration dans l'alphabet latin du huitième siècle à nos jours* (Paris: Gallimard, 1970).

MELOT, Michel. *L'Illustration, histoire d'un art* (Geneva: Skira, 1984).

MINGUET, Philippe, "Figures de lettres dans la poésie concrète," *Écritures, systèmes idéographiques et pratiques expressives* (Paris: Le Sycomore, 1982).

SOLT, Mary Ellen. *Concrete Poetry* (Bloomington: Indiana University Press, 1971).

Fig. 8. A double page from the poem *Le Chant des morts* (Song of the Dead) by Pierre Reverdy and Pablo Picasso (Paris: Tériade, 1948). © Succession Picasso, 2002.

La panique apanée
au déclic d'un regard
Et que tous les malheurs
s'effondrent sur ma tête
Je m'insinue dans les interstices
du temps
A chaque pas du jour brille
une cicatrice
Tout mon sort est tissé
d'un seul fil du hasard
Dans le soleil plissé du rire
des abeilles
Ma place est au niveau
des cercles ~~dépolis~~ désunis
Appels désespéré
Signaux de ma détresse
Voile désemparée
Carcasse de la nuit

79

DIGITAL FORMS OF TYPOGRAPHY

Jacques André

Right from the Renaissance, Albert Dürer, Felice Feliciano, and Geofroy Tory proposed geometric models for the design of roman capital letters,[1] but it was probably only at the end of the seventeenth century that these principles were applied to lower-case characters and thereby became the first digital form of typography. Indeed, practically all the ingredients of computerized typography can be found in the cartoons for the "romain du roi" face designed in France by the Bignon Commission in 1695 and later cut by Philippe Grandjean:[2] Each letter was drawn on a grid and defined with the help of geometric constructions using circles and straight lines (Fig. 1). This method could not be directly used to cut the punches, however,

Fig. 1. Académie Royale, 1695. Fig. 2. Adobe, 1995.

because it required that lines be drawn to a precision of one hundredth of a millimeter (even today no tool can do that). For centuries, then, it was the cutting technique described by Fournier that was used.[3] Three developments would completely alter printing processes: Linn Boyd Benton's 1885 invention of the pantograph (which defined characters by their contours), offset (resulting in the shift from three dimensions to two), and finally computerization and the dematerialization of characters.[4]

Printing with digitized characters is now done in four distinct phases: the production of a set of digital characters (the font), the

use of these characters by a computer-aided typesetting and layout system, the production of an image of the desired text (film for photocompositor or laser print-out), and finally the printing itself (via offset or photocopier). The basic idea behind the first two phases is that a character is a flat, geometric shape defined by its outlines, applied to a grid whose squares are blackened depending on whether or not they are inside the outline.[5] This was the idea already proposed by the Bignon Commission, except that circles are replaced by curves that renders smoother forms, so-called Bézier curves (defined by the two ends of an arc and by the ends of two tangents; in Fig. 2, for example, the Bézier curve running from 1 to 4 is defined by the coordinates of four points, 1, 2, 3, and 4). Thus the "e" in Fig. 2 can be described by a series of mathematical expressions that describe how to trace the outline of this letter, going something like:

Outer curve: Start at point 1
Trace the Bézier curve going from 1 to 4, using points 2 and 3
Trace the Bézier curve going from 4 to 7, using points 5 (aligned with 4 and 3) and 6

. . .

Trace the Bézier curve going from 17 to 20 using points 18 (aligned with 17 and 16) and 19
Close the curve thus drawn (that is to say, draw a straight line from 20 to 1)
Inner curve (counterpunch): Start at point 21
Trace the Bézier curve defined by points 21, 22, 23, and 24
Trace the Bézier curve defined by points 24, 25, 26, and 27
Close the curve (that is to say, draw a straight line from 27 to 21)
Fill in the area defined by these two curves.

Two main methods are used to obtain these curves: either a character is first designed by hand and its outlines scanned into a computer or defined on screen with the help of a mouse; or an existing character

is modified in a graphics program by playing, for example, with various points (ends of curves and tangents).

The character is then set against the "grid" of the output device (printer or computer screen) and is produced (on paper, film, or screen) by darkening the areas delimited by its outlines (usually with a laser beam or inkjet). The visual definition of the final character will be more or less sharp depending on the size of that grid (Fig. 3).

Various techniques then refine this basic principle. One of these

Fig. 3. 10-point characters (enlarged roughly twenty times) seen with definitions of 300, 1,200 and 4,800 dots-per-inch, respectively.

is highly material—insuring that the characters remain true likenesses of their original design, especially when resolution is poor. That is the object of standards such as TrueType, Type 1, and so on. Another is more concerned with the typographic aspect of the character—in the old days type cutters had to cut different punches for every size, or point, of a typeface. Characters cast using pantographs, followed by characters filmed for photocompositors, and finally digitized characters, were often scaled in a linear relation to one another, as though with a zoom. Today's computer technology affords a different approach. Since the outlines of the characters are based on mathematical equations, instead of saying that point 1 (Fig. 2) is the intersection of coordinates 40 and 27, we can define this point as coordinate (x, y) and then calculate the values of x and y as a function of the body size (or "point size"). Just a few years ago, people were still working as though the values for x and y in a 12-point font should be twice as large as those in 6-point font. Now we can modify those values so that the counterpunch of an "e" becomes proportionally greater as its body size diminishes (see Fig. 4). This is the principle employed in Multiple Master fonts, but it is only feasible if a typographer is able to explain why and how a character should be modified from one body size to another.

Although computers were once criticized for lacking accented letters, this reproach no longer holds. Not only can all letters take accents, but fonts now offer various ligatures, terminal letters, and so on—in short, a much richer range than fonts of lead. Furthermore, these digitized forms permit the design of non-Latin characters—not only Arabic and Cyrillic, but also Chinese and Japanese ideograms. Codings such as Unicode now exist to cover all the characters in the world, an indisputable boon for multilingualism.[6]

Rather paradoxically, even as digital forms of characters essentially concern printed texts, in recent times there has been a keen renewal of interest in the study of handwritten characters, with a view not only to the optical recognition of manuscripts but also to the construction of handwritten characters on computer—even animated ones, which are beginning to appear on the Internet as simulated writing. Why? Because modeling makes it possible to understand the physical gesture, or *ductus,* of tracing a letter and thereby to reflect on the very notion of character.

Fig. 4. Body sizes ranging from 8 to 36 points, enlarged to the same scale. The different versions of the character are clearly not identical.

Notes

1. See Gérard Blanchard, *Pour une sémiologie de la typographie* (Andenne, Belgium: Éditions Rémy Magermans/Rencontres de Lure, 1979).
2. See André Jammes, *La Naissance d'un caractère: Le Grandjean* (Paris: Promodis, 1985).
3. Pierre-Simon Fournier (the Younger), *Manuel de typographie utile aux gens de lettres* (Paris, 1764; republished with a commentary by James Mosley, Darmstadt: Technische Hochschule, 1995).
4. See Alan Marshall (ed.), *La Lumitype-Photon, René Higonnet, Louis Moyroud et l'invention de la photocomposition moderne* (Lyon, France: Musée de l'Imprimerie, 1995).
5. See Jacques André, *Création de fontes en typographie numérique* (Dissertation, Université de Rennes, 1993), and Roger D. Hersch (ed.), *Visual and Technical Aspects of Type* (Cambridge: Cambridge University Press, 1993).
6. See The Unicode Standard Version 3.0 (Reading, Mass.: Addison-Wesley, 2000).

WRITING AND MULTIMEDIA

Yves Jeanneret

Should we say "multimedia" or "unimedia"? "Multi" refers to the signifying systems—written text, recorded voice, sound effects, still images, moving images, formal codes—yet what is really new is the condensation of all these systems into a unitary technological device (the computer program that drives processor, screen, keyboard and printer). This "digital integration" makes it possible to combine, in an original way, written signifiers with the storage and display capacities of more novel signifiers. The whole issue of multimedia reading/writing probably hinges on the tension between the material unicity of the device and the complexity of the signifying spheres it exploits. By the same token, it also involves the tension between a novel way of presenting written text and the historical density of all the elements required to interpret that text.

A HISTORY AS YET UNREAD

The most recent level of that history concerns a series of technological advances in various fields—the automatic processing of sound and image (coding and compressing), developments in hardware (miniaturization of circuits, optical readers, screen technology), a new computer culture (interfaces, software for non-experts, hypertext), and telecommunications systems (protocols, architectures, engines, etc.). This history is brief yet multifarious. Early integrated circuits and the efficient use of lasers—enabling data processing on a massive scale—date from the early 1960s. Liquid crystal displays were first used in watches in 1975, while user-friendly software with icons appeared in 1984. Compact discs for the optical storage of information were launched in 1986. Although the Transmission Control Protocol/Internet Protocol (TCP/IP) for exchanging information on the Internet dates back to 1972, the coding that truly created the global network of texts and images, HyperText Markup Language (HTML), was only disseminated in 1989, while the first automatic search engines on the web date from the 1990s.

However swift, these technological revolutions required a certain reflection and creativity that has largely gone overlooked in the face of technico-economic considerations. Indeed, the realm of creative arts was the first to employ the term "multimedia" back in the 1960s, in reference to works that combined various media; the term acquired a technological meaning in the mid 1970s and then a mass-media one in the late 1980s. Yet exploration of a new art of writing—conducted by certain members of the "media arts" community and by certain university departments—has long remained little known, even though the current burst of applied research by players in the cultural industries (publishers, printers, the press, etc.) shows that they are increasingly aware of the stakes involved.

In any case, the logic that has prevailed up till now is a cumulative one, even when it might have been more important to reflect on the significance of various choices. The idea that multimedia is an accumulation of functions is expressed, for example, in the almost ritual references to an article published by Vannevar Bush in 1945 under the title, "As We May Think." Bush imagined a system dubbed "Memex" as a twin of human thought, combining a series of media the way humans combine ideas. But his was a double simplification: multimedia is not a simple addition of media, it creates new forms of message; nor can it imitate thought, but rather presents something new to be read and, therefore, thought anew. Far from that mimetic, cumulative fantasy, what is really involved here is a redefinition of writing, one that may stimulate or smother the rich potential of

writing insofar as the changes affect everything afferent to writing, from the semiotic material of expression, to literary skills, to the ways written texts are socialized, to the conceptualizations involved in reading.

How extensive is this redefinition? Some people have prophesied an anthropological transformation comparable to the invention of writing itself; yet perhaps it is more a question of rediscovering a buried power. Nothing is really new: not the *association* of several types of signification, nor the *non-linearity* that characterizes all written forms, nor the *virtuality* of meaning linked to a reader's interpretation, nor, consequently, the *interactivity* of the reading/writing process. Thus the prophecies have triggered refutations: medieval glosses are alleged to be a form of hypertext, multimedia animation is just a variation on illustration, the computer screen is just another *volumen,* or scroll. That does not resolve the dilemma, however, of deciding whether multimedia either goes totally beyond writing or is simply repeating history. In its very newness, multimedia has reactivated some of writing's overlooked wealth—and, by reactivating it, raised new challenges.

TECHNOLOGICAL CHANGE AND THE ECONOMY OF WRITTEN SIGNS

The constant evolution of technology foils all predictions but does not prohibit hazarding a few comments here. The question is how we should read the changes currently underway, from the standpoint of the material support:

– Lengthy documents can now be presented on a single screen, though liable to take various written forms across time. Written texts therefore acquire a new dynamic of appearance/disappearance. This property raises the possibility of producing complex texts that entail various forms of continuity even as it raises new questions on the way in which readers can appropriate that complexity.

– Digitizing information has a crucial impact when it comes to writing: computer technology can process writing—concurrently or in combination—either in "text mode" (a series of characters) or in "image mode" (a unique spatial configuration). The linguistic reductionism dictated by early computer technology can therefore now make way for work on a text in its double nature—linguistic and visual—on condition that designers can unlearn habits acquired during decades of the tyranny of "code."

– The complex text thus generated can be accessed from various types of physical device or multimodal interface—the typical example being the "mouse"—which means that a text can now be modified without recourse to a keyboard. Such systems represent a radical liberation

from the alphabetic code and revive interpretations based primarily on the "reading" of an "image." At the same time, they generate a new form of reading—following on from oral reading and silent reading—that might be called "gestural" reading.

– Written culture is also being enriched by new types of creativity and work on images, processed as geometric abstractions. These vectorized images are sometimes called "virtual images." Depicted objects are defined by a set of parameterized equations and are endowed with a texture designed to produce the illusion of reality. These images make it possible to create, through writing, dynamic "objects" that reader-players can take for analogs of the perceived world.

– These innovations occur in new types of written document, distributed simultaneously in the form of published products (designated by their material format, such as CD-Roms, DVDs, and so on) and on computer networks. This phenomenon, which can be expected to undergo rapid change, makes collective multimedia reading/writing possible on a vast scale, including via electronic mail that, in certain respects (notably through chat-rooms and forums), is now replacing conversation.

– These changes are only occurring, however, thanks to the formalization and automation of the operations for processing written text, which up till now had been the preserve of a *technique* governed by cultural players and social culture. This means that multimedia might be viewed as a process of reifying and masking certain features of writing, as well as a process of production of new visible forms (one being the condition of the other).

SCREENING CONCEPTS OR CONCEPTUAL SCREEN?

Announcements of the total transformation of written culture poorly convey the true nature of these changes. The experiments they have spurred are limited by both economic considerations and cultural differences. And, on a social level, multimedia writing was actually preceded by its rewriting, first among a few pioneering groups and then in the media. It was a question of spreading the gospel, echoing the tradition of eighteenth-century ideologies of openness and transparency: the multimedia network—immaterial and open to every type of circulation—would free communication from the opacity of symbols and inaugurate a society of minds without borders or differences.

A more realistic approach to these changes involves realizing that, in the first years of the twenty-first century, humans who possess a computer—much less access to the Internet—remain a tiny minority in this world. Economic limitations, however, are not the only ones to consider.

Even within the community of computer-monitor readers and writers—which, despite everything, is fairly large and destined to grow, especially if we include all institutional and professional users—multimedia writing that is fully aware of its own resources would require a rejection of the facile fantasies mentioned above. The integration of information seems to encourage a lack of reflection on the nature of signs, when in fact a deeper awareness of the specific powers of writing, imagery, and speech is needed. The linking of all messages leads to a quest for exhaustiveness, even though it demands, on the contrary, supple codes able to filter possibilities. The interconnection of readers suggests that the sharing of information goes without saying, whereas it requires reflection on the ways of appropriating knowledge. The optionality of documents evokes the idea of a set of informational building-blocks, whereas what is really necessary is some reflection on what constitutes a text.

Against these abstractions, then, I will now propose a material and social approach to texts, followed by some bolder considerations on the semiotic nature of multimedia writing and its potential.

THE READING/WRITING PROCESS

It is impossible to generalize about the major changes occurring in social processes of reading/writing, since they depend heavily on specific context. In multimedia publishing, for example, writing has become a fully "industrial art": teams of professionals are involved in complex processes of formalization, in technical, economic, and artistic studies, and in constant negotiations between designers, managers, and financial backers. All these factors weigh simultaneously on the choice of subject, on tools, and on

the rhetorical level of the writing. The high cost of multimedia productions means they must target a very broad, often transnational, market. That explains the growing number of cultural packages (museums, major artists, great historical figures, etc.) and the preference for highly traditional verbal formulations and visual material. Furthermore, the division of the labor within multimedia composition calls for technical and aesthetic standardization. Thus there is a growing set of meta-writing tools (writing on how to write): paper documents (user manuals) and authoring software that present and harmonize the writing process, browsers that filter reader access to documents, "monitoring" software that records (and can exploit) each act of connection and reading, etc. Finally, the economic stakes involved usually means adopting a compromise rhetoric negotiated among several players.

This industrialization of writing has been accompanied and intensified by the growth of an industrial sector that is simultaneously competitive and interdependent, as well as by the emergence of new skills, professions and methods for presenting/promoting products. As yet, however, there are no institutions of critical analysis—similar, say, to the ones that already exist for literature and movies. This situation probably stems not only from a delay in specific reflection on this aspect of culture but also—among the pioneering communities—from an anti-institutional, informal attitude and an ideal of unmediated communication, which continue to operate, like a standard, within practices and expectations associated with these new media.

The collective nature of multimedia composition assumes different forms on international networks, even though website design and consultancy is now favoring a progressive industrialization of the Internet. As far as most writing is concerned, there is what might be called an anarchic industry of "hyperdocuments," in which the idea of a collective, heterogeneous text is taken to the limit. This is no way implies the disappearance of the power of writing, but rather more complex manifestations of its effects.

Three examples of these highly complex situations can be given here. The first concerns the sphere of corporate and organizational promotion. Marketing managers very swiftly perceived the World Wide Web as a stage on which it was essential to appear. They first produced "sites" using the standard techniques of "institutional" advertising, then called on the services of "web agencies," which now play a role similar to ad agencies in the 1960s. This led to carefully monitored composition not only on the level of advertising spiel but also, in more pressing fashion, on that of visual form. What official "scribes" have been attempting to appropriate is nevertheless a written sphere of communication that, as a very function of its technical characteristics, owes

its appeal to a mode of operation that obeys a number of profoundly differing laws, rejecting that very standardization. This has led to an unstable negotiating process around the text to be placed on-line, displaying the heterogeneous standards of all the various legitimate forms, unbeknownst to the players involved.

Another significant example can be found in the literary field, where items profoundly associated with the reality of books are being transferred to the computer screen. The initial effect of the monitor was to provide certain writers with an opportunity to inject new modernity into their work, opening new spheres of creativity, authorizing editorial practices that broke with literary institutions and—perhaps above all—lending concrete existence to certain concepts such as open-ended writing, the death of the author, and multiple interpretations. Yet once produced in textual form, this fantasy of literary hypertext raises all the issues related to editorial responsibility, to forms of reading, and to the institutional power of a text. In this respect, certain attitudes directly borrowed from computer culture have played a major role in the birth of trite new ideologies of literature, notably including the glamor accorded to various trends of combinatory writing (and, within those trends, to compositional logics), the treatment of works as linguistic reservoirs open to computation, the dedication of hypertextual monuments to a writer or school, the multiplication of personal anthologies of quotations, and the development of sites governed by the principle of "open source" (everything must be visible and accessible).

Finally, another sphere of the Internet's written culture, namely computerized telecommunications and electronic mail, cannot be fully covered here. It is important to mention it, however, if only to combat the spontaneous association of screen text with "multimedia publications" and "websites" alone, and to suggest that the relative semiotic poverty of those systems (a certain alphabetic display of oneself through the intermediary of a keyboard) is accompanied by highly subtle pragmatic and theatrical effects. The most socialized form of monitor-based writing is electronic mail (e-mail), which has certainly impacted on the dynamics, pace and nature of social and professional intercourse, obeying a logic in which new freedoms give birth to new constraints. Although this boom in communication has supplied much grist for commentaries and conventional studies, it is far less common to consider the role that written forms play in this process; forms that, right from the French Minitel system in the early 1980s up to today's e-mail software, concern the construction of a standardized sphere of reading/writing. Software design affects habits of correspondence and, more broadly, written output by defining the way "mailboxes" work, by extending the realm of writing to new practices (the creation of e-mail addresses and pseudonyms), by modifying the visual and technical framework of correspondence, by offering new storage possibilities, by permitting the transmission and sharing of written documents of all kinds. E-mail has slowly merged with "word processing" to affect, in an unnoticed but profound way, the condition of production and dissemination of written documents.

INSTRUMENTALIZING THE CONTRACT OF COMMUNICATION

What, in fact, is word processing? In such a multifarious, diffuse sphere of writing, the difference between text and context tends to get lost in a continuum of fragments with no real borders. This disorientation of the text-object does not mean, however, that textuality has become outmoded. It has simply acquired a new, context-linked complexity as it weaves a triad between author, text, and reader. The material

actualization of texts becomes a new, key moment within a complex and uncertain process dependent on constraints of speed of connection, characteristics of computers and screens, and a growing variety of software. Given this situation, the networking of semiotic plurality demands tricky technological (and political) negotiations in order for the concept of "accessible" text to continue to exist.

Meanwhile, the proliferation of documents has been quickly accompanied by the development of tools to render visible a vast text normally beyond the reach of the eye. This has led to the boom in "browsers" and "engines" that guide our reading and, in a symmetrical way, induce writers to create, in advance, links for potential readers. Strictly speaking, then, this entails instrumentalizing the contract of communication, the inscription of potential readings. In this particular sphere of writing, the status of each sign acquires uncertainty for readers, because it may be considered either as an element of a text that the readers themselves constitute or as an isolated document that a browser has made it possible to "import" and adopt as resource. As early theorists of hypertext correctly anticipated, in this sphere of textuality the requirement of legibility is in constant conflict with an attitude of openness to all potential texts.

This, then, is the framework in which a collective effort must be made to conceptualize the logics of computerization in all their social and semiotic aspects. Just as it is false to say that multimedia means a simple accumulation of languages, so it is false to say that digital technology standardizes all communication by subjecting it to computation. Rather, we must address various levels of writing, from the codes directly linked to the machine to the implementation of spheres of readability, insofar as the functionality, legibility and social appropriation of these various forms of writing are very different. Computerization automates and formalizes a set of interpretative impulses and procedures that had already arisen from human and social activities. It stores, automates and disseminates reified conceptions of writing, of text, of reading, of publication, and of documenting. With every advance in engineering, some things become invisible while new items are brought into view. The programmers have therefore acquired a certain power over the various natures of writing, although each functional operation only assumes meaning by engendering new dimensions of interpretation. Digital technology alone explains none of issues at hand, because any transformation of the nature of writing is accompanied by the production of a new physical, visual sphere of interpretation, which inevitably accompanies the computation of any constructed figure: the program only works if the screen makes sense.

The crucial issue from the standpoint of policies of composition (and therefore of culture) is to remain lucid about these coding operations, about evolving visibility and invisibility, about the shifting dimensions of communication; and also, necessarily, about the effects of awareness and illusion spawned by this universe that is configured by some of us, imposed on the rest of us, and invested with form by all of us.

INTERSECTING RHETORICS

The question that arises in the socio-economic framework sketched above concerns the potential fertility of this technological apparatus of writing: can the multimedia stage of writing ever get beyond quickly outmoded gadgets? People tend to be impatient with new tools, forgetting that it took centuries for traditional culture to take full advantage of the invention of printing.

Right from the experimental phase, multimedia texts have swiftly developed their own spontaneous rhetorical

stances, which might be very schematically described here.

One type of rhetoric stems directly from the pioneering experiments of hypertext. It banks on optionality within a highly interlinked sphere, its architectural logic being based on the automatic processing of characters. This rhetorical tradition has difficulty in freeing itself from the historical connection between computerization and a purely linguistic approach to written texts, and is highly reductive if highly conducive to the multiple branching of writing. The pioneering development of networks by professional scientists led to a special application of this logic in the form of making data openly available. The idea of worldwide accessibility of

documents has encouraged a logic according to which any-one can "send out" any type of document, erratically linked to other documents by virtue of the vagaries of cross-refer-encing. This composition of "pages" containing several "hyperwords" still largely dominates the web, though often limited by its own complacency.

A second tradition has sprung up fairly quickly alongside products published on CD-Rom; it usually entails narrative forms based on traditional metaphors such as the page of a book, architectural spaces, and objects aligned in perspec-tive, as well as on a more or less recurring panoply of icons. The development of specialized writing software has steadily made it easier to transfer certain publishing techniques onto the web. The documents thus produced often offer good leg-ibility but run up against the problem of the fatigue caused by their monotony and, more fundamentally, the fact that they are unable to truly rival—depending on their chosen target— either books or visual exhibition spaces.

Thus they find themselves in a position of opposition— which does not exclude imitation—to a third category of output, namely "installations" created by artists who work in the sphere of video. These installations play on and between imagery, in an effort to halt the sclerotic effects of reading, indeed to interrogate the status of the visible (and the voyeur). In particular, they share a determination to free themselves from slavery to the computer screen, replacing it with original objects, or fragmenting and mul-tiplying it. Thus many installations, rather than cultivate a user-friendly simplicity, strive to prolong the reader's per-plexity and the nature of his or her presence in both the visible and the invisible. For this very reason, and in virtue of a carefully cultivated difference, these works cir-culate almost exclusively within the closed world of the art market.

Far from the spectacular effects duly magnified by the press, multimedia writing is quietly penetrating everyday life through unnoticed things such as automated teller machines, interactive kiosks, and control monitors. Born of purely functional needs, these systems obviously soon run up against their own limitations. Other specifically profes-sional systems are conquering new compositional terrain. One example is "virtual editing" that makes it possible to edit a movie on a computer screen and control monitor, in the same way that writing a text can be done with word pro-cessing software—operations formerly carried out directly on the recording medium can now be done through the manipulation of non-alphabetic written symbols (graphs, cursors, icons, etc.).

Finally, the rhetorics of writing now include specific strategies of rewriting, a trend that appeared after the oth-ers and has turned indexes, lists, and mapping into tools of power. This shift of interest from text to meta-text did not only have pedagogical origins: it was contemporary with investment in computer networks by the dominant players in an information industry for whom capturing a reader's attention represented a source of profit and a requirement for survival. The "portals" incarnating this type of writing (simultaneously antithetical to and parasitical on the tex-tual chaos described above) are in fact industrial forms of a straightforward rhetoric of documentation. The publish-ers or meta-publishers of these sites profit from the hyper-text logic to place themselves in the position not of authors of texts but rather of suppliers of resources. They are grad-ually replacing the image of a centerless network with an invasive rhetoric of lists and charts that rival the panoptic aspirations of the encyclopedic project. The birth of por-tals will probably result in a battle in the rewriting sphere, in which the most diverse players are now engaged. But this trend has merely radicalized multimedia's key trope, the unicity of the screen necessarily implying—sooner or later—a logistics of the gaze.

This categorization is perhaps too brief—here and there, publishers and website designers are conducting experi-ments that aim to prevent a premature sclerosis of forms. Some activists are calling for a creative social use of such writing—not addressed in the preceding categorization— but their voices have had little impact. And such a trend, in order to grow, would require two conditions: on one hand, a convergence of artists and "ordinary" cultural players (mass marketing and promotion on professional, political, scientific and educational levels), and on the other, what must be called new education in—and popularization of— multimedia writing, involving a shrewd level of standardiza-tion in order to socially extend the means of critical, creative reading/writing.

TOWARD A POETICS OF MULTIMEDIA WRITING?

The main condition for the development of a new type of writing nevertheless resides in a true effort to take into account the semiotic possibilities specific to multimedia. Only this effort can halt the current tendency to merely adapt standard forms of publishing and audiovisual products. Since such writing remains to be invented, several possible approaches will be suggested here.

The first requirement would be to acknowledge the importance of all the features of writing described above. These tools were initially promoted under the banner of interactivity—many professionals saw interactivity as the true novelty of these systems, while implying that the combination of images and text was little more than a gadget. I would like to suggest that this very opposition is misleading; interactivity is of no interest if it does not reflect on its semiotic sources.

Recourse to the idea of interactivity in describing a system needs to be "psychoanalyzed," to borrow Gaston Bachelard's concept. A machine does not act, but it bears the projection of several models of action. From the standpoint of logics, what counts is the combinatory aspect: the creation and branching of texts (in the purely linguistic sense of the term). The rhetorical standpoint focuses on the capacity of a document to sustain the desire to read— a document is interactive if it is intriguing, playful, spurs a desire to go further. A design standpoint stresses immediate aesthetic perception—a document will be described as interactive if it moves a great deal, underscoring the role of the latest software developments. The communicational standpoint raises the question of the social fecundity of these innovations—whether the technological device provides the occasion to write something rather than simply manipulating the already-written. The communicational approach therefore leads to two other complex issues, namely the definition of the reader's sphere of writing and an interrogation of what provides coherence and meaning to a text delivered to the joint initiative of multiple writers.

n other words, the question of "interactivity"—the question, in fact, of the *reader's initiative* or the ways of *writing a reading*—only arises as such within a semiotic approach. Semiotics takes issue with the previous thematics, which often neglect the nature of signs and interpretative acts, thereby dumping the written sphere either into the vague generality of a metaphor for aimlessness (browsing) or into the illusionist perspective of a new sensorial sphere (virtual world). Even if such effects of randomness or sensory hallucination do occur, understanding their origins—rather than merely submitting to them—calls for an attentive look at the screen as a site of actualization of non-abstract signs

that stem from a tradition, are determined by their materiality and the social condition of their circulation, and are rendered meaningful by the activity of reading/writing.

Indeed, the new initiative offered to readers exists only by virtue of the structure of the visible sphere made accessible to them. The true novelty of multimedia publications compared to books might thus be characterized as follows: while no one can "circulate" within a book in an intelligent way without being able to read, all readers nevertheless have physical access to the entire text just by turning the pages; in contrast, the electronic screen imposes other ergonomic considerations, being unique and only fleetingly displaying the apparent traces of various textual elements. The act of reading signs on the screen (written signs, both alphabetic and non-alphabetic) is essential to understanding that other texts may exist, essential to evaluating their nature and volume, essential to triggering their actualization. The very materialization of texts therefore becomes a direct product of reading.

That is why, even though the potential presence of nonwritten signs—notably the possibility of directly hearing speech, without having to represent it via writing—is a crucial element of any poetics of multimedia, it is indeed within the visible sphere of the screen that the richest possibilities for a creative reading now reside.

Multimedia's written sphere gains new and paradoxical complexity in confronting this constraint. First, without being immaterial in any way, it possesses a labile, luminescent materiality linked to manifestations of a physics of the invisible, giving new form to what might be called the immanent transcendence of the written text and suggesting that something revelatory is hidden behind its glow and its apparent depth. Thus the overall economics of a text always maintains an unstable balance between *making visible* and *skillfully masking*. In fact, when it comes to writing,

"interactivity" signifies an art of masking: the text can only be called interactive, metaphorically, insofar as it hides itself, imperceptibly revealing itself to our gaze and fingers. The "active" signs of multimedia are the ones on which the questions of initiative and interpretation hinge or, if you will, flicker. Such an image plays a cross-boundary role. To make sense, it must be viewed simultaneously in two ways: as part of a larger image—the text—which is an ever-heterogeneous reality, although one structured by hardware considerations and the more or less constrained temporality of its reading; and as a pointer to other texts toward which it acts, in its very form, as kind of "short cut."

This explains why, in terms of reader initiative, the disjunction between logics (hypertext) and semiotics (multimedia) makes no sense. The stakes are the same, whether involving an understanding of the wealth of the written sign or the potential initiative of shared cultural production. It is by no means certain that multimedia faces a creative, liberating future; it can enjoy one if the instability of the written sign—as exists within ideograms—can be rediscovered in texts of a new type, enriched with a new dynamics of plasticity and rhythm, where visual, discursive, and verbal concepts are mutually stimulating rather than mutually dulling.

That is to say, in contrast to all the metaphors that reduce the written signifier either to immateriality, or to an agglomeration of particles, or to a fluid substance, what is being invoked here is our entire material culture of signs—images, spaces, gestures, objects. What is usually proposed these days is sphere of delusion, employing all the most traditional sites of memory: the window of perspective, the architecture of museums, the box into which objects are invested; the allusion to books is limited to "pages" and "links." Yet the challenge to multimedia writing is perhaps to liberate itself from this culturally constrained imaginative realm, clearly dictated by certain habits of our bodies: the egocentrism of the gaze, the delimitation of spaces, the hoarding of cultural objects. This may only be possible by going beyond the statutory time-limits on which those objects of memory set their store, by seeking the raw, living sources of a writing that grapples with its own institutions and social role. Without that critical awareness, the writing

of web texts and images may well offer little more than the totalizing, indeed totalitarian, habits of our way of looking.

It is impossible to predict whether certain possibilities of multimedia, such as the ubiquitousness of simulation and the accelerating pace of messages—compromising the very comprehension of a text—will lead to a mutation of writing into something as yet unnamed. We might anticipate, however, that as long as the initiative of users requires the recognition of visual elements on a screen, those users will basically remain readers, and multimedia will basically remain a form of writing. That writing will be nourished, of course, on a new interplay of spectacle, speech, and physical gesture, and probably borne by the musical dimension of rhythm.

Bibliography

ANIS, J. *Texte et ordinateur: L'Écriture réinventée?* (Brussels: De Boeck Université, 1998).

BALPE, J.-P. (ed.). *Hypertextes et hypermédias* (Paris: Hermès, 1995).

BEGUIN, A. (ed.). "Nouvelles écritures, nouvelles lectures," *Spirales* 28 (October 2001).

BERNARD, M. (ed.). "Texte et informatique," *Texte. Revue de critique et de théorie littéraire* 13/14 (1993).

CHARTIER, R. *Le Livre en révolutions* (Paris: Textuel, 1997).

JEANNERET, Y. *Y a-t-il (vraiment) des technologies de l'information?* (Villeneuve-d'Ascq: Presses du Septentrion, 2000).

LARDELLIER, P. (ed.). "Penser le multimédia." *Degrés* 92-93 (1998).

LAUFER, R., and D. Scavetta. *Texte, hypertexte, hypermédia* (Paris: PUF, 1992).

LEBRAVE, J.-L. "Hypertextes – Mémoire – Écritures." *Cenesis* 5 (1994): 9–24.

MIGNOT-LEFEVRE, Y. (ed.). "Multimédias en recherche." *Xoana* 6 (January 2000).

PERAYA, D. "Structures et fonctionnement sémiotiques des icônes de logiciels et d'environnements informatiques standardisés (ILEIS)." *Recherches en communication* 10 (1998).

POISSANT, L. (ed.). *Esthétique des arts médiatiques*, 2 vols (Montreal: Presses de l'Université du Québec, 1995).

SOUCHIER, E. "L'Écrit d'écran: pratiques d'écriture et informatique." *Communication et langages* 107 (March 1996): 105–119.

VANDERDORPE, C. *Du papyrus à l'hypertexte: Essai sur les mutations du livre et de la lecture* (Paris: La Découverte, 1999).

VAN SEVENANT, A. *Écrire à la lumière: Le Philosophe et l'ordinateur* (Paris: Galilée, 1999).

GENERAL BIBLIOGRAPHY

Banniard, Michel. *Viva Voce. Communication écrite et communication orale du iv^e au ix^e siècle en Occident latin* (Paris: Institut des études augustiniennes, 1992).

Bischoff, Bernhard. *Paléographie de l'Antiquité romaine et du Moyen Âge occidental* (Paris: Picard, 1985).

Blanchard, A. (ed.). *Les Débuts du codex* (Turnhout: Brepols, 1989).

Blanchard, Gérard. *Pour une sémiologie de la typographie* (Andenne: Magermans, 1979).

Catach, Nina. *La Ponctuation* 2118 (Paris: PUF, 1996, collection "Que sais-je ?").

Chadwick, John. *Le Déchiffrement du linéaire B. Aux origines de la langue grecque* (Paris: Gallimard, 1972).

Chapon, François. *Le Peintre et le livre. L'âge d'or du livre illustré en France, 1870-1970* (Paris: Flammarion, 1987).

Christin, Anne-Marie. *L'Image écrite ou la déraison graphique* (Paris: Flammarion, collection "Champs", 2001).

————. *Poétique du blanc. Vide et intervalle dans la civilisation de l'alphabet* (Leuven: Peeters/Vrin, 2000).

Clanchy, M.T. *From Memory to Written Record, England 1066-1307* (Oxford and Cambridge: Blackwell Publishers, 1993).

Cohen, Marcel. *La Grande Invention de l'écriture et son évolution*, 3 vols. (Paris: Imprimerie nationale-Klincksieck, 1958).

Derrida, Jacques. *De la grammatologie* (Paris: Ed. de Minuit, 1967).

Desbordes, Françoise. *Idées romaines sur l'écriture* (Lille: Presses Universitaires de Lille, 1990).

Detienne, Marcel (dir.). *Les Savoirs de l'écriture. En Grèce ancienne* (Lille: Presses Universitaires de Lille, 1990).

Drucker, Johanna. *The Visible Word. Experimental Typography and Modern Art, 1909-1923* (Chicago and London: University of Chicago Press, 1994).

Eisenstein, Elizabeth. *The Printing Revolution in Early Modern Europe* (Cambridge: Cambridge University Press, 1983).

Fabre, Daniel (ed.). *Par écrit. Ethnologie des écritures quotidiennes* (Paris: Ed. de la Maison des Sciences de l'Homme, 1997).

Février, James G. *Histoire de l'écriture* (Paris: Payot, 1995, collection "Grande bibliothèque").

Fraenkel, Béatrice. *La Signature* (Paris: Gallimard, 1992).

Furet, François, AND Jacques Ozouf. *Lire et Écrire. L'alphabétisation des Français de Calvin à Jules Ferry*, 2 vols. (Paris: Ed. de Minuit, 1977).

Gaur, Albertine. *A History of Writing* (New York-London: Cross River Press, 1992).

Gelb, Ignace J. *Pour une théorie de l'écriture* (Paris: Flammarion, 1973, collection "Idées et Recherches").

Glassner, Jean-Jacques. *Écrire à Sumer. L'invention du cunéiforme* (Paris: Seuil, 2000).

Goody, Jack. *The domestication of the sauvage mind* (Cambridge: Cambridge University Press, 1977).

Gray, Nicolete. *A History of Lettering* (Oxford: Phaidon Press, 1986).

Guyotjeannin, Olivier, Jacques Pycke, and Benoît-Michel Tock. *Diplomatique médiévale* (Turnhout: Brepols, 1993).

Harris, William, V. *Ancient Literacy* (Cambridge [Mass.] and London: Harvard University Press, 1989).

Jefferey, L. H. *The Local Scripts of Archaic Greece* (Oxford: 1961, reprint 1998).

Le Men, Ségolène. *Les Abécédaires français illustrés du xix^e siècle* (Paris: Promodis, 1984).

Leroi-Gourhan, André. *Le Geste et la Parole*, 2 vols. (Paris: Albin Michel, 1964).

Martin, Henri-Jean. *Histoire et pouvoirs de l'écrit* (Paris: Albin Michel, 1996).

————. *La Naissance du livre moderne* (Paris: Cercle de la Librairie, 2000).

Massin. *La Lettre et l'Image* (Paris: Gallimard, 1993).

Melot, Michel. *L'Illustration* (Geneva: Skira, 1984).

————, A. Griffiths, and R. S. Field. *L'Estampe* (Geneva: Skira, 1981).

Petrucci, Armando. *Jeux de lettres. Formes et usages de l'inscription en Italie, XI^e-XX^e siècles* (Paris: Ed. EHESS, 1993).

Roberts, C. H., and T. C. Skeat. *The Birth of the Codex* (London, 1983).

Stiennon, Jacques. *Paléographie du Moyen Âge* (Paris: Armand Colin, 1991).

COLLECTIVE WORKS

De plomb, d'encre et de lumière (Paris: Imprimerie nationale, 1982).

L'Écriture et la psychologie des peuples (Paris: Armand Colin, 1963).

Le Grand Atlas des littératures (Paris: Encyclopædia Universalis, 1990).

Histoire de l'édition française, R. Chartier and H.-J. Martin (eds.), 4 vols.: 1, *Le Livre conquérant. Du Moyen Âge au milieu du XVII^e siècle*; 2, *Le Livre triomphant*; 3, *Le Temps des éditeurs*; 4, *Le Livre concurrencé* (Paris: Fayard/Cercle de la Librairie, 1989-1991).

Le Livre au Moyen Âge, J. Glenisson (ed.) (Paris: Presses du CNRS, 1988).

Le Texte et son inscription, R. Laufer (ed.), actes du colloque de 1984 (Paris: Editions du CNRS, 1989).

EXHIBITION CATALOGS

Naissance de l'écriture. Cunéiformes et hiéroglyphes. Paris, Galeries nationales du Grand Palais, Réunion des musées nationaux, 1982.

L'Aventure des écritures. Naissances. A. Zali and A. Berthier (ed.), Paris, Bibliothèque nationale de France, 1997.

L'Aventure des écritures. Matières et formes. S. Breton-Gravereau and de D. Thibault (ed.), Paris, Bibliothèque nationale de France, 1998.

L'Aventure des écritures. La page. A. Zali (ed.), Paris, Bibliothèque nationale de France, 1999.

PUBLICATIONS OF THE *CENTRE D'ÉTUDE DE L'ÉCRITURE*

"L'espace et la lettre," A.-M. Christin (ed.), *Cahiers Jussieu* 3 (Paris: UGE 10/18, 1977).

"Dire, voir, écrire; le texte et l'image," A.-M. Christin (ed.), *34/44* 6 (1979).

Écritures, A.-M. Christin (ed.), actes du colloque de 1980 (Paris: Le Sycomore, 1982).

Écritures II, A.-M. Christin (ed.) (Paris: Le Sycomore, 1985).

"Écritures paradoxales," *Textuel 34/44* 17 (1985).

Écritures III : Espaces de la lecture, A.-M. Christin (ed.), actes du colloque de 1985 (Paris: Retz, 1988).

"L'appropriation de l'oral," A. Prassoloff (ed.), *Cahiers Textuel* 7 (1990).

Qu'est-ce qu'une promesse?, A. Prassoloff et P. A. Brandt (eds.), actes du colloque de 1990 (Aarhus University Press, 1992).

"Le conte et l'image," S. Le Men (ed.), *Romantisme* 78 (1992).

"Écrire, voir, conter," A.-M. Christin (ed.), *Textuel* 25 (1993).

Illettrismes, Écritures IV, B. Fraenkel (ed.), actes du colloque de 1991 (Paris: Edition BPI/Centre Pompidou-*Textuel*, 1994).

L'Écriture du nom propre, A.-M. Christin (ed.), actes du colloque de 1995 (Paris: L'Harmattan, 1998).

Entreprise et sémiologie, B. Fraenkel and C. Legris (ed.), actes du colloque de 1998 (Paris: Dunod, 1999).

Figures de l'anonymat: médias et société, F. Lambert (ed.), actes du colloque de 1999 (Paris: L'Harmattan, 2001).

"Écriture et typographie en Occident et en Extrême-Orient," Ph. Buschinger (ed.), *Textuel* 40 (2001).

L'Image pour enfants, A. Renonciat (ed.), actes du colloque de 2000 (Poitiers: La Licorne, 2002).

INDEX

Numbers in *italics* refer to illustrations

Abbasids 220

Achaemenid 34, 39, 212

Aegean scripts 197-202

Afghanistan 104, 212

Africa: north, 213; sub-saharan, 225, 278-284. *See also* entries for individual countries

Akkadian 21, 25-26, *26,* 27-29, *34,* 35, 41, 42, 204

Albanian 257-263, *258*

Alberti, Leon Battista 9

Al-Biruni 100

Aleph 54, 216-217

Alexander the Great 98, 212

Amhara (Ethiopia) 283-284

Ammonite 207, *207*

Andhra Pradesh 102

Angoulème, Marguerite d' 350

Antemoro 280

Anuradhapura (Sri Lanka), 110, 111

Apollinaire, Guillaume 379, *381,* 382

Arabic 204, 218-227, 228-231, 279-280, 281, 282-283

Aramaic 21, 98, 110, 111, 113, 114, 205, 208-209, *208, 209,* 210-214, *212,* 219

Armenia *256,* 257-263

Armenian 257-263, *259, 260, 261*

Asia, central 93, 99, 101, 103, 104, 109, 113, 115, 222

Asia, southeast 99, 104, 148-153

Asoka 94, 96, 98, 99, 104, 106, 110, 111, 112, 113, 114, 115, 212

Assurbanipal: library of, *31,* 42; scholar-king, 40

Assyriology 33-43

Athens 234, 238, 240, 240

Augereau, Antoine 350

Axum (Ethiopia) 282, 284

Azerbaidjan 257, 260

Aztec 179-187

Babylon *30. See also* 33-43

Badashanren. *See* Zhu Da

Bade, Josse 349

Balkans 265, 268

Balzac, Guez de 320, 356

Bamum 280-281, *281*

Bangladesh 100

Banskhera *117*

Barthel, Thomas 173, 192

Barthelemy, Abbé Louis 314, *314*

Barthes, Roland 334

Baskerville, John 356, 363

Beaudoire, Théophile 364

Beaudouin, Paul *359*

Beaujeu, Édouard de 316, 317

Behistun (Iran) 33, *34,* 35

Bekele, Momolu 280

Belarus 265

Belloli, Carlo 380

Bengal 100

Benton, Linn Boyd 364, 384

Bergen (Norway) 274

Berlin, Heinrich 172

Berquin, Arnaud 369

Berry, duc de: as patron 303; book of hours, *303*

Berthaud, Abbé 326

Bewick, Thomas *326,* 327

Billeter, J.-F. 76

Bologna 310, 347

Bonnard, Pierre 373, *374*

Bourbourg, Brasseur de 172

Bricker, Victoria 178

Buddhist writings 124-127, 149-153, *158,* 160. *See also* Southeast Asia

Buffon: *Natural History,* 356

Bühler, Georg 102, 112, 114

Bulgaria 17, 265, 266

Burroughs, William 380

Bush, Vanevar 387

Butor, Michel 335

Byzantine era, 314

Caere (Italy) 245, 246, *246,* 248

Cai Rong 76

Cambodia. *See* Southeast Asia

Cameroon 280

Canaanite 203, 205-208, 234

Cappiello, Leonetto 375

Carolingians 287-303

Carroll, Lewis *368,* 370

Caslon, William 363

Cassandre, A. M. 375, 380

Catherwood, Frederick 169

Caucasus 257-263

Cendrars, Blaise *376, 381*

Cera (dynasty) 101

Chalcidians 245
Champfleury (Jules Fleury) 373
Champollion, Jean-François 9, *10,* 50, 54
Chan Chin-Chung 84
Charlemagne 287, 310
Charlet, Nicolas 327, *327*
Charters 296-301
Chéret, Jules 373
Chevalier, Michel 324
Chiapas (Mexico) 169, 171
Chichen Itza (Yucatan) 171, 172
China: Buddhist texts in, 145; divination in, 90-91; printing in, 159-165; writing in, 66-91; 93, 101, 115, 116,
Chinese: and Japanese, 123-141; and Korean, 154-155; and Vietnamese, 156-157
Choa (Ethiopia) 282, 283
Chol 171-172, 176
Cholti 172
Chorti 171
Claudian Table 250
Coba (Yucatan) 171
Coe, Michael 170
Colette 334, 337
Colin, Paul 375
Colonna, Francesco 348, 379
Comenius, Jean Amos 326
Copan (Honduras) 169, 170, 171, 172
Coptic 283, *283*
Corbie (France) 287, 288, 289
Cordovero, Moïse 216
Crane, Walter 328
Crenne, Hélisenne de 320
Crete 197-200, 202. *See also* Aegean scripts
Croatia 265. *See also* Cyrillic
Cros, Charles 381
Cui Yuan 76
Cuneiform 20-43
Cypriot. *See* Aegen scripts
Cyprus 197, 200-201, *201,* 202, 233
Cyrillic 98, 265-270
Czech 265

Damascus (Syria) 208, 228, 229, 230
Damase, Jacques *366*
Dandin 118
Dangxiang (Tangut)160, 162
Danube, civilization of 17-19

Darius I 33, *34,* 114
Deir 'Alla (Syria) 208, *209*
Dekkan 101, 102, 104, 112
Delacroix, Eugène 381
Delaunay, Sonia *366,* 370, *376,* 381
Delhi-Topra *113, 115*
Delphi 235, 252
Démocrite d'Abdère 33
Demotic 33
Demoulins, François 349, *349*
Denis, Maurice 381
Denmark 271, 274
Descartes, René 356
Deveria, Jacques 373, 381
Dhar 118
Didot: family, 356, 364; typeface, *356, 375*
Dong Qichang 81
Dorat, Claude Joseph 356
Dotremont, Christian 380
Dubois, Jacques 350, *350*
Dumas, Louis 326, 370, *370*
Dürer, Albrecht 13-14, *13*
Dutreuil De Rhins, Jules Léon 105

Easter Island. *See* Rongo-Rongo
Ebla (Syria): Eblaite, 35; palace, 35; 42
Edessa 213, 214, 258
Edomite 203, 208, *208*
Egypt: as conduit for Arab texts, 283-284; cuneiform used in, 21; hieroglyphics translated, 9, *10;* scripts of, 44-65; use of Arabic in, *223;* use of Aramaic in, 210
Elam: kingdom of, 34; Elamite, 33, 34, *34,* 110
Elzevier 313
Enkatei Yoshikuri 145
Erasmus 13,*13,* 320
Este (Italy) 248
Estienne, Robert 312, 349, *350*
Ethiopia 282-284
Ethiopian 106
Etruscan 245-247, 253, 310
Euboean alphabet 239
Evans, Arthur 198

Falkenstein, Adam 19
Fang Congyi *79*
Fedorov, Ivan 269, *269*
Feliciano, Felice 384

Fichet, Guillaume 347
Finlay, Ian Hamilton 380
Flaubert, Gustave 334, 335, *336,* 337, 340-341
France: and early Danube culture, 17; humanist script in, 349; printers and printing in, 347, 350, 356, 357-358, 359, 363, 367-368; rise of literacy in, 330, *331*
François I 349, 372
Freinet, Célestin 371
Freire, Paolo 330
Fujiwara no Hideyoshi 142
Fujiwara no Michinaga 126
Fukiwara no Yukinari 135
Furet, François 330
Fust, Johannes *344,* 345-346

Galarza, Joaquín 179, 184
Galtier, Gérard 280
Gandhara 94, *98,* 104, 109, 111, 114, 115
Gandhari *95,* 104, *105,* 106, 112
Garamond, Claude 350, 363
Geez 106, 282-284, *283*
Genet, Jean 334
Georgia 257, 260
Georgian 257-263, *259, 262*
Germany: and early Danube culture, 17; printers and printing in, 344-345, 350, 357-358; typeface for children in, 368; vernacular in, 301
Gezer tablet *205,* 206
Gide, André 337, 381
Gilissen, Léon 292
Girnar (Gujerat) *95, 99*
Godard, Louis 199
Goethe 340, 373, 381
Gomringer, Eugen 380
Goody, Jack 279, 330
Gradesnica 18, *18*
Granjean, Philippe 364, 384
Granjon, Robert 350, 363, 367
Greek: and Aegean scripts, 197-198, 201; alphabet, 97, 98, 113, 114, 232-240, 245; and Caucasian languages, 258, 262; coins, 254-255; and Cyrillic, 265-266; rule of Egypt, 48; spread of, 214; on the stele of Xanthos, 211; use of by Gauls, 239, *240;* vase inscriptions, 241-243

Greenaway , Kate 328, *328*
Griffo, Francesco 348, 363
Grotefend, Georg Friedrich 33
Grube, Nikolai 176, 177, 178
Guatemala 169
Gubbio (Italy), tables of *248, 249*
Gujarati (India) 101
Gummarp Stone *272, 273*
Gupta dynasty 99, 103, 104
Gurage 283
Gutenberg, Johannes 344-346, 363

Hamdullah, Sheikh 225
Hammurabi, code of *25*
Hanasanjin 145, *146*
Han dynasty 73, 76, 77, 225
Harari 283
Harsa *117*
Harunobu, Susuki *122*
Hatra (Mesopotamia) 213
Hebrew 203, 205, *206*, 213, 214, 215,
 216. *See also* Paleo-Hebrew
Heian (Japan) 126, 136
Hellé, André 328
Henri II 315
Herculanum 252
Heynlin, Johann 347
Hieratic 33
Hierogylphics 44-65
Hilprecht, Hermann V. 43
Hittite 35
Hon.Ami Kôetsu 142, *143*
Honduras 171
Hooch, Pieter de 320, *321*
Horapollon 50
Huang Fengchi 165
Huang Tingjian 89
Hugo, Victor 335, *335,*
Huizong, Emperor *75*
Hurrite 35

Icelandic 273
Idalion (Cyprus) 201, *201*
Ifoghas inscriptions 279
Incas 190-191
India: 92-121; *bihari* script in, 225; and
 South Asian scripts, 149-151
Indus river 98, 109, 110, *110*, 113, 210
Ionia (Greece) 234, 239, 254
Iran 33
Ireland. *See* Ogamic script

Irish. *See* Ogamic script
Israel 215
Issunshi Hanasato 139
Italy: literacy in, 330; printers and
 printing in, 345, 348, 356; scripts of
 ancient 244-253; use of Greek alpha-
 bet in, 233; writing in, 310-311
Ixtlilxochitl, Alva 181-182

Jacno, Marcel 375, *375*
Jaina 115, *119*
Japan: press in, 166-167, *167;* printing
 in, 160, 163, 165; writing in, 123-141;
 writing and painting in, 142-147.
 See also Buddhist writings, Xylog-
 raphy
Javel, Émile 368
Jenson, Nicolas 348, 363
Al-Jidr, W. 43
Jien 137
Johannot, Tony 373, *373, 379, 379*
Joyce, James 380
Judeo-Aramaic 213
Justeson, John 173

Kabala 216-217
Kamo No Chômei 137
Kang Youwei 78
Karadzic, Vuk 270
Karnataka (India) 101
Kashmir 100, *100*
Katyayana 112
Kells, Book of 304-307
Kerala (India) 101, 102
Kharaosta 106
Khlebnikov, Velimir 380
Khmers 150, *153*
Khorsabad (Mesopotamia) 35, *35*
Khotan (China) 105, *105*
Kiev Missal *264*
Ki no Tsurayuki *130,* 134
Kitasono, Katsue 380
Knossos (Crete) 197, 198
Knorosov, Yurii 172, 173
Kolar, Jiri 380
Kômyô, Empress of Japan 125
Konkani 98
Korea: alphabet of, 154-155; immigra-
 tion to Japan, 124; printing in, 160,
 163, 165. *See also* Xylography
Koriwn 258, 260, 262, 263

Kôshô 137
Kûkai 128

Laclos, Choderlos de 335
La Fontaine, Jean de 356
Lahore (Pakistan)111
Landa, Diego de 172, *174*
Laos 150, 151. *See also* Southeast Asia
Latin: alphabet in Africa, 280-281;
 alphabet in India, 98, 99; alphabet
 in Japan, 138; alphabet in Vietnam,
 156; and Cyrillic, 265, 270; learning,
 288; letterforms, 363; and Ogamic,
 276, 277; relation to Etruscan, 245,
 310; and runes, 271, 274
Leduc, Violette 337
Leibniz, Karl 50
Lesclache, Louis de 313-314, *313*
Liège hand 299-300
Linear A. *See* Aegen scripts
Linear B. *See* Aegen scripts
Li Ruiqing 84
Li Shimin 87
Lissitsky, El 375, 380, *381*
Lithuania 269
Liu Xie 163
Lloyd Stephens, John 169
Locke, L. L. 191
Loulan 105
Loupot, Charles 375
Lowenstern, Isidore 35

MacLeod, Barbara 173
Madagascar 280
Maghribi 221, 226
Malagasy 280
Maler, Teobert 172
Mali *278,* 280
Malinka 280
Mallarmé, Stéphane 13, 379, 381
Manet, Édouard 373, 381
Mantegna, Andrea 311, *311*
Mantragupta 119
Manutius, Aldus 311, 348, *348,* 349,
 363, 379
Mari (Mesopotamia): archives, 38;
 palace, 37, 40; tablets from, *28, 39,
 42, 42*
Marot, Clément 350
Marsiliana d'Albegna 245, *246*
Masaba syllabary 280

Masson, André 12
Maštoc' 258, 260, 262, 263
Mathews, Peter 172, 176
Mathias Corvin 311
Matisse, Henri 12
Maudslay, Alfred 172
Maurya dynasty 94, 102, 104, 110, 111, 113, 114
Maximilian I 351
Maya 168-178
Mayakovsky, Vladimir *381*
Megasthenes 110
Mende 280
Meroe (Sudan) 48
Meroitic 48
Mesoamerica 168-191
Mesopotamia: cuneiform in, 20-32; map of, *30;* scribes in, 37-43. *See also* Assyriology
Mexico: 169, 172; literacy in, 329, 330
Michaux, Henri 333
Middle East 109, 110
Mi Fu 78
Ming dynasty 78, 83, 87
Mithila 100
Mixtec 179, 188-189, 188, 189
Moabite 203, 208
Mohenjo-Daro *110*
Mons 150
Mons (Belgium) 308-309
Montaigne, Michel de 320, 354
Montpensier, Mademoiselle de *334*
Morohashi Tetsuji 139
Motte, Charles *318*

Nabatean 210, 213, 219
Nagari *96,* 99, 100, 101, 103, 107, 117
Nahuatl 179-187
Naqdh-i-Rustam (Persia) 33
Nara: archives of, 124; period, 125, 127; capital of Japan, 124, 128
Near East 21, 32, 35, 42. *See also* Cuneiform, Assyriology
Nearchus 110
Neolithic calendar 17, *17, 18*
Nepal 100, *101*
Nerval, Gérard de 335
Nguyen-Ngoc-Xuan 157
Niccoli, Niccolo 348
Niebuhr, Carsten 33
Nie Chongyi 162

Nineveh (Mesopotamia) 42
Nippur (Mesopotamia) 22, *30*
Nisbet, John 368
Niya 105
Ni Yuanlu 78
Njoya, King 280, 281
Nodier, Charles 373, 379, *379*
Norway, runes in 271-275
Novgorod 268, *268*

Ogamic script 276-277
Ono no Michikaze *134,* 135
Oppert, Jules 34, 35
Orissa (India) 100
Oromo 283
Ozouf, Jacques 330

Pahlavi 98, 212
Pakistan 104, *104,* 111
Palenque (Yucatan) 169-173, 176, *176, 177, 177*
Paleo-Hebrew 206-207, 208, 213-214
Palestine 203, 204, 209, 213
Pali *102,* 111, 150
Pallava dynasty 101, 104
Palmyra 213
Pannartz, Arnold 363
Panini 96, 109, 110, 111, 112, 113
Paris (France) 320
Parrot, André 40
Parsees 98
Parthian empire 212
Pasquier, Étienne 320
Pech-Merle cave paintings 11, *11*
Perec, Georges *338*
Pergamon 42, 252, 254, 290
Perrin, Louis 364
Persian 222, 225; and cuneiform, 33, 34, *34;* empire, 210-212
Petrucci, Armando 329
Pfinzing, Melchior *351*
Phaistos disk 198, 201-202, *202*
Philistian 203, 205-206
Phoenician 113, 114, 203, 205, 213, 233, 236, 239
Picasso, Pablo 383, *382-383*
Piedras Negras (Yucatan) 172
Plantin, Christophe 313, 367
Poe, Edgar Allan 381
Poisson, Robert 314
Polish 265

Pompeii 252
Ponge, Francis 333, 335
Pound, Ezra 380
Prakrit 94, 99, 104, 106, 109, 112
Prinsep, James 98
Proskouriakoff, Tatiana 172
Proto-sinaitic 33
Proust, Marcel *337,* 340
Puget de La Serre, Jean 320
Punic 213, *214*
Punjab (India) 100, 109
Pylos, tripod tablets of 198, *198,* 200

Qin empire 73-74
Qingchuan, tablets of 74
Qing (Manchu) dynasty 78, 83, 87
Qin Shi huanghi 74, 75
Qiu Wembo *86*
Quechua Cakchiquel 172
Queneau, Raymond 342-343, *342, 343,* 380
Quirigua (Yucatan) 172
Qumran, manuscripts from 213, *215*

Rabanus Maurus 378, *378*
Rabelais, François 378
Radama I 280
Raiju *134*
Ramses III, Pharaoh 59, 60, *60,* 65, *65*
Rawlinson, Sir Henry 33-35. *See also* Assyriology
Renan, Ernest 34
Renouard, Antoine 369
Reverdy, Pierre 379, *382-383*
Rhodes, Alexandre de 156
Richaudeau, François 369
Roman Forum: Arch of Titus, *249,* 250; *lapis niger, 248,* 249
Rome: Egyptian obelisks found in, 49; end of republicanism, 250-251, invention of the book, 290; literacy in Renaissance, 320; Slavic allegiance to, 265; standardized writing, 310
Rongo-Rongo 192-193, *193*
Ronsard, Pierre de 312-313, *313,* 314
Rosny, Léon de 172
Rousseau, Jean-Jacques 335
Roussel, Raymond 335, 337
Rudrata 118
Runes 271-275
Russia 265, 268, 269

Sabean *282*

Safed (Upper Galilee) 216

Sagan, Françoise 334

Sahagún, Bernardino de 180

Sakhamatov, A. A. 270

Samaritan 213, 214

Samsī-Addu, King of Mari 38

Santō Kyōden 145

Sanvito, Bartolomeo 311

Sarzec, Ernest de 35

Sassanid empire 212

Sassoon, Rosemary 369, *369*

Saussure, Ferdinand de 12

Savoie, Louise de 350

Scandinavia 271-275

Schele, Linda 172, 173, 176

Schellhas, Paul 172

Schoeffer, Peter 345

Schwitters, Kurt 380

Scotland 276

Scribes: in Europe, 287-294; in Mesopotamia, 37-43

Scudéry, Madeleine de 355

Seelande (Denmark) 271

Seiichi Niikuni 380

Sejong , King 154

Seler, Eduard 172

Seleucid period 39

Seleucos 254, 255, *255*

Semitic 114, 203-215, 219

Senefelder, Aloys 373

Sennacherib, prism of 31

Serbia 265, 270

Sesostris III, lintel of Pharaoh *46-47, 64*

Seyssel, Claude de 349

Shaduppum (Tell Harmal) 43

Shang dynasty 70, 91

Shi Tao 78

Shōmu, Emperor of Japan 125

Shōtoku, Empress of Japan 125, 160

Shulgi, King of Ur 24, 40

Shu Shi 78, 82, 83-84, 89

Sidney, Sir Philip, 355

Sikhs 100

Sima Qian 74

Simeon, Tsar 265

Simeoni, Gabriello *352*

Simmias of Rhodes 378, *378*

Sinhalese 102, *102*

Sindhi 98

Slavic 265, 266, 270

Slovak 265

Slovenian 265

Spain: conquest of Mesoamerica, 179, 181, 193; illiteracy in, 331; Kabala in, 216; Phoenician colony in, 205; use of paper in, 302

Spanish: translation into, 171-172; vernacular, 301

Somaize, Antoine Baudeau Sieur de 313

Song Bing 80

Song dynasty 77, 83, 128, 162

Sorabe 280, *280*

South Arabian script 209-210

Southeast Asia 149-153

Sri Lanka 102, 110

Stendhal 334, *336*

Sterne, Laurence 379

Stiennon, Jacques 299-300

Stuart, David 176

Subashi *103*

Subiaco (Italy) 363

Su Dongpo. *See* Su Shi

Sui dynasty 83, 128

Sumerian 19, 21, 22-32, 35, 40-41, 42, 110. *See also* Assyriology, Mesopotamia

Susa (Iran), tablets from 34

Swahili 279

Sweden 273, 274

Sweynheym, Conrad 363

Sylvestre de Sacy, Antoine Isaac 34

Syria 23, 208, 233

Syriac 214, 219

Taberd, J.-L. 156

Tachygraphs. *See* demotic, hieratic

Tadamine 135

Tamil *92, 94,* 101, 102, 104

Tang dynasty 71, 77, 78, 80, 83, *86,* 87, 128, 132, 161

Tangut. *See* Dangxiang

Tarquinia 245, *247*

Tartaria (Romania), tablets from 19, *19*

Tawaraya Sōtatsu 142

Tel Dan 208, *209*

Tell El-Fekheriyeh 208, *208*

Tell Harmal. *See* Shaduppum

Telugu 101

Tensini, Agostino *330*

Tériade 382

Teyssèdre, A. Person de *323*

Thomas Aquinius, Saint 303

Thomas, Cyrus 172

Thompson, Eric 171, 172, 173

Thutmosis III, Pharaoh 52, *52*

Tibet 99, 101, 109, 115

Tigrinya 283

Tikal (Guatemala) 170, 171, 172, 176

Tonina (Mexico) 170

Torii Kiyohiro 142, 144

Tōri Kiyonaga 140

Tory, Geofroy 312, *312,* 350, *351,* 379, 384

Tournes, Jean de *354*

Tronchet, Étienne du 20, 320

Trondheim (Norway) 274

Troy 255

Tschichold, Jan 375, 380

Turkey, literacy in 330

Turkish 222

Turkistan *103*

Tuscany 245, 310. *See also* Etruscan

Tzeltal 172

Udi 260

Ugaric 203

Ugarit (Syria) 58

Ujjain (Madhya Pradesh) 117, *120*

Ukraine 260, 265, 268

Un 117

United Kingdom 98; primers in, 326-328, 368; printing and printers in, 356, 358, 363

United States 368

Uppland (Sweden) 274

Ur (Mesopotamia) 21, 38, 41, 43

Urdu 98

Uruk (Mesopotamia), tablets of 19, 21, *22,* 40

USSR 329, 330

Uttar Pradesh *117*

Uygur (Uighur) kingdom 163

Vai 280, 281

Valéry, Paul 10, 337, 379

Veii (Italy) 247, 248

Venice 311

Ventris, Michael 198

Vialou, Denis 12

Vietnam 156-157. *See also* Southeast Asia

Vilar, Jean 375

Vinca (Yugoslavia) 17, 18
Vox, Maximilian *362*

Waesbergue 313
Walfoghel, Procopius 345
Wang Hui *81*
Wang Shiheng *165*
Wang Shouren (Wang Yangming) 78
Wang Wei *76,* 78, 82
Wang Xizhi *73,* 77
Wang Zhen 164, *164*
Watts, Lynne 368
Wechel 313
Wuzhun *78*

Xanthos 211, *211*
Xcalumkin (Yucatan) 171
Xerxes 114
Xiao Sihua *74*
Xie Yingsou 83
Xinjiang 99, 104
Xu Chong 70
Xu Shen 68, 69, 70
Xu Wei *80*
Xylography 159-165

Yâqût al-Musta'simi 225
Yaxchilan (Yucatan) 170, 171, 172, 176,
 177
Yin dynasty 68, 70, *90,* 91
Young, Thomas 50
Yttergärde (Sweden) 273, 274
Yuan dynasty (Mongol) 78, 83
Yucatan 169-172

Zeng Xi *84*
Zhang Ruifu 78
Zhang Xu *75,* 77, 134
Zhang Yanyuan 81
Zhao Kui *79*
Zhao Mengfu *75,* 78

Zheng Chang 83
Zhou dynasty 68, 70
Zhu Da 78, *82*
Zimmermann, Gunter 172
Zoroastrians 98

PHOTOGRAPHIC CREDITS

ACKNOWLEDGMENTS

The authors would like to thank Claire Lagarde
for her dedication to this work.
They would also like to thank her team of collaborators:
Sophie Chambonnière, Audrey Gregorczyk,
Tatiana Nadin, Yves Raynaud, Murielle Vaux.

The Publishers extend their sincere thanks to all those
who helped on this project, in particular Catherine Couderc,
Richard Leydier and Barbara Wright.